1001
INTERNET
Tips

Bill Malone, MCSE, MCT, MCP+I

Andrew Wolfe, MCSE, MCT, CCI

JAMSA
P·R·E·S·S
...a computer user's best friend®

1001 Internet Tips

Published by
Jamsa Press
3301 Allen Parkway
Houston, TX 77019
U.S.A.

http://www.jamsapress.com

For information about the translation or distribution of any Jamsa Press book, please write to Jamsa Press at the address listed above.

1001 Internet Tips

Copyright © 2000 by Jamsa Press. All rights reserved. Except as permitted under the Copyright Act of 1976, no part of this publication may be reproduced or distributed in any format or by any means, or stored in a database or retrieval system, without the prior written permission of Jamsa Press.

Printed in the United States of America.
9876543

ISBN 1-884133-67-3

Director	*Performance Manager*	*Copy Editor*
John W. Wilson	Kong Cheung	Rosemary Pasco
Composition	*Technical Editor*	*Cover Design*
Venture Media Group	Tammy Gildersleeve	eM Group
Helene J. Shin		Venture Media Group
Indexer	*Proofer*	
Venture Media Group	Jeanne K. Smith	

This book identifies product names and services known to be trademarks or registered trademarks of their respective companies. They are used throughout this book in an editorial fashion only. In addition, terms suspected of being trademarks or service marks have been appropriately capitalized. Jamsa Press cannot attest to the accuracy of this information. Use of a term in this book should not be regarded as affecting the validity of any trademark or service mark.

The information and material contained in this book are provided "as is," without warranty of any kind, express or implied, including, without limitation, any warranty concerning the accuracy, adequacy, or completeness of such information or material or the results to be obtained from using such information or material. Neither Jamsa Press nor the author shall be responsible for any claims attributable to errors, omissions, or other inaccuracies in the information or material contained in this book, and in no event shall Jamsa Press or the author be liable for direct, indirect, special, incidental, or consequential damages arising out of the use of such information or material.

This publication is designed to provide accurate and authoritative information in regard to the subject matter covered. It is sold with the understanding that the publisher is not engaged in rendering professional service or endorsing particular products or services. If legal advice or other expert assistance is required, the services of a competent professional should be sought.

Jamsa Press is an imprint of Gulf Publishing Company:

Gulf Publishing Company
Book Division
P.O. Box 2608
Houston, TX 77252-2608
U.S.A.

http://www.gulfpub.com

Beginning of New Sections Bolded

Understanding the Internet .. 1
Understanding the History of the Internet 2
Understanding the Makeup of the Internet 3
Understanding RFCs ... 4
Finding RFCs on the World Wide Web 5
Looking at RFCs .. 6
Funding the Internet ... 7
Accessing the Internet ... 8
Understanding the Content of the Internet 9
Understanding the World Wide Web 10
Differentiating between the World Wide Web
 and the Internet .. 11
Understanding the History of the World Wide Web ... 12
Understanding the World Wide Web's Popularity 13
Adding Your Own Site to the World Wide Web 14
Understanding Internet Service Providers 15
Shopping for an Internet Service Provider 16
Differentiating between an Internet Service Provider
 and an Online Service 17
Understanding Analog Connections 18
Understanding Integrated Services Digital Network
 (ISDN) Connections .. 19
Understanding T-carrier Level 1 and 3 Lines 20
Understanding Connection Types 21
Understanding Online Services 22
Navigating America Online .. 23
Searching AOL .. 24
Understanding AOL Channels 25
Using the "Kids Only" AOL Channel 26
Making Travel Reservations on AOL 27
Using AOL's Instant Messenger 28
Building Your Buddy List ... 29
Configuring Your Buddy List 30
Building Your AOL Favorites List 31
Sending AOL e-mail .. 32
Shopping on AOL ... 33
Taking a Class on AOL ... 34
Understanding the AOL Welcome Window 35
Playing Games on AOL ... 36
Reading the News on AOL .. 37
Searching the AOL Member Directory 38
Getting Up-to-date Wall Street
 Information on AOL .. 39
Understanding the Microsoft Network 40
Getting the Software for MSN 41
Updating Your Current Installation
 of the MSN Software .. 42
Using MSN as your Internet Service Provider 43

The MSN Icon on the Taskbar 44
Finding a Connection Phone Number for MSN 45
Using the MSN Default Viewer 46
Using MSN for e-mail ... 47
Working with the MSN *MSNMember* Web Page 48
Using the MSN Update Page 49
Using the MSN Services Menu 50
Using the Web Communities Page 51
Using the Member Services Page 52
Understanding the Support Flash Page 53
Configuring MSN to Notify You When
 Your Friends Are On Line 54
Navigating CompuServe ... 55
Building Your CompuServe Favorite Places List 56
Sending CompuServe e-mail 57
Using CompuServe's "What's New" Window 58
Using CompuServe Forums 59
Installing the Prodigy Software 60
Starting to use Prodigy Internet 61
Using the Prodigy Site Map 62
The Prodigy Icon in the System Tray 63
Changing Your Access Number 64
Checking Your Prodigy Mail 65
Changing Your Account Information 66
Accessing the Internet through Your Company 67
Understanding LANs .. 68
Understanding WANs .. 69
**Monitoring the Content of Your Internet
 Use by Your Company** 70
Monitoring and Reading of
 Your E-mail by Your Employer 71
Sending Material from the Internet to Co-workers .. 72
Understanding Your Internet Protocol (IP) Address . 73
IP Addresses Are Binary Numbers 74
Classes of IP Address ... 75
Understanding Subnet Masks 76
A Shortage of Addresses .. 77
Other Shortcomings of the Internet Protocol 78
Internet Protocol Version 6 79
Understanding Domain Names 80
Understanding How the Domain Name System
 (DNS) Works .. 81
Configuring Windows 98 to Use a DNS Server 82
Registering Your Own Domain Name 83
Using a Directory on Your ISP's Server for
 Your Web Site ... 84
Understanding Uniform Resource Locators (URL) ... 85
Understanding e-mail Addresses 86

Understanding Usernames 87
Understanding and Working with Passwords 88
Using Good Passwords................................ 89
Preventing Your Password from Being Stolen 90
Customizing Modem Settings
 within Windows 98 91
Installing Software for a New Modem
 Under Windows 98 92
Removing Your Old Modem From the
 Windows 98 Modem List 93
Displaying Your Modem Properties.................... 94
Configuring Your Modem's Dialing Properties 95
Using the Dialing Properties Dialog Box
 To Tell Windows 98
 Your Area Code 96
Controlling Phone Line
 Specific Modem Settings 97
Directing Windows 98 to Use Your Calling Card
for Long-Distance Modem Calls 98
Using Modem Dialing Schemes to Simplify Your
 Modem Connections 99
Using a Modem Dialing Scheme 100
Controlling Your Modem's Hardware Settings 101
Understanding Your Modem's
 Communication Port 102
Controlling Your Modem's Speaker Volume 103
 Understanding the Modem Properties
Maximum Speed Setting.............................. 104
Customizing Your Modem's Data
 Connection Settings 105
Setting Your Modem's Call Preference Settings 106
Configuring Your Modem's UART Settings
 For Maximum Performance 107
Taking Advantage of Your Modem's
 Advanced Settings........................... 108
Using The Modem Log.TXT File to
 Trouble Shoot Modem OperaR 109
Using The Windows 98 ISDN Wizard to
 Configure an ISDN Modem Connection .. 110
Using MultiLink Modem Connections for
 Fast Telecommunications 111
Windows 98 Dial-Up Networking112
Using the Windows 98 Dial-Up Server113
Turning Off The Windows 98 Dial-Up Server 114
Disconnecting a Remote User
 from a Dial-Up Session 115
Understanding Virtual Private Networking116
Understanding the File Transfer Protocol (FTP)117
Connecting to an FTP Site Using
 the Command Line 118
Running DOS Commands from
 the FTP Program 119
Using the ls and dir Commands 120
 Working an FTP Site 121
Downloading a File from an FTP Site................ 122
Transferring Files to an FTP Server 123
Adding a File on the Local System to a File
 on the Remote System 124
Setting the Transfer Mode 125
Having Your Computer Make a Noise
 When a File Transfer Is Complete 126
Exiting the Command Line FTP Program 127
Moving Around in an FTP Site....................... 128
Closing a Connection without Exiting
 the FTP Program 129
Making a Connection to an FTP Site after the
 FTP Program Is Started 130
Deleting Files on the Remote Host.................. 131
Using the Debug Command 132
Understanding the Glob Command 133
Using the Hash Command 134
Getting Help from the FTP program. 135
Changing the Directory
 on the Local Computer 136
Looking at the Literal or Quote Command 137
Deleting Multiple Files from an FTP Site........... 138
Getting a Listing of Multiple Directories 139
Getting Multiple Files from an FTP Site 140
Sending Multiple Files to an FTP Site 141
Creating New Directories on an FTP Site 142
Getting the FTP Program to
 Stop Prompting You 143
Seeing Where You Are in the
 FTP Sites Directory Structure 144
Getting a Listing of Commands from the
 Computer at the FTP Site.................... 145
Changing the Name of a File at an FTP Site 146
Deleting a Directory on an FTP Site 147
Determining the Option Settings
 for Your FTP Program 148
The Trace Command 149
Changing Who You Are Logged
 In As on an FTP Site 150
Having the FTP Program Give Less Output 151
Types of Software on the Internet and Places to
 Get Software 152
Installing a Windows Based FTP Program 153
Starting the FTP Explorer Program and
 Connecting to an FTP Site................... 154

Adding New Connection Profiles 155
Using the FTP Explorer Toolbar to
 Change Directories .. 156
Refreshing the View in the
 FTP Explorer Program 157
Using the FTP Explorer Toolbar to Connect
 and Disconnect from and FTP Site 158
Canceling a Command in the
 FTP Explorer Program 159
Downloading Files from an FTP Site 160
Uploading a File to an FTP Site 161
Deleting a File from an FTP Site 162
Viewing the Properties of a File at an FTP Site 163
Changing the Icon Size in the
 FTP Explorer Windows 164
Changing the Transfer Mode 165
Viewing the FTP Log .. 166
Setting Your E-mail Address and the
 Default Download Path for the
 FTP Explorer Program 167
Creating New Directories on an FTP Site 168
Understanding Archie, How Files on the
 Internet are Found **169**
Installing and Using the
 Archie Client from the CD-ROM 170
Using Your Web Browser to Download Files **171**
Working with Graphics and Other File Formats ... **172**
Working with GIF Files ... 173
Working with JPG Files .. 174
Working with TIFF Files 175
Working with .bmp Files 176
Working with .png Files 177
Working with .eps Files .. 178
Working with .wmf Files 179
Working with the .emf Format 180
Working with the .cgm File Format 181
Working with a .dib Image Format 182
Working with the .txt File Format 183
Working with the .exe File Format 184
Working with the .cdr File Format 185
Working with the .prn File Format 186
Working with the OPI Images 187
Working with the .ct File Format 188
Working with the .doc File Format 189
Working with the Other
 Microsoft Office File Types 190
Working with the .pcx File Format 191
Working with the PICT File Format 192
Working with the .tga File Format 193

Working with the .sit File Format 194
Working with the .uue, .uud, and .uu
 File Formats ... 195
Working with the .hqx File Format 196
Working with the .bin File Format 197
Working with the .sea File Format 198
Working with the .arc File Format 199
Working with the .z and .gz File Format 200
Working with the ZIP File Format 201
Working with the .zoo File Format 202
Working with LHARC and the .lha File Format 203
Working with the .arj File Format 204
Working with the .cab File Format 205
Working with the .avi File Format 206
Working with the .wav File Format 207
Working with .mpg Files 208
Working with .mp3 Files 209
Working with .pdf Files .. 210
Working with .mov Files 211
Understanding Hyperlinks **212**
Understanding Thumbnails **213**
Viewing Graphics with Microsoft Photo Editor **214**
Understanding WinZip .. **215**
Purchasing WinZip from the WinZip Web Site 216
Downloading the Evaluation Version of WinZip ... 217
Installing the Evaluation Version of WinZip 218
Creating an Archive ... 219
Adding Files to an Archive 220
Extracting Files from a Self-Extracting Executable . 221
Extracting Files from an Archive 222
Understanding the tar Command **223**
Using the tar Command to Create an Archive 224
Using the tar Command to Extract an Archive 225
Understanding Telnet .. **226**
Starting the Telnet Program That
 Comes with Windows 227
Logging into a Telnet Site 228
Understanding a Shell Account 229
Listing Files and Directories at a Telnet Site 230
Getting around a Telnet Site 231
Starting a program in a Telnet Site 232
Using Telnet to Work Other Telnet Sites 233
Going to the Library from Home and Other Stuff . 234
Using a Telnet Connection to
 Check Your E-mail .. 235
Understanding Pine .. **236**
Starting Pine in a Shell Account 237
Looking at the Folder List in Pine 238
Looking at Your e-mail in Pine 239

Deleting an e-mail Message	240
Sending an e-mail Message	241
Replying to and Forwarding e-mail in Pine	242
Attaching a File to an e-mail Message in Pine	243
Quitting the Pine Program	244
Understanding Linux	**245**
Understanding the Different Versions of Linux	246
Getting a Linux Installation	247
Other Free Versions of Unix	248
Understanding Unix Shells	**249**
Understanding GNU	**250**
Understanding the Ping Utility	**251**
Sending a Continuous Number of Pings	252
Finding a Computer Name if You Know the IP Address of the Computer	253
Having the Ping Utility Send a Set Number of Pings to a Computer	254
Having the Ping Utility Send Pings of Different Sizes	255
Ensuring that the Ping Is Not Broken Up when It is Sent to a Computer	256
Specifying How Many Computers the Ping You Send Can Be Sent Through	257
Setting the Priority of the Ping You Send	258
Having the Ping Utility Remember the Route that It Takes	259
Placing a Time Stamp on the Ping You Send to a Computer	260
Telling the Ping Utility what Route to Take to Communicate with a Computer	261
Setting the Time that Ping Will Wait for a Computer to Respond to a Request	262
Understanding the Finger Command	**263**
Installing the Finger Program That Is on the CD-ROM	264
Using Finger to Find Information about a Person on the Internet	265
Understanding Whois	**266**
Using Whois to Search for an Internet Domain Name	267
Understanding Newsgroups	**268**
The History and Makeup of Newsgroups	269
Working with Newsgroup Categories	270
Using Net-etiquette When Accessing Newsgroups	271
Using Newsgroups Passively	272
Using Newsreaders	**273**
Starting Outlook Express	**274**
Setting Up Newsgroup Servers in Outlook Express	275
Finding Newsgroups and Viewing Messages in Outlook Express	276
Subscribing to Newsgroups	277
Unsubscribing from Newsgroups	278
Posting a Message to a Newsgroup	279
Posting Messages to Multiple Newsgroups	280
Canceling a Posted Message	281
Finding a Message in a Newsgroup	282
Responding to the Group	283
Responding to the Author	284
Forwarding a Message	285
Sending Large Messages to a Newsgroup	286
Attaching a File to a Message	287
Configuring Outlook Express to Use HTML As Its News Sending File Format	288
Inserting a Hyperlink in a Message	289
Inserting a Picture in a Message	290
Starting the Netscape Newsreader	291
Setting Up a News Server in Netscape Messenger	292
Subscribing to Newsgroups	293
Unsubscribing from Newsgroups	294
Understanding Mailing Lists	**295**
Comparing Mailing Lists and Newsgroups	296
Finding Mailing Lists	297
Subscribing to Mailing Lists	298
Unsubscribing from a Mailing List	299
Posting to a Mailing List	300
Understanding Gopher	**301**
Using Your Browser as a Gopher Client	302
Working with a Gopher Site	303
Comparing Gopher to the Web	304
Understanding Veronica	**305**
Understanding Jughead	**306**
Understanding PAL	**307**
Installing the PAL Software	308
Adding Users to Your PAL Window	309
Sending a Message to a Person Using *PAL*	*310*
Responding to Messages from Other *PAL* Users	311
Holding a Conference in *PAL*	*312*
Editing and Removing Names from Your *PAL* List	313
Taking a Break from *PAL* Without Exiting the *PAL* Program	314
Understanding On-Line Chatting	**315**
Using Microsoft Chat to Chat On-Line	316
Selecting a Chat Server	317

Customizing Your Personal Information with Chat	318
Selecting Your Comic Personality	319
Ignoring a Specific User in a Chat Room	320
Whispering to Other Users in a Chat	321
Using Message Macros to Send Common Messages	322
Participating in Multiple Chats	323
Changing Your Chat Expression	324
Entering and Leaving Chat Rooms	325
Creating Your Own Chat Room	326
Selecting Chat's Text View	327
Viewing a User's Identity in Chat	328
Understanding ICQ	**329**
Installing ICQ	330
Starting ICQ	331
Adding Users to Your ICQ list	332
Changing the ICQ Program Window Display	333
Sending a Message to a User on Your List	334
Sending an ICQ User a Web Page Address (a URL)	335
Chatting with Users on Your ICQ List	336
Viewing and Changing Information about Users in Your ICQ List	337
Changing Your Online Status	338
Understanding the ICQ System Menu	339
Understanding the ICQ Menu	340
Using the ICQ Invitation Wizard	341
Using the Add/Change Current User Sub-Menu	342
Using the Security and Privacy Dialog Box	343
Using the ICQ Preferences Dialog Box	344
Understanding the ICQ Program Advanced Mode	345
Using the ICQ Web Search box in Advanced Mode	346
Using the ICQ Now Button	347
The Advanced Mode User Menu	348
Using the Enhanced Online Status Menu in Advanced Mode	349
Understanding ICQ Services	350
Understanding My ICQ Homepage	351
Using the ICQ Reminder Service	352
Using ICQ Notes Service	353
Using the ICQ To Do List Service	354
Using the ICQ e-mail Service	355
Using the ICQ Follow Me Service	356
Working with the ICQ Message Archive	357
Using the ICQ White Pages	358

Viewing Inappropriate Content by Accident	359
Images and the Law	360
Understanding the Internet Content Advisor	361
Specifying Your System's Language, Nudity, Sex, and Violence Settings	362
Controlling User Access to Non-Rated Sites and Supervisor Access to Rated Sites	363
Controlling Your Content Advisor Password	364
Using a Rating Bureau to Get Site Ratings	365
Methods to Protect Your Children on the Internet	366
Understanding MP3 Players	367
Installing WinAmp	368
Working with WinAmp	369
Using MP3 Portable Players	370
Finding MP3 Files on the Internet	371
Understanding Applications Delivered via the World Wide Web	372
Understanding Thin Client Computing	373
Looking at a Thin Client	374
Looking at the Benefits of Using Thin Clients on the WWW	375
Understanding WinFrame Servers	376
Understanding Microsoft Terminal Server	377
Understanding a MetaFrame Server	378
Working with Thin Clients on the Web	379
Working a Thin Client Web Site	380
Understanding CU-SeeMe	**381**
CU-SeeMe Software and Hardware	382
Configuring Your CU-SeeMe Software	383
Using the CU-SeeMe Phone Book	384
Testing Your CU-SeeMe Configuration	385
Creating a New Contact Card	386
Using the CU-SeeMe Listener	387
Connecting to a Conference with CU-SeeMe	388
Using CU-SeeMe to Communicate with One Other CU-SeeMe User.	389
The CU-SeeMe World Web Site	390
Understanding NetMeeting	**391**
Getting the NetMeeting Software for Windows 98	392
Starting NetMeeting Software for Windows 98	393
Changing the Directory Service That Is Used When NetMeeting Starts	394
Calling Another User within NetMeeting	395
Hosting a NetMeeting Conference	396
Placing a Call by Using an IP Address	397
Working with Chat in NetMeeting	398

Working with the Whiteboard within NetMeeting	399
Sending Messages to Just One NetMeeting Participant	400
Ending a Chat Session in NetMeeting	401
Creating Speed Dials in NetMeeting	402
Preventing NetMeeting from Interrupting You	403
Configuring the NetMeeting Call, Audio, or Video Settings	404
Working with Web Directories	405
Using the NetMeeting Home Page	406
Sending and Receiving Files in NetMeeting	407
Sharing an Application	408
Collaborating in NetMeeting	409
Working with the NetMeeting History	410
Setting Your Personal Information in NetMeeting	411
Hanging Up in NetMeeting	412
Working with the NetMeeting Toolbar and Menus	413
Using the NetMeeting Navigation Bar	414
Using NetMeeting with Outlook	415
Setting Up an Internet Locator Server	416
Using NetMeeting as an Internet Phone	417
Understanding Internet Telephony	**418**
Checking Your Computer for the Equipment to Use an Internet Phone	419
Installing buddyPhone	**420**
Placing a Call with buddyPhone	421
Using the Internet in place of a Fax	**422**
Understanding Virtual Reality Modeling Language (VRML)	423
Installing VRML Support within Windows 98	424
Looking at VRML Sites	425
Understanding Computer Security	**426**
Understanding Network Security	**427**
Understanding Physical Security	**428**
Keeping Hackers Out of Your Computer System	429
Understanding Firewalls	430
Understanding Hackers	431
Understanding Computer Viruses	**432**
Understanding Macro Viruses	433
Catching a Virus on Your Computer System	434
Understanding Computer Worms	435
Understanding Virus Protection Software	436
Updating Your Virus Software	437
Running a Virus Check from the World Wide Web	438
Understanding Encryption	**439**
Understanding Key Length for Encryption	440
Understanding Single Key Encryption	441
Understanding Public Key Encryption	442
Understanding Digital Signatures	443
Understanding Smart Cards	444
Distributing Your Public Key	445
Understanding a Digital ID	446
Getting a Digital ID from Verisign	447
Understanding Encryption Software	448
Understanding Areas to Avoid When Working with Encryption	449
Understanding SSL	**450**
Using Digital Certificates with Internet Explorer	451
Shopping Securely on the Internet with a Credit Card	**452**
Getting Pretty Good Privacy (PGP)	**453**
Installing the PGP Software	454
Creating Your PGP Encrypting Key	455
Using PGP to Digitally Sign a Message in Outlook Express	456
Encrypting a Message with PGP in Outlook Express	457
Decrypting a Message That Has Been Sent to You	458
Listening to and Viewing RealAudio Sites across the Web	**459**
Upgrading Your RealPlayer Software	460
Taking the RealPlayer Software for a Test Drive	461
Using the RealPlayer Presets Menu	462
Using the RealPlayer Sites Menu	463
Playing Multimedia Files Using the Microsoft Media Player	**464**
Finding Information on the Internet	**465**
Understanding an Internet Jump Off (or Web Portal)	**466**
Configuring Your Personalized My Yahoo Web Page	467
Configuring Your Personalized MSN Home Page	468
Using Netscape's Customizable Web Portal	469
Understanding and Using a Search Engine	**470**
Searching the Web with MSN Web Search	471
Searching the Web with SNAP.com	472
Searching the Web with the GO Network	473
Searching the Web with www.excite.com	474
Searching the Web with www.yahoo.com	475
Searching the Web with www.lycos.com	476
Searching the Web with www.hotbot.com	477
Searching the Web with www.altavista.com	478
Searching the Web with www.goto.com	479
Using www.dejanews.com	480

1001 Internet Tips

Understanding Your Search Results 481
Refining Your Search .. 482
Understanding Boolean Operations 483
Using AskJeeves.com .. 484
Understanding the Term Web Agent 485
Searching Multiple Sites ... 486
Using the WebFerret Search Utility 487
Using the e-mailFerretPRO Search Utility 488
Using the NewsFerretPRO Search Utility 489
Searching with www.metacrawler.com 490
Searching with the All-In-One Search Page 491
Searching with InfoZoid ... 492
Searching with 1blink.com 493
Using www.monster.com .. 494
Using www.headhunters.com to Find Work 495
Using www.jobs.com to Find Work 496
Researching Potential Employers Online 497
Using Internet White Pages Directories 498
Using Internet Yellow Pages Directories 499
Understanding How Channels Differ
 from Subscriptions .. 500
Viewing a Channel's Contents 501
Viewing a Channel from the Channel Bar 502
Using the Channel Viewer to
 View a Site's Contents 503
Displaying a Channel as a Screen Saver 504
Managing the Channels Folder 505
Changing a Channel's Properties 506
Understanding Web Site Subscriptions
 AKA Offline Web Sites 507
Subscribing to a Web Site or Making the Site
 Available Offline ... 508
Managing Offline Items Like
 Web Sites or Channels 509
Using the Internet Explorer to Browse Offline 510
Synchronizing a Subscription AKA
 Offline Web Site .. 511
Understanding Active Desktop Components 512
Installing Objects from the
 Active Desktop Gallery 513
Using PointCast ... 514
Using a Stock Ticker ... 515
Listening to the Game on the Web 516
Watching the Game on the Web 517
Understanding WebTV .. 518
Getting a WebTV Internet Unit for Your TV 519
Working with your WebTV Unit 520
Understanding WebTV for Windows 521
Installing the Web TV for Windows Software 522
Understanding the Personal Web Server (PWS) 523
Installing the Personal Web Server 524
Starting and Stopping the Personal Web Server 525
Browsing the Web Site Published
 on Your Personal Web Server 526
Having Other People Use Your Personal
 Web Server Web Site 527
Using the Home Page Wizard in
 Your Personal Web Server 528
Using the Publishing Wizard 529
Adding New Directories to Your Web Site 530
Allowing People to Look at Files on Your
 Computer Using Your
 Personal Web Server 531
Designing Web Pages ... 532
Learning from Poorly Designed Web Sites 533
Looking at the HTML Interactive Tutorial 534
Adding Graphics to Your Web Page 535
Defining Your Business on the Web 536
Looking at the Iconographics Design Web Site 537
Looking at the PhotoDisc Web Site 538
Looking at the Clip Art Connection Web Site 539
Looking at the Iconocast Web Site 540
Looking at Guerrilla Marketing Online 541
Looking at the Web Digest for Marketers 542
Looking at the NetMarketing Web Site 543
Looking at the Internet
 Marketing Center Web Site 544
Understanding FrontPage Express 545
Understanding a WYSIWYG HTML Editor 546
Creating a Simple Web Site
 Using FrontPage Express 547
Linking Your Web Pages Together 548
Viewing Your Web Site in Internet Explorer 549
Moving Your Web Site to a Personal Web Server ... 550
Understanding FrontPage 2000 551
Defining the Purpose of Your Web Site 552
Understanding an Effective Web Site 553
Using Folders Under the Web Root 554
Understanding FrontPage Server Extensions 555
Launching FrontPage from Internet Explorer 556
Working with the FrontPage Folder View 557
Working with the All Files Report 558
Working in the Navigation View 559
Working with the Hyperlink View 560
Working with the Broken Hyperlinks Report 561
Working with Themes .. 562
Working with the Task View 563

Creating New Webs	564
Working with the Page View	565
Working in Normal Page View	566
Working in the HTML Page View	567
Working in the Preview Page View	568
Working with Web Page Components in FrontPage	569
Working with FrontPage Active Components	570
Inserting Tables into Your Web Pages	571
Inserting Images into Your Web Page.	572
Working with the Text in Your Web Pages	573
Working with Hyperlinks	574
Understanding Connecting a Database to Your Web Site	575
Understanding Web Forms	576
Understanding Scripts	577
Understanding FrontPage Toolbars	578
Working with the FrontPage Standard Toolbar	579
Working with the Formatting Toolbar	580
Adding a Spreadsheet to Your Web Page	581
Understanding Visual InterDev	**582**
Understanding Electronic Mail	**583**
Starting Microsoft Outlook Express	**584**
Configuring Outlook Express to Send and Receive Internet e-mail	585
Understanding Your Inbox and Other Folders	586
Using the Outlook Express Toolbar	587
Customizing Your Outlook Express Window Layout	588
Customizing the Columns within Your Outlook Express Window	589
Composing an e-mail Message within Outlook Express	590
Understanding the Cc and Bcc Fields	591
Spell Checking Your e-mail Message	592
Selecting e-mail Message Recipients from Your Contacts List	593
Reading a New Message	594
Printing Your Current e-mail Message	595
Forwarding an e-mail Message	596
Replying to an e-mail Message	597
Displaying Only Unread Messages	598
Sorting Your e-mail Messages	599
Finding a Specific e-mail Message	600
Inserting a File Attachment into an e-mail Message	601
Inserting a File's Text Contents into an e-mail Message	602
Viewing or Saving a File Attachment	603
Inserting a Signature into an e-mail Message	604
Creating and Inserting Your Digital Business Card	605
Attaching a Graphic to an e-mail Message	606
Inserting a Web Address into an e-mail Message	607
Viewing Message Properties	608
Creating Your Own e-mail Folders	609
Moving e-mail Messages into a Different Folders	610
Emptying Your Deleted Items Folder	611
Directing Outlook Express to Empty Your Deleted Items Folder Each Time You Exit	612
Creating e-mail Messages Offline	613
Cutting and Pasting Message Text	614
Initiating a Send and Receive Operation	615
Stopping a Receive Operation	616
Understanding Your Outbox Folder	617
Telling If Another User Has Read Your Message	618
Assigning a Priority to Your e-mail Message	619
Encrypting Your e-mail Message	620
Obtaining a Digital Signature	621
Assigning a Digital Signature to Your e-mail Message	622
Using the Outlook Express Address Book	623
Customizing User Properties within Your Address Book	624
Printing Your Address Book	625
Creating and Using an e-mail Group	626
Understanding Outlook Express Message Rules	627
Forwarding Your e-mail to Another Account	628
Scheduling Outlook Express Operations When You are Not Present	629
Controlling Which Messages Outlook Express Downloads from Your e-mail Server	630
Sending a Standard Reply When You Are Away from Your e-mail	631
Using e-mail Stationery	632
Starting Netscape Messenger	**633**
Configuring Netscape Messenger to Send and Receive Internet e-mail	634
Understanding Your Inbox and Other Folders	635
Using the Netscape Messenger Message Toolbar	636
Composing an e-mail Message within Netscape Messenger	637
Understanding the Cc and Bcc Fields	638
Spell Checking Your e-mail Message	639
Selecting e-mail Message Recipients from Your Address List	640
Reading a New Message	641
Printing Your Current e-mail Message	642

Forwarding an e-mail Message	643
Replying to an e-mail Message	644
Sorting Your e-mail Messages	645
Finding a Specific e-mail Message	646
Attaching a File to an e-mail Message	647
Viewing or Saving a File Attachment	648
Displaying Only Unread Messages	649
Creating Your Own e-mail Folders	650
Moving e-mail Messages into Different Folders	651
Emptying Your Trash Folder	652
Cutting and Pasting Message Text	653
Initiating a Send and Receive Operation	654
Assigning a Priority to Your e-mail Message	655
Using the Netscape Messenger Address Book	656
Customizing User Properties within Your Address Book	657
Inserting a Graphic into an e-mail Message	658
Understanding Cookies	**659**
Viewing the Cached Internet Objects Stored on Your Hard Disk by Internet Explorer	660
Viewing the Cached Internet Objects Stored on Your Hard Disk by Netscape Messenger	661
Controlling Your Cookies While Using Internet Explorer	662
Controlling Your Cookies While Using Netscape Messenger	663
Fun on the Internet	**664**
Playing Chess and Other Board Games by e-mail	665
Understanding MUDs, MOOs, MUSHs, and Such	666
Finding a MUD that You Can Play	667
Logging into a MUD	668
Basic Commands in a MUD	669
Looking at the Z MUD Client	670
The MSN Game Zone	671
Games That You Can Play across the Internet	672
Checking Your Lottery Numbers on the Web	673
Using the Games at Yahoo!	674
Computer Gaming at www.happypuppy.com	675
Sending Electronic Cards with Message Mates	**676**
Sending Electronic Cards with Be Mine	677
Finding Campgrounds on the Web	**678**
Visiting National Parks on the Web	679
Making Reservations for a National Park on the Web	680
Finding Parenting Tips on the Web	**681**
Using the Internet for Teaching and Teachers	**682**
Getting Your Classroom Online	683
Internet Technologies to Use in the Classroom	684
A Teacher FTP Site	**685**
Finding Web Sites for Use in the Classroom	686
Working the Internet into a Lesson Plan	687
Citing Material from the Internet	688
Browsing Encyclopedias Online	**689**
Managing Your Students Online	690
Giving Your Students Internet Projects	691
Creating Your Own Class Web Site	**692**
Developing an Internet Exchange with Other Schools	693
Using Mailing Lists for Education	**694**
Newsgroups for Teachers	**695**
Understanding AskERIC	696
Working with the AskERIC Virtual Library	697
Looking at Project Gutenberg	698
Looking at CIA Publications	699
Legal Information on the Internet	**700**
Looking at the LawOffice.Com Web Site	701
Looking at the FindLaw Web Site	702
Looking at the Hieros Gamos Web Site	703
Getting Financial News on the Internet	**704**
Getting Detailed Financial Information About Publicly Traded Companies	705
Shopping on the Internet	**706**
Looking for a Home Online with a Real Estate Company	707
Looking at the Relocate America.com Web Site	708
Finding a Real Estate Broker Online	709
Looking at the Fannie Mae Web Site	710
Looking at Online Mortgages	711
Looking at the Housing and Urban Development Web Site	712
Looking at the Neville Log Home Web Site	713
Setting Up Your Vacation Online	**714**
Planning a Vacation to Big Sky on the Internet	715
Planning a Trip to Go Skiing in Vail	716
Planning a Trip to Disney Online	717
Booking Travel with Expedia	**718**
Taking a Virtual Tour of a College Campus	**719**
Finding College Classes Offered Online	720
Going to the Western Governors University	721
Looking at Colleges that have Online Degree Programs	722
Buying Your Groceries Online	723
Finding a Restaurant Online	724
Buying Toys Online	725
Shopping for Your Next Car Online	**726**

1001 Internet Tips

Finding the Value of Your Old Car 727
Finding the Price of a New Car
 Before You See a Car Dealer 728
Looking at the Safety of Your Car 729
Using an Online Loan Calculator 730
Shopping for a Loan Online 731
Looking at the Car Connection Web Site 732
Using Surplus Auction ..733
Setting Up Your Account at Surplus Auction
 So You Can Bid ... 734
Placing a Bid at Surplus Auction 735
Checking on Your Bid .. 736
Looking at the Amazon.com Web Site737
Looking at an E-Bank on the Web738
Working with a Traditional Bank online 739
Buying Stock Online ...740
Health on the Internet ..741
Looking at the Onhealth Web Site 742
Looking at the MedicineNet Web Site 743
Looking at the InteliHealth Web Site 744
Getting Information About Your Medications 745
Looking at the MSNBC Web Site746
Looking at the USA Today on the Web 747
Reading Business Week on the Web 748
Reading the Wall Street Journal on the Web 749
Looking at the ABC News Web Site 750
Looking at the CNN Web Site 751
Looking at the ESPN Web Site 752
Checking the Weather on the Web753
Looking at the Whitehouse Web Site 754
Using the Interactive Citizens' Handbook 755
Looking at the Thomas Web Site 756
**Finding Legislation by Word or Phrase on the
 Thomas Web Site ...757**
Finding Legislation by Bill Number on the
 Thomas Web Site ... 758
Looking at the Most Recent Issue of the
 Congressional Record 759
Looking at the Voting Record for
 Roll Call Votes on Legislation 760
Looking at the House of
 Representatives Web Site 761
Looking at the Senate Web Site 762
Finding the Home Page of a Member of Congress . 763
Looking at a Supreme Court Web Site 764
Looking at State and Local Governments
 on the Web .. 765
Looking at the NASA Web Site766

Looking at the Department of
 Education's Web Site 767
Looking at the FedWorld Web Site 768
Understanding Shareware769
Understanding Freeware770
Going to Shareware.com for Software 771
Going to the Download.com Web Site 772
Looking at the Tucows.com Web Site 773
Finding Other Download Sites 774
Understanding the Java Platform775
Understanding Applets .. 776
Understanding JavaScript 777
Learning to Write JavaScript 778
Learning to Write Java Programs and Applets 779
Looking at the JavaScript Planet Web Site 780
Looking at the JavaScript Source Web Site 781
Looking at the Doc JavaScript Web Site 782
Looking at the Java World Web Site 783
Looking at the Java Centre Web Site 784
Understanding the Common Gateway Interface.....785
Looking at the CGI101.COM Web Site 786
Looking at the CGI Resource Web Site 787
Understanding Server Side Includes788
Understanding VBScript789
Looking at the Microsoft VBScript Web Page 790
Understanding ActiveX791
Understanding Active Server Pages 792
Understanding Perl ..793
Looking at the National Center for Supercomputing
 Applications Perl Tutorial 794
Understanding Python795
Looking at a Python Tutorial 796
Understanding Push Technologies797
**Understanding Hyper Text
 Markup Language (HTML)798**
**Understanding Dynamic Hyper Text Markup
 Language (DHTML)799**
**Understanding Extensible
 Markup Language (XML)800**
**Using the Windows Internet
 Naming Service (WINS)801**
Understanding NetBIOS802
What Are NetBIOS Computer Names? 803
**Understanding Dynamic Host
 Configuration Protocol804**
Assigning DHCP Scope Options 805
Understanding Firewalls806

1001 Internet Tips

Using a Proxy Server to Access the Internet 807
Understanding the Features and Benefits of
 Microsoft Proxy Server 2.0 808
Understanding Proxy Server 2.0
 Content Caching ... 809
Understanding the Proxy Server 2.0
 Passive Caching .. 810
Understanding the Proxy Server 2.0
 Active Caching .. 811
Understanding the Proxy Server 2.0
 Web Proxy Service .. 812
Understanding the Proxy Server 2.0
 Winsock Proxy Service 813
Understanding the Proxy Server 2.0
 SOCKS Proxy Service 814
Using Proxy Server 2.0 as a Firewall 815
Using Netscape Navigator with a Proxy Server
 to Access the Internet 816
Using Internet Explorer with a Proxy Server
 to Access the Internet 817
Allowing a Server to Configure Your
 Internet Explorer Settings 818
Differentiating between an
 Intranet and the Internet 819
Setting Up Your Intranet ... 820
Using Microsoft Internet
 Information Server (IIS) 821
Understanding the IIS WWW Service 822
Understanding the IIS FTP Service 823
Understanding the IIS NNTP Service 824
Understanding Microsoft Index Server 2.0 825
Understanding the Apache Web Server 826
Obtaining the Apache Web Server Software 827
Installing the Apache Web Server Software 828
Setting the Host Name for Your Computer 829
Understanding the HTTPD.Conf File 830
Starting the Apache Web Server 831
Understanding the Folder Structure
 of the Apache Directory 832
Testing Your Apache Web Server 833
Adding Memory for Your Apache Web Server 834
Displaying Your TCP/IP Address Configuration
 with IPCONFIG .. 835
Displaying Your TCP/IP Address Configuration
 with WINIPCFG .. 836
Releasing Your System's IP Address 837
Renewing Your System's IP Address 838
Using IPCONFIG with the /all Switch 839
Using the IPCONFIG Command with
 the /batch Switch ... 840
Understanding Address Resolution Protocol 841
Displaying the ARP Table on Your Computer 842
Adding an Entry into the ARP Table 843
Deleting an Entry from the ARP Table 844
Understanding the ROUTE Command 845
Understanding ROUTE PRINT 846
Using the Route Command to Add a Route 847
Understanding ROUTE DELETE 848
Understanding ROUTE CHANGE 849
Understanding TRACERT .. 850
Using Tracert Without Hostnames
 Being Returned .. 851
Setting the Maximum Number of Hops the
 Tracert Command Will Take to Connect .. 852
Listing Computers the Tracert Command
 Must Pass Connecting to a
 Remote Computer 853
Changing the Time that the Tracert Command
 Wait for a Reply ... 854
Understanding Internet Name Server Look-Ups ... 855
Installing the NS-Batch Program 856
Looking Up an Internet Name 857
Doing a Reverse Name Look Up 858
Different Types of Internet Names 859
Looking at Protocols .. 860
Understanding the TCP/IP Protocol 861
Installing the TCP/IP Protocol on
 Your Windows 98 Computer. 862
Configuring the TCP/IP Protocol 863
Understanding the SNMP Protocol 864
Understanding the POP Protocol 865
Understanding the SMTP Protocol 866
Understanding the SLIP Protocol 867
Understanding the PPP Protocol 868
Understanding the PPTP Protocol 869
Understanding the NNTP Protocol 870
Understanding the HTTP Protocol 971
Understanding the ICA Protocol 872
Understanding the RDP Protocol 873
Understanding the LDAP Protocol 874
Using Virtual Private Networks 875
Setting Up a Virtual Private Network
 with Your ISP ... 876
Understanding How Point-to-Point Tunneling Works
 in Windows 98 .. 877
Understanding Using PPTP to Connect to Your
 Company's Internal Private Network 878

Installing the Microsoft VPN Adaptor 879	Selecting Sites Using the Internet Explorer Favorites Bar ... 919
Understanding IPSec ..**880**	Organizing Your Favorites Folder 920
Emailing Your Cellular Phone**881**	Viewing a Web Page's Source Code 921
Sending an e-mail to Your Pager**882**	Changing Your Default Web Page 922
Sending Messages from Your Pager 883	Cleaning up Temporary Internet Files 923
Using a Cell Phone to Connect Your Laptop**884**	Controlling How Windows 98 Manages Temporary Internet Files 924
Using Other Options to Connect When You are Away ... 885	Moving the Folder within Which Windows 98 Stores Your Temporary Internet Files 925
Connecting to the Internet with Your Personal Digital Assistant**886**	Configuring Internet Explorer's Color Utilization .. 926
Getting Web Pages on the Internet to View on Your Personal Digital Assistant 887	Configuring Internet Explorer's Font Utilization ... 927
Sending and Receiving e-mail with Your Personal Digital Assistant 888	Controlling Internet Explorer's Language Support 928
Understanding Hotmail ..**889**	Using History to Access Previously Viewed Webs 929
Getting a Hotmail Account 890	Clearing Your History Folder 930
Logging Into Your Hotmail Account 891	Configuring Your History Folder 931
Viewing e-mail that You Receive 892	Understanding Your Browser's Security Zone Settings 932
Sending an e-mail with Your Hotmail Account 893	Controlling an Internet Zone's Security Settings ... 933
Sending Attachments with Your Hotmail Account .. 894	Adding a Web Site to a Security Zone 934
Replying to Hotmail e-mail Messages. 895	Installing Microsoft Wallet 935
Deleting e-mail Messages from Your Hotmail Account .. 896	Storing Your Credit Card Information in Microsoft Wallet .. 936
Creating Address Nicknames 897	Configuring Your Profile Information for Use While Browsing the Web 937
Creating Hotmail Folders .. 898	Specifying the Programs Internet Explorer will Use for Each Internet Service 938
Moving e-mail to Hotmail Folders 899	
Looking at Hotmail Options 900	Configuring Internet Explorer to Check to See If It Is the Default Browser 939
Understanding Juno Mail**901**	Configuring Internet Explorer's Accessibility Options 940
Getting the Juno Mail Software 902	
Sending New e-mail with Juno 903	Configuring Internet Explorer's Advanced Browser Settings 941
Receiving e-mail with Juno 904	Configuring Internet Explorer's Advanced Multimedia Settings 942
Using Juno to Send Attachments and Browse the Web .. 905	Configuring Internet Explorer's Java Virtual Machine 943
Having a Private e-mail Account 906	
Using the Windows 98 Address Toolbar**907**	Printing Background Colors and Images 944
Adding the Links Toolbar to the Windows 98 Taskbar 908	Using the Internet Connection Wizard to Get You Connected 945
Starting Internet Explorer**909**	Selecting a Modem or Local-Area Network Internet Connection 946
Using the Internet Explorer Toolbars 910	Stopping a Web Site Download 947
Configuring Your Internet Settings 911	Opening a New Internet Explorer Window 948
Configuring the Links Toolbar 912	Refreshing the Current Page 949
Using the Internet Explorer's Address Bar 913	Sending the Current Web Site to an e-mail Recipient 950
Searching by Using the Address Field 914	
Configuring Advanced Search Options 915	
Searching for Text on the Current Page 916	
Using the Explorer Bar ... 917	
Adding the Current Site to Your Favorites Folder... 918	

Understanding HTTP 1.1 in
 Internet Explorer .. 951
Using Internet Explorer's Radio Toolbar 952
Configuring Internet Explorer to Empty the
 Temporary Internet Files Folder When
 the Browser Is Closed 953
Getting Help in Internet Explorer 954
Taking the Web Tutorial .. 955
Getting Support from Microsoft Online 956
Getting Support for a Specific
 Microsoft Product 957
Printing a Web Page within Internet Explorer 958
Turning on the Internet Explorer
 "Tip of the Day" ... 959
Updating Your Software with
 Windows Update from Microsoft 960
Using Netscape Communicator 961
Installing Netscape Communicator 962
Joining Netscape's Netcenter 963
Turning Toolbars On and Off 964
Understanding the Personal Toolbar 965
Using the Navigation Toolbar 966
Using the Location Toolbar 967
Using the Component Bar 968
Searching with the Netsite Field 969
Searching for Text on the Current Page 970
Setting Netscape Communicator Preferences 971
Configuring Appearance Options 972
Configuring Navigator's Color Utilization 973
Configuring Navigator's Font Utilization 974
Configuring the Web Page Navigator
 Starts with ... 975
Changing Your Default Home Page 976
Clearing Navigator's History List 977
Configuring Navigator's History List 978
Clearing Navigator's Location Bar History 979
Configuring Mail and Newsgroups Options 980
Configuring Roaming Access Options 981
Configuring Composer Options 982
Configuring Composer Publishing Options 983
Configuring Advanced Options 984
Cleaning Up Temporary Internet Files 985
Configuring Navigator's Cache 986
Changing the Folder that Navigator
 Uses for Caching Files 987
Adding Bookmarks .. 988
Organizing and Deleting Bookmarks 989
Viewing a Web Page's Source Code 990
Viewing a Web Page's Page Info 991

Getting Help in Navigator 992
Using the Navigator History Window 993
Editing the Current Page Using Composer 994
Printing the Current Page 995
Stopping the Download of a Web Site 996
Reloading the Current Web Page 997
Returning to Your Home Page 998
Opening a New Navigator Window 999
Using Netscape's Online Reference Library 1000
Sending the Current Web Site to an
 e-mail Recipient .. 1001

1001 Internet Tips

1 UNDERSTANDING THE INTERNET

To understand the Internet, you must first understand a network. A network, as used in reference to computers, is a group of computers that can communicate with each other and share information. At its core, the Internet is a network of networks. The Internet is made up of networks of many organizations, including universities, businesses, and governments. It has been touted as the revolutionary thing to come along since the wheel. The Internet is the cause of more hype and talk than almost any other subject in the last twenty years. Hollywood has made several movies about people using the Internet and the Internet has even found its way into the dialog of many television shows. Many people have called the Internet the Information Superhighway and one of the greatest products of the Information Age. It is probably because of all this hype and media coverage that you are reading this book to learn more about the Internet. Given the way users discuss the Internet, it would appear that the Internet is an object, something that you can touch. This perception is only partly true. You can touch the items that make up the Internet but the Internet itself is not just an object, it is also a concept. The Internet is not so much about network hardware, computers, and phone lines as it is about how to get all these components to work together. The Internet began as a concept and developed into methods of communication that let you communicate almost anywhere on the planet and find almost any type of information. The Internet is not completely organized. Anyone can connect to it. There is no center that all communication must go through and there are no checks or filters for communication content. The lack of central control promotes the free exchange of information and ideas. However, since no organization monitors the Internet, you can communicate with little in the way of rules governing the content of what you communicate.

2 UNDERSTANDING THE HISTORY OF THE INTERNET

Where did the Internet come from? This is an often-asked question that a new user to the Internet should ask. In understanding the history of the Internet, you will see the reason why the Internet is set up as it is. To find the roots of the Internet, you must go back to the 60s, the Vietnam War, and the Cold War in general. During the Cold War, the concern that a Communist country might invade the United States was crucial to many military planners. Thus, military planners began plans to deal with an invasion. War consists of troops and supplies, as well as the movement of information. Thus, the military needed to create a highway system for the flow of troops and supplies around the country without going through any one transportation center (the Interstate Highway system). To accomplish this, the military needed a way to communicate between sites using multiple paths. The Department of Defense set the Advanced Research Projects Agency (ARPA) to work on the problem. ARPA devised a solution that put information in small packages, called packets, put an address on the packet, and set up a method that would send the packet around until it got to where it was addressed. While this method may seem haphazard or inefficient, a communication center was not needed to get information from one place to another. With this new method in hand, ARPA set up ARPAnet and connected four universities. The universities were able to transfer information easily. In the 70's and 80's, more universities, groups, and companies connected to the ARPAnet. By the late 80's, the network became overworked. The National Science Foundation (NSF) stepped in to help build new and better technologies, but required all the work be for educational use. By the early 90's, the NSF lacked the resources to keep up with Internet growth and turned it over to businesses to do commerce on the Internet. By its design, there is no center point of control to the Internet. This lack of a center makes the Internet difficult to regulate.

1001 Internet Tips

3 Understanding the Makeup of the Internet

Now that you know how the Internet developed, you may be asking "What is the Internet?" As you have seen in the previous Tip, Internet designers developed the Internet as a means to have several different groups and organizations communicate. But who is doing the communicating? In the Internet, computers are doing the communicating between different places. It is unrealistic to expect that all the computers in the world that are used by different groups and organizations are the same or work the same way. It would be equally unrealistic to expect that everyone would change their systems just to connect to the Internet. In the early days, no one would have done so and the Internet would not have taken off. The Internet is not so much a piece of equipment as it is a way of having different pieces of equipment talk to each other. The development of certain protocols by the Internet designers was very important to making the Internet work.

Protocols are formal ways that computers talk to each other. If two computers are using the same protocols, they can talk even if they are different types of computers. The protocol that the Internet uses is called Transmission Control Protocol/Internet Protocol (TCP/IP). More will be explained about TCP/IP later in the book; for now, you only need to know that it is the language of the Internet. Universities, groups, organizations, and businesses usually have a local network that they use for their computers to talk to each other. If the local network has a computer that communicates via TCP/IP, that computer can provide the whole local network with a connection to the Internet. For smaller networks to talk to each other, they use the Internet's large communication paths called backbones. A *backbone* is a large pipe that computers can communicate over. The backbones of the Internet are similar to large interstate highways criss-crossing the country. Figure 3, a map from the web site of Idaho State University, shows the National Science Foundation's backbone in 1992.

Figure 3 The National Science Foundation's backbone in 1992 taken from the Web site of Idaho State University.

The backbones also cross the whole globe connecting all but a very small number of countries together in the Internet. This connecting of local networks is the makeup of the Internet.

1001 Internet Tips

4 Understanding RFCs

The origin of the Internet's design is very diversified. There is no one company that can claim to own the design to the Internet. The Internet may be one of the few things created by a huge committee that actually works. You can consider the whole Internet community as the committee that has created TCP/IP. As you learned in Tip 3, "Understanding the Makeup of the Internet," TCP/IP is the language of the Internet and is also a set of protocols that let different computers communicate on the Internet. Parts of TCP/IP were created when the Internet was first created and parts of TCP/IP are being created now. As the uses of the Internet change, the TCP/IP set of protocols changes and evolves. There is a group that guides this work but anyone can make a suggestion to change the Internet, and thereby change TCP/IP, by submitting a Request for Comment (RFC) about the change. You can send the RFC to the Internet Society, an advisory board, which will review it. The Internet Society will then publish the RFC so that users may comment on it. If there is general agreement that the RFC is a good change, then it may become part of the Internet. Everything that is in the Internet, except for some early parts, was at one time an RFC. All of the main parts of the Internet can be traced to different RFCs. The RFC for some part of the TCP/IP set of protocols, or some aspect of the Internet, will spell out what that piece of the Internet or that TCP/IP protocol should be and how it should work. Not all of the RFCs are of a technical nature; some are informative and some are just for fun. Tip 6, "Looking at RFCs," gives an example of what RFCs look like. If you are a software developer and you want to write a program, then you can use RFCs to implement your software. If you want to see the definitions of the Internet, look at the RFCs.

5 Finding RFCs on the World Wide Web

You have learned that RFCs define the Internet. To read an RFC, you can find listings at *http://www.rfc-editor.org/rfc.html*. At this Web site, you can search the RFCs by number, title, or author by clicking your mouse on the Search RFC index link. On the Finding/Retrieving an RFC, STD, FYI, or BCP page, at *www.rfc-editor.org/rfcsearch.html*, as shown in Figure 5.1, you can search for an RFC by the number of the RFC or by keywords, author, and so on.

Figure 5.1 Search a Web page to find a RFC by RFC number, author, keyword, and so on.

You will get a screen that shows all the RFCs that match your search. Each RFC will be listed as a link. Click your mouse on that link to retrieve the RFC. As shown in Figure 5.2, you simply click your mouse on the RFC1118 link to retrieve the Hitchhikers guide to the Internet RFC.

Figure 5.2 Search results of a Web page from the search page shown in Figure 5.1.

The RFC-editor site is not the only place to find RFCs but it is an easy site to work with and holds all the RFCs you may want to read.

6 LOOKING AT RFCs

There are different types of RFCs that are used to define the Internet. Standards Track RFCs are used to define the technical aspects of the Internet and to define different protocols. The abbreviation SDT is used with different standards. The standards RFCs have three different categories, depending on how widely they are accepted by the Internet community. There are also groups of RFCs that are Experimental, Informational, and Historic, as well as RFCs from the beginnings of the Internet. The two sub-series of RFCs are the Best Current Practice (BCP) and For Your Information (FYI). The Standards Track category is used for RFCs that are suggesting a change to how the Internet functions. The Best Current Practice category is used for RFCs that suggest a change in the methods of implementing current standards. The Informational category is used for RFCs that only provide information for the Internet Community. The Experimental category is used for experimental projects users on the Internet are testing but are not a standard for the Internet to use. One RFC that users might find interesting is the Hitchhikers guide to the Internet, but it is so difficult to read it may not be useful at all. The notice that goes with the Hitchhikers guide to the Internet is included below.

The notice included with the Hitchhikers guide to the Internet:

> NOTICE: The Hitchhikers guide to the Internet is a very unevenly edited memo and contains many passages, which simply seemed to its editors like a good idea at the time. It is an indispensable companion to all those who are keen to make sense of life in an infinitely complex and confusing Internet, for although it cannot hope to be useful or informative on all matters, it does make the reassuring claim that where it is inaccurate, it is at least definitively inaccurate. In cases of major discrepancy it is always reality that's got it wrong. And remember, DON'T PANIC. (Apologies to Douglas Adams.)

FUNDING THE INTERNET 7

The Internet is made up of the connection of many different organizations' networks. Each of these organizations must pay for its own networks and for a portion of the cost of getting their network connected to every other Internet network. Most of these organizations that are connected charge, in some way, for people to use their networks and their connection to the Internet. Ultimately, it is the users of the Internet that fund the Internet. Everyone pays somehow. If you are a student, part of your student fees or tuition pay for the school to be connected. If you are a business person, then it is an expense to your company to connect to the Internet. If you are part of an organization, some of your dues pay for that organization to connect to the Internet, and if you are an individual, you pay to connect. Even if you are not connected to the Internet, you pay some small price through taxes for government funding for pieces of the Internet or through the purchase of products whose producers are connected to the Internet. Thus, since you are paying for a piece of the Internet already, let's get you online and get your money's worth.

ACCESSING THE INTERNET 8

Accessing the Internet is not hard but it can be very confusing. There are companies that maintain the backbones (see Tip 3, "Understanding the Makeup of the Internet," for a discussion of backbones) of the Internet, and they provide access to their network of backbones to other companies or organizations. An organization or company that is already connected will provide your Internet connection. Almost everyone has someone who supplies their Internet connection until you get to the large providers of the backbones that criss-cross the country. If you use an account at your local university to get onto the Internet, then the university is supplying your Internet connection. In turn, some other company is supplying a connection to the university and there may be another company supplying the connection to the university's Internet connection supplier. This process continues until you reach the main backbones which different types of companies own. Some companies get their connection to the Internet at a higher level but the interesting thing is that no matter what the level you use to connect to the Internet, your connection is a peer to all the other connections. There is no problem having an Internet connection provider who has an Internet connection provider who has . . . well, you get the picture. One of the most common types of Internet connection providers is the Internet Service Provider (ISP), which will be discussed in a later Tip.

UNDERSTANDING THE CONTENT OF THE INTERNET 9

What is on the Internet? You have learned what the Internet is and where it comes from. You have learned what makes up the Internet and how RFCs define the Internet. You have also learned who pays for the Internet and how you gain access to the Internet. In this Tip, you will learn what is on the Internet. It is not an exaggeration to say that almost everything that you may want to know, and many things that you do not want to know, is only part of what you will find on the Internet. The content of the Internet is information. Some of it is true, some is not. The information comes in many forms and from many sources. Much of the information comes from the universities, colleges, and research centers of the world, such as pictures from outer space, or how digestion works, or how to solve a math equation. Some information is about products you can purchase, such as the price and the latest ratings on

a car you want to buy. You can make purchases on the Internet, without having to leave your house, such as buying books and CDs or even food. The real challenge of the Internet's content is not finding information, but finding information that is true and relevant to what you want to know. Whatever you want to know, you have a good chance of finding the information on the Internet. Less than twenty years ago, if you wanted to know about a topic, you would go to a school or a library and research the topic. Today, the information of the world will come to you across the Internet if you know how to ask.

10 Understanding the World Wide Web

For many users, the World Wide Web and the Internet are the same thing. However, the World Wide Web is only a subset of the Internet. The World Wide Web (WWW), or more simply, the Web, is part of the Internet. It is an ever-changing collection of millions of documents stored on many computers found throughout the world. These documents may contain text, images, sound, and even movie clips. While the Web is a fairly new addition to the Internet, it is the part that users most recognize and use. The Web can combine all the aspects of multimedia, text, sound, and video in one presentation on the Internet. To view anything on the Web you need a Web browser program. A Web browser program displays Web pages. A Web page is a computer file or group of computer files that may have text to read, pictures and movies to view, and sound clips to hear. The Web browser will read from all of the Web page files, presenting the text in a readable format. If your computer can play sounds, movies and pictures, the Web browser will display them as well. The computer that puts Web pages on the Internet for you to view is called a Web server. Almost all vendors and organizations on the Internet make use of Web servers to present information about themselves and their product. The Web is the most commonly used part of the Internet today. That leads to the perception that the Web *is* the Internet, but, as you will learn in this book, there is more to the Internet than just the Web.

11 Differentiating between the World Wide Web and the Internet

The Internet and the Web are not the same thing; the Web is only a subset or part of the Internet. As you learned in Tips 1-3, the Internet is a concept of how computers communicate with each other across networks. The World Wide Web contains information. The Internet lets you pass the information. Tip 4, "Understanding RFCs," discussed Request For Comments (RFCs), the documents that specify how the Internet works. RFCs give the specifics of the whole Internet. One group of RFCs talk about the World Wide Web and explain how images, both moving and still, sounds, and text are to be passed across the Internet. The World Wide Web is just one method of passing information on the Internet.

12 Understanding the History of the World Wide Web

The concept of the World Wide Web was first suggested by a group of scientists at the European Particle Physics Laboratory in Geneva in mid-1989. It was a proposal to make a system that would let the scientists share research information with other scientists around the world. The goal was to make the system be consistent in how the information looked, regardless of what kind of computer the user was using or where

the user was located geographically. In late 1990, the World Wide Web project was started to make a system as was proposed in Geneva. By the end of 1991, the first Web browser program was working with the first Web server to pass information to the Web browser. The first Web browser used only text and was limited in what it could do for the user. At the start of 1993, the number of Web servers on the Internet numbered only about 50, and the first graphical Web browser had been produced. By the end of 1993, the number of Web servers had grown to over 500 and several more graphical browsers started to be developed. One of the new browsers in use in 1993 was called Mosaic. In 1994, the group of users that developed Mosaic started a new company that became known as Netscape Corporation. This corporation sold not only the popular Netscape Web browser but would also sell Web server software that made the buying and selling of goods on the Internet secure. From 1994 to 1998, the Web exploded with the number of Web servers numbering in the millions and is growing every day.

Understanding the World Wide Web's Popularity — 13

The Web has become the most popular part of the Internet. The Web's popularity is rooted not in the Web's history but in what the Web can do. The World Wide Web was started as a way to share scientific information by a scientist at the CERN lab in Switzerland. However, being able to combine text with video and audio made the Web a favorable place for businesses to advertise. Businesses at first limited their presence on the Web to giving information or help about their products. However, as the taboo of doing commerce on the Web disappeared, businesses put more emphasis on marketing on the Web. With the increase of information that users could get about consumer products on the Web more people started to turn to the Web as a source of product information. As more users turned to the Web for information, more businesses turned to the Web to advertise. As technology was put in place that made commerce on the Web safe for the consumer, the practice of electronic commerce (*e-commerce*) emerged. Figure 13 shows how the Web's ability to use graphics makes it a perfect place for a business to do its marketing.

Figure 13 An example of marketing on the Web.

1001 Internet Tips

The Web's popularity has fed itself. As users started to use the Web, more businesses started to use the Web, so more users started to use the Web, and more businesses started to use the Web, and so on.

14 ADDING YOUR OWN SITE TO THE WORLD WIDE WEB

It is not only businesses that are on the Web; many people are putting themselves on the Web as well. You will find many examples of individuals putting Web pages about themselves and their families on the Web as shown in Figures 14.1 and 14.2.

Figure 14.1 Bill Malone's home page.

Figure 14.2 Andrew Wolfe's home page.

Note: *Both of the Web pages were made using Front Page which is a program to help you make a Web page (See Tips 545 to 574).*

In the next three Tips, you will find information on how to pick your Internet service provider. One service an Internet service provider offers is the ability to have your own Web home page. It is almost always part of an Internet service package to let customers place a personal Web page on the Web server of the Internet service provider. After the Internet service provider gives you space on its Web server, all you must do to have your own personal Web page is to create it and put it on the server. How complex a web page you create is up to you. It is simply a matter of what you want to create and how much you want to pay your Internet service provider.

UNDERSTANDING INTERNET SERVICE PROVIDERS — 15

Your gateway to the Internet will be your Internet service provider. An Internet service provider is any organization that has a connection to the Internet that it is willing to let you use. There are many types of Internet service providers from which you can choose. Though you may not think of it as such, your employer can work as an Internet service provider for you. If your employer lets you dial into the company network and connect to the Internet through the company's Internet connection, your employer is acting as an Internet service provider for you. You will most likely use as your Internet service provider a employer whose primary business is providing Internet service to users such as yourself. Internet service provider companies include three categories or types. One type, the standard Internet service provider, gives you a connection to the Internet, e-mail, and maybe some space on its servers for a web page. The second type of Internet service provider is an online service that provides access to the Internet, along with other proprietary services. An example of a proprietary service would be member-only services to book travel or information that only members of the online service can view, such as real time stock quotes. The third common type of Internet service provider is a school provider, most often a college or university, though some k-12 schools are doing this as well, that provides dial-in access to the Internet to their students. The organization that gives you access to the Internet is your Internet service provider.

SHOPPING FOR AN INTERNET SERVICE PROVIDER — 16

To get a good Internet service account, you need to find an Internet service provider that provides the type of services you need, connection availability at the time you need to get online, and a price you are willing to pay. When shopping for an Internet service provider, you should understand the purpose for which you want to use your Internet connection. Do you need e-mail? Do you need to have your own Web page? Do you need to have a connection to the Internet 24 hours a day? You do not need to know the answers to all of these questions but you should give some thought to how you think you will be using the Internet, then determine which Internet service providers are available in your local area. If you look in the Yellow Pages under Internet, you should find local companies that provide Internet access. These local companies are usually of the standard Internet service provider types discussed in Tip 15. They are good choices if you are looking for a generic Internet connection that has few limitations placed on the type, time, and amount of Internet browsing you want to do. To choose between the different standard Internet service providers in your local area, you should determine the monthly charge for an account, usually between $15 and $35, what services and software come with your account, what amount of time the Internet service provider's connection to the Internet is working, and if they provide support and classes you can attend to help you with your Internet use. You should also determine if the Internet service provider has a good

reputation for having all the phone lines to the provider open so you can connect. You can also ask the different service providers the ratio of customers to modems (a ratio of 10 to 1 is OK). If you need a connection to the Internet that is prepackaged and would like some value-added services, you may find that a national online service is more useful. See Tip 22, "Understanding Online Services," for information about online services. See Tip 17, "Differentiating between an Internet Service Provider and an Online Service," for the differences between a standard Internet service provider and an online service. If you are a student and need basic Internet access, your school may give you an Internet account for free. Most schools have a policy about what you can use your Internet connection for, so make sure you check that what you want to use the Internet for is allowed by your school. The most important item to check is whether you can do what you want to do with the account you are getting. You may find that as your experience with the Internet grows, your needs will change and you may need to change the type of Internet service provider you are using.

17 Differentiating between an Internet Service Provider and an Online Service

It may seem that standard Internet service providers and online services are the same but there is a difference between the two types of access to the Internet. The online service provider lets you connect to its proprietary network where you will use its software and have access to its electronic services. Since the online service provider lets you use only its software to connect to its network, it is usually easier to set up your connection. With an online service, there are many services you can use all through the program that the online service provider gave to connect to its service. In the past, the online services limited your access to the Internet as well as limited the amount of time you could connect to their network. This is becoming less common. One benefit of the online service providers is that in most cities there are local numbers to connect to the online service. If you travel, it is still a local call in order for you to connect. Some examples of popular online service providers are America Online and CompuServe.

Standard Internet service providers, in contrast, are traditionally local to only the city in which you set up the account; you need to make a long distance call to connect to the provider if you are out of town. Standard Internet service providers usually have no extra electronic services besides connectivity to the Internet, e-mail, and maybe some space for a Web page. On the other hand they also have very little or no restrictions on the amount and type of Internet activity you have with your account. Also, standard Internet service providers give you software from many different sources and you can use software of your own choosing.

The main differences between standard Internet service providers and online services are access to all parts of the Internet and access to other sources of software. The differences, however, are changing. Online service providers are now giving unrestricted access to all parts of the Internet, thus you are able to get access through the Internet to software and services beyond what the online services provider gives you.

18 Understanding Analog Connections

There are two methods you can use to transmit information on a wire, analog and digital. Analog means that the signal that is being sent on a wire is a wave similar to how your radio works. Digital means that the signal is sent as an off or on pulse, similar to how your computer works. While computers are digital, almost all residential phone lines are analog. Research shows that more than half of the users connecting to the Internet use an analog phone line and modem. In fact, a study conducted by the Georgia Tech Research Corporation found that 55% of all users

connect to the Internet with a 33.6 kilobits per second (Kbps) or slower modem. Most PCs shipping today are equipped with a 56 Kbps modem. In the past three years, vendors have packaged most PCs with a 14.4 Kbps, 28.8 Kbps, or 33.6 Kbps modem. A bit is a unit of information that a computer understands and all network connection speeds are measured in how many bits can be sent over a connection. Most modems are measured in kilobits, this measurement is often referred to as the bandwidth for a connection.

Packaged with new PCs, analog modems present a valuable tool for connecting to the Internet. Your existing analog, Public Switched Telephone Network (PSTN) line, will suffice for the connection and will probably provide adequate connection speed for casual Internet use. If you own a modem that is slower than 56 Kbps and wish to upgrade, you will have no difficulty finding a computer retailer who sells 56Kbps modems. If you are searching for a 33.6 Kbps modem or less, it becomes increasingly difficult to find a new one.

If you decide to purchase a 56 Kbps modem or a 56 Kbps modem is included with a new computer you are considering purchasing, you must be aware of the two 56 Kbps modem standards. When 56K technology became available, the industry conformed to two equal but incompatible standards, x2 and K56Flex. In February 1998, the International Telecommunications Union established V.90 as the 56Kbps modem standard. Most modems sold today conform to the V.90 standard. You can have the manufacturer of many 56Kbps modems purchased prior to this standard upgrade your modem, often for free, to the V.90 standard.

Understanding Integrated Services Digital Network (ISDN) Connections — 19

Integrated Services Digital Network (ISDN) is a standard for the delivery of digital telephone and data services for business and home use. ISDN makes it possible for a single wire or optical fiber to carry voice, digital network services, and video. Unless superceded by some other still obscure technology, ISDN intends to replace the current plain old telephone system (POTS). For the most part, ISDN uses the public switched telephone network (PSTN) that you are familiar with but allows for much faster data transfer rates than a standard analog connection.

ISDN services fall into three categories: Basic Rate Interface (BRI), Primary Rate Interface (PRI), and Broadband ISDN (B-ISDN). BRI, intended as the basic option for consumers, offers two 64,000 bit-per-second channels for voice and/or data transmission and one 16,000 bit-per-second channel for signaling purposes. PRI provides 23 channels with 64,000 bits-per-second capacity. B-ISDN is a developing technology that will supply up to 150,000,000 bits-per-second of data transmission capacity.

Currently, ISDN service is available in most metropolitan areas through the local phone company. Most Internet Service Providers support ISDN. You can use ISDN to connect your PC to the Internet and to connect small local area networks (LANs) to the Internet. To take advantage of ISDN, you must purchase an ISDN adapter for your PC or some sort of ISDN router for your local area network. When planning your connection, you can contact your Internet service provider for more information on ISDN Adapters or ISDN Routers.

Understanding T-carrier Level 1 and 3 Lines — 20

Medium to large organizations, or small organizations hosting high traffic Web sites, must consider higher bandwidth solutions than analog modem or ISDN. The T-carrier Level 1 or T-1 is a high-bandwidth telephone trunk line that is capable of transferring 1.544 Mbps of data. The T-1 is a leased line connection typically used by an

organization to connect its network to the Internet or to connect to another LAN within the organization. Small scale Internet service providers might use a T-1 connection to connect many subscribers to the Internet. Theoretically, at maximum capacity, a T-1 line could transfer one megabyte of data in less than ten seconds.

If organizations require a larger pipe, the T-carrier Level 3 line is an option. The T-3 is a leased line connection capable of carrying data at 44,736,000 bits-per-second.

21 UNDERSTANDING CONNECTION TYPES

Choosing an Internet connection type is a matter of factoring in how much speed you need with the cost of the connection type. High bandwidth leased lines are probably cost prohibitive for individuals and smaller businesses. That does not mean that you do not have satisfactory low-cost options for connecting to the Net. The low-cost 56 Kbps modem and analog phone line or an ISDN Adapter and ISDN line are excellent alternatives for individuals and small businesses.

By contrast, medium and large-sized businesses have both the need and the funds to acquire some sort of high bandwidth solution. In fact, when you consider connecting your corporate network and hundreds of users to the Internet, a high-bandwidth leased line becomes a more cost effective option than connecting hundreds of users with modem/analog phone line connections.

Users can select from several types of Internet connections that offer varying degrees of performance. Table 21 presents a comparison of connection options and transmission speeds:

Connection Option	Fastest Transmission Speed
Analog Modem	56 Kbps
ISDN Line	128 Kbps
T-carrier Level 1 (T1) Line	1.544 megabits per second (Mbps)
T-carrier Level 3 (T3) Line	45 Mbps
Cable Modem	56 Kbps
Optical Carrier-level 3 (OC-3) line	155 Mbps
Optical Carrier-level 12 (OC-12) line	622 Mbps

Table 21 The different types of connections to the Internet and their connection speeds.

22 UNDERSTANDING ONLINE SERVICES

An online service, or more properly, an online information service, is an online entity in the business of providing you with an extensive information service. Online services, such as America Online, CompuServe, or the Microsoft

Network, provide users with many electronic services such as e-mail, news, sports information, games, online investing, stock quotes, users forums/special interest groups, and Internet access, just to name a few. Online services are subscription services that began as isolated services but have since grown to compete directly with local Internet service providers for your Internet access dollars. Not only can you access content that is provided solely with that service membership, but now you can access the Internet through the online service, as mentioned in Tip 17, "Differentiating between an Internet Service Provider and an Online Service."

The largest online services—AOL, CompuServe, and the Microsoft Network—provide local dial-in access for much of the United States' urban areas. In many cases, novice users find online services easier to set up and navigate than connecting through an Internet service provider. One of the challenges for the online services has been keeping up with the ever-increasing number of users who want to get connected. Online services are constantly updating content and expanding and updating connection hardware to accommodate an ever growing online population.

Navigating America Online 23

Founded in 1985, America Online (AOL) is the largest and most popular of the online services. On December 30, 1998, America Online, Inc. announced that its worldwide membership had exceeded 15 million. To give you an idea of AOL's growth, in August of 1994 AOL announced it had reached the 1 million member mark. November 17, 1997, marked the milestone of AOL membership of 10 million. America Online, Inc. also recently acquired and now operates the CompuServe Online Service.

America Online is popular due to its ease of use and its high reliability and availability, especially its version 4 interface. Figure 23 shows the AOL 4 Sign On screen.

Figure 23 The AOL 4 Sign On screen.

Like any other Windows 9x application, the AOL 4 interface is straightforward and includes a standard title bar, menu bar, and toolbar. The toolbar buttons are colorful and easy to recognize and use.

1001 Internet Tips

To connect your PC to AOL, simply locate an AOL 4.0 installation CD-ROM and run the installation program from the disk. The installation program is easy to follow and will lead you through the whole process. You must have a personal computer that meets the AOL 4.0 system requirements, which the set-up program will test for before AOL will install on your system, and a working modem.

AOL software is easy to find. Computer magazines will periodically include a copy of AOL 4.0 on CD-ROM with the magazine. You can often find a free copy of AOL 4.0 at your local computer store. If you have a connection to the Internet already, you can browse the AOL Web site at *http://www.aol.com* and simply download the software from there.

24 SEARCHING AOL

AOL provides the AOL Find tool to help you locate what you are looking for without browsing through screens in a hit-and-miss fashion. To launch AOL Find, simply click your mouse on the Find button located on the Navigation bar, as shown in Figure 24.1, then choose Find it on AOL from the menu. America Online, in turn, will display the AOL Find dialog box, as shown in Figure 24.2.

Figure 24.1 The AOL Navigation bar with the Find button.

To search AOL, simply type in a keyword or two that describes your topic of interest and click your mouse on the Find button. You can search for information about any topic, such as a Montana vacation, and AOL Find will return with possible resources. Double-click your mouse on one of the returned selections to move to that dialog box and peruse its information.

The Find button located on the Navigation bar, as shown in Figure 24.1, also gives you the option to Find it on the Web. When you click your mouse on the Find it on the Web option, AOL will launch the Web browser and access AOL's Internet search Web site, *AOL NetFind*, as shown in Figure 24.3.

Figure 24.2 The AOL Find dialog box.

Figure 24.3 The AOL NetFind Web page.

You can use *AOL NetFind* to search Internet sites for keywords you specify. (See Tip 454, "Understanding and Using a Search Engine.")

UNDERSTANDING AOL CHANNELS 25

AOL Channels are groupings or areas of information and forums provided by the online service. Channel buttons provide an easy entry to all of the channel information offered on AOL.

1001 Internet Tips

By default, when you launch AOL, three windows appear within the main AOL window: the Buddy List, the Welcome window, and the Channels window (behind the Welcome window). For purposes of this Tip, you will use the Channels window. After launching AOL, simply click your mouse on the AOL Channels icon located on the left side of the Welcome window to pull the Channels window to the foreground, as shown in Figures 25.1 and 25.2.

Figure 25.1 The AOL Welcome screen.

Figure 25.2 The AOL Channels screen.

You can also click your mouse on the Channels button on the toolbar and select specific channels from the drop-down menu, as shown in Figure 25.3.

Click your mouse on a channel button to go to that Channel's main screen. You can view the News Channel window from which you can access any of a number of news related features, departments, and articles, as shown in Figure 25.4.

To facilitate easy navigation, the AOL 4.0 Channel guide appears on the left side of every main Channel window. Simply click your mouse on a channel in the list to move from channel to channel.

1001 INTERNET TIPS

Figure 25.3 The AOL channels drop-down list.

Figure 25.4 The AOL news screen.

USING THE "KIDS ONLY" AOL CHANNEL 26

Within AOL, you will find hundreds of sites, games, and activities that AOL has created especially for kids. To visit the "Kids Only" section of AOL, click your mouse on the Kids Only Channel. AOL, in turn, will display the AOL

Kids Only Channel screen, as shown in Figure 26.1. You may also type the words "Kids Only" in the top portion of the screen that contains the words "Type Keyword or Web Address here and click Go." AOL has designed the Kids Only Channel to be fun and educational for children. In addition, AOL provides parents with the ability to limit their children's access to the Kids Only Channel in order to regulate the content their children can view.

Figure 26.1 *The AOL Kids Only Channel screen.*

To control which content your child can access, configure your child's screen name as a Kids Only screen name. Kids Only screen names cannot send or receive AOL Instant Messages (described in Tip 28, "Using AOL's Instant Messenger"), enter member-created chat rooms, or use AOL pay-per-visit premium services. AOL restricts Kids Only screen names to sending and receiving text-only mail, and allows no file attachments or embedded objects.

To verify and set a screen name as Kids Only, perform the following steps:

1. Using your master screen name, click your mouse on the Keyword button on the Navigation toolbar. AOL, in turn, will display the Keyword dialog box, as shown in Figure 26.2. Type "parental controls" in the box marked "Enter word(s)". AOL, in turn, will display the Parental Controls window.

2. Click your mouse on the Set Parental Controls Now button. AOL, in turn, will display the Set Parental Controls window containing a list of screen names and the parental control category you have assigned to each screen name, as shown in Figure 26.3.

3. If the Kids Only radio button is not selected for your child's screen name, simply click your mouse on the circle in the Kids Only column, next to the screen name you want to designate as a Kids Only account. Note that there are also settings for Young Teen and Mature Teen from which you can choose, depending on the amount of filtering you desire for your child.

Figure 26.2 Navigating to the Parental Controls window using a Keyword.

Figure 26.3 The Parental Controls window showing categories for which you can set controls.

By providing special Parental Controls, AOL goes a long way toward helping you control the content your children can access online.

1001 Internet Tips

27 — Making Travel Reservations on AOL

One of the AOL Channels you can select is the Travel Channel, as shown in Figure 27, which lets you make your travel plans.

Figure 27 Viewing the Travel Channel.

The Travel Channel can serve as your online travel service through which you can research and book fares and accommodations for business and leisure travel. Through the Travel Channel, you can research travel in a variety of ways: the Destinations button opens a window that you can use to explore a travel destination by perusing articles about specific locations; the Bargains button opens a window that groups low-priced travel options in an easy to browse and search format; the Reservations button provides the tools you will need to research and make air, car, hotel, and cruise reservations. There are many other travel related forums and services accessible from the Travel Channel.

28 — Using AOL's Instant Messenger

When you connect to AOL, whether to surf the Web, send and receive electronic mail, or simply just to shop online, you can use AOL's *Instant Messenger* (*IM*) to locate and chat with another user.

Instant Messenger, or IM, is the tool you can use to chat one-on-one with a friend in real time. You can use the Instant Messenger to notify a friend that you are online and would like to chat. As discussed in Tip 25,

"Understanding AOL Channels," the Buddy List is one of the windows AOL opens by default when you sign on to American Online. After you configure the Buddy List with the screen names of your online friends, you can use Instant Messenger to initiate instant messages or invite friends to chat rooms (Chat rooms are discussed, starting at Tip 315, "Understanding On-Line Chatting," in more detail.) The next two Tips describe the process of building and configuring your Buddy List.

Once your Buddy List is ready to go, whenever one of your configured buddies logs on to AOL, AOL will display his or her screen name in the Buddy List window. In Figure 28.1, for example, you can see that two friends with screen names CURE4EVER and MLPOMP1 have just come online.

Figure 28.1 The Buddy list showing buddies that are online.

Double-click your mouse on one of the screen names in the Buddy List to initiate an instant message to that friend. AOL, in turn, will open the Send Instant Message window, as shown in Figure 28.2.

Type your message in the message area (for example, Hello Dave, as shown in the graphic), format the message text with the formatting tools, if you like, and click your mouse on the Send button. AOL, in turn, will close the Send Instant Message window and open another Instant Message window with two panes. The two-paned Instant Message window provides an area in which you can type your next Instant Message to the current buddy, and above that, a pane that records the history of your online discussion. Once you have finished your conversation, simply say goodbye to your buddy and click your mouse on the Cancel button to close the Instant Message window. Even though you are no longer chatting, your buddy's screen name will remain in the Buddy List window until he or she logs off of America Online.

Your AOL friends can configure their Buddy Lists and add your screen name. By doing so, they will know when you are online and they can initiate instant messages to you. When a buddy tries to initiate an Instant Message session with you, AOL will display an Instant Message window on your screen much like the one shown in Figure 28.3. The AOL member CURE4EVER has noticed that you are online and is trying to communicate with you.

1001 INTERNET TIPS

Figure 28.2 *The Send Instant Message window.*

Figure 28.3 *A buddy starting an Instant Message session.*

29 BUILDING YOUR BUDDY LIST

You can be quickly notified when your friends and family who use AOL are online by placing them on your AOL Buddy List. Building your Buddy List is a simple process of adding screen names of your friends to various Buddy List groups. To begin the configuration of your Buddy List, click your mouse on the Setup button in the Buddy List window. AOL,

1001 Internet Tips

in turn, will open a window titled Screenname's Buddy List. In the configuration window, shown in Figure 29.1, AOL will display a list of your Buddy List Groups and the number of members in each group.

Figure 29.1 The Configuration window.

To build a new Buddy List group, click your mouse on the Create button. AOL, in turn, will open the Create Buddy List Group window, as shown in Figure 29.2.

Figure 29.2 The Create Buddy List Group window.

In this window, you can supply a name for your new Buddy List and add the screen names for the buddies you want to group in that list. You can add screen names by first typing the screen name in the Enter a Screen Name field, and then clicking your mouse on the Add Buddy button. Repeat the process until all of your buddies are added to the list, then click your mouse on the Save button to save the list.

1001 INTERNET TIPS

Adding a buddy to an existing list is a similar process. Within the Screenname's Buddy List window (see Figure 29.1), select the list you want to edit, and click your mouse on the Edit button. AOL, in turn, will open the Edit List Buddies window with your list selected, as shown in Figure 29.3. Notice that the Edit List Buddies window provides a drop-down list from which you can select other lists to edit.

Figure 29.3 Editing a Buddy List.

To add a buddy to the selected list, type your buddy's screen name in the Enter a Screen Name field, as shown in Figure 29.4, then click your mouse on the Add Buddy button. AOL, in turn, will add the name you entered to the Buddies In Group list shown in Figure 29.4. In the next Tip, you will learn how to configure other Buddy List options.

Figure 29.4 Adding a new buddy to your Buddy List.

1001 Internet Tips

CONFIGURING YOUR BUDDY LIST 30

The Screenname's Buddy List window contains additional tools you can use to further configure and control your Instant Messages. You can use the Member Directory button to search the entire AOL membership directory for online friends that you think are using AOL. If you locate them, you can obtain their screen names and chat using Instant Messenger. After you have found the screen name of a person, you can add him or her to your Buddy List. Refer to Tip 38, "Searching the AOL Member Directory," to learn how to use the Member Directory search tools.

As with any online messaging or collaboration tool, unauthorized use of that tool can become a problem. For example, you may not want to have users add you to their Buddy List. You can use the Privacy Preferences button in the *Screenname's* Buddy List window to control who can see you and contact you when you are online. When you click your mouse on the Privacy Preferences button in the Screenname's Buddy List window, AOL, in turn, will open the Privacy Preferences window shown in Figure 30.1. Within this window, you can allow or block AOL members and Instant Messenger users, as you like. You can also build a list of AOL screen names to either block or allow. By taking advantage of the Privacy Preference tools, you can control any abuse of Instant Messaging to which you might be subjected.

Figure 30.1 The Privacy Preferences window.

You can configure the Buddy List window to display or not display upon startup. You can also configure a sound to play when buddies sign on or sign off. To configure your preferences, perform the following steps:

1. Within the Screenname's Buddy List window, click your mouse on the Buddy List Preferences Button. AOL, in turn, will display the Buddy List Preferences window, as shown in Figure 30.2.
2. Click your mouse on the checkbox for the options that you want to set. AOL, in turn, will display a check or remove a check for the option. An option will be set if a check is in the box next to the option.

1001 Internet Tips

Figure 30.2 Configuring a sound to play when a buddy logs on.

3. When you are done setting your options, click your mouse on the Save button. AOL, in turn, will close the Buddy List Preferences window and save your changes.

31 BUILDING YOUR AOL FAVORITES LIST

America Online service includes a feature called Favorites, which you can use to create shortcuts to your favorite sites or to those services you frequent. The Favorites list lets you add your favorite AOL locations and Web sites to the Favorites menu. AOL Sports has been added to the bottom of the Favorites menu shown in Figure 31.1.

America Online actually makes it easy to add a location to the Favorites list. It will not take much AOL browsing before you notice that many windows have a Heart button near the Minimize button on the window title bar. To add a location to your Favorites list, click your mouse on that Heart button. AOL, in turn, will display a dialog box, as shown in Figure 31.2.

Within the Add Favorites dialog box shown in Figure 31.2, you can perform one of three actions. You can simply add the location to your Favorites list, you can insert the location in an Instant Message, or you can insert the message into an e-mail. If you simply want to add a location to your Favorites list, you can drag the Heart icon from the title bar of the location window and drop it on the Favorites button on the toolbar. After adding a few locations to your Favorites list, your Favorites menu will begin to look like the list shown in Figure 31.3. In no time, your Favorites list will become your starting point for all of your AOL navigation.

1001 INTERNET TIPS

Figure 31.1 Working with the Favorites list.

Figure 31.2 **Adding a location to your Favorites list.**

1001 INTERNET TIPS

Figure 31.3 Having multiple locations on your Favorites list.

32 SENDING AOL E-MAIL

Sending and receiving e-mail on America Online is similar to other e-mail programs you may have used. It is a simple matter of learning how to address and send messages, and how to receive and read messages. AOL makes it easy. First, AOL will, when you log on, announce (you will hear a voice) that you have new mail and give you a visual cue. (The Mailbox icon that appears within the AOL Welcome window will contain letters and the title below the mailbox icon reads You Have Mail, as shown in Figure 32.1.)

Figure 32.1 New e-mail notification.

To read your mail, perform the following steps:

1. Click your mouse on the mailbox icon in the Welcome window, or click your mouse on the AOL toolbar Read button. AOL, in turn, will open your Online Mailbox, as in Figure 32.2

Figure 32.2 Working with the Online MailBox.

2. In the Online Mailbox, double-click your mouse on an e-mail you would like to read. AOL, in turn, will open the message. After AOL opens the message, as shown in Figure 32.3, you can choose to Reply to the message, Forward the message on to others, Add the address of the sender to your address book, or Delete the message.

Figure 32.3 An open e-mail message.

1001 Internet Tips

When sending e-mail, perform the following steps:

1. Click your mouse on the AOL toolbar Write button. AOL, in turn, will open a Write Mail window, as shown in Figure 32.4

Figure 32.4 A Write Mail window.

2. In the Send To: text box, type the e-mail address of the person you are e-mailing. The address need only be the screen name of AOL recipients. For non-AOL recipients, you will have to provide the complete e-mail address, including domain name (for example, *bmalone@source.net*). You can use the Copy To: text box to specify addresses for recipients you would like to courtesy copy with this e-mail.
3. After you fill in the subject line and type e-mail text, click your mouse on the Send button. AOL, in turn, will display a dialog box confirming that your mail has been sent.

You can read more about Electronic Mail beginning with Tip 583 "Understanding Electronic Mail."

33 SHOPPING ON AOL

Tip 25, "Understanding AOL Channels," introduces you to America Online channels where you can view special content. One of the most popular channels is the Shopping channel, which you can access via the Channels window, as shown in Figure 33.1.

The Shopping Channel window shown in Figure 33.2 opens up a world of shopping to AOL users. Within the Shopping Channel window, you will find options to shop by category, peruse online stores, and search all online shopping content.

Figure 33.1 The Channels window.

Figure 33.2 The Shopping Channel window.

Shopping by category is very straightforward. Simply click your mouse on a category name in the category list. AOL, in turn, will open a window containing shopping available for that category.

You can read more about shopping on the Internet starting at Tip 722, "Buying Groceries Online."

1001 Internet Tips

34 Taking a Class on AOL

America Online's Research and Learn channel, as shown in Figure 34.1, offers an option called Courses Online.

Figure 34.1 The America Online Research and Learn channel.

Click your mouse on the Courses Online link to open the Courses Online window. Then click your mouse on AOL's Online Campus option to view course catalogs or sign up for courses, as shown in Figure 34.2. The Course Catalog option of the Online Campus window opens up a window of class offerings grouped by category.

Figure 34.2 AOL's Online Campus.

The Course Catalog option of the Online Campus window opens up a window of class offerings grouped by category. By double clicking your mouse on a category, you can open up additional categories, as shown in Figure 34.3. You can then view the topics under a course grouping, as shown in Figure 34.4, and eventually display individual course offerings.

Figure 34.3 The course catalog window showing course groupings.

Figure 34.4 The topics under the Computing group in the course catalog.

After you have located a course you are interested in, as shown in Figure 34.5, you can order the course to enroll and pay fees.

1001 Internet Tips

Figure 34.5 Information about an individual course.

After you have ordered your course, you will interact with your instructor and classmates via e-mail, chat sessions, and sometimes even snail mail. Online education is becoming more and more popular as online services refine, improve delivery, and become more reliable. To some extent, online education is location and schedule independent, making it an attractive option for today's Internet savvy user.

35 UNDERSTANDING THE AOL WELCOME WINDOW

The AOL Welcome window, as shown in Figure 35, is the America Online front page. The AOL Welcome window serves as a launching pad for some of AOL's most popular areas as well as a link to some of today's hot issues and news stories. The left portion of the AOL Welcome window includes three buttons, a mailbox box button which gives you access to your e-mail, the AOL Channels button described in Tip 25, "Understanding AOL Channels," and the People Connection button which lets you enter chat rooms or chat one-on-one with other AOL members.

The rightmost portion of the AOL Welcome window holds five buttons: the What's New button, Parental Controls, Member Services, Go to the Web, and Quotes. The remaining links on the AOL Welcome window provide you with quick access to top news and entertainment stories, weather information, AOL news, and free software, to name a few possibilities.

If, at any time, during your browsing of America Online, you want to return to the Welcome window, you can simply pull down the Window menu from AOL's menu bar and choose Welcome, *Username*! You can also click your mouse on the Keyword button on the Navigation toolbar and type *welcome* in the Enter word(s): field and click your mouse on the Go button.

1001 INTERNET TIPS

Figure 35 The AOL Welcome window.

PLAYING GAMES ON AOL 36

The Games Channel on AOL gives you access to interactive gaming, gaming news, and insider gaming information. The Games Channel window, as shown in Figure 36.1, has three major game type areas that you can visit.

Figure 36.1 The Games Channel window.

1001 Internet Tips

The Game Parlor area, as shown in Figure 36.2, is a place where you can play many different types of card games and board games.

Figure 36.2 The Game Parlor window.

The Game Shows Online area, as shown in Figure 36.3, lets you work on puzzles and game show-type games.

Figure 36.3 The Game Shows Online window.

The Xtreme Games area, as shown in Figure 36.4, lets you play many different types of action, adventure, and strategy games.

1001 INTERNET TIPS

Figure 36.4 The Xtreme Games window.

Be aware that some online games are also AOL premium services, meaning that you may incur an additional charge above and beyond your normal AOL monthly subscription charge. AOL premium game prices range from $0.99 to $1.99 in addition to your monthly service charge. You can grant or deny access to premium games to any of the screen names on your account by performing the following steps:

1. Click your mouse on the Keyword button on the AOL toolbar. AOL, in turn, will display the Keyword window, as shown in Figure 36.5

Figure 36.5 Accessing the Parental Control window.

1001 Internet Tips

2. Type the words "Parental Controls" at the prompt and then click your mouse on Go. AOL, in turn, will display the Parental Controls window, as shown in Figure 36.6.

Figure 36.6 Using the Parental Control window to block access to the Gaming Channel.

3. Click your mouse on the ball to the left of Premium Services. AOL, in turn, will display the Premium Services Controls window. Click your mouse on the box to the right of each screen name to change its access settings. A check mark in the box means access is blocked.

At the bottom of the Games Channel window shown in Figure 36.1, you can access links to gaming Information and News. You can find game reviews, chats, tips and workarounds, free demos, and you can access the link to the Games Store to purchase computer games.

You can read more about playing games on the Internet starting with Tip 663, "Having Fun on the Internet."

37 READING THE NEWS ON AOL

AOL describes its News Channel as news you want, when you want it. The News Channel window displays links to news articles on many of the day's hottest issues and current events. The main News Channel window displays a constantly updated marquee of important headlines, ten department buttons, a Search button, a Today's Features section, and a set of static links to the day's top headlines, as shown in Figure 37.1.

In Figure 37.2, you can take a closer look at one of the specific department windows, the Newsstand department window. The Newsstand department window provides you with a drop down list from which you can select from ten news categories, such as AOL Computing, AOL Entertainment, or AOL Families. AOL News also provides a list of publications you can peruse that correspond to each category. You will also find links to Web sites of popular publications in the News window. Clicking your mouse on the Web links will cause AOL to launch the Web browser and open that publication's Internet Web site.

1001 INTERNET TIPS

Figure 37.1 The AOL News Channel.

Figure 37.2 The AOL Newsstand department window.

SEARCHING THE AOL MEMBER DIRECTORY 38

You can use the Member Directory to search for online friends. To get to the Member Directory, perform the following steps:

1001 Internet Tips

1. Within the Buddy List window, click your mouse on Setup. AOL, in turn, will display the Screenname's Buddy List window.
2. Within the Screennames Buddy List window, click your mouse on the Member Directory button, as shown in Figure 38.1. AOL, in turn, will display the Member Directory window, as shown in Figure 38.2

Figure 38.1 The AOL Member Directory.

Figure 38.2 An advanced search of the Member Directory.

1001 INTERNET TIPS

In the Member Directory window, you can perform a Quick Search from the Quick Search tab, or you can perform an Advanced Search from the Advanced Search tab. AOL searches the database of profile information that each AOL user has entered. AOL offers users the opportunity to be very descriptive in defining their AOL profile, which makes it easy for AOL users with common interests to locate each other. The difference between the two types of searches is that the Advanced Search tab offers a wider selection of specific optional fields to search. The Advanced Search tab makes it easy to narrow down your search to find users of, for example, a particular occupation in a particular city (see the example in Figure 38.2). After entering your search criteria, simply click your mouse on the Search button to execute your search of the AOL Member Directory. AOL, in turn, will search for a short time, then return a search results screen, as shown in Figure 38.3.

Figure 38.3 The results of a search of the Member Directory.

You could use the Simple Search tab, as shown in Figure 38.1, to perform a similar search, but AOL restricts you to using fewer optional fields and therefore cannot be as specific with your search. It follows then that you might have to scroll through more returned results screens to find members that meet your real search criteria.

39 GETTING UP-TO-DATE WALL STREET INFORMATION ON AOL

The AOL Welcome screen provides a link to an area called Quotes, as shown in Figure 39.1.

When you click your mouse on the Quotes link, AOL opens the AOL Investment Snapshot window. This window provides you with market trading information and the ability to obtain stock quotes with at least a 20 minute delay. With the Symbol radio button active, you can obtain stock quotes by simply typing the ticker symbol of a stock in the text field and then clicking your mouse on the Get Quote button. Figure 39.2 shows the Quote information for ticker symbol NEM, Newmont Mining Corp.

Figure 39.1 The AOL Welcome screen with the Quotes link.

Figure 39.2 Stock quote information for Newmont Mining Corp.

If you do not know the symbol of the stock in which you are interested, simply click your mouse on the Name radio button, type the company name in the Name text field, and click your mouse on the Lookup button. AOL, in turn, will return a list of company names that include the text string you were searching for, as shown in Figure 39.3.

Figure 39.3 The results of a lookup search for a company's ticker symbol.

The AOL Investment Snapshot window also provides links to useful market news sources, tickers, research resources, and even a list of online brokers. As you become more familiar with the market research and quote tools on America Online, you may want to go on to create your own online portfolio and eventually begin trading online.

Understanding the Microsoft Network — 40

The Microsoft Network (MSN) plays two roles for Internet users. MSN, like AOL, is an Internet service provider with value added services or online service and is also a site on the Web that you can visit without being a customer of MSN. As a site you visit on the Web, MSN works as Microsoft's home page, so that when you enter the Web address *www.msn.com* in your Web browser, you will get Microsoft's home page. You can also use Microsoft Network as an Internet service provider in much the same way that America Online is an Internet service provider. MSN has local access telephone numbers that you can use to connect to MSN in order to access the Internet. MSN also provides e-mail and other services like shopping and information services.

Getting the Software for MSN — 41

The software for MSN, the online service, is already on your system if you are using Windows 95 or above. Installing the software may be as easy as a shortcut on your Desktop. If there is no shortcut on your Desktop, then you may need to go to the add/remove programs applet in the control panel to add the MSN software. To add the MSN software from the add/remove applet, perform the following steps:

1001 INTERNET TIPS

1. Click your mouse on the Start Menu and then on the settings and control panel. Windows, in turn, will open the Control Panel window.

2. Double-click your mouse on the add/remove programs icon (this should be near the top of the window).

3. Click your mouse on the Windows set-up tab. Windows, in turn, will open the Windows set-up dialog box shown in Figure 41.1.

Figure 41.1 The Windows set-up dialog box.

4. Check Online Services and click the Details button to display the Details dialog box for Online Services shown in Figure 41.2. Check the Microsoft Network. Next, click your mouse on OK on all remaining dialog boxes. Windows, in turn, will start the Install of the MSN software. You may need to place your Windows 98 CD in the CD-ROM drive for the MSN software to be installed.

Figure 41.2 The Online Services Details dialog box.

You must follow the instructions from the MSN installation program to finish the installation.

1001 INTERNET TIPS

42. UPDATING YOUR CURRENT INSTALLATION OF THE MSN SOFTWARE

With MSN you do not need to worry about your software being out of date. If a new release of the MSN software is available, MSN will automatically notify you the next time that you log on to MSN. You will be given a choice of updating your software right at that time or waiting until a more convenient time. MSN will automatically update your MSN software if you select yes when MSN asks if you would like to update.

43. USING MSN AS YOUR INTERNET SERVICE PROVIDER

The Web site *www.MSN.com* is the home or first page that you see of the Microsoft Web site. MSN is an online service that has services for members only. You can also use MSN as your Internet service provider. The MSN service has local phone numbers in many cities that you can use to connect to the MSN service. When you launch MSN, it presents you with the login dialog box shown in Figure 43.

Figure 43 Login dialog box from MSN.

After you have connected to MSN, you can use the Internet Explorer browser, or any other Internet software that you like, to access Internet resources. MSN is acting as your Internet service provider.

44. THE MSN ICON ON THE TASKBAR

The easiest way for you to access any of the options and services of the MSN online service will be to use the MSN icon on the taskbar. When you click your mouse on the MSN icon shown in Figure 44, MSN will display a menu of options and services.

Figure 44 The MSN icon.

1001 Internet Tips

The MSN icon gives you instant access to the services MSN provides and to several Internet sites as well. The next ten tips will describe the different options.

45 Finding a Connection Phone Number for MSN

When you first setup and installed the MSN software, you chose a phone number to use to connect to the MSN service. You can change that number should you move to a new location or if you are traveling and wish to connect to the MSN service while you are on the road. To configure a new connection for the MSN service, perform the following steps:

1. Click your mouse on the MSN icon on the Taskbar. The MSN software, in turn, will display the MSN menu.
2. Select MSN Options and click your mouse on Connection Settings to display the Connection Settings dialog box, as shown in Figure 45.
3. Click your mouse on the Phone Book button to display the Phone Book dialog box, also shown in Figure 45.
4. Select the country, state or province, and local or nearest city to your location.

Figure 45 MSN Connection Settings and Phone Book dialog boxes.

46 Using the MSN Default Viewer

The default viewer that the MSN service uses is Internet Explorer 4.0. Internet Explorer is the program that the MSN service uses for all of the member-only services as well as the program that it uses if you are using your connection to MSN to browse the Internet. Many online services have a separate program to access the service's members-only services from the program that you use for your Internet connection. You access the members-only

1001 Internet Tips

services of MSN through Web pages that you can access from any type of Internet connection. You will still need to login to MSN to use many of the members-only services, but you do not need to have connected to MSN by having dialed an MSN number. The ability to login from any Internet connection is useful if you want to access your MSN account while at work or while using a connection at an office on the road. When you click your mouse on the MSN icon and click your mouse on Connect to MSN, MSN may display the dialog box shown in Figure 46, asking what type of connection you want to make to the MSN service. Depending on the options you selected when you installed the MSN software, the Connection type dialog box may not be present.

Figure 46 Connection type dialog box.

If you select No, dial using MSN, MSN will start the modem dialing process. If you select Yes, use existing modem connection or Yes, use existing LAN connection, you can connect to the MSN service without dialing a MSN phone number. In any of the above cases, MSN will ask you for your username and password and start the Internet Explorer program as the default viewer for your MSN account.

USING MSN FOR E-MAIL — 47

When you get an MSN account, you also get an e-mail account. The setup program for the MSN software will install Outlook Express if it is not already installed on your system. The setup program for the MSN software will also configure the Outlook Express software for you so all that you must do to start using your e-mail from MSN is start using Outlook Express. Tip 584, "Starting Microsoft Outlook Express," provides information on Outlook Express. The MSN icon will, at times, have an announcement box appear that will tell you about any new mail that you may have in your MSN e-mail account. Another place that will tell you if you have e-mail is the opening *MSNMember* Web page. It contains a section that lists the number of e-mail messages that you have waiting for you in your MSN e-mail account. Figure 47 shows the announcement box from the MSN icon. The next Tip explains the *MSNMember* page.

Figure 47 The MSN icon e-mail announcement.

1001 Internet Tips

48 Working with the MSN MSNMember Web Page

The *MSNMember* page is the opening page for your MSN account. MSN will present you with the page shown in Figure 48 if you click your mouse on the MSN icon then click your mouse on Connect to MSN. You can also click your mouse on the MSN icon, then select MSN Home Page and click your mouse on the MSN Home Page link.

Figure 48 The MSNMember home page.

The *MSNMember* page is the starting point for your Internet traveling using the MSN service. In the center of the page, MSN notifies you if you have e-mail. You can click your mouse on the statement of how much e-mail you have to launch Outlook Express. As you move down the page, there is a brief MSN Announcements section that lets you know about changes to the MSN system. Above the e-mail link is a search dialog box that you can use to search for information on the Web using different search engines. (Starting with Tip 470, "Understanding and Using a Search Engine," you can find information about search engines.) On the left hand side of the page, you will find the Web Directory which breaks up Internet Web sites of interest into several categories. After you click your mouse on a category in the Web Directory, MSN takes you to a page that has news stories and links to other sites related to that category. For example, if you click your mouse on the business link, MSN will take you to a Web page that has information about business events and links to other business sites. You will find the *MSNMember* page a great starting point for using the Web.

1001 INTERNET TIPS

USING THE MSN UPDATE PAGE 49

The MSN Update Page changes over time, providing you information about what is new with MSN and with other resources on the Internet. You can get to the MSN Update page by clicking your mouse on the MSN icon and then clicking your mouse on the MSN Update link. The MSN Update page shown in Figure 49 is an extension of the MSN update box you see on the On Stage Page shown in the previous Tip. The MSN Update page is a good source of information about the changing services MSN provides. You may also notice that the Update page has an information box in the upper left hand corner that states if you have e-mail and if any friends are online. (See Tip 54, "Configuring MSN to Notify You When Your Friends Are Online," for information about MSN friends online notification.) There are also links to other MSN pages.

Figure 49 MSN Update Page.

USING THE MSN SERVICES MENU 50

The MSN Services Menu is a quick way to access many different Web sites that you can use to view almost anything. There are links to book travel arrangements as well as travel books. The MSN Services Menu,

1001 Internet Tips

shown in Figure 50, can be used to go to Web sites to buy items or to see the consumer ratings for the things that you are going to buy.

You can use the MSN Service Menu to find users on the Internet and MSN as well as a good television show. The MSN Services menu is a good starting point for Internet surfing.

Figure 50 The MSN Essentials Page.

51 USING THE WEB COMMUNITIES PAGE

The Web Communities Page is like a corner coffee shop. It is a place where you can hear and discuss information about different topics or conversations of the day. As you can see from Figure 51.1, the page deals with discussions on a large variety of topics.

To get to the Web Communities Page from the MSN icon on the taskbar, click your mouse on the MSN icon, select Web Communities, then click your mouse on the Web Communities home.

The Web Communities home page has two main areas: the Chat area and the Communities area.

The Web Communities Page is a listing of different topic areas that may interest you. As seen in this listing, the Web Communities is a place where you can find an interest or hobby that you want more information on and it has links to chat rooms where you can talk to others who hold the same interest or hobby. Microsoft has created a large number of chat rooms, as shown in Figure 51.2. If you just want to chat with others, you can find a chat room that is to your liking and enter it to start chatting.

The Web Communities Page is a place where Microsoft has tried to make virtual communities where people on the Internet can meet and interact.

Figure 51.1 Web Communities Page.

Figure 51.2 A partial listing of the Microsoft Chat Rooms.

52 USING THE MEMBER SERVICES PAGE

The Member Services Page is, as the name suggests, a page were you can get help with, and information about, your account with MSN. You can access the Member Services Page by the normal method using the MSN icon on the taskbar. To access the Member Services from the MSN icon, click your mouse on the MSN icon and select Member Services. At this point, you can select Member Services home page but look at the other options that are available. After you have selected Member Services, the MSN Icon menu should look as shown in Figure 52.1.

Figure 52.1 The MSN Member Services sub-menu.

You may have noticed that all the MSN icon sub-menus offer you other choices besides the home page. The other choices take you to a sub-page of the MSN area you have selected. The Member Services sub-menu has extra options and two help categories for users of other services. If you have been using AOL or CompuServe, you will find help on the Member Services sub-menu to make it easier for you to use MSN.

You use the Member Services Page to view how your account is set up, to make changes to your account, and to get help in working with MSN, as shown in Figure 52.2.

Figure 52.2 Member Services home page.

The Member Services is not a page you work with on a daily basis but you will need to go to the Member Services Page whenever you need to change your account with MSN.

UNDERSTANDING THE SUPPORT FLASH PAGE 53

The Support Flash Page is a page that shows the operational status of the MSN system. You can get to the Support Flash Page by clicking your mouse on the Support Flash link from the MSNMembers Page. The Support Flash Page will tell you if Newsgroups, Chats, Web Sites, and Services are all up and working, as shown in Figure 53.

Figure 53 The MSN Support Flash Page.

You can also see from Figure 53 that two systems are having minor difficulties. You could at this time scroll down the page to see what problems the systems having minor difficulties are experiencing. MSN is a worldwide network and some, if not most, of the problems occur in countries other than the United States. If there is a fix that you can do to solve a problem, a link to the fix is listed. For the most part, the Support Flash Page is used to let you know of problems in the MSN network.

CONFIGURING MSN TO NOTIFY YOU WHEN YOUR FRIENDS ARE ONLINE 54

You can have MSN notify you if a friend comes online while you are online. This lets you send a message to the friend and hold a chat with the online friend. To use MSN's Friends feature, click your mouse on the MSN icon and then choose the Friends Online link. The Friends Online Main Page lets you work with your friends who are online, as shown in Figure 54.1.

1001 Internet Tips

Figure 54.1 Friends Online Main Page.

To start the notification, click your mouse on the Add Friends link to display the Web page shown in Figure 54.2.

Figure 54.2 The Search for Friends Dialog box.

Next, enter your friend's e-mail address or a name and location. (At this writing, use only MSN e-mail addresses as Microsoft is in the process of expanding the service.) When you find your friend, add him or her to your list of friends. After you have added your friend, you can go to the Friends Online Main Page and click your mouse on his or her name to send an e-mail or a private message, depending on your friend's online status.

1001 Internet Tips

Navigating CompuServe 55

Founded in 1979, CompuServe is one of the most well-known pioneers in the Online Service category. CompuServe boasts over 3,000 products and services, including special interest forums, e-mail, and other online information resources. CompuServe also offers Premium Services that carry an extra surcharge. The idea behind separating the Premium Services is that by charging extra to only those customers who use their Premium Services, CompuServe is able to keep its overall rates for membership low. CompuServe's Premium Services focus primarily on the areas of finance, education, and reference services.

As for other online services, it is easy to locate a CompuServe installation CD-ROM. You can find CompuServe's CD-ROM in computer stores, accompanying computer magazines that you purchase, and you can get the CompuServe software from CompuServe's Web site, *http://www.compuserve.com*. You can find a link on the CompuServe site that will let you download the software or order a copy by calling a toll free number.

CompuServe 4.01, the latest version, is streamlined and simplified compared to earlier versions. With just a few simple skills, you can navigate CompuServe and make the most of your service. CompuServe's Main Menu page gives you a map of the tools available for your use, as shown in Figure 55.1.

Figure 55.1 The CompuServe Main Menu screen.

Notice the standard look and feel of the Windows-based application. At the top of the window is a standard Windows title bar and menu bar. Moving down, you see the CompuServe toolbar (sometimes referred to as the CompuServe Ribbon), and below the toolbar, some navigation buttons for moving through CompuServe's pages.

CompuServe's toolbar provides you tools to access CompuServe's most popular features: weather information, stock quotes, the Internet, and e-mail. You can also click your mouse on the Go button to open a window which lets you use a keyword to jump to one of CompuServe's special interest areas, as shown in Figure 55.2.

Figure 55.2 The Go dialog box.

All you have to provide is the keyword. For example, you can use the keyword COMPUTERS to go to the CompuServe Computing area.

56 BUILDING YOUR COMPUSERVE FAVORITE PLACES LIST

On the CompuServe toolbar, you will find a Favorites button (the red heart) and directly to the right of that button, you can see an Add to Favorite Places button. You can use the Favorites and the Add buttons easily to return to your favorite CompuServe services. The Favorites button opens a window that lists favorite CompuServe services or Internet locations. You can select a favorite place for immediate access, or add, change, or delete favorite places, as shown in Figure 56.1.

You may decide that the first thing to do with your Favorite Places window is to clean up the links that the CompuServe software has placed there by default. You can do so by simply selecting the item you want to delete and then clicking your mouse on the Delete button.

Adding Favorite Places to your list is simple. When you find a service or window in CompuServe that you would like to add, just click your mouse on the Add to Favorite Places button on the CompuServe toolbar, as shown in Figure 56.2.

Figure 56.1 The Favorite Places dialog box.

Figure 56.2 Adding a CompuServe page to your Favorite Places.

By clicking your mouse on the Add to Favorite Places button, you can create a shortcut to this location in your Favorite Places window. The Define Favorite Place dialog box with three editable fields, Name, Location, and Priority, is shown in Figure 56.3.

The Name field defines the name you will see in your Favorite Places window after creating the entry. The Location field is the Uniform Resource Locator (URL) path to your favorite location. You can use the Priority field to set the

priority of the entry or to sort your list of Favorite Places. The completed Computing Channel entry in the Favorite Places window is shown in Figure 56.4.

Figure 56.3 The Define Favorite Place dialog box.

Figure 56.4 The Favorite Places window with the Computing Channel listed.

If you would like to make a change to an entry in your Favorite Places list, simply select the entry in the list and click your mouse on the Open button. CompuServe, in turn, will open the Define Favorite Place window, shown in Figure 56.3, to let you make changes to the entry.

To use your Favorites list to Go to a Favorite Place, simply click your mouse on the Favorite Places button on the toolbar or pull down the Favorites menu and select Favorite Places to open the Favorite Places window, as shown in Figure 56.1. Next, select the entry you wish to use, and click your mouse on the Go button.

57 SENDING COMPUSERVE E-MAIL

If you have received new mail, the CompuServe software will issue a voice message stating that you have mail. Two buttons on CompuServe's toolbar, the Get Mail button and the Create New Mail button, provide you with easy access to e-mail tools. When you hear the "You have mail" prompt, simply click the Get Mail button on the toolbar to go to the Online Mail window and view your new mail, as shown in Figure 57.1.

In the Online Mail window, you will see entries representing each of your new e-mail items. Click your mouse to select an item and then click your mouse to Open, or double-click your mouse on an item to open it and read the mail, as shown in Figure 57.2.

Figure 57.1 The Online Mail window in CompuServe.

Figure 57.2 An open e-mail message.

Once you have finished reading your e-mail item, you can do any of a number of things to the e-mail. You can reply to the e-mail, as shown in Figure 57.3, forward the message, file it for future reference, add the sender to your CompuServe address book, or simply delete the message.

Figure 57.3 A reply to an e-mail message.

Note: *See more on e-mail in Tips 583-649.*

1001 Internet Tips

58 — Using CompuServe's "What's New" Window

CompuServe's What's New window, shown in Figure 58.1, alerts you to the day's hot news headlines, provides links to top news stories, notifies you of timely events and marketing specials, and contains special promotions taking place on CompuServe.

Figure 58.1 The CompuServe What's New window.

You can view the What's New page by clicking your mouse on the What's New link from the Main Menu page when you first start CompuServe.

59 — Using CompuServe Forums

Forums are CompuServe's implementation of special interest groups. If you are looking for information, support, or other members that share your interests on almost any subject, the Forum areas on CompuServe may be your answer. These online special interest groups enable members to exchange information in a bulletin board fashion or online chat fashion. Forum members can also download and upload files to and from Forum libraries. Forums provide online conference rooms where member discussions take place or where online speakers present material.

Click your mouse on the Forums and Communities button on CompuServe's Main Menu page to open the Forum Center window, as shown in Figure 59.

From this window, you can choose the Forums you are interested in joining. If you are looking for information on a particular subject or a Forum about that subject, you can also use the Search button found on the Forum Center page.

1001 Internet Tips

Figure 59 The CompuServe Forum Center window.

Installing the Prodigy Software 60

You will need to install the Prodigy software for Prodigy to work on your system. To use the Add/Remove Programs applet in the control panel to add the Prodigy software, perform the following steps:

1. Click your mouse on the Start menu and then select the Settings and Control Panel.
2. Double-click your mouse on the Add/Remove Programs applet icon. Windows, in turn, will display the Add/Remove Program Properties dialog box. Click your mouse on the Windows Setup tab. Windows, in turn, will display a dialog box like the one shown in Figure 60.1. You may need to scroll down to see the Online services.

Figure 60.1 Windows Setup dialog box.

1001 Internet Tips

3. Click your mouse on Online services and then click your mouse on the Details button. Windows, in turn, will display a dialog box like the one shown in Figure 60.2. Click your mouse on the Prodigy checkbox. If there is a check in the Prodigy box, you may already have the software installed and you should look for the Prodigy icon on your Desktop.

Figure 60.2 Online services details dialog box.

4. Click your mouse on OK. The Prodigy install program, in turn, will start.

You should follow the instructions in the Prodigy install program to finish the install of the Prodigy software. If you do not have the Prodigy software on your system, then you can go to the Prodigy site, at *www.prodigy.com* and download the software.

61 STARTING TO USE PRODIGY INTERNET

The very first time that you start to use Prodigy Internet, it will display the Web page that is shown in Figure 61.1. This first time opening screen is to help you find your way around the Prodigy site. In addition to letting you jump right into the Internet, this Web page has links to Web pages that will help former AOL users, people new to the Internet, and users of a different Prodigy service.

All future times that you use Prodigy you should see the screen shown in Figure 61.2. The first area you will want to work with is the Tools for Living section in the upper left-hand corner. In this section, you will see if you have e-mail waiting for you and you can use the links to view other areas of the Prodigy site. The rest of the page has information about news stories, weather, TV listings, stocks, and much more. You can also customize this page so that it has information that is of interest to you. You can start the process of customizing your page by clicking your mouse on the Content or Layout links in the Personalize section of the Tools for Living. The first time you customize your start page you will need to register with Prodigy so that you get your custom page, rather than the normal

page, in future visits to the Prodigy site. After the first time, you can go back to the Personalize links or just click your mouse on the change link over each section.

Figure 61.1 The Prodigy first time welcome screen.

Figure 61.2 The Prodigy start screen.

1001 INTERNET TIPS

62 USING THE PRODIGY SITE MAP

In the Tools for Living section of the Prodigy start screen is the Prodigy Site Map. The Site Map page shown in Figure 62 is a page that has links to all the services you can use in Prodigy.

Figure 62 Prodigy Site Map page.

You can use the Prodigy Site Map to get help quickly on using any of the features of your Prodigy Internet account or to change your account information and your account setup. The site map provides a quick and easy way to get to the main Prodigy Internet pages.

63 THE PRODIGY ICON IN THE SYSTEM TRAY

You can quickly access many Prodigy services by using the Prodigy icon shown in Figure 63.1. When you click your mouse on this icon, you will see the Prodigy menu shown in Figure 63.2. Click your mouse on a menu option to go to that Prodigy Internet site.

Figure 63.1 The Prodigy icon in the system tray.

Figure 63.2 The Prodigy Internet menu.

CHANGING YOUR ACCESS NUMBER 64

If you are moving to a new location or traveling, you may find that you need to change the telephone number that you use to access Prodigy. The best way to change your access number to a new local number is to use the Phone Wizard. You start the Phone Wizard by clicking your mouse on the Prodigy icon in the system tray. Then, click your mouse on Phone Wizard. The wizard can show you all the access phone numbers or just the access phone numbers in your area code. If you have the Phone Wizard show you all the access phone numbers, the numbers are sorted by area code and not alphabetically by state or city. If you are traveling and want to access Prodigy, you must know the area code of the location where you are going to connect to Prodigy. After you configure a new number, Prodigy will display multiple numbers in your Prodigy connection box, as shown in Figure 64.

Figure 64 Prodigy connection dialog box with multiple access locations.

Pick your current location to connect to Prodigy with a local telephone number. If you got to the connection dialog box and forgot to set up the new Prodigy access number, you can click your mouse on the New button, and Prodigy will start the Phone Wizard.

65 CHECKING YOUR PRODIGY MAIL

Checking your Prodigy Internet e-mail is very straightforward. In the Prodigy start page, look at the Tools for Living section. At the top of that section, you will see how many messages you have. If you click your mouse on the You have ## messages link, Prodigy will start your e-mail program. If you are using Internet Explorer 4.01, Outlook Express is your e-mail client and you can start Outlook Express directly to view your e-mail as well. Refer to Tips 584 to 632 for more information on how to use Outlook Express.

66 CHANGING YOUR ACCOUNT INFORMATION

To change your account information, go to the Prodigy Site Map page as described in Tip 62, "Using the Prodigy Sitemap." At the Site Map page, there is a section called My Account, which is where you can change your account information. Use the Change Password option to change the password that you use to access your Prodigy account. Use the Change Plan, Change Profile, and Update Credit Card options to change the type of account you have, personal information about yourself, and your billing information. You can use the E-Mail Controls to control how your e-mail account will respond to junk e-mail, also called spam mail. If you had an old Prodigy account, you can use the Forward E-Mail option to have your e-mail come to your new Prodigy account. You use View Account to display how your account is set up, and View Usage to display your account activity. The Billing FAQs is a good resource for answering questions that you might have about your Prodigy bill and the types of services for which Prodigy is billing you. To change your account in any of the above areas, click your mouse on the appropriate link and fill in the form that Prodigy presents. After submitting the Web form, Prodigy should put your changes into effect.

67 ACCESSING THE INTERNET THROUGH YOUR COMPANY

More and more people are getting onto the Internet through the company for which they work. There are some great benefits to having Internet access at your desk, not the least of which is that you have access to all the information of the Internet. You can also send messages to business partners instantly. You should be aware of some other aspects of using your company's network to surf the Internet. The first thing that your company must have is a connection to the Internet. It is not a given that you have Internet access in your company; some companies have not given full access to the Internet to their employees. It is possible to have the ability to send e-mail from your company to the Internet but not have any access to all the other parts of the Internet. The type of access that you have to the Internet is dependent on what your company has decided to set up and make available to the employees of the company. If your company does have access to the Internet and has given that access to the employees, you should find out if your company has an acceptable use policy. An acceptable use policy is also a policy statement made by companies or organizations that provide access to the Internet for people in their organization. An acceptable use policy is a statement of what the company considers to be acceptable and unacceptable usage of the company's Internet connection. The company's network is company property and the company can control the use of that property, so you should be aware of any possible limits that your company has placed on employee use of the Internet.

Understanding LANs 68

LAN stands for local area network. A LAN is usually confined to a single building or a close group of buildings. A LAN is a high-speed connection of computers and computer equipment. Many businesses have LANs in their offices to let people work together with their computers and to share computer resources like files and printers. Your company may have a Web server on its LAN that you can connect to and get information. You may notice that the connection to the company Web server on the LAN is very quick. This ability to have information pass very quickly from the web server to your computer is why it is said that a LAN is a high-speed connection of computers.

Understanding WANs 69

WAN stands for wide area network. A WAN is a network that connects either single computers or, more commonly, LANs together over distances. Your company may connect to the Internet through a WAN connection to its Internet service provider. Your company's WAN probably uses telecommunications companies like AT&T or MCI Worldcom to connect the LANs of several branch offices together and to provide a connection to the Internet.

LANs, discussed in Tip 68, "Understanding LANs," and WANs are similar in concept in that they are ways of connecting computers so people can share resources and communicate with each other. However, they use different technologies to make the connections and are two physically different concepts. It is possible for you to have a connection over your LAN to a Web server on your LAN but fail to connect to the Internet because your WAN's Internet connection is not working.

Monitoring the Content of Your Internet Use by Your Company 70

It is common for companies to monitor and filter messages crossing their Internet connection. Your company most likely has a single WAN connection to the Internet that serves the whole company. All Internet communications must go through this one connection. By having only one connection to the Internet, your company can place a firewall on that connection. A firewall is hardware and/or software that prevents unauthorized access from the Internet to your company's internal network. It is a first line of defense for keeping out criminals that break into company computers to do damage.

One type of program that your company can use when it has only one connection to the Internet is a program that monitors and filters messages coming from the Internet to your company's network. Your company can also monitor to which part of its network, and to which computer, the material from the Internet is going. Many companies will also subscribe to a service that lists areas on the Internet that are not considered to be appropriate by your company managers for use in a business setting. The firewall may routinely block sites that contain pornography or are strictly for entertainment. It may also monitor and log computers from which a request for inappropriate material is made. The logic for this is that the company has paid for the internal network and the connection to the Internet. It can therefore require that employees use the company's computer equipment for company business and not personal business. Also, the company is able to see if employees are following the company's acceptable Internet use policies.

71 — Monitoring and Reading of Your e-mail by Your Employer

In most cases, your company can legally read your e-mail sent or received using your company's network and equipment. It is not a given but there is some case law to support that an employer can view e-mail sent on the employer's e-mail system. E-mail is viewed by most business managers as any other business communication, such as a company memo or a company telephone. In much the same way that a call center supervisor may listen to a customer call, an employer can look at e-mail going out to a customer. This point of law is not perfectly clear. However, the law does seem to lean toward the belief that if the company owns the computer that the e-mail is on and owns the network that the e-mail traveled on, then it owns the e-mail and can view it.

72 — Sending Material from the Internet to Co-workers

Sexual harassment or harassment of any kind has been in the limelight of American business and relates to what you do on the Internet *while at work*. What you do on the Internet at home does not count unless you bring that material to work. Harassment cases are not cut and dry, but there is case law that supports companies taking action against employees for electronically sending what some might consider harassing material to co-workers. There is even support for action against employees viewing what some might consider harassing material in the view of other employees. This is not to say that you cannot send a humorous Web page to a co-worker, but be aware that what may be considered humorous by one person might be harassment by someone else.

73 — Understanding Your Internet Protocol (IP) Address

Just as you need an address at your house to receive mail from the U.S. Post Office, your computer needs an address to receive information from the Internet. To use the Internet, you must have a valid Internet Protocol address or IP address so other computers can send information to your computer. An IP address is a quad dot notation address, meaning a set of four 3-digit numbers that range from 0 to 255, each set of numbers being separated by dots. An example IP address is 10.243.92.254. (The last dot is a period, not a dot.) You must have an IP address and the number must be unique on your network for your computer to talk to the Internet. An IP address has a network part and a host part. You can think of the network part as the street name of your address and the host part as the house number of your address. The network portion and the host portion of your IP address change depending on how your network is configured. Depending on how your network administrator or ISP has configured your network, the network part of your IP address could be the first number of the four or the first three numbers of the four. You can even have networks where the network part of your IP address is one, two, or three numbers of the four and a part of the next number in the four. A second number, called a subnetmask, shows which part of your address is network and which portion is host. You must always have a subnetmask with an IP address so the computer can determine what part of your IP address is the network part. For the most part, you do not need to worry about this address as it is most often given to your computer automatically when you connect to your network, or to your Internet service provider by the computer that you are connecting to on the network or at the ISP. In some cases, you may need to enter this number manually. In that case you need to get a valid IP address from your computer system administrator or your Internet service provider. (See Tip 863, "Configuring TCP/IP," for information about manual configuration of your IP address.)

IP Addresses Are Binary Numbers 74

An IP address is really a binary number, a number of only ones and zeros. The representation of the number as a set of four numbers is a way of representing the number so it is easy to work with. The address of 10.243.92.254 is a way of representing the binary number of:

00001010 11110011 01011100 11111110

You convert from the binary number to the decimal number by breaking the binary number into four eight-number blocks. Each of the four eight-number blocks is represented by the respective the four numbers in your IP address. Each position in the eight-digit block represents a value from 128 to 1. Figure 74 shows the value of each position.

```
 1    1    1    1    1    1    1    1
 ↓    ↓    ↓    ↓    ↓    ↓    ↓    ↓
128   64   32   16    8    4    2    1
```

Figure 74 The value of each of the eight digits in a binary number that make up an IP address.

To find the decimal value of a binary IP number, just add the value of the position if there is a 1 in the position. In the binary number given above, the first eight digits are 00001010 which is a 1 in the eight position and a 1 in the two position, thus eight plus two is ten which is the first number in the decimal representation of the IP address given above.

Classes of IP Address 75

IP addresses come in five different classes. Three classes are for general use on the Internet and two classes are reserved for special use. The first three are used to designate what part of your IP address is network address and what part is host address. You can tell the class of an IP address by looking at the first number in the quad dot notation. Table 75 shows the different classes:

Classes of IP address	Range of numbers for the first number
Class A	1 to 126
Class B	128 to 191
Class C	192 to 223
Class D	224 to 239
Class E	240 to 255

Table 75 IP Classes and the ranges of the IP addresses in each class.

A class A address, like the example in the previous two Tips, uses just the first number in the IP address for the network address and the remaining three numbers for the host address. A class B address uses the first two numbers of the IP address for the network address and the last two for the host part. A class C address uses the first three numbers in an IP address for the network address and the last number for the host address. The other two classes for IP addressing are not used with a single computer. Class D addresses are used with multicasting, a method of sending information to many computers at one time. Internet designers have reserved the Class E addresses for experimental use and they are not used on the Internet for normal purposes.

76 Understanding Subnet Masks

As you learned in Tip 73, "Understanding Your Internet Protocol (IP) Address," an IP address has two parts: the host address and the network address. You learned that the two parts change depending on the network configuration. You also learned in Tip 75, "Classes of IP Address," that IP addresses come in different classes and the classes give a default definition for which part of your IP address is network and which part is host. You do not need to follow the default definition, in which case, you must use a custom subnet mask. You use the subnet mask to configure which part of your IP address is the network address and which part is the host address.

A subnet mask will look like an IP address but the numbers will be different. A common subnet mask is 255.255.255.0, the default subnet mask for a Class C IP address. As you have learned, a Class C address uses the first three numbers of the IP address for the network address and the last number as the host address. Within the subnet mask, any position that is zero means the corresponding position in the IP address is the host address. In the example 255.255.255.0, the last 0 in the subnet mask means the last number in the IP address is the host part of the IP address. Within the subnet mask, any position that is a 1 in the binary number means the corresponding position of the IP address is the network address. In the example 255.255.255.0, the first three numbers are all 1s in binary, therefore the first three numbers in the IP address are the network address. You may be thinking that you must have missed something by calling the number 255 a 1. However, you must remember, IP addresses are representations of binary numbers and this is true of subnet masks as well. Refer to Tip 74, "IP Address are Binary Numbers." The number 255 is the representation of the binary number 11111111 or all 1s. You may see subnet masks of numbers other than 255, such as 192 or 224. These are just representations of binary numbers.

77 A Shortage of Addresses

One of the new problems the Internet is dealing with is that there is a finite number of IP addresses and every IP address on the Internet must be unique. When the Internet was first started, its designers intended to use the Internet to network 50 or so computers. The millions of computers now connected are far beyond the original design goals of the Internet. When the designers developed the IP address scheme, they set up a large number of IP addresses, a little over 4 billion. The designers figured that the number of addresses they developed should hold. However, the great expansion of the Internet, network equipment using several addresses, and addresses being rendered unusable due to other aspects of the Internet, such as a company being given 32 Internet addresses but only using 20, or computer equipment that does not use a block of IP addresses so they are wasted, is exhausting the number of unused addresses. During 1996 and 1997, running out of IP addresses was a large concern, so plans were made to fix the problem.

Computer scientists developed several processes and methods that greatly reduced the demand for IP addresses, taking some of the pressure off the shortage. One process is the automatic configuration of your computer's IP address. Your computer's IP address is configured by a computer called a Dynamic Host Configuration Protocol (DHCP) server. (See Tip 804, "Understanding Dynamic Host Configuration Protocol," for more information on DHCP.) When your computer is not using its IP address, a different computer can use the address. A second method scientists developed is to have a reserved set of IP addresses for a company's internal network. The company only needs one IP address at the point where the company's internal network and the Internet meet. Although, the Internet is not going to run out of IP addresses tomorrow, there is only a finite number of IP addresses and they are being used more and more every day. Plans are being made by the Internet Society to fix the problem of the IP address shortage. Companies and computer scientists are summoning RFCs on how to fix the shortage.

78 Other Shortcomings of the Internet Protocol

Besides providing for IP addresses, the Internet Protocol has other responsibilities such as getting information from one computer to another. With the increase in Internet usage, users are using the Internet Protocol for things the original designers never foresaw or planned. Users are sending video and sound across the Internet. Electronic commerce (e-commerce), the conducting of business transactions electronically, is now an important use of the Internet. Features such as video and sound, referred to as time-dependent traffic, have to come in a steady stream to avoid being choppy and broken up. The Internet Protocol does not give priority to time-dependent traffic very well right now. Also, with the advent of e-commerce, Internet security has become more important. Many users feel that the Internet Protocol should, at a very basic level, encrypt information so users whom the information is not meant for cannot read it.

Two big additions to the Internet are the ability to set a priority on information going through the Internet and having the Internet Protocol encrypt every piece of information for security when doing e-commerce. Many users are submitting RFCs to the Internet Society and the Internet community on how to add, using a priority system, to the Internet Protocol, so there is much discussion about who gets to set the priority and for what types of communication. There are also RFCs that are being used on the Internet that deal with the encryption of all communications by the Internet Protocol.

79 Internet Protocol Version 6

The solution to the problems that the Internet is facing is being addressed and plans are being made to update the Internet to handle the changing nature of the Internet. One plan that is being worked on is a revision of the Internet Protocol called Internet Protocol Version 6, (IPv6). In IPv6, there will be four times the number of usable addresses to deal with the growing number of users that the Internet must handle. IPv6 will also have built-in encryption to make business on the Internet more secure than it already is. The third major addition in IPv6 will be the ability to prioritize traffic so that time-dependent traffic on the Internet will be more likely to get to its destination in a timely manner. There are many other details in IPv6 that are being changed, but these are the areas that you are most likely to notice in your use of the Internet.

80 Understanding Domain Names

Because computers on the Internet can communicate only by IP address and because long strings of numbers are difficult to remember, the Domain Name System, DNS, was developed. The Domain Name System uses a hierarchical name structure to identify computers on the Internet. The name that a computer has is its host name. A host name is a human friendly way of addressing a computer. The Internet has too many computers to just use host names so it uses a hierarchical name structure called a domain name. Because the Internet is large, the Domain Name System has been broken down into subsections or zones. The Name Space or root contains all the names that you can use on the Internet. The main subdivisions of the Internet Name Space are the top-level domain names. An example of a top-level domain name is *.com* or *.net*. Depending on who your Internet service provider is, it will most likely have a top-level name of *.com* or *.net*. If you are a student at a college or university, your school most likely has

a top-level domain name of *.edu*. The second level domain name is what users ask for from InterNIC, which governs the Internet Name space. An example of a second level name with its corresponding top-level name is *microsoft.com* or *AOL.com*. Under the second level name are sub-domains that a second level name owner has made to help in the administration of his or her network, such as *ccs.unr.edu*. The *ccs* in *ccs.unr.edu* is a sub-domain of the second level domain name *unr* which is part of the top-level domain name *edu*. Figure 80 shows a graphical representation of the Internet Name Space.

Figure 80 The Internet Name Space.

The top-level names are set by InterNIC and represent certain sectors of the Internet. The top-level name *edu* is reserved for colleges and universities and a few other educational organizations, *com* is used for commercial businesses, and *uk* is a top-level name for domain names in the United Kingdom. By looking at a domain name, you can tell something about the site to which the name belongs. The first part of the domain name is the host name. A fully qualified domain name of a computer at the University of Nevada Reno with a host name of equinox would be *equinox.ccs.unr.edu*. (The last dot is a period, not a dot.) You should notice that in Figure 80, equinox is not in the domain name space because it is a host name and not part of the name space. It is like a given name and a family name.

81 UNDERSTANDING HOW THE DOMAIN NAME SYSTEM (DNS) WORKS

If you have worked on the Internet, you most likely use domain names to connect to a computer on the Internet. For computers to communicate with each other over the Internet, they must translate the names they use into an IP address. The Domain Name System, DNS, handles the translation of domain names to IP addresses. The full Domain Name System is a collection of computers, called name servers, that translate a full domain name to an IP address—this process is called name resolution. Each second level name should have at least two name servers that are responsible for name resolution for all domain names that include that second level domain name in them. For example, Microsoft has a second level name, *microsoft.com*, therefore Microsoft should have at least two name servers that can resolve names that include *microsoft.com*. Each owner of a second level name is responsible for providing a name server to resolve domain names to IP addresses for names that include the second level name they own. By having each owner of a second level name have a name server that will resolve domain names to IP addresses for their zone of the domain name space, the job of name resolution is spread out among users of the Internet.

When you (or your system administrator) configure your computer to use DNS and configure a name server for it to use, your computer will take the full domain name and pass it to the name server. The name server will then

1001 Internet Tips

search a data base that it maintains for a record which has an IP address that is associated with the domain name it has been passed. If the name server does not have an IP address for the name it was passed, the name server will forward the request for name resolution to the server that holds information about the second level name in the domain name it was passed. If there is no IP address for the domain name on the servers responsible for the second level name you are trying to resolve, you will get an error on your computer stating that the name was bad.

When you enter a domain name, your computer sends the request to the name server you configured it to use for name resolution. A name server may also need to forward a name resolution request on to a second name server that is responsible for the second level name that you originally entered into your computer. When the name server resolves the name and returns an IP address to your computer, your computer and the computer that you named can communicate.

CONFIGURING WINDOWS 98 TO USE A DNS SERVER 82

Configuring Windows 98 Dial-Up Networking to add a DNS server is simple. You must obtain the correct IP address for the DNS server from your Internet Service Provider. To configure your Dial-up Networking connection for a DNS server, perform the following steps:

1. To open the Dial-Up Networking Folder, shown in Figure 82.1, click your mouse on the Start menu, move to Programs, Accessories, Communications, then click your mouse on Dial-Up Networking.

Figure 82.1 The Dial-Up Networking folder on the Start button.

2. Right-click your mouse on the connection you wish to change, then choose Properties from the pop-up menu, as shown in Figure 82.2.

1001 INTERNET TIPS

Figure 82.2 The Properties option from the Connection shortcut menu.

 3. In the connection dialog box, shown in Figure 82.3, click your mouse on the Server Types tab, then click your mouse on the TCP/IP Settings button in the Allowed Network Protocols area of the dialog box.

Figure 82.3 The Dial-Up Networking connection properties dialog box.

 4. In the TCP/IP Settings dialog box, click your mouse on the Specify name server addresses radio button.
 5. Type the IP address of the Primary DNS server in the Primary DNS: field and if your ISP has provided one, type the address of the Secondary DNS server in the Secondary DNS: field. Figure 82.4 displays the TCP/IP settings dialog box.

1001 Internet Tips

Figure 82.4 *The TCP/IP settings dialog box.*

6. Click your mouse on OK to close the TCP/IP Settings dialog box, then click your mouse on OK to close the connection dialog box.

REGISTERING YOUR OWN DOMAIN NAME 83

Registering your own fully qualified Internet domain name is a process that your Internet service provider can lead you through. In fact, you will probably use your Internet service provider to supply the DNS services for your domain, meaning your ISP will maintain, and edit, if necessary, the DNS records pertaining to your domain name.

The first step in the registration process is to find out if the domain name you wish to register is available. You can search using name.space's Whois database at, *www.swhois.net*, to see if your proposed domain name has been taken. The Whois database contains records for all of the domains that are registered for use on the Internet. If you find that your proposed domain has already been registered, you will have to come up with an alternative choice. If there is no match, then the name is available and you can register the domain name for yourself through your Internet service provider. The best way to register your Internet name is to use your ISP as they have had experience working with the different name registration authorities. If you want to register your name yourself, you should go to the Web site for the Internet Corporation for Assigning Names and Numbers, at *www.icann.org*. At the ICANN Web site, you will find links to the different companies that are responsible for assigning Internet domain names.

84 — Using a Directory on Your ISP's Server for Your Web Site

Many ISPs offer a small amount of server disk space that you can use to host your own personal Web site. The ISPs typically include the cost of this space with the monthly cost of your dial-up account. If your Web site is relatively small and it is not important that you register your own fully qualified domain name, you might take advantage of this additional service.

In Figure 84, you can see a Web site that is hosted by the Internet service provider. You can see in the address field that this Web site is simply a directory on the ISP's server and the user has not registered his or her own fully qualified domain name. You can read more about publishing your own Web site in Tips 523 through 582.

Figure 84 A personal web page that is hosted on ISP's web server.

85 — Understanding Uniform Resource Locators (URL)

The Uniform Resource Locator (URL) path name is the string of information you type in the Address field of your Web browser. In Figure 85.1 you see the URL *http://www.jamsapress.com* entered in the Address field of Internet Explorer. The URL is the How, Where, and What of the Web browser. This URL provides three pieces of information for retrieving a file from the Internet. The URL tells the browser *HOW* to get the data, meaning which protocol to use (usually HTTP, FTP, or sometimes Gopher), *WHERE* to get the data, meaning what domain to search for, and *WHAT* file to retrieve, usually a file in HTML format.

Figure 85.1 A Web page URL in the address box of Internet Explorer.

In many cases, the browser will retrieve a file called *default.htm* or *index.html* without your having to specify the file name. Typically, Web servers send the default file to your browser if you do not specify a file name at the end of the URL. Usually, if you are accessing a UNIX-based Web server, the default file that loads for a given Web site is called *index.html*. If you happen to be accessing a site on a Microsoft Internet Information Server-based Web server, the default file that loads is called *default.htm*.

You will also encounter URL paths that provide the *HOW, WHERE,* and *WHAT* as well as additional directory path information. For example, the path *http://www.jamsapress.com/catalog/catalog.htm* specifies the protocol to be used, **http:**, the domain name of the web site, **//www.jamsapress.com/**, then a path or alias to a directory on the Web server, **/catalog/**, and finally the file to retrieve, *catalog.htm*. Figure 85.2 shows how a URL is used to display a Web page.

Figure 85.2 Using a URL to display a specific Web page.

86 Understanding e-mail Addresses

Electronic mail is a system that lets users send and receive messages and data through networks and the Internet. An e-mail address identifies a person and the computer on which that person's mail account exists for purposes of exchanging electronic mail messages.

The basic structure of an e-mail address is:

username@host.subdomain.second-level-domain-name.first-level-domain-name

A few examples of e-mail addresses include:

- *cheungk@gulfpub.com*
- *bmalone@source.net*
- *andreww@source.net*

You read an e-mail address from left to right. For example, in the e-mail address *cheungk@gulfpub.com,* cheungk is the name of the person sending or receiving the message (the username). *Gulfpub* is the domain name of the organization, and *com* is the first level domain name that indicates a commercial organization.

When you send an e-mail message, a DNS server resolves the domain name portion of the e-mail address, *gulfpub.com*, to the IP address of the mail server. When the message then reaches the e-mail server, the e-mail program running on the server takes the responsibility of placing the message in the appropriate mail box, in this case, the *cheungk* mailbox.

87 Understanding Usernames

Usernames are the keys to multi-user computer systems and networks. When you log on to a computer system, or dial in to your Internet service provider, or access your online electronic mail, you present a username/password combination to identify yourself to the system to which you are connecting. A username, sometimes referred to as user account or login name, is your unique identifier and the credential used when you log on to a computer system or network. You are uniquely identified and granted access to various resources by virtue of the username you present when you log on to a system.

The Internet is a network of networks, and therefore the same principles apply. You will connect to your ISP and be validated to see if you can access the ISP's network and then pass through to the Internet. Once you are browsing the Internet, you may find protected sites that require you to present a username/password combo to access that specific site. Sometimes protected sites on the Internet even require that you pay a fee before you receive your credentials to access the information on that site.

Further, you will find that, based on the username and password combination you provide when logging on to computer systems, the systems will grant you access to some resources and deny you access to others. For example, when you dial in to check your electronic mail at your Internet service provider, you are retrieving information on a mail server that only your user account can access. That means that other customers of your Internet service provider and other Internet users can send you e-mail, but they cannot read the mail you have received.

1001 Internet Tips

In Figure 87.1, you see the Windows 98 Dial-Up-Networking dialog box. In this dialog box, you specify the username and password that will be used to check to see if you can log on to the Internet service provider's network to check e-mail or to get on to the Internet.

Figure 87.1 Entering a username in the Dial-Up Networking log on dialog box.

In Tips 62 and 63, you learned about local area networks or LANs. When you start up your computer at work, a computer that is connected to the LAN, you are typically presented with a login dialog box much like the one in Figure 87.2. In this dialog box, you present your credentials that the system will use to determine what resources you can access and use on the company LAN.

Figure 87.2 Entering a username in the Microsoft Networking log on dialog box.

Understanding and Working with Passwords 88

Passwords are an integral part of securing your dial-up account with your Internet service provider. If you do not assign a password to your account, anyone who knows your username can use it to access your Internet service provider and take advantage of the services for which you are paying. That means that somebody can use your e-mail account and access your private information. Not only is your private e-mail data exposed, but a user posing as you could send e-mail using your account. It is essential that you assign a password and that you maintain password security. If possible, do not write your password down; memorize your password and keep it to yourself. In the next tip, you will learn more about using secure passwords.

89 USING GOOD PASSWORDS

To be most effective, passwords have to be secret, known only to you, and they have to be difficult to guess. It is impossible to know who might try to hack into your account. It might be a co-worker or it might be an unknown computer jock from Germany.

Because you cannot know who will try to guess our account information, we have to assume it might be anyone, even someone you know. With that in mind, one of the first rules of password security is to avoid using obvious associations. Do not use names or words that people will easily associate with you. For example, do not use any part of your name, the name of your spouse or significant other, your children's names, names of pets, your favorite sports team, or the type of car you drive. If a hacker knows anything at all about you, he or she can easily guess these types of passwords.

After discarding obvious associations, the next step in securing your password is to avoid using words that might be found in the dictionary. Use passwords that are not words at all. Include special characters, like the dollar sign ($) or asterisk (*), and/or numbers in your passwords. History proves that hackers break in by trying to guess passwords. This is a very tedious task if the intruder simply sits down at his or her keyboard and begins typing in guesses at the password prompt. It is much easier to write a simple computer program that will try different passwords, commonly referred to as a dictionary attack. The hacking program simply cycles through a list of words, trying each one at the password prompt. If a dictionary attack hacking program cannot match your password to a word in its dictionary list, it will not get into the system. On the server side of the connection, some server operating systems protect against a dictionary attack by locking out a username after a given number of login attempts.

The longer your password is the more difficult it is to guess. A 14-character password is more difficult to guess than a 4-character password. In fact, you will probably encounter systems online that require that your password be a certain number of characters long. In this way, system operators or system administrators force at least some level of enhanced security on the users.

Some online systems will support case-sensitive passwords. That means that you can use both upper and lower case letters in your password. On such systems, the password goosetown is different than the password gOosEtown. If a hacker does not capitalize the correct letters when guessing your password, he or she will not get into the system.

In short, to be most secure with your password, use long passwords, include numbers and special characters, avoid using words in the dictionary, avoid obvious associations, and change your password frequently.

90 PREVENTING YOUR PASSWORD FROM BEING STOLEN

As you learned in Tip 88, "Understanding and Working with Passwords," long, non-word passwords that include numbers, special characters, and case variation are difficult to guess. However, passwords can still be stolen.

You can adopt a few simple procedures to prevent other users from guessing or stealing your password. First, never write your passwords down, commit your password to memory and keep it to yourself. If security is an issue, and it almost always is at some level, never share your account with another person. Many Internet service providers offer

multiple usernames, often as many as five usernames, per account. That means you can use a separate username/password combo for each member of the family, depending on how many the ISP allows. The only catch using this procedure is that only one user can be dialed in at a time, which is usually not a problem since not many homes have multiple computers, at least for now.

Many online services offer the capability to store your password so you do not have to type the password each time you log on to the service. Such a feature presents a gaping security hole. If you choose to store your password, anyone who can get access to your computer can use your account.

The longer you use a particular password, the more likely it is to be stolen or guessed. To add security, change passwords frequently, once per month or more.

To learn more about advanced security topics, refer *Hacker Proof*, by Lars Klander (Jamsa Press).

CUSTOMIZING MODEM SETTINGS WITHIN WINDOWS 98 91

Today users make extensive use of their PC's modem to connect to the Internet to surf the World Wide Web and to send and receive electronic mail. Several of the Tips that follow examine ways you can configure your modem for ease of use and top performance. To perform the operations the Tips present, you will make extensive use of the Modems Properties dialog box, as shown in Figure 91.

Figure 91 The Modems Properties dialog box.

To display the Modems Properties dialog box, perform the following steps:

1. Click your mouse on the Start menu Settings option and choose Control Panel. Windows 98, in turn, will open the Control Panel window.

2. Within the Control Panel window, double-click your mouse on the Modems icon. Windows, in turn, will display the Modems Properties dialog box.

92 INSTALLING SOFTWARE FOR A NEW MODEM UNDER WINDOWS 98

Today, telephone, cable, and modem manufacturers are constantly coming up with faster and more efficient ways for users to connect to the Internet and the World Wide Web. As a result, to save time, you may find yourself purchasing a new modem every six months, simply to keep up with technology. When you install a new modem, you must tell Windows 98 about your new hardware. Depending on the modem you purchase, you will tell Windows 98 about your modem using one of three techniques:

- Windows 98 will recognize your new modem using its plug-and-play capabilities requiring very little user input.
- From within the Windows 98 Control Panel, you can start the Install New Modem Wizard which will help you install the software you need.
- From within the Windows 98 Control Panel, you can start the Add New Hardware Wizard which, in turn, will recognize that you have installed a new modem and will help you install the software you need.

If you install a plug-and-play modem, Windows 98 will display a dialog box that identifies your modem and tells you that it must now install software to support it.

In most cases, you can simply follow the dialog boxes Windows 98 displays to install your plug-and-play modem's software. If, for some reason, Windows 98 does not recognize your new modem, the easiest way to install your modem's software is to start Install New Modem Wizard from within the Control Panel, by performing the following steps:

1. Select the Start menu Settings option. Windows 98, in turn, will display the Settings submenu.
2. In the Settings submenu, select the Control Panel option. Windows 98, in turn, will open the Control Panel window.
3. In the Control Panel window, double-click your mouse on the Modems icon. Windows 98, in turn, will display the Modems Properties dialog box, as shown in Figure 92.

Figure 92 The Modems Properties dialog box.

4. In the Modems Properties dialog box, click your mouse on the Add button. Windows 98, in turn, will start the Install New Modem Wizard which will walk you through the modem installation process. Follow the instructions the Wizard displays on your screen to install your modem software. At some point during the installation, the Wizard might prompt you to insert the Windows CD-ROM or floppy disk or the CD-ROM or floppy disk that accompanied your new modem.

Note: *If the Install New Modem Wizard fails to identify your modem, you may need to run the SETUP program which resides on the CD-ROM or floppy disk that accompanies your modem.*

REMOVING YOUR OLD MODEM FROM THE WINDOWS 98 MODEM LIST — 93

In the previous Tip, you learned how to install software for a new modem using the Control Panel Modems icon. After you install your new modem and have it up and running, you will want to remove your old modem from the Windows 98 modem list. If you do not remove your modem, many modem-based programs will continue to list the modem as available for use. To remove your modem from the list of available modems, perform the following steps:

1. Select the Start menu Settings option. Windows 98, in turn, will display the Settings submenu.
2. In the Settings submenu, select the Control Panel option. Windows 98, in turn, will open the Control Panel window.
3. In the Control Panel window, click your mouse on the Modems icon. Windows 98, in turn, will display the Modems Properties dialog box.
4. In the Modems Properties dialog box, select the entry that corresponds to the modem that you want to remove, then click your mouse on the Remove button. Windows 98, in turn, will remove the modem from the list of available modems.
5. In the Modems Properties dialog box, click your mouse on the Close button.

When you remove a modem from the Windows 98 list of available modems, Windows 98 will not remove the modem's device drivers from your system. Therefore, should you later re-install the modem, the software Windows 98 needs to run the modem already resides on your disk. To add the old modem, you must follow the steps described in Tip 92, "Installing Software for a New Modem Under Windows 98."

DISPLAYING YOUR MODEM PROPERTIES — 94

Using the Windows 98 Control Panel, you can view or change various configuration settings for many of your hardware devices—modems are no exception. Several of the Tips that follow discuss ways you can configure your modem. To change your modem settings, you will use the Modems Properties dialog box, as shown in Figure 94.

1001 Internet Tips

Figure 94 The Modems Properties dialog box.

To display the Modems Properties dialog box, perform the following steps:

1. Select the Start menu Settings option. Windows 98, in turn, will display the Settings submenu.
2. On the Settings submenu, select the Control Panel option. Windows 98, in turn, will open the Control Panel window.
3. In the Control Panel window, click your mouse on the Modems icon. Windows 98, in turn will display the Modems Properties dialog box.

In the Modems Properties dialog box, select the entry that corresponds to your modem and click your mouse on the Properties button to display and configure information about your modem's hardware settings. Likewise, you can click your mouse on the Dialing Properties button to set your modem's phone characteristics, such as whether or not your modem must dial 9 to access an outside line, or what number your modem must dial to disable call waiting. Several of the Tips that follow discuss your modem's hardware settings and call settings in detail.

95 CONFIGURING YOUR MODEM'S DIALING PROPERTIES

As you know, a modem lets you connect your PC to another computer over standard telephone lines. Using your PC's modem to connect to another computer is very much like making a phone call. You must tell your data-communication software the number you want to call and then your modem will dial the number. If the number corresponds to a long distance call, you will pay the same long distance rates for your modem call as you would for your phone call.

Depending from where you place your call, you may also need to tell your modem to dial 9 to access an outside line or that your modem should disable call waiting to prevent an incoming call from disabling your modem connection. To simplify your modem use, Windows 98 lets you define these call settings one time for your modem. Then, each time you make a modem connection, Windows 98 will automatically use the settings. To define your modem's dialing settings, perform the following steps:

1. Select the Start menu Settings option. Windows 98, in turn, will display the Settings submenu.
2. On the Settings submenu, select the Control Panel option. Windows 98, in turn, will open the Control Panel window.
3. In the Control Panel window, click your mouse on the Modems icon. Windows 98, in turn, will display the Modems Properties dialog box.
4. In the Modems Properties dialog box, select the entry that corresponds to your modem and click your mouse on the Dialing Properties button. Windows 98, in turn, will display the Dialing Properties dialog box, as shown in Figure 95. Several of the Tips that follow discuss the steps you must perform to configure specific settings in the Dialing Properties dialog box.

Figure 95 *The Dialing Properties dialog box.*

Using the Dialing Properties Dialog Box to Tell Windows 98 Your Area Code — 96

Placing a long distance call using your modem is no different than placing a long distance call with your phone. Your modem software must dial the area code and the phone number. To simplify your modem calls, you should use the Dialing Properties dialog box to tell Windows 98 your current area code. Most data-communication software programs will use the area code value that you specify to determine when they are placing a long-distance call, and can then determine, on their own, what prefixes they must dial, even if you want the software to charge the call to your phone card. To assign your current area code to your modem settings, perform the following steps:

1. Select the Start menu Settings option. Windows 98, in turn, will display the Settings submenu.
2. In the Settings submenu, select the Control Panel option. Windows 98, in turn, will open the Control Panel window.
3. In the Control Panel window, double-click your mouse on the Modems icon. Windows 98, in turn, will display the Modems Properties dialog box.

4. In the Modems Properties dialog box, select the entry that corresponds to your modem and click your mouse on the Dialing Properties button. Windows 98, in turn, will display the Dialing Properties dialog box.

5. In the Dialing Properties dialog box, click your mouse on the I am in this country/region drop-down list. Windows 98, in turn, will display a list of countries similar to that shown in Figure 96.

Figure 96 The country/region drop-down list.

6. On the pull-down list, click your mouse on the country in which you currently reside. Windows 98 will later use this information when you place calls to other countries.

7. Within the Dialing Properties dialog box, click your mouse in the area code field and type in your area code.

8. Depending on where you live, you may have local area codes that differ from your area code, but that do not require you to dial a 1 to place the call as a long distance number. To inform Windows 98 about such area-code rules, click your mouse on the Dialing Properties dialog box Area Code Rules button. Windows 98, in turn, will display the Area Code Rules dialog box, in which you can specify how your modem software should treat different local area codes.

97 CONTROLLING PHONE LINE SPECIFIC MODEM SETTINGS

Depending from where you are placing your modem calls, there may be times when you must dial 9 to access an outside line (common in hotels or offices, for example), or you must dial a different access number before you can place a long distance call (which is common in many businesses). In addition, if you are making modem calls over a phone line that supports call waiting, you may want to disable the call waiting feature during your modem calls to prevent an incoming call from disconnecting your modem connection.

1001 Internet Tips

To specify settings which are specific to your current phone line, perform the following steps:

1. Select the Start menu Settings option. Windows 98, in turn, will display the Settings submenu.
2. In the Settings submenu, select the Control Panel option. Windows 98, in turn, will open the Control Panel window.
3. In the Control Panel window, click your mouse on the Modems icon. Windows 98, in turn, will display the Modems Properties dialog box.
4. In the Modems Properties dialog box, select the entry that corresponds to your modem and click your mouse on the Dialing Properties button. Windows 98, in turn, will display the Dialing Properties dialog box.
5. If you must dial a specific number to access an outside line for local calls, click your mouse in the For local calls, dial text box and type the number you must dial to access the outside line.
6. If you must dial a specific access code before you can place a long distance call, click your mouse in the For long distance calls, dial text box and type your access code.
7. If you want to disable call waiting for the duration of your modem call, click your mouse on the checkbox that appears to the left of the To disable call waiting, dial field, placing a check mark within the box. Then, click your mouse on the To Disable call waiting drop-down list. Windows 98, in turn, will display a list of codes that disable call waiting. In the drop-down list, select the code that disables call waiting for your current phone service.
8. In the Dialing Properties dialog box, click your mouse on the OK button to apply your changes.

DIRECTING WINDOWS 98 TO USE YOUR CALLING CARD FOR LONG-DISTANCE MODEM CALLS — 98

As you have learned, placing a long distance modem call is similar to placing a long distance phone call. Your modem software must specify the long distance area code and the phone company will charge you the same rate for your modem call as it would for a phone call. To simplify your modem calls, Windows 98 lets you configure Dial-Up Networking to charge your calls to a calling card.

To assign your calling-card number to your modem settings, perform the following steps:

1. Select the Start menu Settings option. Windows 98, in turn, will display the Settings submenu.
2. In the Settings submenu, select the Control Panel option. Windows 98, in turn, will open the Control Panel window.
3. In the Control Panel window, double-click your mouse on the Modems icon. Windows 98, in turn, will display the Modems Properties dialog box.
4. In the Modems Properties dialog box, select the entry that corresponds to your modem and click your mouse on the Dialing Properties button. Windows 98, in turn, will display the Dialing Properties dialog box.
5. In the Dialing Properties dialog box, click your mouse on the Calling Card button. Windows 98, in turn, will display the Calling Card dialog box, as shown in Figure 98.1.
6. Within the Calling Card dialog box, click your mouse on the pull-down list which appears near the top of the dialog box. Windows 98, in turn, will display a list of the common calling cards, as shown in Figure 98.2.

1001 Internet Tips

Figure 98.1 The Calling Card dialog box.

Figure 98.2 List of common calling cards that you can configure to work in Windows 98.

7. Within the pull-down list, click your mouse on your calling card plan. Windows 98, in turn, will display the calling card access numbers within the Calling Card dialog box.

8. Within the Calling Card dialog box, click your mouse on the Settings for this calling card field and type in the Personal ID Number (your PIN number) that your phone company gave you with the card. Within the Calling Card dialog box, click your mouse on the OK button.

Note: If Windows 98 does not list your calling card in its pull-down list, click your mouse on the Calling Card New button and define a name for your card. Next, in the Calling Card dialog box, you must enter your PIN number and your calling card company's long distance and international dialing codes.

99 USING MODEM DIALING SCHEMES TO SIMPLIFY YOUR MODEM CONNECTIONS

In several of the previous Tips, you have learned ways to define settings for your current phone line. If you are like many users who use a notebook PC at work, at home, and on the road, you can simplify your modem operations by

defining a modem dialing scheme, which defines the dialing settings for a specific location. You might, for example, create one dialing scheme that you name *Work Office*, for which you enter the numbers you must dial to access an outside line, and so on. Then, you might create a scheme that you call *Home Office*. In addition, if you travel on a regular basis and your company provides you with a calling card, you might create a scheme that you call *Business Travel*, within which you direct Windows 98 to use your calling card for all long-distance calls. To create a modem dialing scheme, perform the following steps:

1. Select the start menu Settings option. Windows 98, in turn, will display the Settings submenu.
2. In the Settings submenu, select the Control Panel option. Windows 98, in turn, will open the Control Panel window.
3. In the Control Panel window, double-click your mouse on the Modems icon. Windows 98, in turn, will display the Modems Properties dialog box.
4. In the Modems Properties dialog box, select the entry that corresponds to your modem and click your mouse on the Dialing Properties button. Windows 98, in turn, will display the Dialing Properties dialog box.
5. In the Dialing Properties dialog box, click your mouse on the New button. Windows 98, in turn, will create an entry in the I am dialing from pull-down list named New Location.
6. In the Dialing Properties dialog box, click your mouse in the I am dialing from text field and type in your modem dialing scheme name, such as Work Office, overwriting the name New Location.
7. Within the Dialing Properties dialog box, change the Phone settings to match the location for which you are defining your new scheme.
8. Within the Dialing Properties dialog box, click your mouse on the OK button to save your new scheme.

USING A MODEM DIALING SCHEME 100

In Tip 99, you learned how creating a modem dialing scheme for each location from which you use your modem can simplify your modem operations. After you define a modem dialing scheme, you will want to select the scheme that corresponds to your current location before you try to place a modem call. To select a modem dialing scheme, perform the following steps:

1. Select the Start menu Settings option. Windows 98, in turn, will display the Settings submenu.
2. In the Settings submenu, select the Control Panel option. Windows 98, in turn, will open the Control Panel.
3. In the Control Panel window, double-click your mouse on the Modems icon. Windows 98, in turn, will display the Modems Properties dialog box.
4. In the Modems Properties dialog box, select the entry that corresponds to your modem and click your mouse on the Dialing Properties button. Windows 98, in turn, will display the Dialing Properties dialog box.
5. In the Dialing Properties dialog box, click your mouse on the I am dialing from drop-down list. Windows 98, in turn, will display a list of your modem dialing schemes, as shown in Figure 100.
6. In the drop-down list, click your mouse on the modem dialing scheme that corresponds to your current location.

1001 Internet Tips

Figure 100 Using the I am dialing from drop-down list.

7. In the Dialing Properties dialog box, click your mouse on the OK button to apply your changes.
8. In the Modems Properties dialog box, click your mouse on the OK button. You are now ready to place your modem calls.

101 Controlling Your Modem's Hardware Settings

In several of the previous Tips, you learned how to configure the settings your modem uses to place calls. Usually, newer plug-and-play modems work fine from the moment you take them out of the box and install them into your PC. Periodically, however, your modem may simply not work or may fail intermittently. In such cases, you may be able to troubleshoot your modem's problem and then change a hardware setting from within the Modems Properties dialog box. To view your modem's current hardware properties, perform the following steps:

1. Select the Start menu Settings option. Windows 98, in turn, will display the Settings submenu.
2. In the Settings submenu, select the Control Panel option. Windows 98, in turn, will open the Control Panel window.
3. In the Control Panel window, double-click your mouse on the Modems icon. Windows 98, in turn, will display the Modems Properties dialog box.
4. In the Modems Properties dialog box, select the entry that corresponds to your modem and click your mouse on the Properties button. Windows 98, in turn, will display the Modem Properties dialog box General tab, as shown in Figure 101.

Several of the Tips that follow discuss ways you can use the Modems Properties dialog box to configure your modem's hardware settings.

1001 Internet Tips

Figure 101 The Modem Properties dialog box General tab for Motorola VoiceSURFR 56K Internal PnP.

Understanding Your Modem's Communication Port — 102

Years ago, modems were external devices that you connected to one of your PC's serial ports. Most PCs come with two serial ports, but can support up to four. Your PC's serial ports are usually referred to as COM1, COM2, COM3, and COM4. The COM portion of the serial port name corresponds to the fact that the PC uses the serial ports to communicate with different hardware peripheral devices. In the past, users would connect a serial mouse to one of their serial ports and an external serial modem to the second port. The user then had to tell Windows which port he or she was using for the mouse and which port he or she was using for the modem.

Today, most PCs use internal modems which you (or your PC's manufacturer) install inside the PC as a hardware add-on card. To communicate with the modem, your PC sends and receives electronic signals over a specific set of wires. Because most PCs do not use all four serial ports, you will usually borrow the wires that correspond to one of the serial port locations for use by your modem. Therefore, when you install a modem yourself, you must tell your PC (and the modem, usually by using switches or jumpers on the modem card) which port the modem will use. Often, the modem will use the COM2 wires.

If you experience intermittent errors when you use your modem (such as your mouse suddenly stops working when you place a modem call, or each time you move your mouse, your modem disconnects), you probably have two devices trying to use the same port. In such cases, you will need to change your settings on the modem card itself. (Have an experienced user help you assign your modem to a new COM port. The documentation that accompanies your modem will tell you how.) Then, you must configure Windows 98 to change the modem's port setting. To tell Windows 98 that you have changed the modem port, perform the following steps:

1. Select the Start menu Settings option. Windows 98, in turn, will display the Settings submenu.
2. In the Settings submenu, select the Control Panel option. Windows 98, in turn, will open the Control Panel window.

1001 Internet Tips

3. In the Control Panel windows, double-click your mouse on the Modems icon. Windows 98, in turn will display the Modems Properties dialog box.

4. In the Modems Properties dialog box, select the entry that corresponds to your modem and click your mouse on the Properties button. Windows 98, in turn, will display the Modems Properties dialog box General tab.

5. On the General tab, click your mouse on the drop-down Port list. Windows 98, in turn, will display a list of available serial ports.

6. On the Ports drop-down list, click your mouse on the serial port that corresponds to your modem and then click your mouse on the OK button to apply your changes.

7. In the Modems Properties dialog box, click your mouse on the OK button.

103 CONTROLLING YOUR MODEM'S SPEAKER VOLUME

When you use your modem to connect to another computer, you will typically hear your phone line's dial tone, followed by your modem dialing, and then the two computers will exchange a series of tones. If you are working with a computer in an office space, your modem's noises may begin to irritate employees who are working nearby.

In such cases, you can use the Modems Properties dialog box to turn down the volume of your modem's built-in speaker. Likewise, if your modem is having trouble connecting to a remote computer, there may be times when you want to listen to the tones, so that you can ensure your modem is successfully completing the call. In that case, you may want to turn up your modem's speaker volume. To control your modem's speaker volume, perform the following steps:

1. Select the Start menu Settings option. Windows 98, in turn, will display the Settings submenu.

2. In the Settings submenu, select the Control Panel option. Windows 98, in turn, will open the Control Panel window.

3. In the Control Panel window, double-click your mouse on the Modems icon. Windows 98, in turn, will display the Modems Properties dialog box.

4. In the Modems Properties dialog box, select the entry that corresponds to your modem and click your mouse on the Properties button. Windows 98, in turn, will display the Modems Properties dialog box General tab.

5. On the General tab, use your mouse to drag the Speaker Volume slider higher or lower, as your needs require, and then click your mouse on the OK button.

6. In the Modems Properties dialog box, click your mouse on Close to apply your changes and close the dialog box.

104 UNDERSTANDING THE MODEM PROPERTIES MAXIMUM SPEED SETTING

If you examine the Modems Properties dialog box General tab, as shown in Figure 104, you will find that the tab provides a Maximum speed drop-down list.

1001 Internet Tips

Figure 104 The Modem Properties dialog box General tab.

Most users can ignore this Maximum speed setting for their modem. In short, this setting refers to the maximum speed at which the modem can transmit and receive data in an ideal world (such as a direct connection between two modems that did not use standard telephone lines). Usually, the Maximum speed setting contains a value that is faster than your modem speed. Unless you are having problems, ignore this setting's value.

If, however, you have a fast modem, such as a 56Kbps modem, and you are having trouble connecting to a slower 14.4Kbps modem, for example, you can use this setting to slow down your modem. Usually, the faster modem will determine the speed of the slower modem automatically but, if for some reason your modem cannot adjust to the slower speed on its own, you may be able to use the Maximum speed setting to force your modem to slow down.

CUSTOMIZING YOUR MODEM'S DATA CONNECTION SETTINGS 105

When you use a modem to communicate with another PC, your modem's hardware and your data-communication software do a lot of work behind the scenes. To begin, both modems must agree on the speed at which they will communicate. If one modem sends the information faster than the second modem can receive it, errors will occur and the modems will lose information. Next, the modems must agree on how much data they will send at one time and whether or not they will include extra data (called a parity bit) to help the modems detect transmission errors. These values, upon which the modems must agree, are connection settings. Most users never have to worry about assigning values to the connection settings. Instead, the default settings will work just fine. However, if for some reason, you must change your settings in order to communicate with a specific PC, perform the following steps:

1. Select the Start menu Settings option. Windows 98, in turn, will display the Settings submenu.
2. In the Settings submenu, select the Control Panel option. Windows 98, in turn, will open the Control Panel window.
3. In the Control Panel, double-click your mouse on the Modems icon. Windows 98, in turn, will display the Modems Properties dialog box.
4. In the Modems Properties dialog box, select the entry that corresponds to your modem and click your mouse on the Properties button. Windows 98, in turn, will display the Modems Properties dialog box General tab.

1001 Internet Tips

5. In the Modems Properties dialog box, click your mouse on the Connection tab. Windows 98, in turn, will display the Modems Properties dialog box Connection tab, as shown in Figure 105.

Figure 105 *The Modem Properties dialog box Connection tab.*

6. On the Connection tab, use the Data bits, Parity, and Stop bits drop-down lists to assign the settings you need and then click your mouse on the OK button.
7. In the Modems Properties dialog box, click your mouse on Close to apply the changes and close the dialog box.

106 SETTING YOUR MODEM'S CALL PREFERENCE SETTINGS

When you place a modem call, your modem, much like a phone, will usually wait for a dial tone and then dial a number. If you are traveling in another country, however, a dial tone may be different than the one your modem expects. As a result, if your modem waits to hear a recognized dial tone before dialing, it may never place your call. In addition, when you place a modem call, most modems will wait up to 60 seconds for a modem at the other end of the call to answer. If another modem does not answer the call within the 60-second window, most modems will hang up, terminating the call. Depending upon from where you are calling and the computer you are calling, there may be times when 60 seconds simply is not long enough for the receiving modem to answer the call. Lastly, there may be times when you simply forget to end your modem call. Rather than let your modem stay connected indefinitely (which might result in your running up a very large long distance phone bill), you can direct Windows 98 to disconnect your modem when your modem has not sent or received any data over a specific time interval, like 15 minutes. To control your modem's call preferences, perform the following steps:

1. Select the Start menu Settings option. Windows 98, in turn, will display the Settings submenu.
2. In the Settings submenu, select the Control Panel option. Windows 98, in turn, will open the Control Panel window.
3. In the Control Panel window, double-click your mouse on the Modems icon. Windows 98, in turn, will display the Modems Properties dialog box.

1001 Internet Tips

4. In the Modems Properties dialog box, select the entry that corresponds to your modem and click your mouse on the Properties button. Windows 98, in turn, will display the Modems Properties dialog box General tab.

5. In the Modems Properties dialog box, click your mouse on the Connection tab. Windows 98, in turn, will display the Modems Properties dialog box Connection tab, as shown in Figure 106.

6. On the Connection tab, use the Call Preferences field to customize your modem settings and then click your mouse on the OK button to apply your changes.

7. In the Modems Properties dialog box, click your mouse on OK to close the dialog box.

Figure 106 The Modem Properties dialog box Connection tab.

Configuring Your Modem's UART Settings for Maximum Performance 107

To communicate over standard telephone lines, the sending modem converts the computer's digital signals into analog signals which it then transmits across the wires. The receiving modem, on the other hand, converts the incoming analog signals back into digital signals its PC can process. This process is called modulation/demodulation, hence the name modem. At the heart of this analog/digital conversion is a chip on the modem called UART (the Universal Asynchronous Receiver Transmitter). As you shop for a modem, look for one that comes with a 16550 or 16650 UART chip. These two UART chips are significantly faster than their predecessors and will improve your modem's speed.

Although most users will never know that their modem has a UART, much less want to configure the UART, there are times when you can make a few simple adjustments to the UART settings that will further improve your modem's performance. To view your current UART settings, perform the following steps:

1. Select the Start menu Settings option. Windows 98, in turn, will display the Settings submenu.

2. In the Settings submenu, select the Control Panel option. Windows 98, in turn, will open the Control Panel window.

3. In the Control Panel window, double-click your mouse on the Modems icon. Windows 98, in turn, will display the Modems Properties dialog box.

1001 Internet Tips

4. In the Modems Properties dialog box, select the entry that corresponds to your modem and click your mouse on the Properties button. Windows 98, in turn, will display the Modems Properties dialog box General tab.

5. In the Modems Properties dialog box, click your mouse on the Connection tab. Windows 98, in turn, will display the Modems Properties dialog box Connection tab.

6. On the Connection tab, click your mouse on the Port Settings button. Windows 98, in turn, will display the Advanced Port Settings dialog box, as shown in Figure 107.

Figure 107 The Advanced Port Settings dialog box for your modem.

In the Advanced Port Settings dialog box, you can customize the number of buffers Windows 98 uses to hold the information the UART is to transmit or receive. In general, by increasing the number of the buffers, you will improve your modem performance. Like all system-tuning operations, however, you may need to experiment to determine the best settings for your system.

108 Taking Advantage of Your Modem's Advanced Settings

When two PCs use modems to communicate, the modems, as well as your data-communication software, perform many operations behind the scenes. Although most users will never have to control the low-level modem operations, there may be times when you have difficulty connecting to a specific computer (a specific computer that you are trying to dial into, as opposed to a site on the Internet). In such cases, you may need to enable or disable specific data-communication operations by performing the following steps:

1. Select the Start menu Settings option. Windows 98, in turn, will display the Settings submenu.

2. In the Settings submenu, select the Control Panel option. Windows 98, in turn, will open the Control Panel window.

3. In the Control Panel window, double-click your mouse on the Modems icon. Windows 98, in turn, will display the Modems Properties dialog box.

4. In the Modems Properties dialog box, select the entry that corresponds to your modem and click your mouse on the Properties button. Windows 98, in turn, will display the Modems Properties dialog box General tab.

5. In the Modems Properties dialog box, click your mouse on the Connection tab. Windows 98, in turn, will display the Modems Properties dialog box Connection tab.

6. On the Connection tab, click your mouse on the Advanced button. Windows 98, in turn, will display the Advanced Connection Settings dialog box, as shown in Figure 108.

7. In the Advanced Connection Settings dialog box, enable or disable the settings that you require and then click your mouse on the OK button to apply your changes.

8. In the Modems Properties dialog box, click your mouse on the OK button.

Figure 108 The Advanced Connection Settings dialog box.

USING THE MODEM LOG.TXT FILE TO TROUBLESHOOT MODEM OPERATIONS 109

If Windows 98 has trouble working with your modem, you can request that Windows 98 log all modem operations in a file named MODEMLOG.TXT, stored in the Windows folder. Later, using a text editor such as the Notepad accessory, you can open the log file and use its contents to troubleshoot your modem connections. To direct Windows 98 to create the MODEMLOG.TXT log file, perform the following steps:

1. Click your mouse on the Start menu Settings option and then choose the Control Panel option. Windows 98, in turn, will open the Control Panel window.

2. In the Control Panel window, double-click your mouse on the Modems icon. Windows 98, in turn, will open the Modems Properties dialog box.

3. In the Modems Properties dialog box, select the entry that corresponds to your modem and then click your mouse on the Properties button. Windows 98, in turn, will display a Properties dialog box specific to your modem. Click your mouse on the Connection tab. Windows 98, in turn, will display the Connection tab.

4. On the Connection tab, click your mouse on the Advanced button. Windows 98, in turn, will display the Advanced Connection Settings dialog box.

5. In the Advanced Connection Settings dialog box, click your mouse on the Record a log checkbox, placing a checkmark within the box, and then click your mouse on the OK button.

6. In your Modems Properties dialog box, click your mouse on the OK button to apply your changes.

7. In the Modems Properties dialog box, click your mouse on the OK button.

1001 Internet Tips

110 Using the Windows 98 ISDN Wizard to Configure an ISDN Modem Connection

To reduce the amount of time they spend waiting for their e-mail or information from sites across the Web to download, many users are turning to ISDN (Integrated Services Digital Network) modems and Internet connections. Although ISDN connections are more expensive than traditional phone connections and they require a special ISDN adapter, users find that the speed and reliability of ISDN makes it well worth the cost. To help you get started with an ISDN adapter, Windows 98 provides an ISDN Configuration Wizard. After physically installing your ISDN adapter in your PC, start the ISDN Configuration Wizard by performing the following steps:

1. Click your mouse on the Start menu Programs option and choose Accessories. Windows 98, in turn, will cascade the Accessories submenu.

2. In the Accessories submenu, click your mouse on the Communications option and then choose ISDN Configuration Wizard. Windows 98, in turn, will start the Wizard. Perform each step within the Wizard's dialog box and then click your mouse on the Next button to continue through the Wizard.

Note: You will not be able to run the ISDN Wizard if you do not have an ISDN adapter.

111 Using MultiLink Modem Connections for Fast Telecommunications

In addition to using ISDN modems, as discussed in Tip 110, to improve their telecommunications speeds, some users are installing multiple modems within their systems which they then connect simultaneously to their Internet provider over separate phone lines. To use two or more modems in this way, you must first have multiple modems installed in your PC. Next, you must have a separate phone line for each modem. Your Internet service provider (your ISP) must support multilink connections. And, finally, you must direct Windows 98 to take advantage of your multilink capabilities by performing the following steps:

1. On your Desktop, double-click your mouse on the My Computer icon. Windows 98, in turn, will open the My Computer window.

2. In the My Computer window, double-click your mouse on the Dial-Up Networking icon. Windows 98, in turn, will open the Dial-Up Networking window.

3. In the Dial-Up Networking window, right-click your mouse on the icon that corresponds to the connection you want to configure. Windows 98, in turn, will display a small pop-up menu. On the pop-up menu, click your mouse on the Properties option. Windows 98, in turn, will display the connection's Properties dialog box.

4. In the Properties dialog box, click your mouse on the Multilink tab. Windows 98, in turn, will display the Multilink tab, as shown in Figure 111.1.

5. On the Multilink tab, click your mouse on the Use additional devices radio button.

6. On the Multilink tab, click your mouse on the Add button to specify one of the devices you want the connection to use. Windows 98, in turn, will display the Edit Extra Device dialog box, as shown in Figure 111.2.

1001 Internet Tips

Figure 111.1 The Multilink tab in the Dial-Up Networking dialog box.

Figure 111.2 The dialog box for adding an extra device to enable Multilink on your computer.

7. In the Edit Extra Device dialog box, click your mouse on the Device name drop-down list and select the device you want to add. Then, click your mouse on the OK button. (Your ISP may want you to provide a specific phone number for the device as well.)
8. Repeat Steps 6 and 7 to add each modem you want your connection to use. Then, in the Properties dialog box, click your mouse on the OK button to apply your changes.

WINDOWS 98 DIAL-UP NETWORKING — 112

Today, most users are comfortable with the process of using their modem to dial into an Internet service provider or online service. In a similar way, Windows 98 lets you use your modem to dial into a remote PC. After you connect to the remote PC, Windows 98 lets you share files and folders with the remote user, run remote programs, and even print documents to a remote printer. By using Windows 98 Dial-Up Networking, you can use your laptop, for example, to connect to your office computer from home or from the road. To create a Windows 98 dial-up network connection for a remote PC, perform the following steps:

1. On the Windows 98 Desktop, double-click your mouse on the My Computer icon. Windows 98, in turn, will open the My Computer window.
2. In the My Computer window, double-click your mouse on the Dial-Up Networking folder. Windows 98, in turn, will open the Dial-Up Networking folder.

1001 Internet Tips

3. In the Dial-Up Networking folder, double-click your mouse on the Make New Connection icon. Windows 98, in turn, will start the Make New Connection Wizard, which will walk you through the steps you must perform to name your connection and to assign the connection's phone number.

To use your connection to access the remote computer, perform the following steps:

1. In the My Computer window, double-click your mouse on the icon that corresponds to your connection. Windows 98, in turn, will display the Connect To dialog box, as shown in Figure 112.

Figure 112 The Connect To dialog box used in Windows 98 Dial-Up Networking.

2. In the Connect To dialog box, type in the username and password the remote computer will use to authenticate your access and then click your mouse on the Connect button to start the connection.

113 USING THE WINDOWS 98 DIAL-UP SERVER

In Tip 112, you learned that by using the Windows 98 Dial-Up Networking tool, you can use your modem to connect to a remote computer. Usually, the remote computer to which you connect will be a server running an operating system, such as Windows NT. Depending on your needs, however, there may be times when you need other users to dial into your PC. To let a user connect to your PC, you can use the Windows 98 Dial-Up Server.

To start, you may have to install the Windows 98 Dial-Up Server software using the Control Panel Add/Remove Programs applet. Next, to enable the Windows 98 Dial-Up Server, perform the following steps:

1. On the Windows 98 Desktop, double-click your mouse on the My Computer icon. Windows 98, in turn, will open the My Computer window.
2. In the My Computer window, double-click your mouse on the Dial-Up Networking folder. Windows 98, in turn, will open the Dial-Up Networking folder..
3. In the Dial-Up Networking folder, click your mouse on the Connections menu and choose the Dial-Up Server option. Windows 98, in turn, will display the Dial-Up Server dialog box, as shown in Figure 113.

1001 Internet Tips

Figure 113 The Dial-Up Server dialog box.

4. In the Dial-Up Server dialog box, click your mouse on the Allow caller access radio button to get dial-in access to your PC.

5. If you want to force users to specify a password before they can access your system, click your mouse on the Change Password button. Windows 98, in turn, will display the Dial-Up Networking Password dialog box. In the dialog box, type in the password you desire.

6. In the Dial-Up Server dialog box, click your mouse on the OK button. Windows 98, in turn, will enable the Dial-Up Server which, in turn, will listen for an incoming call. In addition, Windows 98 will display a Dial-Up Server icon on the Windows 98 Taskbar.

TURNING OFF THE WINDOWS 98 DIAL-UP SERVER — 114

In Tip 113, you learned how to turn on the Windows 98 Dial-Up Server. To turn off the Windows 98 Dial-Up Server, perform the following steps:

1. On the Windows 98 Taskbar, locate and double-click your mouse on the Dial-Up Server. Windows 98, in turn, will display the Dial-Up Server dialog box.

2. In the Dial-Up Server dialog box, click your mouse on the No caller access radio button and then click your mouse on the OK button. Windows 98, in turn, will turn off the Dial-up Server and will remove the Server's icon from the Taskbar.

DISCONNECTING A REMOTE USER FROM A DIAL-UP SESSION — 115

In Tip 113, you learned how to enable the Windows 98 Dial-Up Server which lets a remote user dial into your PC and access your system's shared resources. In Tip 114, you learned how to turn off dial-up access to your system.

Depending on your needs, there may be times when you want to disconnect the current remote user without turning off the dial-up server. To disconnect the current remote user, perform the following steps:

1. Double-click your mouse on the Dial-Up Server Taskbar icon. Windows 98, in turn, will display the Dial-Up Server dialog box.
2. In the Dial-Up Server dialog box, click your mouse on the Disconnect User button. The Dial-Up Server, in turn, will log the current remote user off of your system.

116 UNDERSTANDING VIRTUAL PRIVATE NETWORKING

In Tip 112, you learned how to use the Windows 98 Dial-Up networking to dial into a remote computer. In addition to dial-up networking operations, Windows 98 provides virtual private networking, a new technology that lets you access a corporate network across the Internet. Using virtual private networking operations, you can, for example, connect your notebook PC to the Internet and, from there, connect to your corporate network. Before you can use Windows 98 virtual private networking, you must use the Dial-Up Network Wizard to create two connections. The first connection is to your Internet service provider. The second is to your corporate network. Later, to connect to your corporate network, you first connect to your Internet service provider and then, while connected to the Internet, you connect to your corporate network. To support virtual private networking, your Internet service provider and your corporate network must support a "tunneling" protocol, such as the point-to-point tunneling protocol (PPTP). (See Tip 877, "Understanding How Point-to-Point Tunneling Works in Windows 98"). Follow the steps Tip 112 discusses to create a dial-up network connection to your Internet service provider. To create a connection to your corporate network, perform the following steps:

1. On the Windows 98 Desktop, double-click your mouse on the My Computer icon. Windows 98, in turn, will open the My Computer window.
2. In the My Computer window, double-click your mouse on the Dial-Up Networking folder. Windows 98, in turn, will open the Dial-Up Networking folder.
3. In the Dial-Up Networking folder, double-click your mouse on the Make New Connection icon. Windows 98, in turn, will launch the Make New Connection Wizard.
4. In the Make New Connection Wizard, click your mouse on the Select a device drop-down list and select the Microsoft VPN Adapter option, then click your mouse on the Next button. The Make New Connection Wizard, in turn, will display a dialog box that prompts you for your corporate network's host name (such as *microsoft.com*) or the network's Internet protocol (IP) address.
5. Type in your company's host-name or IP address and then click your mouse on the Next button to finish the Wizard's processing.

Note: If the Make New Connection Wizard does not display the Microsoft VPN Adapter, you must install the VPN Adapter using the Control Panel Network applet.

Understanding the File Transfer Protocol (FTP) 117

The File Transfer Protocol, FTP, is a method of copying files between computers on the Internet. FTP is a core part of the TCP/IP suite of programs and all computer systems that are compliant with the TCP/IP protocol suite have implemented it. FTP is used universally and is one of the most useful programs on the Internet. No matter what type of system that you are using and no matter what type of system to which you are trying to send files, if they are both on the Internet, both systems most likely have an FTP program. With both systems having an FTP program, it is easy to move files between computers on the Internet. Another use of the FTP is for retrieving files from a file archive on the Internet. FTP lets a user connect to a system anonymously, supplying his or her e-mail address as a courtesy in order to access the archive. In this way, you can get public information and programs from a computer without needing an account on that computer. If you want to make files available to the Internet, you can do so without having to give an account out to every user who wants to access your site. In effect, you do not need to open your system to every user while, at the same time, making information available to the public. You can use the command line version of FTP that comes with your Windows 98 system, an FTP program that is Windows-based, or you can use your Web browser to do FTP file transfers.

Connecting to an FTP Site Using the Command Line 118

The first thing you need to do with the FTP program that is included with Windows 98 is to start the program and connect to an FTP site. The FTP program that comes with Windows 98 is a command line program, meaning that you can only run it from a command prompt window. To get a command prompt window, click your mouse on the Start menu, then on program, and then on the MS-DOS option. The MS-DOS program is a command line interface for Windows 98. At the DOS prompt, type the command FTP followed by the FTP site to which you want to connect. Figure 118.1 shows an FTP connection to the wolfe FTP site (as with other examples, *wolfe.source.net* is a fictitious site and is not on the Internet). The example shows the use of the name wolfe to connect, but on the Internet you will need to use a full site name, such as *ftp.cdrom.com*, to connect to an FTP site. In the example, a connection is being made to an FTP server that is on a LAN and so does not need to have a full name as you would on the Internet.

Next, you will be required to log in to the FTP site. You have two options: logging in as a user or logging in anonymously. In Figure 118.2, you see a user log which will give the user access to all the files and directories that the user would normally have on the remote system.

You can use the user name of anonymous or ftp to log into a FTP site that gives anonymous access to the FTP site, as shown in Figure 118.3.

It is common courtesy to enter your e-mail address as a password. You can enter your e-mail name and the @ sign. The FTP server will add the rest of your e-mail address. When you connect with the anonymous logon, the site usually restricts what you can do on the remote system. For example, a site may restrict you to a reserved directory called pub, for public information, that a site is making available to all users. It is also courteous to limit your time at an FTP site and to download files that will take a long time at non-peak hours, early in the morning or late at night. To place your files on an FTP site or to get files from an FTP site, you need to connect to the site and log in either with your user name or with an anonymous connection. Tips 122 and 123 explain how to put and get files when working with an FTP site.

Figure 118.1 The initial connection to an FTP site.

Figure 118.2 A valid user logging into a FTP site.

Figure 118.3 An anonymous connection to a FTP site.

1001 Internet Tips

Running DOS Commands from the FTP Program 119

If you need to run a DOS command on your local computer after you have connected to an FTP site, you can do so without having to exit the FTP program. You will get a DOS shell prompt from within the FTP program by using the '!' command. Once you get a DOS command prompt, you can run any DOS command and any program that you can normally run from a DOS prompt. After you run the DOS command, you must type exit to quit the DOS command shell and return to the FTP program. If you do not spend much time at the DOS prompt, then you should still be logged into the FTP site that you connected to before entering the '!' command. The command syntax is

```
FTP>!
```

Figure 119 shows the connection to an FTP site. The user has entered the '!' command to get a DOS prompt, followed by the DOS mkdir command. Next, the user has entered the exit command to return to the FTP program.

Figure 119 Using the '!' command to run DOS commands.

As you can see, it can be helpful to be able to quickly drop back to the DOS prompt without having to exit the FTP program. The '!' command gives you this power.

Using the Ls and Dir Commands 120

After you have connected to an FTP site and have logged on, you will need to look at the contents of the login directory. You can display the contents of a directory with the command line FTP program by using the ls or dir commands.

The ls command will produce a listing of the files and sub-directories that are in the current directory that you are working from. As you can see from Figure 120.1, the listing gives you no more information than the name; you do not know if the name is a directory or a file. The lines between the numbers 150 and 226 are the output from the ls command. The numbers 150 and 226 are command numbers and do not represent order or line numbers in output.

1001 Internet Tips

Figure 120.1 Output from an FTP ls command.

When you would like more detailed information about the contents of a directory, use the dir command rather than the ls command. Figure 120.2 shows the contents of the same directory shown in Figure 120.1 using the dir command.

Figure 120.2 Output from an FTP dir command.

In the output from the dir command, the first set of characters indicates whether the name is for a file or a directory. A "d" in the first column of the dir output means that the name is the name of a directory and a dash means that the name is the name of a file. In Figure 120.2, the file index has a dash in the first column of output and the directory pub has a "d" in the first column of output. The rest of the information in the first block of characters states who can write to, or read from, a file or directory. The next group of columns gives you information about the owner of the directory or file and group that owns the directory or file. The next column is the size of the file followed by the date that the file or directory was created. The last column is the name of the file or directory.

121 WORKING AN FTP SITE

Now that you are in the FTP site and are able to view the contents of the directory that you are in, there are three important concepts to be aware of. First, unlike Windows, upper and lower case at an FTP site count. You should be careful about whether a file has upper case letters or lower case letters. Using the wrong case may cause the action

you are trying to complete to fail. Next, when working on an FTP site, you should look for a README file. In Figures 120.1 and 120.2, you can see that in the first directory there is a README file and the login directs your attention to the README file. The README file has information about the FTP site, such as restrictions on that particular site, what directories are open to you, and instructions to upload files to the site, and so on. You should always make an attempt to look at a README file if this is the first time that you are accessing an FTP site. For example, a partial listing of the README file from the OAK Software Repository is shown below.

Welcome to OAK.Oakland.Edu
 THE OAK SOFTWARE REPOSITORY
 A service of Oakland University, Rochester Michigan

OAK.Oakland.Edu is a primary mirror of Simtel.Net, Keith Petersen's
world-wide distribution network for Shareware, Freeware, and Public
Domain programs for MS-DOS, Windows 3.x, and Windows 95. To access, cd
to /pub/simtelnet. If you would like to subscribe to a mailing list
that announces new uploads to the Simtel.Net collections see ms-news.txt
in subdirectory 00_info in any of the directories under /pub/simtelnet.

The third thing that you should always use when working on an FTP site is the index file. The name of the index file may vary, but it should always have index in the title. The index file will have a listing of files that are at the FTP site that you can download to your computer. The index file is a good place to start your search for a file at an FTP site if you do not know if or where the file is. A partial listing of the index file at the OAK Software Repository is shown below.

README
pub/ad-asp/aatsp.zip
pub/ad-asp/aczarw.zip
pub/ad-asp/addrmn.zip
pub/ad-asp/adds.zip
pub/ad-asp/admake.zip
pub/ad-asp/agavb.zip
pub/ad-asp/ahandy.zip
pub/ad-asp/airvb.zip
pub/ad-asp/aquiz.zip

At large sites like the OAK Repository, you will not want to read through the file line by line looking for a file. If you were to print the index file out for the OAK Repository, it would be over 750 8 ½ by 11 pages long.

Downloading a File from an FTP Site — 122

You have learned that you should read the README and index files. In this Tip, you will learn how to transfer them back to your computer system. You will use either the get or recv commands. The get and recv commands retrieve files from a remote system to your computer system. The two commands work the same and are simply different names for doing the same thing. The command syntax is

```
FTP>get {file name}

FTP>recv {file name}
```

At the FTP prompt, enter the command followed by the name of the file you want to transfer. Figure 122 shows both the get command and the recv command to retrieve the README and index files.

Figure 122 The use of the get and recv commands.

The command line program will respond to a get or recv command by copying the file to the local system and giving statistics about the file transfer. As shown in Figure 122, the FTP program displays a message that the file transfer is complete followed by the statistics. The README file took very little time (shown as 0.00 seconds) to transfer.

123 TRANSFERRING FILES TO AN FTP SERVER

The two main commands you use to transfer files from your local system to an FTP server are put and send. As with the get and the recv commands, put and send are the same basic command. The syntax to the two commands are

```
FTP>put {file name}

FTP>send {file name}
```

As shown in Figure 123, the two commands give the same result.

Figure 123 The use of the put and send commands.

As you can see in both cases, the file was placed on the remote system and, as with the get and recv commands, statistics of the transfer were displayed.

ADDING A FILE ON THE LOCAL SYSTEM TO A FILE ON THE REMOTE SYSTEM — 124

You can add the contents of a file on your local computer to the contents of a file on a remote system by appending the local file to the remote file with the append command. If you want to add information to the end of a file that is on a remote system, you would append the information to the file. The syntax to the append command is

```
FTP>append {local file} {remote file}
```

Figure 124 shows an example of the contents of a local index file being added to a remote index file. If the file names match, as in Figure 124, you do not need to add the name of the remote file.

Figure 124 The use of the append command.

The index file on the remote system now has its original contents and the contents of the local index file that has been appended to it.

SETTING THE TRANSFER MODE — 125

The FTP program can work in two types of transfer modes, ascii or binary, and, conveniently, the names of the commands to switch between the modes are ascii and binary. When in the ascii mode, the FTP program transfers a file as a set of characters. This is the default mode used for most FTP programs. You use this mode to transfer text files and character output from a ls or dir command. In the second transfer mode, binary, the FTP program transfers an exact image of the file. Binary mode is also referred to as image mode. You use binary mode to transfer files that are programs or executables and other types of non-character based files. If you are using FTP to transfer a file that is a program, you must transfer the program in binary mode. If the mode is set to ascii, the FTP program will try to interpret a program file as characters and will corrupt it. A third method for setting the mode for transfer is to use

the type command. The type command uses either ascii or binary to set the type. Most people do not use the type command because it is easier to type ascii or binary rather than to type "type ascii" or "type binary." The syntax for the commands are

```
FTP>ascii

FTP>binary

FTP>type ascii

FTP>type binary
```

Figure 125 shows the commands being used and the FTP program confirming that the mode of transfer has been changed from one mode to another.

Figure 125 The use of the ascii and binary commands.

As you can see, when you set the mode to binary, the FTP program reports that the FTP program is using type "I" mode which stands for image. The FTP program confirms that the transfer mode is ascii by showing that the program is in type "A" mode. You need to set the mode of transfer according to the type of transfer you are doing, binary if you are transferring programs and ascii if you are transferring text based files.

Note: Many of the commands have a short form as well as the normal form. For example, binary can be shortened to just bi or bin. You can experiment with shortening the commands to see if there is a shortened form.

126 HAVING YOUR COMPUTER MAKE A NOISE WHEN A FILE TRANSFER IS COMPLETE

You can use the bell command to have the computer make noise when you have completed a transfer of a file, either uploading or downloading. First, issue the bell command and then start the file transfer. The syntax of the command is

```
FTP>bell
```

Figure 126 shows the output of an FTP session in which the user has issued the bell command and started a file transfer with the get command. (You do not hear the sound but the computer beeps after the transfer.) The bell command is helpful if you are making a long file transfer and you want some kind of notice when the transfer is done.

Figure 126 Using the bell command and then transferring a file.

EXITING THE COMMAND LINE FTP PROGRAM 127

After you have completed your file transfers, you can exit the command line FTP program by using the bye or the quit commands. When you issue the bye or quit commands, the FTP program will close your connection to the remote computer and will exit, returning you back to your operating system prompt. The command syntax is

```
FTP>bye

FTP>quit
```

In Figure 127, you can see that either command leaves you at the DOS prompt.

Figure 127 Using the bye and the quit commands.

1001 Internet Tips

128 — Moving Around in an FTP Site

Once you have connected to an FTP site you will need to move around the site as many sites store almost no files, other than the index and the README files, in the login directory. The command for moving around an FTP site is the cd command. The cd command will change the directory that you are in to a new directory. After you have looked at the index file and found the file and directory you want, or a friend has told you where to get a file, you can move to that directory using the cd command. The command syntax is

```
FTP>CD {directory name} or  FTP>CD ..
```

When you type cd and the directory name you will go to that directory. If you type cd and two dots (..) then you will go back and up one directory. Using the cd command and the name of a directory, you can move down a directory structure and with the cd command and '..', you can move back up a directory structure. If you are not sure of the directory where you can find files to download, almost all FTP sites have a pub directory where files that are publicly available are stored. After changing to the pub directory, you can use the ls command (see Tip 120, "Using the ls and dir Commands") to see what subdirectories are under the pub directory. If you are looking for a program for Windows, you can look in the Windows directory; most FTP sites with programs have one. After changing to the Windows directory, use the ls command to see where to go next. You will continue this pattern of changing to a directory and then looking at the contents until you find the file you need. Figure 128 shows an FTP session where several directory changes are made.

Figure 128 Using the cd command to move around in a FTP site.

In Figure 128, the first command is an ls command to find a subdirectory to change to. The next command is the cd command changing to the Windows directory. You then see a second ls command listing what is in the Windows directory. The last command is the cd command using two dots to move back up to the Windows directory.

129 — Closing a Connection without Exiting the FTP Program

If you need to close a connection to a FTP site without exiting from the FTP program, you will use the close or the disconnect commands. The command syntax for the close and the disconnect commands are

```
FTP>close

FTP>disconnect
```

Figure 129 shows an FTP session where the user has issued the close, open, and disconnect commands. The open command is discussed in Tip 130, "Making a Connection to an FTP Site After the FTP Program Is Started." Note that the FTP program responds to the close and disconnect commands with the message "Goodbye.", but continues to run.

Figure 129 Using the close, open, and disconnect commands.

MAKING A CONNECTION TO A FTP SITE AFTER THE FTP PROGRAM IS STARTED 130

You use the open command to connect to an FTP site after you have already started the FTP program. For example, if you start the FTP program without specifying the name of a site to which you wish to connect, you can then use the open command. If you close a connection using the close or disconnect commands, the FTP program continues to run, and you can start a new connection by issuing the open command. If you let your FTP connection sit idle, most FTP sites will disconnect after a few minutes. You can issue the open command to reconnect to the same site. You will also want to use the open command to reconnect to the same site if a communication problem causes the loss of your connection. The command syntax is

```
FTP>open {some FTP site}
```

DELETING FILES ON THE REMOTE HOST 131

If you need to remove a file from an FTP site, you would use the DELETE command or the DELE command. The DELETE command and the DELE command do the same thing, it is just easier to type DELE than DELETE. You must have write permission to the directory to delete a file from it on an FTP site. The most common place where you will delete files is in your own home directory on a shell account (see Tip 229 for information about shell accounts). The command syntax is

```
FTP>delete {file name}

FTP>dele {file name}
```

Figure 131 shows the deletion of the file README from jsmith's home directory.

Figure 131 Using the delete command.

132 USING THE DEBUG COMMAND

You use the debug command if you are trying to find a problem with an FTP server. Users who are having problems trying to set up or maintain an FTP site are the main users of the debug command. You will most likely never need to use the debug command. The debug command displays all the messages the remote FTP server returns. Debug mode is off by default. The command syntax to toggle debug mode on and off is

```
FTP>debug
```

Figure 132 shows the output from an ls command when the debug mode is on. Notice that the debug option generates extra lines all starting with the '—>' character string.

Figure 132 Output from an ls command with debugging information.

Understanding the Glob Command 133

The glob command will turn file name globbing on or off. File name globbing deals with the use of wildcards in a file name. A wildcard is a character that can be replaced with any character. For example, an asterisk (*) can be replaced by any string of characters, so that k*t would include kit as well as kent. Globbing is the process of expanding the filenames that have wildcards. Globbing is on by default and there is little need to turn globbing off. The command syntax to toggle globbing off and on is

```
FTP>glob
```

Using the Hash Command 134

You use the hash command to cause the FTP program to display a series of pound signs (#) across the screen during a file transfer. The hash command can be useful if you are using a connection to the Internet that may disconnect you without notice. You issue the hash command and then start the file transfer. The hash command will display pound signs (#) across the screen as the file transfers and will stop if the transfer stalls. The command syntax is

```
FTP>hash
```

Figure 134 shows a hash command in action. Every time that 2KB were transferred, a pound sign was printed.

Figure 134 The use of the hash command with the put command.

Getting Help from the FTP Program 135

You can get quick help on an FTP command by using the help or the "?" commands. If you enter the help command or the "?" command by themselves, the FTP program will display a listing of all the commands that are usable with the FTP program. The command syntax is:

```
FTP>help {} or {command name}

FTP>? {} or {command name}
```

In Figure 135, you see the help command used by itself to show a list of commands, the help command being used to get help with the put command, and the "?" command being used to get help with the get command.

Figure 135 *The use of the help and "?" commands.*

You do not need to be connected to an FTP site to use the help or "?" commands. While the help and "?" commands give you a quick reminder of the command, they are not very detailed about what the commands do.

136 Changing the Directory on Your Local Computer

You use the lcd command to change directories on your local computer from within the FTP program. When you download a file from an FTP site, the FTP program places the file on your computer in the directory from which you started FTP. If you start the FTP from one directory but want to download a file to a different directory, you can use the lcd command to change the local directory to which the FTP program will download files. The command syntax is

```
FTP>lcd {local path to directory}
```

Figure 136 shows the FTP program starting in the root of the C: drive and shows the use of the lcd command to change to the download directory on the D: drive.

Notice in Figure 136 that the lcd command does not change the directory that the program is run from, shown by the program exiting in the same directory from which it started. The lcd command can be very useful when you are downloading multiple files in one FTP session and want to place the files in different local directories.

Figure 136 Using the lcd command to change the directory used for downloads on the local computer.

LOOKING AT THE LITERAL OR QUOTE COMMANDS 137

When you use a command in the FTP program, the program translates the command you gave into a set of commands that the program sends to the computer at the FTP site. You use the literal command or the quote command to send a command directly to the computer at the FTP site. The literal command and the quote command are troubleshooting commands which you will not need in your normal use of the FTP program. The command syntax is

```
FTP>literal {FTP server command}

FTP>quote {FTP server command}
```

DELETING MULTIPLE FILES FROM A FTP SITE 138

If you need to delete multiple files from a directory on an FTP site, you use the mdelete command. Before you can delete files, you must have the proper permissions on the FTP site in order to delete a file, just as with the delete command. The mdelete command can take multiple file names as arguments or you can use a filename(s) with wildcard characters to delete all files that match a pattern. The command syntax is

```
FTP>mdelete {filename filename ...} or {filename with wildcard characters}
```

The wildcard characters are an asterisk (*) and a question mark (?). The asterisk is any string of characters and the question mark is any single character. You can also use any combination of groups of file names and file names with wildcard characters. You can also use a range of characters by placing the characters in brackets ([]).

1001 Internet Tips

Examples of wildcard characters include

 c*t would include cat, cut, chant, chat

 c?t would include cat and cut but not chant and chat

 c[a-o]t would include cat and cot but not cut

In Figure 138, all files that start with temp will be erased from the directory in use at the FTP site.

Figure 138 The use of the mdelete command.

As you can see, all the files that matched the pattern temp* were deleted. The mdelete command will ask for a confirmation before deleting a file. You must enter a 'y' and press the ENTER key to have the file deleted. The mdelete command is a good way to get rid of multiple files having a similar pattern in their names.

139 Getting a Listing of Multiple Directories

If you need to get a listing of the contents of multiple directories on a remote site, you can use the mdir or the mls command. Both commands work like their single directory counterparts, dir and ls, but return multiple directory listings. The mdir and mls commands also differ from the dir and ls commands in that the FTP program sends the output from the commands to a file. You must supply the name of a file that you want the output to go to as part of the command. As with mdelete, you can use wildcard characters. The command syntax is

```
FTP>mdir {directoryname directoryname ...} or {directory name with wildcard charactors} {local filename}

FTP>mls {directoryname directoryname ...} or {directory name with wildcard charactors} {local filename}
```

Figure 139 shows the use of the mdir command. The mls command will work in the same manner.

1001 Internet Tips

Figure 139 The use of the mdir command.

Notice in the figure that the FTP program asks you to confirm that the last name in the command is a local file to which it should send the output from the mdir command.

Getting Multiple Files from a FTP Site 140

If you need to copy several files from the same directory at an FTP site to your local computer, you can use the mget command. The mget command, like the other commands for working with multiple files, can take either a list of filenames or use wildcard characters or any combination of filenames and filenames with wildcard characters. The files should all be in the same directory at the FTP site. The command syntax is

```
FTP>mget {filename filename ...} or {filename using wildcard characters}
```

In Figure 140, several files are being retrieved from a site by using wildcard characters. As with the mdelete command, the mget command asks you to confirm each file transfer.

Figure 140 Using the mget command to retrieve multiple files.

141 Sending Multiple Files to an FTP Site

If you need to place multiple files on an FTP site, you can use the mput command. Just like the mget command, you can use a list of filenames or filenames with wildcard characters or any combination of filenames and filenames with wildcard characters. All the files that you wish to upload to the FTP site should be in the same local directory. The command syntax is

```
FTP>mput {filename filename ...} or {filename with wildcard charactors}
```

Figure 141 shows the mput command being used with a list of filenames. As with the mget and mdelete commands, you are asked to confirm the transfer of each file.

Figure 141 The use of the mput comand with a list of file names.

142 Creating New Directories on an FTP Site

You may need to create a new directory on an FTP site to store files that you are about to upload. Before uploading your files, use the mkdir command to create a new directory on the FTP site, then use the cd command to change to the newly created directory. The command syntax for the mkdir command is

```
FTP>mkdir {directory name}
```

Figure 142 shows the use of the mkdir command to create a directory called test_data.

You can create a directory structure at an FTP site for you to upload files by using the mkdir command to make the directories.

Figure 142 Using the mkdir command.

GETTING THE FTP PROGRAM TO STOP PROMPTING YOU 143

If you are transferring a large number of files, the constant prompting from the mput, mget, or mdelete commands can slow the process greatly. The prompting feature of the FTP program is on by default. The first time you issue the prompt command, the FTP program will turn off prompting. The command syntax to toggle prompting off and on is

```
FTP>prompt
```

Figure 143 shows the FTP program has turned off prompting as the result of someone issuing the prompt command. You can see the FTP program executes the mput command without asking for confirmation.

Figure 143 The use of the prompt command and its effect on an mput command.

When you need to transfer a large number of files, turning off the program prompting with the prompt command saves you from having to watch the transfer so that you can respond to the prompt before each file transfer.

144 Seeing Where You Are in the FTP Sites Directory Structure

You will find that after working at an FTP site for a while, you may lose track of where you are in the directory structure. Use the pwd command to have the FTP program return the present working directory to you. The command syntax is

```
FTP>pwd
```

Figure 144 shows several cd commands changing the current working directory. The last command is a pwd command that reports what the current directory is after the cd commands.

Figure 144 The pwd command used after several cd commands.

145 Getting a Listing of Commands from the Computer at the FTP Site

As you learned in Tip 137, "Looking at the Literal or Quote Commands," when you enter a command in the FTP program it sends a set of commands to the computer at the FTP site. You can get a list of the commands that the computer at the remote site uses by using the remotehelp command. As with the literal and quote commands, you use the remotehelp command in troubleshooting and it is not a command that you would normally use with your FTP program. The command syntax is

```
FTP>remotehelp

FTP>remotehelp {command name}
```

The remotehelp command will return a list of the commands that the computer at the FTP site uses. For information about a specific command, you would enter remotehelp and then the specific command. The commands returned by remotehelp may vary slightly from one FTP site to the other.

Changing the Name of a File at an FTP Site — 146

If you need to change the name of a file on an FTP site, you will use the rename command. The rename command will change the name of a file to a new name. The command syntax is

```
FTP>rename {filename} {newfilename}
```

Figure 146 shows the rename command changing the name of the tempo file to semper.

Figure 146 The use of the rename command.

The rename command checks to see if the file name exists on the remote system and then renames the file.

Deleting a Directory on an FTP Site — 147

You have learned in Tip 142, "Creating New Directories on FTP site," how to create a directory. It is also possible for you to delete a directory with the rmdir command. The rmdir command will remove a directory from an FTP site. As with any command that changes files or directories at an FTP site, you need to have the right permissions to remove directories. The command syntax is

```
FTP>rmdir {directory name}
```

Figure 147 shows the test directory being deleted. The rmdir command will only delete empty directories so you must delete all the files in a directory before you delete the directory.

1001 Internet Tips

Figure 147 Deleting an empty directory at an FTP site.

148 — Determining the Option Settings for Your FTP Program

If you want to know the state of several option settings for your FTP program, you use the status command to get a report of option settings. The status command will report whether an option, like the bell command (see Tip 126, "Having Your Computer Make a Noise When a File Transfer Is Complete"), is set and what type of transfer mode the program is working in (see Tip 125, "Setting the Transfer Mode"). The command syntax is

```
FTP>status
```

Figure 148 shows you a status report with all the default option settings. If you are not sure why your FTP program is working in an unusual way, running a status report may help determine if an option is set wrong.

Figure 148 The status report of the default option settings for the MS FTP program.

The Trace Command 149

You use the trace command for troubleshooting a problem with a FTP connection. The trace command will turn on the program's tracing mode. When the FTP program has tracing turned on, information about the route that your connection to the FTP site is taking through the Internet is tracked. The command syntax is

```
FTP>trace
```

Trace is an advanced troubleshooting command and is not used in the normal operation of the FTP program.

Changing Who You are Logged in as on an FTP Site 150

If you need to change who you are logged in as at an FTP site, you can do so with the user command. A second use of the user command is if you give a bad user name or password, you can use the user command to reenter your username and password. The user command will start the login process so you can login to a FTP site. The command syntax is

```
FTP>user {} or {username}
```

Figure 150 shows a failed login attempt followed by the use of the user command with the username argument.

Figure 150 Using the user command to login after a bad login attempt.

Having the FTP Program Give Less Output 151

You can have the FTP program give less output when you issue commands by using the verbose command. If you do not care what your transfer speeds are and do not want to see all the responses to your commands from the server,

1001 Internet Tips

you can use the verbose command to toggle off this information. The verbose option is on by default, so when you first issue the command after starting the FTP program you will turn off verbose printing of information. If you issue the verbose command again during a single session, then the verbose mode will start again. The command syntax is

```
FTP> verbose
```

In Figure 151, you see the verbose command being used and then a get command being issued. Compare the output from the get command in Tip 122 to the output here.

Figure 151 The use of the verbose command and its effect on a get command.

152 Types of Software on the Internet and Places to Get Software

There are many good FTP sites that you can visit to obtain software. At an FTP site, you may download a document, but the most common type of file to download is a program that you can run on your own computer. There are three types of programs that you can download: trial version, shareware, and freeware. You may be able to find pirated software on the Internet but you should avoid such software. You should avoid pirated software not only from a legal standpoint, but as you can get no support for the software, it may cost you more in the long run. Trial version software is software that is sold commercially but the vendor lets you try it out before buying it. Trial versions usually have a limited time period for which they will work. Typically, you can run the software for 30, 90, or 120 days before the program stops working. Trial version software may also not have all the features of the working program. After you have tried the software, you can decide to buy it so the program will not expire or will have all its features work, or to not buy the software and be out nothing. Shareware, by contrast, is fully functional and has no expiration time. However, the vendor still expects that you will pay for the software if you use it past a trial period. The big difference between trial version software and shareware is that you are on your honor to pay for the shareware. The last main type of software on the Internet is freeware. As the name suggests, freeware is free and you do not have to pay anyone to use it. Many times, freeware originates from a hobbyist who has written the software, has no interest in helping anyone with it, and chooses to give it away. You should always scan any software that you download from the Internet for viruses before you try to run or install it. What types of programs are out on the Internet? Almost anything you can imagine, from games to word-processing to engineering programs, and it is all available for you to try.

You will find a lot of the software on the Internet at FTP sites. The first source that you should look at to find software, both for the Internet and other types of programs, is your ISP (Internet service provider). Check with your ISP for the Internet address of their FTP site and what type of software is at their site. There are other large repositories of software that you can access to download software besides your ISP. The OAK Repository, Internet address *oak.oakland.edu*, is a site that has many MS-DOS and Windows programs. The SIMTEL site is also a large

repository of MS-DOS and Windows programs. Its address is *ftp.cost.net*. If you need fixes or patches for your Microsoft products, you can always go to the Microsoft site at *ftp.microsoft.com*. The Winsite is also a large repository of programs. Its Internet address is *ftp.winsite.com*. These are just a few of the sites that you can use the FTP program to get files and programs from. If you do not find what you want at these sites, you can always use a Web search engine to find programs as well.

INSTALLING A WINDOWS-BASED FTP PROGRAM 153

The CD-ROM that accompanies this book contains a program called FTP Explorer. (The setup program is called FTPx.) This program is an FTP program that looks like your Windows Explorer program. You can use the FTP Explorer program to connect to FTP sites on the Internet. To install the FTP Explorer program, you must run the setup program in the FTPx directory on the CD-ROM. You can also download the program from the FTP Explorer FTP site *ftp.ftpx.com*, in the /pub/ftpx directory. To start the install from the CD-ROM, put the CD-ROM in the CD-ROM drive, go to the Start Menu, and select the Run command. In the run command dialog box, enter the command

```
D:\programs\ftpx\setup (Where D is the drive letter of your CD-ROM)
```

After you have entered the above command, the setup program will display the starting install screen for the FTP Explorer program shown in Figure 153.

Figure 153 The FTP Explorer starting install screen.

To install the FTP Explorer, perform the following steps:

1. Click your mouse on the Next button to start the install.
2. Click your mouse on the Next button to accept the default directory for the program installation or change the directory and then click your mouse on the Next button.
3. Select the checkboxes you want for the options for shortcuts, file associations, and whether to display the README file.
4. Click your mouse on the Finish button to finish the install.
5. You must restart your computer system to complete the full installation of the FTP Explorer program.

You are now ready to use the FTP Explorer program to work with FTP sites.

154 STARTING THE FTP EXPLORER PROGRAM AND CONNECTING TO AN FTP SITE

To start the FTP Explorer program, you can either double-click your mouse on the FTP Explorer icon on your Desktop or click your mouse on the Start menu, select the Programs sub-menu, and click your mouse on the FTP Explorer program. If you unchecked either of the above options in the setup of the FTP Explorer program then they will not be present on your system. The first time you start the FTP Explorer program it will present you with three dialog boxes. The first dialog box will ask you to accept the License Agreement. If you agree with the license, click your mouse on the I Agree button. The FTP Explorer program is shareware and is free for home, personal, and educational use. If you are using the program for commercial use, you can try the program for thirty days. If you are still using the program after thirty days and do not qualify for free use of the program, you should send the registration fee to the creator of the FTP Explorer program. The *Readme.txt* file in the FTPx directory on the CD-ROM has further details about registering the FTP Explorer program. The second dialog box will ask you to enter your e-mail address. As you learned in Tip 118, "Connecting to a FTP Site Using the Command Line," whenever you make a connection to an anonymous FTP site, you should send your e-mail address. By entering your e-mail address in the second dialog box, the FTP Explorer program will enter your e-mail address for you at anonymous FTP sites and save you the step. The last dialog box will ask you if the program should set up some sample *connection profiles*. A connection profile has all the information needed to connect to an FTP site. You should answer yes to this question as it will set up some useful connections for you and give you an idea of what connection profiles are. Next, the FTP Explorer program will display the connection dialog box, as shown in Figure 154. From now on, when you start the FTP Explorer program, it will initially display this connection dialog box.

Figure 154 The FTP Explorer screen and the connection dialog box.

You can connect to an FTP site by selecting one from the list of connection profiles and clicking your mouse on the connect button. The FTP Explorer program will connect you to the FTP site whose connection you have selected. Changing directories with the FTP Explorer program is as simple as changing directories in the Windows 98 Windows Explorer. When you double-click your mouse on a directory in the directory tree view pane, FTP Explorer will display the contents of that directory just as it would in Windows Explorer when you are looking at your own hard drive. The FTP Explorer program makes working with FTP sites seem as if you are working with your own hard drives.

Adding New Connection Profiles 155

You can add new connection profiles to your FTP Explorer program so that you can connect to new FTP sites. You add connections by using the connection dialog box that the FTP Explorer program presents when you start it or by clicking your mouse on the Connect button on the toolbar. (See Tip 158, "Using the FTP Explorer Toolbar to Connect and Disconnect from a FTP Site".) In the connection profile dialog box, click your mouse on the Add button. FTP Explorer, in turn, will present you with a new connection profile dialog box, as shown in Figure 155.

Figure 155 A new connection profile dialog box.

The new connection profile dialog box is a blank connection profile. You must fill in a Profile Name to identify your new connection profile. You must also fill in the Internet address of the FTP site that you want to connect to in the Host Address box. Leave the Port at the default of 21. Leave the Use PASV Mode and the Use Firewall boxes unchecked unless you are connecting from your company's network or to your company's FTP site, in which case you should check with your system administrator for the correct settings. If you are connecting to a private FTP site, you should fill in the Username and Password boxes with the correct username and password. If you are connecting to a public FTP site, you can check the Anonymous box and the FTP Explorer program will enter the anonymous information for you. If you know a directory path that you want to start in at the FTP site to which you are connecting, you can enter the path in the Initial Path box. It is not mandatory to fill in the Initial Path box. Use the Attempts and the Retry boxes to have the FTP Explorer program try to reconnect to an FTP site if your initial connection attempt fails. The Download Path is the path to the directory on your local hard drive where you want to store all the files you download. Use the Description box to place a description of the FTP site, if you wish. The last checkbox is for caching data between sessions, which will let you view some directory information when you are not connected to the FTP site. After you have filled in all the information, click your mouse on the Save button to save the connection profile or click your mouse on the Connect button to save the profile and connect to the FTP site. As you learn of new FTP sites, you will want to add connection profiles so you can easily connect to them.

Using the FTP Explorer Toolbar to Change Directories 156

You can use the first two buttons on the FTP Explorer Toolbar to move to different directories on an FTP site. You use the first button in the toolbar, shown in Figure 156, to move up one directory in the directory structure of an

1001 Internet Tips

FTP site. If you have changed to some subdirectory at an FTP site, you can click your mouse on the first button to move up one directory. You use the second button on the FTP Explorer Toolbar, also shown in Figure 156, to go directly to a subdirectory at an FTP site. After clicking your mouse on the second button, called the Goto button, the FTP Explorer program will display a dialog box asking you to enter the full path of the directory that you want to go to at the FTP site. The Goto button can be a quick way to get to a directory at an FTP site if you know the path to the directory.

Used to move up one directory **Goto button**

Figure 156 FTP Explorer toolbar with a pointer to the button used to move up a directory.

157 REFRESHING THE VIEW IN THE FTP EXPLORER PROGRAM

After you have made changes at an FTP site, you may need to refresh your view of the directory you are currently working in. The third button on the FTP Explorer Toolbar, shown in Figure 157, is the Refresh button. You use the Refresh button to reload the file listing from the directory you are working with so that the listing in your FTP Explorer program matches what is on the FTP site.

Refresh button

Figure 157 The Refresh button.

158 USING THE FTP EXPLORER TOOLBAR TO CONNECT AND DISCONNECT FROM A FTP SITE

You use the Connect button, shown in Figure 158, to make a connection to an FTP site. After clicking your mouse on the Connect button, FTP Explorer will display the connection dialog box shown in Tip 154. You complete the connection to an FTP site the same as when you start the FTP Explorer program.

Connect button **Disconnect button** **Quick connect button**

Figure 158 The Toolbar showing the buttons used to connect to and disconnect from an FTP site.

You use the Disconnect button, as shown in Figure 158, to disconnect from an FTP site after you have finished transferring files. You use the Quick Connect button, shown in Figure 158, to connect to an FTP site for which you

1001 Internet Tips

know the Internet address but do not want to add a connection profile. After you click your mouse on the Quick Connect button, you must fill in the Quick Connect dialog box with the Internet address of the FTP site to which you want to connect. The Quick Connect button will use all your default information and try to make an anonymous connection to the FTP site whose address you enter in the Quick Connect dialog box.

CANCELLING A COMMAND IN THE FTP EXPLORER PROGRAM — 159

You can cancel a command in the FTP Explorer program by using the Cancel button, as shown in Figure 159. If you have started a command, such as a connection to an FTP site or a download, you can stop the command before it completes by clicking your mouse on the Cancel button.

Figure 159 The Cancel button on the FTP Explorer Toolbar.

The Cancel button is only active, as shown in Figure 159, when a command is in the process of performing a task. The Cancel button is dimmed at all other times.

DOWNLOADING FILES FROM AN FTP SITE — 160

You can use the FTP Explorer Download To and Download buttons, shown in Figure 160.1, to download files from an FTP site to your local computer.

Figure 160.1 The Download To and the Download buttons on the FTP Explorer Toolbar.

You will use the Download To button to download a file to a specific directory. Click your mouse on a file in the right pane of the FTP Explorer window and then click your mouse on the Download To button to start the download of the file you selected. The FTP Explorer program, in turn, will display the Download To dialog box, shown in Figure 160.2. You can then find the directory that you want to save your file in. The download to function works like the save as function in many Windows programs.

Use the Download button if you want to download a file to the default download directory you specified in the FTP Explorer options. The Download button will start the download of a file without the need to prompt you for a directory to which it should download. (See Tip 167, "Setting Your E-mail Address and the Default Download Path for the FTP Explorer Program").

1001 Internet Tips

Figure 160.2 The Download To dialog box.

161 UPLOADING A FILE TO AN FTP SITE

You can use the FTP Explorer Upload button, shown in Figure 161.1, to upload a file to an FTP site.

Figure 161.1 The Upload Button on the FTP Explorer Toolbar.

The FTP Explorer Upload button will upload a file to the FTP site directory you are currently working in. After you click your mouse on the Upload button, the FTP Explorer program will display the Upload dialog box, as shown in Figure 161.2.

Figure 161.2 The Upload dialog box.

Pick the file you want to upload in the Upload dialog box. The Upload dialog box works like the Open dialog box in many Windows programs.

DELETING A FILE FROM AN FTP SITE
162

You can delete a file from a FTP site by using the FTP Explorer Delete button shown in Figure 162.

Figure 162 The Delete button on the FTP Explorer Tool Bar.

The Delete button will remove the currently selected file from the FTP site. You can select multiple files and use the Delete button to delete all of the files selected.

VIEWING THE PROPERTIES OF A FILE AT AN FTP SITE
163

If you need to view the properties of a file or directory that is on an FTP site, you should use the Properties button shown in Figure 163.

Figure 163 The Properties button on the FTP Explorer Toolbar.

The Properties button will show the file or directory permissions on a given file or directory. File and directory permissions determine whether you can view, read, write, or change files or directories on an FTP site. If you cannot work with a file or directory, you can use the Properties button to see what permissions you have to the file or directory.

CHANGING THE ICON SIZE IN THE FTP EXPLORER WINDOWS
164

You can use the icon size buttons, shown in Figure 164, to change the size of icons the FTP Explorer program uses.

The Large Icon button will cause the FTP Explorer program to use large icons to represent files and folders in the right hand pane of the FTP Explorer window. You can change to small icons by using the Small Icon button. The

1001 Internet Tips

List button will make the FTP Explorer program show the directories and files as a list with a very small icon. The Detail button uses the same icon size as the List button but in detail view. You also get information about the file or directory, also called a folder, such as the size, date it was modified, and so on.

Figure 164 The icon size buttons on the FTP Explorer Toolbar.

165 CHANGING THE TRANSFER MODE

You can use the FTP Explorer Ascii and Binary mode buttons, shown in Figure 165, to change the mode that the FTP Explorer program uses to transfer files to and from a FTP site.

Figure 165 The transfer mode buttons on the FTP Explorer Toolbar.

You can select the mode of transfer by clicking one of the transfer mode buttons. In Figure 165, the Binary Mode button is pressed in so the program is going to use binary mode to transfer a file. If you want to change the transfer mode of the FTP Explorer program, just click your mouse on the Ascii or Binary mode button and that button will look as if it is pushed in.

166 VIEWING THE FTP LOG

You can choose to have the FTP Explorer program make the FTP Log visible or hidden by clicking your mouse on the FTP Log button, as shown in Figure 166.1.

Figure 166.1 The FTP Log button on the FTP Explorer Toolbar.

The FTP Log is the bottom pane of the FTP Explorer window, as shown in Figure 166.2. The FTP Log shows the FTP commands that you send to the FTP site and the response the computer at the FTP site returns to your computer. The FTP Log view can be helpful if you are having problems transferring a file. You will be able to see any error messages that the computer at the FTP site returns.

Figure 166.2 The FTP Log pane in the FTP Explorer window.

SETTING YOUR E-MAIL ADDRESS AND THE DEFAULT DOWNLOAD PATH FOR THE FTP EXPLORER PROGRAM 167

You can set your e-mail address in the FTP Explorer program so that when you connect to an anonymous FTP site, the FTP Explorer program will automatically enter your e-mail address to gain access to the site. The other option that you may want to set is the default download path. By having a default download path, you can use the Download button rather than having to specify a download path with the Download To button. You can set both options by clicking your mouse on the View menu and then clicking your mouse on the Options menu. When you click your mouse on the Options menu item, the FTP Explorer program will display the Options dialog box. The Options dialog box has several tabs. The first tab that you will work with is the General tab, as shown in Figure 167.1. The first box on the General tab is where you can set or change your e-mail address FTP Explorer uses for anonymous downloads.

Figure 167.1 The General tab of the Options dialog box.

1001 Internet Tips

To set the default download path, click your mouse on the Paths tab, as shown in Figure 167.2. In the Default Download Path box, type the path to the folder that you want as the default directory for files that you download from FTP sites.

Figure 167.2 The Paths tab of the Options dialog box.

168 CREATING NEW DIRECTORIES ON AN FTP SITE

You can easily create new directories using FTP Explorer on an FTP site by using a shortcut menu. You get to the shortcut menu by clicking your right mouse button in the contents view pane (the right hand pane), and selecting the New submenu, then clicking your mouse on the folder option, as shown in Figure 168.

Figure 168 The New Folder shortcut menu.

After you click your mouse on the folder option, FTP Explorer will create a new folder in the contents pane with the title, new folder. You must change the title of the folder and press the <Enter> key to cause FTP Explorer to create the folder on the FTP site.

169 Understanding Archie, How Files on the Internet Are Found

Now that you have learned how to download files from an FTP site, you will need to understand how to find files on the Internet. Archie is a service on the Internet that indexes files that are available from anonymous FTP sites. There are two parts to the Archie service, an Archie server and an Archie client. You use an Archie client to connect to an Archie server. After you have connected to an Archie server, you send a query to the server of a filename that you would like to locate. The Archie server will search its database of filenames and return to your Archie client an answer to your query. If the filename was in the Archie server's database, the server's answer to your query will be a list of anonymous FTP sites and the directory on each site that holds the file you are looking for. If the Archie server does not have the file you are looking for in its database, the server will respond to your query with a file not found. You can use wildcards and search patterns with Archie if you do not know the exact name of the file you are looking for. The Archie service is your index to files on the Internet.

170 Installing and Using the Archie Client from the CD-ROM

Included on the CD-ROM that accompanies this book is a program called fpArchie. The fpArchie program is an Archie client program that can connect to a variety of Archie servers. You use the fpArchie program to find files on the Internet.

To start the install of the fpArchie Program, perform the following steps:

1. Put the CD-ROM that accompanies this book in your CD-ROM drive.
2. Click your mouse on the Start button and then click your mouse on the Run Command.
3. In the Run dialog box, enter the command below to bring up the screen shown in Figure 170.1.
4. Click your mouse on Next to start the Install. The setup program will display a screen showing the directory where it will install fpArchie.

```
D:\programs\archie\setup <Enter>  (Where D is the drive letter of your CD-ROM)
```

5. Click your mouse on Next to accept the default install path.
6. The setup program will give you the option to verify your information for the fpArchie program. Click your mouse on Next to finish the installation.
7. The setup program will display the program install progress screen and will close it when the install is finished.

After the installation is complete, you can start the fpArchie program by clicking your mouse on the Start button, selecting the programs submenu, and clicking your mouse on the fpArchie command. When you start the fpArchie program, it will display a screen that is similar to the Windows Find dialog box. Figure 170.2 shows the fpArchie window.

1001 Internet Tips

Figure 170.1 The start screen of the fpArchie program install.

Figure 170.2 The fpArchie program window.

To find a file, enter the name of a file or part of a file name in the Named box and click your mouse on the Find Now button. The fpArchie program will contact an Archie server and return the results of your search, as shown in Figure 170.3.

Figure 170.3 The results of an Archie search.

You can use any FTP program to connect to an FTP site listed in the search results window to download a file you are searching for. You may need to try different servers to make a successful Archie search. You can click your mouse on the servers tab and fpArchie will display the Servers dialog box, as shown in Figure 170.4. Scroll through the list of servers, click your mouse on a new server, and click your mouse on the Find Now button to retry your search on a new server.

Figure 170.4 The fpArchie Servers dialog box.

USING YOUR WEB BROWSER TO DOWNLOAD FILES 171

You have learned about using the different FTP utilities but you can also use your Web browser to download files as well. Many Web sites have links to files that you can download. When a Web site contains a link to a downloadable file, all that is required is that you click your mouse on the link and the Web browser will start the download. Figure 171 displays an example of a Web page that has a link to a file that you can download. If you click your mouse on the link labeled *Click here*, your Web browser will perform an FTP transfer as it downloads the file *getrt333.exe* to your computer.

Figure 171 A Web page with a link that will start a file download.

The file *getrt333.exe* is a shareware utility that will aid you in downloading files with your Web browser. You can find the latest version of Get Right at *www.headlightsw.com/getright.html* which is the home page for the Get Right program.

Several good Web-based download sites include

- Tucows' Web site at *www.tucows.com*
- C|Net's download site *www.download.com*
- Also C|Net's shareware site *www.shareware.com*

The Internet has a wealth of software that you can download using FTP. Whether you download using an FTP program or your browser, you can get almost any type of program you want.

172 Working with Graphics and Other File Formats

One of the big attractions of the World Wide Web is the richness of its content, such as colorful graphics, photos, rich text, software downloads, and so on. As you browse the Internet, you will probably encounter a variety of file types that you may not recognize. The next several Tips will give you some insight into the various file types, what software created them, and what they are used for.

Because so much of the Web is graphical, it is useful to know a little about image resolution and color. Image resolution is typically measured in pixels, short for *picture elements*. A pixel is a single point in a graphic image. You will often find digital image size expressed in terms of screen sizes, such as 640 x 480 pixels or 720 x 1028 pixels, and range of color, like 16-bit color. The number of bits, *binary digits*, used to represent each pixel determines the number of colors that can be displayed. For example, 16-bit color means that two to the sixteenth power, or 65,536 colors can be displayed on your computer screen.

As you have learned, while surfing the Internet, and in computing in general, you will encounter many different file types like EXE, COM, BIN, BAT, SYS, DLL, and so on. Further, there are many types of graphic files, such as EPS, GIF, TIFF, JPEG (JPG), PNG, and BMP, to name just a few. Fortunately, Web developers have settled primarily on two graphic file types, Graphic Interchange Format (GIF) and Joint Photographic Experts Group (JPEG, sometimes shortened to JPG). Each type has its merits as you will see in the Tips to follow.

173 Working with GIF Files

Graphic files are very large and take a relatively long time to download if you do not compress them. For that reason, Web site administrators almost always compress graphics on the Web or store them in some sort of compressed format to improve transmission speed over modem lines. Graphics Interchange Format (GIF) images are always compressed using a compression program like Winzip (see Tip 215, "Understanding Winzip"). The GIF file type was originally developed by CompuServe to facilitate the transfer of graphic images over its online service network.

In spite of some limitations, the GIF file format remains very popular on the Web. GIF supports a maximum of 8-bit color (256 colors) in depth and is best suited for uncomplicated images with few color variations. GIF images

have one distinct benefit over other popular file types. GIF supports the ability to make a color within the graphic transparent. Color transparency means that you can place a GIF image on a background and have the background show through.

Working with JPEG Files 174

Joint Photographic Experts Group, sometimes referred to as JPEG or JPG, is another popular graphic file format among Web developers. JPEG gets beyond the 8-bit color limitation of GIF and supports up to 16,777,216 colors, or 24-bit color. The extended palette makes JPEG extremely popular for publishing photographs or high-color artwork on the Web.

JPEG allows for variable compression rates and, often, smaller files than GIF. JPEG's compression does have its drawbacks, though. To achieve smaller files sizes with JPEG, you sometimes have to sacrifice detail and crispness. JPEG employs what is termed "lossy compression." Lossy compression is a data compression technique that deliberately discards file data in order to achieve significant reductions in file size. JPEG's lossy compression discards information about some of the graphic's millions of colors in order to shrink the file size. This loss of color detail usually does not deteriorate the quality of the viewing experience for Web graphics.

Working with TIFF Files 175

The Tagged-Image File Format (TIFF) is a flexible bitmap image format. Virtually all applications that allow for importing, exporting, or creation of graphic images support TIFF. Practically all word processing, paint, image editing, and page-layout applications support TIFF. TIFF is an image standard that is application-and-computer platform independent. Virtually all Desktop scanners can produce TIFF images. Applications that allow for the creation of TIFF images typically let you save TIFF images in a range of image resolution settings using the RGB (red, green, blue) color model, the CMYK (cyan, magenta, yellow, black) color model, or grayscale color model.

The TIFF file format supports the Lempel-Ziv & Welch (LZW) compression algorithm. LZW compression handles a wide variety of repetitive patterns and is reasonably fast for compression and decompression of the graphic file. LZW is a lossless compression type. Lossless compression retains all of the original data through the compression and decompression processes.

The Aldus Developers' Association formerly owned and maintained the Tagged Image File Format. After Aldus' merger with Adobe Systems, the Adobe Developers Association (ADA) took over maintenance of the TIFF file format.

Working with .BMP Files 176

The bitmap file format or BMP is the standard Windows bitmap image format on DOS and Windows-compatible computers. It is an efficient file format for storing graphics data. A bitmap image is quite simply a group of dots, called pixels. Every dot or pixel is the same size, but may be one of a series of colors. Bitmaps work well for images

such as scanned pictures or computer screen captures. You can resize, stretch, or shrink bitmaps, but doing so usually causes image deterioration or other undesirable effects, such as rough edges and odd patterns in the picture.

You typically store Windows BMP files in an uncompressed format, but they compress well using standard and readily available archiving tools like PKZIP or WinZip. (Refer to the CD-ROM that accompanies this book to try out the latest version of WinZip.)

BMP is an excellent choice for a simple bitmap format which supports a wide range of RGB image data. RGB image data is red, green, and blue image data and is the color scheme that your computer monitor uses. BMP is the default file format for Microsoft Paint, the accessory program included for drawing, modifying, or displaying images.

177 WORKING WITH .PNG FILES

Creators of the Portable Network Graphics (PNG) file format designed it to improve on the GIF file format. The PNG format successfully combines the best features of both GIF and JPEG. PNG supports slightly better compression than GIF but also supports millions of colors like the JPEG file format. Unlike a JPEG however, PNG compression is lossless compression and therefore does not discard any color data during compression. Similar to the GIF file format, the PNG can load "progressively" to give the user the impression that the graphic is loading faster. PNG also supports transparency of colors and variable image brightness across platforms. To read about PNG features in more technical detail, begin by reading the PNG introduction and history page at *http://www.cdrom.com/pub/png/pngintro.html*. Then, review some of the other PNG links at *http://www.cdrom.com/pub/png*. Take a look at *http://www.cdrom.com/pub/png/pngapps.html* to review information about applications that support PNG.

178 WORKING WITH .EPS FILES

The Encapsulated PostScript file format is a common file format often used to store high-quality pictures or clipart images. Most often, you will find an EPS image incorporated into a Desktop publishing document of some sort.

An EPS file can stand on its own and you can output it to a printer that supports the PostScript language. The PostScript language is a page-description language developed by Adobe Systems that supports sophisticated and flexible font capabilities and high quality graphics. Along with PostScript, Adobe Systems also developed the Display Postscript language which allows for true WYSIWYG display and printing. WYSIWYG is What You See Is What You Get and refers to the fact that way that the file looks on your computer screen is what you should see on the paper when you print the file.

179 WORKING WITH .WMF FILES

The Windows Metafile Format (WMF) is the native vector file format for Microsoft Windows 3.x applications. A metafile or a vector file differs from a bitmap in that a metafile is actually a database of graphic elements defined in

terms of a series of shapes and colors and the geometrical properties of those shapes. Because they are defined in this manner, you can resize and move drawn objects easily. You can closely analogize the drawing process for a metafile by saying it is a recording of the image's original creation, where each shape is drawn in the same order in which it was originally created. WMF files are actually a collection of Graphics Device Interface (GDI) function calls also native to the Windows environment. The GDI is the component of the operating system responsible for part of the task of rendering print and screen images.

Many books that deal with the subject of Microsoft Windows programming contain sections on the inner workings of WMF files. You can also find numerous articles about WMF files by searching the various support services available on Microsoft's Web site at *http://www.microsoft.com*.

Working with the .emf Format — 180

Enhanced Metafile (EMF) is the new native graphics file format for Windows 95 and beyond. EMF replaces WMF (see Tip 179, "Working with .wmf Files") in this role for the 32-bit versions of Windows. Like WMF, EMF contains a set of device-independent GDI calls used to render an image.

EMF is also the default spool file format used by the Windows 95 print spooler. EMF spooling improves printing and enhances the user experience by releasing the application back to the user very quickly while the print job completes in the background. Compared to printing RAW data, where the program must write all the data to the printer, the user gets his or her application back much quicker with EMF spooling.

Working with the .cgm File Format — 181

The Computer Graphics Metafile (CGM) file format is another device-independent format used for exchanging object-oriented graphics across different computer systems and different programs. CGM became an ANSI standard in 1986 (see Note below) and often serves as a least common denominator graphics file format for older applications. Like previously mentioned vector "Metafiles," CGM is a collection of the geometrical components, color information, and so on, that includes the instructions necessary to re-create or re-draw an image.

Note: *ANSI X3.122-1986 American National Standard for Information Systems - Computer Graphics - Metafile for the Storage and Transfer of Picture Description Information.*

Working with a .dib Image Format — 182

A Device Independent Bitmap (DIB) is a device-independent raster image format. That means DIB as a raster image is an image format in which the sequence and depth of pixels in the file is not specifically related to their layout in any particular device. An example of a DIB image format is the Windows bitmap file format discussed in Tip 176, "Working with .bmp Files". Because Windows stores BMPs in a DIB format, Windows can display the bitmap on any type of display device.

183 WORKING WITH THE .TXT FILE FORMAT

A TXT file extension most often indicates that the file is made up of clear American Standard Code for Information Interchange (ASCII) text. Text editors like the Windows Notepad accessory let you save files in "clear text" format that you can read across platforms and applications. It follows, when you hear the term "ASCII file" or "ASCII text," the file being referred to is a text file based on the ASCII character set.

The ASCII character set is a standard character set consisting of upper and lower case letters and non-printing control characters, each numbered for uniformity across computer devices. Developed in 1960, the ASCII character set is based on a 7-bit encoding scheme and is incapable of representing most non-English language character sets. ASCII text or an ASCII file is plain text without special formatting such as Bold or Italics.

ASCII text files are useful for distributing text files like README files that you can view with any editor, applet, word processor, or other program that supports the ASCII character set. DOS batch files like autoexec.bat or batch files used in Windows are ASCII text files.

184 WORKING WITH THE .EXE FILE FORMAT

A file with an EXE extension is an executable program file. In Windows, that means that once you have located the file using Windows Explorer, you can simply double-click your mouse on the file to execute the program. When you click your mouse on your Windows Start menu and launch a program from the Programs menu or one of its sub-menus, in most cases you are actually launching an executable file that starts an application. The entry on the Start menu is a shortcut to the executable (EXE) file that resides on one of your disk drives.

As you browse the Web, you might encounter executable files of a slightly different type. Often you will encounter free software that you can download and install on your computer. This free software is often packaged in the form of a compressed, self-extracting archive of files. Self-extracting archives of files are groups of files "bundled" together in the form of compressed archives for the purpose of a quick and simple delivery to your Desktop. Once you have downloaded a self-extracting archive file and placed it in a directory on your hard drive, you simply have to double-click your mouse on the file to extract its contents to the directory or folder on your hard drive. See Tip 222, "Extracting Files from an Archive," to learn about extracting files from an archive.

The tools used to create the archives are usually one of the archiving utilities distributed by either PKWARE, Inc., who distributes PkZip for Windows (*www.pkzip.com*) or Nico Mak Computing, Inc. who distributes WinZip at *www.winzip.com*. See Tips 215-222 for information about downloading and using WinZip.

185 WORKING WITH THE .CDR FILE FORMAT

As you browse the Internet, you may encounter a file with a CDR extension. CDR is the standard file format for CorelDraw, Corel Corporation's illustration software package. CorelDraw is a vector graphics/desktop publishing program that has become popular among today's Desktop publishing community. Many of today's page layout

programs and word processing programs include a filter for importing CDR files. Likewise, many printing services use CorelDraw and support printing and preparing for print runs using CorelDraw files. To learn more about CorelDraw and CDR files, access the Corel Corporation Web site at *www.corel.com*.

186 WORKING WITH THE .PRN FILE FORMAT

A PRN file is a PostScript print file. PRN files are application independent files that most applications can generate and you can print them easily without the use of the application that actually created the file. The PRN file contains all of the graphic, font, and color information required to print a job. It is often easiest for service bureaus to deal with a PRN print file rather than trying to match software applications with a client.

To create a PRN file, you must set up a virtual printer on your system that matches the print device your service bureau will use to output your job. You will set up a printer in Windows, but the physical device does not actually exist.

You will use the Windows Add Printer wizard to set up a printer driver on your system. The Add Printer wizard is in your Printers folder. Click your mouse on the Setting option on the Start Menu and then click your mouse on the Printers option in the Settings submenu. You set up the driver, but the print device itself does not actually exist. You simply configure the driver to match the settings that the service bureau will use to print out your job. Then, within your application, when you print the job, select the Print to file option in the Print dialog box.

You may encounter Web sites that will display a thumbnail image of a graphic or illustration, and then offer you a link to download a PRN file of that graphic or illustration. See Tip 213, "Understanding Thumbnails," for a description of the term Thumbnail.

187 WORKING WITH THE OPI IMAGES

Open Prepress Interface images sometimes make their way to Internet Web sites. The primary goal behind the OPI standard is making large documents or projects easier to handle by shrinking the overall size of the file you are editing. OPI involves using low-resolution images as layout placeholders in Desktop publishing documents. The low-resolution images are usually stored in the form of a TIF file (see Tip 175, "Working with TIFF Files") or a CT file (see Tip 188, "Working with the .ct File Format") and are linked to a high-resolution version of the image. When you print the document or job, the printing instruction set swaps the high-resolution image for the low-resolution placeholder graphic. In this way, you can keep the working document file size small and manageable and only call the high-resolution graphics at print time to achieve a high-quality output.

188 WORKING WITH THE .CT FILE FORMAT

A file with the *.ct* file extension is usually a Scitex Continuous Tone bitmap developed by Scitex Corporation, *http://www.scitex.com*. The Scitex Continuous Tone bitmap format supports CMYK color images and gray scale images.

CMYK represents the four colors used in printing presses and stands for cyan, magenta, yellow, and black. The CT file type is commonly used as the low resolution image, for position only (FPO) graphics in documents that take advantage of the OPI specification discussed in Tip 187. When graphic artists or Desktop publishers use the OPI method, they scan two sets of images for use with a project, a high-resolution set that is used when the project is printed and a low-resolution set that is used for placeholders in the Desktop publishing document.

189 Working with the .doc File Format

Usually word processors create files with the *.doc* file extension. For the Microsoft version, that means a file that ends in *.doc* is a Microsoft Word file. Chances are good that you will encounter DOC files that you would like to read during your Internet surfing.

DOC files are usually easy to deal with because only a couple of popular word processors dominate the market and, for the most part, they understand each other's files. For example, if you own Microsoft Word, chances are you will be able to open a DOC file even if it was created with WordPerfect. The only catch might be version differences. In general, you cannot open a file created with a later version of software than you are currently running. For example, if you have Microsoft Word version 7.0 (often called Word 95) and you download a DOC file created in Word 97, you will have trouble opening the file in your word processor.

190 Working with the Other Microsoft Office File Types

In addition to Microsoft Word document (DOC) files discussed in Tip 189, "Working with the .doc File Format," you might encounter other files on the Internet that were generated with some of the other applications in the Microsoft Office Suite. In addition to the Microsoft Word word processor, the Microsoft Office 97 Professional Suite contains a spreadsheet application called Microsoft Excel, a presentation application called Microsoft PowerPoint, and a database application called Microsoft Access.

Each of the applications in the Microsoft Office Suite produces its own data file type. Microsoft Excel produces spreadsheet data files with an *.xls* file extension. Microsoft PowerPoint produces presentation data files with a *.ppt* file extension. Microsoft Access produces database data files with a *.mdb* extension.

In general, you cannot open a data file created with an Office 97 application in an older version of the software application. For example, you cannot open a presentation file that was created with PowerPoint 97 in the older versions of PowerPoint, PowerPoint 95, or PowerPoint 4.0. However, you can open and edit older data files with newer versions of the software applications. That means you can open and edit a PowerPoint 95 file with PowerPoint 97.

191 Working with the .pcx File Format

The PCX file format is a bitmap file format used by the PC Paintbrush family of products. Similar to Microsoft Paint, PC Paintbrush is a pixel painting program that creates images as bitmaps. Like Paint, PC Paintbrush provides

tools for drawing text, lines, curves, and other geometrical shapes, such as rectangles, but since PC Paintbrush paints only pixels, there is no utility for resizing objects without distorting the object.

Working with the .pict File Format — 192

The .pict file format is a standard graphic file format for both vector graphics and bitmapped graphics. The PICT file format can support object-oriented graphics likes lines, arcs, rectangles, and circles while, at the same time, storing bitmap graphics. Programmers originally developed the PICT format for the Macintosh and its applications. More specifically, programmers initially developed the PICT format for the Apple MacDraw application. Now many PC and Windows applications support the PICT file format.

Working with the .tga File Format — 193

The .tga file extension is actually short for Targa. Targa is a raster graphics file format, like the .dib image format, developed by Truevision, Incorporated. Targa will accommodate 16-, 24-, and 32-bit color. The Targa standard is now widely used for high-end graphic output like rendering and ray tracing. Rendering and ray tracing are methods for producing sophisticated three dimensional output that includes variations in color and shading to produce the illusion of light sources and shadowing.

Working with the .sit File Format — 194

If you encounter a file named with a .sit extension, you can be reasonably sure that the file was created with a popular Macintosh compression utility called StuffIt. Although StuffIt was originally a piece of shareware software written for the Macintosh, you can now find commercial versions for both the Mac and the PC.

Like many such utilities, the StuffIt compression software is available for a cost, but you can download the expander utility for free. For more information about StuffIt compression software or Stuffit Expander, see the Aladdin Systems, Inc. Web site at *http://www.aladdinsys.com/index.html*.

Working with the .uue, .uud, and .uu File Formats — 195

In order to describe the UUE, UUD, and UU file extensions, you must first understand two common Unix utilities called Uuencode and Uudecode. First, Uuencode is a utility that converts an 8-bit binary file, such as an image file or an executable program, into a 7-bit ASCII text file that you can distribute via e-mail or newsgroups. Uudecode,

in turn, is a utility you use to convert the 7-bit ASCII text file back into its original 8-bit binary form. This process was, and still is, very useful in disseminating binary files through the traditionally text based mediums of newsgroups or e-mail. The distribution of image files through newsgroups in this manner is still popular and heavily used on the Internet.

You usually find the UUD and/or UU file extensions on files that the Uuencode utility has encoded from binary format into ASCII text. Again, you use uuencoding for dissemination of a file via a text based medium.

The uudecode utility places a UUE file extension on files that it decodes from ASCII format into binary format.

196 WORKING WITH THE .HQX FILE FORMAT

Occasionally, while browsing the Web, you may encounter a file with an .hqx extension. An .hqx file is a Macintosh-based BinHex text-formatted file. BinHex is a method of encoding binary files so that the encoded file contains nothing but American Standard Code for Information Interchange (ASCII) text which makes the file easy to disseminate via e-mail and newsgroups on the Internet. BinHex files are similar to Uuencoded files, discussed in the previous Tip, in that Uuencode also converts binary files to ASCII text files for transmission as a text file on the Internet.

BinHex is not a compression technique so .hqx files are not compressed files. In fact, a BinHexed file could actually be larger than the original file. People working with BinHex files generally compress them using the Macintosh-based StuffIt compression utility discussed in Tip 194, "Working with the .sit File Format," so they are not as large when sent across the Internet.

When you download a .hqx file, you can unpack and decode the file with the Stuffit Expander. (See Tip 194, "Working with the .sit File Format.") When you expand/decode a .hqx file, Stuffit Expander converts it into an Installer file. A simple double-click with your mouse on the Installer file will install the contents of the file.

Users of Microsoft's Internet Explorer 4.0 for the Macintosh can configure the browser to decode .hqx files as it downloads them.

197 WORKING WITH THE .BIN FILE FORMAT

While browsing the Web, you may encounter a file with a *.bin* extension. A *.bin* file extension may mean that the file is a MacBinary formatted file. MacBinary is a Macintosh-based file transfer protocol, that among other things, lets you store Macintosh files on non-Macintosh computers without losing the characteristics of the Macintosh file. Most Macintosh communication programs send and receive files in MacBinary format.

Much like the .hqx files mentioned in the previous Tip, you can unpack and decode MacBinary files with the Stuffit Expander discussed in Tip 194, "Working with the .sit File Format," and Tip 196, "Working with the .hqx File Format." When you expand/decode a *.bin* file, Stuffit Expander converts it into an Installer file. A simple double-click with your mouse on the Installer file will install the contents of the file.

Users of Microsoft's Internet Explorer 4.0 for the Macintosh can configure the browser to decode *.bin* files as they are downloaded.

Working with the .sea File Format — 198

Another file type the Macintosh based StuffIt compression utility creates is *.sea*. Similar to PC-based self-extracting executable files with an *.exe* extension (described in Tip 184, "Working with the .exe File Format"), *.sea* is a self-extracting archive file you can create on a Macintosh with the StuffIt compression software. You can extract files from the *.sea* archive by simply double-clicking your mouse on the file.

Working with the .arc File Format — 199

You will usually find the *.arc* file extension on a file that is a compressed archive encoded using the Advanced RISC Computing Specification (ARC) format. The Advanced RISC Computing Specification is a specification defining the minimum hardware requirements enabling a RISC-based system to comply with the Advanced Computing Environment standard.

Advanced RISC stands for Advanced Reduced Instruction Set Computer. Advanced RISC is a specification developed by MIPS Computer Systems to provide guidelines for binary compatibility among software applications. If an application is binary compatible, that means the application can run on any hardware platform supported by a particular operating system. For example, if an application is binary compatible for Windows NT 4.0, that application can run on the Intel i386 version of NT or the MIPS version of NT. Compare a binary compatible application to an application that is source compatible. You must re-compile a source compatible application for each hardware platform.

Working with the .z and .gz File Format — 200

Since many of the servers you will access on the Internet are running Unix as the underlying operating system, you may encounter files compressed with various Unix compression utilities. One of the utilities used in UNIX to compress files is the *gzip* utility. If you happen across a file with a *.z* extension, it is probably a file that was compressed with the Unix *gzip* utility. Likewise, a file with a *.gz* extension is most likely an archive that was compressed with the Unix *gzip* utility.

You can restore files compressed with *gzip* to their original form by using *gzip* with a *-d* switch or by using either *gunzip* or *zcat*, both Unix decompressing utilities. *Gunzip* can also uncompress files that have been compressed with other Unix utilities like *zip*, *pack*, or *compress*.

Working with the ZIP File Format — 201

Files named with a ZIP extension are compressed archives encoded in the ZIP file format. Two popular compression utilities that support the ZIP file format are PKZip, distributed by PKWARE Inc. (*www.pkzip.com*), and WinZip, distributed by Nico Mak Computing, Inc. (*www.winzip.com*). See Tips 215-222 for more information about WinZip.

1001 Internet Tips

You will often encounter ZIP files on Web sites, FTP sites, or as e-mail attachments. Grouping files into ZIP file archives makes them easy for you to manage and distribute via the Internet and improves transmission speed. You can also use Zip utilities to compress files for archiving purposes. Compressing your files reduces the amount of disk space taken up by files you must keep but that you rarely use.

202 Working with the .zoo File Format

A file with a *.zoo* extension is most likely a compressed archive file created by the zoo file compression utility. Zoo or zoo210 are compression utilities available for Unix and Intel-based systems. Zoo210 is version 2.1 of the zoo compression utility.

Originally developed for Unix, the zoo compression algorithm is based upon the LHARC compression utility. See Tip 203 for more information about LHARC.

203 Working with LHARC and the .LHA File Format

LHARC is a freeware file-compression utility program developed by a programmer named Haruyasu Yoshizaki. Like other compression utilities, LHARC compresses one or many files into a single smaller archive file to save time, bandwidth, or disk space when sending files over the Internet or archiving files to disk.

LHARC creates a compressed archive file with an *.lha* extension. You must use the LHARC utility to uncompress the *.lha* archive file. LHARC can also embed a runtime version of the program to create a self-extracting archive with an *.exe* extension. See Tip 184, "Working with the *.exe* File Format," and Tip 220, "Understanding WinZip Self Extractor," for more information about self-extracting archive files.

204 Working with the .ARJ File Format

You can use the *.arj* file extension to identify compressed archive files created with the ARJ compression utility. Although ARJ Software originally developed the ARJ compression utility as a DOS application, you can now obtain Windows 32-bit versions from the ARJ Software Web site at *http://www.arjsoftware.com*. Like most compression utilities, new versions of ARJ include the capability to create self-extracting archive files.

205 Working with the .CAB File Format

Microsoft Corporation commonly distributes software in the form of cabinet files with a *.cab* extension. Cabinet files are compressed archive files that contain multiple files required to install a particular software package. Figure 205.1 shows you all of the cabinet files included on the Windows 98 installation CD-ROM.

Figure 205.1. The Windows 98 cabinet files that are on the Windows 98 CD-ROM.

With WinZip installed (see the WinZip Tips, starting with Tip 215, "Understanding WinZip"), you can view the contents of a cabinet file by simply double-clicking your mouse on the cabinet file in Windows Explorer. Figure 205.2 displays the contents of the Windows 98 *PRECOPY1.CAB* file in the WinZip archiving utility. Using Winzip, you can extract individual files from a cabinet file, as described in Tip 219.

Figure 205.2 The contents of the Windows 98 PRECOPY1.CAB file.

206 WORKING WITH THE .AVI FILE FORMAT

The Audio Video Interleaved (AVI) file format is a Windows multimedia file format that incorporates sound and moving pictures. The AVI format uses the Microsoft Resource Interchange File Format (RIFF) specification. In short, AVI files include video with an associated sound track in the same file. AVI files can produce near CD quality stereo sound but consume large amounts of file space relative to other audio/video file formats. Figure 206 depicts the Microsoft Media Player playing back a simple AVI file that includes video and sound.

Figure 206 The Microsoft Media Player playing an AVI file.

207 WORKING WITH THE .WAV FILE FORMAT

Files stored in the waveform (WAV) audio file format have the *.wav* file extension. The quality of the *.wav* file's playback and the size of the *.wav* file itself is determined by the frequency and precision with which the sound is digitized.

Sampling is the process of digitizing sound. Simply put, sampling is the conversion of an analog signal into a digital form that you can play back on the computer. Taking a sample of the analog signal over a short time and making that into a digital signal accomplishes this process of converting an analog signal to a digital signal. Two factors affect the playback quality of the digitized *.wav* file sampling rate, the rate at which the samples are taken, and sampling precision, the accuracy at which the sample is taken. The higher the sampling rate and sampling precision, the higher the quality of the *.wav* file play back. Waveform audio format supports storing sound in monaural or stereo using 8-bit or16-bit sampling precision.

Figure 207 shows the Windows Media Player playing back a WAV audio file.

Figure 207 *The Microsoft Media Player playing a WAV file.*

WORKING WITH .MPG AND .MPEG FILES 208

The *.mpg* and *.mpeg* file extensions usually identify multimedia files based on the Moving Pictures Experts Group (MPEG) standards for audio and video compression. The Joint ISO/IEC Technical Committee on Information Technology, often referred to as JTC 1, established the MPEG standards.

Note: *The acronym ISO stands for International Organization for Standardization. The acronym IEC stands for International Electrotechnical Commission. You can access the ISO Web site at* ***www.iso.ch*** *and the IEC Web site at* ***www.iec.ch****.*

There are several different standards that fall under the heading of MPEG. The original goal was the development of standards for coded representation of moving pictures for digital storage media at the target bitrate of 1.5 Mbps. The JTC 1 called the first standard MPEG-1. MPEG-1 defined a bandwidth of 1.5 Mbps and two audio channels and non-interlaced video. The next iteration of the standard, MPEG-2, defined higher bandwidth of 40 Mbps, five audio channels, more frame sizes, and interlaced video. The JTC 1 has essentially absorbed MPEG-3 into MPEG-2, and MPEG-4 is currently under development.

To explain in simpler terms, MPEG-1 supports near CD quality sound (termed Audio Layer II) and CD quality sound (termed Audio Layer III) in the form of .mp3 files (discussed in the next Tip). MPEG-1 supports video resolutions of 352 X 240, often referred to as "postage stamp" video resolutions. The MPEG-2 standard provides video resolutions of 720 X 480 and CD quality stereo sound.

WORKING WITH .MP3 FILES 209

The file extension for an MPEG audio file based upon the MPEG-1 Audio Layer III standard is *.mp3*. MPEG–1 Audio Layer III supports CD quality audio with a 12-1 file compression ratio. MP3 has become very popular for the distribution of sound tracks from standard stereo audio compact discs. In fact, you can purchase albums and singles

from your favorite artists online at various locations on the Web. Further, the emergence of the MP3 standard has spurred new growth in the piracy of such material.

There are several popular Web sites dedicated to the MP3 compression standard. Not only can you download MP3 files, but you can access MP3 search engines, download MP3 players, and you can access MP3 technical information. One of the most popular MP3 sites is MP3now.com at *http://mp3now.com*. You can also try out MP3Leach, a MP3 Internet search utility that lets you search for MP3 files by artist or song title.

You can find several popular MP3 players available via the Web. Winamp is a shareware MP3 player available at *www.winamp.com*. You can also download MP3 recording software that will let you record audio CD tracks to your PC. You simply use the utility to transfer CD audio tracks from an audio CD in your CD-ROM drive to MP3 files on your hard drive. One popular example is ZipAudio, available at *www.zipaudio.com*.

210 WORKING WITH .PDF FILES

The *.pdf* file extension usually identifies files encoded in the Portable Document Format developed by Adobe Systems. The goal of *.pdf* was to create a common file format that contains formatting, is printable, easy to create, and easy to distribute. Adobe came up with a product called Adobe Acrobat that is used to create *.pdf* files. You can purchase Adobe Acrobat at software retailers or from the Adobe Web site at *http://www.adobe.com*.

Adobe also distributes an Acrobat Reader software package that you can download for free from Adobe's Web site. You use Acrobat Reader to read, search, and print *.pdf* files. Many companies distribute product documentation and other documents in the *pdf* file format so chances are good that you will encounter the *pdf* format at some time during your Web browsing excursions.

211 WORKING WITH .MOV FILES

You will typically find the *.mov* file extension on movie files in Apple's QuickTime format. The latest Macintosh operating systems include the QuickTime movie extensions. Support for the *.mov* file extension is also available with the Windows operating system. QuickTime lets applications display video sequences synchronized with accompanying audio tracks. For more information about QuickTime or to download your copy of QuickTime 3, see the QuickTime section of the Apple, Inc. Web site at *http://www.apple.com/quicktime/*.

212 UNDERSTANDING HYPERLINKS

A hyperlink is an element found in HTML or SGML pages that serves as a link to another document, file, script, image, and so on. The hyperlink takes you to a new Web page or it may take you to an image file. Typically, you can

identify Hyperlinks on a Web page by underlined text or different colored text. For example, in Figure 212, you see several hyperlinks that are underlined. You can configure Internet Explorer to display a different color when you hold your cursor over the link. Notice the red link in Figure 212. The red link is the link that the mouse pointer was positioned over when the screen capture was taken. When you click your mouse on one of the underlined hyperlinks, your browser immediately attempts to load the associated Web page. Hyperlinks are the main navigation tool you will use when browsing the Web.

Figure 212 A Web page with several hyperlinks to other Web sites.

UNDERSTANDING THUMBNAILS 213

While you are browsing the Web, you will encounter many Web pages that display pictures that you might want to view or download. Web developers often use thumbnail graphics to give you an idea of what graphics files are available for viewing or download. The thumbnail is simply a miniature version of the image file or page that is available for download. The thumbnail graphic is usually just a smaller version of the actual graphics file. Web developers usually save the smaller version at a much lower resolution than the actual graphics file and, therefore, it loads quicker than the full-sized image file. Further, Web developers configure many thumbnail graphics as hyperlinks (see the previous Tip) to the full-sized version of the graphic. In Figure 213, you can see a Web page with several thumbnailed graphics files.

1001 Internet Tips

Figure 213 A Web page with thumbnail images.

214 Viewing Graphics with Microsoft Photo Editor

Microsoft Photo Editor is a photo editing application that is included with Microsoft Office 97, as shown in Figure 214. Using Photo Editor, you can view and manipulate images that you scan or download off of the Web. Photo Editor supports virtually all of the popular image file types like *gif, jpg, tif, bmp,* and *png,* just to name a few.

Photo Editor also includes a set of tools that you can use to manipulate images. You can rotate, crop, or resize images. You can also apply a set of special effects to your image files, such as Chalk and Charcoal, Emboss, and so on.

Most importantly, the Photo Editor offers you the capability to view and print your image files using a very streamlined and simple interface.

Figure 214 The Microsoft Photo Editor.

Understanding WinZip 215

WinZip is a Windows-based application used for managing ZIP files. (See Tip 201, "Working with the ZIP File Format," for a discussion of ZIP files.) WinZip provides an easy-to-navigate graphical user interface for creating and working with archives. An archive is a single file that stores one or many individual files for the purpose of distributing the files via the Internet or storing the files. For example, if you are trying to send a group of files to a friend via e-mail, you can use WinZip to group the files into a single compressed archive file. Sending a single file saves you the trouble of attaching multiple files to your e-mail message and also reduces the overall size of the files to speed transmission over the Internet. Figure 215 shows a screen shot of the trial version of WinZip 7.0 with an open archive.

Figure 215 The unregistered trial version of WinZip 7.0.

Purchasing WinZip from the WinZip Web Site 216

The CD-ROM that accompanies this book contains the latest evaluation version of WinZip (version 7.0). You can also download the evaluation version or purchase and download a fully licensed version of WinZip from the WinZip Web site at *http://www.winzip.com*.

To purchase WinZip, perform the following steps:

1. Type in *http://www.winzip.com* in the address field of your Web browser and press the ENTER key. Your browser will respond by loading the home page of the WinZip Web site, as shown in Figure 216.1.

1001 Internet Tips

Figure 216.1 The WinZip Web site's home page.

2. Click your mouse on the Order Now link to be taken to the WinZip Order Form page. Scroll down to the WinZip Orders portion of the page and type the number of licenses you would like to purchase in the Quantity box next to the product you should like to order, as shown in Figure 216.2.

Figure 216.2 The WinZip Order Form.

1001 Internet Tips

3. Click your mouse on the Continue button at the bottom of the page to go to the Registration page shown in Figure 216.3. On the Registration page, fill out the registration form with your name, address, phone, and credit card information.

Figure 216.3 The WinZip Registration page.

4. Click your mouse on the Submit Order button at the bottom of the page to submit your registration and credit card information. Once your order is approved, you will be taken to the download page to download your copy of WinZip. See the next Tip for a demonstration of downloading and installing the evaluation version of WinZip.

DOWNLOADING THE EVALUATION VERSION OF WINZIP 217

A trial version of WinZip that you can download is available from the WinZip Web site at *http://www.winzip.com*. The evaluation version is a fully functional version of WinZip intended for previewing and testing the product to make a purchasing decision. You are entitled to use the evaluation of WinZip for a period of 21 days. After the evaluation period, you must pay a $29 registration fee or uninstall the software.

To download the evaluation version, perform the following steps:

1. Type in *http://www.winzip.com* in the address field of your Web browser and press the ENTER key. Your browser, in turn, will load the home page of the WinZip Web site, as shown in Figure 216.1.

2. Click your mouse on the Download Evaluation Version link to go to the Evaluation Version download page, as shown in Figure 217.1.

1001 Internet Tips

Figure 217.1 The WinZip Evaluation Version download page.

3. On the Download page, click your mouse on the Download WinZip 7.0 SR-1 for the Windows 95, 98, NT link to begin the download. Your Web browser, in turn, will display the File Download dialog box, as shown in Figure 217.2.

Figure 217.2 The File Download dialog box.

4. In the File Download dialog box, select the Save this program to disk radio button, then click your mouse on the OK button. Your Web browser, in turn, will display the Save As dialog box, as shown in Figure 217.3.

5. In the Save As dialog box, select the folder you would like to download the WinZip software to and then click your mouse on the Save button. Your Web browser, in turn, will display the File Download dialog box, as shown in Figure 217.4, indicating the progress of the file copy operation.

1001 INTERNET TIPS

Figure 217.3 The Save As dialog box.

Figure 217.4 The File Download dialog box indicates the progress of your download.

6. Once the download is complete, your Web browser will display a notification dialog box, as shown in Figure 217.5, indicating that the file copy is complete.

Figure 217.5 The Download Complete dialog box indicates that the file copy operation is complete.

INSTALLING THE EVALUATION VERSION OF WINZIP 218

Now that you have completed the download of WinZip described in Tip 217, you are =ready to install the software. To begin the software install, perform the following steps:

1. Using Windows Explorer, locate the *Winzip70.exe* file you just downloaded and double-click your mouse on the file. Windows, in turn, will display the WinZip Setup dialog box, as shown in Figure 218.1.

Figure 218.1 Beginning the WinZip setup.

2. In the WinZip Setup dialog box, click your mouse on the Setup button. Setup, in turn, will quickly extract the files to the Windows/temp directory on your hard drive. Next, Setup will display the WinZip Setup dialog box, as shown Figure 218.2, prompting you for an installation directory for the WinZip program files.

Figure 218.2 Extracting the setup files.

3. Click your mouse on OK to accept the default installation directory and Setup will respond with a WinZip Setup thank you dialog box that describes the features of WinZip, as shown in Figure 218.3.

Figure 218.3 Accepting the default installation directory.

4. In the WinZip Setup thank you dialog box, click your mouse on the Next button. Setup, in turn, will display a License Agreement and Warranty Disclaimer dialog box, as shown in Figure 218.4. You can use the License Agreement and Warranty Disclaimer dialog box to view the license agreement or you can simply click your mouse on the Yes button and Setup, in turn, will display the WinZip Setup, Select Wizard or Classic dialog box as shown in Figure 218.5.

Figure 218.4 WinZip License Agreement and Warranty Disclaimer dialog box.

1001 Internet Tips

Figure 218.5 Electing WinZip Wizard or WinZip Classic.

5. In the WinZip Setup, Select Wizard or Classic dialog box shown in Figure 218.5, you can elect to start WinZip and use the WinZip Wizard or you can start with WinZip Classic.

Note: The WinZip Wizard is a tool for novice users that automates most of the tasks involved in creating a ZIP archive file. WinZip Classic is for more experienced users who are familiar with Windows and ZIP files. WinZip Classic is more powerful and provides more flexibility.

Select the Start with WinZip Classic radio button and then click your mouse on the Next button. The next two Tips describe how to create archives and then add files to archives with WinZip Classic.

6. The WinZip Setup dialog box will give you a choice between Express setup and Custom setup, as shown in Figure 218.6. Click your mouse on the Express setup radio button and then click your mouse on the Next button. Setup, in turn, will display the WinZip Setup thank you dialog box, as shown in Figure 218.7. You have now completed the setup of WinZip.

Figure 218.6 Choosing your WinZip setup type.

Figure 218.7 WinZip Setup thank you dialog box.

219 CREATING AN ARCHIVE

To start the WinZip program, click your mouse on the Start button. Then, select Programs, then WinZip. Next, click your mouse on WinZip 7.0. WinZip, in turn, will open the WinZip main window. After opening WinZip, perform the following steps to create a new archive:

1. On the WinZip toolbar, click your mouse on the New button as shown in Figure 219.1. (Alternatively, you could select New archive from the WinZip file menu.) WinZip, in turn, will display the New Archive dialog box, as shown in Figure 219.2.

Figure 219.1 The WinZip user interface.

2. In the Filename field in the New Archive dialog box, type the filename you would like to use to name the new archive file. You don't need to type an extension, WinZip will automatically tack on the *.zip* file extension. You can use the Create drop-down list, shown in Figure 219.3, to select a new drive on which to save the archive. From the folder list located below the Create drop-down list, open the folder in which you would like to save the zip file. Then, click your mouse on the OK button. WinZip, in turn, will display the

1001 Internet Tips

main WinZip window. To start adding files to your archive, click your mouse on the Add button. WinZip, in turn, will display the Add dialog box, shown in Figure 219.4.

Figure 219.2 The WinZip New Archive dialog box.

Figure 219.3 The Create drop-down list in the WinZip New Archive dialog box is used to select a drive location on which to place the new archive.

Figure 219.4 The WinZip Add dialog box in which you can add files to your archive.

1001 INTERNET TIPS

3. Use the Add dialog box (see Figure 219.4) to select the files you would like to add to the newly created archive. You can select multiple files by holding down the CTRL key on your keyboard while clicking your mouse on each file.
4. Once you have selected the files you would like to add to the archive, simply click your mouse on the Add button. WinZip will return to the main WinZip window and display the files you have added to the new archive. The process is complete and you can close WinZip.

Note: *To quickly create a zipped archive, you can right click your mouse on a file you would like to zip in the Windows Explorer and then choose Add to Zip or Add to filename.zip from the Explorer context menu.*

220 ADDING FILES TO AN ARCHIVE

Once you have created some zipped archive files, you might find it necessary to update the files in the archives or to add new files to the archives. Once you are familiar with how to build an archive, as described in the previous Tip, adding files to an existing archive is a simple process.

To add additional files to an existing archive file, perform the following steps:

1. Launch WinZip by clicking your mouse on Start, then Programs. Next, click your mouse on WinZip and choose WinZip 7.0, as shown in Figure 220.1.

Figure 220.1 Launching WinZip from the Windows Start Menu.

1001 Internet Tips

2. In the WinZip window, click your mouse on the Open toolbar button or alternatively, select Open Archive on the WinZip File menu. WinZip, in turn, will display the Open Archive dialog box, shown in Figure 220.2.

Figure 220.2 The WinZip Open Archive dialog box.

3. Use the Look In drop-down list and the folder list to locate and select the ZIP file you would like to open. In Figure 220.3, note that the archive called *letters.zip* has been selected. After you have located and selected the archive you would like to open, click your mouse on the Open button in the Open Archive dialog box. WinZip, in turn, will open the selected archive and display its contents in the WinZip window, as shown in Figure 220.4.

*Figure 220.3 The WinZip Open Archive dialog box with the **letters.zip** archive selected.*

*Figure 220.4 The WinZip window with the **letters.zip** archive open.*

1001 Internet Tips

4. To add additional files to the open archive, click your mouse on the Add button on the WinZip toolbar. WinZip, in turn, will display the Add dialog box, as shown in Figure 220.5.

Figure 220.5 The WinZip Add dialog box in which you can add files to your archive.

5. Use the Add dialog box (see Figure 220.5) to select the files you would like to add to the archive. You can select multiple files by holding down the CTRL key on your keyboard while clicking your mouse on each file with your mouse.
6. Once you have selected the files you would like to add to the archive, simply click your mouse on the Add button. WinZip, in turn, will return to the main WinZip window and display the files contained in the archive. The process is complete and you can close WinZip.

221 EXTRACTING FILES FROM A SELF-EXTRACTING EXECUTABLE

Another component of WinZip is the WinZip Self-Extractor utility. WinZip Self-Extractor is a utility program that creates Windows self-extracting ZIP files. The self-extracting executable file is an executable program file that includes an archived file (or files) and the software to extract or unzip the contents of the archive. Users can run a self-extracting executable file just as they run any other program. These self-extracting ZIP files are ideal for electronic file distribution because they do not require that WinZip be installed on the user's system to extract and decompress the files in the archive. The recipients of your files do not have to know anything about WinZip and do not have to own the product. They simply double-click their mouse on the executable file and it extracts its contents while preserving the directory structure of the contents.

To extract the contents of a self-extracting executable, perform the following steps:

1. Locate the executable file in Windows Explorer, similar to the one shown in Figure 221.1.
2. Double-click your mouse on the executable file. Windows, in turn, will display the WinZip Self-Extractor dialog box, as shown in Figure 221.2.

Figure 221.1 A self-extracting executable file.

Figure 221.2 The WinZip Self-Extractor dialog box.

3. Specify the folder to which you would like to extract the contents of the archive in the Unzip to folder: field in the WinZip Self-Extractor dialog box. Then, click your mouse on the Unzip button. The WinZip Self-Extractor, in turn, will display a progress bar to indicate the progress of the extraction process, as shown in Figure 221.3.

Figure 221.3 The WinZip Self-Extractor dialog box displaying a progress bar as archived files are extracted.

4. When the extraction process is complete, WinZip will display a dialog box like the one shown in Figure 221.4.

1001 Internet Tips

Figure 221.4 The extraction process is complete.

222 EXTRACTING FILES FROM AN ARCHIVE

After you have WinZip installed, as described in Tip 218, extracting files from an archive is a simple process. As shown in Figure 222.1, once WinZip is successfully installed, Windows associates any file that has a *.zip* extension with the WinZip program. Note the clamped folder icon next to the filename. Then, double-click your mouse on the file in the Explorer window and WinZip will automatically launch and open that archive, as shown in Figure 222.2.

Figure 222.1 Windows Explorer with several zipped archives displayed.

Figure 222.2 The WinZip window with an archive file opened.

1001 INTERNET TIPS

Now that the archived file is open in WinZip, you can extract one or many files from the archive. To extract a single file or several individual files, perform the following steps:

1. In the WinZip window, hold down your CTRL key and click your mouse on each of the files you would like to extract. WinZip, in turn, will highlight each selected file, as shown in Figure 222.3.

Figure 222.3 Selecting files from the WinZip window.

2. Now that you have selected the files you would like to extract, click your mouse on the Extract button on the WinZip toolbar. WinZip, in turn, will display the Extract dialog box, as shown in Figure 222.4. Notice that the Selected Files radio button in the Files area of the Extract dialog box is chosen.

Figure 222.4 The Extract dialog box with the Files radio button selected.

3. In the Extract dialog box, use the Extract to: field and the Folders/drives: window to select the folder in which WinZip will store the extracted files.
4. After you have selected the destination folder, simply click your mouse on the Extract button to complete the operation.

Note: *To quickly extract files from a zipped archive, you can right-click your mouse on a ZIP file you would like to unzip in the Windows Explorer and then choose Extract to or Extract to current directory path from the Explorer context menu, as shown in Figure 222.5.*

Figure 222.5 Extracting an archive from the Explorer context menu.

223 UNDERSTANDING THE TAR COMMAND

You use the tar command to run the Unix *tar* utility. The original use of the tar utility was to store files or a collection of files on a magnetic tape. A collection of files you place on a tape is referred to as an archive. A common use of the tar command is to store multiple related files as one file at an FTP site. You will almost always see Unix programs stored in a single tar file at an FTP site so that the user has to download only a single file, rather than multiple files. If you visit FTP sites, you have a strong possibility of seeing tar files.

224 USING THE TAR COMMAND TO CREATE AN ARCHIVE

To create a tar archive on a UNIX computer, you use the tar command. The tar command creates and extracts tar files. To create a tar file, you use the command flag or switch *–c* with the tar command. The command syntax is

```
$ tar -c [file1 file2...] or [directory1 directory2...] -f filename <ENTER>
```

An example of the use of the command is *tar –c myFile1 myFile2 myFile3 –f filename.tar*. The –f command flag tells the tar command what to name the tar archive file if you are archiving to a file. As the command syntax shows, you can archive entire directory trees in a single file. The tar command is useful for bundling a large collection of files into one file so it is easier to transfer that file, using an FTP utility, to other computers.

225 Using the Tar Command to Extract an Archive

When you are ready to work with the files in a tar archive, you must un-archive the tar file using the tar command. To un-tar a file, you use the command flag or switch *–x* with the tar command. The command syntax is

```
$ tar -x -f filename <ENTER>
```

The filename is the name of the tar file. Most tar files will have an extension, or last set of characters, of *.tar*. An example of the command for tar files is: *tar –x –f myArchive.tar*. You will often need to use the tar command after you have transferred a file from an FTP site to un-archive the file for use.

226 Understanding Telnet

Telnet is a program that will let you use a computer that is not at your location. With a Telnet program on your computer that is connected to the Internet, you can work anywhere in the world on any other computer running a Telnet server that is connected to the Internet. There are many different types of Telnet programs on the Internet, but they all serve the same function: they let you log on to a computer from your computer. A Telnet program will start a *dumb terminal* connection with the remote computer system. A dumb terminal is a computer that does not really run your programs, it just communicates to the computer that is running your programs. When you are using Telnet, the Telnet program is talking only to the remote computer. All the commands and programs that you may run are running on the remote computer. There may be many users sharing a Telnet system, so you should follow two rules when Telnetting into a system:

1. Only Telnet into computers that you have an account on, you have been given a username and password, or that is a public access computer.
2. Try to not waste time and computing power by staying on a computer longer than you need or running programs that you do not need to run.

Following these rules, there are some useful things you can do with Telnet and some interesting places to go.

227 Starting the Telnet Program That Comes with Windows

To start the Telnet program that comes with Windows 95 and 98, go to the Start menu and click your mouse on the Run command. Windows, in turn, will open the Run dialog box. Type *Telnet* into the textbox. After you have finished typing the command, the Run dialog box should look like Figure 227.1

Next, click your mouse on the OK button and the Telnet program will display a blank Telnet screen like the one shown in Figure 227.2.

1001 Internet Tips

Figure 227.1 The Run dialog box you use to start the Telnet program.

Figure 227.2 The Telnet program.

Now you can start to use the Telnet program to connect to remote computers.

228 Logging into a Telnet site

After you have the Telnet program running, you can log into a Telnet site. First, you must establish a connection to a Telnet server. Click your mouse on the Connect menu Remote System... option. The Telnet program will, in turn, display the Connect dialog box, shown in Figure 228.1.

To make a connection to a Telnet system, you will need to type the full host name of the system you would like to connect to in the host name box. Figure 228.1 shows a Host Name wolfe.source.net which is not a real system on the Internet. The Telnet program has set the other information in this dialog box to the standard Telnet settings and you should not need to change it. After you enter all the information into the dialog boxes, you can click your mouse on the Connect button. If the remote system is up and running, then Telnet will display the Login screen of the remote system, as seen in Figure 228.2

Next, you will need to type in your username for the remote system and your password, as shown in Figure 228.2. If all goes well, the remote system will log you in. You can tell that you are logged into the remote system because the Telnet program will display a shell prompt on your screen. A shell prompt should resemble the last line in Figure 228.3.

Figure 228.1 The Connect dialog box.

Figure 228.2 The Login screen after connecting to a Telnet server.

Figure 228.3 A successful login to a Telnet server.

1001 Internet Tips

229 Understanding a Shell Account

As you learned in the previous Tip, you can use Telnet to log into a remote system. After you are logged into the remote system, you will be in a shell account. The computer that you Telnet into is most likely a Unix computer system. Unix is a computer operating system that runs a computer in much the same way that Windows runs your computer, but Unix is made for bigger and more complex systems. Unix is designed to have many users using it at one time instead of only one user as with your Windows system. For many users to use a computer at the same time, each user and all the programs that each user may run must be separated. Otherwise, a user could cause problems for other user's programs. Unix separates users by giving them each a separate shell to work in. A shell is a section of the computer's equipment that is usable by just you. Users do all their work in a shell so they do not cause problems for each other's programs.

An account on a Unix system is your right to use that system and some space to store all your files on the system. You will access this account using a shell on the Unix system, hence the name shell account. There are some systems on the Internet for which you must have a valid account to gain access. To have a valid account, a system administrator must give you a username and a password. You use the username and password to access your shell account. As you saw in the previous Tip, you must enter a username and a password to complete the login process when you use the Telnet program.

Public use Telnet sites are available on the Internet for use even if you do not have a username and password. These sites have a special account called a guest account or an anonymous account that you can use if you do not have your own account.

230 Listing Files and Directories at a Telnet Site

After you are in your shell account at the Telnet site, you will want to look at what is in your shell account. As shown in Figure 228.3, when you login to the shell account at a Telnet site, you do not see much. If you want to look around in the shell account, you must first know where you are. If this is your personal shell account, the operating system will place you in your *home directory*. A home directory is the area on the computer where you can store all your personal files. You will always start at your home directory but you do not need to stay there. The simplest way to list the contents of your home directory is to use the ls command. Figure 230.1 shows the use of the ls command to display the contents of user jsmith's home directory.

Just below the ls command is the listing of what is in the home directory for the user jsmith. The output from the basic ls command only includes names. This would be very confusing if it were not for the ability you have to modify the ls command with a *switch or flag*. A switch or a flag is a way to modify how a command will function. If you use the ls command with the –F switch, it will give you a more meaningful output, as shown in Figure 230.2.

All the names that are followed by the forward slash (/) are subdirectories of the home directory. All the names that are followed by an asterisk (*) are programs that run on the computer that you Telneted into. All the other files that you see listed are simply files with symbols in their names.

If you do not have the rights to a directory, the operating system will not let you list the contents. Rights are the permissions that the administrator of the computer gives to you. These rights tell what directories you can list, if you can change to the directory, and if you can run programs.

Figure 230.1 Using the ls command at a Telnet site to list the contents of a directory.

Figure 230.2 Using the –F switch ls command to list the contents of a directory.

GETTING AROUND A TELNET SITE 231

Now that you have learned how to list the contents of your home directory, you can start to move around. If you look at the prompt in Figure 231.1, you will see the line

`[jsmith@wolfe jsmith]$`

This prompt line tells you that you are user jsmith on computer wolfe and are in the jsmith directory. It is helpful to know which directory you are working in, but not all shell accounts will have this type of prompt. If your shell account does not have this type of prompt, you can always see what directory you are in by using the pwd command. Figure 231.1 shows a listing of a pwd command.

The pwd command tells you that you are in the jsmith subdirectory of the home directory of the root directory. The root directory, shown by the first forward slash (/), is the topmost directory and everything else is a subdirectory of the root directory. The pwd command can be useful even if your Telnet account prompt does include the current directory because the prompt does not normally show all the directories above the directory where you are.

1001 Internet Tips

Figure 231.1 Listing of a pwd command.

Now that you know where you are, you can move around. If you refer to Figure 230.2, you will see a games directory under the jsmith directory. To change to that directory, enter the cd command, *cd games*, at the prompt. Next, list all the files so you can see what is in that directory. As shown in Figure 231.2, the prompt shows the new directory's name and the listing tells you that there are more directories in the games directory and one program. As with listing files, you need to have the rights to the directory before you can change to that directory.

Figure 231.2 The new directory's name and listing.

To move back to the jsmith directory, you can do a second cd command with the whole path, */home/jsmith*. Because the jsmith directory is jsmith's home directory, just entering the cd command, *cd*, with nothing else will also work. When you enter the cd command without any directory, Unix will return you to your home directory.

232 STARTING A PROGRAM IN A TELNET SITE

Starting a program may happen automatically for you depending on the Telnet site that you are connecting to. If you are connecting to a public Telnet site where you use a guest shell account, as discussed in Tip 229,

"Understanding a Shell Account," the site may have a program start as soon as you make a connection. If you are connecting to your own shell account through a Telnet connection, then starting a program can get slightly more difficult. If the program is a standard program, then all you may need to do is to type the program name at the prompt. You have already started some programs using a Telnet connection. The ls, pwd, and cd commands are all programs. If, however, the system is not able to find the program in the normal program directories, you may need to tell the computer where the program is. In Figure 230.2, the file *hiworld* is a program on the wolfe computer. This program is not a standard program on the computer and it is not in a normal program directory. For you to run this program, you need to tell the computer where this program is by typing the whole path to the program. In Figure 232.1, the output from the ls command shows the program is in the current directory and the output from the pwd command shows the whole path to that directory.

Figure 232.1 A listing of the contents of jsmith's home directory and the path to the directory.

Now that you have this information, you can enter the command to start the hiworld program. The command syntax is

```
/home/jsmith/hiworld <ENTER>
```

After typing in the above command and pressing the ENTER key, the system will run the program. You do not need to be in the program's directory if you know the whole path to the program. As you do when changing to directories and listing directories, you will need to have the correct permissions to run the program that you typed at the command prompt.

If the program is in a directory that is many subdirectories below the root directory, the command to run that program could be very long. To shorten the typing of a command, you can use a short cut if the program is in the same directory that you are. The current directory that you are in is represented by a dot (.) so an easy way to give the path to your current directory is to use a dot (.). The command given with the short cut would be

```
./hiworld <ENTER>
```

Figure 232.2 shows the running of the hiworld program using both methods given above.

*Figure 232.2 Running the **hiworld** program on a Telnet site.*

233 USING TELNET TO WORK OTHER TELNET SITES

Now that you have connected to a Telnet site and you have learned to run a program at a Telnet site, you can start to nest Telnet sessions. Nesting a Telnet session means to run a Telnet session from a Telnet session. The Telnet program is a common program on computers that work as Telnet servers and is usually a standard program on a computer system. If you need to Telnet to a second computer but do not want to quit the current Telnet session, you can start Telnet from within your first Telnet session. In this way, you will have a Telnet program running on your Windows system and a Telnet program running on the computer that you have made the Telnet connection to from your Windows system. To do this, you will start the Telnet program with the Telnet command in your current Telnet session. As shown in Figure 233, you will get a login screen when you first start your Windows Telnet session and a second login screen when you connect to a second Telnet site.

Figure 233 Making a connection to a Telnet site from a Telnet connection.

234 Going to the Library from Home and Other Stuff

The World Wide Web is replacing many Telnet sites. The World Wide Web is easier to use and many companies and organizations are replacing Telnet sites with Web sites. If you are going to a local college, you may find that Telnet is still in active use. You may even be able to get to your college computer account and register for your classes by using Telnet from your current ISP connection. People are also still using Telnet to play MUDs, which are games you play over Telnet sessions. A third common user of Telnet is local public libraries. If your local library supports it, you can Telnet into the library Telnet site and look at the status of a book to see if it is checked in. You can also see if you have any overdue books and, on some systems, you can even put a hold on a book so you can come in and pick the book up. Figures 234.1 and 234.2 show the Telnet site at the local public library in Reno, Nevada. This site allows public access but runs a program as soon as you connect. You can check with your local library to find out if it supports this and how you can Telnet into the system.

Figure 234.1 The initial screen that is displayed after you make a Telnet connection to the public library in Reno, Nevada.

Figure 234.2 Using Telnet to check on a book at the public library in Reno, Nevada.

235 USING A TELNET CONNECTION TO CHECK YOUR E-MAIL

If your ISP gives you a shell account and an e-mail address, you can use the shell account to check your e-mail instead of using your normal e-mail program. This can be useful if you are away from home but can connect to the Internet. Almost all computers with software for connecting to the Internet will also have a Telnet program so that if you can work on a computer with a connection to the Internet, then you can make a Telnet connection to your ISP. After you have made a connection to your ISP, you can run an e-mail program to check your e-mail.

236 UNDERSTANDING PINE

As you learned in the previous Tip, you can check your e-mail by making a Telnet connection to your ISP's e-mail system and starting an e-mail program. One e-mail program that is common for shell accounts is the e-mail package Pine. Pine is an e-mail package created at the University of Washington for use on Unix systems. Almost all Unix type systems have the Pine e-mail package available for users to use. Pine uses a text type graphical screen output that you can use from a Telnet connection. Pine also uses folders so that you can store your e-mail messages in different folders for better organization. In addition, Pine has the ability to send and receive attachments and to let you view news groups. Pine provides a very functional e-mail program and when you couple it with Telnet, it provides a convenient way for you to retrieve your e-mail when you are away from home.

237 STARTING PINE IN A SHELL ACCOUNT

As you learned in Tip 232, you start a program in a shell account by typing the name of the program at the command prompt. The program name is Pine. The command syntax is

```
[jsmith@wolfe jsmith]$ pine <ENTER>
```

After you start Pine, it will display the opening screen shown in Figure 237.

The Pine e-mail program is menu driven, as shown by the opening screen where it displays a set of menu items from which to choose. If you type the letter next to a menu choice, Pine will activate that menu choice. For example, if you enter the command ?, Pine will display Help information. You can also enter a command by using the up and down arrows until pine highlights the command and then press the ENTER key. You can return to the Main Menu from most screens in Pine by typing the M command. If you are entering text, such as when you are typing an e-mail, you may need to use the CONTROL key (usually abbreviated on the keyboard as **Ctrl**) together with the letter of a command. Pine lists the commands that are available for you to use at the bottom of the Pine screen. If a ^ character is before a command, you need to use the CTRL key with the command. To use the CTRL key you must hold down the CTRL key, and then press the command key.

1001 Internet Tips

Figure 237 The opening screen for the Pine e-mail program in a shell account.

LOOKING AT THE FOLDER LIST IN PINE 238

Pine makes use of folders to store and organize your e-mail messages. You start with three folders: the inbox, the sent-mail, and the saved messages. You can add new folders to the list to help you organize your e-mail messages. You can see your folders and switch from one folder to the other by using the Folder List command. At the main screen, enter the L command. Pine, in turn, will display the Folder List, as shown in Figure 238.

Figure 238 The Folder List.

The Inbox is the folder that Pine uses to store all of your incoming mail. The sent-mail folder holds a copy of all the e-mails that you have sent from the Pine program. The saved messages folder is a general storage folder of messages that you want to keep but do not want to keep in your inbox. If you use Pine for any length of time, you will see folders that are archives of other folders. For example, after January 1999 has passed to February, Pine will transfer messages in your sent-messages folder to a folder called sent-mail-jan-1999 to archive your sent e-mail from January 1999. You can add your own folders to the Folder List by using the A (add) command. When you add a folder, you can save messages from your inbox to the new folder. To save a message to a folder from the inbox, you highlight a message and then use the S (save) command. Pine, in turn, will prompt you to enter the name of the folder in which you want to save the message. By adding new folders, you can organize your messages by saving related messages to a folder.

239 LOOKING AT YOUR E-MAIL IN PINE

To view your e-mail in Pine, you must display your Inbox folder. You display your Inbox folder by displaying the folder list and then choosing the Inbox folder. If the Inbox is the currently selected folder, you can use the I command to see a list of the messages in your Inbox. You can tell if the Inbox is the currently selected folder by looking at the folder name *Pine* lists in the upper right hand corner of the main menu screen, as shown in Figure 239.1.

Figure 239.1 The Pine main menu showing the currently selected folder.

After you are in the Inbox folder, Pine will display a screen like the one shown in Figure 239.2, which lists all of the e-mail messages in your Inbox.

Figure 239.2 The Inbox folder with e-mail messages.

There are four messages in Joe Smith's Inbox. You can tell if you have not read the messages yet by looking at the status code for the message. The status code is the second column in the list of messages. An N in the status code means that the message is new or has not been read. If you have marked the message to be deleted by highlighting the message and using the D command, then Pine will place a D in the status code column to show the message is marked for deletion when you exit Pine. If you reply to the message by using the R command, then the message will have an A as its status code. To forward a message, you use the F command and Pine will not display a status code for the message. To read your e-mail, highlight the first message you want to read then press the ENTER key or use the greater than symbol (>). Pine, in turn, will display the message. You will use the space bar to page down in the

message as you read. After you are done with the first message, you can read the next message by using the N command to move to the next message. If you want to go back one message, you can use the P command to go to the previous message. If you do not need the message, you can delete the message with the D command. Use the S command to save the message to a different folder. If you need to get back to the Inbox list of messages, use the less than (<) command.

DELETING AN E-MAIL MESSAGE 240

As you saw in the previous Tip, you delete an e-mail message by highlighting the message for deletion and using the D command. As with all commands in Pine, you need only enter the letter of the command you want to use. You may notice that Pine marks the message for deletion but does not delete it. If you use the U command, Pine will unmark the message for deletion and will not delete it. Pine deletes the messages marked for deletion when you exit Pine. You can cause items that are marked for deletion to be expunged prior to exiting by using the X command. Once Pine has expunged an item from your mail folders, the message is gone and you cannot undelete the message.

SENDING AN E-MAIL MESSAGE 241

To send an e-mail message, you can reply to or forward a message that has been sent to you, or you can compose a new message. To compose a new message, you use the C command. Enter the letter C and then start a new message. When you start a new message, Pine will display a screen similar to Figure 241.

Figure 241 A new e-mail message in Pine.

Your cursor is now in the To: field in the e-mail message. You must know the e-mail address of the user you want to send a message to, such as *jsmith@wolfe.source.net*. Enter the e-mail address in the To: field of the new e-mail message screen. If you want to send a copy of your e-mail to another user, use the TAB key to move to the Cc field, then enter an e-mail address. Use the Attachment field to send other files with your e-mail message. (See Tip 243, "Attaching a File to an E-mail Message in Pine.") The Subject field is important as it lets the user preview his or her e-mail messages before reading them. The last area that you will fill in is the Message area where you will put the content of your e-mail. After you type your e-mail, press CTRL+X to send the e-mail. Pine will ask if you want to send the e-mail. Enter a Y to confirm the send, or an N to cancel the send.

242 — REPLYING TO AND FORWARDING E-MAIL IN PINE

After you read an e-mail message, you may want to reply to the message or forward the message to another e-mail recipient. To reply to a message, you use the R command. Enter the letter R when the e-mail message is highlighted in your Inbox or when you are viewing the message. After you enter the R command, Pine will display a screen like the one shown in Figure 242.1.

Figure 242.1 Replying to a message in Pine.

Note that you do not need to enter the address of the recipient of the e-mail message as this is a reply going to the person who sent you the original message. Pine will automatically enter the address of the recipient and the subject line with a Re: in front of the subject from the original message. You can then type your message in the body of the e-mail message.

To forward an e-mail message is slightly different than replying to an e-mail message. You use the Forward command to send an e-mail message to a new recipient. You forward an e-mail by using the F command when the message that you want to forward is highlighted or when you are viewing the message. Figure 242.2 shows the screen in Pine when you are forwarding an e-mail message.

Figure 242.2 Forwarding a message in Pine.

You will enter the e-mail address of the person to whom you are forwarding the message. The Pine system will fill in the subject information using the subject from the original message and will place a (fwd) at the end of the subject line. You can then enter text in the body of the e-mail message.

Whether you are replying to a message or forwarding a message to another recipient, you will send the message as you did with a new message. The CTRL+X command sends replies and forwards.

ATTACHING A FILE TO AN E-MAIL MESSAGE IN PINE 243

An easy way you can send files to a user is to attach a file to an e-mail you are sending. To send an attachment, you must start an e-mail message to a user. You start the e-mail message that you are going to attach a file to by starting a new message, replying to a message, or forwarding a message. After you have started the e-mail message, you must use the TAB key to move to the Attachment field in the e-mail message and use the CTRL+J command to attach the file. You will then need to type in the path and the name of the file you want to attach to your e-mail. If you are not sure of the path to your file or the name of your file, you can use the CTRL+T command to see the file browser screen shown in Figure 243.1.

Figure 243.1 The file browser screen used to attach a file in Pine.

You will use the arrow keys to move around and pick a file. When the file you want to attach is highlighted, you use the S command to select the file. Pine will give you the opportunity to add a comment to the file attachment. After you have attached a file to your message, your e-mail Pine will place information in the Attachment field, as shown in Figure 243.2.

Figure 243.2 The e-mail message screen after a file has been attached.

244 QUITTING THE PINE PROGRAM

The command you use to quit Pine is the Q command. After you use the Q command, you must confirm that you want to quit, and, if you have marked any messages to be deleted, you must confirm that you want to expunge, really delete, the messages. You may use the Q command only when there are no other commands currently active. For example, if you have started to compose a message, you will need to complete the message and send it, postpone the message, or cancel the message if you want to quit Pine.

245 UNDERSTANDING LINUX

You may have noticed that the computer operating system in many of the Figures in the preceding Tips is not a Microsoft Operating System. Unix is the most common operating system in use by Web, FTP, and Telnet sites on the Internet. While most users such as yourself will use a Microsoft operating system to connect to the Internet, most of the sites that you are connecting to on the Internet are Unix sites. The Unix operating system has been around since the 1970s. Vendors have refined and enhanced Unix and split it into many different types. All types of Unix share many common aspects but each type also has its own differences. Linux is a free version of Unix that more and more users and businesses are starting to use. Linux is a very small part of an overall Unix type operating system. Any operating system that makes use of the Linux kernel, the heart of an operating system, is called a Linux operating system. Many other parts of the operating system come from a project called the GNU Project (see Tip 250, "Understanding GNU"). The interesting aspect of Linux is that groups of users on the Internet are the ones who develop and write Linux and constantly update it with new features. Linux is an operating system that has the flexibility to be able to run your Desktop PC or to run a large Internet Web site.

246 UNDERSTANDING THE DIFFERENT VERSIONS OF LINUX

As you learned in the previous Tip, Linux refers to an operating system that it is different than the Microsoft Windows operating system. There are different versions of Linux in use. All versions of Linux have the Linux kernel, the most basic part of the operating system, but versions differ by what people have added to the kernel. A version of Linux can also differ depending on what software and what options a company has added. Some companies add their own programs to their distribution of Linux and then resell their programs with Linux tossed in for free. Any company that is creating an operating system based on Linux must make the operating system free to download, but they might not include their best programs in the free download version. Some companies that offer a version of Linux make programs that make the installation of the operating system easier and a little more intuitive.

One version of Linux is RedHat Linux. Many of the Figures that show a Unix type operating system in this book show a computer using a RedHat Linux version of Linux. The RedHat company adds many enhancements to the Linux operating system and provides the RedHat version of Linux for free on the Internet. To save you what could be many hours of downloading with a modem, RedHat offers the operating system on a CD-ROM, for a small price. RedHat also sells other software packages you can run on the Linux operating system. One of the main

products that RedHat sells is support for their version of Linux. You can buy a support contract from RedHat that lets you call RedHat to get help with a problem.

GETTING A LINUX INSTALLATION — 247

There are many places where you can get a version of the Linux operating system. You can get Linux online at the Linux mall at the Web site *http://linuxmall.com*. You can also order Linux from a vendor's Web site or, in most cases, download a version of Linux from their site for free. If you cannot wait for the mail or the download time, many computer stores now carry several versions of Linux.

OTHER FREE VERSIONS OF UNIX — 248

If you do not want to use Linux, there are other free versions of Unix you can find on the Internet. Two of the most common, besides Linux, are FreeBSD and NetBSD. Both of these versions of Unix are based on a type of Unix developed at University of California at Berkeley. You can find more information about FreeBSD at *www.freebsd.org*, and you can also download a copy of the FreeBSD operating system at this Web address. You can find more information about NetBSD at *www.netbsd.org*, and you can also download the operating system at this Web address. Both the FreeBSD and the NetBSD Web sites have good documentation.

UNDERSTANDING UNIX SHELLS — 249

In Tip 229, "Understanding a Shell Account," you learned about working in a shell account. A shell is a program that lets you enter commands in a computer. In Unix, there are several types of shells that you can use. Depending on the type of shell that you are using, you may see subtle differences from some of the examples and Figures shown in this book. The type of shell you see in the examples in this book is the bash shell. Other shell types include the csh shell, the tcsh shell, the zsh shell, and the sh shell. All of the commands shown in this book should work independently of the shell you are using. The two most common shell types for users of Linux are the bash shell and the tcsh shell. You can usually tell which type of shell you are in by the type of command prompt Unix gives you. The tcsh will most likely have a % sign in the command prompt and the bash shell will most likely have a $. You should not need to worry about which type of shell you have, as both are usable.

UNDERSTANDING GNU — 250

In your Internet travels, you may see software that comes from the GNU Project. The acronym GNU stands for GNU's Not Unix. The GNU Project is run by the Free Software Foundation and is dedicated to making good high quality software freely available to all users. The software that GNU produces is for Unix and Unix-like operating

1001 Internet Tips

systems. If you want to get GNU Unix software, you can go to the GNU software download page at *www.gnu.org/software/software.html*. The GNU Project also services software. The GNU Project software is not public domain software but is licensed under the General Public License (GPL) copyright. The main purpose of the GPL is to guarantee that all software that the GNU Project creates or that is created using GPL licensed code in the program is made available free of charge. All of the GNU Project's source code is available so that users can modify a program to meet their own needs. A stipulation for using the GNU code is that any program that uses it must also be covered by the GPL.

251 UNDERSTANDING THE PING UTILITY

You use the ping utility to test the connection from your computer to another computer that is on your network or on the Internet. Ping stands for Packet Internet Groper. Ping will send letters of the alphabet to another computer. When the other computer receives a ping, it will send an answer to the ping back to the sending computer. If your computer is able to send a ping to a second computer and receive a ping back from the computer, then the two computers can communicate with each other. For example, if you want to see if your computer can communicate with the computer *www.microsoft.com,* you send a ping to *www.microsoft.com*. If the *www.microsoft.com* computer sends a ping back to your computer, then your computer is able to communicate with the *www.microsoft.com* computer. You should be able to use the ping command on any system that supports the TCP/IP protocol. To use the ping command on a Windows computer, click your mouse on the Start menu, Programs, then click you mouse on the MS-DOS Prompt option. The syntax of the *ping* utility is

```
>ping [host name] (for example www.microsoft.com)<ENTER>
```

You can also send a ping to a computer IP address (see Tip 73 "Understanding Your Internet Protocol (IP) Address,") rather than the name of the computer. The syntax for sending a ping to an IP address is

```
>ping [computer IP address] (for example 10.0.1.10)<ENTER>
```

Figure 251 shows the output of successful pings using both a computer name and a computer IP address.

Figure 251 The Ping utility and its output.

SENDING A CONTINUOUS NUMBER OF PINGS 252

The Ping utility that comes with Windows will send only four pings by default. You may, in the testing of your connection to the Internet, need to send a continuous numbers of pings so you can see if you get disconnected from your Internet connection after a short amount of time. To have the Windows Ping utility send a continuous number of pings, you must use the *t* switch. A switch is a way that you can modify how a program will operate. As shown in Figure 252, the syntax for sending a continuous number of pings is

```
>ping -t [Host name or IP address]<ENTER>
```

Figure 252 The Ping utility using the t switch.

FINDING A COMPUTER NAME IF YOU KNOW THE IP ADDRESS OF THE COMPUTER 253

If you know an IP address and are trying to find the host name for the IP address, you can use the *a* switch to have the Ping utility return the host name. When you use the *a* switch, the Ping utility looks up the host name of the IP address you are trying to ping and then pings the address. The syntax is

```
>ping -a [Host IP address]<ENTER>
```

1001 Internet Tips

Figure 253 The Ping command using the *a* switch.

Shown in Figure 253, the difference between the two ping commands is that the Ping utility returns the name of the host before the reply statements when you use the *a* switch.

254 Having the Ping Utility Send a Set Number of Pings to a Computer

You have learned in the previous two Tips that the Ping utility will send four pings to a computer by default and if you use the *t* switch, it will send a continuous number of pings. If you want to send a specific number of pings, you must use the *n* switch. You specify a number with the *n* switch to tell the Ping utility how many pings to send. The syntax is

```
>ping -n [Number of pings] [Host name or IP address]<ENTER>
```

Figure 254 shows the Ping utility being used with the *n* switch to send eight pings to a computer.

Figure 254 The Ping utility using the *n* switch.

Having the Ping Utility Send Pings of Different Sizes 255

You can have the Ping utility send pings of different sizes by using the *l* switch. You would use this function of the ping command to test if you are having problems connecting to a computer due to the size of the information that you are sending. The ping command sends characters of the alphabet. The *l* switch tells the Ping utility to send a specific number of characters. The syntax is

 >ping -l [ping size] [Host name or IP address]<ENTER>

Figure 255 shows a ping that is sending 1,024 letters to the remote computer.

Figure 255 The Ping utility using the *l* switch.

Ensuring the Ping Is Not Broken Up When It Is Sent to a Computer 256

When you ping a computer on the Internet, the ping that you send may pass through several other computers as it travels to its destination. When your ping passes through other computers, they may break it up so they can send it on to its destination. If you want to test whether your pings can get to a computer without being broken up, you can use the *f* switch. The *f* switch prevents the ping you send from being broken up. You would use this function of the ping command to test if you are having problems connecting to a computer due to the way your information is being broken up as it crosses the network. The syntax is

 >ping -f [Host name or IP address]<ENTER>

Figure 256 shows the use of the *f* switch.

Figure 256 The Ping utility using the *f* switch.

1001 Internet Tips

257 — Specifying How Many Computers the Ping You Send Can Be Sent Through

Information that travels across the Internet moves through many different computers before it gets to its destination. Each piece of information contains a Time to Live (TTL) counter. When a piece of information, like a ping, passes through a computer, the computer lowers its TTL counter by one. When a computer lowers a TTL counter in a piece of information to zero, it will no longer pass the information to the next computer. You can use the *i* switch to change how many computers the ping can go through before its TTL reaches zero. You would use this to test if you are having problems connecting to a computer because of how many hops the computer is away from your computer on the network. The syntax is

```
>ping -i [TTL] [Host name or IP address]<ENTER>
```

In Figure 257, you can see two pings. One has a response to it, the other has had its Time to Live counter reach zero, seen in Figure 257 as a TTL expired. The ping did not make it to the other computer.

Figure 257 The Ping utility using the i switch.

As shown in Figure 257, the second ping has a TTL set with the *i* switch to two and the ping expired before it could get to the other computer.

258 — Setting the Priority of the Ping You Send

The ping that you send to a computer is usually a low priority piece of information. It can be delayed when it gets passed through computers on the Internet before it reaches the computer you are pinging. When a computer is passing information for many other computers along a network, all the information may be ordered by the priority of the information—higher priority information will be passed along the network while lower priority information is delayed. You can use the *v* switch to change the priority of your ping. The priority of a piece of information moving across the Internet is called its Type of Service, or TOS. The range of the TOS setting is 1 to 255 and the syntax is

```
>ping -v [tos] [host name or IP address]<ENTER>
```

The *v* switch modifies how the ping will cross the Internet, but the Ping utility will display the same output as you see for a normal ping, as shown in Tip 251, "Understanding the Ping Utility."

259 HAVING THE PING UTILITY REMEMBER THE ROUTE IT TAKES

The ping you send can keep track of up to nine other computers that it passes through as it travels to the computer you are pinging. This is used in advanced troubleshooting of network problems and you would need special programs to make use of this information. The Ping utility does not display this information. It only keeps track of computer addresses and you would need to use a different program to see the address information stored in the ping. You use the *r* switch to cause the Ping utility to keep track of the addresses of the computers it passes through as it travels across the Internet. The syntax is

```
>ping -r [number of computer addresses to keep track of] [host name or IP address]<ENTER>
```

The Ping utility will display the same output as you see for a normal ping, as shown in Tip 251, "Understanding the Ping Utility."

260 PLACING A TIME STAMP ON THE PING YOU SEND TO A COMPUTER

You can have the Ping utility have a time stamp placed on the ping you send for the time that it takes the ping to pass through the different computers to get to the computer you are pinging. This time stamp is used in advanced troubleshooting and you would need special programs to make use of this feature. The *s* switch will cause the Ping utility to use a time stamp as the ping moves across the Internet. The syntax is

```
>ping -s [number of computers to timestamp for] [host name or IP address]<ENTER>
```

The time stamp will work for only about nine computers and does not change the output from the normal ping, as shown in Tip 251 "Understanding the Ping Utility."

You must have a different program to see the timestamp.

261 TELLING THE PING UTILITY WHAT ROUTE TO TAKE TO COMMUNICATE WITH A COMPUTER

You can also use the Ping utility to test a specific path that the ping can use to get from your computer to the computer you are pinging. When you ping a computer on the Internet, the ping will travel through several computers. The list of computers that the ping passes through is the path or route of the ping. The *j* and *k* switch of the Ping utility will let you set the route that a ping to a computer must follow. In other words, you are listing the computers

1001 INTERNET TIPS

that the ping must pass through. When you use the *j* switch, you specify a list of computers that the ping must pass through. With the *j* switch, the Ping utility uses a loose route, meaning the ping can pass through other computers to get to each computer in the list. You use the *k* switch to specify the ping is to use a strict route, meaning that the ping must pass through only the computers you specify. The syntax is

```
>ping -k or -j [ a list of host names or IP address]<ENTER>
```

Figure 261 shows each of the switches being used to get to the same address.

Figure 261 The Ping utility using the k and j switch.

When you use the *j* switch, you do not need to list every computer on the route to the computer that you are trying to ping.

262 SETTING THE TIME THAT THE PING WILL WAIT FOR A COMPUTER TO RESPOND TO A REQUEST

The Ping utility will only wait a small amount of time for a computer to respond to a ping that you send before it will return an error. You use the *w* switch to set the amount of time that the Ping utility will wait for a response. If the Ping utility does not get a response in time, it will give an error of *request timed out*. You can increase the time that the Ping utility waits for a response to see if the connection is just slow or if you cannot connect to the computer you are trying to ping. You must enter a number with the *w* switch that represents how long the Ping utility should wait in milliseconds (1/1000 of a second) for a response to a ping. The syntax is

```
>ping -w [time in milliseconds] [Host name or IP address]<ENTER>
```

Figure 262 shows a ping with the *w* switch set very low so that it times out as well as a normal ping.

1001 INTERNET TIPS

Figure 262 *The Ping utility using the w switch.*

UNDERSTANDING THE FINGER COMMAND 263

You use the finger command to get information about a person who has an account on a large computer system or information about a large computer system. For finger to work, you must have two programs running, which is called a client/server program. The first program runs on the computer that you are trying to get information from; this program will give information to the second program and is called the finger server. The second program is a client program that you use to get the information from the first program. You would expect to find finger running only on large Unix type systems to respond to requests from your finger program because you usually only need to maintain user accounts and information on a large system where many users use the computer. Many administrators of large systems have stopped using finger because users were using the information that the finger program returns to break into the computer systems.

INSTALLING THE FINGER PROGRAM THAT IS ON THE CD-ROM 264

If you want to get information about a user from a finger server on the Internet, you can use the finger program on the CD-ROM. The finger program included on the CD-ROM that accompanies this book is called *Total Finger* and is a shareware program that you can try out. If you find it useful, you can send money to the program creator to pay for the program. You should look at the Help menu to learn how to properly license the program.

To install the *Total Finger* program, perform the following steps:

1001 Internet Tips

1. Click your mouse on the Start menu Run option. Windows, in turn, will display the Run dialog box. In the Run dialog box Open field, type *D:\finger\tfinger*, replacing the letter D with the letter of the CD-ROM drive on your computer, as shown in Figure 264.1.

*Figure 264.1 The Run dialog box with the command to start the install of the **Total Finger** program.*

2. Click your mouse on OK. Windows, in turn, will display a dialog box asking if you want to install the *Total Finger* program. Click your mouse on Yes. The Setup program will uncompress the *Total Finger* program and start the installation of the program. Next, the Setup program will display a Welcome screen, as shown in Figure 264.2.

*Figure 264.2 The Welcome screen from the **Total Finger** installation program.*

3. Click your mouse on the Next button. The Setup program, in turn, will display some information about the *Total Finger* program that you can scroll through and read. Then, click your mouse on the Next button. The *Total Finger* Setup program, in turn, will display the User Information dialog box.

4. You must enter your name and company name in the two textboxes, then click your mouse on the Next button. The *Total Finger* Setup program, in turn, will display the Installation Directory dialog box.

5. The default directories in the Installation Directory dialog box should be acceptable for your system and you can click your mouse on the Next button. The *Total Finger* Setup program, in turn, will display the Select Program Folder dialog box.

6. You can accept the default program folder, specify a new folder, or choose an existing folder, then click your mouse on the Next button. The *Total Finger* setup program will display the Start Copying Files dialog box. Click your mouse on the Next button. The Setup program, in turn, will start copying files to your computer.

7. After the Setup program finishes copying files to your computer, it will display the Setup Complete dialog box. Within the Setup Complete dialog box, select Yes. Select the Program File checkbox if you would like to run the program as soon as you click your mouse on the Finish button. The *Total Finger* program is now installed and ready to use.

To run the *Total Finger* program after you have installed it, click your mouse on the Start button. Windows, in turn, will display the Start menu. Click your mouse on the Programs option, then choose Total Finger. Windows, in turn, will display a submenu. Within the submenu, click your mouse on Total Finger.

USING FINGER TO FIND INFORMATION ABOUT A PERSON ON THE INTERNET 265

You can use the finger program to find information about another user on the Internet if you know the user's e-mail address. The computer that the user uses for his or her e-mail must have a finger server running. It is still common to find computers that are running finger servers at colleges and universities. In Figure 265, you see the information that is returned from the finger server program on the computer that you are fingering when a name is looked up using the finger program on the CD-ROM that accompanies this book.

Figure 265 The Total Finger program getting information from a finger server at Brown University.

The finger program is able to get contact information for a user for whom you may have just an e-mail address.

266 UNDERSTANDING WHOIS

Whois is one of the first directory servers on the Internet. A directory server is a server that you use to find information about a user on the Internet or a domain name on the Internet. A Whois server has a database of users' names, their e-mail addresses, and other contact information. You use a Whois client program to connect to a Whois server and search for a user's name. You can also use Whois to find the contact person for an Internet domain name. If you intend to lease an Internet domain name, you can use a Whois server to see if anyone is already using the name.

267 USING WHOIS TO SEARCH FOR AN INTERNET DOMAIN NAME

If you want your own Internet Domain Name, you should first look to see if the domain name you would like is already being used on the Internet. You can check for Internet Domain names by using a Whois server. If the search for the domain name returns that a user is using the name, you cannot use the name. You can search for an Internet Domain Name at *http://www.swhois.net*. The swhois server is shown in Figure 267.1. The result of the search for *gulfpub.com* is shown in Figure 267.2.

Figure 267.1 The swhois server.

*Figure 267.2 The results from a search for **gulfpub.com**.*

As you can see, the Internet Domain *gulfpub.com* is in use. You can also see contact information for the user responsible for the *gulfpub.com* domain.

UNDERSTANDING NEWSGROUPS 268

Newsgroups (Network News) are the Internet equivalent of bulletin board systems such as those found on private dial-up facilities. To appropriately use the terminology to describe the service, you could say that Network News organizes topical discussions into a broad heading called Newsgroups. The tool you will use to access the Newsgroup information is called a Newsreader. Newsreaders are discussed in Tip 273, "Using Newsreaders."

THE HISTORY AND MAKEUP OF NEWSGROUPS 269

Special news networks have sprouted and grown over the years in response to the need to have online forums available for support and discussion about special interest topics. E-mail is not the best medium for distributing support and discussion information because e-mail requires constant management, sorting, and deleting by you, the user.

Imagine having your e-mail inbox filled with messages from your boss, co-workers, and clients, along with questions (and answers) you have sent to and received from your special interest group members, like the outdoor recreation group and the Linux users' group. Your inbox would quickly become an unmanageable mess. Newsgroups solve the e-mail nightmare problem very nicely.

USENET is a set of rules devoted to passing and maintaining newsgroups. (While USENET is the primary set of network news rules, other such services include Clarinet and BITNET.) USENET is made up of seven newsgroup categories. The USENET rules for using, creating, and deleting groups have been around for many years, since before the Internet as we know it. USENET grew its roots back when news was shared via dial-up connections to bulletin board systems. The USENET categories are discussed in Tip 270.

WORKING WITH NEWSGROUP CATEGORIES 270

As discussed in previous Tips, newsgroups are the headings into which network news is divided and organized. USENET has the following seven major newsgroup categories:

- comp Covers computer science and related topics. The comp group includes not only computer science proper, but also software resources, hardware resources, and other topics of general computer-related interest.
- news Covers groups concerned with the news network itself and news software. It is recommended that new USENET users peruse this group to get a feel for the service.
- rec Covers hobby groups, recreational activities, and the arts.

1001 Internet Tips

sci	Covers groups interested in scientific research and issues other than computer science. The sci group includes newsgroups dedicated to specific scientific and engineering disciplines.
soc	Covers groups that deal with social issues, such as politics.
talk	Covers groups that are interested in debating controversial topics like religion.
misc	Covers information that does not fit into the other categories or information that crosses categories.

In addition to the seven major USENET categories, administrators can create and propagate whatever groups they find necessary. Further, a server's administrator may make agreements with other news server administrators to exchange news feeds from one server to another. A news feed is simply a site that provides your news server with one or more newsgroups.

Over time, several widespread local groups have grown to be just as popular as the seven main USENET categories. The most common alternative newsgroup hierarchies include:

alt	Covers groups that discuss alternative ways of looking at things. The alt group contains many bizarre newsgroups but also contains information that you might find useful.
biz	Covers discussions related to business.
info	Includes a group of mailing lists on a wide variety of topics.
gnu	Covers discussions about the GNU project and the FSF (Free Software Foundation).
k12	Covers kindergarten through twelfth grade teachers and students.

271 USING NET-ETIQUETTE WHEN ACCESSING NEWSGROUPS

Net-etiquette describes how you act when you are working on the Internet. You use Net-etiquette in many parts of the Internet, such as e-mail, chat, using FTP sites, and when working with newsgroups.

When working with a newsgroup, common net-etiquette is to look at postings of the newsgroups and become familiar with the content and tone of the discussion in the newsgroup before you start posting to the newsgroup. Then, when you do post, you can compose your message so that it is appropriate for the newsgroup to which you are posting.

It is poor net-etiquette to post to a group just to upset the other users who are posting to the group. If a user does post a rude newsgroup posting, resist the urge to send back comments to the newsgroup. If you must respond to that user, respond to the user directly. In this way, you do not give the rude poster what they want, which is to disrupt the newsgroup.

Before posting to Help newsgroups, such as a newsgroup to help you setup your Windows 98 system, you should look at old postings to see if your question has been answered for someone else. As a side note, reviewing old postings can save you the time of waiting for a user to respond. You will find that a little net-etiquette will go a long way when working with newsgroups.

272 USING NEWSGROUPS PASSIVELY

A great benefit to you in using newsgroups is that you do not need to be actively involved in newsgroups that you find interesting. You can passively participate in a newsgroup by just reading the postings of other users. Many users just use the newsgroups as a source of information without getting actively involved in the newsgroup by posting a message. Observing in a newsgroup, as you saw in the previous Tip, is a good way to get a feel for what a newsgroup is all about. You will find that newsgroups are a great source of information for you and you do not need to post a single message.

273 USING NEWSREADERS

A newsreader program organizes newsgroups in a logical orderly fashion that is easy to view and easy to search. Like many other Internet technologies you will encounter, you will find many different newsreader programs from which you can choose. Microsoft offers Microsoft *Outlook Express*, shown in Figure 273.1, as its latest mail and news client software. Netscape's Communicator Suite of products contains Netscape *Collabra*, shown in Figure 273.2, as its newsreader. UNIX offers *rn, trn, nn*, and *tin* as newsreader alternatives. Figure 273.3 shows *tin*.

*Figure 273.1 Microsoft **Outlook Express**.*

1001 Internet Tips

Figure 273.2 Netscape Collabra.

Figure 273.3 The UNIX-based tin utility.

274 STARTING OUTLOOK EXPRESS

As discussed in the previous Tip, *Outlook Express* is Microsoft's latest e-mail and news client package. *Outlook Express* brings you an e-mail client that lets you manage multiple e-mail accounts on multiple e-mail servers, and a news

1001 Internet Tips

client from which you can connect to multiple news servers.

To start *Outlook Express,* click your mouse on the Start menu button. Windows, in turn, will display the Start menu. Select the Programs option and then choose Internet Explorer. Windows, in turn, will display a submenu. Within the submenu, choose Outlook Express, as shown in Figure 274.1.

*Figure 274.1 Starting **Outlook Express** from the Start menu.*

Windows, in turn, will start *Outlook Express,* as shown in Figure 274.2.

*Figure 274.2 The **Outlook Express** window.*

You are now ready to begin using *Outlook Express*. First, you must configure *Outlook Express* for your e-mail server and news server. You will learn more about setting up and using news servers in *Outlook Express* in the next few Tips.

1001 Internet Tips

275 Setting Up Newsgroup Servers in Outlook Express

Now that you have *Outlook Express* running, you will need to configure it to use a newsgroup server so you can start to view different newsgroups. Your ISP should be able to give you the name of a newsgroup server you can use in *Outlook Express*. To start the configuration of the *Outlook Express* newsreader, perform the following steps:

1. Click your mouse on the Outlook Express Tools menu and select the Accounts option. Outlook Express, in turn, will display the Internet Accounts dialog box, as shown in Figure 275.1.

*Figure 275.1 The Internet Accounts dialog box in **Outlook Express**.*

2. Click your mouse on the Add button. Outlook Express, in turn, will display a submenu. Within the submenu, click your mouse on the News... option. Outlook Express, in turn, will start the Internet Connection Wizard that will step you through the rest of the process of setting up a news server account. In the opening dialog box of the Internet Connection Wizard for newsgroups, as shown in Figure 275.2, you should enter the name you want others to see when you post a message to a newsgroup.

Figure 275.2 The first dialog box of the Internet Wizard for setting up newsgroups.

3. After you have entered your name, click your mouse on the Next button. The Internet Connection Wizard, in turn, will display a dialog box, as shown in Figure 275.3, that asks you for your e-mail address.

1001 Internet Tips

Figure 275.3 The E-mail Address dialog box.

4. Within the e-mail address field, enter an e-mail address where you want users send a message to you to reply to a message you have posted to a news group. Then, click your mouse on the Next button.

5. The Internet Connection Wizard, in turn, will display a dialog box requesting the name of the Internet news server your ISP has given you. Your ISP may have included the name of the news server with information it sent you when you opened your Internet account. Within the dialog box, enter the name of the news server that you are going to use in the News (NNTP) server field, (NNTP stands for Network News Transport Protocol) as shown in Figure 275.4, and click your mouse on the Next button.

Figure 275.4 The News Server dialog box in the Internet Connection Wizard for newsgroups.

6. The next dialog box will ask you for a friendly name to use for the newsgroup server that you are setting up, as shown in Figure 275.5. You should enter a name and then click your mouse on the Next button. This name is what you will see in *Outlook Express* as the name of the folder where *Outlook Express* holds all of your newsgroups. Click your mouse on the Next button.

7. The last question you will need to answer is what connection type you are going to use. You need to pick a connection type in the Connection Type dialog box shown in Figure 275.6. If you want *Outlook Express* to start the phone connection to your ISP, then you should select Connect using my phone line. If you are on a local area network like you might have at your

work place, you should select Connect using my Local Area Network (LAN). If you make your connection to your ISP before you start *Outlook Express,* then you should manually select I will establish my Internet connection. After you select your connection type, click your mouse on the Next button. The Internet Connection Wizard, in turn, will display the Finish dialog box. Click your mouse on the Finish button. Now you are ready to start selecting newsgroups to view.

*Figure 275.5 The friendly name for your newsgroup folder in **Outlook Express**.*

Figure 275.6 The Connection Type dialog box.

276 FINDING NEWSGROUPS AND VIEWING MESSAGES IN OUTLOOK EXPRESS

After setting up your news server, as described in the previous Tip, you can begin perusing newsgroups for information that interests you. To find and view newsgroups, perform the following steps:

1. Select your news server in the *Outlook Express* Folder List, as shown in Figure 276.1.

1001 INTERNET TIPS

*Figure 276.1 Select your news server in the **Outlook Express** Folder List.*

2. With your server selected in the Folder List, click your mouse on the News groups button on the *Outlook Express* toolbar. *Outlook Express,* in turn, will display the Newsgroups dialog box, as shown in Figure 276.2.

*Figure 276.2 The **Outlook Express** Newsgroups dialog box.*

3. In the Newsgroups dialog box, you can use the scroll bar on the right side of the News groups window to scroll through the list of available newsgroups on your server. You can also type the name of the newsgroup you are looking for in the Display newsgroups which contain: field. In Figure 276.3, notice that the characters **micro** have been typed in the Display newsgroups which contain: field. *Outlook Express* has responded by filtering through the list of newsgroups to display the groups that contain the characters entered.

1001 Internet Tips

Figure 276.3 Searching for newsgroups using the Display newsgroups which contain: field.

4. After you locate a newsgroup that you are interested in, you can simply select it in the Newsgroups window then click your mouse on the Go to button near the bottom of the Newsgroups dialog box. *Outlook Express,* in turn, will download the selected newsgroup's messages, as shown in Figure 276.4.

*Figure 276.4 Looking at a newsgroup in **Outlook Express**.*

5. To view an individual posting, simply click your mouse on the Subject for the message you want to read. *Outlook Express,* in turn, will display the message in the lower right preview window, as shown in Figure 276.5.

You now have the skills necessary to locate newsgroups of interest and view the messages contained in that newsgroup without subscribing to the newsgroup. Keep in mind that the first time you view a newsgroup's contents, *Outlook Express* may appear slow as it downloads the newsgroup's messages. On successive attempts to view the same newsgroup, *Outlook Express* may appear to work more quickly because it has to download only new messages.

1001 Internet Tips

*Figure 276.5 Displaying a newsgroup message in the lower right preview window of **Outlook Express**.*

SUBSCRIBING TO NEWSGROUPS 277

Like other newsreaders, *Outlook Express* lets you subscribe to newsgroups. You might find it beneficial to subscribe to newsgroups because *Outlook Express* conveniently adds subscribed newsgroups to the *Outlook Express* Folder List, as shown in Figure 277.1. You can then access the newsgroup quickly and easily by simply selecting it in the Folder List.

*Figure 277.1 The **Outlook Express** Folder List displays the newsgroups to which you have subscribed.*

1001 Internet Tips

You can subscribe to newsgroups using a number of methods. If you are viewing a newsgroup, as described in the previous Tip, you can simply right-click your mouse on the newsgroup in the Folder List. *Outlook Express* will display a Context menu. Within the Context menu, click your mouse on the Subscribe to this newsgroup option, as shown in Figure 277.2.

Figure 277.2 The Context menu in **Outlook Express**.

You can also choose to subscribe to a newsgroup when you locate the group in the Newsgroups dialog box. To subscribe to a newsgroup using this method, perform the following steps:

1. Select your news server in the *Outlook Express* Folder List, as shown in Figure 276.1.

2. With your server selected in the Folder List, click your mouse on the News groups button on the *Outlook Express* toolbar. *Outlook Express,* in turn, will display the Newsgroups dialog box, as shown in Figure 276.2.

3. In the Newsgroups dialog box, you can use the scroll bar on the right side of the News groups window to scroll through the list of available newsgroups on your server. You can also type the name of the newsgroup you are looking for in the Display newsgroups which contain: field. In Figure 276.3, notice that the characters **micro** have been typed in the Display newsgroups which contain: field. *Outlook Express* has responded by filtering through the list of newsgroups to display the groups that contain the characters entered.

4. After you locate a newsgroup that you are interested in, you can simply select it in the Newsgroup window then click your mouse on the Subscribe button in the upper right corner of the Newsgroups dialog box. Alternatively, you can double-click your mouse on a newsgroup name in the News groups list to subscribe to the newsgroup. *Outlook Express,* in turn, will insert a Subscribed icon next to the newsgroup name.

5. When you are finished subscribing to newsgroups, click your mouse on the OK button in the Newsgroups dialog box. *Outlook Express,* in turn, will close the dialog box and display the names of the newsgroups in the Folder List, as shown in Figure 277.3.

1001 Internet Tips

*Figure 277.3 The **Outlook Express** Folder List displays the newsgroups to which you have subscribed.*

Unsubscribing from Newsgroups 278

At some point in time you might decide that you are no longer interested in a particular newsgroup and you might want to unsubscribe. You can cancel your subscription to a newsgroup and remove a newsgroup from your *Outlook Express* Folder List at any time. To unsubscribe and remove a newsgroup from your *Outlook Express* Folder List, right-click on the newsgroup name in the *Outlook Express* Folder List. *Outlook Express*, in turn, will display a Context menu from which you should select Unsubscribe from this newsgroup. See Figure 278. *Outlook Express*, in turn, will remove the newsgroup from the Folder List.

Figure 278 Unsubscribing from newsgroups using the Context menu.

1001 Internet Tips

279 Posting a Message to a Newsgroup

You can get actively involved in a newsgroup by posting messages to the group. You can share information or ask questions of the group when you post messages. When actively participating in a newsgroup, you should practice proper net-etiquette, as described in Tip 271, "Using Net-etiquette When Accessing Newsgroups."

Posting a message to a newsgroup is easy with *Outlook Express*. To post a new message to a newsgroup, perform the following steps:

1. In the *Outlook Express* Folder List, select the newsgroup to which you would like to post a message.
2. On the *Outlook Express* toolbar, click your mouse on the Compose Message button. *Outlook Express*, in turn, will open a New Message window, as shown in Figure 279.

*Figure 279 The **Outlook Express** New Message window.*

3. In the New Message window, type the subject of your message in the Subject: field and then compose the body of the message. ***Tip:*** *You cannot post a message to a newsgroup using Outlook Express if you do not supply a subject line.*
4. When you have completed your message, click your mouse on the Post button in the New Message window. *Outlook Express*, in turn, will send your message to the news server.

280 Posting Messages to Multiple Newsgroups

In some cases, you may want to post the same message to several newsgroups. As long as the newsgroups are on the same news server, you can post to multiple groups with a single posting. To address a message to more than one newsgroup, perform the following steps:

1001 Internet Tips

1. In the *Outlook Express* Folder List, select one of the newsgroups to which you would like to post a message.
2. On the *Outlook Express* toolbar, click your mouse on the Compose Message button. *Outlook Express,* in turn, will open a New Message window, as shown in Figure 279.
3. In the New Message window, pull down the Tools menu and choose Select Newsgroups. *Outlook Express,* in turn, will display the Pick Newsgroups on *news server name* dialog box, as shown in Figure 280.
4. Use your mouse to select an additional newsgroup to which you would like to post the message and then click your mouse on the Add button. *Outlook Express,* in turn, will add the newsgroup name to the Newsgroups to post to: list, as shown in Figure 280.

Figure 280 Posting your message to more than one news server.

5. Repeat step 4 until you have selected all of the newsgroups to which you would like to post the message.
6. In the New Message, window type the subject of your message in the Subject field and then compose the body of the message. ***Tip:*** *You cannot post a message to a newsgroup using Outlook Express if you do not supply a subject line.*
7. When you have completed your message, click your mouse on the Post button in the New Message window. *Outlook Express,* in turn, will send your message to the news server.

CANCELLING A POSTED MESSAGE 281

Sometimes it is beneficial to be able to remove a message that you have posted to a newsgroup. If you happen to make an error when posting a message or you decide that you would just like to remove a message that you have posted to a newsgroup, *Outlook Express* gives you the capability to cancel the message. To cancel a message, perform the following steps:

1. In the Message List, click your mouse to select the message you wish to delete.
2. From the Compose menu, choose the Cancel Message option, as shown in Figure 281. *Outlook Express,* in turn, will send a delete message to the news server.

1001 INTERNET TIPS

*Figure 281 The Cancel Message option on the **Outlook Express** Compose menu.*

Note: *The Cancel Message feature will remove a message from the newsgroup, but it will not remove the message from a user's computer if the user downloaded the message before the server removed it.*

282 FINDING A MESSAGE IN A NEWSGROUP

Outlook Express includes a search tool you can use to locate a message. To find a message, perform the following steps:

1. Click your mouse on the Edit menu Find Message option. *Outlook Express,* in turn, will display the Find Message dialog box, as shown in Figure 282.

Figure 282 The Find Message dialog box.

2. In the From: field, you can type text that *Outlook Express* will find in the posted messages From field. In the Subject: field, type text that *Outlook Express* will find in the posted mes-

sages Subject field. *Tip: Type as much text information as possible in the searchable fields to narrow down the scope of your search results.*

3. In the Posted area of the Find Message dialog box, you can narrow down the scope of Sent dates for the message for which you are searching.
4. After entering the text and date range by which you want *Outlook Express* to search, click your mouse on the Find button. *Outlook Express,* in turn, will move to the first message in the list that meets your search criteria.
5. Select the Find Next option from the Edit menu to move to the next message in the list that meets your search criteria. Alternatively, you can press the **F5** shortcut key on your keyboard to move to the next message that meets your search criteria.

Note: *You can use the column headings in the Message List to sort the message by Subject, From, Sent, and Size. Simply click your mouse on the column heading by which you would like to sort.*

RESPONDING TO THE GROUP 283

You can become actively involved in a newsgroup discussion by simply responding to a posted message. You can respond to a posted newsgroup message from within the message window. To respond to a message, perform the following steps:

1. Double-click your mouse on the message you would like to read. *Outlook Express,* in turn, will open the message in its own window, as shown in Figure 283.1.

Figure 283.1 The Reply to Group button in the Message window.

2. To reply to the group, click your mouse on the Reply to Group button in the Message window, as shown in Figure 283.1. *Outlook Express,* in turn, will open a reply window for the

1001 Internet Tips

message that includes the original message text as well as addressing information for the newsgroup from which you retrieved the message, as shown in Figure 283.2.

Figure 283.2 Replying to the Group.

3. In the reply window, type your response text in the message area. Next, click your mouse on the Post button on the message toolbar. *Outlook Express,* in turn, will send your reply to the newsgroup.

284 RESPONDING TO THE AUTHOR

You might want to reply to just the author of a particular newsgroup message instead of replying to the newsgroup. *Outlook Express* provides you with a Reply to Author option in the message dialog box. To reply to just the author of a message, perform the following steps:

1. Double-click your mouse on the message you would like to read. *Outlook Express,* in turn, will open the message in its own window, as shown in Figure 284.1.
2. To reply to the author of the message, click your mouse on the Reply to Author button in the Message window, as shown in Figure 284.1. *Outlook Express,* in turn, will open a reply window for the message that is addressed to the author of the posted message, as shown in Figure 284.2.

Figure 284.1 The Reply to Author button in the Message window.

Figure 284.2 Replying to the Author.

1001 Internet Tips

3. In the reply window, type your response text in the message area. Next, click your mouse on the Send button on the message toolbar. *Outlook Express,* in turn, will send your reply to the message author.

*Note: To reply to the author of a newsgroup message as described above, you must have **Outlook Express** configured as your e-mail client as described in Tip 579. If you use something other than **Outlook Express** as your primary e-mail client, clicking your mouse on the Reply to Author button in step 2 will launch your e-mail client program.*

285 FORWARDING A MESSAGE

You might want to forward an interesting message to one of your friends or co-workers instead of replying to the newsgroup or the author of the message. *Outlook Express* provides you with a Forward option in the message dialog box. To forward a message, perform the following steps:

1. Double-click your mouse on the message you would like to read. *Outlook Express,* in turn, will open the message in its own window, as shown in Figure 285.1.

Figure 285.1 The Forward button in the Message window.

2. To forward a message, click your mouse on the Forward button in the Message window, as shown in Figure 285.1. *Outlook Express,* in turn, will open a forward window for the message that you can address to any e-mail recipient, as shown in Figure 285.2.
3. In the To: field of the forward message window, type the e-mail address of the recipient to whom you would like to send the message. In the message area, type any additional text you would like to add to the message, as shown in Figure 285.3.

Figure 285.2 Forwarding a message to an e-mail recipient.

Figure 285.3 Addressing and typing body text in your forwarded message.

4. When you have addressed the message and finished adding text to the body, click your mouse on the Send button on the message toolbar. *Outlook Express,* in turn, will forward the message to the e-mail recipient.

Note: *To forward a newsgroup message as discussed above, you must have* **Outlook Express** *configured as your e-mail client. (See Tip 585, "Configuring Outlook Express to Send and Receive Internet E-Mail.") If you use something other than* **Outlook Express** *as your primary e-mail client, clicking your mouse on the Forward button in step 2 will launch your e-mail client program.*

286 SENDING LARGE MESSAGES TO A NEWSGROUP

Many news servers limit the size of the messages you can post to the newsgroups on that server. The message size limit set on many news servers is 1MB per posted message. For this reason, you can configure *Outlook Express* to automatically break up large messages into a set of smaller messages of a given size.

To configure *Outlook Express* to automatically break up large messages into smaller messages that a news server will allow, perform the following steps:

1. Click your mouse on the *Outlook Express* Tools menu and select Accounts. *Outlook Express,* in turn, will open the Internet Accounts dialog box, as shown in Figure 286.1.

Figure 286.1 The Internet Accounts dialog box.

2. Click your mouse on the News tab to bring that tab to the foreground of the dialog box, as shown in Figure 286.2.
3. Click your mouse on the News account you would like to configure and then click your mouse on the Properties button. *Outlook Express,* in turn, will display the Properties sheet for the selected News account, as shown in Figure 286.3.
4. In the Properties dialog box for the selected news account, click your mouse on the Advanced tab to bring the Advanced tab to the foreground of the Properties dialog box, as shown in Figure 286.4.

Figure 286.2 The News tab in the Internet Accounts dialog box.

Figure 286.3 The Properties dialog box for your news account.

Figure 286.4 The Advanced tab of the Properties dialog box for your news account.

1001 Internet Tips

5. On the Advanced tab, click your mouse on the Break apart messages larger than checkbox, then enter the maximum file size (in KB) you can send to this news server, as shown in Figure 286.5.

Figure 286.5 Configuring the posting area of the advanced properties for your news account.

6. Click your mouse on the OK button to close the news account Properties dialog box, then click your mouse on the Close button to close the Internet Accounts dialog box.

Note: Remember that each of your individual e-mail and news server accounts must be configured separately for maximum message size.

287 ATTACHING A FILE TO A MESSAGE

In Tips 283, 284, and 285, you learned how to reply to messages posted in newsgroups. As you reply to or forward messages, you might decide you want to attach a file to your response. *Outlook Express* supports attaching files to e-mails or messages posted to newsgroups. To attach a file to your response or to your posted message, begin by replying to or forwarding a message, as discussed in Tips 283, 284, and 285, but before clicking your mouse on the Send or Post button, perform the following steps to attach a file:

1. In the reply message window, click your mouse on the Insert menu and select File Attachment..., as shown in Figure 287.1. *Outlook Express,* in turn, will open the Insert Attachment dialog box.
2. Use the Insert Attachment dialog box, as shown in Figure 287.2, to locate the file you would like to attach.

3. Once you have located the file you would like to attach to the message, select the file (see Figure 287.2) and then click your mouse on the Attach button. *Outlook Express,* in turn, will close the Insert Attachment dialog box. Now you can see the attached file's icon at the bottom of the message window, as shown in Figure 287.3.

4. Click your mouse on the Post button (or the Send button) to send the message.

*Figure 287.1 The **Outlook Express** Insert Menu.*

*Figure 287.2 The **Outlook Express** Insert Attachment dialog box.*

Figure 287.1 A message window showing the attached file's icon.

288 CONFIGURING OUTLOOK EXPRESS TO USE HTML AS ITS NEWS SENDING FILE FORMAT

With a little preparation, *Outlook Express* lets you insert hyperlinks and pictures into your message text. You must first change *Outlook Express's* News sending format to hypertext markup language or HTML. The News sending format is simply the file format of the messages you post to newsgroups. As you will see in the next two Tips, the HTML format enables some useful features for posting messages to news groups.

To change the default file format for newsgroup postings, perform the following steps:

1. In the *Outlook Express* window, click your mouse on the Tools menu and choose Options... *Outlook Express*, in turn, will open the Options dialog box, as shown in Figure 288.1.

2. In the Options dialog box, click your mouse on the Send tab to bring the Send tab to the foreground of the Options dialog box, as shown in Figure 288.2.

3. On the Send tab, click your mouse on the HTML radio button in the News sending format area. Choosing HTML as your news sending format enables HTML to insert hyperlinks and pictures into your messages.

4. Click your mouse on the OK button to close the Options dialog box.

*Figure 288.1 The **Outlook Express** Options dialog box.*

*Figure 288.2 The Send tab of the **Outlook Express** Options dialog box.*

INSERTING A HYPERLINK IN A MESSAGE 289

After you configure *Outlook Express* to send news postings in HTML format, as described in the previous Tip, you can create hyperlinks within your news text. (Refer to Tip 212, "Understanding Hyperlinks," for a description of hyperlinks.) A user reading your posting can click the mouse on the text that you specify as a hyperlink, and the hyperlink will launch the Web browser and open that page.

1001 Internet Tips

You have already learned how to respond to messages posted in newsgroups. To include a hyperlink in your response text, begin by replying to or forwarding a message, as described in Tips 283, 284, and 285. Before clicking your mouse on the Send or Post button, perform the following steps:

1. The first step in the process of creating a hyperlink is to select the text that you want to be the hyperlink. To select the text, simply click and drag your mouse cursor over the text, as shown in Figure 289.1.

Figure 289.1 Selecting the text that will eventually become the hyperlink.

2. Next, click your mouse on the Insert menu and choose Hyperlink. *Outlook Express*, in turn, will open the Hyperlink dialog box, as shown in Figure 289.2.

*Figure 289.2 The **Outlook Express** Hyperlink dialog box*

3. By default, the hyperlink type selected is *http*. You could select any of a number of protocol types depending on the site to which you are trying to point. In the URL, you type the URL of the Web site to which you would like the hyperlinked text to point, as shown in Figure 289.3. Then click your mouse on the OK button. *Outlook Express,* in turn, will close the Hyperlink dialog box and display the hyperlinked text as underlined and in a different color, as shown in Figure 289.4.

Figure 289.3 Specifying the URL for your hyperlink.

1001 Internet Tips

Figure 289.4 Your completed hyperlink.

4. Click your mouse on the Post button (or the Send button) to send the message.

INSERTING A PICTURE IN A MESSAGE 290

In the same fashion that you inserted a hyperlink into a message in the previous Tip, you can insert a graphic. Before you can insert graphics into a message, you must have completed the steps described in Tip 288, "Configuring Outlook Express to Use HTML As Its News Sending File Format." After you have configured *Outlook Express* to send news postings in HTML format, as described, you can insert graphics right into your news text. Users reading your posting can then view the graphic as they read your message.

In Tips 283, 284, and 285, you learned how to reply to messages posted in newsgroups. To include a graphic in your response text, begin by replying to or forwarding a message, as described in Tips 283, 284, and 285. Then, perform the following steps:

1. To insert a graphic, you should first place your cursor in the position within the message that you would like to place the graphic.
2. To insert the image, click your mouse on the Insert menu and choose Picture. *Outlook Express,* in turn, will open the Picture dialog box, as shown in Figure 290.1.
3. Click your mouse on the Browse button to the right of the Picture Source: field to select the picture. *Outlook Express,* in turn, will open a dialog box from which you can browse and select the picture file.
4. Select the picture file you want to insert, then click your mouse on the Open button. *Outlook Express,* in turn, will close the dialog box and return you to the Picture dialog box.
5. Next, you can make changes to the Layout and Spacing areas of the Picture dialog box as well as specify Alternate Text you would like a recipient's mail reader to display if it does not support images or if it has images turned off.

1001 Internet Tips

*Figure 290.1 The **Outlook Express** Picture dialog box from which you can select the picture you would like to insert.*

6. When you have finished specifying the image and making other settings in the Picture dialog box, click your mouse on the OK button. *Outlook Express*, in turn, will close the Picture dialog box and display the message with the image inserted, as shown in Figure 290.2.

*Figure 290.2 An **Outlook Express** message with a picture inserted.*

7. Click your mouse on the Post button (or the Send button) to send the message.

STARTING THE NETSCAPE NEWSREADER 291

As discussed in Tip 273, "Using Newsreaders," Netscape also includes a newsreader in its Netscape Communicator suite of products. As of this printing, the latest version of Netscape Communicator is version 4.51. To launch Netscape's newsreader (called *Collabra* in previous Netscape Communicator releases, now incorporated with the e-mail client and called *Netscape Messenger*), click your mouse on the Start menu button. Windows, in turn, will display the Start menu. Move your mouse to Programs, Netscape Communicator, and then click your mouse on *Netscape Messenger*, as shown in Figure 291.1.

Figure 291.1 Launching Netscape Messenger, the Netscape mail and news client.

Windows responds by opening the *Netscape Messenger,* as shown in Figure 291.2.

You are now ready to begin using *Netscape Messenger*. First, you must configure *Netscape Messenger* for your e-mail and news server. You will learn more about setting up news servers in the next Tip.

Figure 291.2 Netscape Messenger, the Netscape mail and news client.

292 Setting Up a News Server in Netscape Messenger

With *Netscape Messenger* running as discussed in the previous Tip, you are ready to configure *Netscape Messenger* to connect to a news server. Typically, your Internet service provider can provide you with configuration information for a news server to which you can connect. To set up *Netscape Messenger* for a news server, perform the following procedure:

1. Click your mouse on the Edit menu and choose Preference. *Netscape Messenger*, in turn, will open the Preferences dialog box, as shown in Figure 292.1. Note that the configurable options are arranged neatly by category.

Figure 292.1 The Netscape Messenger Preferences dialog box.

2. In the Category list, expand the Mail & Newsgroups if it is not already expanded. Then, click your mouse on the Newsgroup Servers, as shown in Figure 292.2.

Figure 292.2 Adding newsgroups in the Netscape Messenger Preferences dialog box.

1001 INTERNET TIPS

3. In the Newsgroup Servers area, click your mouse on the Add button. *Netscape Messenger*, in turn, will open the Newsgroup Server Properties dialog box, as shown in Figure 292.3.

Figure 292.3 Add new news servers to your configuration using the Newsgroup Server Properties dialog box.

4. In the Newsgroup Server Properties dialog box, type the name of the news server that your ISP provided, as shown in Figure 292.4. You will also want to click your mouse on the Supports encrypted connections (SSL) checkbox, if instructed to do so by your ISP or system administrator. You should do the same for the Always use name and password checkbox.

Figure 292.4 Typing in the name of your news server.

5. When you have finished configuring your news server, click your mouse on OK to close the Newsgroup Server Properties dialog box. Then, click your mouse on OK to close the Preferences dialog box. *Netscape Messenger*, in turn, will display the newly configured news server in the Folder List, as shown in Figure 292.5.

Figure 292.5 The Netscape Messenger Folder List with your newly configured news server displayed.

293 SUBSCRIBING TO NEWSGROUPS

Like other newsreaders, *Netscape Messenger* lets you subscribe to newsgroups. You might find it beneficial to subscribe to newsgroups because *Netscape Messenger* adds subscribed newsgroups to the *Netscape Messenger* Folder List, as shown in Figure 293.1. You can then access the newsgroup quickly and easily by simply selecting it in the Folder List.

Figure 293.1 The Netscape Messenger Folder List.

You can subscribe to newsgroups using a number of methods. After you have set up the news server as described in Tip 292, you can simply right-click your mouse on the news server in the Folder List to bring up the Context menu. Then, click the Subscribe to Newsgroups... option on the Context menu, as shown in Figure 293.2.

Figure 293.2 The Netscape Messenger Subscribe to Newsgroups...option on the Context menu.

Netscape Messenger, in turn, will open the Communicator: Subscribe to Newsgroups dialog box shown in Figure 293.3.

*Figure 293.3 The **Netscape Messenger** Communicator: Subscribe to Newsgroups dialog box.*

In the Newsgroup list, you can use the scroll bar on the right side of the Newsgroups window to scroll through the list of available newsgroups on your server. You can also type the name of the newsgroup you are looking for in the Newsgroup: field. After you locate a newsgroup that you are interested in, you can simply select it in the Newsgroups list, then click your mouse on the Subscribe button in the upper right corner of the dialog box. Alternatively, you can double-click your mouse on a newsgroup name in the News groups list to subscribe to the newsgroup. *Netscape Messenger*, in turn, will insert a checkmark in the Subscribe column, as shown in Figure 293.4.

Figure 293.4 The Subscribed newsgroups in the Subscribe column of the Communicator: Subscribe to Newsgroups dialog box.

When you are finished subscribing to newsgroups, click your mouse on the OK button in the Communicator: Subscribe to Newsgroups dialog box. *Netscape Messenger*, in turn, will close the dialog box and display the names of the subscribed newsgroups in the Folder List, as shown in Figure 293.5.

1001 INTERNET TIPS

*Figure 293.5 The **Netscape Messenger** Folder List with subscribed newsgroups.*

294 UNSUBSCRIBING FROM NEWSGROUPS

If you decide that you are no longer interested in a particular newsgroup, you might want to unsubscribe. You can cancel your subscription to a newsgroup and remove a newsgroup from your *Netscape Messenger* Folder List at any time. To unsubscribe and remove a newsgroup from your *Netscape Messenger* Folder List, right-click your mouse on the newsgroup name in the *Netscape Messenger* Folder List and select Remove Newsgroup, as shown in Figure 294.1.

*Figure 294.1 Unsubscribing using the **Netscape Messenger** Folder List.*

Netscape Messenger, in turn, will display a confirmation dialog box, as shown in Figure 294.2. Within the confirmation dialog box, click your mouse on the OK button to complete the removal of the newsgroup from the Folder List.

Figure 294.2 Confirming the removal of a newsgroup.

UNDERSTANDING MAILING LISTS 295

A mail list provides a method for a user to send an e-mail message to many users at one time. Most mail lists have a person that moderates the mail list; this person is called the moderator. The moderator is responsible for receiving e-mail messages, deciding if the e-mail message should be sent to the rest of the users using the mailing list, and then sending the e-mail message to all the users on the mailing list. The moderator may use special mailing list software to run a mailing list or may just keep a list of users who are on the mailing list and send an e-mail message to each user. To receive the e-mail messages from a mailing list, you must subscribe to that mailing list (see Tip 298 " Subscribing to Mailing Lists.") A moderator keeps a list of all the users who have subscribed to the list and every time the moderator needs to send a message, the moderator will send a message to the list of users that have subscribed. You cannot get the message from a mailing list unless you have subscribed to the mailing list or someone who has subscribed to the mailing list sends the message to you.

COMPARING MAILING LISTS AND NEWSGROUPS 296

The main difference between a newsgroup and a mailing list is that in a newsgroup you use a newsgroup reader to subscribe to the newsgroup and read the message, and in a mailing list you just use your e-mail reader. The newsgroup system is separate from your e-mail system, though most e-mail programs also have a newsreader built in to them. The concept of a newsgroup and a mail list is the same: that a large number of people get information. The difference between them is in how the information gets sent out to users. In a newsgroup, a message gets posted to the newsgroup and you go to the newsgroup to see the message. In a mailing list, the message gets sent to a moderator, either a user or a computer program, and the message is e-mailed directly to you. Some users like mailing lists because they do not need to do anything after they subscribe to the mail list to get the message; it is e-mailed directly to them. Some users like newsgroups because their e-mail inbox does not fill up with mailing list messages; if they want the information they look at the information. Sometimes you do not have a choice of whether to use a newsgroup or a mailing list because the information you are interested in comes only as a newsgroup or as a mailing list.

1001 Internet Tips

297 Finding Mailing Lists

Probably the most common way that you can find a mailing list is by word of mouth, having a friend or co-worker tell you about a mailing list. You also may read about a mailing list. For example, after reading a magazine article about a subject, you may see that a mail list is given in the references for the article so that people who want more information can subscribe to a mailing list. Web pages are also good sources of mail lists. If you have found a Web page that has information that interests you, you should check to see if the Web page has a mail list you can join. If you have not been able to find a mail list that interests you by using the above methods, you can also try a Web-based search of the available mail lists. At the time of this writing the Web page *www.neosoft.com/internet/paml* is a good source of information about mail lists. The Publicly Accessible Mailing Lists (paml) site is able to search for mailing lists by topic and by the name of the mailing list you may be looking for. You can also use a search engine on the World Wide Web to search for mailing lists.

298 Subscribing to Mailing Lists

There are many ways that you can subscribe to a mailing list. The first thing you should determine is if your source for the mailing list also tells you how to subscribe to the list. The most common way to subscribe to a mailing list is to send an e-mail to an e-mail address used for subscribing to the mail list. What you send in the e-mail to subscribe to a mailing list is determined by how the mailing list is maintained. If a user who is manually sending the e-mail maintains the mailing list, all you must do is send an e-mail to the user asking to be added to the list. Computer programs maintain most mailing lists; adding users to the list, removing users from the list, and sending messages to all users on the list. If a program maintains the mailing list, then depending on the type of program, you will send the mail in different ways. One type of mailing list you may see is a list run by a program called majordomo. If you are joining a majordomo list, you will send mail to majordomo at the domain name for the mailing list you wish to join. In the subject and body of the message, you type subscribe some_mail_list. For example, if you want to subscribe to the beer mailing list where you can talk about beer, then your e-mail to subscribe should look like the e-mail in Figure 298.

Figure 298 E-mail to subscribe to the beer mailing list.

The e-mail message is sent to the majordomo program at the domain name where the beer list is located (To: *majordomo@cuy.net*). The e-mail subject and body text list which mailing list you are going to join and that you want to join the list. The program knows who to send the mailing list messages to by using the return address from the e-mail you are sending. The e-mail shown in Figure 298 will start your subscription to the beer mailing list.

A second type of mail list program you may see is called a listserv (list server) mail list program. You would send an e-mail as you did with the beer list but you would send the e-mail to listserv at a domain name. For example, to join the baseball mailing list, you would send an e-mail to the address *listserv@apple.east.lsoft.com* with the subject and body text of subscribe baseball. The e-mail should look like the e-mail in Figure 298, but with the new information. You can tell which type of mailing list you are sending to from the place you found out about the list.

After you send your subscribe e-mail, you will get an e-mail back from the mailing list welcoming you to the list and giving you information about the list. You should always save the welcome message because it will have information about how to unsubscribe from the mailing list, which you may want to do later. You may also receive a message between your subscribe message and the welcome message which is asking you to confirm your subscription to the mailing list. If you get a confirmation message, read the message and follow the instructions on how to confirm your subscription to the mailing list. You can also subscribe to some lists by going to a Web page and following the directions on the Web page.

UNSUBSCRIBING FROM A MAILING LIST 299

If you no longer want to receive the messages from a mailing list, then you will need to unsubscribe from the mailing list. The welcome message that you receive when you first subscribe to a mailing list should have all the instructions on how to unsubscribe from a mailing list. It is best to save the welcome message to a mailing list so you can use the directions in the welcome message to unsubscribe from the mailing list. If you have lost the welcome message, you can unsubscribe from most mailing lists by sending a message to the mailing list program. Your e-mail should contain the subject and body text of unsubscribe list_name. Figure 299 shows what an e-mail to unsubscribe to the beer mailing list would look like.

Figure 299 E-mail to unsubscribe from the beer mailing list.

1001 Internet Tips

If you have lost the welcome message and you cannot get unsubscribed from a mailing list by using an unsubscribe e-mail message then, as a last resort, you can send an e-mail asking for assistance to the system administrator or postmaster at the mailing list's domain name.

300 Posting to a Mailing List

To post to a mailing list, you must send an e-mail to the mailing list's address. Using the example in the previous Tips if you want to post a message to the beer mailing list, you address your e-mail message to *beer@cuy.net,* as shown in Figure 300.

Figure 300 Posting a message to a mailing list.

The mailing list program will send your message to all members of the mailing list.

301 Understanding Gopher

In 1991, before the widespread use of the World Wide Web and the Internet, the University of Minnesota developed a protocol that would help users find information on the growing Internet. The protocol divided the Internet into a hierarchical listing of menus. Needing a name for their new method of using the Internet, the users at the University of Minnesota, home of the Golden Gophers, chose the name gopher for their invention. The gopher server at the University of Minnesota displays a menu of other sources of information that you can use. You can click your mouse on a menu item and the server will communicate with a second gopher server that has information that you are interested in viewing. The second gopher server will display a new menu of sources of information and new gopher sites to visit. Gopher was an early method of organizing the massive amount of information that is available on the Internet. The World Wide Web today has almost completely replaced gopher but you can still come across some active gopher sites.

1001 Internet Tips

Using Your Browser as a Gopher Client — 302

You can still use gopher clients today because most Web browsers are also able to view gopher sites.. To tell your browser that you are going to use a gopher site instead of a Web site, you start the URL address with gopher. An example of a gopher address in your browser is *gopher://gopher.micro.umn.edu*. A gopher site displays a list of other gopher sites or documents that you can connect to or view, as shown in Figure 302.

Figure 302 A gopher site as viewed from Internet Explorer.

Working with a Gopher Site — 303

When you work with a gopher site you pick a very broad topic at the first menu you see when you connect to the gopher server. Next, the gopher server will display a new set of menu items from which you can choose. You continue this process until you find the information you want to view. For example in Figure 302, which shows the University of Minnesota's gopher server, the broad topic you may pick is Fun and Games. When you click your mouse on the Fun and Games menu item, the gopher server will display a new set of menu items from which you can pick a more detailed topic.

Comparing Gopher to the Web — 304

Gopher was developed shortly before the Web and was an early method of organizing the information found on the Internet. The World Wide Web is an attempt at organizing the information on the Internet. The gopher sites and Web sites on the Internet have many aspects in common. In a gopher site, you click your mouse on menu items that will take you to other gopher sites. In the Web, you click your mouse on Web links that take you to other Web sites. The major difference between the Web and gopher is that the Web is more graphical than gopher. Gopher sites are

1001 Internet Tips

text-based and most Web sites are graphical based. Most users like to deal with pictures and so the Web has become more popular than gopher.

305 Understanding Veronica

Veronica is a method of searching many gopher servers for a menu that contains a keyword. Veronica stands for Very Easy Rodent Oriented Netwide Index to Computer Archives and, as its name suggests, Veronica is an attempt to make it easier to search gopher servers for menus that deal with a specific topic. Veronica is based on the gopher protocol. Veronica lets you use your gopher client to search gopher menus for a keyword you specify. Today, the majority of Internet users do not use gopher or Veronica.

306 Understanding Jughead

Jughead is a gopher search program you use to search for gopher menus. Jughead stands for Jonzy's Universal Gopher Hierarchy Excavation And Display. Jughead is similar to Veronica in that you use Jughead to search for gopher menu items by using keywords. Today, the majority of Internet users do not use gopher or Jughead.

307 Understanding PAL

PAL is an instant message service you can use to talk to your friends, family, and business associates in real time. *PAL* stands for Personal Access List and is a program that can keep a list of users you want to talk to and let you talk to them over the Internet. For you to talk to another user using *PAL,* both you and the user you want to talk to must download and install *PAL* on your computers. With *PAL* installed, you can send messages to the other user and he or she can respond to you as if you were talking on a phone. You can also use *PAL* to have a one-on-one conversation or to have a conference with many users.

308 Installing the PAL Software

To install the *PAL* software, first download the *PAL* installation program from Excite's Web site, *www.excite.com*. Next, use Windows Explorer to locate the file you downloaded and to start the installation program by double-clicking on it. The installation program, in turn, will display the opening screen shown in Figure 308.1.

You must click your mouse on the Yes button to start the installation of the *PAL* software. The next screen that the *PAL* installation program will display is the License Agreement screen. You should read the license and if you agree with its content, click your mouse on the Yes button. The *PAL* program, in turn, will display a dialog box asking you to what directory it should install the software. The default directory given by the *PAL* installation program should

Figure 308.1 The opening screen from the PAL install.

be appropriate for most installations. To accept the default, click your mouse on the OK button. The *PAL* installation program will now ask you in what program group should it place the *PAL* icon. Again, the default should be OK, so click your mouse on the OK button. The installation will finish and then ask you if you would like to start the *PAL* program. You should click your mouse on the Yes button to start using *PAL*.

The first time that you start *PAL*, you must sign in to the *PAL* system and register your address so other *PAL* users can find you. The first time you use *PAL*, you will need to set your e-mail address and you will receive your password. If you install *PAL* on other computers you use, you can reuse your e-mail address and password. If you check the save password checkbox, you will not need to enter your password in the future. After you have signed in, you should see the program window shown in Figure 308.2.

Figure 308.2 The PAL program window.

Now that you have the *PAL* software installed, you can start talking to all your friends that have *PAL* installed as well.

ADDING USERS TO YOUR PAL WINDOW — 309

You can list users in the *PAL* program window who you want to talk to when they are online. The users that you add to your list can be either in the friend or work category. To add a user, click your mouse on the People menu within the *PAL* program window. *PAL*, in turn, will display a submenu. Within the submenu, click your mouse on the

1001 Internet Tips

Add... menu option. *PAL*, in turn, will display the Add Person/Group dialog box shown in Figure 309.1. You can also simply click your mouse on the Add button in the *PAL* program window and *PAL* will, in turn, display the Add Person/Group dialog box.

Figure 309.1 The Add Person/Group dialog box.

In the Add Person/Group dialog box, enter a user's e-mail address and a name that *PAL* will display in the *PAL* program window. After you have added some users to your list of users in *PAL* your *PAL* program window should look like Figure 309.2.

Figure 309.2 The PAL program window with users listed.

PAL will display the names of any users you have listed in bold green type when they are online and using *PAL*. You can leave your *PAL* program running so that you can tell when your friends and co-workers come online.

310 SENDING A MESSAGE TO A USER USING PAL

You can send messages to your friends and co-workers you have listed in *PAL* after they have *PAL* installed and working as well. When a name appears as green and in bold type in the *PAL* window, you can send a message to that user. Click your mouse on the user's name to highlight it, then click your mouse on the Message button. The *PAL* program, in turn, will display the Message dialog box shown in Figure 310.1.

Figure 310.1 The Message dialog box when you send a message to a person using PAL.

Type your message in the message box and click your mouse on the Send button. When the user you are sending the message to responds, the *PAL* program will display the *PAL* Reply dialog box shown in Figure 310.2.

Figure 310.2 The Reply dialog box sent as a reply to a message sent to a PAL user.

You can now talk to the user by clicking your mouse on the respond button. *PAL*, in turn, will display the Talk dialog window shown in Figure 310.3.

Figure 310.3 The PAL Talk dialog window.

You will type your messages in the lower window and *PAL* will display your messages in the upper window, along with the responses from the user to whom you are talking. You can hold a conversation with the user to whom you are talking as long as you like.

RESPONDING TO MESSAGES FROM OTHER PAL USERS — 311

If someone sends you a message with *PAL*, you will get a *PAL* Reply dialog window, as shown in Figure 311.

Figure 311 The Reply dialog window displayed by PAL when you are sent a message.

You can respond to this dialog window by clicking your mouse on the Respond button the same as you do when you send a message to someone using *PAL. PAL,* in turn, will display a talk dialog box, as it does when you send a message, and you can talk as long as you like.

312 HOLDING A CONFERENCE IN PAL

You can also use *PAL* to talk to more than one user at a time. You send a message and start a *PAL* talk window, as normal, but after you start the talk window, you click your mouse on the Conference button. *PAL*, in turn, will display the Conference window shown in Figure 312.1.

Figure 312.1 The PAL Conference window.

You can click your mouse on the Invite Others button at any time to invite other *PAL* users to the conference. When you click the Invite Others button, *PAL*, in turn, will display the Invite to Conference dialog box. You should drag names from your *PAL* program window to the Invite to Conference dialog box. You will only be able to drag the names of users who are online and using *PAL*, with their names displayed in bold green type. *PAL* will display all the users in the conference on the right hand pane of the window. The left hand upper and lower panes will work just like the normal *PAL* talk window. Figure 312.2 shows both windows that you will work with to invite users from you *PAL* list to your conference.

After you have dragged all the names of users that you want to invite, click your mouse on the Send button. *PAL*, in turn, will add any user to the conference who responds to your invitation and they will receive all messages that the members of the conference send.

1001 Internet Tips

Figure 312.2 The Invite to Conference and PAL windows.

Editing and Removing Names from Your PAL List 313

You can edit or even remove a name from your list of friends or co-workers in your *PAL* program window. To remove or edit a name, right click your mouse on the name you wish to change. *PAL*, in turn, will display the short cut menu shown in Figure 313.1.

Figure 313.1 The short cut menu to edit or remove a name from PAL.

If you click your mouse on the Edit menu item, *PAL* will display the Edit Person Name dialog box shown in Figure 313.2.

Figure 313.2 The Edit Person Name dialog box.

You can use the Edit Person Name dialog box to change the name *PAL* displays in the *PAL* program window and to change the e-mail address *PAL* uses to identify a *PAL* user. You can use the Remove menu item in the short cut menu, shown in Figure 313.1, to remove the highlighted name from your *PAL* window. If you remove a name from the *PAL* window, that person can still send you a message, however, you will not see their name in your *PAL* program window.

314 Taking a Break from PAL Without Exiting the PAL Program

You can show yourself as being off-line or as being away when other users try to send you a message by changing your *PAL* status. To change your *PAL* status, click your mouse on the status indicator in the *PAL* program window. *PAL*, in turn, will display the *PAL* status short cut menu, shown in Figure 314.1.

Figure 314.1 The status short cut menu.

If you click your mouse on the I am hidden menu item, you will appear to be off-line to other users. If you pick the I am away menu item, you will be able to display a message to all users that you are away but you will still show as online in other users' *PAL* program window. If a user sends you a message when you are away, the user sending the message will see the dialog box shown in Figure 314.2.

Figure 314.2 The message users get when you are in away status in **PAL**.

The user then has the choice of sending the message to you anyway or sending you an e-mail.

1001 Internet Tips

Understanding Online Chatting 315

Across the Internet, users chat online about any and all topics imaginable. To chat, users get together in virtual rooms within which the users type messages that appear instantly to all members of the chat. To participate within a chat, you must first run chat software. Then, you must select a chat server which, in turn, will display a list of thousands of chat rooms you can join and start chatting with others. In the past, chat programs were pretty simple. As discussed, to chat, a user simply types a line of text and then presses ENTER. The chat software, in turn, makes the user's line of text immediately visible to all users within the chat room.

To help you start chatting, Windows 98 provides the Microsoft Chat software, shown in Figure 315. Unlike older chat programs that simply displayed each user's name (or chat nickname), Microsoft Chat lets you select a cartoon character to represent you within the chat. Other users within the chat room that are running Microsoft Chat will see your characters and the expressions you select. Several of the Tips that follow will examine Microsoft Chat online.

Figure 315 Chatting online with Microsoft Chat.

Using Microsoft Chat to Chat Online 316

In the previous Tip, you learned that Windows 98 provides Microsoft Chat software that you can use to chat with other users online. To start the Microsoft Chat software, perform the following steps:

1. Click on the Start menu Programs option and choose Internet Explorer. Windows 98, in turn, will cascade the Internet Explorer submenu.

2. On the Internet Explorer submenu, click your mouse on the Microsoft Chat option. Windows 98, in turn, will start the Microsoft Chat program's Chat Connection dialog box, as shown in Figure 316.

1001 Internet Tips

Figure 316 Microsoft Chat's Chat Connection dialog box.

If your Internet Explorer submenu does not include the Microsoft Chat option, you can install the software from the Windows 98 CD-ROM by performing the following steps:

1. Click your mouse on the Start menu. Next, move to Settings and choose Control Panel. Windows 98, in turn, will open the Control Panel window.
2. In the Control Panel window, double-click your mouse on the Add/Remove Programs icon. Windows 98, in turn, will open the Add/Remove Programs Properties dialog box.
3. In the Add/Remove Programs Properties dialog box, click your mouse on the Windows Setup tab. Windows 98, in turn, will display the checkboxes for the Windows 98 components.
4. In the component list, select the Communications item and then click your mouse on the Details button. Windows 98, in turn, will display the Communications dialog box.
5. In the Communications dialog box, click your mouse on the Microsoft Chat 2.5 checkbox to place a checkmark in the box. Then, click your mouse on the OK button.
6. In the Add/Remove Programs Properties dialog box, click your mouse on the OK button. Windows, in turn, will copy the appropriate files to your hard disk to run Chat.

317 SELECTING A CHAT SERVER

When your browser connects to a remote site, your browser actually connects to a Web server at the remote site, which sends information to your browser. Likewise, when you use the FTP command to connect to a remote site, you actually connect to an FTP server which lets you upload and download files. Similarly, before you can chat with other users, you must connect to a chat server. After you select a chat server, your server will display a list of the Chat rooms you can join. To select a chat server, click your mouse on the Chat Connection dialog box drop-down server list and select the server to which you wish to connect.

If the Chat Connections dialog box is not currently visible, click your mouse on the Room menu Connect option to display the dialog box.

CUSTOMIZING YOUR PERSONAL INFORMATION WITH CHAT — 318

As briefly discussed in Tip 315, "Understanding Online Chatting," users will enter chat rooms to discuss a myriad of topics. Before you join such chats, you may want to change the personal information other users in the chat room can view about you. That way, other users in the chat room cannot determine your true identity. To change your personal information in Microsoft Chat, perform the following steps:

1. Within the Chat Connection dialog box, click your mouse on the Personal Info tab or click your mouse on the View menu and choose Options. Microsoft Chat, in turn, will display the Personal Information dialog box, as shown in Figure 318.

Figure 318 Microsoft Chat's Chat Connection dialog box with the Personal Info tab selected.

2. Within the Personal Information dialog box, you may want to change your name and e-mail address. In the Nickname field, type in the name by which users will reference you in Chat and then click your mouse on the OK button.

SELECTING YOUR COMIC PERSONALITY — 319

In Microsoft Chat, you can select a comic personality that will represent you in the Chat room. For example, Figure 319.1 shows a Microsoft Chat session with multiple comic characters.

To select the comic personality that will represent you in Chat, perform the following steps:

1. Within the Chat Connection dialog box, click your mouse on the Personal Info tab or click your mouse on the View menu and choose Options. Microsoft Chat, in turn, will display the Microsoft Chat Options dialog box.

1001 Internet Tips

Figure 319.1 The Microsoft Chat comic personalities.

2. Within the Microsoft Chat Options dialog box, click your mouse on the Character tab. Microsoft Chat, in turn, will display the Character sheet, as shown in Figure 319.2.

Figure 319.2 The Microsoft Chat Character sheet.

3. On the Characters sheet character list, click your mouse on the name of the character that you would like to use. As you click your mouse on a character's name, Chat will display the character's appearance within the dialog box. After you select the character that you would like to use, click your mouse on the OK button.

After you select the character you would like to use, you can also check the background you would like Chat to display for the room. To select a background image, perform the following steps:

1. Within the Chat Connection dialog box, click your mouse on the Personal Info tab or click your mouse on the View menu and choose Options. Microsoft Chat, in turn, will display the Microsoft Chat Options dialog box.

1001 Internet Tips

2. Within the Microsoft Chat Options dialog box, click your mouse on the Background tab. Microsoft Chat, in turn, will display the Background sheet, as shown in Figure 319.3.

Figure 319.3 The Microsoft Chat Background sheet.

3. On the Background sheet's Background list, click your mouse on the name of the background that you would like to use. As you select a background, Chat will display the background's appearance within the dialog box. After you select the background that you would like to use, click your mouse on the OK button.

Note: *If your Microsoft Chat Options dialog box does not have a Character or Background tab, select the View menu Comic Strip option.*

IGNORING A SPECIFIC USER IN A CHAT ROOM 320

If you participate in online chats, you will eventually encounter users who speak their mind on a variety of topics. If you find that a user's comments are offensive or simply a waste of your time, you can direct Microsoft Chat to ignore a the user by performing the following steps:

1. Within the chat room's member list, right-click your mouse on the user you want to ignore. Windows 98, in turn, will display a pop-up menu.
2. Within the pop-up menu, click your mouse on the Ignore option.

In a similar way, there may be times within a chat that a user simply bombards the discussion with a flurry of messages. To direct Chat to discard such message flurries, perform the following steps:

1. Click your mouse on the Microsoft Chat View menu and choose Options. Microsoft Chat, in turn, will display the Microsoft Chat Options dialog box.
2. In the Microsoft Chat Options dialog box, click your mouse on the Automation tab. Microsoft Chat, in turn, will display the Automation sheet, as shown in Figure 320.

1001 Internet Tips

Figure 320 The Automation tab in the Microsoft Chat program.

3. Within the Automation sheet, click your mouse on the Auto ignore enabled checkbox to place a checkmark in checkbox. Use the Message Count field to set the number of messages you consider excessive. In the Interval field, specify the time interval in which Chat should apply your message count. When you are finished configuring Chat options, click your mouse on the OK button to close the dialog box.

321 WHISPERING TO OTHER USERS IN A CHAT

As you chat with a group of users online, there may be times when you want to whisper to a specific user. In other words, you want to monitor the chat room's current discussion while you talk to another user (so that only that user can read your messages). To whisper to another user, perform the following steps:

1. In the chat room's member list, right-click your mouse on the user to which you would like to whisper. Chat, in turn, will display the Context menu.

2. Within the Context menu, click your mouse on the Whisper Box option. Chat, in turn, will display a Whisper Box, like the one shown in Figure 321.

Figure 321 Using a Whisper Box to chat with a specify user.

3. Within the Whisper Box, you can type messages to just the selected user without posting the message to the entire group.

Using Message Macros to Send Common Messages 322

As you chat online, you will find that there are many phrases you repeatedly type, such as "That was hilarious," or "I'm from Montana." Rather than having to continually re-type such text, Microsoft Chat lets you define a message macro that contains the text. Later, you can press the keyboard combination you associate with the macros and Chat will send the corresponding text. To create a message macro, perform the following steps:

1. Click your mouse on the Microsoft Chat View menu and choose options. Chat, in turn, will open the Microsoft Chat Options dialog box.
2. In the Microsoft Chat Options dialog box, click your mouse on the Automation tab. Chat, in turn, will display the Automation sheet as shown in Figure 322.

Figure 322 Creating macros using Chat's Automation sheet.

3. In the Automation sheet's Macro area, click your mouse in the text field near the bottom of the dialog box and type the message text you wish to automate.
4. In the Automation sheet's Name field, type a name that describes your macro text.
5. Next, click your mouse on the Key combination drop-down list to select a key combination to associate with the macro text.
6. Click your mouse on the Add Macro button.
7. When you are finished creating your macro, click your mouse on the OK button to close the Microsoft Chat Options dialog box.

You are now ready to use the macro combination whenever you like within a chat dialog.

1001 Internet Tips

323 Participating in Multiple Chats

As you have learned, to join a chat within Microsoft Chat, you simply enter a chat room. As it turns out, Chat lets you participate in more than one chat at a time. Actually, you only chat in one room at any time, but you can move from room to room easily and quickly. When you take part in multiple chats, Microsoft Chat will display a tab upon which you can click your mouse to move to that chat's discussion, as shown in Figure 323.

Figure 323 Taking part in multiple chats at the same time.

To open multiple chat rooms, you simply enter each room, one at a time, by performing the following steps:

1. Click your mouse on the Microsoft Chat Room menu and choose Room List. Chat, in turn, will display the Chat Room List dialog box that lists the available chat rooms.
2. Within the Chat Room List dialog box, click your mouse to select the room you would like to enter and then click your mouse on the Go To button. Chat, in turn, will enter you into that chat.

324 Changing Your Chat Expression

As you send messages in Microsoft Chat, you want to change your expression to reflect emotion and match the flow of the conversation. To change your comic character's expression in Chat, click your mouse on the facial expression you desire in the table of facial expressions that Chat displays at the lower right hand side of your window. As you click your mouse on a specific expression, Chat will immediately change your character's expression to match your choice.

Figure 324 By changing your expression, you can add more emotion to your Chat conversations.

1001 Internet Tips

ENTERING AND LEAVING CHAT ROOMS 325

A Chat server will normally list thousands of chat rooms that you can enter. To display the chat room list, click your mouse on the Room menu and choose the Room List option. Chat, in turn, will display the Chat Room List dialog box that lists the available chat rooms, as shown in Figure 325.

Figure 325 The Chat Room dialog box listing available chat rooms.

To join a chat room, click your mouse on the Chat Room List to select the room you would like to enter, and then click your mouse on the Go To button. Chat, in turn, will enter you into that chat. To leave a chat room, you can click your mouse on the Room menu and choose the Leave Room option.

CREATING YOUR OWN CHAT ROOM 326

In Microsoft Chat, you might want to create your own chat room. Once you have created a room, you can then invite others to join you in the newly created room. Further, you can restrict your chat room to be, in essence, an invitation-only chat room. To create your own chat room, perform the following steps:

1. Click your mouse on the Room menu and choose the Create Room option. Chat, in turn, will open the Create Chat Room dialog box, as shown in Figure 326.
2. In the Create Chat Room dialog box, use the Chat room name field to name your chat room and use the Topic text box to describe the topic for your newly created room.
3. You can use the set of checkboxes and fields at the bottom of the dialog box to control and administer your chat room, including setting the chat room to be invitation-only.
4. When you have finished configuring your new chat room, click your mouse on the OK button to close the Create Chat Room dialog box.

Note: *In Chat, you can join multiple chat rooms at the same time. When you join multiple chats, Microsoft Chat will display tabs in the Chat window that you can use to move from one chat to the next. See Tip 323, "Participating in Multiple Chats."*

1001 Internet Tips

Figure 326 The Create Chat Room dialog box.

327 SELECTING CHAT'S TEXT VIEW

Although the Comic Chat is entertaining, its performance is relatively slow. Comic Chat is the default mode for Microsoft Chat. In a busy chat room, users can exchange 100 messages per minute—meaning heavy traffic. Because of the heavy traffic, you might find that Comic Chat simply cannot keep up. If Comic Chat does not perform adequately, you can switch to Chat's text mode. In text mode, Chat displays each user's message as a line of text, as shown in Figure 327.

Figure 327 Using Chat's text mode to display chat messages in a chat.

To switch to Microsoft Chat's text mode, simply click your mouse on the View menu and choose the Plain Text option. If you decide later that you want to switch back to Comic Chat, click your mouse on the View menu and choose the Comic Strip option.

Viewing a User's Identity in Chat — 328

In Chat, each user has a nickname that appears within the Chat window. Using nicknames, Chat users can maintain some degree of anonymity. As you chat however, there may be times when you will want to know more about a user, such as a user's e-mail address or a user's real name.

To display a Chat member's profile (Chat will display the profile as text within the Chat window), right-click your mouse on the user's name in Chat's list of users and then select Display Profile from the Context menu. To display a user's e-mail address, right-click your mouse on the user's name in the list of users and choose Get Identity from the Context menu.

Note: *Just as you can use these techniques to display information about other users, other users can use the same techniques to display information about you. You may want to customize your personal information, as described in Tip 318, "Customizing Your Personal Information with Chat," to maintain your own anonymity.*

Understanding ICQ — 329

ICQ, I Seek You, is a multi-purpose communication program that you can use for communicating on the Internet. You can use the ICQ program to send messages, chat, send files, start network programs like Internet Phone or games, just to name a few of the options. ICQ will also let any user on the Internet, even a user who is not an ICQ user, contact you and send you messages. When you register with ICQ, ICQ will give you a unique identifier which it uses to let others on the Internet find you and communicate with you when you are online or leave you a message when you are not online. One function of ICQ is to notify you if other users that you communicate with are online at the same time that you are online. After ICQ notifies you that other users are online you can communicate, work, and play with them.

Installing ICQ — 330

The ICQ software is a shareware program that is free for the time being. The Beta program of ICQ, which is also the free version of the program, is on the CD-ROM that accompanies this book and is being distributed without charge, but the makers of ICQ may start charging for the program in the future. To quote the ICQ developers: for the time being, enjoy. To install the program, perform the following steps:

1. Start the install by placing the companion CD-ROM in your CD-ROM drive and clicking your mouse on the Start menu. Next, click your mouse on the Run command. Windows, in turn, will display the Run dialog box.

2. In the Run dialog box, type *D:\icq\icq99a.exe*. Replace the letter D with the letter of your CD-ROM. Then, click your mouse on the OK button. The ICQ installation program, in turn, will display the license agreement screen, as shown in Figure 330.1.

Figure 330.1 The opening screen of the ICQ installation program.

3. Read the license agreement and if you agree with its content, click your mouse on the Continue button. The ICQ installation program, in turn, will display the License Notice dialog box.
4. If you agree with all the statements in the dialog box, click your mouse on the I Agree button. The ICQ installation program, in turn, will display the Welcome screen and the Installation Confirmation dialog box.
5. If you want to install the ICQ software, click your mouse on the Next button. The ICQ installation program, in turn, will display the Select Destination Directory Dialog Box. The default directory that the ICQ installation program suggests should work for most installations.
6. Click your mouse on the Next button. The ICQ installation program, in turn, will display the Add items to Windows Program Groups dialog box.
7. Select the yes radio button and then click your mouse on the Next button. The ICQ installation program, in turn, will display the Select Program group dialog box.
8. The default used by ICQ should work for most installations. Click your mouse on the Next button. The ICQ installation program, in turn, will display the Multi-Lingual Message Text Support dialog box.
9. Within the Multi-Lingual Message Text Support dialog box, select the radio button that best describes your computer system and click your mouse on the Next button. If you find that you need to change this option later, you can do so in the ICQ Preferences Dialog Box. The ICQ installation program will copy files to the destination directory you specify and then display an Install/Update Complete informational box.
10. Within the informational box, click your mouse on OK. The ICQ installation program will display the Installation Complete Message Box. The message box is also informing you that the installation program may need to convert some of the ICQ files if you are updating from an older version of ICQ.

1001 Internet Tips

11. Click your mouse on the OK button. The ICQ installation program will now start the Registration Wizard, as shown in Figure 330.2.

Figure 330.2 The Registration Wizard opening screen.

12. If you are using ICQ for the first time, you should select the New ICQ# radio button which will step you through the Registration process. Then, click your mouse on the Next button to start the Registration Wizard. The ICQ Registration Wizard, in turn, will display the User Type Registration dialog box.

13. Select the method that you use to connect to the Internet, then click your mouse on the Next button. The ICQ Registration Wizard, in turn, will display an Entering Info Warning Message.

14. Read the message, then click your mouse on the OK button. The ICQ Registration Wizard, in turn, will display a dialog box asking for your user type, e-mail address, nickname, first name, and last name. You can ask that your e-mail address not be published in the ICQ directory.

15. After you complete all the information in this dialog box, click your mouse on the Next button. The ICQ Registration Wizard, in turn, will display another dialog box that asks more personal information about you.

16. You can fill in as much information as you wish, or you do not have to provide any of the information. After you complete this dialog box, click your mouse on the Next button. The ICQ Registration Wizard, in turn, will ask you if you would like to participate in a survey.

17. After you have finished with the survey dialog box, click your mouse on the Next button. The ICQ Registration Wizard, in turn, will display the password dialog box.

18. You should type in a password that you can remember and then confirm the password. The ICQ Registration Wizard, in turn, will ask you to pick which privacy level you would like to use for your ICQ program.

19. If you would like any user to be able to contact you, then you should use the Anyone may contact me and see when I'm online radio button. If you want to be more specific about who may contact you, use the My authorization is required radio button. You can also select whether or not to publish on the World Wide Web if you are online and whether or not to publish with the IP address you are currently connected to the Internet. After you complete this dialog box, click your mouse on the Next button. The ICQ Registration Wizard, in turn, will display your ICQ #.

20. Write down your ICQ#. (You can give your ICQ# to other users so they can easily find you in the ICQ directory.) Then, click your mouse on the Next button. The ICQ Registration Wizard, in turn, will display the Confirm your outgoing e-mail server dialog box.

21. You should confirm that your e-mail server is correct in this dialog box and click your mouse on the Next button. The ICQ Registration Wizard, in turn, will display the Completion dialog box which will give you information about successfully registering yourself with the ICQ network.

22. After you read the information in the Completion dialog box, click your mouse on the Done button.

You are now ready to use the ICQ program. The ICQ program can operate in two modes: the simple mode and the advanced mode. (See Tip 345 "Understanding the ICQ Program Advanced mode.") You should start using ICQ in the simple mode. After you get comfortable with the ICQ program in the simple mode, you should start to work with the program in the advanced mode.

331 STARTING ICQ

When you first start your computer, the ICQ program will just be a flower icon in the system tray, the area on the task bar next to the time. If you are online, the icon will be green, as shown in Figure 331.1, and if you are off-line, the icon will be red.

Figure 331.1 The system tray icon for ICQ.

To start using the ICQ program, double-click your mouse on the flower icon, as shown in Figure 331.1, or start the ICQ program from the Start Menu. The ICQ program, in turn, will display the ICQ program window as shown in Figure 331.2.

Figure 331.2 The ICQ program window.

The ICQ program window will float on top of all other windows so that it is visible even when you are working in some other program. You can have the ICQ program window return to an icon in the system tray by clicking your mouse on the Minimize button in the upper right corner of the window. If you click your mouse on the Close button, the X, you will close the ICQ program and the flower icon will not be displayed in the system tray. To restart the ICQ program, click your mouse on the Start menu, choose the program submenu, then choose the ICQ submenu, and click your mouse on the ICQ program icon. The ICQ program, in turn, will load and display the

1001 Internet Tips

ICQ program and it will connect to the ICQ system. The ICQ program should start by default when you turn your computer on but you can also start the ICQ program by using the Start menu as you would start other programs.

Adding Users to Your ICQ List — 332

After the ICQ program is running on your computer, you must add users to your list of people with whom you will communicate. If you click your mouse on the Add Users button, shown in 332.1, the ICQ program will display the Find/Add users to your list dialog box.

Figure 332.1 The Add Users button in the ICQ program window.

The find/add users dialog box has four different ways that you can search for a user to add to your ICQ list. As shown in Figure 332.2, the Find/Add Users to your list dialog box has three separate sections.

Figure 332.2 The Add User dialog box.

You use the first section to find users that you know. You use the second section to find a user to chat with at random or to invite a person to start using ICQ. You use the last section to start the ICQ Help.

1001 Internet Tips

The ICQ program gives you several ways to locate a user you know who uses ICQ. If you know the e-mail address the user is using in his or her ICQ directory settings, you can search for the e-mail address. If you know the nickname the user is using in his or her ICQ directories, you can search for his or her nickname. You can also search for the first and last name of the user using the ICQ program. The easiest way to find an ICQ user is by ICQ number. If a user gives you his or her ICQ number, you can use it to search for the user.

You may find that a user must first authorize you in order for you to add the user to your ICQ list. If the user must authorize you, the ICQ program will display an Authorization Request dialog box. In the Authorization Request dialog box, you can type a short message and send the request to the user. If the user that you are trying to add is online, he or she can send you an approval message and the ICQ program will add the user to your list.

After you add a new user, the ICQ program displays the User has been added dialog box and lets you place the user you have added into an existing group or into a new group it lets you name. The ICQ program pre-defines the group names as friends, family, co-workers, and general. You can also create your own groups by clicking your mouse on the group headings. The ICQ program will cascade a menu from which you can choose Create New Group. The ICQ program will alert you when a user on your list is online and you will be able to easily communicate with the user.

The Random Chat Partners option enables you to chat with an ICQ user picked at random from a list of ICQ users who want to participate in a random chat. If you want to be available for someone to randomly chat with you, you must select this option. You set the option to make yourself available for random chats in the advanced mode of ICQ, where you will be able to set your online status as available for a random chat. You can use the Invitation Wizard to notify other users about ICQ so that you can communicate with them. The last section in the Add Users dialog box provides a hyperlink that lets you use the ICQ online Help.

333 CHANGING THE ICQ PROGRAM WINDOW DISPLAY

The ICQ program gives you two controls you can use to set the display of users on your list within the ICQ program window. The first control is the Online/All display control in the upper left-hand corner of the ICQ program window, as shown in Figure 333.1.

Figure 333.1 The Online/All button in the ICQ program window.

The Online/All display control will display either only the users in your list that are online or it will display all the users in your list. In Figure 333.1, the All option is selected. If you click your mouse on the All button, the ICQ program will change to the Online option where it will display only the users in your list who are online.

1001 Internet Tips

The second control is the User/Groups display control, as shown in Figure 333.2, that controls in what order the ICQ program displays the users in your list.

Figure 333.2 The User/Groups button in the ICQ program window.

Figure 333.2 shows the group display. In the group display, the ICQ program orders the users on your list by the group settings that you assigned to the users when they were added to your list. If you click your mouse on the User/Groups button, the ICQ program will display the user display, as shown in Figure 333.1.

SENDING A MESSAGE TO A USER ON YOUR LIST 334

After you have added users to your ICQ list, you can send the users a message by clicking your mouse on the user's name in the ICQ program window. The ICQ program, in turn, will display a menu of options, as shown in Figure 334.1.

Figure 334.1 The menu displayed after you click your mouse on a user in the ICQ program window.

Select the Message option in the menu shown in Figure 334.1. The ICQ program, in turn, will display the Message dialog box, as shown in Figure 334.2.

After you type your message in the text area, click your mouse on the Send button to send your message to an ICQ user. You can send a message to an ICQ user even when he or she is off-line. When you send a message to an ICQ user who is off-line, the user will receive the message the next time he or she connects to ICQ.

Figure 334.2 The Message dialog box.

335 SENDING AN ICQ USER A WEB PAGE ADDRESS (A URL)

You can send the link to a Web page at which you are looking to an ICQ user on your ICQ user list. Click your mouse on the user's name; the ICQ program, in turn, will display the Send menu. To send the URL address of the Web page your browser is displaying, click your mouse on the Web Page Address (URL) option. The ICQ program, in turn, will display the Send URL message dialog box, shown in Figure 335.

Figure 335 The Send URL message dialog box.

As with sending messages, you can send a URL to an ICQ user even if the ICQ user is off-line. The send Web Page Address option is an easy way to send a new or interesting Web page that you have found to your friends that are using ICQ.

336 CHATTING WITH USERS ON YOUR ICQ LIST

You can start a chat session with other users on your ICQ list. Click your mouse on a name in your ICQ list. The ICQ program, in turn, will display the Send menu from which you chose the ICQ Chat option. The ICQ program, in turn, will display the Send Chat Request dialog box, as shown in Figure 336.

Figure 336.1 The Send Chat Request dialog box.

As with sending messages and URLs, you can send a chat request to a user who is off-line. If you send a chat request to an off-line user, the ICQ program will store your chat request in your outbox for the ICQ program and will send it the next time the user and you are both online. If the user to whom you are sending the chat request is online when you send the request, you can start a chat session at that time. The two styles of chat that you can use with ICQ are the traditional chat style, called IRC (Internet Relay Chat) mode or the talk style of chat, called split mode. In the traditional style of chat, a line of your text appears in the chat screen and then a line of text from another person with whom you are chatting appears on the chat screen. In the talk style of chat, the chat screen is split into two halves; the upper half is where you type your text and the bottom half is where the text from the user who you are chatting with will appear. You can use the button shown in Figure 336.2 to switch from one style of chat to the other style of chat.

Figure 336.2 The talk style of the ICQ chat screen.

1001 Internet Tips

337 Viewing and Changing Information about Users on Your ICQ List

The last three items on the Send menu, as shown in Figure 337, let you view information about the ICQ user whose name you clicked, change the user's display name on your list, and delete the user from your list.

Figure 337 The Send menu for the ICQ program.

Use the Info option to view information about the user you have selected. The information the ICQ program displays about the user is only what the user chose to have displayed, so for some users there may be a lot of information and for some users there may be none at all. The Rename option will change the username that the ICQ program displays in your list. Changing the user's display name in your list does not change the user's name; it just changes what name the ICQ program displays in your list for that user. The Delete option does as the name suggests. It will delete the user from your list. If the user whom you delete has added you to his or her list, he or she will still be able to send you messages.

338 Changing Your Online Status

You can use the Status button in the ICQ program window to switch between being online and off-line. When you click your mouse on the Online status button, the ICQ program, in turn, will display the Status menu, as shown in Figure 338.

Figure 338 The online Status menu.

The Status menu has two options: Available/Connect and Offline/Disconnect. If you select Offline/Disconnect, the ICQ program will disconnect you from the ICQ network and the Status button at the bottom of the ICQ program window will display a Disconnected status. You will no longer get the status of users in your list. When you are off-line, you are not visible to other ICQ users. They will see you as off-line. When you are off-line, you can click your mouse on the Disconnected status button and the ICQ program will display the status menu from which you can choose Available/Connect to place yourself online again.

UNDERSTANDING THE ICQ SYSTEM MENU 339

You can use the ICQ System menu, shown in Figure 339.1, to jump quickly to information about yourself and about ICQ on the World Wide Web, as well as to invite others to join you online with ICQ.

Figure 339.1 The System menu.

You can use the Invitation to Join ICQ option to tell other users about the ICQ program. When you click your mouse on the Invitation to Join ICQ option on the System Menu, the ICQ program will display the Invitation to Join ICQ dialog box, shown in Figure 339.2.

In the Invitation to Join dialog box enter the e-mail address of a user that you want to send the invitation to and click your mouse on the Send Invitation button. You can use the Add a personal message button to add a message to the invitation so the user you are inviting will have more information about who you are and why you are inviting them to join ICQ. When the user gets the invitation, he or she can go to the ICQ home page on the World Wide Web, download the ICQ program, and register with ICQ. After the user registers with ICQ, you can use ICQ to communicate with each other.

The World Wide Pager provides the means for users that do not have ICQ to contact you using the ICQ network. The World Wide Pager section of the System menu is used for people to communicate with you by using a Web browser instead of the ICQ program. Use the Send My ICQ Four Addresses button to send four addresses that someone can use to contact you. The first address is your ICQ#. Another user who uses ICQ can contact you by using your ICQ#; that user would just need to add you as a user in his or her ICQ list. The second address that another user can use to contact you is your Personal Communication Center Web page. Your Personal Communication Center Web page has information

about you and a section where a user can send a message to your ICQ session by using the Web page rather than using an ICQ program. The user who wants to contact you would just need to go to your Personal Communication Center Web page and fill in the Web form to send you a message. The third address that someone can use to contact you is your E-mail Express e-mail address, which is *ICQ#@pager.mirabilis.com*. E-mail Express is a service that ICQ provides for users to contact you if they have e-mail but do not have the ICQ program. When a user sends an e-mail to your E-mail Express e-mail address, you get the message through your ICQ program. The last ICQ address that you have is your ICQ home page. You set up your ICQ home page in the ICQ advanced mode. Until you set up your ICQ home page, the ICQ system will direct users who visit your home page address back to your ICQ Communication Center page. The second option under the World Wide pager, View My Communication Center, lets you view your Personal Communication Center page on the World Wide Web.

The Web section of the System Menu lets you connect to several Web pages that deal with the ICQ program or the ICQ network. You can view the ICQ home page, what is new in the ICQ network, or the status of the ICQ network at the time you select the ICQ Network Status option. You can also view ICQ message boards, which are the ICQ version of newsgroups. You will find many topics being discussed on ICQ message boards. The Web section of the System Menu will take you to many of the ICQ Web pages instantly.

Figure 339.2 The Invitation to Join ICQ dialog box.

340 UNDERSTANDING THE ICQ MENU

You can control many of the ICQ program settings with the ICQ menu options. You access the ICQ menu by clicking your mouse on the ICQ button, as shown in Figure 340.

Figure 340 The ICQ menu.

1001 Internet Tips

From the ICQ menu, you can send invitations to other users to use the ICQ network as well as configure settings dealing with your personal ICQ user on your computer and how the ICQ program itself is configured. The ICQ menu is where you will do most of your configuration of the ICQ program after you have installed the program.

Using the ICQ Invitation Wizard 341

The ICQ Invitation Wizard helps you invite other users to use ICQ to communicate. You can start the Invitation Wizard by clicking your mouse on the ICQ menu, then clicking your mouse on the Invitation Wizard. The Invitation Wizard will search through your Windows e-mail Address Books as well as any other e-mail address book programs you have configured on your computer to find e-mail addresses of people to whom you can send invitations to use the ICQ program. You can also use the Invitation Wizard to invite a single person or to search for an e-mail address in one of the Internet e-mail directory services, such as the Bigfoot Internet directory. After you have a valid e-mail address, you can send the invitation to use ICQ as discussed in Tip 339, "Understanding the ICQ System Menu."

Using the Add/Change Current User Sub-Menu 342

The Add/Change Current User sub-menu provides options for configuring many aspects of an ICQ user's information, as shown in figure 342.

Figure 342 The Add/Change Current User sub-menu in the ICQ program.

The My Info section of the Add/Change Current User sub-menu has three options: View/Change My Details, Publicize in White Pages, and Publicize in Web Directories. You select the View/Change My Details option to change what information is displayed about you in the ICQ directory. You select the Publicize in White Pages and Publicize in Web Directories if you want information about you listed in various Internet directories, such as the Bigfoot Internet directory.

The My Computer section of the Add/Change Current User sub-menu has the following three options: Change the Active User, Add Another Registered User, and Remove ICQ# From Computer. The Change the Active User option

1001 Internet Tips

is used to switch who is listed with the ICQ system as being online from your computer. The Add Another Registered User option is used to have more than one user be able to use ICQ from your computer. The Remove ICQ# From Computer option is used to remove an ICQ user from your computer.

The ICQ Network Registration section of the Add/Change Current User sub-menu has the two following options: Register A New User (ICQ#) and Unregister Existing User. The Register A New User option is used to register a new user to the ICQ network. The Unregister Existing User option removes you from the ICQ network, not just the computer that you are working on at the time.

343 USING THE SECURITY AND PRIVACY DIALOG BOX

The Security and Privacy menu option in the ICQ menu will display the Security and Privacy dialog box, as shown in Figure 343. The Security and Privacy dialog box lets you configure who can communicate with you using ICQ and who and what the ICQ program will filter out when you are online working with the ICQ program.

Figure 343 The Security and Privacy dialog box.

Within the Security dialog box, you use the Security tab to configure several security settings in the ICQ program. On the Security tab, you can use the My authorization is required option button to require ICQ users to get your authorization before they can add your name to their list of ICQ users with whom they communicate. You can use the Change Password section of the Security tab to change your password. Within the Security Level section of the Security tab, you can set password usage requirements, as shown in Figure 343. Other options you can set on the Security tab are whether the ICQ program will display your IP address and online status on the ICQ Web pages.

Within the Security and Privacy dialog box, you use the Ignore List tab to list users from whom you do not want to receive messages any more. When you put a user on the Ignore List, the ICQ program will no longer show that you have received a message from that user. You can put a user on the Invisible List so that the user can no longer tell if you are online.

Within the Security and Privacy dialog box, you use the Visible List tab to let some users see that you are online even if you have yourself in invisible mode. You use the Words List tab to specify objectionable words the ICQ program should not display in ICQ messages. The ICQ program can replace words listed in the Words List with symbols or not display them at all.

1001 Internet Tips

Using the ICQ Preferences Dialog Box 344

The Preferences option on the ICQ menu will display the Preferences dialog box, shown in Figure 344. The Preferences dialog box has various tabs you can use to configure how your ICQ program will respond to events and what actions the ICQ program will perform.

Figure 344 The Preferences Dialog box.

The Contact List tab lets you configure the display of the ICQ program window on your system. You can configure such things as whether the window floats on top of other active windows and the order in which the ICQ program displays the users in your list. The Events tab lets you configure how the ICQ program will respond to events such as chat requests from other users. The Status tab lets you configure the message that the ICQ program will display when you are away from your computer and the amount of time that your computer is idle before you go into away status. Within the Accept tab, you can configure the directory on your hard drive the ICQ program will place files that you receive from other users. The Email tab lets you configure your ICQ program to work as an e-mail client. The Check Email tab lets you configure the ICQ program to check if you have e-mail waiting for you on your e-mail server and to notify you of any e-mail that you may have on the server. The Internet Telephony/ Games/ Chat tab lets you configure ICQ to work with other Internet programs, such as Microsoft's *Netmeeting* or Id Software's *Quake*. The Servers tab lets you configure which ICQ servers your ICQ program will connect to when you are using the ICQ program. The Connections tab lets you configure how and when the ICQ program will connect to an ICQ server. The Plugins tab lets you configure other programs (usually developed by third party vendors) that work within the ICQ program but are not part of the ICQ program.

Understanding the ICQ Program Advanced Mode 345

The ICQ program works in two modes: simple mode and advanced mode. You have been working with the simple mode of the ICQ program in each of the previous ICQ Tips. You can activate the advanced features of the ICQ program from the ICQ program window by clicking your mouse on the To Advanced Mode button. The To Advanced Mode button is visible when you are in Group display mode, which was discussed in Tip 333, "Changing the ICQ Program Window Display." If the To Advanced Mode button is not visible, you can switch to the advanced mode from either the ICQ menu or the System menu by clicking your mouse on the Advanced Features option. Advanced mode enables you to access many ICQ features that are not available under simple mode. When you

switch to advanced mode, the ICQ program may display the Simple / Advanced Mode Selection dialog box, shown in Figure 345, asking you to confirm that you are switching modes.

Figure 345 *The ICQ Mode Change dialog box.*

If you check the Don't remind me to switch to Advanced Mode checkbox in the lower left-hand corner, the ICQ program will not display the Simple / Advanced Mode Selection dialog box when you switch modes in the future. After you have switched to advanced mode, the ICQ program expands many of the menus. Also, after you have switched to advanced mode, the ICQ program changes all the options to switch to advanced mode to options to switch to simple mode so that you can switch back to simple mode if you wish.

Simple mode has fewer options to remember so it is a good mode to start with as you are learning the ICQ program. As you become more comfortable with the ICQ program, you may want to make use of the advanced mode features in the ICQ program.

346 USING THE ICQ WEB SEARCH BOX IN ADVANCED MODE

You can use ICQ to search for information on the Internet. In the advanced mode of the ICQ program, you can use the Web Search Panel, shown in Figure 346, to quickly search the World Wide Web using a keyword.

Figure 346 *The ICQ program Web Search Panel.*

1001 INTERNET TIPS

To start a Web search, type your search keywords in the Web Search Panel textbox and click your mouse on the Go button. If your Web browser is not running when you start a search, the ICQ program will start the browser and display the results of your search. When you click your mouse on the arrow on the right hand side of the Web Search Panel, the ICQ program will display a menu of search options. You can also float the Web Search Panel on your Desktop, independent of the ICQ program, by clicking your mouse on the button with the three dots on the left hand side of the Web Search Panel.

USING THE ICQ NOW BUTTON 347

You can use the ICQ Now button, shown in Figure 347.1, to quickly access information about ICQ topics, such as music, sports, news, and many other topics.

Figure 347.1 The ICQ Now button.

When you click your mouse on the ICQ Now button, the ICQ program opens the ICQ Now window, as shown in Figure 347.2. The ICQ Now feature is separate from your Web browser so your Web browser will not start when you click your mouse on the ICQ Now button.

Figure 347.2 The ICQ Now window.

348 THE ADVANCED MODE USER MENU

The advanced mode user menu has many options for communicating and collaborating with other ICQ users. You learned in Tip 334, "Sending a Message to a User on Your List," and Tip 335, "Sending an ICQ User a Web Page Address (a URL)," that when you click your mouse on a name in your ICQ user list, you can send that user a message or Web URL. In advanced mode, when you click your mouse on a user in your ICQ list, the ICQ program displays an enhanced menu of options, as shown in Figure 348.

Figure 348 The Enhanced User menu when the ICQ program is in advanced mode.

Under the Send section of the Enhanced User menu, you can send files, voice messages, contact information from your user list, electronic greeting cards, and e-mail to a specific user. The Invite section in the Enhanced User menu includes the ability to request a user to have a phone conversation and two options to use third party network communications software, such as an, IP Phone program, with ICQ setting up the connection to the user for you. You can also see the user's ICQ homepage and information about the user that you have selected from your ICQ list.

349 USING THE ENHANCED ONLINE STATUS MENU IN ADVANCED MODE

In advanced mode, you have many more choices about the status that your ICQ program reports to other ICQ users. In Figure 349, you can see all the statuses that you can set for your ICQ session from the Online/Offline menu in Advanced mode.

In the extended Online status menu, you can have the ICQ program show yourself as being available to other ICQ users for a random chat or you can look for someone to have a random chat with. You can set yourself as being away from your computer when you take a break; others will get your away message. When you are in away mode, you can still receive messages. You can also set yourself in different levels of not being disturbed. In occupied mode, the ICQ program will still alert you of incoming urgent messages but in Do Not Disturb (DND) mode, the ICQ

program will not alert you of incoming messages, although your ICQ program will still receive messages. You can also set yourself in Privacy status where you will appear as being off-line to other ICQ users. In Privacy status, only users you list in your visible list will see you as being online. In Privacy status, the ICQ program will still receive messages. Of course, you can still set yourself in off-line status but the ICQ program will not receive messages when it is offline.

Figure 349 The advanced mode Online status menu.

UNDERSTANDING ICQ SERVICES 350

Besides the ability to send and receive messages, the ICQ program provides other services that can help you be more productive. The other ICQ services are available only in the ICQ program advanced mode. To see the list of services, click your mouse on the Services button. The ICQ program, in turn, will display the Services menu, shown in Figure 350.

Figure 350 The ICQ Services menu.

In advanced mode, you can use the ICQ program to help you remember things with to do lists, notes, and reminders. You can also configure information about yourself, such as e-mail, phone, and Web information, as well as find

and list yourself in the ICQ white pages. Further, you can also look back through your messages to look for transcripts of online conversations that you had with other ICQ users.

351 UNDERSTANDING MY ICQ HOMEPAGE

The ICQ service of My ICQ Homepage lets you create a home page on your computer that other users on the Internet can view. To work with the ICQ My Homepage, click your mouse on the Services button. ICQ, in turn, will display the Services menu. Click your mouse on My ICQ page. ICQ, in turn, will display the ICQ My Homepage sub-menu. The ICQ My Homepage sub-menu has three sections: My ICQ Homepage Factory, View, and Find Homepages, as shown in Figure 351.

Figure 351 The My ICQ Homepage sub-menu.

The first section, My ICQ Homepage Factory, lets you create and activate your ICQ home page. The second section, View, has options for you to view your ICQ homepage and your My Communication Center Web page. The ICQ program stores your home page on your computer and stores the Communication Center page on the ICQ servers. The last section, Find Homepages, lets you search for home pages of other users. If you activate the My ICQ Homepage, remember that the home page is on your computer. When you let users view your home page, you are giving users on the Internet access to your computer's hard drive. Giving access to your computer's hard drive is a potential security risk and may expose you to the chance, though a slight chance, of having someone damage your computer system from over the Internet.

352 USING THE ICQ REMINDER SERVICE

The ICQ program has a reminder service that you can use to remind yourself of events that happen at a date and time in the future or of things to do when a user on your ICQ user list comes online. The reminder service is a good way to keep yourself from forgetting about important events. You can have the reminder service remind you of something at a certain time by setting a reminder notice and adding the notice to your list of reminders. To add a reminder in ICQ, click your mouse on the Services button. The ICQ program, in turn, will display the

1001 Internet Tips

Services sub-menu. Click your mouse on the Reminder menu item. The ICQ program, in turn, will display the Reminder sub-menu. Click your mouse on the New Reminder menu option. The ICQ program, in turn, will display the Add To Reminder dialog box, shown in Figure 352.1.

Figure 352.1 The Add To Reminder dialog box.

As shown in Figure 352.1, you can set a reminder to trigger at a date and time set by yourself or you can have a reminder trigger the next time a user in your ICQ list is online. You can also configure the reminder to give you a message when the reminder is triggered. After you have filled in the information in the Reminder dialog box, click your mouse on the Add To Reminder button to set the reminder in the ICQ program.

To view the reminders you have set in the ICQ program, display the Reminder sub-menu as you did to set the reminder and click your mouse on the View Reminder menu item. The ICQ program, in turn, will display a list of currently set reminders. When you click your mouse on a reminder in the list of currently set reminders, the ICQ program, in turn, will display the Reminder message box. You can also click your mouse on the Open Reminders List item to view a list of currently set reminders. The ICQ program, in turn, will display a list of set reminders and the text of the reminder in the same message box.

When a reminder is triggered, either due to the time or to a user being online, the ICQ program will display the Reminder message box, as shown in Figure 352.2, and will sound an alarm.

Figure 352.2 The Reminder message box.

You can dismiss the reminder by clicking the Dismiss button with your mouse. If you want the reminder to trigger again, click your mouse on the down arrow button to select a delay time from the drop-down list, then click your mouse on the Remind Again in button.

1001 Internet Tips

353 Using ICQ Notes Service

The ICQ notes service lets you place the electronic equivalent of a yellow sticky note on your computer screen. To create an ICQ note, click your mouse on the Services button. The ICQ program, in turn, will display the Services menu. Select the Notes menu item. The ICQ program, in turn, will display the Notes sub-menu as shown in Figure 353.1.

Figure 353.1 The ICQ Notes Service sub-menu.

Click your mouse on the New Note menu item to create a new ICQ note. The ICQ notes, by default, will float on top of all open windows on your Desktop, as shown in Figure 353.2.

Figure 353.2 ICQ notes on top of an active Internet Explorer window.

As shown in Figure 353.2, the notes are visible even though the Internet Explorer window is the active window, as if the notes were sticky notes pasted on your computer screen. You can close and re-open notes that you have created by using the Open and Close options on the ICQ Notes sub-menu. Both the Open and the Close menu options let you open or close all your notes or just a single note. You can also close an open note by clicking your mouse on the X in the upper right hand corner of the note. The ICQ program, in turn, will display a menu with an option to Hide the note. From the Notes sub-menu, you can open a list of all of your notes by clicking your mouse on the Open Notes List menu item. The ICQ program, in turn, will display a list of all your current notes.

Using the ICQ To Do List Service 354

You can use the ICQ To Do list service to create a list of things you need to do. To create a to do list item, click your mouse on the Services button. The ICQ program, in turn, will display the Services menu. Click your mouse on the To Do menu item. ICQ, in turn, will display the To Do sub-menu, as shown in Figure 354.1.

Figure 354.1 The To Do sub-menu in the ICQ Services menu.

Click your mouse on the New menu item. ICQ, in turn, will display the To Do dialog box, as shown in Figure 354.2.

Figure 354.2 The To Do dialog box.

Type in the text box what you have to do and then click your mouse on the Add To Do button. The ICQ program, in turn, will add the item to your To Do list and display the 2do icon in the system tray. You can view your to do list by clicking your mouse on the Open To Do List menu item in the ToDo sub-menu. If you click your mouse on the Open menu item in the To Do sub-menu, the ICQ program will display the individual items on your to do list and you can choose one to open. You can also display the To Do sub-menu when you click your right mouse button on the 2do icon in the system tray, as shown in Figure 354.3.

Figure 354.3 The 2do system tray icon with the To Do sub-menu.

1001 Internet Tips

The ICQ program will only display the 2do icon when there is an outstanding to do item. After you have completed a to do item you can open the item, and delete it by clicking your mouse on the Edit menu Unmark To Do option, as shown in Figure 354.4.

Figure 354.4 The Edit menu on an open to do item.

355 USING THE ICQ E-MAIL SERVICE

You can use the ICQ program to send e-mail to users in your ICQ list or to users on the Internet, to search for the e-mail address of other users using Internet directories, and to check for e-mail that is waiting for you on your ISP's e-mail server. Before you can use the e-mail capabilities of the ICQ program, you must configure the e-mail properties of the ICQ program. To use the e-mail services of the ICQ program, click your mouse on the Services button. The ICQ program, in turn, will display the Services menu. Click your mouse on the E-mail menu item. The ICQ program, in turn, will display the Email sub-menu, as shown in Figure 355.1.

Figure 355.1 The Email sub-menu on the ICQ Services menu.

To configure your ICQ program for e-mail click your mouse on the "Send Email" setup to configure for the sending of e-mail and on the "Check Email" setup to check e-mail on your ISP's e-mail server. You will use the e-mail information that your ISP gave you when you signed up for your Internet service. You can check if you have e-mail

1001 Internet Tips

waiting for you on your e-mail server by clicking your mouse on the Check New Email menu item. The ICQ program, in turn, will check for e-mail at your e-mail server and display the subject lines for any mail you may have. You can send an e-mail message by clicking your mouse on the Send Email menu item of the Email sub-menu. The ICQ program, in turn, will display the E-mail message dialog box, as shown in Figure 355.2.

Figure 355.2 The ICQ E-mail message dialog box.

As you can see, the e-mail dialog box looks like a normal e-mail message. You complete it as you would if you were sending the e-mail message in any other e-mail package by putting the person's e-mail address in the To: text box, filling in the Subject: and Message text boxes, and clicking your mouse on the Send button. The Search Email Directories option in the Email sub-menu will launch your Web browser and load the ICQ Email search Web page where you can search for a user's e-mail address. The Email Signature option will launch your Web browser and help you create an e-mail signature, (see Tip 604 "Inserting a Signature into an E-mail Message,") in e-mail messages that you create. The Email Center options in the Email sub-menu will launch your Web browser and load ICQ help pages dealing with the ICQ Email servers.

USING THE ICQ FOLLOW ME SERVICE 356

You can use the ICQ Follow Me service to list the phone number where you are so users can find you using ICQ. Click your mouse on the Services button. Then, click your mouse on the Phone- Follow Me menu item. The ICQ program, in turn, will display the Follow Me sub-menu, as shown in Figure 356.

You can configure the phone number that you are currently at by clicking your mouse on the Currently At Phone # menu item and selecting the phone number of the place at which you are currently located. You can set your phone status to Available or Busy with the My Phone Status menu item so that users can tell if you are available to receive a phone call. You must configure your phone numbers in order to set a phone number to currently be at, which you do by clicking your mouse on the Update/Add Current Phone number menu item. The ICQ program, in turn, will display the ICQ Global Directory Phone- Follow Me tab where you can configure a location and phone number that you can later select from the Currently At Phone # menu. The ICQ Phone Center option will launch your Internet browser and load an ICQ phone help Web page where you will find information on how to use the ICQ Phone services. Click your mouse on the Phone Directories menu item in the Follow Me sub-menu. The ICQ

program, in turn, will launch your Web browser and load a phone number search Web page where you can search for phone numbers of other users using Internet phone directories.

Figure 356 The Phone- Follow Me sub-menu in the ICQ Services menu.

357 WORKING WITH THE ICQ MESSAGE ARCHIVE

The message archive holds a copy of the messages, chats, to do lists, and other ICQ services that you have saved. After you close a chat session, you are given the option of saving the chat session. Also, your messages are saved automatically to your archive. To look at your message archive, click your mouse on the Services button and then move your mouse to the Message Archive menu item. The ICQ program, in turn, will display the Message Archive sub-menu. Click your mouse on the Open Message Archive menu item. The ICQ program, in turn, will display the ICQ Message Archive dialog box, as shown in Figure 357.

Figure 357 The Message Archive dialog box.

The Message Archive dialog box lets you view all past messages that you have saved. You can navigate the message archive in the same manner that you use Windows Explorer, but in the message archive you are viewing messages from different ICQ services instead of files in different directories. You can search for a message by who you sent the message to or by who you received the message from by using the Advanced Find menu item from the Message Archive sub-menu. You can also search the body of messages for text with the message archive Advanced Find feature. The Incoming Files Folder menu item of the Message Archive sub-menu lets you display the directory on your hard drive that is holding any files that were sent to you using the ICQ program. The Incoming Bookmarks menu item lets you display a Web page that holds all Internet URLs that have been sent to you as bookmarks.

Using the ICQ White Pages — 358

The ICQ White Pages let you search a listing of all ICQ users using information about the user, such as age, interest, home location, and other categories. To search the White Pages, click your mouse on the Services button. Next, click your mouse on the White Pages menu item. The ICQ program, in turn, will display the White Pages sub-menu. Click your mouse on the search White Pages menu item. The ICQ program, in turn, will display the White Pages Search Engine dialog box, as shown in Figure 358.

Figure 358 The ICQ White Pages Search Engine dialog box.

You can enter search criteria in any of the categories listed in Figure 358 by clicking your mouse on the category button. ICQ, in turn, will display a dialog box with search criteria for that category. The Publicize in White Pages option lets you fill in your own personal information. When you click your mouse on the Publicize in White Pages option, the ICQ program will display the ICQ Global Directory My Details dialog box. It is the same dialog box as in the Add/Change Current User sub-menu My Details menu item, discussed in Tip 342, "Using the Add/Change Current User Sub-Menu." When you add information to the My Details dialog box, you make that information available to other ICQ users.

Viewing Inappropriate Content by Accident — 359

In many cases, it may seem that the main topic of discussion about the Internet is pornography on the Internet. You may have even come across pornography on the Internet by accident yourself. Hitting a pornographic site by accident is easy to do if you are not paying attention to the Web address that you are typing into your browser.

1001 Internet Tips

Because administrators of any Web site, including pornographic sites, often look at their site as being successful by how many users visit the site, they name the site in such a way that users may view it by mistake. A good example of a site users may view by mistake is the site *www.whitehouse.com*. Users who want to see the real Whitehouse Web page may mistakenly use the *.com* extension instead of the correct *.gov* ending. There are many sites that are the same name as a government agency but with a *.com* extension instead of the *.gov* extension that a government agency has at the end of its Web address. There should be little problem with this as most of the sites that employ this technique also have a first page that warns the viewer as to the content of the site so you can leave the Web page prior to entering the Web site. If you see a pornographic site when you were expecting something else, check to see that you have the correct Web address.

360 IMAGES AND THE LAW

The law about pornographic images is very explicit. The law places electronic images in the same category as video and photographic images. Storing illegal images on your computer that are not legal in your local area is the same as having the images in a physical form. As the Internet is of an international nature, you may be able to download an image that might be illegal to own in your local area. It may be legal to own images of a certain nature where the image was originally stored, but it may not be legal for you to store the image on your computer.

361 UNDERSTANDING THE INTERNET CONTENT ADVISOR

If your PC is accessible by children, and you want to prevent them from viewing adult-oriented Web sites, you can take advantage of the Windows 98 Content Advisor to restrict the sites users can browse. The Content Advisor will prevent the site from being displayed by your browser if it is restricted. The Content Advisor can also stop the display of adult-oriented Web sites that you find by accident. To enable the Content Advisor, perform the following steps:

1. Click your mouse on the Start menu Settings button and choose Control Panel. Windows 98, in turn, will display the Control Panel window.

2. Within the Control Panel window, double-click your mouse on the Internet Options icon. Windows 98, in turn, will display the Internet Properties dialog box.

3. Within the Internet Properties dialog box, click your mouse on the Content tab. Windows 98, in turn, will display the Content sheet, as shown in Figure 361.

4. Within the Content sheet, click your mouse on the Enable button. Windows 98, in turn, will display the Supervisor Password Required dialog box, within which you must type (the first time you use the Content Advisor, you will need to assign your password in the Create Supervisor Password box) your supervisor password (the supervisor is the person who will be responsible for enabling and configuring the Content Advisor).

5. Type in the password and click your mouse on the OK button. The Content Advisor, in turn, may display a dialog box that tells you sites you recently viewed may still be accessible.

6. Within the dialog box, click your mouse on the OK button. After you enable the Content Advisor, you can use the Settings button to configure the Content Advisor settings, as discussed in the next Tip.

Figure 361 The Internet Properties dialog box Content sheet.

SPECIFYING YOUR SYSTEM'S LANGUAGE, NUDITY, SEX, AND VIOLENCE SETTINGS — 362

In the previous Tip, you learned how to enable the Windows 98 Content Advisor to restrict the Web sites that users can view from your system. Within the Content Advisor, you can select the level of language, nudity, sex, or violence you will let the browser display. Your browser will not display the Web pages for a site where the Web page has content that exceeds the settings you have selected. To control the content levels for your system, perform the following steps:

1. Click your mouse on the Start menu Settings button and choose Control Panel. Windows 98, in turn, will open your Control Panel window.
2. Within the Control Panel window, double-click your mouse on the Internet Options icon. Windows 98, in turn, will display the Internet Properties dialog box.
3. Within the Internet Properties dialog box, click your mouse on the Content tab. Windows 98, in turn, will display the Internet Properties dialog box Content sheet.
4. Within the Content sheet, click your mouse on the Settings button. Windows 98, in turn, will display the Supervisor Password Required dialog box.
5. Within the Supervisor Password Required dialog box, type in the Supervisor password and then click your mouse on the OK button. Windows 98, in turn, will display the Content Advisor dialog box.
6. Within the Ratings sheet's Category field, click your mouse on the category for which you want to specify the viewing level (such as the Language, Sex, Nudity, or Violence category). The dialog box will display a Rating sliding bar that you can use to select the level you desire. Using your mouse, drag the slider to the left or to the right to decrease or increase the current level. As you select a level, the dialog box will display a description of the level's meaning. For example, Level 0 within the Language field allows inoffensive slang but no profanity.
7. After you select the settings you desire, click your mouse on the Content Advisor dialog box OK button to put your changes into effect.

1001 Internet Tips

8. Within the Internet Properties dialog box, click your mouse on the OK button.

The Recreational Software Advisory Council (RSAC) defines the ratings levels. To assist parents, educators, and others in controlling access to content on the Web, sites can optionally specify their own ratings for language, nudity, sex, and violence. If a site's ratings exceed the Content Advisor levels you have selected, your browser will not display the site. Unfortunately, few sites support such ratings today. In such cases, you can perform the steps discussed in the next Tip to control how your browser handles non-rated sites.

363 CONTROLLING USER ACCESS TO NON-RATED SITES AND SUPERVISOR ACCESS TO RATED SITES

As you learned in the previous Tip, you can use the Windows 98 Content Advisor to control which Web sites users can view within your browser. However, as you learned, many sites across the Web do not comply with the Content Advisor's ratings system. Using the Content Advisor dialog box General sheet, shown in Figure 363, you can prevent the browser from displaying a non-rated site. In addition, within the sheet, you can specify that the supervisor can type in a password that lets the user view restricted content so that you can restrict content but also use the supervisor password to override the restrictions and view a restricted Web page. You will need to use the supervisor to view each new Web page if it contains restricted content.

Figure 363 The Content Advisor dialog box General sheet.

To adjust settings using the Content Advisor's General sheet, perform the following steps:

1. Click your mouse on the Start menu Settings button and choose Control Panel. Windows 98, in turn, will open your Control Panel window.

2. Within the Control Panel window, double-click your mouse on the Internet Options icon. Windows 98, in turn, will display the Internet Properties dialog box.

3. Within the Internet Properties dialog box, click your mouse on the Content tab. Windows 98, in turn, will display the Internet Properties dialog box Content sheet.

4. Within the Content sheet, click your mouse on the Settings button. Windows 98, in turn, will display the Supervisor Password Required dialog box.

1001 Internet Tips

5. Within the Supervisor Password Required dialog box, type in the Supervisor password and then click your mouse on the OK button. Windows 98, in turn, will display the Content Advisor dialog box.

6. Within the Content Advisor dialog box, click your mouse on the General tab. Windows 98, in turn, will display the General sheet.

7. Within the General sheet, use the checkboxes to specify the settings you desire and then click your mouse on the OK button.

8. Within the Internet Properties dialog box, click your mouse on the OK button to put your changes into effect.

CONTROLLING YOUR CONTENT ADVISOR PASSWORD 364

As you learned in Tip 361, "Understanding the Internet Content Advisor," Windows 98 lets you define a Content Advisor Supervisor who can select various viewing settings to help you control which Web sites users on your system can view. To control the Content Advisor settings, you must type in the correct Supervisor password. If you must change your Supervisor password, perform the following steps:

1. Click your mouse on the Start menu Settings button and choose Control Panel. Windows 98, in turn, will open your Control Panel window.

2. Within the Control Panel window, double-click your mouse on the Internet Options icon. Windows 98, in turn, will display the Internet Properties dialog box.

3. Within the Internet Properties dialog box, click your mouse on the Content tab. Windows 98, in turn, will display the Internet Properties dialog box Content sheet.

4. Within the Content sheet, click your mouse on the Settings button. Windows 98, in turn, will display the Supervisor Password Required dialog box.

5. Within the Supervisor Password Required dialog box, type in the Supervisor password and then click your mouse on the OK button. Windows 98, in turn, will display the Content Advisor dialog box.

6. Within the Content Advisor dialog box, click your mouse on the General tab. Windows 98, in turn, will display the General sheet.

7. Within the General sheet, click your mouse on the Change Password button. Windows 98, in turn, will display the Change Supervisor Password dialog box, as shown in Figure 364.

Figure 364 The Change Supervisor Password dialog box.

8. Within the Change Supervisor Password dialog box, click your mouse on the Old password field and then type your current Supervisor password. Next, click your mouse on the New password field and type in your new password. Then, click your mouse on the Confirm new

password field and type your new password a second time. Finally, click your mouse on the OK button to put your changes into effect.

9. Within the Content Advisor dialog box, click your mouse on the OK button.
10. Within the Internet Properties dialog box, click your mouse on the OK button.

365 Using a Rating Bureau to Get Site Ratings

As you have learned, many (most) sites across the Web do not yet support the Content Advisor's rating system. Rather than simply disallow a site because the site does not provide ratings information, you may be able to get information about the site from a rating bureau. A rating bureau is a site on the Web that your browser will contact to determine a site's rating. When you enable the use of a rating bureau, your browser will contact the bureau each time you try to view a site that does not specify a rating. If the rating bureau has rated the site, it will return the rating to your browser which, in turn, can determine whether or not (based on your rating selections) it should display the site's contents.

Although using a rating bureau in this way may let you get ratings for a wider number of sites, it will also slow down the speed at which you browse sites because your browser will have to request, and then wait, for ratings for each site you visit. Your Internet service provider may be able to provide you with the Web address for one or more rating bureaus. To use a rating bureau to rate sites, perform the following steps:

1. Click your mouse on the Start menu Settings button and choose Control Panel. Windows 98, in turn, will open your Control Panel window.
2. Within the Control Panel window, double-click your mouse on the Internet Options icon. Windows 98, in turn, will display the Internet Properties dialog box.
3. Within the Internet Properties dialog box, click your mouse on the Content tab. Windows 98, in turn, will display the Internet Properties dialog box Content sheet.
4. Within the Content sheet, click your mouse on the Settings button. Windows 98, in turn, will display the Supervisor Password Required dialog box.
5. Within the Supervisor Password Required dialog box, type in the Supervisor password and then click your mouse on the OK button. Windows 98, in turn, will display the Content Advisor dialog box.
6. Within the Content Advisor dialog box, click your mouse on the Advanced tab. Windows 98, in turn, will display the Advanced sheet.
7. Within the Advanced sheet, click your mouse on the Rating bureau field and type in the bureau's corresponding Web address. Then, click your mouse on the OK button.
8. Within the Internet Properties dialog box, click your mouse on the OK button to put your changes into effect.

366 Methods to Protect Your Children on the Internet

In connection with the Internet Online Summit Focus on Children, several researchers for ATT labs developed some good methods to protect your children when they are on the Internet. There are six types of actions that you can

take to help your children use the Internet in a safe manner. The first action is to suggest to your children sites that they should use when they are on the Internet. A good site to help you find a child-appropriate site is *www.yahooligans.com*, a child version of the popular Internet site Yahoo. The second action that you can take is to search for sites that are appropriate for your children. If you preplan some of your children's Internet trips, your children are less likely to go off to non-appropriate areas of the Internet. The third action you can take is to be informed about the content of the different sites that your children are viewing while on the Internet. The fourth action that you can take is to monitor your children while they are on the Internet. You can also look at a browser history to see what sites your children have visited. The fifth action you can take is to explain to your children that they should not visit adult sites that display warning pages, and make use of programs that provide warnings, like Internet Explorer Content Advisor. The sixth action that you can take is to use blocking software that will block inappropriate content from your children.

UNDERSTANDING MP3 PLAYERS 367

You learned in Tip 209, "Working with .mp3 Files," that an MP3 file format holds audio recordings on your computer. You also learned that you must decode the MP3 file to hear the audio stored in the MP3 file with a program called an MP3 Player. An MP3 Player is a program that works with your sound card to play music on your computer that is encoded in an MP3 file. There are many MP3 players on the market that you can install on your computer. You can search for MP3 Player in any World Wide Web search engine to get a list of different players. One of the most popular MP3 players is WinAmp. You can download the WinAmp player from the WinAmp Web site at *www.winamp.com*.

INSTALLING WINAMP 368

To install the WinAmp program, you must first download the WinAmp program from the WinAmp Web site. The WinAmp program is freeware, which means that you can download and use it for free. After you download the WinAmp program, you can install it by performing the following steps:

1. Start the WinAmp install program by double-clicking your mouse on the program you downloaded from the WinAmp site. The WinAmp setup program, in turn, will start and display the Install File Location dialog box.
2. The default installation folder should be correct for most installations. Click your mouse on the Next button. The WinAmp install program, in turn, will install the program files and display the Settings dialog box.
3. The Settings dialog box will let you configure the WinAmp program to launch automatically and place the WinAmp program icons. If you are on a LAN, you must change the type of Internet connection from Dial-Up Modem to LAN.
4. After you have changed the settings to match your computer system, click your mouse on the Next button. The install program, in turn, will show that the Winamp is successfully installed.
5. Click your mouse on the Run WinAmp button to start the WinAmp program.

The WinAmp program is now ready to play MP3 files.

1001 Internet Tips

369 Working with WinAmp

Besides the ability to play MP3 files, the WinAMP program has many of the features of a full stereo system and a Web browser as well. Now that you have installed WinAmp, you can start playing MP3 files. You can start the WinAmp program by double-clicking your mouse on the WinAmp shortcut on your Desktop. The WinAmp screen may be confusing at first, as shown in Figure 369.1, but is easy to work with once you get the hang of the program.

Figure 369.1 The WinAmp program screen.

To listen to MP3 files, you must add the files to the play list in the WinAmp playlist dialog box in the lower left hand corner of the WinAmp program screen. To add MP3 files to the WinAmp play list, click your mouse on the +File button in the Playlist dialog box. The WinAmp program, in turn, will display the Add file(s) to Playlist dialog box, which works like a normal Windows open dialog box, as shown in Figure 369.2.

Figure 369.2 The Add File(s) to Playlist dialog box.

You add MP3 files to the play list in the same way you select files to open in any Windows application. After you load all the MP3 files that you want to listen to, click your mouse on the Play button in the main WinAmp dialog box in the upper left hand corner of the WinAmp program screen. The Play button looks like the play button on many music CD players. The WinAmp program, in turn, will play all the songs in the Play list for you.

The WinAmp program also has a graphical equalizer and a mini Web browser. You can tailor the sound output with the equalizer to your home or office but you may only notice the difference if you are using stereo speakers with your computer. You can use the mini Web browser to search the many MP3 sites that are on the Internet.

Using MP3 Portable Players — 370

Now that you are listening to MP3 files on your computer, you may want to take your music with you on the road. If you have a laptop computer, you can travel with your music, but an MP3 portable player would be more convenient if you went for a jog or a drive in your four wheeler in the backcountry. An MP3 portable player is an electronic device that can play MP3 files. Diamond Multimedia makes the Rio, an MP3 portable player that can hold over an hour of music in the palm of your hand. Several other companies are following Diamond in producing MP3 portable players. If you have ever walked or driven with a CD player, you will enjoy the skip-free ability of the no moving parts, solid-state electronic portable MP3 player. All MP3 players come with a program that will download MP3 files from your computer to the player as well as put music from your music CDs on to the player. A few companies are building car stereos that use MP3 rather than tapes or CDs. The MP3 portable player may be the new way to listen to music when you are on the go.

Finding MP3 Files on the Internet — 371

The two best ways to find MP3 music is to go to MP3 sites or to use Internet search engines to search for your favorite artists.

A good place to start looking for MP3 files is on Web pages about your favorite music artist. You can use an Internet search engine to do your search. You should be careful about what you download as some of the music that you are downloading may be copyrighted material that is not free to download. There are many sites that have free music to download and music that you can purchase and download. There is also a large amount of pirated music on the Internet that you can download as well, but that is not considered legal in some areas. You can also look for MP3 files on sites dedicated to MP3, such as *MP3.com*, as shown in Figure 371.

Figure 371 The MP3.com Web site home page.

372 UNDERSTANDING APPLICATIONS DELIVERED VIA THE WORLD WIDE WEB

Delivering applications to users using Web technology is one of the new areas of the World Wide Web. A company may want to make an application that its traveling sales force uses available to its sales agents from the World Wide Web. The benefit of this is that the application is available to the sales agents no matter where they are in the world. The writing of applications for the Web is a difficult and time-consuming process, especially if you want the Web application to interact with another application, such as a database. A company that wants to make an application available on the Web often has the application rewritten in a Web programming language, like VBScript, Java, CGI, or some other Web programming language. One of the newer developments in the use of applications on the Web is to use thin-client technology to make an application made for the Windows operating system usable on the World Wide Web.

373 UNDERSTANDING THIN CLIENT COMPUTING

There are many different ways of running applications over a network or even a network of networks like the Internet. The traditional method is to download the whole application to the client computer every time a user runs the program and to run the application on the client computer. Programmers have modified the traditional method of running an application over a network with Web computing technologies like Java. Java requires the download of only small program pieces, called applets, to the client computer every time you want to run the applet. When you use applets, the server computer has less data to transmit to the client computer at one time so the server uses a smaller amount of bandwidth and the client does not need to hold as much information. Thin client computing is a type of network computing where the server computer, rather than the client computer, runs an application program and sends the program output over the network to the client.

The thin client computing method does not require the download of any of the programs you run to the client computer. In a thin client computing system, you run a client program on the client computer. You may need to download the client program once, and that is the only program that runs on the client computer. You request an application on your client computer and connect to a server computer that runs the application. The server sends to the client what the program would display to you if you were running it on your computer. This passing of the display information takes very little bandwidth so it works well over the Internet. A second benefit of thin client computing is that because the server is running the application and the data that the application may need is already on the server, the data does not need to be sent on the network. This process of having the data local to the application, even when the user is across the Internet, means less data sent over the Internet. It is safer to work with a thin client because no one can intercept your data as it crosses the is Internet, and it takes less time because the server does not need to transmit your data at all.

374 LOOKING AT A THIN CLIENT

A thin client gets its name from the fact that it has a reduced amount of hardware; in other words, the client is very thin on hardware. A thin client is a piece of computer hardware that works as a client to a server but it is not

necessarily a full-functioning computer. A thin client usually does not have a hard drive or any other type of storage device. A thin client has very small amounts of memory compared to a traditional computer you might have on your desk. Many different types of thin clients exist. Users have made some thin clients by design. Some thin clients were full computers that are now not able to run today's latest applications. Some thin clients are full computers that people use as thin clients for a specific program.

A thin client does not need a lot of hardware or can use old hardware because the only program that it must run is a client program that connects the thin client to a server. As you saw in the previous Tip, the server in Thin client computing really runs the programs and does all the program processing. The thin client program just receives the video output of the application from the server and sends the keyboard and mouse input to the application on the server. A thin client does not require a large communication connection to connect to a server. You can use as low as a 14.4 Kbps modem to connect a thin client to a server. The ability to use such a low speed connection is one reason why even users with full computers will use a thin client program. If your full computer is not on the same network as the server, you could use your modem and a thin client program to connect to the server.

Looking at the Benefits of Using Thin Clients on the World Wide Web — 375

Thin client computing on the World Wide Web provides many benefits. The first is ease of integrating applications into your Web pages. When you use thin clients, you do not have to rewrite all of your applications for use on the Web. You can simply install the application on a thin client server and create a Web page that makes a connection to the thin client server. Using thin clients will greatly reduce the development time it takes to put applications that you use into a Web format. A second benefit of using thin client computing on the World Wide Web is that the amount of bandwidth used to connect to the server by the thin client is small. This is helpful in increasing the speed with which the application you put on the World Wide Web will respond to user actions, as many users will be connecting to your application using limited bandwidth connection, such as modems. You may not know how users using your application will be connecting to the Internet, so using a thin client ensures that if they are using a low bandwidth connection they will get almost the same response that another user with a high bandwidth connection might get. The third benefit is that the data the program uses will stay safely on the server where the program is running; the server does not need to send it across the Internet to the client computer. The client computer will get only the video display of what the program is showing and does not need to receive any of the data that the program is using.

Understanding WinFrame Servers — 376

A WinFrame server is a thin client server developed by Citrix Corporation which will run applications for a thin client. The WinFrame server is based on Microsoft Windows technology and so can run most Windows programs. The WinFrame server brings Windows programs to computers that cannot run Windows programs, such as a DOS only computer. You can also run a Windows programs across the Internet with a WinFrame server. As shown in Figure 376, the program running in a WinFrame window looks as if it is running on a Windows 3.1 computer and not on a Windows 9x computer.

This appearance of a Windows 3.1 type window on a Windows 9x computer is due to the Access application running on a WinFrame computer and the Windows 9x computer using a Citrix client program to connect to the

WinFrame computer. You can tell if a program is using a Windows 9x type window or a Windows 3.1 type window by looking at the number and type of buttons in the upper right hand corner of the window. The Citrix client program is running in Windows 9x, so it has the Windows 9x type set of three buttons, an underscore, a window (gray in this example), and an 'X' button. The Access program is running on a WinFrame computer and is displaying a Windows 3.1 type window to the client with just two buttons, an up triangle and a down triangle, in its upper right hand corner. Even though the Windows 9x computer is not a true thin client, it is using thin client technology to connect to a WinFrame computer across the Internet and uses the Access program that is running on the WinFrame server.

Figure 376 WinFrame client running Access.

377 UNDERSTANDING MICROSOFT TERMINAL SERVER

Microsoft Terminal Server is a thin client server like the WinFrame server in the previous Tip. Terminal Server is made by Microsoft and uses the Windows 9x type windows to display programs. Client Connection Manager, shown in Figure 377.1, is the client program that you must use with Terminal Server.

Figure 377.1 The Microsoft Terminal Server client.

After starting the Connection Manager and double-clicking your mouse on a program icon, you are connected to a Terminal server, as in Figure 377.2, where you are connected to a Terminal server Desktop in a window on your Windows 9x Desktop.

Figure 377.2 Running programs on a Microsoft Terminal Server from a Win 9x client.

Even though Terminal Server is newer than WinFrame, it does not have some of the features of a WinFrame server. The most important feature lacking for discussion in this book is the use of a Web browser as a client.

UNDERSTANDING A METAFRAME SERVER 378

A MetaFrame server brings thin client computing to many different computing environments, including the Internet. A MetaFrame server is an add-on software product made by Citrix that you install on a Microsoft Terminal Server. A MetaFrame server extends the functions of a Terminal server by adding a support for clients from many different operating systems, such as Unix and Unix-like systems, Macintosh, and DOS, as well as the different versions of Windows. You use a client program to connect to a MetaFrame server in much the same way that you do with Terminal Server. The results of the connection are different when using a MetaFrame server. Figure 378 shows a Word program that is running on a MetaFrame server but due to a seamless window MetaFrame enhancement, the program looks as it is running on your local computer.

This feature of MetaFrame is called a seamless window because it seamlessly integrates into your desktop. MetaFrame has clients for almost any operating system in use on Desktop and laptop computers. MetaFrame also has Web browser clients for Netscape Navigator, Internet Explorer, and any Java enabled browser. It is the Web browser clients that makes it easy to use a MetaFrame server in different Web applications.

Figure 378 *The MetaFrame client running Microsoft Word.*

379 WORKING WITH THIN CLIENTS ON THE WEB

To work with a Web-based thin client, you must have the correct software installed on your system. You must also know the URL of the thin client server page. The thin client server page is a Web page that points to an application running on a thin client server. You must have a Web browser that supports frames, a Java script, and a thin client program. The two main browsers in use on the Internet, Internet Explorer and Netscape, both work with the main Web thin client servers in use on the Internet. The WinFrame and the MetaFrame servers are the most common thin client servers on the Web. You can freely downloaded the client software Internet Explorer or Netscape uses to connect to a WinFrame or MetaFrame server from Citrix, the maker of WinFrame and MetaFrame, at *www.citrix.com*.

380 WORKING A THIN CLIENT WEB SITE

The best Web site to use to see a thin client working on the World Wide Web is the Citrix site. The software for Microsoft's Internet Explorer will download and install automatically so it is the easiest browser to use to connect to the Citrix Web site. (If you are using Netscape, then Citrix has the software to connect to the thin client server but you will need to install the software into the Netscape browser as a Netscape plug-in.) To test drive a thin client Web site, start your Internet Explorer browser. In the address box of your browser, type the URL of *http://www.citrix.com/*

demoroom. The demo page explains how Citrix Web applications are delivered to your computer and has a small form that you fill out to see a demo of the Web-based thin client computing. Figure 380 shows Microsoft Excel running in a Web page across the Internet.

Figure 380 Microsoft Excel running in a Web browser using a thin client.

UNDERSTANDING CU-SEEME — 381

CU-SeeMe is a program that lets you do videoconferencing on the Internet. Cornell University developed the CU-SeeMe program in 1993. The CU-SeeMe program was the first Internet videoconferencing program. The CU-SeeMe program will let you talk and see other users on the Internet. The users that you are talking to must have the proper video equipment on their computer. White Pine Software, Inc. bought the CU-SeeMe program. If you do not have a version of CU-SeeMe already and you want to use it, you must buy the program from White Pine Software.

CU-SEEME SOFTWARE AND HARDWARE — 382

You can buy the CU-SeeMe software from many retail stores now that White Pine Software, Inc. is marketing the program. You can also purchase the CU-SeeMe software from the White Pine Web site at *www.wpine.com*. To do video conferencing using CU-SeeMe, you must install equipment that will create a video picture of you and record your voice. You must have a Web cam and a microphone attached to your computer so that the CU-SeeMe program can send your video and voice over the Internet. For a smoother installation, you should install the hardware equipment before you install the CU-SeeMe program.

1001 Internet Tips

383 Configuring Your CU-SeeMe Software

To start the CU-SeeMe program, click your mouse on the Start menu. Select the Programs menu item, then select the CU-SeeMe menu item. Click your mouse on the CU-SeeMe menu option to start the CU-SeeMe Setup Assistant, as shown in Figure 383.1.

Figure 383.1 The CU-SeeMe Setup Assistant.

The first dialog box of the Setup Assistant will have you fill in information about yourself. After you fill in your personal information, the CU-SeeMe Setup Assistant will return you to the dialog box shown in Figure 383.1 but with the checkmark in the next section to be configured. You can register yourself with the Four11 directory so that others will be able to look up your name in the Four11 Internet directory and connect to you using CU-SeeMe. You can register with Four11 by entering a password in the two password boxes and then clicking your mouse on the Register on Four11 button, as shown in Figure 383.2.

Figure 383.2 The Four11 Registration dialog box.

Four11 is an Internet directory that will list your CU-SeeMe information. After you have registered with Four11, the CU-SeeMe Setup Assistant will display the next section to be configured, your network configuration. You must pick the type of network connection that you have to the Internet, which is the speed of your modem most of the

1001 Internet Tips

time. If you are on a LAN, you should ask your network administrator the speed of your connection to the Internet. The CU-SeeMe Setup Assistant will return to the Setup assistant dialog box and move to the next section to be configured, your video source. If your Web camera is already installed, you will see a picture in the Setup Assistant dialog box. You can click your mouse on the Take a Picture button to have the Setup Assistant add a still picture of yourself to your CU-SeeMe address card. The Setup Assistant will now take you to the last area of the CU-SeeMe setup, your audio source. If you have your microphone installed, you will be able to set the sound level of your microphone and the sound level of your speakers. After you click your mouse on the Finish button, as shown in Figure 383.3, you should be ready to use your CU-SeeMe videoconferencing software.

Figure 383.3 The Finish screen of the CU-SeeMe Setup Assistant.

You may need to close the CU-SeeMe Tip of the day to start using the CU-SeeMe software.

USING THE CU-SEEME PHONE BOOK 384

Each time you start the CU-SeeMe program, it will display the CU-SeeMe Phone Book, as shown in Figure 384.

Figure 384 The CU-SeeMe Phone Book screen.

1001 Internet Tips

The CU-SeeMe Phone Book holds contact cards for other CU-SeeMe users and conference servers. From the CU-SeeMe Phone Book screen, you can test your setup, as discussed in the next Tip, to see if you are able to send sound, receive sound, and send video. You can also place all of your CU-SeeMe calls from the Phone Book. To place a call from the CU-SeeMe Phone Book, select the person you wish to call from the Phone Book by clicking your mouse on the Contact Card. Alternatively, you can click your mouse on the Speed Dial button or click your mouse on the Click here to call link.

385 TESTING YOUR CU-SEEME CONFIGURATION

You can test your Video and Audio equipment in your CU-SeeMe configuration by clicking your mouse on the Test Setup button on the Phone Book screen. The CU-SeeMe program, in turn, will display the Test Setup dialog box, as shown in Figure 385.

Figure 385 The CU-SeeMe Test Video tab of the Test Setup dialog box.

The Test Setup dialog box has two tabs, the Video tab and the Audio tab. You will use the Test Setup dialog box to confirm that your video and audio equipment are working with the CU-SeeMe software. You can also change the settings for your equipment. On the Video tab, you can set the picture quality so that you can send a clearer picture that will be slow to transmit or a fuzzier picture that will transmit much quicker. On the Audio tab, you can set the volume for your speakers and the sensitivity of your microphone.

386 CREATING A NEW CONTACT CARD

As you learned in Tip 384, you can use the Contact Cards in the CU-SeeMe Phone Book to connect to other CU-SeeMe users. It is unlikely, however, that a Contact Card already exists for the users you want to contact in your Phone Book after you install the software. To create a Contact Card, start the CU-SeeMe program and perform the following steps:

1001 Internet Tips

1. Click your mouse on the New Card button. The CU-SeeMe program, in turn, will display the New Contact Card Assistant dialog box, as shown in Figure 386.1.

Figure 386.1 The New Contact Card Assistant dialog box.

2. Click your mouse on the Next button. The CU-SeeMe program, in turn, will display the Calling Information dialog box.
3. Fill in the contact information for the user or server. You will need to fill in the name and either an e-mail or IP address for the new contact. If the contact does not have a permanent IP address, you may want to use Manual Dial, as discussed in Tip 389, "Using CU-SeeMe to Communicate with One Other CU-SeeMe User," to contact the user. After you have entered the contact information, click your mouse on the Next button. CU-SeeMe, in turn, will display the New Contact Card Assistant dialog box.
4. Click your mouse on the Next button. The CU-SeeMe program, in turn, will display the Card Type dialog box. Click your mouse on the Radio button that best describes the type of contact you are creating, personal or professional. Click your mouse on the Next button. The CU-SeeMe program, in turn, will display the Enter Data on the Contact Card dialog box.
5. Complete the contact information on the Enter Data on the Contact Card dialog box. Click your mouse on the Next button. The CU-SeeMe program, in turn, will display the New Contact Card Assistant dialog box.
6. Click your mouse on the Next button. The CU-SeeMe program, in turn, will display the Add a picture of the user dialog box.
7. If you have an electronic picture on your computer for the contact, click your mouse on the Browse button and find the picture file for your contact. After you have found the picture, or if you do not have a picture of the user, click your mouse on the Next button.
8. The CU-SeeMe program will display the Finish screen, as shown in Figure 386.2. Click your mouse on the Finish button to complete the New Contact Card.

Figure 386.2 The Finish screen for your New Contact Card.

387 USING THE CU-SEEME LISTENER

You can use the CU-SeeMe Listener to receive incoming CU-SeeMe calls when the CU-SeeMe program is not running. You can also use the CU-SeeMe Listener to screen calls for you as well. To start the CU-SeeMe Listener, select the Start menu Programs option and then choose the CU-SeeMe Start CU-SeeMe Listener option. When the CU-SeeMe Listener starts, it will display a yellow bell in the system tray, the area by the clock, and it will display the Listener Status window on your Desktop. To set options for the CU-SeeMe Listener, click your mouse on the Options button within the Listener Status window. The CU-SeeMe Listener, in turn, will display the CU-SeeMe Call Options dialog box, shown in Figure 387.1.

Figure 387.1 The CU-SeeMe Call Options dialog box.

You can have the Listener start automatically for you when your computer starts by checking the Run listener at startup checkbox. The Listener Active Filters are what CU-SeeMe uses to block users whom you do not want to connect to your CU-SeeMe listener, similar to screening phone calls. To set your Listener Active Filters, perform the following steps.

1. Click your mouse on the New button in the CU-SeeMe Call Option dialog box. The Listener program, in turn, will display the New Listener Filter dialog box, shown in Figure 387.2.
2. Give the filter a label and set the value that you want to filter. You can filter by CU-SeeMe name or by IP address of the caller. You also set the filter to respond to calls that match the value you set or to respond to calls that do not match the value you set.
3. Set the actions that you want to happen when a call comes in to your computer.
4. Click your mouse on the OK button to complete the filter.

Figure 387.2 The New Listener Filter dialog box.

After you are finished with the CU-SeeMe Call Options, click your mouse on the OK button to apply your call options.

Connecting to a Conference with CU-SeeMe 388

You can view and work with several users at the same time when you are using the CU-SeeMe software. To work with several users at the same time, you must connect to a server that will "reflect" your video and audio to all the other users in your conference—this server is called a reflector. White Pine makes the reflector that it sells as the MeetingPoint program. To connect to a conference, start the CU-SeeMe program. Find the Contact Card for the server that is hosting your conference or click your mouse on the Manual Dial button and enter the IP address of the server that is hosting your conference. When you connect to the server, it will present you with a group of conferences that you can join, as shown in Figure 388.1.

Figure 388.1 Different conferences running on a server to which you can connect.

To join a conference, click your mouse on the conference that you are to join and then click your mouse on the Join button. When you join a conference, you will work with the Conference screen, as shown in Figure 388.2.

Figure 388.2 The CU-SeeMe Conference screen.

Within the Conference screen, you can communicate with only one user or with the whole group. You can also use a text chat screen to communicate with text if you do not have audio on your computer system. You will not see the picture of the other users in the conference if they do not have video on their computer systems.

You can connect to several public conferences on the servers at White Pine and at other companies and universities. Many universities hold classes using a CU-SeeMe conference. You may need a password to join a conference because not all conferences on a server will be open to the public. You can also pay a service provider to set up a private conference where only you and the people you invite to the conference will gain access to the conference.

389 USING CU-SEEME TO COMMUNICATE WITH ONE OTHER CU-SEEME USER

You can use the CU-SeeMe program to communicate with one other CU-SeeMe user without the need of a server. To use CU-SeeMe to talk one-on-one with another CU-SeeMe user, both you and the other user must have the CU-SeeMe software. The user you are trying to connect with must have the CU-SeeMe program running or the Listener program running to receive your CU-SeeMe call. You should have the user e-mail you his or her IP address because with most dial-up accounts the IP address changes. You should check the IP address each time you connect to a CU-SeeMe computer. After you have the IP address of the user you want to connect with, click your mouse on the Manual Dial button. The CU-SeeMe program, in turn, will display the Manual Dial dialog box, as shown in Figure 389.

Figure 389 The Manual Dial dialog box.

Enter the IP address of the user you are connecting to then click your mouse on the Manual Dial button. If the other user has the software running, you will connect to his or her computer and the two of you will start a conference.

THE CU-SEEME WORLD WEB SITE — 390

The CU-SeeMe World Web site, at *www.cuworld.com*, is a place for users of video chat software to connect with other users. The Web site is not just for users who have the CU-SeeMe software but for any user of video chat software, such as Microsoft NetMeeting and others. The Web site has links to video chat rooms for public use as well as links to private chat rooms that you can use for a fee. You can find other users and list yourself as a video chat user so that other video chat users can find you. You must join CU-SeeMe World to use it, but there is no charge to join. The members' area of CU-SeeMe World has places for users with common interests to talk, forums to participate in, and sections for learning how to better use your video chat software.

UNDERSTANDING NETMEETING — 391

Throughout this book's Tips, you have learned many ways to use the Internet and the World Wide Web. One of the most exciting programs Windows 98 includes is NetMeeting, a program that users can use to chat, exchange e-mail, exchange files, talk, or even videoconference. Employees at offices all over the country can use NetMeeting to get together online within a virtual meeting room. NetMeeting is similar to the CU-SeeMe program.

As with CU-SeeMe, if your PC has a microphone and speakers, you can use NetMeeting to talk with users worldwide across the Internet for free. Likewise, as with CU-SeeMe, if your PC has a video camera, you can use NetMeeting for simple video conferencing. In the future, the NetMeeting software may become as valuable as your browser.

GETTING THE NETMEETING SOFTWARE FOR WINDOWS 98 — 392

The NetMeeting software should already be on your computer, but, if not, you can get the NetMeeting software by installing the full version of Internet Explorer 5. You can download Internet Explorer 5 from the Microsoft Web site at *www.microsoft.com*, then go to the downloads page. When you start the download, you will be asked the type of download that you want. You should select a minimal/custom install. At the Custom Install dialog box, select a full install. By selecting a full installation of Internet Explorer 5, you will install the latest version of NetMeeting.

STARTING NETMEETING SOFTWARE FOR WINDOWS 98 — 393

Now that you have NetMeeting, it is easy to start using. To run the NetMeeting software, perform the following steps:

1001 Internet Tips

1. Click your mouse on the Start menu Programs option and choose Internet Explorer. Windows 98, in turn, will display the Internet Explorer submenu.
2. Within the Internet Explorer sub-menu, click your mouse on Microsoft NetMeeting. The first time you run NetMeeting, Windows 98 will start a wizard that will help you configure your NetMeeting settings.

The opening screen on the Setup wizard describes what you can do with NetMeeting, as shown in Figure 393.

Figure 393 The starting screen for the NetMeeting Setup wizard.

To configure the NetMeeting that comes with Windows 98 for use on your computer system, perform the following steps.

1. Click your mouse on the Next button. NetMeeting, in turn, will display a dialog box to configure the directory server that you can use. A directory server lists your name for other users to find you and for you to use to find other NetMeeting users. The default will work for most installations but if you are familiar with different directory servers, you can choose a directory server from the drop-down list. You can change the directory server that NetMeeting logs on to when NetMeeting starts, so you can change this choice later, if needed.
2. Select the directory server that NetMeeting will use, then click your mouse on the Next button. NetMeeting, in turn, will display a User Information dialog box.
3. Within the User Information dialog box, you must complete at least the First name, Last name, and e-mail address textboxes to continue with the Setup wizard. Then, click your mouse on the Next button. NetMeeting, in turn, will display a Type of Use dialog box.
4. Select the radio button that best describes how you are planning to use the NetMeeting program, then click your mouse on the Next button. NetMeeting, in turn, will display a Connection Speed dialog box.
5. Click your mouse on the radio button that best describes the type of connection that you have to the Internet. Then, click your mouse on the Next button. NetMeeting, in turn, will display an Information dialog box. The Information dialog box is informing you that you are about to configure your audio settings and should close all programs that record or produce sound.
6. After you have closed all programs, click your mouse on the Next button. NetMeeting, in turn, will display the Volume Test dialog box.
7. Within the Volume Test dialog box, click your mouse on the Test button. NetMeeting, in turn, will play a noise.
8. Click your mouse on the volume scale where the sound is at a good level for your listening. After you have set the volume level, click your mouse on the Stop button and then click your mouse on the Next button. NetMeeting, in turn, will display the Microphone Setup dialog box.

1001 Internet Tips

9. Read the paragraph in the dialog box at a normal tone of voice. As you read the paragraph, NetMeeting will display a green, yellow, and possibly red-colored bar under the paragraph that you are reading.
10. After you are finished setting up your microphone, click your mouse on the Next button. NetMeeting, in turn, will display the Finish screen.
11. Click your mouse on the Finish button. NetMeeting, in turn, will start the NetMeeting program.

Now that you have configured NetMeeting, you are ready to use NetMeeting to do videoconferencing.

394 CHANGING THE DIRECTORY SERVICE THAT IS USED WHEN NETMEETING STARTS

You may find that the directory service you selected during the Setup wizard does not fit your needs. You can change the directory service that NetMeeting uses at the time NetMeeting starts. To change the directory service that NetMeeting starts with, perform the following steps:

1. Click your mouse on the Tools menu in the NetMeeting toolbar. NetMeeting, in turn, will display the Tools menu.
2. Click your mouse on the Options menu item. NetMeeting, in turn, will display the Options dialog box.
3. Click your mouse on the Calling tab. NetMeeting, in turn, will display the Calling options page.
4. Click your mouse on the drop-down box of the Directory section and select the new directory server that you want to use, as shown in Figure 394.

Figure 394 The Directory Server drop-down box.

5. After you have selected your new directory server, click your mouse on the OK button to complete the change of the directory server.

395 CALLING ANOTHER USER WITHIN NETMEETING

To hold a meeting within NetMeeting, each user must agree upon a NetMeeting server at which they will meet. You can find a list of NetMeeting servers in the upper right hand corner of the NetMeeting window. After you select a server, NetMeeting will display a list of users who are currently using that server. Within the user list, you should begin to see your associates' names. To refresh the list's contents, click your mouse on the toolbar Refresh button or click your mouse on the View menu Refresh option.

To call another user, click your mouse on the user within the user list and then click your mouse on the Toolbar Call button. NetMeeting, in turn, will display the Current Call window that lists users who are participating within the call, as shown in Figure 395. If the users are broadcasting video, NetMeeting will display each user's video window.

Figure 395 Viewing users within the current call.

396 HOSTING A NETMEETING CONFERENCE

You can host a NetMeeting conference from your computer without using a directory server by performing the following steps:

1. Click your mouse on the Call menu. NetMeeting, in turn, will display the Call menu.
2. Click your mouse on the Host Meeting menu option. NetMeeting, in turn, will display a dialog box explaining how to host a meeting. If you check the checkbox for Don't show me this message again, NetMeeting will not display the message in the future. Click your mouse on the OK button and NetMeeting will display the opening meeting screen. If you have previously checked the Don't show me this message checkbox, NetMeeting will display the opening meeting screen after you click your mouse on the Host Meeting menu option.

1001 INTERNET TIPS

After you have started the meeting, other NetMeeting users can connect to your meeting. As users connect to your meeting, NetMeeting will display them in the current call screen, as shown in Figure 396.

Figure 396 *The opening screen.*

When you host a meeting, all other participants in the meeting must connect to your meeting. Also, when you hang up from the meeting, NetMeeting will disconnect all users. You can exchange video and audio with just one other user but all users in the call can use Chat and the Whiteboard. The chat program works like the Microsoft Chat program in that you can type messages to all the users involved in your call. The Whiteboard works like a Microsoft Paint program that is shared by everyone in your call.

PLACING A CALL BY USING AN IP ADDRESS — 397

As you learned in the previous Tip, you can host a meeting and have other users connect to your computer. The easiest way to have users connect to your computer is if you are listed in a directory. As you also learned, you can host a meeting when there is no directory server; the users will need to connect to you when you are not listed in a directory. A user can connect to your computer by using your IP address like a telephone number. To have users connect to your computer by using your IP address, you must first know what IP address your computer is using. You can use *winipcfg*, discussed in Tip 836, "Displaying Your TCP/IP Address Configuration with WINIPCFG," to determine the IP address that your computer is using. You can use the IP address to connect to another NetMeeting user that is hosting a meeting or to connect one-on-one. Either way, you can use the IP address of a computer to connect to a computer running NetMeeting even though the computer is not listed in a directory. You connect to a NetMeeting meeting by performing the following steps:

1. Click your mouse on the Call button on the NetMeeting toolbar, NetMeeting, in turn, will display the New Call dialog box, as shown in Figure 397.

2. In the Address text box, enter the IP address of the user you are connecting to for your NetMeeting conference.

Figure 397 The New Call dialog box.

3. In the Call using text box, click your mouse on the drop-down list and select the Network (TCP/IP) option.
4. Click your mouse on the Call button. NetMeeting, in turn, will attempt to connect to the IP address that you entered.

If the computer using the IP address that you entered is not running NetMeeting or if the user of the computer refuses your call, NetMeeting will be unable to make the connection. If the computer you are trying to connect to is running NetMeeting and the user accepts your call, NetMeeting will connect you to the NetMeeting conference.

398 WORKING WITH CHAT IN NETMEETING

Although NetMeeting lets you talk to another user using your PC microphone and speakers and also lets you perform simple video conferencing, many users still find online chatting is fast and effective. To chat with another user within NetMeeting, click your mouse on the toolbar Chat button or click your mouse on the Tools menu Chat option. NetMeeting, in turn, will display a Chat window, as shown in Figure 398.

Figure 398 Using the Chat window within NetMeeting.

Each user in the current call can now participate in the chat. Within the Chat window, you can use the File menu Save and Print options to later print or save the chat discussion.

Working with the Whiteboard within NetMeeting 399

Within NetMeeting, you can use the Whiteboard to draw simple shapes or to preview images, as shown in Figure 399.

Figure 399 Using the Whiteboard to draw or exchange images.

The Whiteboard looks like the Windows 98 Paint program and you can use it in much the same manner as the Paint program. When you open the Whiteboard, every user in your meeting can view or edit the Whiteboard's contents. In fact, several users can each draw on the Whiteboard at the same time. To display the Whiteboard, click your mouse on the Tools menu and choose Whiteboard.

Sending Messages to Just One NetMeeting Participant 400

You learned in Tip 398, "Working with Chat in NetMeeting," that you can use the Chat window in NetMeeting to send messages to all users in a meeting. You can also use the Chat window to send a message to just one user in the meeting. You select the user to receive the private message by clicking your mouse on the Send to drop-down list and then enter your message. NetMeeting, in turn, will send the message to only the user you select from the drop-down list and will display the user's name in Italics within the chat window, as shown in Figure 400.

Figure 400 The Chat window in NetMeeting with a private message being sent to only one user.

1001 INTERNET TIPS

401 ENDING A CHAT SESSION IN NETMEETING

After you have finished with a chat session, you can exit out of the chat program without ending the NetMeeting call by using the Chat File menu Exit command, as shown in Figure 401.

Figure 401 The Exit command for the Chat program.

The exit command in the Chat program does not exit you out of the NetMeeting call, it will close only the current chat window.

402 CREATING SPEED DIALS IN NETMEETING

You can use a Speed Dial entry in NetMeeting to quickly call other users who are using NetMeeting. To create a Speed Dial entry, perform the following steps:

1. Click your mouse on the SpeedDial button on the NetMeeting toolbar. NetMeeting, in turn, will display the Add SpeedDial dialog box shown in Figure 402.

Figure 402 The Add SpeedDial dialog box.

2. Within the Address field, enter the address of the user you are going to call with the SpeedDial entry. The address can be an IP address or a directory server address if the user is listed in a NetMeeting directory.
3. Select the type of address you entered in the Address field from the Call using drop-down list.
4. Use the After creating the SpeedDial set of radio buttons to select where NetMeeting is to place the SpeedDial entry.
5. After you have entered all of the information, click your mouse on the OK button. NetMeeting, in turn, will close the Add SpeedDial dialog box and add the SpeedDial entry you selected in step 4.

You can now use the SpeedDial entry to quickly call a NetMeeting user, if he or she is online, by double-clicking your mouse on the SpeedDial entry. You open the Speed Dial window by clicking your mouse on the SpeedDial button in the Navigation bar on the left side of the NetMeeting screen.

PREVENTING NETMEETING FROM INTERRUPTING YOU 403

If you do not want to be interrupted by a NetMeeting call, you can stop NetMeeting from notifying you of an incoming NetMeeting call. To prevent NetMeeting from interrupting, you will place NetMeeting in Do Not Disturb. You can place NetMeeting in Do Not Disturb by performing the following steps:

1. Click your mouse on the Call menu on the NetMeeting menu bar. NetMeeting, in turn, will display the Call menu.
2. Click your mouse on the Do Not Disturb menu item. NetMeeting, in turn, will display an information dialog box stating that Do Not Disturb will prevent NetMeeting from notifying you of any incoming calls. You can stop this dialog box from being displayed by clicking your mouse on the Don't show me this message again checkbox.
3. Click your mouse on the OK button. NetMeeting, in turn, will close the information dialog box and put NetMeeting in Do Not Disturb.

If other users try to call you, NetMeeting will notify them that you did not accept the call. NetMeeting will not notify you that a call came in to you.

CONFIGURING THE NETMEETING CALL, AUDIO, OR VIDEO SETTINGS 404

As you have learned, within NetMeeting users can talk using their PC's microphone and speakers and can download video to create a simple video conference. If you experience problems with the audio or video that you send or receive, you may need to tune your current settings. To adjust your NetMeeting settings, click your mouse on the Tools menu and choose Options. NetMeeting, in turn, will display the Options dialog box, shown in Figure 404. Using the Options dialog box sheets, you can configure your call, audio, video, and personal information.

1001 Internet Tips

Figure 404 The NetMeeting Options dialog box.

Note: *To adjust your audio settings, you may want to use the NetMeeting Audio Tuning Wizard that you can start from the Tools menu. You used the Audio Tuning Wizard in Tip 393, "Starting NetMeeting Software for Windows 98," to set up NetMeeting to be used for the first time.*

405 Working with Web Directories

You can use the Microsoft Web Directory to help you find other users who are using NetMeeting on the Internet. You can display the Microsoft Web Directory by clicking your mouse on the Call menu in the NetMeeting menu bar. NetMeeting, in turn, will display the Call menu. Click your mouse on the Web Directory item in the Call menu. NetMeeting, in turn, will launch your Web browser and display the Web Directory for your default Internet Locator Service (ILS) directory. You can use the Web interface to find NetMeeting users who are online rather than using the Directory screen in NetMeeting. The Web interface to the Microsoft public ILS directories works in much the same manner as the NetMeeting Directory screen.

A second Web site for finding NetMeeting users that you can view with your browser is the NetMeeting Zone Web site, shown in Figure 405.1.

The NetMeeting Zone Web site has links to many different NetMeeting Web sites for developers of NetMeeting-enabled Web pages and applications, Web pages and applications that use some of the functions of NetMeeting, as well as links to sites for the beginner user, such as links to FAQ Web pages. The NetMeeting Zone also has a listing of ILS directories around the world at *www.netmeet.net/bestservers.asp*, as shown in Figure 405.2.

1001 INTERNET TIPS

Figure 405.1 The NetMeeting Zone Web site home page.

Figure 405.2 The NetMeeting Zone listing of other ILS directories throughout the world.

You can use the Web link to see who is online at a directory or use the address with NetMeeting to connect to the ILS directory in NetMeeting. You can use an ILS directory server in the NetMeeting program or you can use a Web browser to find a NetMeeting user.

USING THE NETMEETING HOME PAGE 406

The NetMeeting home page, at *www.microsoft.com/windows/netmeeting*, is a good Web page to get information about the latest developments with NetMeeting. You can also use the NetMeeting home page to see if there are new

1001 INTERNET TIPS

releases of the NetMeeting product so you can download the latest NetMeeting program. The NetMeeting home page has links to information about using NetMeeting for the first time and how to get the most out of your NetMeeting usage.

407 SENDING AND RECEIVING FILES IN NETMEETING

You can send to and receive a file from a user you are connected to using NetMeeting. To send a file to a user, you must connect to the user in a NetMeeting call, as discussed in Tips 395, "Calling Another User within NetMeeting," and 397, "Placing a Call by Using an IP Address." After you connect to the user you wish to send a file to, perform the following steps:

1. Click your mouse on the Tools menu in the NetMeeting toolbar. NetMeeting, in turn, will display the Tools menu.
2. Click your mouse on the File Transfer menu item. NetMeeting, in turn, will display the File Transfer sub-menu.
3. Click your mouse on the Send File menu item on the File Transfer sub-menu. NetMeeting, in turn, will display the Select a File to Send dialog box, as shown in Figure 407.1.

Figure 407.1 The Select a File to Send dialog box.

4. Use the Select a File to Send dialog box like a normal Windows open dialog box to find the file that you wish to send. Click your mouse on the file to send and click your mouse on the Send button. NetMeeting, in turn, will display an information dialog box showing that it sent the file.

When you receive a file from a NetMeeting user, you must respond to the File Receive dialog box, as shown in Figure 407.2.

Figure 407.2 The File Receive dialog box.

You can close the dialog box saving the file to your Received Files Folder, open the file, or delete the file. To open your Received Files Folder, click your mouse on the Tools menu File Transfer option, as when you were sending a file, then click your mouse on the Open Received Files Folder menu item. NetMeeting, in turn, will open the Received Files Folder with all files that you received from the file transfer.

Sharing an Application — 408

When you are in a NetMeeting call, you can share an application that is running on your system. When you share an application, other users that are connected to your NetMeeting call can see the application on their computers. You share an application by performing the following steps:

1. Start the application that you want to share with other users in the NetMeeting call.
2. Switch to the NetMeeting program and click your mouse on the Share button on the NetMeeting toolbar. NetMeeting, in turn, will display a list of applications running on your computer, as shown in Figure 408.1.

Figure 408.1 The Share button showing a list of applications that you can share with other NetMeeting users.

3. Click your mouse on the application that you want to share with the NetMeeting call. NetMeeting, in turn, will display an information dialog box. If you click your mouse on the Don't show me this message again checkbox, you will not receive this message when you share other applications from your computer.
4. Click your mouse on the OK button. NetMeeting, in turn, will close the dialog box and share the application you selected with other users in the NetMeeting call.

To work with the shared application, you will switch to the application and use it normally. The users with whom you are sharing the application will be able to see the work that you are doing but will not be able to use the application that is being shared.

When another user is sharing an application for you to see, NetMeeting will display the application in a window, with a tag showing who is sharing the application. You can see the results of what the user sharing the application is doing, but you cannot use the application, as shown in Figure 408.2. The shadow cursor that you see shows the initials of the user who is controlling the program.

Sharing an application lets you show others what you are doing with an application rather than only being able to describe what is happening with your program.

Figure 408.2 The view of an application that is being shared to let a NetMeeting user view the application.

409 — COLLABORATING IN NETMEETING

You learned how to share an application in the previous Tip. When you share an application, you can use the application and other users can watch you use the application. If you want to have other users in your NetMeeting call to be able to use the application so that all users in the call can work together, you must set the application to collaborate. To set an application for collaboration, you must first share the application, as discussed in the previous Tip. After you share the application, click your mouse on the Collaborate button on the NetMeeting toolbar. NetMeeting, in turn, will display an information dialog box warning you about collaborating with an application. When you are collaborating with an application, NetMeeting users who are viewing the application can request to use the application. Only one user can use the application at a time. If you are the one who shared the application, you can click your mouse in the application to regain control of it. You can stop collaborating the application by clicking your mouse on the Collaborate button on the NetMeeting toolbar or by pressing the ESC key on your keyboard.

410 — WORKING WITH THE NETMEETING HISTORY

The NetMeeting History screen will show the history of calls that you have received, as shown in Figure 410.

You can use the History screen for time-tracking purposes to give you a detailed list of all calls that you have received in one day. The History screen will display the name of the user that called you and whether you accepted or ignored the call. The History screen also will display the day and time of the call.

Figure 410 The NetMeeting History screen.

SETTING YOUR PERSONAL INFORMATION IN NETMEETING 411

You can change your personal information in NetMeeting after you have installed NetMeeting. To open the NetMeeting options dialog box, click your mouse on the Tools menu. Next, click your mouse on the Options menu item, then click your mouse on the My Information tab to make changes to your personal information in the NetMeeting program, as shown in Figure 411.

Figure 411 The My Information tab of the Options dialog box.

1001 Internet Tips

After you have changed your personal information, click your mouse on the OK button. NetMeeting, in turn, will close the dialog box, save your changes and it may ask you to log on to a directory server if you are not already logged on to a directory server.

412 Hanging Up in NetMeeting

When you are finished with a NetMeeting call, you can leave the NetMeeting call by hanging up. To hang up, click your mouse on the Hang Up button on the NetMeeting toolbar, as shown in Figure 412.

Figure 412 The Hang Up button on the NetMeeting toolbar.

If you have joined a NetMeeting and you hang up when there are more than two users in the NetMeeting call, the NetMeeting call will continue. If you hosted the NetMeeting call and you hang up, the NetMeeting call will end for all the users on the NetMeeting call.

413 Working with the NetMeeting Toolbar and Menus

You can use the NetMeeting toolbar to use many of the features of the NetMeeting program, as shown in previous Tips. You can also use the NetMeeting menu items to access any of the NetMeeting features. The Call and Hang Up toolbar buttons are in the Call menu and all the other toolbar buttons are in the Tools menu. If you prefer to use the menus, you can have NetMeeting hide the toolbar so you have more space in the NetMeeting main screen. To hide the NetMeeting toolbar, click your mouse on the View menu. NetMeeting, in turn, will display the View menu. On the View menu, click your mouse on the Toolbar menu item. NetMeeting, in turn, will hide the NetMeeting Toolbar. If you want to unhide the Toolbar, just repeat the steps to hide the Toolbar and NetMeeting will display the Toolbar again.

414 Using the NetMeeting Navigation Bar

You can use the NetMeeting Navigation bar to move quickly between the different NetMeeting screens. The Navigation bar is displayed along the left side of the NetMeeting screen, as shown in Figure 414.

Figure 414 shows the NetMeeting main screen displaying the directory screen. If you want to see your list of SpeedDial entries, click your mouse on the SpeedDial Navigation button. NetMeeting, in turn, will display the

SpeedDial entry list in the main screen. Likewise, you will see the current call that you are on if you click your mouse on the Current Call button and the History screen if you click your mouse on the History button.

Figure 414 The NetMeeting Navigation bar.

USING NETMEETING WITH OUTLOOK 415

Combining NetMeeting with Outlook offers an effective and inexpensive way to work with users in your company all over the globe without the need for travel. NetMeeting can integrate into Outlook to make it easier to connect to other users by placing the NetMeeting icon on the Outlook toolbar, as shown in Figure 415.

Figure 415 The NetMeeting icon on the Outlook toolbar.

You can click your mouse on the icon to start the NetMeeting program and connect to other users in your company. You can also plan NetMeeting meetings using the Outlook Calendar. You simply set an appointment when other users will be able to call into a meeting you are hosting. Using this method for a conference call, you can share applications so that all the users involved in the meeting can participate.

SETTING UP AN INTERNET LOCATOR SERVER 416

In previous Tips, you used public Internet Locator Server (ILS) directories to find other NetMeeting users but you may want to set up a private ILS directory for your organization. A private directory will make it easy for employees

in your company to connect using NetMeeting. You must use a special server with a program from Microsoft called Site Server 3.0, which can act as an ILS directory. A networking professional with experience setting up Internet servers should perform the installation of Site Server. Microsoft no longer supports the old Internet Locator Server program, though you may still be able to download the program and use the older ILS program rather than Site Server. After you have your Internet server installed with programs to have the server work as an ILS directory, users in your company can start to use your private ILS directory.

417 USING NETMEETING AS AN INTERNET PHONE

You can use NetMeeting to call anyone who is connected to the Internet. If you have family on the opposite side of the world, you can talk to them across the Internet as if you were using a telephone. To use NetMeeting as a phone, both you and the user you want to call must have the NetMeeting software and a connection to the Internet. NetMeeting is free from Microsoft and an Internet connection is usually under $20 per month. After you have all the pieces in place, you can set a time to meet at an ILS directory or find out what your Internet IP address is using *winipcfg*, as described in Tip 836, "Displaying Your TCP/IP Address Configuration with WINIPCFG," so the user can call you using advanced dial. If you have special equipment in your company, you can use NetMeeting to connect to a computer that is local to who you want to call and have the computer make a local call to the user and connect your NetMeeting call from the Internet to the phone line.

418 UNDERSTANDING INTERNET TELEPHONY

Internet telephony is the process of sending and receiving voice communication over the Internet. Internet telephony is not limited to sending just voice but also includes video conferencing. The use of the Internet to send voice communication can differ widely in the type of quality. With a medium to high end personal computer and a good connection to the Internet, you may experience a sound quality that is better than calling a user long distance. With a low end personal computer or a bad connection to the Internet, you may experience a sound quality that is much below a normal long distance call.

An Internet phone gateway is a device that connects the Internet to a local phone system. You use an Internet phone gateway by connecting to a gateway that is local to a person that you wish to call across the Internet. After you have connected to the gateway from the Internet, you will have the gateway place a local telephone call to the user you wish to call. The phone call is a local call so it is at little or no charge to you and you are using the Internet as the long distance carrier, also at little or no charge. There are many new possibilities that are available to users of Internet telephony from full video conferencing with a product like NetMeeting to just calling a family member to talk with a simple program like buddyPhone.

419 CHECKING YOUR COMPUTER FOR THE EQUIPMENT TO USE AN INTERNET PHONE

Before you can use products like NetMeeting or any Internet phone to make calls on the Internet, you must have some extra equipment on your computer. To start, your computer should be at least a Pentium 75 with 16MB of

memory. In addition to the computer, you must have a modem that is rated at least a 28.8 Kbps modem and a sound card that will let you attach a microphone and speakers to your computer. This equipment is only minimal and will most likely not give you a high sound quality when using an Internet phone. The two most important items that will help your Internet phone experience are a faster connection to the Internet and a faster computer.

INSTALLING BUDDYPHONE 420

BuddyPhone is an Internet phone program that you can use to talk across the Internet to another user who is also using buddyPhone. To use buddyPhone, your computer must have the equipment discussed in the previous Tip. You can install buddyPhone by performing the following steps.

1. Insert the CD-ROM that accompanies this book in your CD-ROM drive. Click your mouse on the Start button. Windows, in turn, will display the start menu. Click your mouse on the Run command. Windows, in turn, will display the Run dialog box.

2. In the Run dialog box, enter *D:\Inetphone\buddyphone.exe*. Replace D: with the drive letter of your CD-ROM. Click your mouse on OK. The buddyPhone installation program, in turn will start and display the opening screen shown in Figure 420.1.

Figure 420.1 The buddyPhone installation program Welcome screen.

3. After you have read the information, click your mouse on the Next button. The installation program, in turn, will display the Choose Destination Location dialog box for the program files.

4. The default destination for the program files should work for most installations. Click your mouse on the Next button. The install program, in turn, will display the Select a Program Manager Group dialog box.

5. The default Program Manager Group should work for most installations. Click your mouse on the Next button. The installation program, in turn, will display the Start Up Folder dialog box.

6. You should read where the installation program is going to place a short cut to the buddyPhone program on your system. If you do not want the installation program to place a short cut to the buddyPhone program in a location, then click your mouse on the corresponding checkbox to uncheck the option. After you have selected only the locations where you want a short cut, click your mouse on the Next button. The install program, in turn, will display the Start Installation dialog box.

7. To start the installation, click your mouse on the Next button. The installation program, in turn, will start the installation of files. After installing all the files, the installation program will display the Installation Complete dialog box.

8. Click your mouse on the Finish button. The install program, in turn, will close the installation program. You may need to start the buddyPhone program to start the Setup wizard that will display a Welcome screen.

9. Click your mouse on the Next button. The Setup wizard, in turn, will display the User Information dialog box.

10. The buddyPhone program can work with the ICQ program so that if you have installed the ICQ program, you can click your mouse on the Get From ICQ button and the Setup wizard will fill in the information from your ICQ information. After you have completed the User Information, click your mouse on the Next button. The Setup wizard, in turn, will display the Internet Connection dialog box.

11. Select the connection type that best describes the connection speed that you have to the Internet, then click your mouse on the Next button. The Setup wizard, in turn, will display the Web Pages dialog box.

12. If you want your information on the Internet, click your mouse on the Make my online presence public in the Web pages checkbox, otherwise leave the checkbox unchecked. Click your mouse on the Next button. The Setup wizard, in turn, will display the Finish dialog box.

13. Click your mouse on the Finish button. The Setup wizard, in turn, will display the About this software dialog box.

14. If you want to complete the survey, click your mouse on the Next button. Otherwise, click the Cancel button. If you complete the surveys, you will answer several dialog boxes of survey type questions. After you finish the survey, click your mouse on the Click here link to remove the ad dialog box.

The buddyPhone program is free if you leave the ad banner above the Buddyphone program, as shown in Figure 420.2.

Figure 420.2 The buddyPhone program with the ad banner for the free version.

Now that the buddyPhone program is installed, you are ready to enjoy Internet Telephony.

421 PLACING A CALL WITH BUDDYPHONE

To place a call with buddyPhone, start the buddyPhone program. In the buddyPhone program window, click your mouse on the phone icon. The buddyPhone program, in turn, will display the Connect to menu, as shown in Figure 421.1.

1001 Internet Tips

Figure 421.1 The Connect to menu in the buddyPhone program.

If you have installed the ICQ program and created a list of ICQ contacts, buddyPhone will display your list of ICQ contacts that are currently online. You can click your mouse on one of your ICQ contacts to connect and if the contact that you are trying connect to has buddyPhone running on his or her computer, you will connect to his or her computer. If you are calling a user who does not use ICQ, or if you do not use ICQ, you can click your mouse on the Connect to menu option. The buddyPhone program, in turn, will display the Place a call dialog box, shown in Figure 421.2.

Figure 421.2 The Place a call dialog box.

To place a call, enter a host name, an e-mail address, or the IP address of the user that you are calling. Click your mouse on the Connect button. The buddyPhone program, in turn, will connect you to the user that you are calling and you can start talking as you would on a phone.

USING THE INTERNET IN PLACE OF A FAX — 422

You can use the Internet in place of sending a fax to a user. While there are parts of the Internet Telephony that do involve faxing across the Internet, you can send an e-mail with an attachment in most situations that you would send a fax. If you just need to send a document to a co-worker, you can simply attach the document to an e-mail message to the co-worker. You will save the cost of fax supplies and a phone call.

UNDERSTANDING VIRTUAL REALITY MODELING LANGUAGE (VRML) — 423

Today, many users are familiar with the term *virtual reality*, but few users have ever experienced a virtual reality site. Virtual Reality Modeling Language, or VRML, is a programming language that lets you create three-dimensional (3-D) graphics on the Web. In the mid-90's, VRML became popular with programmers to create 3-D virtual worlds in which users could interact with one another by manipulating 3-D animated characters. Users considered the 3-D characters, or avatars, an improvement over traditional text-based chat rooms. The only requirement to use

1001 Internet Tips

VRML is a VRML reader which is included with Windows 98, but can also be obtained from various Web sites. One example of a VRML reader is WorldView which is available from Intervista Software *www.intervista.com*.

424 INSTALLING VRML SUPPORT WITHIN WINDOWS 98

After you have installed the Windows 98 VRML viewer, you can use Internet Explorer to view virtual reality sites. For example, Figure 424 shows a site that supports virtual reality.

Figure 424 A site that displays virtual-reality images.

As discussed in the previous Tip, programmers often use VRML to create virtual-reality images. To let the Internet Explorer display the contents of sites that use VRML 2.0 (the most recent VRML specification), Windows 98 provides software you can install from the Windows 98 CD-ROM. To install support for VRML 2.0, perform the following steps:

1. Click your mouse on the Start menu move to Settings and choose Control Panel. Windows 98, in turn, will open the Control Panel window.
2. Within the Control Panel window, double-click your mouse on the Add/Remove Programs icon. Windows 98, in turn, will display the Add/Remove Programs Properties dialog box.
3. Within the Add/Remove Programs Properties dialog box, click your mouse on the Windows Setup tab. Windows 98, in turn, will display checkboxes for the Windows 98 components.
4. Within the Windows 98 component list, click your mouse on the Internet Tools checkbox, then click your mouse on the Details button. Windows 98, in turn, will display the Internet Tools dialog box.
5. Within the Internet Tools dialog box, click your mouse on the Microsoft VRML 2.0 Viewer checkbox, placing a checkmark within the box. Then, click your mouse on the OK button.
6. Within the Add/Remove Programs Properties dialog box, click your mouse on the OK button.

After you install the Windows 98 VRML 2.0 software, perform the steps in the next Tip to take a VRML test drive.

LOOKING AT VRML SITES

425

In the previous Tip, you learned how to install Windows 98 support for VRML 2.0. After you install the VRML 2.0 software, you may want to test drive some VRML sites using the Internet Explorer. To view a VRML site, you simply type in the site's address within the Internet Explorer's Address field. The site, in turn, will usually provide instructions that tell you how to view its virtual world. To get a better feel for virtual worlds, check out the sites shown in Figures 425.1 and 425.2.

Figure 425.1 Viewing virtual reality at www.janvier.com/vrml/Fvrml.htm.

Figure 425.2 Viewing virtual worlds at www.worldwar1.com/vrml/spad/spad.wrl.gz.

To link to these sites and more, browse the VRML gallery at *http://www.intervista.com/vrml/gallery*. You might also want to check out the Web 3D Consortium site at *http://www.vrml.org*.

426 UNDERSTANDING COMPUTER SECURITY

Computer security has many meanings and many faces in the world of the Internet today. In its simplest form, computer security is the practice of protecting your computer system and the information on your computer system from harm. You may only have a small computer system but you should take care to incorporate some level of computer security into all aspects of your computer system when you are working on the Internet. Computer security covers several categories: the physical security of your computer system, network security of your computer system, intruder detection, and virus program detection. As a home user, you will not need to be as concerned about all of the categories of computer security but it would not be wise to ignore all aspects of computer security. In your place of work, if your company's network connects to the Internet, computer security becomes a greater concern for the user responsible for keeping your system running. At home, you are less likely to have problems with users breaking into your system. If a computer hacker, someone who breaks into computer systems, invades your home system, the consequences are not as drastic. A hacker breaking into your computer system at work can be a devastating blow to your company. In the following Tips, you will look at computer security in greater detail.

427 UNDERSTANDING NETWORK SECURITY

Network security deals with protecting your network and the computers connected to your network from intrusion by users not authorized to use your systems. Network security tries to keep unauthorized users from using a network connection to gain access to your computer systems. Network security involves protecting the data on your computer systems as well as the computer system itself, and also protecting communications across your network from being intercepted and viewed by unauthorized people.

428 UNDERSTANDING PHYSICAL SECURITY

One area that users often overlook when they implement computer security plans is the physical security of the computer systems themselves. While you may have the best security in the world for your network, if users can walk up to your computers and turn them off or steal data from them directly, you do not have a complete security plan. You should keep your servers or central computers systems in a controlled area so that only authorized personnel can access the computers. You should also have some of your printers in controlled areas if you print sensitive documents, such as personal information or checks.

429 KEEPING HACKERS OUT OF YOUR COMPUTER SYSTEM

Keeping intruders out of your computer system is a major concern of computer administrators at companies with large computer systems. The average home computer user, however, does not need to be as concerned with hackers breaking into their home computer. At home, three aspects of home Internet use protect you: obscurity, being on the Internet for relatively short periods of time, and the probability that your home computer is not of interest to most hackers. Obscurity protects your computer in that your computer is only one of a large number of computer systems on the Internet. It is difficult to find your computer, the electronic needle in the Internet haystack. When you connect to the Internet, you most likely connect for a short time that does not give a hacker much time to find and break into your computer. Even though you may spend hours on the Internet, it is short compared to computer systems that connect to the Internet 24 hours per day, 7 days per week.

A hacker may be able to get into your home computer but it is unlikely. The computer system at your work is a more likely target. Even if you are not the user responsible for your computer at your place of work, you should take some precautions to keep hackers out of your computer system. The biggest precaution that you can take to prevent computer break-ins at your place of work is to use a password to log into your work computer system. DO NOT write the password down and stick it to your monitor. Many times users who break into a company's computer are users that work for the company using passwords they got from other employees. A second popular way for a hacker to break into a computer system is to call an employee of a company. The hacker will pretend to be an employee from the company's computer department and say he or she needs your password. You should never give your password over the phone to a user you do not know, and you should be cautious about giving your password to anyone. If you follow these steps, you can go a long way to helping your company keep hackers out of your company's computer system.

430 UNDERSTANDING FIREWALLS

One method you can use to protect your computer network from attack from the Internet is to use a firewall. In the context of building construction, a firewall separates and isolates rooms from each other so in case of a fire, the fire does not spread. A computer firewall performs the same function in that a computer firewall separates and isolates computer networks. A firewall is a computer that separates your internal network from an external network, such as the Internet.

The strongest protection you can use is to not connect your network to the Internet but then you do not get any of the benefits of the Internet. An example of a more usable firewall is to have one computer, and only one computer, connected to the network you do not trust, such as the Internet, and also connected to your internal or private network. A common name for the one computer that separates your network from all other networks is a bastion host. When your internal network and the Internet connect through only one computer, you can secure that one computer. All users can get the benefits of the Internet, but you must monitor only one computer to see if a hacker is trying to break into your network.

431 UNDERSTANDING HACKERS

You may have heard the term hacker before you read the preceding Tips but you may not have known the definition of a hacker. Hacker did not always have the negative meaning that it has now. It used to mean someone who was skilled at writing programs for computers. As some of these hackers started to use their skills to break into computers at universities and corporations, the term hacker started to take on the meaning that it now has today. Today, hacker refers to a person who uses knowledge of computer systems to get around computer security systems to gain unauthorized access to a computer system. Some hackers break into systems just to see if they can break-in, and leave everything unchanged. It is a challenge for the hacker to beat the security systems. Some companies pay a person to be a hacker to test if the security on the their computer systems is safe from break ins. Some hackers break into computers just so they can break the system and cause problems for the users who own the computer system. This last type of hacker has done more damage to the concept of the Internet, the free exchange of information, than any other group. In the early days of the Internet, users trusted other users. However, as hackers became more common, the users who ran the computers on the Internet had to start restricting who could access their computer systems, thereby restricting the free flow of information.

432 UNDERSTANDING COMPUTER VIRUSES

A computer virus is a program that attaches itself to other programs and automatically makes a copy of itself to attach to other files. The term virus refers to the method that a computer virus uses to copy itself, which is similar to how a biological virus will copy itself from cell to cell. A computer virus will try to make a copy of itself on something a user may send to a second computer so it can move to the second computer and copy itself again. Some viruses will only try to copy themselves to floppy disks and files. Some more damaging viruses try to copy themselves to other disks and then, at a certain time, try to erase files on your computer system. While the former type of virus is a nuisance, the later type can be extremely damaging to your computer system. Unlike hackers breaking into your home computer, computer viruses are very common and can damage your home computer as well as your office computer. Firewalls do not help to keep viruses out as computer users transfer most viruses between computers by using the same floppy on each computer or by transferring files between two computers.

Several types of viruses can infect your computer. The Trojan Horse virus is a virus that looks like a usual piece of software but actually has malicious code in the program. A polymorphic virus is a virus that will use a randomly generated number to change part of the virus code so that the virus looks like a different program from the original program. Because a polymorphic virus changes its code each time it infects a file, it is much more difficult to find and remove from your system. A stealth virus is a virus that infects a computer and also monitors your computer system to see if any anti-virus software is looking for viruses. If a program can detect a virus by reading an infected disk drive, the virus will fake the response to the program trying to read the file and show that no virus is on the disk drive, thus hiding the presence of the virus. A slow virus will only infect a file when a user copies it to some other drive so that the original file is never infected and the virus may go undetected. A retrovirus is a virus that attacks anti-virus software. Phage viruses are viruses that replace a file completely rather than just attaching to a file. By replacing the file, a phage virus causes more of a problem because even after you detect the virus, it has destroyed the original file.

Understanding Macro Viruses 433

All of the viruses discussed in Tip 432 are part of some program. For the virus to work, a program must run that has the virus as a part of the program. If you do not run a program that is sent to you, then the virus cannot infect your system. In the past, plain old documents were never a concern when worrying about viruses. The use of "were never a concern" is correct due to the emergence of a document-based virus known as a macro virus. Macro viruses are quickly becoming the most common type of virus. A macro is a small program that automates some task in an application, such as Word. You can save a macro with a document and configure the macro to execute when you open the document to view it. A macro virus is a virus that is saved in a document rather than a program and the macro virus activates when you open infected documents. The important thing to remember about macro viruses is that they are part of a document, like a Word document or an Excel spreadsheet, and not a program that you must execute. Macro viruses do not change the document, so when you open the document, you will not notice any problems with the document but the macro could be doing harm to your system as you look at the document.

Catching a Virus on Your Computer System 434

Users pass most viruses through the sharing of files. The most common way for your computer to catch a virus is from files that other users send to you on a floppy disk, in an e-mail, or over a network. Another common way to get a virus is to download a program from the Internet. Most sites on the Internet that have files for download are very careful about keeping their programs virus free, though sometimes a virus will slip through. Users pass most viruses when they share programs or floppy disks. The first user may get the virus by downloading a program from the Internet but users sharing the original program then pass it around. The macro virus is becoming more common than any other type of virus infecting computers today. When users get macro viruses, they often do not know that a virus has infected their computer and send files to other users without realizing that they are spreading a virus. You will realize you have some viruses as soon as you get them, but the viruses will have already done damage. In general, you should use anti-virus software to scan any files that you download off of the Internet or that another user gives you.

Understanding Computer Worms 435

The computer worm is similar to a computer virus in that it is a program that copies itself to other computer systems and is also destructive to the computer system that it is infecting. A worm performs two operations. The first is to find other computers connected to the computer that the worm has infected to which the worm can copy itself. The second operation is to take over the computer's memory slowly until the computer system crashes and is shut down. A worm will slowly take down a computer system so that the worm has time to find connected computers and to copy itself to the connected computers. A worm does not need to change any existing programs so a worm does not infect files like a virus. For a worm to work and to copy itself to other computers, the computer's operating system must let a program from a computer connected by a network start a program. The Win9x operating systems are not suited to have a worm infect computers running the Win9x operating system. Worms run on network server systems like Windows NT and Unix-style systems.

1001 Internet Tips

In the late 80s, a worm on the Internet shut down over a thousand main computers at universities, businesses, and government agencies. Because all of these systems were Unix-style systems, connected together through the Internet, and users still trusted other users on the Internet, the Internet Worm was able to copy itself to many systems across the Internet. In some cases, as soon as a computer administrator erased the Internet Worm off of a computer, the worm was copied right back from a second system. It is less likely today that a worm in the Internet could cause as many problems as it did in the late 80s because computer administrators are much better prepared to deal with worms and viruses, and users are not as trusting on the Internet as they used to be.

436 UNDERSTANDING VIRUS PROTECTION SOFTWARE

The best way to protect your system from computer viruses is to use anti-virus software. Every virus has a signature that identifies the virus to itself so that the virus does not change its own code. The signature can be a set of characters or a math algorithm that the virus uses to see itself. Anti-virus software uses a database of virus signatures to scan through a file or a disk drive to find and try to eliminate any viruses that may be present. Modern anti-virus software will also monitor the computer system to alert you if any program that is executing is behaving like a virus program. To truly protect your computer from viruses, you should get good anti-virus software that has a large database of known viruses and a monitor that will monitor your system for viruses that may try to infect your system. After you have the anti-virus software, you should scan all files that you download from the Internet or that another user gives to you as well as your e-mail, and any e-mail attachments. If your company has a firewall out to the Internet, as discussed in Tip 430, "Understanding Firewalls," your system administrator can place an anti-virus program on the firewall to scan incoming files for viruses. Running an anti-virus program on the firewall can dramatically slow your access to the Internet.

Many different anti-virus software programs exist on the market today. Some of the more reputable anti-virus software vendors are McAfee Associates, who makes McAfee Anti-Virus; Symantec Corporation, who makes Norton AntiVirus; IBM, who makes IBM Anti-Virus; and Kaspersky Lab, who makes Anti-virus Toolkit Pro. Many of the anti-virus software makers have a Web page where you can download a trial version of their anti-virus software. The page for Anti-virus Toolkit Pro is shown in Figure 436.

Figure 436 The home page for Anti-virus Toolkit Pro.

Downloading a trial version is a good way to get anti-virus software in your hands right away and for you to see what an anti-virus program can do for your system's protection. As shown in Figure 436, the home pages of virus software vendors are also a good source of information about current viruses in the world.

UPDATING YOUR VIRUS SOFTWARE 437

As you learned in the previous Tip, anti-virus software uses a signature to identify viruses and try to eliminate them from your computer system. The anti-virus software uses a database of virus signatures to find viruses on your computer. You should update your anti-virus program's database on a regular basis to keep current with the latest viruses that may infect your computer system. Most anti-virus software on a computer connected to the Internet will remind you that the virus database must be updated and will download the updated database from the software maker's Web site. Most anti-virus programs have an Update option you can use if you need to Update your database before the program reminds you. Figure 437 shows the update option for the Anti-virus Toolkit Pro.

Figure 437 The Update option for the Anti-virus Toolkit Pro.

RUNNING A VIRUS CHECK FROM THE WORLD WIDE WEB 438

Anti-virus software has come to the Web for easy use by you. You can have your system scanned for viruses by viewing a World Wide Web page with your Web browser. One company that is bringing virus scanning to the Web is Trend Micro with a product called HouseCall, as shown in Figure 438.

To use this virus scanner, view the Web page from which you can download and run an active X control, small program, to scan for viruses. The only problem with the HouseCall package is that it does not protect your computer system from being infected with a virus. The HouseCall program can only check to see if there are viruses on your system at the time that you scan for viruses. The HouseCall program is good if you think you have a virus but you do not have virus software. When you use a Web-based virus scan, you should be careful that you know the company that is presenting the Web page is a real anti-virus company. If the program that an anti-virus Web site downloads to your system is a virus in itself from a Web page that is pretending to be an anti-virus page, you could be damaging your system rather than helping it.

1001 Internet Tips

Figure 438 The HouseCall virus scanning Web page.

439 UNDERSTANDING ENCRYPTION

When you send information over the Internet, your information moves over many different networks to get to its final destination. As your information goes over the different networks, users unknown to you could intercept and read it. Sending information over the Internet is often compared to sending a postcard in the mail: for the most part, no one is interested in reading it but they can if they want. To prevent other users from reading communications you send over the Internet, you can encrypt them.

Encrypting communications is the process of scrambling your information by using a mathematical process that is complex and difficult to reproduce. The mathematical process uses an encryption key to scramble your information and also to unscramble your information. The mathematical process used to create encrypted information must be complex enough that it is difficult and time consuming to recreate the information that is encrypted without the key used to encrypt. The key used to encrypt the information is a number that must be large enough that it is also difficult and time consuming to guess or find by random trial. There are different methods of encryption but they all involve the use of a complex mathematical process and a large number used as a key.

440 UNDERSTANDING KEY LENGTH FOR ENCRYPTION

As you learned in the previous Tip, a mathematical process to encrypt information uses a large number. The large number is called a key. The length of a key will determine how difficult it is to break the encryption. You measure key length in the number of bits, a 1 or a 0 in the computer, used to represent the key. The more bits used to

represent your key, the more secure your encryption. If 512-bit encryption protected your information, it would take most home computers many years to crack. Even 40-bit encryption would take an average home computer years to crack. The important thing to remember about encryption is that no matter what the key length, the encryption can be cracked in time. If you use fast, expensive computers, the time to crack encryption for small keys may be days or, given the rate of computer advances, even hours or minutes by the time you read this Tip. You need to determine if what you are encrypting is worth the time and energy that it would take to crack your encrypted information. In most cases, the 40- or 128-bit encryption that most Web browsers can use is more than enough. However, if you need stronger encryption, you can get programs that use key lengths up to 4,096 bits. The longer the key length the more computer resources an encryption program uses. In the 40- or 128-bit encryption key length, there is little difference, but in the 4,096 key length, you may notice that your system slows slightly as you encrypt information.

UNDERSTANDING SINGLE KEY ENCRYPTION 441

Single key encryption, as the name suggests, uses a single key to both encrypt and decrypt a message. After you encrypt a message using single key encryption, you must give the key you used to the user who is going to decrypt the message. When the user to whom you are sending an encrypted message has the message and the key, he or she can then decrypt the message. The main problem with single key encryption is that both the sender and the receiver of an encrypted message must know the key that is used to encrypt and decrypt the message. If, in the process of sending the encryption key the key is copied, any user who has a copy of the key can decrypt a message that has been encrypted with the copied key. The need to have the single key known by both parties causes difficulty in using single key encryption by itself over the Internet because it is easy to copy the single key as it passes over the Internet. To ensure that only the recipient of an encrypted message can decrypt a single key encrypted message, you must exchange the single key in a secure manner. A secure manner is one that ensures that only the intended recipient of the key receives the key. A benefit of single key encryption is that it is a fast method of encrypting a message. In single key encryption, only a single encryption key is used to both encrypt and decrypt a message and requires a secure method of exchanging the key.

UNDERSTANDING PUBLIC KEY ENCRYPTION 442

Unlike single key encryption, public key encryption uses a set of two keys that work together to encrypt and decrypt a message. You will have both a public key and a private key to work with encrypting messages. You use a private key to decrypt a message that a user has encrypted with a public key that was made to work with the private key. A public-key private key set is made at the same time and one key will work only with the other key in the set. You can also encrypt with a private key and only the corresponding public key can decrypt the message. Also, when a public key encrypts a message the public key cannot decrypt the message, only the private key can decrypt the message. The ability of a public key to encrypt a message and not be able to decrypt a message makes public key encryption a strong method of encrypting information for the Internet. If you want to send encrypted messages across the Internet, you can publish your public key to the whole Internet and no user can use the public key to decrypt your messages. You will keep your private key in a secure place so that only you can decrypt messages encrypted using your public key. Any user on the Internet can encrypt a message to you and send the message without you needing to get an encrypting key to the sender through a secure method. The use of public keys makes it easy to send an encrypting key to a user over the Internet and not have the

key copied or used to decrypt messages that are sent to you encrypted. The use of a public key that can be sent across the Internet to encrypt a message sent to you, and a private key that is known only to you that can decrypt, makes it possible to send encrypted messages across the Internet.

443 UNDERSTANDING DIGITAL SIGNATURES

A digital signature is used to verify that a message came from a sender and has not been changed after the sender sent the message. A digital signature is created by first using a mathematical algorithm on the message to produce a unique number for the message, called a message digest. If any part of a message is changed, then the message digest will change as well. When the message is received, the same mathematical algorithm will be used to produce a message digest and the digest is compared to the digest that was created by the signer. If the digests are the same, the message has not been changed. The digest is used to ensure that a message is not changed after it has been sent. The digest does not verify who the message came from or that the message digest was not changed. To do both of these tasks, the sender of a message will encrypt the digest with the private key. If the sender is the only person that has the private key, and the public key that matches the private key is the only key that can decrypt a message that is encrypted with a private key, then, if you are able to decrypt a message digest with a public key for the sender, then the sender sent the message. It is both the encryption of the message digest and the message digest itself that make a digital signature. The message digest ensures that the message has not changed and the fact that you can decrypt the message digest with the sender's public key ensures that the sender sent the message. A digital signature does not encrypt a message, it only signs a message. You will still need to use the public key of the user who is to receive the message to encrypt the message. A digital signature uses a sender's private key to encrypt a message digest to ensure that the sender sent the message and that the message was not changed after the message was sent.

444 UNDERSTANDING SMART CARDS

A smart card is a device that is the size of a standard credit card. There are many different types of smart cards that serve different functions, but the type of smart card that is useful for working as a digital ID is the integrated circuit card (ICC). The integrated circuit card smart card has a small computer that is stored in the plastic card itself. The ICC smart card will store an encryption key and a digital certificate so that you can have your digital certificate with you even when you are working on a computer that is not yours. You can use the smart card to log on to computer systems by using the digital certificate that is stored on the card. The smart card requires a smart card reader to be attached to the computer on which you are trying to use the smart card. Smart cards provide good security for your digital certificate because the certificate is stored on the smart card and not on a computer. When you leave a computer on which you used your smart card, you take the smart card and your certificate with you without leaving the certificate on the computer.

445 DISTRIBUTING YOUR PUBLIC KEY

As you learned in Tip 442, "Understanding Public Key Encryption," users can use your public key to encrypt messages they send to you. You learned in the previous Tip that users can use your public key to decrypt digital

signatures that you add to messages. You can distribute your public key in many ways without concern for the security of the public key, because having your public key will not let a person decrypt messages sent to you. The most common way to distribute your public key is to include the key in an e-mail to all users that may need to encrypt a message to you. You can also use some type of central directory to publish your public key where users can go get your public key when they want to send a message to you. Companies that create encrypting software and products will often have a directory where you can publish your public key. Many users will also include their public key at the bottom of every e-mail they send so that any user to whom they send e-mail can use their public key.

Understanding a Digital ID — 446

A digital ID is like any other ID that you may use, such as your driver's license. Another name for a digital ID is a certificate or an X.509 certificate. X.509 is an international standard of what information a digital ID should include in the ID. A digital ID is a public key private key pair you use for encryption but the key pair is connected to a user's identity to make the key pair an ID for the user. You can get a digital ID from a certificate authority like Verisign who will create a digital ID for you and may attempt to verify that you are who you say you are depending on the level of digital ID you purchase. When you receive the digital ID, you can then use the digital ID to authenticate yourself to Web sites without the need to use a password, as the digital ID is the verification that you are who you say you are. You can also use your digital ID to sign messages that you send to other users using a digital signature, as discussed in Tip 443, "Understanding Digital Signatures." The digital ID has a public-key/private-key encryption pair as a part of the certificate. The certificate authority that issues the digital ID attests that the identity of the user using a digital ID is the real user that is claiming to use the ID. When you sign an e-mail or if you send your public key part of your digital ID to a user, that user can then send you encrypted messages. The service that you use to create your digital ID can also hold the public encryption key part of your digital ID so that other users can use your digital ID to send you encrypted messages.

Getting a Digital ID from Verisign — 447

You can get a digital ID from Verisign via the link from their Web page at *www.verisign.com* to their Individuals Certificates page. At the Individuals Certificate page, you can obtain your digital ID that is valid for a year or you may be able to get a sixty day trial digital ID. To start the process of getting your digital ID, you will enroll with Verisign to get a class 1 digital ID. A class 1 digital ID is an ID used to create digital signatures, list you in a directory so users can encrypt messages to you, and will give you some monetary protection if another user misuses your digital ID. You will need to fill out information about yourself, and if you are purchasing the ID, you will need to include credit card information. All this information is encrypted using SSL encryption in your Web browser (see Tip 850.) After you submit the enrollment form, Verisign will e-mail the information about your digital ID and how to start to use your digital ID to the e-mail address that you enter on the enrollment form. It is important that you enter the right e-mail address for yourself, as Verisgin will send all information about your digital ID to that e-mail address. The e-mail that you receive from Verisign will contain a digital ID PIN and a link to a Web page at the Verisign Web site where you will get your digital ID. Verisign will automatically install the digital ID into your browser and you can also install it into your *Outlook Express* e-mail client. To install your digital ID in your e-mail client, perform the following steps:

1001 Internet Tips

1. Start *Outlook Express* and click your mouse on the Tools menu. *Outlook Express*, in turn, will display the Tools menu.
2. Click your mouse on the Accounts… option. *Outlook Express*, in turn, will display the Internet Accounts dialog box.
3. Click your mouse on the Mail tab and then click your mouse on your e-mail account that you want to use with the Digital ID. Next, click your mouse on the Properties button. *Outlook Express*, in turn, will display the e-mail account Properties dialog box.
4. Click your mouse on the Security tab and select the Use a digital ID when sending secure messages from checkbox. Then, click your mouse on the digital ID button. *Outlook Express*, in turn, will display the digital ID dialog box with your digital ID you just installed in your Web browser.
5. Select your digital ID and click your mouse on the OK or on the Close button for all remaining dialog boxes.

After you receive the e-mail from Verisign and you install your digital ID, you can start signing your e-mail messages.

448 UNDERSTANDING ENCRYPTION SOFTWARE

Previous Tips have presented the concept of encryption to you but for you to use encryption, you must use a software program that makes use of encryption. There are many different programs that can make use of encryption technologies. *Outlook Express*, which you set up with a digital ID in the previous Tip, is using encryption when you send an encrypted message to a user. Your browser uses encryption when you make a connection to a secure Web site. You can also get encrypting software to encrypt files on your computer. The most common encrypting program is the Pretty Good Privacy or PGP program (see Tips 453 to 458). The methods of encrypting information may change between programs but you must have a program that is designed to use encrypting technology before you can send encrypted information. Encryption software is any software program that uses some form of encryption technology.

449 UNDERSTANDING AREAS TO AVOID WHEN WORKING WITH ENCRYPTION

While encryption is important to being able to send private information on the Internet, you should also be aware of the laws of your country and of company policy regarding the use of encryption where you work before you use encryption software. In some countries, the use of encrypting programs by private citizens is illegal. In the United States, it is illegal to send programs that can create a certain level of encryption out of the country. At the time of writing this Tip, the law in the United States that does not allow the export of certain types of encryption is being challenged in court. You also may have rules in your work place about the use of encryption on company equipment. You should check with your network administrator or refer to your employee handbook to see if you have any limitations on using encrypting software. You should also check to see if you are subject to any laws in your country before using or sending encrypting software to others.

1001 Internet Tips

Understanding SSL 450

SSL stands for Secure Socket Layer and is the protocol Web servers and Web browsers use to pass information securely over the Internet. The SSL protocol is a method of encrypting all the data browsers and Web servers send to each other. A Web server will send a public encrypting key to your browser when your browser tries to set up a secure connection to a Web server that supports SSL. Your browser will then create a single encrypting key and encrypt that single key with the server's public key that it sent to your browser. The server can then decrypt the single key and encrypt all future messages with the single key sent by your browser. Your browser can also send all future messages by using the single key that it sent to the server. In this way, a browser and Web server can encrypt all information they send between each other. SSL is very important to conducting business on the Internet because, by using SSL, you can safely send private information, such as credit card numbers, over the Internet.

Using Digital Certificates with Internet Explorer 451

You can use a digital certificate to verify your identity when you connect to a Web site that requires you to log in to the Web site. You can obtain a digital certificate from a certificate authority like Verisign, as discussed in Tip 443, "Understanding Digital Signatures." You can control and work with your digital certificates in the Certificates section of the Internet Explorer Web browser's Internet Options Content tab, as shown in Figure 451.

Figure 451 The digital certificate options in Internet Explorer.

To work with Internet Explorer's Certificates section, perform the following steps.

1. Click your mouse on the Start menu and then choose Programs. Windows, in turn, will display the Programs menu.

1001 Internet Tips

2. Select Internet Explorer. Click your mouse on the Internet Explorer Tools menu. Internet Explorer, in turn, will display the Tools menu.
3. Click your mouse on the Internet Options menu item. Internet Explorer, in turn, will display the Internet Options dialog box.
4. Click your mouse on the Content tab. Internet Explorer, in turn, will display the Content tab with the Certificates options buttons.

The Certificates... button lets you control your certificates and the Publishers button lets you control what certificate authorities you trust.

452 SHOPPING SECURELY ON THE INTERNET WITH A CREDIT CARD

Each day, across the Web, many more sites support secure credit card transactions. As a rule, you can feel as confident placing a credit card order across the Internet as you would giving your credit card number to a vendor during a telephone call. Admittedly, if you send your credit card information to a site on the Web using an unsecure data transfer, a hacker could potentially capture your credit card number. However, most sites today offer secure and safe credit card transactions. Further, the latest Web browsers also support sending secure data over the Internet to secure sites.

However, should a hacker get your credit card number and go on a wild shopping spree, in most cases, you will only be responsible for $50 of the amounts the hacker charges. Soon, to promote Web-based commerce, you will find many credit card companies that will reduce or eliminate the $50 liability. The Microsoft Wallet, discussed in Tips 933 through 935, does not increase or decrease the security of your credit card information. Instead, its purpose is to simplify your transactions by eliminating your need to repeatedly type in your credit card information.

453 GETTING PRETTY GOOD PRIVACY (PGP)

The Pretty Good Privacy (PGP) is a data encryption set of programs. The PGP software is a strong cryptographic program that can make it almost impossible for someone to eavesdrop on your connection and steal or snoop your data. By encrypting your data, you can protect the privacy of your information. The United States government controls the export of encrypting software from the United States. For this reason, if you wish to get the PGP software from a United States distributor, you must be a citizen of the United States or Canada. If you are a United States or Canadian citizen and you live in the United States or Canada, you can download the PGP software from the MIT PGP Web site, *http://web.mit.edu/network/pgp.html,* as shown in Figure 453.

At the MIT site, you must fill out a form on which you state you are a citizen of the United States or Canada and live in either of the two countries. After you fill the form out and submit it, you will be able to download the PGP software. The Web page that you download the software from will change every ten minutes so you cannot use the address that you get for one download to start a second download or give the address to someone else to download the software. Once you start the download, you will be able to continue the download, even if the download takes

longer than ten minutes, but you cannot start a new download from the same Web page. The PGP software from MIT is freeware as long as you use it only for personal use and not commercial purposes. You can find the PGP software distributed by commercial software companies, such as the Network Associates version of the PGP software. There are some distributions of PGP-like software that you can download from outside the United States but they are not discussed here.

Figure 453 The MIT Pretty Good Privacy Web site.

INSTALLING THE PGP SOFTWARE 454

After you download the PGP software, you must install the software on your system. To start the installation, you must locate the file that you downloaded that holds the PGP software. You should then unzip the software to a PGP directory. The file should be named, for example, PGPfreeware6.5.1.zip. The numbers after PGPfreeware may be different, depending on the version you downloaded from the MIT site. If you downloaded a version from a different site than the MIT site, then the name may be totally different. After you have unzipped the file, you should go to the directory that you unzipped the file to and perform the following steps:

1. Double-click your mouse on the Setup program. The PGP setup, in turn, will extract the files and display the PGPfreeware 6.5.1 setup Welcome dialog box, as shown in Figure 454.

2. Click your mouse on the next button. The PGP setup, in turn, will display the PGP software license agreement.

3. Read the agreement and if you agree with its contents, click your mouse on the Yes button. The PGP setup, in turn, will display the What's New dialog box. If you do not agree with the contents of the license, then you should not install the software.

4. After you have read what is new in PGP, click your mouse on the Next button. The PGP setup, in turn, will display the User Information dialog box.

1001 Internet Tips

Figure 454 The PGPfreeware 6.5.1 setup Welcome dialog box.

5. Complete the User Information dialog box, then click your mouse on the Next button. The PGP setup, in turn, will ask you to confirm the destination folder.
6. The default should work for most installations. Click your mouse on the Next button. The PGP setup, in turn, will display the Select Components dialog box.
7. After you have selected the components that you need, click your mouse on the Next button. The PGP setup, in turn, will display the Ready to Start Copying Files dialog box.
8. Click your mouse on the Next button. The PGP setup, in turn, will display the PGP Set Adapter dialog box, if you elected to install the PGPnet component.
9. Click your mouse on the OK button. The PGP setup, in turn, will display the Existing Key Rings dialog box.
10. If you have a key ring from an existing install of PGP, click your mouse on the Yes button. If this is the first time you have used PGP, then click your mouse on the No button. The rest of the steps will be for users who clicked the No button. The PGP setup, in turn, will display the Setup Complete dialog box.
11. Click your mouse on the Finish dialog box. PGP setup, in turn, will shut down your computer and reboot to complete the installation of the software.

The PGP software will be installed on your system when your computer has rebooted.

455 CREATING YOUR PGP ENCRYPTING KEY

To start the process of creating your private key, click your mouse on the Start menu. Windows, in turn, will display the Start menu. Select Programs, then select PGP. Windows, in turn, will display the PGP sub-menu. Click your

1001 Internet Tips

mouse on the PGPKeys program to start the PGP Key Generation Wizard. To create your PGP keys, perform the following steps.

1. Click your mouse on the Next button. The Key wizard, in turn, will ask for your full name and your e-mail address.
2. Enter your name and e-mail address and click the Next button. The Key wizard, in turn, will display the key pair type.
3. The default key pair type should work for most installations. Click your mouse on the Next button. The Key wizard, in turn, will display the Key Size Dialog box.
4. The default should work for most installations. Click your mouse on the Next button. The Key wizard, in turn, will display the Key Expiration dialog box.
5. If you want the key to expire at a certain time, click you mouse on the Key pair expires on radio button and fill in a date. If you do not want your key to expire or you have completed the expired date, then click your mouse on the Next button. The Key wizard, in turn, will display the Pass Phrase dialog box.
6. Type and confirm the pass phrase that you will use to access your PGP keys. The Key wizard, in turn, will create your PGP encrypting keys.
7. After the keys creation is complete, click your mouse on the Next button. The Key wizard, in turn, will ask if you want to have your public key sent to an Internet server so users can send you encrypted messages more easily.
8. Click your mouse on the checkbox if you want to send your public key to an Internet server or leave the checkbox unchecked if you do not want to send your public key to an Internet server. Click your mouse on the Next button. The Key wizard, in turn, will display the finish dialog box.
9. Click your mouse on the Finish button. The Key wizard, in turn, will open the PGPkeys program.

You are now able to encrypt information on your computer and to digitally sign messages. If you want to let users send you an encrypted message, you will need to send your public key to them.

USING PGP TO DIGITALLY SIGN A MESSAGE IN OUTLOOK EXPRESS 456

To digitally sign a message in *Outlook Express* using PGP, you use the PGP Sign button. You start by composing a new message in *Outlook Express*. In the *Outlook Express* New Message window toolbar, as shown in Figure 456, click your mouse on the Sign(PGP) button.

Figure 456 The Sign(PGP) button on the New Message toolbar.

When you send the message, the PGP program will ask you for your PGP pass phrase that you used when you created your PGP keys. The PGP program will then add your digital signature to the bottom of your e-mail message.

1001 Internet Tips

457 Encrypting a Message with PGP in Outlook Express

To encrypt a message in *Outlook Express* using PGP, you should start to compose a new message in *Outlook Express*. In the *Outlook Express* New Message window toolbar, as shown in Figure 457, click your mouse on the Encrypt (PGP) button.

Figure 457 The Encrypt(PGP) button on the New Message toolbar.

When you send the message, the PGP program will ask you to select the user that you are sending the message to. You must have a PGP public encrypting key from that user before you can encrypt the message. When you send the message, PGP will encrypt it and only the user you sent the message to can decrypt the message.

Note: PGP uses a public and private key encrypting system so that once you encrypt a message with another user's public key, it can no longer be viewed even by you.

458 Decrypting a Message That Has Been Sent to You

When you receive an encrypted message, you will need to decrypt the message. Open the encrypted message as you would open a normal message, as shown in Figure 458.

Figure 458 The Decrypt(PGP) button on the New Message toolbar and the encrypted message.

1001 Internet Tips

Click your mouse on the Decrypt button on the New Message toolbar. The PGP program, in turn, will ask you for the pass phrase that you used when you created your private key. After you enter the correct pass phrase, the PGP program will decrypt the message and you can read it.

LISTENING TO AND VIEWING REALAUDIO SITES ACROSS THE WEB — 459

Across the World Wide Web, designers are creating new ways to present content. Often, a Web site's content will consist only of text and images. At other sites, however, designers are making full use of multimedia video, audio, and animations. To help Internet Explorer make better use of sites that integrate audio and video content, Windows 98 includes Real Audio software that your browser can use to play back audio and video from sites across the Web. To install the Windows 98 Real Audio software, perform the following steps:

1. Click your mouse on the Start menu. Select the Settings option and choose Control Panel. Windows 98, in turn, will open the Control Panel window.
2. Within the Control Panel window, double-click your mouse on the Add/Remove Programs icon. Windows 98, in turn, will display the Add/Remove Programs Properties dialog box.
3. Within the Add/Remove Programs Properties dialog box, click your mouse on the Windows Setup tab. Windows 98, in turn, will display checkboxes for the Windows 98 components.
4. Within the Windows 98 component list, click your mouse on the Internet Tools item and then click your mouse on the Details button. Windows 98, in turn, will display the Internet Tools dialog box.
5. Within the Internet Tools dialog box, click your mouse on the RealAudio Player 4.0 checkbox, placing a checkmark within the box. Then, click your mouse on the OK button.
6. Within the Add/Remove Programs Properties dialog box, click your mouse on the OK button.

After you install the Real Audio software, follow the steps the next Tip presents to upgrade the Real Audio software and then follow the steps Tip 461, "Taking the RealPlayer Software for a Test Drive," presents to use the Real Audio software.

Note: The version of Real Audio Player that Windows 98 includes is Real Audio Player 4.0. See Tip 460 for information on how to obtain the latest versions of RealPlayer. If you install Netscape Communicator 4.61, as discussed in Tip 962, one of the programs you will install is RealPlayer G2, the latest RealPlayer version available as of this writing.

UPGRADING YOUR REALPLAYER SOFTWARE — 460

In the previous Tip, you learned how to install the RealPlayer software that Microsoft bundles on the Windows 98 CD-ROM. As discussed, if you follow the steps in the previous Tip, you will install the RealPlayer version 4 software on your system. As it turns out, the RealPlayer Web site offers regular software upgrades to the RealPlayer software that you download. To upgrade your RealPlayer software, perform the following steps:

1. Click your mouse on the Start menu. Select the Programs option, then choose Internet Explorer. Windows 98, in turn, will cascade the Internet Explorer sub-menu.

1001 Internet Tips

2. On the Internet Explorer submenu, click your mouse on the RealPlayer option. Windows 98, in turn, will display the RealPlayer window.

3. Within the RealPlayer window, click your mouse on the Help menu About option. The RealPlayer software, in turn, will display the About dialog box, as shown in Figure 460.1.

Figure 460.1 The RealPlayer About dialog box.

4. Within the About dialog box, click your mouse on the Check for Upgrade Availability button. The RealPlayer, in turn, will display a dialog box describing the availability of an upgrade, as shown in Figure 460.2.

Figure 460.2 The RealPlayer dialog box from which you can begin the download of the latest RealPlayer software.

5. Within the RealPlayer dialog box, click your mouse on the Get It Now button. RealPlayer, in turn, will display your browser and open the RealPlayer download site.

6. Follow the instructions on the RealPlayer download Web page to complete the download of the RealPlayer upgrade.

461 Taking the RealPlayer Software for a Test Drive

In Tip 459, "Listening to and Viewing RealAudio Sites across the Web," you learned how to install the Real Audio Player software that you can use to play back audio and video from across the Web. In the previous Tip, you learned how to obtain the latest version of the RealPlayer software. To begin using the Real Audio software, perform the following steps:

1001 Internet Tips

1. If you are not currently connected to the Internet, connect to it now. Click your mouse on the Start menu. Select the Programs option, then choose Internet Explorer. Windows 98, in turn, will cascade the Internet Explorer sub-menu.
2. Within the Internet Explorer sub-menu, click your mouse on the RealPlayer option. Windows 98, in turn, will display the RealPlayer window, as shown in Figure 461.

Note: *You can double-click your mouse on the RealPlayer icon on your Desktop if it exists.*

Figure 461 The RealPlayer window.

3. Within the RealPlayer window's Channels area, click your mouse on one of the channel links, such as the ESPN.com channel, the Weather Channel, or Rolling Stone Radio. RealPlayer, in turn, will begin playing a production from your chosen channel.

Alternatively, you can make selections from the RealPlayer Presets and Sites menus to listen to or view Real Media content, as discussed in Tips 462 and 463.

Note: *To find more sites across the Web that support Real Audio, visit a search engine, such as Yahoo, and type in Real Audio as your search criteria.*

USING THE REALPLAYER PRESETS MENU 462

The RealPlayer's Presets menu contains links to media stations organized categorically on an easy to use menu. The RealPlayer Presets menu, shown in Figure 462, provides you with a quick method to reach RealMedia content on the Internet, such as radio stations. Similar to the station buttons on a car or home stereo, instead of punching a button on your radio, you make a selection from a Preset menu category to connect to and listen to that station. RealPlayer, in turn, will connect to and play that radio station over your computer's sound card and speakers.

After you become more familiar with RealPlayer and RealMedia content on the Internet, you can use the Presets menu Add to Presets and Organize Presets options to customize your Presets menu selections.

1001 Internet Tips

Figure 462 The RealPlayer Presets menu from which you can select radio stations.

463 Using the RealPlayer Sites Menu

The RealPlayer Sites menu gives you quick access to various Internet sites that contain RealMedia content. The RealPlayer Sites menu works in conjunction with your installed Web browser to open the Internet sites associated with each menu option. As you use RealPlayer, you will probably continually upgrade the product as new versions become available as described in Tip 460, "Upgrading Your RealPlayer Software." Be aware that your RealPlayer Sites menu can and will update itself over time as well as reflect updated links and content changes. In this way, your RealPlayer will always provide you with links to the most current content sites and their interesting content. Table 463 offers a description of the options on the RealPlayer Sites menu (current as of this printing).

Menu Option	Description
RealNetworks Home Page	The home page of the company that delivers the RealPlayer.
RealPlayer Home Page	The RealPlayer home page provides up-to-date information, links, and updates RealPlayer software and content.
RealGuide	A categorized list of up-to-date content sites.
MusicNet	A link to the MusicNet, a popular content provider.
LiveConcerts.com	A link to the *LiveConcerts.com* Web site, a site that delivers live concerts via your RealPlayer software.
Film.com	A link to the *Film.com* Web site's screening room.
Broadcast.com	A link to the *Broadcast.com* Web site, a site that provides audio books, sports broadcasts, live radio, and other events.
WebActive	WebActive is a RealNetworks site that offers resources to progressive activists in a variety of areas.

Table 463 Sites that you can access via the RealPlayer Sites menu.

Playing Multimedia Files Using the Microsoft Media Player 464

To let you play back just about any type of multimedia file, Windows 98 provides the Media Player accessory program. Using the Media Player, you can play back audio files, MIDI sound files, audio CDs, and even video files. Depending on the type of file you are playing, the Media Player's appearance will differ. Figure 464.1, for example, shows the Media Player window as it plays back a MIDI file. Figure 464.2 shows the window as the Media Player plays back an MPEG file.

Figures 464.1 Using the Media Player to play back multimedia files and devices.

Figures 464.2 Using the Media Player to play back multimedia files and devices.

To start the Media Player, perform the following steps:

1. Click your mouse on the Start menu. Select Programs, then select Accessories, then Entertainment. Windows 98, in turn, will display the Entertainment submenu.
2. On the Entertainment sub-menu, click your mouse on the Media Player option. Windows 98, in turn, will open the Media Player window.

465 FINDING INFORMATION ON THE INTERNET

In the first fourteen Tips, you learned a little about the history of the Internet and about what makes up the Internet. You also learned how vast this "network of networks" has become and how much information is available at your fingertips. Because the Internet is so vast, and growing more so every day, it is difficult to manage all of the information that the Internet has to offer. There is no single central record keeper or custodian of the Internet who can manage, organize, order, and present the information to you in a logical manner. Therefore, you must take advantage of a variety of tools available to you for finding information. A number of organizations have undertaken the tall order of indexing and categorizing the vast array of information into searchable databases.

In the next four Tips, you will begin to learn about Internet jump off sites or Web portals. Tips 470-488 discuss general Internet or Web search techniques and services. You will also find many Tips in this book that describe how you can use the Internet to search for specific information, such as a candidate to fill a position at your firm.

466 UNDERSTANDING AN INTERNET JUMP OFF (OR WEB PORTAL)

An Internet jump off or Web portal is a special Web site that provides you with many services besides just a search engine. Web portals attempt to combine all of the popular elements and services commonly found on the Web. More and more search sites are providing additional services to attract advertising dollars and to entice Web users to their sites. Web portals, in addition to searching, provide user with services like free e-mail, editorial content, news headlines, classified ads, chat rooms, and customizable personal data. Web portals let you customize your own personal Web page with your favorite Internet links, sports scores for your favorite teams, stock quotes, news from your favorite sources, local weather information, favorite online magazines, and even your local television schedule, to name just a few of the services available.

Internet jump off/Web portal sites typically obtain agreements with Internet content providers to list links to pages, services, and headline information on the portal site. The portal becomes your personalized information page, complete with the free services mentioned and a great search engine built in. Most popular Web portals are built around popular search engines like Yahoo, Lycos, Snap, and Excite. The next three Tips will introduce you to three popular, user configurable, Web Portal sites: My Yahoo, MSN.COM home, and Netscape's Customizable Web portal. Microsoft's MSN.COM is shown in Figure 466.

1001 INTERNET TIPS

Figure 466 The MSN customizable Web portal MSN.COM.

The convenience of a configurable, personalized portal is popular among Internet users. Because of their popularity, Web portals are key areas for doing business on the Web. Many portal providers have sophisticated contracts with content providers and Web marketers. Those relationships ensure that the content available on the Web portal is fresh and interesting.

CONFIGURING YOUR PERSONALIZED MY YAHOO WEB PAGE — 467

As you learned in the previous Tip, Web portals, are special Web sites that provide you with many services besides just a search engine. To access Yahoo's Web portal, within your browser's Address field type *http://my.yahoo.com* and then press the ENTER key on your keyboard. Your browser, in turn, will load the My Yahoo Web site, as shown in Figure 467.1. Note that the My Yahoo Web page has several areas like *Message Center, Portfolios,* and *My Front Page Headlines,* to name a few. You can personalize each of these areas to suit your needs.

The first step in personalizing your personalized My Yahoo home page is to register yourself with Yahoo and get your Yahoo! ID and password. To do so, within the My Yahoo Web page, click your mouse on the Get Your Own My Yahoo! link.

To configure your personalized My Yahoo home page's content simply click your mouse on the Web page's Personalize Content button, shown in Figure 467.1. Your browser, in turn, will load the Sign up! registration page, as shown in Figure 467.2.

Simply follow the instructions on the Sign Up! page to register yourself with Yahoo. After you have signed up, you can log in and access all of Yahoo's free services including configuring your customizable My Yahoo page.

To configure your personalized My Yahoo home page's content, simply login with your newly created Yahoo ID and password and then click your mouse on the Web page's Personalize Content button, shown in Figure 467.1. Your browser, in turn, will load the Personalize Page Content page, as shown in Figure 467.3.

*Figure 467.1 The My Yahoo Web portal at **http://my.yahoo.com**.*

Figure 467.2 The My Yahoo Web portal's registration page.

Note: *You can also use the Personalize Layout button to customize the layout of your My Yahoo page.*

After you login and load the Personalize Page Content page, building your own personalized page is as simple as clicking the appropriate checkboxes and radio buttons and making choices from the lists provided to select

the content and services you would like to include on your page. After you have finished making choices on the configuration page, you can click the Finish button to save your changes and update and view your new personalized home page.

Figure 467.3 The My Yahoo Web portal's Personalize Page Content page.

Note: *You may want to cause your new personalized page to load by default each time you start your browser. If so, refer to Tip 922, "Changing Your Default Home Page," to learn how to set the default Web page in Internet Explorer or refer to Tip 976, "Changing Your Default Home Page," to learn how to set the default Web page in Netscape Navigator.*

CONFIGURING YOUR PERSONALIZED MSN HOME PAGE — 468

As you learned in Tip 466, "Understanding an Internet Jump Off (or Web Portal)," Web portals, like MSN.com, are special Web sites that provide you with many services besides just a search engine. To access the MSN Web portal, within your browser's Address field type *www.msn.com* and then press the ENTER key on your keyboard. Your browser, in turn, will load the MSN Web site, as shown in Figure 468.1. Note that the MSN.com Web page is divided into several areas, such as today, e-mail, news, and stock quotes, to name a few. You can personalize each of these areas to suit your needs.

To configure your personalized MSN home page, simply click your mouse on the Web page's Personalize button, shown in Figure 468.1. Your browser, in turn, will load the Personalize page, as shown in Figure 468.2

*Figure 468.1 The MSN Web portal at **www.msn.com**.*

Figure 468.2 The MSN Web portal's Personalize page within which you can customize your Web portal to suit your needs.

Building your own personalized page is as simple as clicking the appropriate checkboxes and radio buttons and making choices from the lists provided to select the content and services you would like to include on your page.

1001 Internet Tips

After you have finished making choices on the configuration page, you can click the Update Home Page Now button to save your changes and update and view your new personalized home page.

Note: *You may want to cause your new personalized page to load by default each time you start your browser. If so, refer to Tip 922 to learn how to set the default Web page in Internet Explorer or refer to Tip 976 to learn how to set the default Web page in Netscape Navigator.*

Using Netscape's Customizable Web Portal — 469

As you learned in Tip 466, "Understanding an Internet Jump Off (or Web Portal)," Web portals are special Web sites that provide you with many services besides just a search engine. To access Netscape's Web portal, within your browser's Address field type *http://my.netscape.com* and then press the ENTER key on your keyboard. Your browser, in turn, will load the My Netscape Web site, as shown in Figure 469.1. Note that the My Netscape Web page is divided into several areas, such as Search the Web, My Portfolio, Netcenter Apps, and Headlines, to name a few. You can personalize each of these areas to suit your needs..

Figure 469.1 The My Netscape Web portal at http://my.netscape.com.

The first step in personalizing your personalized My Netscape home page is to register yourself with Netscape and get your Netscape ID and password. To do so, within the My Netscape Web page, click your mouse on the Personalize link. Your browser, in turn, will display the Express Registration Web page, as shown in Figure 469.2.

Simply follow the instructions on the registration page to register yourself with Netscape. After you have signed up, your browser, in turn, will load Netscape's Build My Page! Web page, as shown in Figure 469.3.

Figure 469.2 The My Netscape Web portal's registration page.

Figure 469.3 Configuring Netscape's Build My Page! personalized content page.

Building your own personalized page is as simple as clicking the appropriate checkboxes and radio buttons and making choices from the lists provided to select the content and services you would like to include on your page. After you have finished making choices on the configuration page, click your mouse on the Build My Page! button to save your changes and update and view your new personalized home page. You can now access all of Netscape's free services.

Note: *You may want to cause your new personalized page to load by default each time you start your browser. If so, refer to Tip 922 to learn how to set the default Web page in Internet Explorer or refer to Tip 976 to learn how to set the default Web page in Netscape Navigator.*

UNDERSTANDING AND USING A SEARCH ENGINE — 470

In general, four types of Internet search tools exist. There are search engines, multi-engines, search directories, and combination directory/search engines. The term search engine generally refers to any tool you use to search the Internet, but not all search engines are, in fact, search engines. Many of the tools you consider search engines work in similar ways and appear to perform the same task, but the way in which they go about it may be different. For example, a Web directory is similar to a search engine in that you can use keyword searches to search a database. But a Web directory also provides a categorized list of Internet links grouped by topic, such as business, computers & Internet, entertainment, and home and family, to name just a few. When using a Web directory, you can browse information by topic without doing a search.

A search engine is defined as a tool that prompts the user for keywords, and then uses those keywords to locate information in a database or index. Further, programs that collect information from the Internet constantly update search engines. These programs are commonly called spiders or worms, among other things.

Spiders automatically search the Internet, locating new information on Internet sites. They add newly discovered information to the search engine's index. The search engine queries the index when Internet users submit key words in the search field on the search engine Web page. The rate at which new information is added to Internet sites requires a tool such as a spider because manual indexing is just not fast enough.

After the spider locates material, a search engine's indexing software takes over, saving each instance of each word on each Internet site, along with the site's URL, in the searchable database. When you use a search engine, the engine ranks Internet sites based on how many times your keywords occur on a particular Internet page. The search engine presents you with a set of Web pages that include a list of links with information that matches your search. You can simply click on each link to view the information on each pertinent Internet site. Because the spider programs are so effective at gathering content information, some of the largest search engines claim to index as much as ninety percent of the content on the Web.

In general, search engines provide a data field within which you type the keywords for which you are searching. Then you click your mouse on a button to initiate the search. When the search engine finishes your query, it presents you with a set of Web pages that include a list of links to Web pages that contain information that matches your search criteria. You can simply click on each link to view the information on each pertinent Internet site.

The next several Tips introduce you to many of today's popular search engines.

1001 Internet Tips

471 — Searching the Web with MSN Web Search

As you learned in the previous Tip, a search engine is a generic term for a piece of software, delivered via a Web site, that lets you search a database according to criteria you specify. Some search engine sites build the database by employing software (a spider or worm) that is constantly prowling the Web gathering information, and other sites build the database by gathering sites suggested by Internet users.

You can access the MSN Web search engine through your personalized MSN Web portal (described in Tip 468, "Configuring Your Personalized MSN Home Page"). The MSN search engine provides a search field within which you enter your search keywords, and a drop-down list from which you can select a search engine. The MSN page also provides a link to the MSN Web directory from which you can browse information and links organized by category. To use the MSN search engine, perform the following steps:

1. Within your Web browser's Address field, type *www.msn.com* and then press your keyboard's ENTER key. Your browser, in turn, will display the MSN Web site. Near the top of the MSN page, you will notice the Search the Web for field and the using drop-down list, as shown in Figure 471.1.

Figure 471.1 Searching the Web using www.msn.com.

2. Within the Search the Web for field, type the keywords for which you would like to search. From the using drop-down list, choose MSN to search the MSN database.

3. After you have entered your keywords and selected the MSN search engine, click your mouse on the Go button directly to the left of the using drop-down list. MSN, in turn, will display a Search Results Web page, as shown in Figure 471.2.

1001 INTERNET TIPS

Figure 471.2 An MSN Search Results page displaying search results for the keyword baseball.

By default, the MSN Search Results page displays the first 20 results that match your keywords and displays a results summary for each entry, if one exists. To further customize your search by taking advantage of MSN's advanced search capabilities, click your mouse on the use Advanced Search link near the top right portion of the results page. Your browser, in turn, will load the MSN Advanced Search page, as shown in Figure 471.3. Within the Advanced Search page, you can use the checkboxes, fields, and drop-down lists to further refine your search.

Figure 471.3 MSN's Advanced Search page, from which you can refine your search to limit the number of returned entries.

1001 Internet Tips

Note: *To open the MSN Advanced Search page right from your browser's address field, type the address **http://search.msn.com** and then press your keyboard's* ENTER *key.*

472 SEARCHING THE WEB WITH SNAP.COM

As you learned in Tip 470, "Understanding and Using a Search Engine," a search engine is a generic term for a piece of software, delivered via a Web site, that lets you search a database according to criteria you specify. Some search engine sites build the database by employing software (a spider or worm) that is constantly prowling the Web gathering information, and other sites build the database by gathering sites suggested by Internet users.

You can access the SNAP.com Web search engine at the Internet address *http://snap.com*. The SNAP.com page also provides a Web directory in which you can browse information and links organized by category. To use the SNAP.com search engine, perform the following steps:

1. Within your Web browser's Address field, type *http://snap.com* and then press your keyboard's ENTER key. Your browser, in turn, will display the SNAP.com Web site. Near the top of the SNAP.com page, you will notice the Search field, as shown in Figure 472.1.

Figure 472.1 Searching the Web using SNAP.com.

2. Within the Search field, type the keywords for which you would like to search and then click your mouse on the Search button. SNAP.com, in turn, will display a Search Results Web page, as shown in Figure 472.2.

Figure 472.2 A SNAP.com Search Results page displaying Search Results for the keyword baseball.

Notice that SNAP.com results page displays feature sites, matching categories, as well as numerous Web sites that match your keywords. To further customize your search by taking advantage of SNAP.com's advanced search capabilities, scroll to the bottom of the Search Results page and click your mouse on the Power Search link near Search field at the bottom of the page. Your browser, in turn, will load the SNAP.com advanced search page, as shown in Figure 472.3. Within the Power Search page, you can use the radio buttons, fields, and drop-down lists to further refine your search.

Figure 472.3 SNAP.com's advance search page from which you can refine your search to limit the number of returned entries.

1001 Internet Tips

473 Searching the Web with the GO Network

As you learned in Tip 470, "Understanding and Using a Search Engine," a search engine is a generic term for a piece of software, delivered via a Web site, that lets you search a database according to criteria you specify. Some search engine sites build the database by employing software (a spider or worm) that is constantly prowling the Web gathering information, and other sites build the database by gathering sites suggested by Internet users.

You can access the GO Network Web search engine at the Internet address *http://www.go.com*. Infoseek, another popular Web search tool, powers the GO Network's search engine. The GO Network page also provides a Web directory, personalized Web portal pages, communities, shopping, and several other services. To use the GO Network search engine, perform the following steps:

1. Within your Web browser's Address field, type *http://www.go.com* and then press your keyboard's ENTER key. Your browser, in turn, will display the GO Network Web site. Near the top of the GO Network page, you will notice the Search field and a drop-down list from which you can choose what database you would like to search—the Web, Topics, News, Companies, or Newsgroups—as shown in Figure 473.1.

Figure 473.1 Searching the Web using the GO Network.

2. Within the Search field, type the keywords for which you would like to search. From the drop-down list, choose the database you would like to search, usually the Web.

3. After you have entered your keywords and selected the Web database, click your mouse on the Find button. The GO Network engine, in turn, will display a Search Results Web page, as shown in Figure 473.2.

1001 INTERNET TIPS

Figure 473.2 A GO Network Search Results page displaying Search Results for the keyword baseball.

Notice that the GO Network results page displays matching topics as well as Web sites that match your keywords. To further customize your search by taking advantage of GO Network's advanced search capabilities, click your mouse on the Search options link located below the Search field at the top of the results page. Your browser, in turn, will load the GO Network's Infoseek Advanced Search page, as shown in Figure 473.3. Within the Advanced Search page you can use the drop-down lists to further refine your search.

Figure 473.3 The GO Network's Infoseek Advanced Search page from which you can refine your search to limit the number of returned entries.

1001 Internet Tips

474 Searching the Web with www.excite.com

As you learned in Tip 470, "Understanding and Using a Search Engine," a search engine is a generic term for a piece of software, delivered via a Web site, that lets you search a database according to criteria you specify. Some search engine sites build the database by employing software (a spider or worm) that is constantly prowling the Web gathering information, and other sites build the database by gathering sites suggested by Internet users.

You can access the Excite Web search engine at the Internet address *http://www.excite.com*. The Excite page also provides a personalized Web portal page, free email, stock quotes, weather, and several other services. To use the Excite search engine, perform the following steps:

1. Within your Web browser's Address field, type *http://www.excite.com* and then press your keyboard's ENTER key. Your browser, in turn, will display the Excite Web site. Near the top of the Excite page, you will notice the Search field, as shown in Figure 474.1.

Figure 474.1 Searching the Web using www.excite.com.

2. Within the Search field, type the keywords for which you would like to search and then click your mouse on the Search button. The Excite engine, in turn, will display a Search Results Web page, as shown in Figure 474.2.

Notice that the Excite results page displays Search Results from different areas, including featured sites, news articles, directory matches, Web sites, and discussion groups (Excite Communities) that match your keywords. To further customize your search by taking advantage of Excite's advanced search capabilities, scroll to the bottom of the Search Results page and click your mouse on the Advanced Search link near the More Search Services title at the

bottom of the page. Your browser, in turn, will load the Excite Advanced Web Search page, as shown in Figure 474.3. Within the Advanced Web Search page, you can use the checkboxes, radio buttons, fields, and drop-down lists to further refine your search.

Figure 474.2 An Excite Search Results page displaying Search Results for the keyword baseball.

Figure 474.3 Excite's Advanced Web Search page from which you can refine your search to limit the number of returned entries.

475 SEARCHING THE WEB WITH WWW.YAHOO.COM

As you learned in Tip 470, "Understanding and Using a Search Engine," a search engine is a generic term for a piece of software, delivered via a Web site, that lets you search a database according to criteria you specify. Some search engine sites build the database by employing software (a spider or worm) that is constantly prowling the Web gathering information, and other sites build the database by gathering sites suggested by Internet users.

You can access the Yahoo! Web search engine at the Internet address *http://www.yahoo.com*. The Yahoo! page also provides a personalized Web portal page, free email, stock quotes, weather, directory categories, and several other services, many of which are discussed in Tip 467, "Configuring Your Personalized "My Yahoo" Web Page." To use the Yahoo! search engine, perform the following steps:

1. Within your Web browser's Address field, type *http://www.yahoo.co*m and then press your keyboard's ENTER key. Your browser, in turn, will display the Yahoo! Web site. Near the top of the Yahoo! Page, you will notice the Search field, as shown in Figure 475.1.

*Figure 475.1 Searching the Web using **www.yahoo.com**.*

2. Within the Search field, type the keywords for which you would like to search and then click your mouse on the Search button. The Yahoo! Search engine, in turn, will display a Search Results Web page, as shown in Figure 475.2.

Notice the Yahoo! results page is organized a little differently than some of the other search tools you may have used. Yahoo! displays Search Results called Category Matches. You can click your mouse on a matching category link to load a category page that includes news stories, related Web sites, newsgroups, and others that match the category you have chosen. To further customize your search by taking advantage of Yahoo! Advanced Search capabilities,

1001 INTERNET TIPS

scroll to the bottom of the Search Results page and click your mouse on the advanced search link (or you might see an options link) near the Search field at the bottom of the page. Your browser, in turn, will load the Yahoo! advanced search page as shown in Figure 475.3. Within the Advanced Search page, you can use the radio buttons, fields, and drop-down lists to further refine your search.

Figure 475.2 A Yahoo! Search Results page displaying Search Results for the keyword baseball.

Figure 475.3 Yahoo!'s Advanced Web Search page from which you can refine your search to limit the number of returned entries.

1001 Internet Tips

476 Searching the Web with www.lycos.com

As you learned in Tip 470, a search engine is a generic term for a piece of software, delivered via a Web site, that lets you search a database according to criteria you specify. Some search engine sites build the database by employing software (a spider or worm) that is constantly prowling the Web gathering information, and other sites build the database by gathering sites suggested by Internet users.

The Lycos Web search engine is accessed at the Internet address *http://www.lycos.com*. The Lycos page also provides access to a personalized Web portal, chat rooms, free e-mail, Lycos radio, weather, directory categories, and several other Web services. To use the Lycos search engine, perform the following steps:

1. Within your Web browser's Address field, type *http://www.lycos.com* and then press your keyboard's ENTER key. Your browser, in turn, will display the Lycos Web site. Near the top of the Lycos page, you will notice the Search for field, as shown in Figure 476.1.

*Figure 476.1 Searching the Web using **www.lycos.com**.*

2. Within the Search field, type the key words for which you would like to search and then click your mouse on the Go Get It! button. The Lycos engine, in turn, will display a search results Web page, as shown in Figure 476.2.

Notice that the Lycos results page is organized similarly to the Yahoo! search results page discussed in Tip 475. Lycos displays search results called Categories. You can click your mouse on a category to see a further category breakdown as well as Web links, featured Web pages, and even a selection of books related to your search key words. To further customize your search by taking advantage of Lycos advanced search capabilities, scroll to the bottom of the search results page and click your mouse on the Advanced Search link above the Search field at the bottom of the page. Your browser, in turn, will load the Lycos Advanced Search page, as shown in Figure 476.3. Within the Advanced Search page, you can use the checkboxes, radio buttons, fields, and drop-down lists to further refine your search.

Figure 476.2 A Lycos search results page displaying search results for the key word baseball.

Figure 476.3 Lycos's Advanced Search page, from which you can refine your search to limit the number of returned entries.

SEARCHING THE WEB WITH WWW.HOTBOT.COM 477

As you learned in Tip 470, a search engine is a generic term for a piece of software, delivered via a Web site, that lets you search a database according to criteria you specify. Some search engine sites build the database by employing

1001 Internet Tips

software (a spider or worm) that is constantly prowling the Web gathering information, and other sites build the database by gathering sites suggested by Internet users.

The HotBot Web search engine is accessed at the Internet address *http://www.hotbot.com*. The HotBot page also provides access to free e-mail, free home pages, message boards, chat rooms, directory categories, and several other Web services. Another special feature that you might notice about the HotBot search page is that on the main search page HotBot provides many of the specialized search features you find on the other search engine's advanced search pages. For this reason, HotBot cleverly titles its search field Search Smarter. To Search Smarter with HotBot, perform the following steps:

1. Within your Web browser's Address field type *http://www.hotbot.com* and then press your keyboard's ENTER key. Your browser, in turn, will display the HotBot Web site. Near the top of the HotBot page, you will notice the Search Smarter for field, as shown in Figure 477.1.

*Figure 477.1 Searching the Web using **www.hotbot.com**.*

2. Within the Search Smarter field, type the key words for which you would like to search.
3. Use the drop-down lists and checkboxes found along the left side of the page to further refine your search. Once you have made your selections, click your mouse on the Search button directly to the right of the Search Smarter field. The HotBot engine, in turn, will display a search results Web page, as shown in Figure 476.2.

Notice that the HotBot results page displays search results that include Related Searches, links to search HotBot partner sites for the same criteria, directory matches, and Web results. To further customize your search by taking advantage of HotBot's advanced search capabilities, click your mouse on the Advanced Search link in the left column of the page. Your browser, in turn, will load the HotBot's Advanced Search page, as shown in Figure 474.3. Within the Advanced Search page, you can use the checkboxes, radio buttons, fields, and drop-down lists to further refine your search.

Figure 477.2 A HotBot search results page displaying search results for the key word baseball.

Figure 477.3 HotBot's Advanced Search page, from which you can refine your search to limit the number of returned entries.

SEARCHING THE WEB WITH WWW.ALTAVISTA.COM 478

As you learned in Tip 470, a search engine is a generic term for a piece of software, delivered via a Web site, that lets you search a database according to criteria you specify. Some search engine sites build the database by employing software (a spider or worm) that is constantly prowling the Web gathering information, and other sites build the database by gathering sites suggested by Internet users.

1001 Internet Tips

AltaVista is the largest and most frequently updated search engine on the World Wide Web. Statistics show that AltaVista contains information cataloging approximately 150 million Web pages. AltaVista's spider collects, on the average, of 6 million Web pages per day. The task of managing all of this data is handled by AltaVista's 16 computers.

The AltaVista Web search engine is accessed at the Internet address *http://www.altavista.com*. The AltaVista page also provides access to a personalized Web portal page, free e-mail, finance information, careers, maps, directory categories, and several other Web services. AltaVista, like HotBot, sports some unique features on its main page that you can use to refine your search. For example, you can choose to search in any language or you can choose specific languages from a drop-down list near the Search field. You can also choose to search for Web pages, images, video, or audio that matches your search criteria by simply clicking the appropriate radio button. To search with AltaVista, perform the following steps:

1. Within your Web browser's Address field type *http://www.altavista.com* and then press your keyboard's ENTER key. Your browser, in turn, will display the AltaVista Web site. Near the top of the AltaVista page, you will notice the Search field, as shown in Figure 478.1.

*Figure 478.1 Searching the Web using **www.altavista.com**.*

2. Within the Search field, type the key words for which you would like to search. From the language drop-down list, choose the language you would like to use. Then make a choice to search for Web Pages, Images, Video, or Audio related to your key words.

3. After you have made your search criteria selection, click your mouse on the Search button directly to the right of the Search field. The AltaVista engine, in turn, will display a search results Web page, as shown in Figure 478.2.

Notice that the AltaVista results page displays search results that include Related Searches, links to search AltaVista partner sites for the same criteria, and Web results. To further customize your search by taking advantage of AltaVista's advanced search capabilities, click your mouse on the Advanced Text Search link located to the right of the language drop-down list at the top of the page. Your browser, in turn, will load the AltaVista 's Advanced Search page, as shown in Figure 478.3. Within the Advanced Search page, you can use Boolean expressions and date ranges to further refine your search. See Tip 483 for a discussion of Boolean expressions.

1001 INTERNET TIPS

Figure 478.2 An AltaVista search results page displaying search results for the key word baseball.

Figure 478.3 AltaVista's Advanced Search page, from which you can refine your search to limit the number of returned entries.

SEARCHING THE WEB WITH WWW.GOTO.COM 479

As you learned in Tip 470, a search engine is a generic term for a piece of software, delivered via a Web site, that lets you search a database according to criteria you specify. Some search engine sites build the database by employing software (a spider or worm) that is constantly prowling the Web gathering information, and other sites build the database by gathering sites suggested by Internet users.

GoTo.com takes a different approach compared to some of the other search engines. The motto of the GoTo.com site is Search made simple. One look at the site and you can see the meaning of the motto (see Figure 479.1). The site's start page is uncluttered and easy to use.

1001 Internet Tips

The GoTo.com Web search engine is accessed at the Internet address *http://www.goto.com*. The GoTo.com home page, while simplistic, also provides links to other services you are accustomed to seeing associated with a search site. To search with GoTo.com, perform the following steps:

1. Within your Web browser's Address field, type *http://www.goto.com* and then press your keyboard's ENTER key. Your browser, in turn, will display the GoTo.com Web site. Near the top of the GoTo.com page, you will notice the search field, as shown in Figure 479.1.

Figure 479.1 GoTo.com, a clean and simple search engine.

2. Within the search field, type the key words for which you would like to search and then click your mouse on the Find It! button. The GoTo.com engine, in turn, will display a search results Web page, as shown in Figure 479.2.

Figure 479.2 A GoTo.com search results page displaying search results for the key word baseball.

Notice that the GoTo.com results page displays search results in a very simple and easy to use fashion. The GoTo.com search results page also provides a set of links to searches related to your key word search.

480 USING WWW.DEJANEWS.COM

As you learned in Tip 470, a search engine is a generic term for a piece of software, delivered via a Web site, that lets you search a database according to criteria you specify. Some search engine sites build the database by employing software (a spider or worm) that is constantly prowling the Web gathering information, and other sites build the database by gathering sites suggested by Internet users.

Formerly known as DejaNews, the *www.dejanews.com* address now redirects to the Deja.com Web site at the address *www.deja.com*. The Deja.com search site is a little different than some of the other search sites in that Deja.com is built upon a base of searchable discussion forums or newsgroups, ratings, and communities. Like many other search sites, the Deja.com page provides access to the services you are familiar with, including personalized Web portal (My Deja), chat rooms, ratings, weather, directory categories, and several other Web services. To use the Deja.com search engine, perform the following steps:

1. Within your Web browser's Address field, type *http://www.deja.com* and then press your keyboard's ENTER key. Your browser, in turn, will display the Deja.com Web site. Near the upper right corner of the Deja.com page, you will notice the Search Deja.com field, as shown in Figure 480.1.

*Figure 480.1 Searching the Deja.com site at **www.deja.com**.*

2. Within the Search Deja.com field, type the key words for which you would like to search. Click one of the radio buttons above the Search Deja.com field to choose to search discussions, ratings, or communities. Then, from the Search discussions in drop-down list, choose the category within which you would like to search.

3. After you have made your search criteria selections, click your mouse on the Find button directly to the right of the Search Deja.com field. The Deja.com engine, in turn, will display a search results Web page, as shown in Figure 480.2.

1001 INTERNET TIPS

Notice that the Deja.com results page returns hits selected from newsgroups rather than Web hits that you are used to from other search engines. At the bottom of the search results page, you can further customize your search by taking advantage of Deja.com Power Search capabilities. To do so, click your mouse on the Power Search link above the Search for field at the bottom of the page. Your browser, in turn, will load the Deja.com Power Search page, as shown in Figure 480.3. Within the Advanced Search page, you can use the checkboxes, radio buttons, fields, and drop-down lists to further refine your search.

Figure 480.2 A Deja.com discussion search results page displaying search results for the key word baseball.

Figure 480.3 Deja.com's Power Search page, from which you can refine your search to limit the number of returned entries.

481 UNDERSTANDING YOUR SEARCH RESULTS

As you use various search sites to find information on the Web, you might find that search results pages are cluttered and difficult to understand. You will probably also find that you receive numerous entries on search results pages that do not direct you to information in which you are interested (see Tip 482 to learn how to refine your search). For these reasons, this Tip will discuss search results. The screen shots used in this Tip are taken from one of the most popular search sites, AltaVista (see Tip 478).

In Figure 481, you see entries from an AltaVista search results page resulting from a search for the word baseball. Each resulting entry contains a page title which is typically also a link to the site, a brief sentence or a small paragraph that describes the contents of the site, the site's URL, a last modified date and time, and the size of the corresponding Web page in kilobytes. You might also note that AltaVista provides a Translate link with each search results entry that you can use to translate the site's contents into another language, if you desire. If you look just above the first search results entry in Figure 481, you will see that AltaVista found 3,593,910 Web pages resulting from a search for the key word baseball. For this reason, you will require tools that let you refine your search.

Figure 481 Understanding search results entries.

482 REFINING YOUR SEARCH

When you use a search Web site, the simplest way to improve your search results is to include more words that are specific to the topic for which you are searching. While each search site may have its own set of search rules, many sites employ the same features and methods to let you narrow down your search.

Most search sites will also let you enclose phrases in quotes to search for an exact match for that phrase. For example, if you are searching for a specific baseball team, you might try a search like `baseball "Atlanta Braves"`.

Many search sites will let you exclude words from a search by using a minus (-) sign. AltaVista mentions the following example on its help page. If you are searching for sites that discuss red delicious apples, you might use `apple -computer delicious` to exclude any sites that pertain to Apple computers.

Sometimes you might find it beneficial to search for all the derivatives of a particular word. For this purpose, most search sites support the use of the asterisk (*) as a wild card. For example, you might use the keywords `home renovat*` to include any derivative of the word renovate, like renovated or renovation.

Another search refinement technique, discussed in Tip 483, includes the use of Boolean operators and proximity operators. Many search sites contain the foregoing features and more. Experiment with each site and refer to each site's Help pages to find more specific searching Tips and information for that site.

483 Understanding Boolean Operations

To refine your search and ensure that the results you do get include the information you are looking for, you can employ the use of Boolean and proximity operators within your searches. Boolean operators let you create relationships among key words and phrases for which you are searching. Proximity operators return results based on the key word's relative location to another key word on a Web page. Table 483 lists the names and functions of common Boolean and proximity operators.

Boolean and Proximity Operators

Keyword	Description
AND	Finds only documents that contain all of the specified keywords and/or phrases. For example, a search for `baseball AND braves` would return Web pages containing both the word baseball and the word braves.
OR	Finds documents that contain at least one of the specified keywords and/or phrases. For example, a search for `baseball OR braves` would return Web pages containing either the word baseball or the word braves, or both.
NOT	Excludes documents that contain the specified keyword or phrase. For example, a search for `baseball AND NOT braves` would return Web pages containing the word baseball but not containing the word braves.
NEAR	Finds documents that contain both specified keywords and/or phrases within a certain number of words of each other (within 10 words when searching AltaVista's site). For example, a search for `baseball NEAR braves` would return Web pages containing the word baseball and the word braves but only if the two keywords are proximal.

Table 483 Names and functions of common Boolean and proximity operators.

Note: *While you will find Boolean and proximity operator choices on the Advanced Search pages for many search sites, many of the search sites also let you use Boolean and proximity operators within the main search field. You can experiment with Boolean and proximity operators while using each search site or simply refer to a site's Help page to get the search specifics.*

Using AskJeeves.com — 484

As you have learned, the Internet is a wealth of information that sometimes becomes difficult to manage and use efficiently. To help you manage all of the information you have available to you on the Internet you have a plethora of search engines from which you can choose. Ask Jeeves is a fresh approach to managing the Internet's information. The AskJeeves.com Web site at *www.askjeeves.com* provides a Web interface you can use in a question and answer type format. You ask Jeeves questions and he does his best to answer your questions.

Jeeves is a butler and the design of the Web sites lets you ask any question you want of Jeeves the butler. He will, in turn, answer your question as best he can. The AskJeeves Web site has received millions of questions and maintains a catalog of those questions and answers. So chances are great that Jeeves has addressed your question for some other Internet user already and will be able to retrieve an answer from the catalog very quickly. The best way to experience AskJeeves is to simply try the site out or you might take a look at some of the most common questions by clicking on the Popular Questions link on the *www.askjeeves.com* home page.

Understanding the Term Web Agent — 485

As you browse the Internet, you might come across the term Web agent. A Web agent is a program that acts autonomously to perform some task, often data collection, on the Internet. The agent is a program that interacts and assists an end user. One of the most common examples, and one that is discussed within the Web searching Tips in this book, is a spider. A spider is a program that constantly searches the Internet for new information to add to a database. Some search engine sites build databases of information by using spiders that constantly prowl the Web gathering information.

Agents of various types are at work every second on the Internet gathering information resources. The use of Web agents spawns several ethical issues such as how much Internet bandwidth an agent should ethically use and whether or not an agent's use or actions produce email spamming. Poorly written agent software can severely impact the overall performance of the Internet's network infrastructure, the performance of servers exposed to the Internet, and the Internet's user population. For these reasons, it is a good idea to understand that Web agents are at work on the Internet, and in many cases, you can take advantage of the results of that work on a daily basis.

Searching Multiple Sites — 486

As you have learned in the previous Tips, there are many search sites on the Internet that you can use to locate the information you require. You can also find many sites and tools that will help you to query many search engines or directories at the same time.

The multiple site search tool or meta search engine presents you with a one-to-many search option. Rather than conducting individual searches on many different search sites, you can submit your search criteria to a single

1001 Internet Tips

interface, the multiple site search tool or Web site, and your search criteria are executed against many different search engines and databases.

The following Tips discuss several multiple site search tools and Web sites.

487 USING THE WEBFERRET SEARCH UTILITY

As you have learned in the previous Tips, there are many search engines available on the Internet that you can use to locate the information you require. You can also find many sites and tools that will help you to query many search engines or directories at the same time. WebFerretPRO by FerretSoft at *www.ferretsoft.com* provides a search utility that queries the most popular Web-based search engines quickly and efficiently and returns the results in a single window.

WebFerret is available in two versions, a WebFerret freeware version and WebFerretPRO. WebFerret freeware currently supports nine popular Web search engines, while WebFerretPRO (retail single user price $26.95) queries 33+ search engines, offers free upgrades, technical support, and the capability to turn off advertising banners.

In Figure 487, you can see the WebFerret freeware version as it responds to a query for the words multiple search utilities.

Figure 487 Searching the World Wide Web with WebFerret by FerretSoft.

Note: *FerretSoft provides numerous other search tools to search various Internet related content. See the FerretSoft Web site at www.ferrettsoft.com to read about other search products available.*

488 USING THE EMAILFERRETPRO SEARCH UTILITY

As you have learned in the previous Tips, there are many search engines available on the Internet that you can use to locate the information you require from the World Wide Web. You can also find many sites and tools that will help

you to query many search engines or directories at the same time. As you learned in Tip 487, WebFerretPRO by FerretSoft is one such tool that queries many search engines from a single interface.

FerretSoft also delivers a utility that helps you find another user's e-mail address. EmailFerretPRO queries Web-based e-mail directories to find the e-mail address of the user for whom you are looking. EmailFerretPRO can be purchased and downloaded from the FerretSoft Web site at *www.ferretsoft.com*.

Note: *FerretSoft provides numerous other search tools to search various Internet related content. See the FerretSoft Web site at www.ferrettsoft.com to read about other search products available.*

USING THE NEWSFERRETPRO SEARCH UTILITY 489

As you learned in Tip 268, USENET newsgroups are one of the most useful and popular Internet-based services. Also, as you have learned in the previous Tips, there are many search engines available on the Internet that you can use to locate the information you require from newsgroups or the World Wide Web. You can also find many sites and tools that will help you to query many search engines or directories at the same time. WebFerretPRO by FerretSoft, discussed in Tip 487, is one such tool that queries many search engines from a single interface.

FerretSoft also delivers a utility that helps you locate information within newsgroups on the Internet. NewsFerretPRO queries USENET newsgroups to find and retrieve newsgroup articles that pertain to the topic for which you are searching. You can then retrieve the articles and display or save the articles for later review. NewsFerretPRO will even decode binary attachments, such as pictures within newsgroups. NewsFerretPRO can be purchased and downloaded from the FerretSoft Web site at *www.ferretsoft.com*.

Note: *FerretSoft provides numerous other search tools to search various Internet related content. See the FerretSoft Web site at www.ferrettsoft.com to read about other search products available.*

SEARCHING WITH WWW.METACRAWLER.COM 490

Metacrawler, as shown in Figure 490, is an example of a meta search engine. Like other meta search tools, Metacrawler enables you to search through one or more of the major search engines by entering your query information into a single interface. Metacrawler receives your query and transforms it into the particular syntax of each of the Metacrawler supported search engines. Metacrawler then issues the query to each of its supported search engines and waits for responses or waits for the site to timeout. Upon receiving all of the responses from each of the different search engines, Metacrawler collates the responses, removes duplicate entries, ranks the responses, and returns the result to your Web browser.

The Metacrawler site provides a Customize link that will take you to a Web page that lets you fully customize the Metacrawler search options. Customizable options include which search engines to use, how to organize the results, and how many results to display on each returned page, to name just a few.

1001 Internet Tips

Figure 490 Searching the World Wide Web with the Metacrawler meta search engine.

491 SEARCHING WITH THE ALL-IN-ONE SEARCH PAGE

The All-In-One Search Page, as shown in Figure 491, provides access to over 500 of the Internet's databases, search engines, and indexes from a single site. Unlike meta search tools, the All-In-One Search Page does not necessarily query multiple search engines with a single entry in a query form, but rather provides a separate search field for each search site, arranged categorically, on the same page. The site is organized into an expandable/collapsible set of headings organized around search categories like World Wide Web, General Internet, or Software and Images.

For example, to search for information on the World Wide Web, you simply expand the World Wide Web category by clicking your mouse on the plus-sign graphic to the left of the words World Wide Web. The All-In-One Search Page, in turn, will display search fields for numerous search sites, arranged alphabetically by the name of the site. You simply pick the search site you want to use, type your key words into the search field, and click your mouse on the Search button to execute your search. The All-In-One Search Page, in turn, will route your request to the search site you chose and that search site will return a search results page to your browser.

1001 Internet Tips

Figure 491 The categorically arranged All-In-One Search Page.

SEARCHING WITH INFOZOID 492

InfoZoid, as shown in Figure 492, is an example of a meta search engine. Like other meta search tools, InfoZoid enables you to search through one or more of the major search engines by entering your query information into a single interface. As shown in Figure 492, you can use a set of checkboxes to specify which search engines you would like InfoZoid to query. You can use the And, Or, Phrase, and Native radio buttons below the Search field to specify how you would like to combine your key words when conducting the query.

Note: See Tip 483 for a discussion of Boolean Operators such as 'and' and 'or'. The InfoZoid home page also includes a "NewsZoid" search tool that you can use to query newsgroup listings.

Figure 492 Searching the World Wide Web with the InfoZoid meta search engine.

1001 Internet Tips

493 Searching with 1blink.com

1blink.com, as shown in Figure 493, is an example of a meta search engine. The motto of this site is displayed right at the top of the 1blink page, Search the engines in the blink of an eye! Like other meta search tools, 1blink.com enables you to search through many of the major search engines by entering your query information into a single interface. As shown in Figure 493, you can use a set of radio buttons to apply Boolean operators like And, Or, and Phrase that specify how you would like to combine your key words when conducting the query.

Note: *See Tip 483 for a discussion of Boolean Operators such as 'and' and 'or'. The 1blink.com home page also includes an Alaska & Canada search field that you can use to query for sites in Alaska and Canada.*

Figure 493 Searching the World Wide Web with the 1blink.com meta search engine.

494 Using www.monster.com

Monster.com at *www.monster.com* is a job search and job posting Web site that was launched in January, 1999. Monster.com is actually the convergence of The Monster Board (*www.monsterboard.com*), founded in 1994, and the Online Career Center (*www.occ.com*), founded in 1993. Monster.com is one of the leading global online locations for new careers, job postings, and resume posting.

Monster.com provides job listings, a configurable job search agent, and online resume management. Job seekers can also participate in chats and post articles to message boards. Monster.com also provides free newsletters that offer career and job search advice.

For employers, Monster.com provides an online recruiting solution at a reasonable price. Hiring organizations can post job openings, provide company profiles and contact information, and peruse the more than one million resumes archived by Monster.com. Organizations can also take advantage of online resume skills screening and resume routing features.

1001 Internet Tips

495 Using www.headhunters.com to Find Work

Headhunters.com at *www.headhunters.com* is a subscription service designed to be a resource businesses can use to locate job candidates for high-tech positions. Headhunters.com calls its home page, shown in Figure 495, the Jungle Menu. The Jungle Menu provides an uncomplicated interface to the site's services.

Figure 495 The Headhunters.com Jungle Menu.

To get past the Jungle menu, you can click on the Global Job Postings to see that job postings are initially categorized by geography and by industry. As you drill down through the site's links, you will see that the site contains numerous job postings in a variety of industries. Companies can subscribe to the service and place a company profile on the site for 90 days for a fee of U.S. $108. Companies can also place job descriptions on the site for an additional $45 per listing per 90 day term. The job description can be changed up to three times over the course of the 90 day term. If an organization happens to fill a position, it can use the same posting to advertise a new position.

Headhunters.com boasts as many as 15,000 hits per day by visitors referred by search engines or other referrals. Within a company profile, most companies also include an address to the company Web site so users can further research a company and its job openings. See Tip 497, Researching Potential Employers Online to research potential employees.

496 Using www.jobs.com to Find Work

Jobs.com is an easy to navigate job search site centered around the concept that most individuals strive to focus their job search in a certain geographical area. By providing a Quick Search drop-down list organized by city, Jobs.com makes it easy for individuals to find openings in a given geographical area .

1001 Internet Tips

Jobs.com, shown in Figure 496, also provides easy to use links to search for jobs by category, employment type, and salary range.

Figure 496 Using Jobs.com to search for employment or post job openings.

Johs.com provides Resumail software available for free download. Resumail provides an easy to use interface that individuals can use to create and post online resumes. Resumail also provides the capability to immediately respond to a job posting by resumailing your resume to the prospective employer.

Organizations, in turn, can download and use Resumail Recruiter software which lets the organization post jobs, including company profile information, and also manage resumes and find resumes that fit a particular job posting. Resumes can actually be delivered right to the Desktop via the Resumail Recruiter software.

497 RESEARCHING POTENTIAL EMPLOYERS ONLINE

Not only do organizations use dedicated job search sites to post jobs and recruit talent, but also, more and more employers are advertising available job openings online via corporate Web sites. Likewise, individuals can look for work and research companies using the same Web sites. This Tip presents some hints that you can use when researching potential employers online.

Many, in fact it seems like almost all, corporate Web sites have a jobs link somewhere on their site. For example, if you browse to Microsoft Corporation's Web site at *www.microsoft.com*, you can hover your mouse cursor over the About Microsoft link near the top of the home page and you will see a Jobs link on the resulting menu, as shown in Figure 497.1.

Click your mouse on the Job menu item. The Microsoft Web site, in turn, will display the Jobs home page from which you can choose various job categories, geographical locations, submit a resume, or even conduct job searches. Many corporations post jobs to the corporate Web site in a similar fashion and you need only peruse the listings until you find a position for which you would like to apply.

1001 Internet Tips

Figure 497.1 The Jobs link on the Microsoft Web site.

Frequently, when searching for work, individuals require more information about a particular company before they apply or accept a position with that company. Again, in doing company research, a corporation's Web site can prove to be an invaluable tool. A company's Web site will often provide insight into not only the products and services offered by the company, but also the corporate culture, branch office locations, and even background information on key employees within the company. For example, the Jamsa Press Web site, shown in Figure 497.2, includes a link called Contact Jamsa Press.

Figure 497.2 The Jamsa Press Web site. Notice the Contact Jamsa Press link on the left side of the page.

If you click your mouse on the link, Contact Jamsa Press, you will be shown a page that includes pictures and contact information for key Jamsa Press employees, as shown in Figure 497.3.

Figure 497.3 Key employees or contacts can often be located on a corporation's Web site.

Sometimes you have to search thoroughly, but often you can find all of the information you need about a company through that company's corporate Web site. If nothing else, a corporate Web site can almost always provide you with the name, e-mail address, or phone number of a key contact within that company.

498 USING INTERNET WHITE PAGES DIRECTORIES

In addition to providing extensive Internet search capabilities, most of the major search sites also provide the capability to search for people much as you would if you were using your telephone book. To find the street address, phone number, e-mail address, or even a map to the home of a particular individual, you can use the people search or white pages links on many search sites. Simply browse to any of the main search engines, like Yahoo, discussed in Tip 475, or AltaVista, discussed in Tip 478, and look for a link that says White Pages or, possibly, People Search. Another popular directory site is AT&T's AnyWho Info page, at *http://anywho.com*, as shown in Figure 498. AnyWho Info is a dedicated directory you can use to search for people, businesses, toll-free numbers, or Web sites.

Many White Pages and Yellow Pages sites also provide maps to specific addresses you have located. See Tip 499 for a discussion of searching for business addresses, phone numbers, toll-free numbers, e-mail addresses, and Web sites.

1001 INTERNET TIPS

Figure 498 Use AT&T's AnyWho Info directory site to find street addresses, phone numbers, and e-mail addresses of individuals you are trying to locate.

USING INTERNET YELLOW PAGES DIRECTORIES 499

As you learned in Tip 498, in addition to providing extensive Internet search capabilities, most of the major search sites also provide the capability to search for people or businesses much as you would if you were using your telephone book. To look for business addresses or Yellow Pages type information, simply browse to any of the main search engines, like Yahoo!, discussed in Tip 475, or AltaVista, discussed in Tip 478, and look for a link that says Yellow Pages or, possibly, Business Search. Figure 499 presents AltaVista's Yellow Pages search page.

Figure 499 Use the Yellow Pages on AltaVista to locate directory information for businesses you need to contact or visit.

1001 Internet Tips

500 — Understanding How Channels Differ from Subscriptions

In Tip 507, you will learn how to subscribe to sites on the Web whose contents you want the Internet Explorer to download when the contents change. As you have learned, when you subscribe to a Web site, the Internet Explorer will check the corresponding Web site on a regular basis to determine if the site's contents have changed. In addition to supporting subscriptions, Windows 98 and Internet Explorer also support channels—which are quite similar.

A channel, like a subscription, corresponds to a Web site. Like a subscription, you subscribe to a channel, which directs Windows 98 to either download the site's new contents or to notify you of the change. Unlike a subscription, however, a channel requires a special channel definition file (CDF) that the Web site will provide to Windows 98 and Internet Explorer that defines the site's attributes—such as how often or when the site will offer new contents. You can display a channel's contents on your Desktop or use the channel as a Desktop screen saver. Several of the Tips that follow discuss Windows 98 and Internet Explorer channel operations in detail.

501 — Viewing a Channel's Contents

Windows 98 lets you subscribe to a channel on the Web for which your system will notify you of, or even download, content changes. To help you get started with channels, Windows 98 provides a channel bar, from which you can select and view several channel sites. To view one of the Windows 98 predefined channels, perform the following steps:

1. Click your mouse on the Start menu Favorites option. Windows 98, in turn, will cascade the Favorites sub-menu.
2. Within the Favorites sub-menu, move your mouse to the Channels option and then choose the channel that you desire. Windows 98, in turn, will launch the Internet Explorer and will display the channel's Web site. In addition, along the edge of its window, the Internet Explorer will display the channel bar. For example, Figure 501 shows the Disney Web site within Internet Explorer.

Note: When selecting a channel for the first time, as described above, a channel wizard will ask you how you would like to access the channel site and also how you would like to store the site. After you answer a few simple questions, the channel site will be available for your use.

1001 Internet Tips

Figure 501 Viewing the Disney Web site using a channel.

VIEWING A CHANNEL FROM THE CHANNEL BAR 502

In Tip 501, you learned how to use the Start menu Favorites option to view a channel. If you are using the Internet Explorer, you can view a channel's contents by selecting the channel from the Favorites menu and the Channels sub-menu. In addition, if you select the View menu Explorer Bar option and choose Favorites, the Internet Explorer will display its Explorer bar along the edge of its window from which you can select the Channels sub-folder, as shown in Figure 501. Alternatively, within Internet Explorer, you can display the Explorer bar's Favorites folder by clicking your mouse on the Favorites toolbar button. Within the Channels folder, you can click your mouse on the channel you want to display.

USING THE CHANNEL VIEWER TO VIEW A SITE'S CONTENTS 503

In Tip 502, you learned how to view a channel's contents within the Internet Explorer. When you view channels within the Internet Explorer, you can use the Favorites Channel folder to choose the channel you want to display. In addition to letting you view a channel within the Internet Explorer, Windows 98 also provides a special icon on the Quick Launch Toolbar called the Channel Viewer that, as shown in Figure 503, you can use to display a channel's contents. By clicking your mouse on the Channel Viewer icon, you can immediately launch Internet Explorer and open the Explorer bar to your Channels folder.

To use the Channel Viewer to display a channel's contents, click your mouse on the Taskbar's Quick Launch toolbar's View Channels icon. To locate the View Channels button on the Quick Launch toolbar, simply point to the icons with your mouse and use the tool tip Help until you locate the correct button.

1001 Internet Tips

Figure 503 Using the Channel Viewer to view a channel's contents.

Note: *If your Taskbar is not currently displaying the Quick Launch toolbar, right-click your mouse on the Taskbar and select the Toolbar's Quick Launch option.*

504 DISPLAYING A CHANNEL AS A SCREEN SAVER

As you have learned, a channel is a Web site whose contents you can view within the Internet Explorer Channel Viewer. Within Windows 98, you can use your current channels as screen savers. Each time the screen saver becomes active, it will cycle through your current channels, displaying each site's contents on your screen. If you are connected to the Internet, your screen saver will display the site's current contents. If you are not connected to the Internet, your system will cycle through the contents it has previously downloaded for each channel. To use your channels for a screen saver, perform the following steps:

1. Right-click your mouse on the Desktop. Windows 98, in turn, will display a pop-up menu. Within the pop-up menu, click your mouse on the Properties option. Windows 98, in turn, will display the Display Properties dialog box.

2. Within the Display Properties dialog box, click your mouse on the Screen Saver tab. Windows 98, in turn, will display the Screen Saver sheet.

3. Within the Screen Saver sheet, click your mouse on the pull-down Screen Saver list and select the Channel Screen Saver option. Then, click your mouse on the Settings option. Windows 98, in turn, will display the Properties Sub-dialog box, as shown in Figure 504, within which you can select the channels you want the screen saver to display and for how long.

4. Within the dialog box, select the properties you desire and then click your mouse on the OK button.

1001 INTERNET TIPS

Figure 504 *Configuring your channel screen saver options.*

5. Within the Display Properties dialog box, click your mouse on the OK button to apply your changes.

MANAGING THE CHANNELS FOLDER 505

As the number of channels to which you subscribe increases, you may eventually want to delete, rename, or move one or more channels. To manage your system's channels, perform the following steps:

1. Within the Internet Explorer, click your mouse on the Favorites menu Organize Favorites option. The Internet Explorer, in turn, will display the Organize Favorites dialog box.

2. Within the Organize Favorites dialog box, click your mouse on the Channels folder. The Internet Explorer, in turn, will display your current channels within the Organize Favorites dialog box, as shown in Figure 505.

Figure 505 *Using the Organize Favorites dialog box to manage your system's channels.*

1001 Internet Tips

3. Within the Organize Favorites dialog box, click on the channel you desire and then use the Move, Rename, or Delete option to perform the operation that you desire.

506 CHANGING A CHANNEL'S PROPERTIES

As you work with channels on your system and become more comfortable with their use, there may come a time when you want to change a particular channel's properties. For example, you might want to make a channel available off-line, meaning download the channel's contents for use when you are not connected to the Internet. When you add a channel, as discussed in Tip 501, you have the option to make the channel available offline. If you did not make it available offline when you added it, you can still do so without re-adding the channel. To make an existing channel available offline, perform the following steps:

1. Within the Internet Explorer, click your mouse on the Favorites menu Organize Favorites option. The Internet Explorer, in turn, will display the Organize Favorites dialog box.

2. Within the Organize Favorites dialog box, click your mouse on the Channels folder. The Internet Explorer, in turn, will display your current channels within the Organize Favorites dialog box, as shown previously in Figure 505.

3. Within the Organize Favorites dialog box, click on the channel you want to make available offline. Internet Explorer, in turn, will display some information about that channel along with a checkbox that lets you make the channel available off-line, as shown in Figure 506.

Figure 506 Making a channel available offline.

4. Click your mouse on the Make available offline checkbox, placing a checkmark in the box. Notice that Internet Explorer adds a Properties button to the dialog box that you can use to configure the properties of the offline channel site.

5. Once you have configured your offline channel, click your mouse on the Close button to apply your changes.

507 Understanding Web Site Subscriptions AKA Offline Web Sites

As you use the Internet Explorer to surf sites across the World Wide Web, you will eventually find one or more sites whose contents you want to view on a regular basis. Rather than forcing you to continually visit a site (and wait for the site's content to download), Windows 98 lets you make a site available offline or subscribe to a site, which directs Windows 98 to download the site's contents for you (at specific intervals that you define). Later, after Windows 98 downloads the site's contents, you can browse the site offline (without having to wait for downloads).

Several of the Tips that follow discuss offline Websites or subscriptions in detail. In general, subscribing to a Web site will not cost you any money. Instead, by subscribing to a site, you will have the site's contents available when you want it—without a download delay. In other words, just as a magazine to which you have subscribed automatically shows up in your mailbox every month, the Web content to which you subscribe will automatically show up on your PC (within the folder that stores temporary Internet files). When you subscribe to a site within Windows 98, you can configure a schedule for Internet Explorer to use to download the site's content, or you can choose to manually synchronize the site's content.

508 Subscribing to a Web Site or Making the Site Available Offline

In Tip 507, you learned that Windows 98 lets you subscribe to a Web site whose contents you want Windows 98 to download to your system at regular intervals. To subscribe to a Web site, perform the following steps:

1. As you view the site within the Internet Explorer, click your mouse on the Favorites menu and choose the Add to Favorites option. Internet Explorer, in turn, will display the Add Favorite dialog box, which includes a checkbox that lets you make the site available offline.
2. When you click your mouse on the Make available offline button, Internet Explorer, in turn, will turn on the Customize button directly to the right of the checkbox. Use the Customize button to specify how you would like to synchronize the site's content to the offline folder. Clicking your mouse on the Customize button will launch a wizard that offers you choices for configuring the offline folder.
3. Within the Add Favorite dialog box, click your mouse on the Name field and type in the name you want the Internet Explorer to display for this site on the Favorites menu. Then, click your mouse on the OK button.

Your site will now be available even when your computer is not currently connected to the Internet.

509 Managing Offline Items Like Web Sites or Channels

In Tip 508, you learned how to use the Internet Explorer to make a Web site available offline. Over time, you may find that you want to cancel the automatic downloading of an offline Web site. To turn off offline viewing for a particular Web site or channel, perform the following steps:

1001 Internet Tips

1. Within Internet Explorer, click your mouse on the Favorites menu and choose Organize Favorites. Internet Explorer, in turn, will open the Organize Favorites dialog box.
2. Within the Organize Favorites dialog box, choose the Web site you want to configure. Internet Explorer, in turn, will display that folder's description and the Make available offline checkbox.
3. To turn off offline viewing, simply click your mouse on the Make available offline checkbox to clear the checkbox. Click your mouse on the Close button to close the Organize Favorites dialog box.

510 Using the Internet Explorer to Browse Offline

In Tip 508, you learned how to direct the Internet Explorer to make a Web site's contents available offline. Later, at your convenience, you can view the downloaded contents offline (without the downloading delay). To view a site's contents offline, perform the following steps:

1. Click your mouse on the Start menu and move to the Favorites option. Windows 98, in turn, will cascade the Favorites sub-menu.
2. Within the Favorites sub-menu, click your mouse on the Web site whose contents you want to view offline. Windows 98, in turn, will launch the Internet Explorer, displaying the site's contents even though you may not be currently connected to the Internet.

511 Synchronizing a Subscription AKA Offline Web Site

In Tip 508, you learned how to direct the Internet Explorer to make a Web site's contents available offline. At the time that you configure a Web site to be available, you also make a choice to schedule updates to the offline site or to manually synchronize the offline site with the actual Web site on the Internet. If, when setting up the offline Web site, you choose to manually synchronize the site, the site will not update until you force it to do so. To manually synchronize an offline Web site, perform the following steps:

1. Within the Internet Explorer, click your mouse on the Tools menu and choose Synchronize. The Internet Explorer, in turn, will display the Items to Synchronize dialog box, as shown in Figure 511.
2. Within the Items to Synchronize dialog box, use the checkboxes to choose which offline Web sites you would like to synchronize.
3. When you have selected the sites you wish to synchronize, click your mouse on the Synchronize button. Internet Explorer, in turn, will connect to each Internet Web site and synchronize its contents with your offline Web folder.

Figure 511 Synchronizing offline Web sites using the Items to Synchronize dialog box.

UNDERSTANDING ACTIVE DESKTOP COMPONENTS 512

In addition to letting you subscribe to Web sites and use channels for your Desktop screen saver, Windows 98 also lets you place *active objects* on your Desktop. In general, an active object is a program that interacts with a site on the Web to get and display information as you work. For example, many sites on the Web offer active content that you can place on your Desktop, like a stock ticker tape that displays stock prices or a weather map for the United States.

Across the Web, you will find a variety of active objects that you can install on your system. However, to avoid computer viruses, you should only download active objects from reputable sites, and then make sure the objects have a digital signature that you can use to verify that the object's file has not been altered.

The next few Tips discuss some of the active content that you can find on the Web for display on your Desktop.

INSTALLING OBJECTS FROM THE ACTIVE DESKTOP GALLERY 513

In Tip 512, you learned that Windows 98 and Internet Explorer let you display active objects on your Desktop. To help you get started with active objects, Microsoft provides an online gallery of objects from which you can download and install desired objects. To visit the Microsoft Active Desktop Gallery, perform the following steps:

1. Right-click your mouse on the Desktop. Windows 98, in turn, will display a pop-up menu. Within the pop-up menu, select the Properties option. Windows 98, in turn, will display the Display Properties dialog box.

1001 Internet Tips

2. Within the Display Properties dialog box, click your mouse on the Web tab. Windows 98, in turn, will display the Web sheet, as shown in Figure 513.1.

Figure 513.1 *The Display Properties dialog box Web sheet.*

3. Within the Web sheet, click your mouse on the New button. Windows 98, in turn, will display a dialog box asking you if you want to visit the Active Desktop Gallery at this time. Click your mouse on the Yes option. Windows 98, in turn, will start the Internet Explorer which, in turn, will display the Active Desktop Gallery at the Microsoft Web site, as shown in Figure 513.2.

Figure 513.2 *The Active Desktop Gallery at the Microsoft Web site.*

4. Within the Active Desktop Gallery, click your mouse on the active object that you want to download and install. Follow any specific instructions presented to you by the Web site to complete the installation of your Active object.

Using PointCast — 514

You will learn in Tip 798 that once they are installed, *push technologies* deliver data automatically to your PC. One of the most common and popular push services is PointCast at *www.pointcast.com*.

PointCast is a free Internet news service that broadcasts news information directly to your computer screen. PointCast is personalized and configurable so you can get the news you are interested in pushed to your computer. PointCast is funded by advertising so it is free to Internet users. You must simply download the PointCast Network software and install it on your PC to take advantage of the service.

PointCast also offers a free suite of tools called the PointCast Intranet Broadcast Solution that network administrators can deploy on their corporate network to provide news broadcast services for all of the corporation's employees. Further, you can even broadcast internal company news over your intranet via a private PointCast channel that appears alongside PointCast's public channels.

You can download PointCast software for free at *www.pointcast.com*, as shown in Figure 514.

Figure 514 Downloading PointCast for use on your workstation.

515 USING A STOCK TICKER

As you learned in Tip 513, Microsoft provides an online gallery of objects from which you choose the active components you would like to add to your Desktop. One such active object is the Microsoft Investor stock ticker. To install the Microsoft Investor Active Desktop object, perform the following steps:

1. Right-click your mouse on the Desktop. Windows 98, in turn, will display a pop-up menu. Within the pop-up menu, select the Properties option. Windows 98, in turn, will display the Display Properties dialog box.
2. Within the Display Properties dialog box, click your mouse on the Web tab. Windows 98, in turn, will display a Web sheet.
3. Within the Web sheet, click your mouse on the New button. Windows 98, in turn, will display a dialog box asking if you want to visit the Active Desktop Gallery at this time. Click your mouse on the Yes option. Windows 98, in turn, will start the Internet Explorer which, in turn, will display the Active Desktop Gallery at the Microsoft Web site (see Figure 513.2).
4. Within the Active Desktop Gallery, click your mouse on the Add to Active Desktop button right below the Microsoft Investor graphic on the Web page. Internet Explorer, in turn, will ask you for a confirmation that you do want to install the Active Desktop item. Click your mouse on the Yes button to install the component. Internet Explorer, in turn, will download and install the Microsoft Investor stock ticker to your Desktop, as shown in Figure 515.

Figure 515 *The Microsoft Investor stock ticker Active Desktop component.*

516 LISTENING TO THE GAME ON THE WEB

As you learned in Tips 459-464, you can use special software to listen to radio stations as well as other media across the World Wide Web. You can easily take advantage of this technology to listen to live sporting events piped over the Internet through the sound card and speakers on your personal computer.

One of the most popular sports Web sites on the Internet today is the ESPN Web site at *http://espn.go.com*. The ESPN Web site includes links to many online radio sports broadcasts. For example, Figure 516 shows one of the scoreboard pages from the ESPN Web site. Notice the Listen link below the Boston College at Virginia

1001 INTERNET TIPS

Tech score in the middle of the page. By clicking your mouse on one of the Listen links on the ESPN Web site, you will open a connection to the radio broadcast of that particular game, as long as the game is currently being played.

Figure 516 Click on the Listen link while the game is happening and you will hear the game's radio broadcast through your computer sound card and speakers.

WATCHING THE GAME ON THE WEB — 517

As you learned in Tip 516, you can listen to a radio broadcast of a particular sporting event through your personal computer's sound card and speakers. Likewise, you can watch the game's progress right on your computer screen using another tool accessible via the ESPN Web site. For example, Figure 517.1 shows one of the scoreboard pages from the ESPN Web site. Notice the NFL.com GameDay Live link below the Chicago at Detroit score in the middle of the page.

By clicking your mouse on one of the NFL.com GameDay Live links on the ESPN Web site, you will open a Java applet that tracks the status of the game right on your Desktop, as shown in Figure 517.2. The applet receives pushed updates of game progress and you will see the window change as the game progresses as long as the game is currently being played.

1001 Internet Tips

Figure 517.1 Click on the NFL.com GameDay Live link while the game is happening to open a Java applet that displays game progress on your Desktop as the game happens.

Figure 517.2 The NFL.com GameDay Live applet tracks the progress of the game automatically on your Desktop.

1001 Internet Tips

Understanding WebTV — 518

WebTV is a service to which you can subscribe to receive access to the Internet through the TV that you currently own. You can use the WebTV Web site, as shown in Figure 518, to gain more information about the WebTV service.

Figure 518 The home page for the WebTV Web site.

The Web address for the WebTV Web site is at *www.Webtv.net*. You can use the WebTV service to send and receive e-mail, surf the Internet, to view TV listings, participate in Internet chats, and much more. WebTV does not provide you with TV programming, you will still need to receive programming from your TV antenna or your cable provider. WebTV gives you access to the Internet and services to enhance your TV viewing experiences. You will need to buy an electronic unit called a Web TV Internet unit to be able to use the WebTV service. You will connect the WebTV Internet unit to your TV and to your phone line to connect you to the Internet. You can use the WebTV Internet Service Provider (ISP) or you can use any third party ISP to use as your Internet connection. The WebTV Internet unit and the WebTV service will turn your TV into an Internet-enabled device.

Getting a WebTV Internet Unit for Your TV — 519

You can get your WebTV Internet unit from many consumer electronic stores. You can also buy your WebTV Internet unit from the Web. Philips, one of the makers of WebTV Internet units, maintains a Web site on the several different types of WebTV Internet units that they sell, as shown in Figure 519.

From the Philips Web site you can get information about the different types of WebTV Internet units and the different types of service supported by the various units. If you like what you find about the WebTV Internet units from Philips, you can even buy the unit online from Philips.

1001 INTERNET TIPS

Figure 519 The home page for the Philips WebTV Internet unit Web site.

520 WORKING WITH YOUR WEBTV UNIT

Your WebTV Internet unit will come with a remote control that you will use to select options from screen menus. If you are going to send e-mail, you can use the remote control and an onscreen keyboard to enter your message into your e-mail. You can also purchase a remote keyboard to be able to type your messages on your keyboard. The remote can function as a mouse as you navigate the Internet on your TV but you may find that using the remote and the onscreen keyboard to enter long or many e-mail messages to be tedious. If you send a fair number of e-mails, you may find that the keyboard is well worth the extra expense.

521 UNDERSTANDING WEBTV FOR WINDOWS

You can use the WebTV for Windows program on your Windows 98 computer to use some of the WebTV functionality. You can use the WebTV for Windows to watch TV programs on your computer if you have a TV tuner card in your computer and it is connected to your antenna or cable network. Even if you do not have a TV tuner, you can use the WebTV for Windows program to view the TV listings for your local area, as shown in Figure 521.

You can use the WebTV for Windows to remind you of a program that you want to watch as well as search for a specific program or a type of program, such as Sci-Fi or Drama. If you have a TV tuner card connected to your computer, you can click the program that you want to watch and tune in the program on your computer. If the Web TV software is installed on your system, you may start the software by clicking your mouse on the Start menu. Next, select the Programs, Accessories, and Entertainment sub-menus, and click your mouse on the WebTV for Windows menu item. Windows, in turn, will display the WebTV for Windows display.

1001 Internet Tips

Figure 521 The TV Guide listing in the WebTV for Windows program.

Installing the Web TV for Windows Software — 522

If the WebTV for Windows software is not installed on your computer, you can install the software by performing the following steps:

1. Click your mouse on the Start menu and select the Settings sub-menu. Next, click your mouse on the Control Panel menu item. Windows, in turn, will display the Control Panel window.

2. Click your mouse on the Add/Remove Programs icon, Windows, in turn, will display the Add/Remove Programs Properties dialog box.

3. Click your mouse on the Windows Setup tab. Windows, in turn, will display the Windows Setup properties sheet.

4. Click your mouse in the WebTV for Windows checkbox (if the box already has a checkmark, then WebTV for Windows may already be installed). To verify that WebTV for Windows is installed, click your mouse on the WebTV for Windows item and then click your mouse on the Details button. Windows, in turn, will display the WebTV for Windows dialog box.

5. Verify that there is a checkmark in the WebTV for Windows checkbox. If there is no checkmark in the WebTV checkbox, click your mouse in the box to place a checkmark. After you have verified that the WebTV checkbox has a checkmark in it, click your mouse on the OK button. Windows, in turn, will close the WebTV for Windows dialog box.

6. Click your mouse on the OK button in the Add/Remove Programs Properties dialog box. Windows, in turn, will close the Add/Remove Programs Properties dialog box and install the WebTV for Windows program. You may need to insert your Windows 98 CD-ROM so that the Windows Setup can install the WebTV for Windows program. You will then need to reboot your system.

After your system reboots, additional software may be installed on your computer by the Windows setup process.

523 UNDERSTANDING THE PERSONAL WEB SERVER (PWS)

As you have learned, each site across the Web has a corresponding server, that is, the computer responsible for sending your Web browser the site's text and image files. If you want to have your own Web site, you must place your HTML files on a system that is running Web-server software. Normally, when a user wants to have a Web site, he or she will place the files at a location on the Internet Service provider's Web server. Likewise, if a user within a local-area network wants to have a Web page, he or she will normally place the files on a network server that is running Web-server software. Windows 98, however, provides a simple Web server that you can run on your own system. In this way, if you are part of a local-area network, you can run the Personal Web Server software on your PC and users from across the LAN can use their browsers to view HTML files that reside on your PC. The Personal Web server is a Web server that will run on your PC that you can use to create and test Web pages that you create. The Personal Web Server is small and not meant to be an Internet Web server, but if you are connected to the Internet, users across the Internet can view your Web pages using the Personal Web server.

524 INSTALLING THE PERSONAL WEB SERVER

The Personal Web Server is included with the Windows 98 operating system, so if you are running Windows 98, you already have the Personal Web Server. You will need to install the Personal Web Server on your computer before you can use it to deliver Web pages. To install the Personal Web Server, perform the following steps:

1. Click your mouse on the Start menu Run option. Windows 98, in turn, will display the Run dialog box.
2. Within the Run dialog box, use the Browse button and then select the *\add-ons\pws* folder from within the Windows 98 CD-ROM. Select the Setup program and then click your mouse on the OK button. Windows 98, in turn, will start the Setup program that will install the Personal Web Server on your system.
3. The default options in the setup should work for most installations. If you agree to the license, click your mouse on all of the Next buttons to accept the default options. When Windows 98 displays the type of installations, select the Typical installation.

Now that you have the Personal Web Server installed, you are ready to deliver Web pages to your network from your PC.

525 STARTING AND STOPPING THE PERSONAL WEB SERVER

From time to time, you may want to disable the browsing of pages published on your personal Web server without having to uninstall the product. You do have the ability to stop the service. You will use the icon in the system tray, the area on the Taskbar next to the time, as shown in Figure 525, to start and stop the Personal Web Sever.

1001 Internet Tips

Personal Web Server systray icon

Figure 525 The Personal Web Server systray icon.

To stop the Personal Web Server, perform the following steps:

1. Double-click your mouse on the PWS icon in the systray shown in Figure 525. Personal Web Server, in turn, will display the Personal Web Manager and Tip of the Day dialog boxes.
2. Click your mouse on the Close button to close the Tip of the Day dialog box. On the Personal Web Manager, click your mouse on the Stop button. Personal Web Server, in turn, will stop the Web server.

When you want to start your Web server again, you will need to go to the Personal Web Manager and click your mouse on the Start button using the same steps listed in this Tip.

BROWSING THE WEB SITE PUBLISHED ON YOUR PERSONAL WEB SERVER — 526

You can quickly look at your Personal Web Server site by entering the Web address of *http://localhost* in your Web browser, as shown in Figure 526.1.

Figure 526.1 Viewing a Web site that is hosted on your computer.

You can also view the Web site on your computer by entering the Web address of your Web site in the address box of your Web browser. You can find the Web address of your Web site by opening the Personal Web Manager. To open the Personal Web Manager, double-click your mouse on the Personal Web Server icon in the system tray, as you did in Tip 525, "Starting and Stopping the Personal Web Server." In the Personal Web Manager screen, the Web address of your Web site is listed, as shown in Figure 526.2.

Figure 526.2 The Personal Web Manager window showing the Web address of your PWS Web site.

The Web address of your Personal Web Server Web site is listed just above the Stop/Start button in the Personal Web Manger window.

Note: *The Web address displayed in the Personal Web Manager is a hyperlink. If you click your mouse on the link, your Personal Web Server Web site will be displayed.*

527 HAVING OTHER USERS USE YOUR PERSONAL WEB SERVER WEB SITE

You can have other people visit your Web site by providing them with the address of your Web site. Tip 526, "Browsing the Web Site Published on Your Personal Web Server," explained how to find the address of your Web site. You may need to check with your network administrator to determine if your Web site can be viewed outside of your local network. If you are connecting to the Internet through an ISP, you should have the ISP assign you an address and host name so that users can connect to your Web site. In most cases, you would only use your Personal Web Server Web site on your company's local network so you can share information with your co-workers. If you need to publish a Web site that is available on the Internet, it is usually more cost effective to have your ISP host your Web site on their Web servers rather than hosting the Web site on your Personal Web Server Web site.

528 USING THE HOME PAGE WIZARD IN YOUR PERSONAL WEB SERVER

You can quickly create your home page for your Personal Web Server Web site by using the Home Page Wizard, as shown in Figure 528.

You can start the Home Page Wizard by opening the Personal Web Manager, as discussed in Tip 526, "Browsing the Web Site Published on Your Personal Web Server." After you have opened the Personal Web Manager, click your mouse on the Web Site button in the navigation bar at the left of the Personal Web Manager window. The Personal Web Manager, in turn, will display the Home Page Wizard. The Home Page Wizard will step you through the creation of your home page.

1001 Internet Tips

After you answer all the questions in the Home Page Wizard your Personal Web Server Web site will use the home page you just created. You can modify your home page by using the Web Site button in the Personal Web Manager.

Figure 528 The Personal Web Server Home Page Wizard.

Using the Publishing Wizard 529

The Publishing Wizard will help you publish content to your Web site. You will start the Publishing Wizard by going to the Personal Web Manager, as you did in Tip 526, "Browsing the Web Site Published on Your Personal Web Server." After you have opened the Personal Web Manager, click your mouse on the Publish button in the Navigation bar on the left side of the Personal Web Manager window. The Personal Web Manager, in turn, will display the Publishing Wizard, as shown in Figure 529.

Figure 529 The Personal Web Server Publishing Wizard.

When you are working with other users in your company, you can make documents available to your co-workers quickly and easily by publishing the document to your Personal Web Server. For a co-worker to view a document, he or she can visit your Web site and view the Published Documents page. The Publishing Wizard will step you through how to make documents that you have created available on your Personal Web Server to other users.

530 ADDING NEW DIRECTORIES TO YOUR WEB SITE

After you have your Personal Web Server Web site running, you can add new sections to the Web site by adding a virtual directory to your Web site. A virtual directory is a directory on your computer that you make available to be used in your Web site. If you want to add a section to your Web site that is devoted to a project, you can add all your Web pages for the project to a single directory on your computer. You should create the Web pages as if you are creating a new Web site, including making a default Web page and linking all of your pages together. You can then make that directory available to your Web server by adding it as a virtual directory in your Personal Web Server. To add a directory containing Web pages to your Web site as a virtual directory, start the Personal Web Manager as you did in Tips525, then perform the following steps.

1. Click your mouse on the Advanced button in the Navigation bar on the left side of the Personal Web Manager. The Personal Web Manager, in turn, will display the Advanced Option window, as shown in Figure 530.

Figure 530 The Advanced settings window in the Personal Web Manager window.

2. Click your mouse on the Add button. The Personal Web Manager, in turn, will display the Add Directory dialog box.
3. In the Directory text box, enter the path to the directory that is holding the Web pages you want to add to your Web site. In the Alias text box, enter the name that you want to use for this new section of your Web site and click your mouse on the OK button. The Personal Web Manager, in turn, will add the directory to your Web site and return to the Personal Web Manager window.

To connect to the new section in your Web site, add the alias you named in step 3 above to the name of your computer. For example, if the alias you used in the virtual directory is jones, then you would use /jones/ after the name of your computer to see the new site, *http://reno/jones/*, for the computer, as shown in Figure 530.

1001 Internet Tips

531 Allowing Users to Look at Files on Your Computer Using Your Personal Web Server

You can make files available to other users on your network using your Personal Web Server. First, place all the files that you wish to make available on your network in a single directory. Next, start the Personal Web Manager and go to the Advanced Options as you did in the preceding Tip. On the Advanced Settings window, check the box next to Allow Directory Browsing, as shown in Figure 531.

Figure 531 The Allow Directory Browsing checkbox.

After you have allowed a directory to be browsed through your Personal Web Server, you can add the directory that is holding the files you are making available as a virtual directory by following the steps in the previous Tip. Users will go to the alias at your Web site and see a directory listing of the files and can download the files by clicking their mouse on a filename.

532 Designing Web Pages

Many of the Web page creation and editing tools available today include professional looking and well-designed templates you can use to quickly create professional looking pages and Web sites. For example, Tips 545-582 teach you about FrontPage Express and FrontPage. FrontPage includes a large assortment of Web page templates as well as Web site wizards that you can take advantage of to create pages or sites. Such templates provide a great place to start as a beginner. You can study the existing templates to get a feel for important design concepts, such as color schemes, use of frames, graphic use and placement, and text formatting, to name just a few.

To learn about Web page and Web site design, look at popular sites on the Internet and study the organization and layout of these sites. When you are ready to design and layout your own pages, consider the use of each of the following elements and concepts:

- To layout your pages, take advantage of frames and tables.
- Learn about and use text styles or style sheets.
- Use animations sparingly to spruce up your page.
- Carefully place text and graphics and other components adhering to good page layout principles.
- Set consistent background colors and graphics across your Web site's pages.
- Save your own best page designs to be used as templates.

Web page design is not an exact science, but it can be mastered by sticking to a few simple rules and studying successful sites.

1001 Internet Tips

533 Learning from Poorly Designed Web Sites

In Tip 532, you learned about some solid Web page and Web site design considerations. Another method for learning how to design professional Web pages and Web sites is to study Web sites that are poorly designed. Point your browser at the following URL to begin to learn about good Web site design by studying inferior sites: *www.Websitesthatsuck.com*. As you will find while looking at the Web Sites That Suck.com Web site, the purpose behind the site is to teach you how to design professional Web sites. Web Sites That Suck.com provides links to poor Web sites that you can look at and learn from, but there is also a wealth of information on solid design fundamentals. It is a site that you might find useful to check on from time to time just to see what is new and cool and also to see what is below par on the Web.

Web Sites That Suck.com provides a clever redirect site that you can use to let a user know his or her site sucks. E-mail the Webmaster of the site and tell him or her to check out the Web site at *http://www.herbal.com/sweetness.html*.

534 Looking at the HTML Interactive Tutorial

You can use the HTML Interactive Tutorial Web site, as shown in Figure 534, to learn the basics of creating HTML Web pages.

Figure 534 The HTML Interactive Tutorial Web site home page.

The Web address of the HTML Interactive Tutorial is *www.davesite.com/webstation/html/*. The tutorial will step you through several mini-lessons about HTML and creating Web pages. You will be able to create a Web page and then a small Web site after you have worked your way through the HTML Interactive Tutorial.

535 ADDING GRAPHICS TO YOUR WEB PAGE

When you add graphics to your Web site, you should be careful that you do not overload your Web pages with graphics. The graphics that you add to a Web page should entice a Web surfer to stay and visit your site and not have a dizzying effect. You should always be conscious of how long a Web page will take to download over a modem connection to the Internet. There are many styles of graphics that you can add to your Web page that promote quick downloads but still enhance the Web page. A technique that you can use to add several pictures to a Web page but still have a good download time for the Web page is to use thumbnails of your graphics. By using thumbnails, visitors at your Web site will be able to see the graphics and view only the ones that they want to view and not have to wait for the graphics that they do not want to view to be downloaded. Although adding graphics to your Web pages make the pages more dynamic and interesting, but you should also use graphics sparingly.

536 DEFINING YOUR BUSINESS ON THE WEB

When you plan to create a business Web site, you should not enter the design phase of your Web site lightly. It is important that you have clear goals for your Web site before you start the design of your Web site. Your Web site should portray your company and your product to the customer in a clear and easy to understand manner. While having a dizzying array of graphics and active components on your Web page look impressive at first, if the user viewing your Web page cannot understand what it is you are trying to promote, the user will not stay long to find out what you are promoting. Also, if your Web pages take too long to download, users may never see them as they will move on rather than wait for your page to download. You also do not want to completely redesign your Web site too often as it will be confusing to users who visit your site repeatedly and they may stop going to your Web site. The Web lets you create any image that you want to have. You do not have to worry about users having preconceived images of what your business does or what street the business is on in a town. You are equal to all other businesses on the Web so you will want to plan your image well to promote your business.

537 LOOKING AT THE ICONOGRAPHICS DESIGN WEB SITE

If you are looking for graphics for your Web site, you can use the Iconographics Web site, as shown in Figure 537, to look for graphics that you can download.

The Web address of the Iconographics Web site is *www.iconographics.com*. The Iconographics Web site has a free graphics section where you can download files to use in your Web page. If you need to have custom graphics designed for your Web project, the staff at Iconographics can do custom design on a fee basis.

1001 INTERNET TIPS

Figure 537 The Iconographics Web site home page.

538 LOOKING AT THE PHOTODISC WEB SITE

If you need to include photo images in your Web site, you may find the perfect picture at the PhotoDisc Web site, as shown in Figure 538.

Figure 538 The home page for the PhotoDisc Web site.

You can download a large number of photo images from the PhotoDisc Web site for a charge. The site has some sample photo images that you can download and use in your Web site. The photos are royalty-free which gives you

more freedom to use the photo images in many publications or Web sites. If you cannot find the image that you want in the free samples, then you may need to pay for the full service.

539 LOOKING AT THE CLIP ART CONNECTION WEB SITE

You can add clip art to your Web site to add character to your Web pages. The Clip Art Connection Web Site, as shown in Figure 539, has many clip art images that you can use.

Figure 539 The home page for the Clip Art Connection Web site.

You will find a large array of different clip art images that you can use in your Web pages at the Clip Art Connection Web site. You can download the clip art images to your Web server or you can link your Web pages to the Clip Art Connection servers to add the clip art image to your Web pages. You will need to manually search through the categories to find the right clip art that you may want to use for your Web pages.

540 LOOKING AT THE ICONOCAST WEB SITE

A helpful source for you to find information, facts, trends, and rumors in Internet marketing is the Iconocast Web site, as shown in Figure 540.

The Web address for the Iconocast Web site is *www.iconocast.com*. The Iconocast Web site is loaded with facts and figures about the Internet and who is using the Internet. You will find all the rumors on the net about marketing trends that may affect your business. The Iconocast Web site also gives you access to market analysis and insider information about marketing on the Internet.

1001 Internet Tips

Figure 540 The Iconocast Web site home page.

541 Looking at Guerrilla Marketing Online

You will find at the Guerrilla Marketing Online Web site, as shown in Figure 541, the type of information that you would get from the popular Guerrilla Marketing series of books used by marketers and MBA students the world over.

Figure 541 The Guerrilla Marketing Online Web site home page.

The Web address for the Guerrilla Marketing Online Web site is *www.gmarketing.com*. You will find at the Guerrilla Marketing Online Web site stories and information that will inspire and invigorate your marketing efforts. The

Guerrilla Marketing Web site can help any small business develop creative and innovative new marketing plans. At the Guerrilla Web site, you will be inspired to think of new and creative Web site marketing campaigns.

LOOKING AT THE WEB DIGEST FOR MARKETERS — 542

You can find information about the latest marketing Web sites on the Internet at the Web Digest for Marketers (WDFM) Web site, as shown in Figure 542.

Figure 542 The Web Digest for Marketers Web site home page.

The WDFM Web site is a summary of Web sites that market products on the Internet with commentary on what Web sites are working for the Web site developers and what Web sites are not attracting users to their Web pages. You can use the WDFM to stay up on what companies are using the Web effectively for marketing and what companies are not able to get their Internet image off the ground.

LOOKING AT THE NETMARKETING WEB SITE — 543

You can use the NetMarketing Web site, as shown in Figure 543, to learn how to create and effectively maintain a Web site to market your business.

The Web address for the NetMarketing Web site is *www.netb2b.com*. You can take eight different education tracks on how to develop and maintain a business Web site. The NetMarketing Web site has a ranking of Web sites that are effective business Web sites that you can use as examples of Web site design. The NetMarketing Web site also has monthly articles about different Internet marketing news and trends. The NetMarketing Web site is a good starting point for you to learn how to effectively market on the Web.

Figure 543 The home page of the NetMarketing Web site.

544 — LOOKING AT THE INTERNET MARKETING CENTER WEB SITE

You can use the Internet Marketing Center Web site, as shown in Figure 544, to help you market and promote any business you may have on the Internet.

Figure 544 The home page for the Internet Marketing Center Web site.

The Web address for the Internet Marketing Center is *www.marketingtips.com*. You will find many tips and suggestions on how you can use the Internet to promote your business regardless of your type of business. The Internet Marketing Center offers innovative ideas on how to use the Internet as a marketing tool. You will find a marketing newsletter, success stories of individuals who have used the Internet to promote their business, and links to many

Internet resources to help you develop your Internet presence, as well as marketing tips. If you are trying to market on the Internet, the Internet Marketing Center is a good source of information.

UNDERSTANDING FRONTPAGE EXPRESS — 545

FrontPage Express is a program that you can install as a part of Internet Explorer 5.0 to help you create your own Web pages. As you have learned, Web pages are made using a code called HTML. FrontPage Express is a program for creating a Web page where you do not need to know HTML code. You can use tools in the FrontPage Express program that will create the HTML code based on what you use the tool to create. For example, if you want a line of text to be in the center of your Web page and in a bold font, you can click your mouse on the bold and center tools. FrontPage Express, in turn, will create the HTML code to make the text bold and centered. While it is helpful to know something of the HTML code language, you could create a Web site using just FrontPage Express. FrontPage Express is a helper program used to create Web pages that you can install when you install Internet Explorer 5.0.

UNDERSTANDING A WYSIWYG HTML EDITOR — 546

The term WYSIWYG stands for What You See Is What You Get. It refers to the fact that as you edit a document, you can see its formatting on your computer screen. FrontPage Express is a WYSIWYG HTML editor in that you see how the Web page will look as you are editing the Web page. Figure 546.1 shows a Web page being edited.

Figure 546.1 An example of a Web page being edited in the FrontPage Express WYSIWYG HTML editor.

Any changes that are made to the Web page show up in the editor similarly to how they would show up in a Web browser. If you were editing the Web page shown in Figure 546.1 in a non-WYSIWYG editor, you would see all the HTML code, as shown in Figure 546.2.

Using a WYSIWYG editor can greatly help your production of Web pages. The WYSIWYG editor lets you see how your Web page will look in a browser as you are creating the Web page.

1001 Internet Tips

Figure 546.2 The Web page from Figure 546.1 displayed in FrontPage when not using the WYSIWYG editor.

547 CREATING A SIMPLE WEB SITE USING FRONTPAGE EXPRESS

You can easily create a simple Web site with FrontPage Express. To start creating your Web page, you should decide what you want to display on your Web page. After you determine the information that you want to present in your Web page, draw a diagram of the order that you want the information to be viewed. For example, you might want users to see an opening Web page followed by several pages with more detailed information. Your diagram might look like Figure 547.1.

Figure 547.1 A diagram of a simple Web site.

After you have mapped out your Web site, you can start creating your Web pages. To create a Web page, perform the following steps:

1. Click your mouse on the File menu. FrontPage Express, in turn, will display the File menu. Click your mouse on the New menu item. FrontPage Express, in turn, will display the New Page dialog box.

2. The Normal Page option should be highlighted. If it is not, click your mouse on the Normal Page option to highlight the option. Next, click your mouse on the OK button. FrontPage Express, in turn, will display a new blank Web page.

3. You should enter the information that you want on your Web page in much the same manner that you would use a word processor program. In each Web page you create, you should have a line that will be used to reference the next page or pages that you want users to see.

4. After you are done, click your mouse on the File menu. Then, click your mouse on the Save menu item. FrontPage Express, in turn, will display the Save As dialog box, as shown in Figure 547.2.

Figure 547.2 The FrontPage Express Save As dialog box.

5. If you are using Personal Web Server, (see Tip 523), you can publish this Web page to your PWS Web server. This will be a simple Web site and you do not need to have PWS running, so click your mouse on the As File button. FrontPage Express, in turn, will display a standard save dialog box. You should create a separate directory for your Web site and save all of your files to the same directory.

Now that you have created your first Web page, you can create the rest of your Web pages for your site using the same steps that you used to create the first Web page. Remember to have a line referencing other Web pages in your Web site that matches the Web page references to the diagram that you created for the flow of information. You should have a line that references the preceding Web page in your information flow as well, so that you have a line that references the next Web page in your information flow and a line that references the first page in your Web site. The first page in your Web site is called the home page, which is a good name to use when referencing the first page in your Web site. While you are on your Web pages, you can reference your first Web page and save it by the name *default.htm*. By calling your home Web page *default.htm*, you can transfer your Web site to a computer running Personal Web Server and your Web site will be displayed by default when a Web browser addresses the Web server. You can create the Web pages for your Web site using FrontPage Express.

LINKING YOUR WEB PAGES TOGETHER 548

Now that you have created your Web pages, you will need to link all the pages together so that a user can move from one page to another by using Web hyperlinks. You will use the lines that you wrote on each Web page referencing other Web pages to create your hyperlinks. To create hyperlinks for your Web pages in FrontPage Express, perform the following steps.

1001 Internet Tips

1. Open the home Web page, the first Web page you created, in FrontPage Express.
2. Highlight the word or words that you want to use as a link to your next Web page, as shown in Figure 548.1.

Figure 548.1 *The word to be used as a hyperlink is highlighted in FrontPage Express.*

3. Click your mouse on the Edit menu. FrontPage Express, in turn, will display the Edit menu. Click your mouse on the Hyperlink menu item. FrontPage Express, in turn, will display the Create Hyperlink dialog box.
4. In the Create Hyperlink dialog box, click your mouse on the Hyperlink Type dropdown list and select the file type (you may need to scroll in the dropdown list to find file). Then, click your mouse on the URL text box and delete any text that may be in the box. In the URL dialog box, enter the file name of the Web page that you want the link you are creating to display, and check the spelling of the file name, as shown in Figure 548.2.

Figure 548.2 *The Create Hyperlink dialog box showing a link to the **Outline.htm** file.*

5. Click your mouse on the OK button. FrontPage Express, in turn, will close the dialog box. The highlighted word or words will change color and be underlined to indicate they are a hyperlink.

You should now create links to all of your Web pages that follow the information flow in your diagram in tip 547. You will also create hyperlinks to the Web pages previous in your information flow and a hyperlink to the home page

using the lines referencing these Web pages (see Tip 547). After you have created all of your hyperlinks, your Web site is ready to be used. The hyperlinks between your individual Web pages are what make your Web pages into a Web site.

549 VIEWING YOUR WEB SITE IN INTERNET EXPLORER

Now that you have finished your Web site, you can view your Web site in Internet Explorer. To view your Web site in Internet Explorer, start the Internet Explorer program. As the Web site you have just created is not yet published to a Web server, click your mouse on the File menu. Internet Explorer, in turn, will display the File menu. Click your mouse on the Open menu option. Internet Explorer, in turn, will display a standard open dialog box. Use the Open dialog box to open the file that is the first Web page of your site and click your mouse on the OK button. Internet Explorer, in turn, will display the first Web page in your Web site, as shown in Figure 549.

Figure 549 The Web page file from a Web site being displayed in Internet Explorer.

Click on your links and check how your Web site works when viewed from a Web browser. Opening your Web site in a Web browser is a good way to test your Web site for problems and errors. If you find an error in your Web site, go back to FrontPage Express and edit the Web page to fix the mistake. You can open your Web page files in Internet Explorer to view how your Web site will look.

550 MOVING YOUR WEB SITE TO A PERSONAL WEB SERVER

After you have created all of your Web pages, linked the pages together, and tested your Web site by viewing the pages in a Web browser, you are ready to move the Web site to your Personal Web Server (PWS). If you have PWS running your computer system, all you will need to do is move the Web site you have created from the directory that you put all your Web pages in to the PWS Web directory. The PWS root Web directory is on your hard drive (most likely c:\) in the Inetpub\Webroot directory, as shown in Figure 550.

1001 Internet Tips

Figure 550 The root folder for your Web site when you are using PWS.

After you have copied all of your Web pages over to the Webroot folder, your Web site will be ready to be viewed by putting the address of the computer your Web site is on into any Web browser. If you did not name your first Web page *default.htm*, you will need to change the name of the file that holds your first Web page to *default.htm*. When you change the name of the file that holds a Web page, you will also have to change all the hyperlinks to that Web page to point to the new file name for your Web site to continue to work. After you have created your Web site, you can copy the Web site to the Webroot folder on a computer running PWS to make your Web site available on your network.

551 UNDERSTANDING FRONTPAGE 2000

FrontPage 2000 is a Web site development tool like FrontPage Express but has a much larger number of features and functions. FrontPage Express helped you create Web pages and is a free add-on for Internet Explorer. FrontPage Express is a cut down version of the full FrontPage 2000 program. FrontPage 2000 will help you create and manage your Web site. The FrontPage 2000 program will also help you more easily modify your Web pages. FrontPage 2000 also includes several different windows that display the makeup of your Web site where you can view the files that make up your Web site and then view and change how your Web pages link together. By using different windows you can get a different view of the Web site. FrontPage not only lets you manage the content on your Web site but the flow of your site as well. You can change how the different Web pages link together easily in FrontPage 2000 thereby changing how a person would move through your Web site. FrontPage 2000 is a full Web site development and management program.

552 DEFINING THE PURPOSE OF YOUR WEB SITE

The first task that you will have in creating a Web site will be to define the purpose of the Web site. To try to develop a Web site without having a purpose will lead to a cluttered and difficult to understand Web site. When you start

the design process, you will find that having a clear goal for your Web site will focus your site's development efforts. Whether you are creating a Web site to promote your business, to keep family members who live far away up to date on what your are doing, or to provide information about a topic in which you are interested, knowing your purpose at the outset will speed the development time of your site. After you define the purpose of your Web site, you can start adding content to your site. If you find that you want to add to the purpose of your Web site, think about saving the new Web content for a separate site that you tie together with the Web site you are working on by using a common home page. The purpose of a Web site will help guide your design decisions so that you make an efficient and well-presented Web site.

Understanding an Effective Web Site 553

An effective Web site is a Web site that fulfills the purpose for which you made the Web site. You may have a very simple Web site that you made to show off pictures of your new child to other family members. If your family members can find the Web site and can view all of the pictures that you placed on the site, the Web site is effective in that it fulfills the purpose for which it was created. You may have a most spectacular Web site that you created to market your product. However, if no one visits the Web site to learn about your product, your site is not effective. It does not fulfill its purpose. Sometimes glitz will help, as users will visit your Web site just to see the glitz and then browse around to learn about your product. Sometimes glitz will hurt, as users may not be patient enough to wait for the glitz to download. While it is difficult to know exactly what will make an effective Web site for your purpose, there are some good guidelines to follow in Web site design. Start with a home page that clearly states the purpose of the Web site. If users cannot tell what it is you are presenting, they may not wait long enough to find out what the Web site is about. You should not hide your content behind graphics so that users cannot read the information. If users cannot read the content on your Web site, they will leave it. You should use small pages with narrow topics that users can download quickly and get the information they want over a large Web page that has many different topics. If a user has a long wait for a huge page to download, he or she may go to a different Web site to get information. Using these three simple rules, you will be well on your way to building an effective Web site.

Using Folders Under the Web Root 554

When you create a Web site with FrontPage 2000, the FrontPage program will create several folders and files for you in the Web root. FrontPage 2000 creates two important folders for you: Images and _private. The Images folder can hold any image files that you add to your Web site. The _private folder will hold files that you do not want to have users who visit your Web site view but are still part of your Web site, such as your Web log files. While FrontPage 2000 does not require the use of folders, folders may greatly increase your ability to manage your Web site. You can use a folder structure under the Web root to separate Web pages from different parts of your Web site. By using folders to segment your Web site's Web pages, you will easily be able to find Web pages you want to modify even in large complex Web sites.

555 UNDERSTANDING FRONTPAGE SERVER EXTENSIONS

A Web server is the program that responds to Web browser requests for Web pages. Many different types of Web server programs exist that you can use to host your FrontPage 2000 created Web site. To use the full features of FrontPage 2000, you must install the FrontPage Server Extensions on your Web server. The FrontPage Server Extensions are a group of programs that run on a Web server and support the use of FrontPage 2000 to create and manage a Web site. With the FrontPage Server Extensions, you can use the FrontPage 2000 program to add active Web page components to a Web page without writing extensive program code. The FrontPage Server Extensions also support administering who can access and modify your Web site without you having to know the details of how a server's security works. The FrontPage Server Extensions provide extra functionality that you can get from the FrontPage program when you develop and manage a Web site with the FrontPage program.

556 LAUNCHING FRONTPAGE FROM INTERNET EXPLORER

When you are viewing Web pages in Internet Explorer, you can quickly launch the FrontPage program from the Internet Explorer toolbar if you have FrontPage 2000 installed on your computer, as shown in Figure 556.

Figure 556 The Internet Explorer toolbar with a tool button for the FrontPage program.

When you click your mouse on the FrontPage button, the FrontPage 2000 program will start will load the Web page that you are viewing into the FrontPage program. You can view the Web page in the normal FrontPage view where you will be able to see the basic construction of the Web page. You can also choose to view the HTML source for the Web page. Tip 565, "Working with the Page View," explains how to switch from Normal to HTML view. You can also edit the Web page and save the page to your computer.

557 WORKING WITH THE FRONTPAGE FOLDER VIEW

You use the FrontPage 2000 folder view to display all the files and the folders on your Web site. The folder view works and looks like the Windows Explorer program, as shown in Figure 557.

Figure 557 The Folder view in the FrontPage program.

In the folder view, you can create new folders and Web pages for your Web site. You can also rename files and move files into folders. FrontPage 2000 will automatically change hyperlinks that point to the file to reflect the changes in file name and location. The folder view is useful in organizing your Web site into folders while not breaking existing hyperlinks or having to rewrite all the hyperlinks that referenced the changed Web pages. You can change to the folder view by clicking your mouse on the Folders icon in the Views bar on the left hand side of the FrontPage program window.

WORKING WITH THE ALL FILES REPORT 558

The FrontPage 2000 All Files report will display details about all the files you use in your Web site. The All Files report displays the name of all the files you use in your Web site with other information, such as location of the file, the last time another user modified the file, and who last modified the file, as shown in Figure 558.

Figure 558 The All Files report in the FrontPage program.

1001 Internet Tips

The All Files view is very useful in a Web site development project where several users are modifying the Web pages. You can quickly determine who was the last user to modify a Web page and when the page was modified. You can generate the All Files report by clicking your mouse on the View menu and selecting the Reports menu item. FrontPage 2000, in turn, will display the Reports sub-menu. Click your mouse on the All Files menu item. FrontPage 2000, in turn, will display the All Files report. If you click your mouse on the View bar Report button, FrontPage 2000, in turn, will display the last report that was selected from the Reports sub-menu.

559 WORKING IN THE NAVIGATION VIEW

You use the FrontPage 2000 Navigation view to display a graphical representation of the flow of Web pages in your Web site. The Navigation view displays a graphical representation of how the Web pages fit together in your Web site, as shown in Figure 559.

Figure 559 The Navigation view of a Web site in FrontPage.

In the Navigation view, you can see how your Web site moves from one Web page to another Web page. You can still create the hyperlinks to the different pages in your Web site or you can have FrontPage define the hyperlinks, based on the Navigation view of the Web site. You can also move Web pages around in the Navigation view to change where pages are linked to other pages by simply dragging and dropping the page under a different page. You can display the Navigation view by clicking your mouse on the Navigation button on the Views bar.

560 WORKING WITH THE HYPERLINK VIEW

You can use the FrontPage 2000 Hyperlink view to see all the Web pages with hyperlinks that point to a Web page and all the Web pages to which hyperlinks on a Web page point, as shown in Figure 560.

As shown in Figure 560, the *default.htm* Web page has two links pointing to the *staff2.htm* Web page. The *staff2.htm* Web page has three links pointing to three different Web pages: *bob.htm, sue.htm* and *jim.htm*. The Hyperlinks view is helpful to see all the links that may affect a Web page. You can display the Hyperlinks view by clicking your mouse on the Hyperlinks button on the View bar.

Figure 560 *The Hyperlinks view for a Web page.*

WORKING WITH THE BROKEN HYPERLINKS REPORT 561

The FrontPage 2000 Broken Hyperlinks report is a quick way to see which hyperlinks are not working in your Web site. A broken hyperlink is a hyperlink that no longer points to a valid Web page. If you click your mouse on a hyperlink that does not work, you get an error message instead of a Web page. The Broken Hyperlinks report can display the status of all hyperlinks in your Web site. By default, the report will display only the hyperlinks in your Web site that do not point to a Web page that exists. To change the Broken Hyperlinks report to show all hyperlinks, perform the following steps:

1. Right-click your mouse in the Broken Hyperlink report screen on a blank line. FrontPage, in turn, will display a short-cut menu.
2. On the short-cut menu, select Show All Links. FrontPage, in turn, will display all the links in your Web site with the status of each hyperlink, as shown in Figure 561.

The Broken Hyperlink report will show the status of hyperlinks to Web pages on your server and hyperlinks to Web pages on an external server. In Figure 561, if the document listed in the Hyperlink column starts with an *http:* tab, then the link is most likely an external server link. You may need to force the FrontPage program to verify the hyperlinks in your Web site. To force a verification of hyperlinks to get an updated report, right-click your mouse in a blank area of the Broken Hyperlinks report to bring up the Broken Hyperlinks Shortcut menu. Click your mouse on the Verify Hyperlinks menu item. FrontPage, in turn, will verify all of the hyperlinks in the Web site. The Broken Hyperlinks report is a quick way to see what hyperlinks are not working in your Web site.

1001 Internet Tips

Figure 561 The Broken Hyperlink report in FrontPage.

562 WORKING WITH THEMES

Themes are styles of formatting that you can apply to a whole Web site at one time. When you use a theme, you will apply a style to your whole Web site. A theme can be a quick and easy method to create an attractive Web site. By using themes, you can create stylish Web sites with a click of your mouse. To apply a theme to your Web site using FrontPage 2000, click your mouse on the Format menu item and then click your mouse on the Theme menu item. FrontPage 2000, in turn, will display the Themes dialog box, as shown in Figure 562.

Figure 562 The FrontPage 2000 Themes dialog box.

Click your mouse on a theme name. FrontPage 2000, in turn, will display a preview of the theme in the Sample of Theme preview window. When you have found the theme that you like, click your mouse on the

OK button. FrontPage 2000, in turn, will apply the theme to all the Web pages in your Web site. You can still modify and create Web pages when you have applied a theme to a Web site. Themes provide a quick and easy method to apply styles to your Web site.

WORKING WITH THE TASK VIEW 563

When you are working with a team of people to develop a Web site, you may find that the task function in FrontPage 2000 will help you manage the development of the Web site. A task is an electronic way of tracking what jobs need to be completed on your Web site. In Navigation view, you can add a task to be associated with a Web page by right clicking on the Web page and clicking on the Add Task menu item. FrontPage, in turn, will display the New Task dialog box, as shown in Figure 563.1.

Figure 563.1 The New Task dialog box used to add tasks in FrontPage.

After you have created tasks, any time a user is working on a Web page that has a task associated with it, the user can save the Web page. FrontPage will prompt the editor of the Web page to see if he or she wants to mark the task complete. You can keep track of the tasks by displaying the Task view, as shown in Figure 563.2, by clicking your mouse on the Task button on the view bar.

Figure 563.2 The Task view in FrontPage.

1001 Internet Tips

A task can have one of three statuses: Not Started, In Progress, and Completed. The different fields in the list can sort the task list so that you can sort by Status or to whom the task was assigned. The assigning of tasks in the Task view is a good method of keeping track of the work being done on a Web site when a team of users are developing the site.

564 CREATING NEW WEBS

You can create multiple Web sites on the same computer using FrontPage 2000. In FrontPage 2000, you can create additional Web sites by creating Web sites in different directories. The use of directories to create a Web site lets you use your workstation as a staging area for Web sites that you are developing. You can also use FrontPage 2000 to connect to a Web server running FrontPage Extensions to create sub-Webs from an existing Web site. A sub-Web is a different section in an existing Web site. To create a new Web site, click your mouse on the FrontPage 2000 File menu and then select the New menu item. Front Page, in turn, will display the New menu. Click your mouse on the Web menu item. FrontPage 2000, in turn, will display the New dialog box, as shown in Figure 564.

Figure 564 The New dialog box you use to create a new Web site.

As you can see from Figure 564, you can choose from a drop-down list of places to create your Web site or you can just type a new Web site location in the Specify the location of the new web text box. The New dialog box also contains several templates and wizards to help you create a new Web site. You can use FrontPage to create a new Web site on your hard drive to be moved to a production Web server, or you can use FrontPage to connect to a Web server using FrontPage Server Extensions to create a sub-Web from an existing Web server.

565 WORKING WITH THE PAGE VIEW

You will use the Page view in FrontPage 2000 as you create the Web pages for your Web site. In Page view, you can create a new Web page, modify an existing Web page, and preview how a Web page will look in a potential Web browser. You display the Page view by clicking your mouse on the Page icon on the Views bar. FrontPage 2000, in turn, will display the Page view. As discussed in the next three tips, Page view provides three different views of your Web page: Normal, HTML, and Preview. When you work in Page view, you can switch between the Normal, HTML, and Preview views by clicking your mouse on the Normal, HTML, and Preview tabs at the bottom of your screen.

WORKING IN NORMAL PAGE VIEW 566

The Normal Page view is the default view FrontPage 2000 displays when you are working with a Web page. In the Normal Page view, you will see the individual element of a Web page in a WYSIWYG (What You See Is What You Get) environment, as shown in Figure 566.

Figure 566 The Normal Page view of a Web page in FrontPage.

The different dotted lines in Figure 566 show the different sections of the Web page FrontPage 2000 displays for your reference when you are creating the Web page but they will not be displayed in the final Web page. In the Normal Page view, you can add text to the Web page, format the text into lists or modify the size, color, or font style of the text as well as add images and other Web page components. You can display the Normal Page view by displaying the Page view in FrontPage 2000, as discussed in the previous Tip, and then clicking your mouse on the Normal tab at the bottom of the screen. The Normal Page view in FrontPage is a WYSIWYG Web page editing environment.

WORKING IN THE HTML PAGE VIEW 567

You use the FrontPage 2000 HTML Page view to edit the HTML code of a Web page. The HTML Page view in FrontPage will display the raw HTML code that makes up your Web page, as shown in Figure 567.

If you understand HTML code, you may find that it is easier to work with the HTML code rather than use the WYSIWYG environment. In the HTML view, you can create any Web page element the HTML code supports, which is all Web page elements. The HTML Page view will also color the HTML statements different from the normal text of the Web page so you can see the HTML code easier. You can display the HTML view by clicking your mouse on the HTML tab in Page view.

1001 Internet Tips

Figure 567 *The Web page in Figure 566 shown in the HTML Page view.*

568 WORKING IN THE PREVIEW PAGE VIEW

You use the Preview Page view to quickly switch from an editing view, like Normal or HTML view, to a view of what the Web page will look like in a Web browser. The Preview Page view will display the Web page you are editing as it would look in a Web browser, as shown in Figure 568.

Figure 568 *The Preview Page view of the Web page in Figure 566.*

You display the Preview Page view by clicking your mouse on the Preview tab at the bottom of the screen while in Page view.

1001 Internet Tips

Working with Web Page Components in FrontPage — 569

FrontPage 2000 provides many different Web page components that you can add to your Web page to enhance its look. You can add horizontal lines and breaks in your Web page to separate regions of text. You can add a date and time of last change to your Web page so users will know how recently the Web page has been updated. You can also add symbols, comments, and banners to your Web page, all by the click of your mouse. Many Web pages have these standard Web page components and you can easily add components to a Web page that is on any Web server. To add a Web page component, click your mouse on the Insert menu. FrontPage, in turn, will display the Insert menu, as shown in Figure 569.

Figure 569 *The Insert menu in FrontPage 2000 with the Component sub-menu displayed.*

Click your mouse on the Web page component that you want to add. If you do not see a component that you want to add, such as the date and time, click your mouse on the two down pointing arrows at the bottom of the menu to display more menu options.

Working with FrontPage Active Components — 570

FrontPage 2000 also provides dynamic components that change on the Web page as different users view the Web page. You should place Web pages with the FrontPage components on a Web server that has the FrontPage Server Extensions for the component to function properly. To add a FrontPage component, click your mouse on the Insert menu and select the Components menu item. FrontPage, in turn, will display the Components sub-menu. Click your mouse on the component that you wish to insert in your Web page. FrontPage 2000 provides many components you can add to enhance your Web page, such as a hit counter, shown in Figure 570, that will show how many users have viewed your Web page.

1001 INTERNET TIPS

Figure 570 *The Components sub-menu of the FrontPage program.*

For your FrontPage 2000 components to work properly, you should publish your Web pages on a Web server with the FrontPage Server Extensions.

571 INSERTING TABLES INTO YOUR WEB PAGES

A table is an efficient method to display many types of information in a Web page. FrontPage2000 provides an easy method for creating tables on your Web pages. To add a table to your Web page, perform the following steps:

1. Click your mouse on the Table menu and select the Insert menu item. FrontPage, in turn, will display the Insert menu.

2. Click your mouse on the Table menu item. FrontPage, in turn, will display the Insert Table dialog box, as shown in Figure 571.

Figure 571 *The Insert Table dialog box.*

3. In the Insert Table dialog box, enter the number of rows and columns that you will need for your table. You can change other table style options, such as how thick the table borders are, and when FrontPage 2000 displays the table in your Web page.

4. After you have set all the options, click your mouse on the OK button. FrontPage 2000, in turn, will close the Insert Table dialog box and place a table on your Web page.

After you have inserted the table into your Web page, you can enter your data into the table.

INSERTING IMAGES INTO YOUR WEB PAGE 572

One of the great strengths of a Web page is its ability to display not only text but also graphics and pictures. FrontPage makes it easy to add an image to your Web pages. To add an image file to your Web page, perform the following steps:

1. Click your mouse on the Insert menu and select the Picture menu item. FrontPage, in turn, will display the Picture menu.

2. Click your mouse on the From File menu item. FrontPage, in turn, will display the Picture dialog box, shown in Figure 572.

Figure 572 The Picture dialog box you use to add a picture to a Web page.

3. You should have a folder under your Web root that will hold all of your pictures for your Web site or a section of your Web site. The Images folder is included with the install program of Personal Web Server (PWS) for this purpose. Navigate to the picture that you want to add to the Web page and click your mouse on the OK button. FrontPage 2000, in turn, will close the Picture dialog box and add the picture to your Web page.

You can also use the Picture dialog box to add clip art and pictures that you have scanned in or taken from a digital camera by using the ClipArt and Scan buttons.

573 WORKING WITH THE TEXT IN YOUR WEB PAGES

FrontPage 2000 gives you all the same functionality of Microsoft Word to manipulate the text you use on your Web page. You can choose the size of the text, alignment, font style, and color of the text in much the same manner that you would manipulate the text in the Word program. When you are working with text, you must be aware that users running computer systems and browsers other than Windows and Internet Explorer will view your Web page. Many different computers systems using different types of Web browsers exist. When picking text font styles always think about the different types of Web browsers that may display the Web page you are creating. When you create a Web page in FrontPage with different colors and text font styles, the Web page may look good in Internet Explorer. However, because there is no matching font on a Linux computer system using Netscape Navigator, the Web page may look completely different and present a very poor Web page. When you are deciding on what type of text font style to use, you should try the Web page with the text in several different Web browsers to ensure that the text font style you chose looks right in most browsers.

574 WORKING WITH HYPERLINKS

The hyperlink is the part of a Web page that connects all the Web pages in your Web site together and lets you link your Web site to Web sites on the Internet. To create a hyperlink in FrontPage 2000, perform the following steps:

1. Create the Web page content that you want to link to other pages.
2. Use your mouse to highlight the word or words that you want to use as a hyperlink.
3. Click your mouse on the Insert menu and then click your mouse on the Hyperlink menu item. FrontPage 2000, in turn, will display the Create Hyperlink dialog box, shown in Figure 574.

Figure 574 The Create Hyperlink dialog box in FrontPage.

4. Navigate to the Web page file to which you wish to link the Web page you are working on and click your mouse on the file. If you want to make a hyperlink to a Web page on the Internet, rather than to a Web page in your site, enter the full URL in the URL text box.

5. Click your mouse on the OK button. FrontPage 2000, in turn, will close the Create Hyperlink dialog box and show the text that you highlighted as a hyperlink.

The text that you use for your hyperlinks should be related to the page to which the hyperlink points.

Understanding Connecting a Database to Your Web Site — 575

You can make a connection from a Web page to a database, such as Microsoft Access, using FrontPage 2000. FrontPage uses wizards to create connections to many different types of databases from Web pages in your Web site. You can use a database on a server to store information and then define a connection to a Web page that will display the information. This is an effective method of setting up your Web site because you must only keep the database up to date and the Web page will update automatically through the connection to the database. You can also create a Web page that will query a database and return information as well as Web pages that can enter information into a database. The combination of a Web site and a database server can create a powerful Web site.

Understanding Web Forms — 576

A Web form is a Web page that you can use to gather information from users when they visit your Web site. A Web form is made up of form elements, such as text boxes and radio buttons, as shown in Figure 576.1.

Figure 576.1 The FrontPage editor showing a Web page form with several text boxes and two radio buttons.

The boxes next to the labels, Name and City, are text box form elements and the radio buttons next to the Yes and No labels are radio button form elements. To add form elements to your Web page, create a form box on your Web

page by clicking your mouse on the Insert menu and then scrolling your mouse to the Form menu item. FrontPage, in turn, will display the Form sub-menu, as shown in Figure 576.

Figure 576.2 The Form sub-menu in Front Page 2000.

Click your mouse on the Form menu item on the Form sub-menu. FrontPage, in turn, will create a form on your Web page with a Submit and Reset button. You can press the ENTER key several times to increase the size of the form. Now that you have a form on your Web page, you can add form elements from the Form sub-menu to your Web form. As with other FrontPage components, you must publish your Web site on a Web server that supports FrontPage Extensions for the Web form you create in FrontPage to work.

577 UNDERSTANDING SCRIPTS

Web page scripts are small programs you can add to your Web page that will run when another user views the Web page or when the user viewing the Web page completes some action. You can write Web page scripts in several scripting languages. The two most common scripts to use with FrontPage are JavaScript and Visual Basic Script. See Tips 775, "Understanding Java," and 787, "Understanding VBScript," for information about Java and Visual Basic script. Using scripts in your Web pages can create dynamic Web pages that can change each time users view the Web page. To work with scripts in FrontPage, you can use the Microsoft Script Editor, as shown in Figure 577.

Figure 577 The Microsoft Script Editor with a simple Visual Basic Script for a Web page.

You can start the Script Editor in FrontPage by clicking your mouse on the Tools menu and selecting the Macro menu item. FrontPage, in turn, will display the Macro sub-menu. Click your mouse on Microsoft Script Editor. FrontPage, in turn, will start the Microsoft Script Editor.

UNDERSTANDING FRONTPAGE TOOLBARS 578

FrontPage 2000 toolbars hold tools that provide a quick and easy method to use FrontPage features. The FrontPage program has nine toolbars. The two main toolbars that you will work with are the Standard Toolbar and the Formatting toolbar. If you are not in the correct view, the FrontPage program will not make some of the toolbars active. Figures 578.1 and 587.2 show the Navigation toolbar is only active in the Navigation view.

Figure 578.1 The Navigation toolbar in Page view with the toolbar inactive.

Figure 578.2 The Navigation toolbar in Navigation view with the toolbar active.

To activate the different toolbars, perform the following steps:

1. Click your mouse on the View menu, then select the Toolbars menu item. FrontPage, in turn, will display the Toolbars sub-menu.

1001 Internet Tips

2. Click your mouse on the name of a toolbar to activate it. FrontPage, in turn, will close the menu and display the toolbar.

579 WORKING WITH THE FRONTPAGE STANDARD TOOLBAR

The FrontPage Standard toolbar has many of the most common FrontPage functions that you may use when creating a Web page. The Standard toolbar is present in all views in FrontPage, as shown in Figure 579.

Figure 579 The FrontPage Standard toolbar.

The first tool on the toolbar is the New button that you can use to create a new Web page, Web site, folder, or task. The second button, the Open button, lets you open an existing Web page or existing Web site. You use the third tool, the Save button, to save the current Web page on which you are working. The fourth tool lets you Publish your Web site to a Web server. The fifth tool is the Folder List button and lets you toggle between displaying the folder list and hiding the folder list in the FrontPage program. The sixth tool, the Print button, prints the current Web page. The seventh tool is the Preview button and lets you preview the Web page that you are working on in a Web browser. The eighth tool is the Spell check button and is used to spell check your document. The ninth, tenth, eleventh, and twelfth tools are the standard Cut, Copy, Paste, and Format Painter that are present in all Microsoft Office applications. The thirteenth and fourteenth tools are the standard Undo and Redo tools. The fifteenth tool is the Insert Component button and is used to insert a FrontPage component into your Web page. The sixteenth tool is the Insert Table button and is used to insert a table into your Web page. The seventeenth tool is the Insert Image button and is used to insert an image into your Web page. The eighteenth tool is the Hyperlink button and is used to create a hyperlink in your Web page to other Web pages or files. The nineteenth tool is the Refresh button and is used to refresh the view of your Web page after you have made changes. The twentieth tool is the Stop button and is used to stop the load of a Web page or stop an active component running on your Web page that you are working with in FrontPage. The twenty-first tool is the Show All button and is used to show all hidden characters in your Web page. The last tool is the Help button and is used to display the online help in FrontPage 2000.

580 WORKING WITH THE FORMATTING TOOLBAR

The second toolbar you will use often in FrontPage 2000 when you create Web pages is the Formatting toolbar, as shown in Figure 580.

Figure 580 The FrontPage Formatting toolbar.

The first drop-down box on the Formatting toolbar lets you define the style of the text you use in your Web page, such as normal, headline2, or numbered list. The second drop-down box lets you choose the font you use in your Web page. The third drop-down box lets you define the size of the font. FrontPage 2000 does not use point sizes, it uses a font size number which approximates the point size listed in parentheses next to the font size number. FrontPage 2000 uses the font size number because different browsers show font sizes differently, thus the point size

of a Web page text would be different on different browsers. The first, second, and third tools are the standard bold, italic, and underline tools. The underline tool underlines only a word or group of words. It does not make hyperlinks. The fourth, fifth, and sixth tools are the standard text alignment tools you use for aligning your text on your Web page. The seventh tool lets you create a numbered list on your Web page, and the eighth tool lets you create a bulleted list on your Web page. You use the ninth and tenth tools to decrease and increase, respectively, the indentation of the text on your Web page. You use the last two tools on the Formatting toolbar to highlight text and to set the text color in your Web page. The FrontPage Formatting toolbar has the most common formatting options that you can use to control how your Web page will look when viewed in a Web browser.

ADDING A SPREADSHEET TO YOUR WEB PAGE 581

FrontPage 2000 lets you add a spreadsheet interface to your Web page by adding the Microsoft Spreadsheet component to your Web page, as shown in Figure 581.

Figure 581 The Microsoft Spreadsheet component in a Web page.

To add the spreadsheet component to your Web page, click your mouse on the Insert menu and then select the Component menu item. FrontPage, in turn, will display the Component sub-menu. Click your mouse on the Office Spreadsheet menu item. FrontPage, in turn, will add the Office Spreadsheet to the Web page. After FrontPage adds the spreadsheet to your Web page, you can move the spreadsheet around the Web page by inserting new lines, pressing the ENTER key, and inserting spaces.

UNDERSTANDING VISUAL INTERDEV 582

The Visual InterDev program is a Web site development program like FrontPage but it is designed for the developers of large complex Web sites, most often involving commerce on the Internet. Web site designers use the InterDev program to create Web sites that work with databases and have customized programs that can process customer orders from a Web page. Long-time Web site developers, and not the average user, would use the InterDev program. The industrial strength Web site development program from Microsoft is Visual InterDev.

1001 Internet Tips

583 UNDERSTANDING ELECTRONIC MAIL

Today, users from all walks of life are making extensive use of the Internet to send and receive electronic mail. In fact, each day hundreds of millions of e-mail messages make their way across the Internet. Using e-mail software, you can type a message that you can later send across the Internet to another user. Because the Internet is a worldwide network of networks, you can use the Internet to send an e-mail message to the office down the hall, across town, across the country, or even on the other side of the world. Depending on the Internet's current level of electronic traffic, your message will usually arrive at its destination in a matter of minutes (or much less). Best of all—electronic mail messages are free! Depending on your needs, you can make your e-mail message brief or long, you can include pictures of your kids, or even attach documents, such as an Excel spreadsheet.

To send another user an e-mail message, you must know the user's e-mail address. E-mail addresses usually follow the format, *Name@someprovider.com*, such as *john_doe@gulfpub.com*. When you send an e-mail message, your recipient does not have to be online. Instead, the message will wait on a server until the next time the user connects to his or her online service or Internet account, and your message will be waiting.

Just as you have to have Web browsing software before you can surf the World Wide Web, you must also have e-mail software and an online service account before you can send and receive electronic mail. As you have learned, Windows 98 and Internet Explorer include *Outlook Express*, and Netscape Communicator includes *Messenger* for use as your e-mail and news client software.

584 STARTING MICROSOFT OUTLOOK EXPRESS

As you learned in Tip 583, one of the PC's most common uses today is to send and receive electronic mail messages. Again, just as Windows 98 includes the Internet Explorer program that you can use to surf the Web, Windows 98 and Internet Explorer provide *Outlook Express*, shown in Figure 584.1, an e-mail client that you can use to send and receive electronic mail.

Figure 584.1 The Outlook Express e-mail and news client.

1001 Internet Tips

To start *Outlook Express*, perform the following steps:

1. Click your mouse on the Start menu Programs option and choose Internet Explorer. Windows 98, in turn, will cascade the Internet Explorer sub-menu, as shown in Figure 584.2.
2. On the Internet Explorer sub-menu, click your mouse on the *Outlook Express* menu item. Windows 98, in turn, will launch *Outlook Express*.

*Figure 584.2 Starting **Outlook Express** from the Windows 98 Start menu.*

Note: *To simplify your access to **Outlook Express**, Windows 98 displays an icon within the Taskbar upon which you can click your mouse on to start the program. If your system does not display the **Outlook Express** Taskbar icon, right-click your mouse on the Taskbar and select the pop-up menu Toolbars sub-menu Quick Launch option.*

CONFIGURING OUTLOOK EXPRESS TO SEND AND RECEIVE INTERNET E-MAIL 585

Now that you have *Outlook Express* running, you must configure *Outlook Express* to use your account on your Internet Service Provider's mail server so you can start to send and receive e-mail. Prior to setting up *Outlook Express* to send and receive e-mail, you must have obtained your account and e-mail server information from your Internet service provider. To configure *Outlook Express* to use your e-mail account, perform the following steps:

1. Within *Outlook Express*, click your mouse on the Tools menu and move down and choose the Accounts option. *Outlook Express*, in turn, will display the Internet Accounts dialog box.
2. Within the Internet Accounts dialog box, click your mouse on the Mail tab. *Outlook Express*, in turn, will display the Mail tab as shown in Figure 585.1.

Figure 585.1 The Mail tab in the Internet Accounts dialog box.

1001 Internet Tips

3. On the Mail tab, click your mouse on the Add button to cascade the Add sub-menu. From the Add sub-menu, click your mouse on the Mail option. *Outlook Express*, in turn, will launch the Internet Connection Wizard, a wizard designed to walk you through the process of configuring your new account information.

4. On the first screen of the Internet Connection Wizard, you are asked to provide your name, the name that will appear in the From field on e-mail you send. Type in your name as you would like it to appear on outgoing e-mail and then click your mouse on the Next button.

5. The next Wizard screen prompts you for an Internet e-mail Address. At this screen, you have two options: you can choose to supply an e-mail address you have already arranged with your ISP or you can set up a new Microsoft Hotmail account. (See Tip 891, "Understanding HotMail.") Figure 585.2 shows an e-mail address provided by an Internet service provider. After you have chosen your e-mail address option and specified your e-mail address, click your mouse on the Next button. The wizard, will display the E-mail server names screen.

Figure 585.2 A sample e-mail address provided by an Internet service provider.

6. On the E-mail server names screen, complete the server type drop-down list and the incoming and outgoing mail server fields as specified by your Internet service provider. When you are finished entering server information, click your mouse on the Next button. *Outlook Express*, in turn, will display the Internet Mail Logon screen.

7. On the Internet Mail Logon screen, provide the account name and password supplied or arranged with your Internet service provider. When you are finished entering the account name and password, click your mouse on the Next button. The wizard, in turn, will display the final wizard Congratulations screen. You have now finished configuring your Internet mail account. Click your mouse on the Finish button to end the Wizard. *Outlook Express*, in turn, will return to the Internet Accounts dialog box Mail tab displaying your new account entry. Click your mouse on the Close button to return to *Outlook Express*.

586 UNDERSTANDING YOUR INBOX AND OTHER FOLDERS

To help you manage the e-mail messages that you send and receive, *Outlook Express* provides you with several folders in which you can store related messages. To start, each time you receive an e-mail message, *Outlook Express* places the message in the Inbox folder, much as someone might place an envelope in your mailbox at home or in your inbox at work. When you send a message, *Outlook Express* places the message into your Outbox until *Outlook Express* has had a chance to send the message.

1001 Internet Tips

After *Outlook Express* sends your message, it moves the message from the Outbox into the Sent Items folder. Finally, when you delete an e-mail message, *Outlook Express* moves the deleted message into the Deleted Items folder. Figure 586 shows folders within the *Outlook Express* folder list.

*Figure 586 The **Outlook Express** folder list.*

In *Outlook Express*, you can display a folder's contents by clicking your mouse on the folder's icon in the folder list. In Tip 609, "Creating Your Own e-mail Folders," you will learn how to create your own folders to further organize your e-mail messages. As you create your own folders, there may be times when you create subfolders (folders within a folder). To display a folder's subfolders, simply click your mouse on the plus sign that precedes the folder's name within the folder list. *Outlook Express*, in turn, will expand the folder's list of subfolders. To later collapse the expanded folder list, click your mouse on the minus sign that precedes the folder name.

Using the Outlook Express Toolbar 587

Like most Windows-based programs, *Outlook Express* provides a toolbar that contains icons you can use to simplify common operations. If *Outlook Express* is not displaying its toolbar, click your mouse on the *Outlook Express* View menu and choose the Layout option. *Outlook Express*, in turn, will display the Window Layout Properties dialog box. Within the Window Layout Properties dialog box, place a checkmark next to the Toolbar option name. Table 587 depicts the toolbar's icons.

New Mail	Creates a new e-mail message
Reply	Sends a reply message to the current message's author
Reply All	Sends a reply message to everyone who received the current message

*Table 587 The **Outlook Express** toolbar buttons. (continued on next page)*

1001 Internet Tips

Forward	Forwards the current message to another user
Print	Opens the Print dialog box so you can send the current message to the printer
Delete	Deletes the current message
Send/Recv	Directs *Outlook Express* to download messages from your e-mail server and to send messages that are waiting in your Outbox
Addresses	Displays your Address Book
Find	Opens the Find Message dialog box that you can use to search for specific messages within the *Outlook Express* folders

*Table 587 The **Outlook Express** toolbar buttons. (continued from previous page)*

Note: *In Tip 588, you will learn how to use the **Outlook Express** Window Layout Properties dialog box to customize the appearance of the **Outlook Express** window. Using the Window Layout Properties dialog box Customize Toolbar button, you can add or remove buttons from the **Outlook Express** toolbar.*

588 CUSTOMIZING YOUR OUTLOOK EXPRESS WINDOW LAYOUT

After using *Outlook Express* for a time, you may want to customize the appearance of the *Outlook Express* window so that the window better suits your needs. Figure 588.1 shows two *Outlook Express* windows, each of which uses a different layout.

*Figure 588.1 The Customizable appearance of the **Outlook Express** windows.*

1001 Internet Tips

To customize the appearance of your *Outlook Express* window, perform the following steps:

1. Within *Outlook Express*, click your mouse on the View menu Layout option. *Outlook Express*, in turn, will display the Window Layout Properties dialog box, as shown in Figure 588.2.

Figure 588.2 The **Outlook Express** *Window Layout Properties dialog box.*

2. Within the Window Layout Properties dialog box, use the checkboxes to enable or display specific window components and the radio buttons to position the components.
3. When you have finished making your choices, click your mouse on the OK button to apply your changes.

CUSTOMIZING THE COLUMNS WITHIN YOUR OUTLOOK EXPRESS WINDOW 589

In Tip 588, you learned how to customize the appearance of the *Outlook Express* window. In addition to changing the window's appearance, you may want to customize the items *Outlook Express* displays for each message in its message list. By default, *Outlook Express* will display the message priority, a paper-clip icon if the message has an attachment, the message flag if it has one, the sender of the message, the message subject, and the date and time you received the message, as shown in Figure 589.1.

Depending on your preferences, you can increase or decrease the amount of space *Outlook Express* uses for each column by using your mouse to drag the small bars that separate the column names in the bar that appears above the message list. By dragging the bars to the left or the right, you can increase or decrease a column's width.

To add or remove columns, perform the following steps:

1. Click your mouse on the *Outlook Express* View menu and choose Columns. *Outlook Express*, in turn, will display the Columns dialog box, as shown in Figure 589.2.

1001 Internet Tips

*Figure 589.1 The columns within the **Outlook Express** message list.*

*Figure 589.2 The **Outlook Express** Columns dialog box.*

2. To add a column to the current display, within the Columns list click your mouse on the checkbox that corresponds to the column you would like to add. *Outlook Express*, in turn, will display that column.

3. To remove a column from the current display, within the Columns list click your mouse on the checkbox that corresponds to the column you would like to remove. *Outlook Express* will remove the column from the display.

4. Click your mouse on the OK button to apply your changes.

1001 Internet Tips

Composing an e-mail Message within Outlook Express 590

As you have learned, you can use *Outlook Express* as your Internet e-mail client software to send and receive e-mail messages. To create and send an e-mail message, you use the New Message dialog box, as shown in Figure 590.

*Figure 590 The **Outlook Express** New Message dialog box.*

In the New Message dialog box, you will specify the e-mail address of each user to whom you want to send the message, type a single-line entry that summarizes the message subject, then type the message text.

More specifically, to send an e-mail message within *Outlook Express*, perform the following steps:

1. Within *Outlook Express*, click your mouse on the toolbar's New Mail button or select the Message menu New Message option. *Outlook Express*, in turn, will display the New Message dialog box, as shown in Figure 590.

2. Within the New Message dialog box, click your mouse on the To: field and type in your recipient's e-mail address. Tip 591 discusses the Cc: and Bcc: fields which you can use to send courtesy copies of your message to other users.

3. Within the Subject: field, type in a one-line message that briefly describes the message contents.

4. Within the Message Text field, type in your message and then click your mouse on the toolbar's Send button or click your mouse on the File menu Send Message option. *Outlook Express*, in turn, will move your message into the Outbox folder. To direct *Outlook Express* to immediately send your message, click your mouse on the toolbar Send/Receive button or select the Tools menu. Move your mouse to the Send and Receive option, and choose Send and Receive All from the fly-out menu.

1001 Internet Tips

You can send yourself an e-mail message by performing the following steps:

1. Within *Outlook Express*, click your mouse on the toolbar New Message button or select the Message menu New Message option. *Outlook Express*, in turn, will display the New Message dialog box, as shown in Figure 590.
2. Within the New Message dialog box, click your mouse on the To: field and type your own e-mail address, for example, *kcheung@gulfpub.com*.
3. Within the Subject: field, type the text Sample Test Message.
4. Within the Message Text field, type in the message This is a sample test message! and then click your mouse on the toolbar Send button or click your mouse on the File menu Send Message option. *Outlook Express*, in turn, will move your message into the Outbox folder. To direct *Outlook Express* to immediately send your message, click your mouse on the toolbar's Send/Receive button or select the Tools menu. Move your mouse to the Send and Receive option, and choose Send and Receive All from the fly-out menu.

591 UNDERSTANDING THE CC AND BCC FIELDS

As you learned in Tip 590, when you send an e-mail message, you specify the e-mail address of your message recipients within the To: field, the Cc: field, or the Bcc: field. (See Tip 593 "Selecting E-mail Message Recipients from Your Contacts List," for information on the Bcc field.) The letters Cc are an abbreviation for courtesy copy. When you send e-mail messages, there will be many times when you are sending a message to a specific user, but you also want other users to receive a courtesy copy of the message. For example, suppose you are sending a note to your project leader that tells him or her that you need to schedule a meeting with the team to discuss the budget. In this case, you would put the project leader's e-mail address within the To: field and you would put the e-mail addresses for the team members within the Cc: field, with each name separated by semicolons.

In a similar way, there may be times when you want to send a courtesy copy of your message to a user and you do not want other recipients to know that you have courtesy copied that user. In such cases, you can use the blind courtesy copy field (Bcc) to send the message to the user. When your message recipients view the message header to see who received the message, users to whom you blind copied the message will not appear in the list of recipients. Given the previous team meeting scenario, you might use the Bcc: field to notify your company's accounting director that you will be holding the budget meeting. When your team receives your message, they will be unaware that you have also sent a copy to the accounting director.

592 SPELL CHECKING YOUR E-MAIL MESSAGE

Before you send an e-mail message using *Outlook Express*, you might want to take time to spell check your message text. To start spell checking your current message, in the New Message dialog box, click your mouse on the Tools menu and choose the Spelling option. If the spell checker encounters an error within your message, *Outlook Express* will display the Spelling dialog box, as shown in Figure 592, in which *Outlook Express* highlights the error and displays suggested corrections.

*Figure 592 The **Outlook Express** Spelling dialog box.*

Within the Spelling dialog box, select the Ignore button if your word is spelled correctly (or the Ignore All button if the word appears many times throughout the document). Likewise, if the Spelling dialog box provides a correction that you wish to use, click your mouse on the appropriate selection and then click your mouse on the Change button (or the Change All button to change the word throughout the document).

Note: *If you want the spell checker to add your word to its dictionary, prior to clicking your mouse on the Ignore button, click your mouse on the Add button. The spell checker, in turn, will add the word to the dictionary.*

SELECTING E-MAIL MESSAGE RECIPIENTS FROM YOUR CONTACTS LIST — 593

If you are like many users, you may have a Rolodex or card file on your desk that contains names, addresses, and phone numbers for your key contacts. Within *Outlook Express*, you can store your contact information within an electronic Contacts List. Later, when you want to send an e-mail message to a user, you can select your recipients from your Contacts List and eliminate your need to look up or memorize each user's e-mail address. If you examine the New Message dialog box (shown in Figure 590), you will find a small book-like icon that appears next to the To: and Cc: fields. If, as you are addressing your e-mail message, you click your mouse on the book-like icon, *Outlook Express*, in turn, will display the Select Recipients dialog box, as shown in Figure 593, from which you can select the users to whom you want to send a copy, a courtesy copy, or a blind courtesy copy of your message.

To select a recipient for your message, click your mouse on the user's name within the recipient list and then click your mouse on the To, Cc, or Bcc buttons to assign the user to the corresponding field. After you select the entries you desire, click your mouse on the OK button. *Outlook Express*, in turn, will return you to the New Message dialog box, within which you can complete and then send your message.

1001 Internet Tips

*Figure 593 The **Outlook Express** Select Recipients dialog box.*

594 READING A NEW MESSAGE

Within Windows 98, you can use *Outlook Express* to send and receive e-mail messages. When you receive an e-mail message, *Outlook Express* will place the message within your Inbox folder. To display the Inbox folder's contents, click your mouse on the Inbox folder icon within the *Outlook Express* folder list, or, if *Outlook Express* is displaying its opening screen, click your mouse on the unread Mail message link (if you see it) or the Read Mail link.

Within the Inbox folder, *Outlook Express* will highlight your unread messages using a bold typeface. In addition, *Outlook Express* will display a closed envelope to the left of the message, as shown in Figure 594.

*Figure 594 **Outlook Express** highlights your unread messages using a bold typeface.*

To read an e-mail message within *Outlook Express*, click your mouse on the message within the message list. *Outlook Express*, in turn, will display the message text in the preview frame that usually appears near the bottom of your window. After you read a message, *Outlook Express* will change the envelope icon that appears next to the message (within the message list) from a closed to an open envelope.

Note: *If your* **Outlook Express** *window does not contain a preview frame within which you can view a message's contents, you can use the Window Layout Properties dialog box that Tip 588 describes to enable the frame's display or you can double-click your mouse on your messages, which will direct* **Outlook Express** *to open a window within which it will display the message contents. Most users will find the preview frame more convenient than having to open and close a window for each message.*

Note: *In Tip 609, you will learn how to create your own folders within* **Outlook Express** *that you can use to organize your e-mail messages. To view a message within any* **Outlook Express** *folder, simply click your mouse on the folder icon within the* **Outlook Express** *folder list and then click your mouse on the message you desire within the folder's message list.*

PRINTING YOUR CURRENT E-MAIL MESSAGE 595

As you view e-mail messages within *Outlook Express*, there will be many times when you will want to print a copy of a message's contents. To print the current message (the contents of which you can currently read on your screen display), perform the following steps:

1. Click your mouse on the *Outlook Express* File menu Print option. *Outlook Express*, in turn, will display the Print dialog box.
2. Within the Print dialog box, make any necessary changes and then click your mouse on the OK button to send the print job.

To print a message that is not the currently displayed message within *Outlook Express*, perform the following steps:

1. Within the *Outlook Express* message list, right-click your mouse on the message you desire. Windows 98, in turn, will display the context sensitive pop-up menu.
2. From the pop-up menu, select the Print option. *Outlook Express*, in turn, will open the Print dialog box.
3. Within the Print dialog box, make any necessary changes and then click your mouse on the OK button to send the print job.

FORWARDING AN E-MAIL MESSAGE 596

As you read through electronic mail messages, there may be times when you will want to forward a copy of a message to another user. To forward the current e-mail message within *Outlook Express*, perform the following steps:

1. If the message you want to send is not the current message (the contents of which you can view within the *Outlook Express* window), click your mouse on the message within the message list to select the correct message.

2. On the *Outlook Express* toolbar, click your mouse on the Forward button (or select the Forward option from the Message menu). *Outlook Express*, in turn, will display the Fw: dialog box (Fw is an abbreviation for forward).

3. Within the Fw: dialog box To: field, type in the e-mail address (or addresses separated by semicolons) of the recipient or recipients to whom you want to forward the message.

4. Within the message box, you may want to type a short message to the recipient.

5. When you are ready to send the message, click your mouse on the toolbar Send button or select the File menu Send Message option.

597 REPLYING TO AN E-MAIL MESSAGE

One of the reasons users often become buried with e-mail messages is that it seems that each message he or she receives requires a response which, in turn, generates a response from another user. To respond to a message within *Outlook Express*, you have two choices. First, you can reply to just the author (sender) of the message, or, if the message was sent to you and several other users, you can reply to all of the recipients of the message. That is to say, you can reply to every user who received the initial message, excluding those recipients who may have been blind courtesy copied because you will have no way of knowing who was blind copied.

To reply to an e-mail message, perform the following steps:

1. Within *Outlook Express*, click your mouse on the toolbar Reply button or Reply to All button, depending on whether or not you want to reply only to the author or to all of the recipients of the message. *Outlook Express*, in turn, will display the Re: dialog box. (Re: is an abbreviation for Reply.) *Outlook Express* will fill in the To: and Cc: fields for you, depending on whether you are replying to the author or to all recipients.

2. Within the Re: dialog box, use the To:, Cc:, and Bcc: fields to include the e-mail addresses of every user to whom you want to send the message. Note that you can add additional recipients if you like.

3. Click your mouse within the Re: dialog box Message field and type your reply. Then, click your mouse on the Send button to send your message.

598 DISPLAYING ONLY UNREAD MESSAGES

If you receive a large number of e-mail messages, it may not take long before your Inbox folder fills up with so many messages that you find it difficult to locate specific messages. In fact, there may be times when you have difficulty locating the e-mail messages you have not yet read. To help you locate your unread messages, you can direct *Outlook Express* to only display your unread messages by selecting the View menu Current View option and then choosing Hide Read Messages. *Outlook Express*, in turn, will display only your unread messages.

Later, if you want to view all your messages, click your mouse on the View menu Current View option and choose All Messages.

SORTING YOUR E-MAIL MESSAGES 599

As discussed in Tip 598, there may be times you receive such a large number of e-mails that your Inbox becomes unmanageable and your messages difficult to organize. When your Inbox folder becomes cluttered with an excessive number of messages, you may want to create additional folders within the *Outlook Express* folder list to group and organize related messages, as discussed in Tips 609 and 610. Next, if you are looking for a specific message, you can direct *Outlook Express* to sort your messages by the sender, date and time your message was received, or the subject, the message attachment, or even the message priority.

When you are looking for messages from a specific user, for example, you may find it convenient to sort your messages by sender. To sort your messages within *Outlook Express*, select the View menu Sort by option. *Outlook Express*, in turn, will cascade the Sort By menu, as shown in Figure 599. Within the Sort By menu, click your mouse on the field by which you want *Outlook Express* to sort your messages.

Figure 599 The Outlook Express Sort By menu.

FINDING A SPECIFIC E-MAIL MESSAGE 600

As the number of e-mail messages you receive increases, there may be times when you cannot find a specific message. In such cases, you can use the Find Message dialog box, as shown in Figure 600. To open the Find Message dialog box, simply click your mouse on the Find button on the *Outlook Express* toolbar.

Figure 600 The Outlook Express Find Message dialog box.

Within the Find Message dialog box, you can specify how to search for messages from a certain user or you can search for messages you sent to a specific user. If you do not specify the sender or receiver, *Outlook Express* will search all your messages. Within the dialog box Subject: or Message: fields, you can type in the specific text strings for which you are searching. For example, if you are looking for an e-mail message that discussed your company budget, you might type the word budget within the Message: field.

To further refine your message search, you can use the Received after: and Received before: fields to specify a range of dates within which *Outlook Express* should limit its search. For example, if you know you received the message in May, you would type in the After date, 5-1-99, and the Before date, 6-1-99.

Lastly, using the dialog box Look in: field and Browse... button, you can specify the folder within which you want *Outlook Express* to search for your messages and whether or not you want *Outlook Express* to search subfolders that reside beneath your selected folder. To change the folder from which *Outlook Express* will begin the search, simply click your mouse on the Browse button and select a new folder. Then, click your mouse on the Include Subfolders checkbox to search all subfolders of the folder specified in the Look in: field.

After you specify the settings you desire, click your mouse on the Find Now button. *Outlook Express*, in turn, will display a list of matching messages at the bottom of the dialog box. To view a message's contents, double-click your mouse on the message within the dialog box list.

601 INSERTING A FILE ATTACHMENT INTO AN E-MAIL MESSAGE

As you work, there will be times when you will want to send documents or pictures with your e-mail messages, and files such as word processing documents, spreadsheets, or a digital pictures to another user. In such cases, you can use *Outlook Express* to attach the file to an e-mail message. Later, when your recipient receives your e-mail message, he or she can view or save your attached file. To attach a file to an e-mail message, perform the following steps:

1. Within *Outlook Express*, click your mouse on the New Mail button. *Outlook Express*, in turn, will display the New Message dialog box.
2. Within the New Message dialog box, address your message, add a message subject, and type your message text telling your recipient that you have attached a document.
3. Click your mouse on the New Message dialog box Insert menu File Attachment option or click your mouse on the toolbar Attach button. *Outlook Express*, in turn, will display the Insert Attachment dialog box, as shown in Figure 601.1.

Figure 601.1 The Insert Attachment dialog box.

1001 INTERNET TIPS

4. Within the Insert Attachment dialog box, locate the folder that contains the file that you want to attach, click your mouse on the file, and then click your mouse on the Attach button. *Outlook Express*, in turn, will display your attached document in the Attach: field, as shown in Figure 601.2.

Figure 601.2 A document file attached to an e-mail message.

Note: *For your message recipient to view your document, in most cases the recipient must have the software that you used to create the document. For example, if you send the recipient a Word document, to view the document the recipient must have Microsoft Word on his or her system or at least some application that can open Word files.*

Note: *Drag-and-drop will also work for attaching a file to an e-mail message. Simply locate the file you wish to attach using Windows Explorer and then click your mouse and drag the file into the e-mail message.*

INSERTING A FILE'S TEXT CONTENTS INTO AN E-MAIL MESSAGE 602

In Tip 601, you learned how to attach a document file to an e-mail message. As discussed, for your recipient to view the document's contents, the user must have software on his or her system that can open and read the file. If you send an attached message to a user that the user cannot view (either because the user does not have the software you used to create the document, or the user's e-mail program does not support attached documents, or the user does not know how to view attached documents), you can direct *Outlook Express* to insert a file's text within your message. (The file that you specify must be an ASCII text file or an HTML file. *Outlook Express* will not insert the text from a word processing document in this manner.)

To insert the text from a document into an e-mail message, perform the following steps:

1. Within *Outlook Express*, click your mouse on the New Mail button. *Outlook Express*, in turn, will display the New Message dialog box.

1001 Internet Tips

2. Within the New Message dialog box, address your message, add a message subject, and type message text.

3. With your cursor positioned within the message text area, click your mouse on the New Message dialog box's Insert menu and choose the Text from File option. *Outlook Express*, in turn, will display the Insert Text File dialog box.

4. Within the Insert Text File dialog box, select the text file or HTML file, the contents of which you want to insert within your message. *Outlook Express*, in turn, will load the file's contents into your message.

Note: Alternatively, you can experiment with cutting or copying text from another application into the message field of your e-mail messages using the Windows standard cut, copy, and paste tools from the applications toolbar or Edit menu.

603 VIEWING OR SAVING A FILE ATTACHMENT

In Tip 601, you learned how to attach a document, such as a word processing document, a spreadsheet, or a graphic, to an e-mail message. Just as there may be times when you attach documents to the messages that you send to other users, there will be times when users send attached documents to you. When you receive an e-mail message with an attached document, *Outlook Express* will display a paper-clip icon within your message bar, as shown in Figure 603.1.

Figure 603.1 Outlook Express uses a paper-clip icon to indicate an attached document.

If you click your mouse on the paper-clip, *Outlook Express* will display the document name or will list multiple document names, depending on the number of documents the sender attached, as shown in Figure 603.2.

1001 INTERNET TIPS

Figure 603.2 Viewing the names of documents attached to an e-mail message.

If you click your mouse on the document name, *Outlook Express* will start the program that the sender used to create the document (provided you have the program installed on your system) and will load the document for you to view or edit. If you simply want to save the document to a file on disk, click your mouse on the Save Attachments option or choose the Save Attachments option from *Outlook Express*'s File menu. *Outlook Express*, in turn, will display the Save Attachments dialog box, within which you can use the Browse button to select the folder in which you would like to store the file and then you can specify the filename for the document file you are saving.

INSERTING A SIGNATURE INTO AN E-MAIL MESSAGE 604

When you send e-mail messages, you may find it convenient to include a signature block at the bottom of your message that includes your name, phone and fax number, e-mail address, and possibly your street address. For example, Figure 604.1 shows a signature block at the bottom of an e-mail message. Within *Outlook Express*, you can send your signature block with every e-mail message you send, or you can insert the signature into your message, as you desire.

To create your signature block, perform the following steps:

1. Within *Outlook Express*, click your mouse on the Tools menu and choose Options. *Outlook Express*, in turn, will display the Options dialog box.
2. Within the Options dialog box, click your mouse on the Signatures tab. *Outlook Express*, in turn, will display the Signature tab of the Options dialog box, as shown in Figure 604.2.

1001 Internet Tips

Figure 604.1 A signature block at the bottom on an e-mail message.

Figure 604.2 The Signature tab of the Options dialog box.

3. On the Signatures tab, click your mouse on the New button. *Outlook Express*, in turn, will add a new signature to the Signatures list, as shown in Figure 604.3.

4. Within the Edit Signature field, type in the signature information you desire. If you want *Outlook Express* to include your signature on each message you send, click your mouse on the Add this signature to all outgoing messages checkbox, placing a checkmark within the box. Then, click your mouse on the OK button.

5. Within the Options dialog box, click your mouse on the OK button to apply your changes.

1001 INTERNET TIPS

Figure 604.3 A new Signature added to the Signatures list. Use the Edit Signature area to add your signature text.

If you do not choose to send your signature automatically with each e-mail message, you can use the New Message dialog box Insert menu Signature option to insert your signature text into messages, as you desire.

Note: *Within the Signature dialog box, you can specify that* **Outlook Express** *use a specific file's contents for your signature field.*

CREATING AND INSERTING YOUR DIGITAL BUSINESS CARD — 605

In Tip 604, you learned how to insert signature text at the end of your e-mail messages. In a similar way, *Outlook Express* lets you send a digital business card with your e-mail messages.

Before you can send a business card with your e-mail messages, you must first create your business card by performing the following steps:

1. Create an entry for yourself in the *Outlook Express* Address book (also referred to as the Contacts list). Within *Outlook Express*, click your mouse on the Tools menu and choose the Address Book… option. *Outlook Express*, in turn, will display the Address Book dialog box.

2. Within the Address Book dialog box, click your mouse on the New button and choose New Contact… from the menu. *Outlook Express*, in turn, will display the new contact Properties dialog box.

3. Within the Properties dialog box, create an entry for yourself, including the information you would like to include on your digital business card, as shown in Figure 605.1.

1001 INTERNET TIPS

Figure 605.1 The Properties dialog box within which you add your digital business card contact information.

4. Within the Properties dialog box, click your mouse on each tab and complete the corresponding sheet's fields. Then, click your mouse on the OK button.

After you have created your Address book entry, you can have your business card attached to every e-mail that you send by performing the following steps:

1. In the *Outlook Express* window, click your mouse on the Tools menu and then click your mouse on the Options menu item. *Outlook Express*, in turn, will display the Options dialog box.
2. Click your mouse on the Compose tab. *Outlook Express*, in turn, will display the Compose dialog sheet, as shown in Figure 605.2.

Figure 605.2 The Compose dialog sheet where you will select the business card to add to your sent e-mails.

3. Click your mouse on the Mail: checkbox and select your name from the drop-down list. Click your mouse on the OK button. *Outlook Express*, in turn, will close the Options dialog box.

A digital business card will be added to each new e-mail that you create. If you do not want your business card to be added to an e-mail message in the new e-mail message window, click your mouse on the Insert menu and then click your mouse on the My Business Card menu Item to remove the checkmark, as shown in figure 605.3.

Figure 605.3 The Insert menu where you will select to add or not add a business card to an e-mail.

ATTACHING A GRAPHIC TO AN E-MAIL MESSAGE 606

In many cases, your e-mail messages will consist of a text message and an attached document. *Outlook Express*, in addition, will let you insert a graphic file within an e-mail message. Figure 606.1, for example, shows an e-mail message that contains a picture and text. You will not see the graphic when you send the message, but the graphic will be seen by the user who is receiving the message or by you if you open the message from your Sent items folder.

To insert a graphic into your current e-mail message, perform the following steps:

1. Within your e-mail message, click your mouse on the toolbar's Attach button. *Outlook Express*, in turn, will open the Insert Attachment dialog box.
2. Within the Insert Attachment dialog box, select the graphics file you would like to attach to the e-mail message and then click your mouse on the Attach button. *Outlook Express*, in turn, will display the file name in the New Message Attach: field, as shown in Figure 606.2.

1001 Internet Tips

*Figure 606.1 An e-mail message that contains a graphics image. Notice that **Outlook Express** displays graphics within the e-mail message.*

Figure 606.2 A New Message with an attached image file.

 3. Address the message, add subject line text, and type your message as you like. Then, click your mouse on the Send button to deliver the message and its attached file to the recipient or recipients you have specified.

1001 Internet Tips

607 — Inserting a Web Address into an e-mail Message

As you compose e-mail messages, there may be times when you want to tell the user about a specific Web site. For example, if the user has asked you how to get support information for *Outlook Express*, you might send the user an e-mail message that tells the user to visit the Microsoft Web site at *www.microsoft.com*. To insert a Web address within an e-mail message, simply type in the address within your message text. Later, when the user receives your message, the user's e-mail program will display the link within his or her message text, as shown in Figure 607. By clicking his or her mouse on the link within the message text, the user can direct Windows 98 to launch his or her browser to view the corresponding Web site.

Figure 607 Including a Web address within an e-mail message.

608 — Viewing Message Properties

Within *Outlook Express*, you can use the View menu Columns option, as discussed in Tip 589, to specify the information that *Outlook Express* displays about each message. If *Outlook Express* is not displaying a column that you desire, such as the message size, you can often view the column's value by examining the message's Properties dialog box, as shown in Figure 608.

Within the Properties dialog box, you can view a message's size, subject, send and receive times, priority, attachment information, and more. To display a message's Properties dialog box, perform the following steps:

1. Within the *Outlook Express* message list, right-click your mouse on the message about which you require additional information. *Outlook Express*, in turn, will display a context sensitive pop-up menu.

1001 Internet Tips

Figure 608 Viewing a message's Properties dialog box's Details tab.

2. On the pop-up menu, click your mouse on the Properties option. *Outlook Express*, in turn, will display the message's Properties dialog box like the one shown in Figure 608.

609 CREATING YOUR OWN E-MAIL FOLDERS

As you have learned, when you receive a new e-mail message, *Outlook Express* places your message in the Inbox folder. If you receive a large number of e-mail messages, you may find that your Inbox folder becomes difficult to manage. In such cases, you can create mail folders within *Outlook Express* in which you can store related messages. You might, for example, create a folder for Work, another for Publishing, and one for Friends messages. Figure 609.1, for example, shows an *Outlook Express* folder list that contains a variety of folders.

*Figure 609.1 An **Outlook Express** folder list including several user-created folders used for organizing e-mail messages.*

To create a folder within *Outlook Express*, perform the following steps:

1. Click your mouse on the *Outlook Express* File menu, move to Folder, and choose New from the fly-out menu. *Outlook Express*, in turn, will display the Create Folder dialog box, as shown in Figure 609.2.

*Figure 609.2 The **Outlook Express** Create Folder dialog box.*

2. Within the Create Folder dialog box, click your mouse on the folder within which you want to create the new folder. Next, click your mouse in the Folder name field and type a name for your new folder. Finally, click your mouse on the OK button.

Moving e-mail Messages into Different Folders 610

In Tip 609, you learned how to create your own folders in *Outlook Express*, within which you later store related messages. To move a message to a specific folder in *Outlook Express*, simply click and hold your mouse on the message and drag the message onto the folder in which you would like to store the message. When you release the mouse button, *Outlook Express*, in turn, will move your message into the destination folder you have chosen. To move multiple messages in one step, simply select messages just as you would select files within Windows Explorer (hold down the CTRL key as you click your mouse on each message or hold down the SHIFT key to select consecutive messages).

To copy a message to a different folder, simply hold down your keyboard's CTRL key as you perform the drag-and-drop operation.

Note: Outlook Express also provides Edit menu options that you can use to move or copy a selected message to a folder. In most cases, however, you should find simply dragging and dropping messages into the folders that you desire is a fast way to move or copy messages.

611 EMPTYING YOUR DELETED ITEMS FOLDER

After you have read and no longer need an e-mail message, you can delete the message and reduce the clutter within your Inbox. To delete a message, simply click your mouse on the message to select it. *Outlook Express*, in turn, will highlight the message. Then, click your mouse on the Delete button or press your keyboard's DEL key. Alternatively, you could drag a message from your Inbox (or some other *Outlook Express* folder) and drop it on the Deleted Items folder.

When you delete an e-mail message, *Outlook Express* does not delete the message from your system. *Outlook Express* moves the message from its current folder into the Deleted Items folder—much like Windows 98 moves the files that you delete into the Recycle Bin. Should you later decide that you need the message's contents, you can move the message out of the Deleted Items folder back into the folder that you desire. To permanently delete messages from your Deleted Items folder, perform the following steps:

1. Within *Outlook Express*, click your mouse on the Deleted Items folder. *Outlook Express*, in turn, will display the list of messages you have previously deleted.
2. Within the list of deleted messages, select the messages you want to permanently delete (you can hold down your keyboard CTRL key as you click your mouse on messages, you can select the Edit menu Select All option, or you can hold down your keyboard SHIFT key and use your arrow keys to highlight the messages you desire). After you select the messages you want to delete, click your mouse on the toolbar Delete button. *Outlook Express*, in turn, will display a dialog box asking you to confirm that you want to permanently delete the messages. Within the dialog box, click your mouse on the Yes button.

Alternatively, you can right-click your mouse on the Deleted Items folder and choose Empty Deleted Items from the pop-up context sensitive menu.

Note: You might want to delete messages from your Deleted Items folder on a regular basis. By deleting the messages, you free up disk space the messages consume. In addition, if you work in an office where other users may have access to your system, you prevent other users from viewing messages you have previously deleted.

612 DIRECTING OUTLOOK EXPRESS TO EMPTY YOUR DELETED ITEMS FOLDER EACH TIME YOU EXIT

As you learned in Tip 611, when you delete an e-mail message, *Outlook Express* does not remove the message from your system. Instead, *Outlook Express* moves the message into your Deleted Items folder. In Tip 611, you also learned how to manually delete messages from your Deleted Items folder. Depending on your needs, you may want *Outlook Express* to automatically empty the Deleted Items folder each time you exit the *Outlook Express* program. To direct *Outlook Express* to automatically empty your Deleted Items folder in this way, perform the following steps:

1. Within *Outlook Express*, click your mouse on the Tools menu and choose Options. *Outlook Express*, in turn, will display the Options dialog box, as shown in Figure 612.

*Figure 612 The **Outlook Express** Options dialog box.*

2. Within the Options dialog box, click your mouse on the Maintenance tab and then click your mouse in the Empty messages from the Deleted Items folder on exit checkbox, placing a checkmark within the box. Next, click your mouse on the OK button to apply your changes.

CREATING E-MAIL MESSAGES OFFLINE 613

If your PC is not always connected to the Internet (which means you use a dial-up connection that uses your modem to access the Internet), there will be times when you will want to reply to your e-mail messages or compose new messages while you are offline. You might, for example, want to catch up on your e-mail messages on an airline flight during which it is difficult to connect your PC to the Internet. In such cases, simply start *Outlook Express* as you usually would. Next, within *Outlook Express*, click your mouse on the File menu Work Offline option, placing a checkmark next to the option. Thereafter, each time you compose, reply to, or forward a message, *Outlook Express* will place the message within your Outbox folder. When you are done with your messages, you can exit *Outlook Express*.

Later, when you connect your PC to the Internet, you can start *Outlook Express* and click your mouse on the Send and Receive button to send the messages that reside within your Outbox folder.

CUTTING AND PASTING MESSAGE TEXT 614

As you read or compose an e-mail message, there may be times when you will want to copy text from one message that you can then paste into a second message. To start, you must first select the text you want to copy, by either

1001 Internet Tips

holding down your keyboard's SHIFT key as you use your keyboard arrow keys to highlight the text, or by holding down your mouse-select button as you drag your mouse pointer over the text. As you select text within a message, *Outlook Express* will highlight your selected text using reverse video. After you select the text that you desire, click your mouse on the Edit menu Copy option. Then, click your mouse within the message into which you want to paste the text and position the cursor to the text's starting position. Finally, select the Edit menu Paste option to place the text into the message.

Note: *If you want to select the entire message text for a cut-and-paste operation, click your mouse within the message that contains the text and then select the Edit menu Select All option.*

615 INITIATING A SEND AND RECEIVE OPERATION

By default, *Outlook Express* checks for new messages every 30 minutes. Further, as you have learned, when you first send an e-mail message, *Outlook Express* places your message in its Outbox until it has time to send the message. By clicking your mouse on the Send and Receive button, or by selecting the Tools menu Sendand Receive option, you can direct *Outlook Express* to immediately check for new messages and to immediately send messages that reside in your Outbox. When you initiate a Send and Receive operation, *Outlook Express* will display the *Outlook Express* dialog box, as shown in Figure 615, which you can use to monitor the status of your system's send and receive operation.

*Figure 615 Monitor e-mail send and receive operations within the **Outlook Express** dialog box.*

616 STOPPING A RECEIVE OPERATION

If *Outlook Express* is downloading your e-mail messages or if you want to initiate a download operation, you can click your mouse on the Send and Receive button to display the *Outlook Express* dialog box within which you can monitor the message download operation. Depending on the number of messages you receive, there may be times when you have more messages to download than you have time to wait. In such cases, you can stop the download operation by clicking your mouse on the Stop button to stop the download after the current message.

Later, when you have time to perform the download operation, you can start *Outlook Express* and use the Send and Receive operation to initiate the e-mail message download.

UNDERSTANDING YOUR OUTBOX FOLDER 617

As you have learned, when you receive e-mail messages, *Outlook Express* places your messages in the Inbox folder. Similarly, when you send an e-mail message, *Outlook Express* first places your message into the Outbox folder. After *Outlook Express* successfully sends your message, it will move your message into the Sent Items folder. For example, if you are working off-line (perhaps you are composing your e-mail message on an airline flight), *Outlook Express* will place all your messages within the Outbox folder. Later, when you connect to the Internet, you can click your mouse on the toolbar Send and Receive button (or select the Tools menu Send and Receive option) to direct *Outlook Express* to send the messages.

If you examine your Outbox folder within the *Outlook Express* folder list, you will find that *Outlook Express* places a count of the number of messages that it has yet to send next to the folder name. If, for example, your window displays the text Outbox (2), you know that two messages reside in your Outbox that *Outlook Express* will send the next time you initiate a send operation.

If you are not sure if *Outlook Express* has sent your message, click your mouse on the Outbox. If the Outbox folder contains messages, click your mouse on the Tools menu Send and Receive button to direct *Outlook Express* to send them. Otherwise, if the Outbox folder is empty, click your mouse on the Sent Items folder within which *Outlook Express* will display a list of all the messages it has successfully sent.

TELLING IF ANOTHER USER HAS READ YOUR MESSAGE 618

Within *Outlook Express*, you can view the contents of the Sent Items folder to determine which messages you have successfully sent. However, just because you sent the messages does not mean that the messages reached their destination or that the recipient has read them. You might, for example, misspell the user's e-mail address, or the user may have changed his or her e-mail address since you last sent mail. Unfortunately, *Outlook Express* cannot immediately report such errors to you. Instead, *Outlook Express* will send your message out onto the Internet in an attempt to deliver the message. Eventually, the message will return to your system as undeliverable. *Outlook Express*, in turn, will place a message within your Inbox folder that tells you that it could not deliver the message. In most cases, the problem that prevented the message delivery is an error in the recipient's address.

In addition, *Outlook Express* has no way of knowing when (or if, for that matter) your message recipient has read your message, just as you have no way of knowing when the recipient of a letter you send by US mail or Federal Express actually opens and reads your message.

ASSIGNING A PRIORITY TO YOUR E-MAIL MESSAGE 619

Today, it is not uncommon for users to receive dozens, if not hundreds, of e-mail messages each day. When you send an e-mail message to another user, *Outlook Express* lets you assign a priority (Low, Normal, or High) to the message.

1001 Internet Tips

When the user receives the message, his or her e-mail software may display an icon next to the message that corresponds to the message priority. *Outlook Express* will display an exclamation point for high-priority messages, as shown in Figure 619, and a down-arrow icon for low-priority messages.

Figure 619 Outlook Express displays icons that correspond to a message's priority.

To help manage their e-mail, some users will sort their messages by priority. (Users may also be unhappy with you if you send them messages marked as high-priority, the contents of which really do not merit the user's urgent response.) To assign a priority to an e-mail message you are about to send, click your mouse on the *Outlook Express* Message menu, move to Set Priority and choose a priority level from the fly-out menu. Alternatively, you could use the Priority button on the New Message dialog box's toolbar to set a priority level.

620 ENCRYPTING YOUR E-MAIL MESSAGE

When you send an e-mail message to a user across the Internet, your message travels over a relatively unsecure network, through or past many computers, each of which is capable of capturing and viewing your message contents. To protect your message contents from being read by anyone except your desired recipient, you can encrypt your message. To encrypt a message within *Outlook Express*, you must have your recipient's digital certificate (an encryption key which your recipient can send to you by sending you a signed message, or which you can look up on the Web at a site, such as VeriSign, which provides the public portion (the part other users such as you can see) of a user's encryption key. After you record the user's digital certificate within the user's Address Book entry, you can send the user an encrypted e-mail message simply by clicking your mouse on the *Outlook Express* Tools menu Encrypt option.

When the user receives your encrypted message, his or her software will automatically decrypt the message using his or her digital signature. In other words, you will encrypt the message that you send to the recipient using the public portion of the recipient's digital certificate. (You do not use your digital signature to encrypt the message, you use the recipient's certificate.) Then, when the message arrives, the recipient uses the private portion of his or her digital signature to decrypt the message. Because only the recipient has the private portion of a digital signature, only the recipient can decrypt the message.

Note: When you receive a signed message from a user, click your mouse on the File menu Properties option to display the message's Properties dialog box. Within the dialog box, click your mouse on the Security tab and then click your mouse on the Add Digital ID to Address Book button to ensure that your Address Book contains the user's digital certificate.

OBTAINING A DIGITAL SIGNATURE 621

In Tip 620, you learned how to encrypt an e-mail message within *Outlook Express*. As you have also learned, before you can encrypt a message, you must purchase a digital signature—which you can do online from VeriSign, Inc. To purchase your digital signature, start the Internet Explorer and then connect to the VeriSign Web site at *www.verisign.com*. From the VeriSign Web site, you can perform the steps listed to purchase and download your digital signature. To direct *Outlook Express* to use the digital signature that VeriSign installs on your system, perform the following steps:

1. Within *Outlook Express*, click your mouse on the Tools menu and choose Accounts. *Outlook Express*, in turn, will display the Internet Accounts dialog box.
2. Within the Internet Accounts dialog box, click your mouse on the Mail tab. *Outlook Express*, in turn, will display the Mail sheet.
3. On the Mail tab, select the account for which you created the digital signature. Then, click your mouse on the Properties button. *Outlook Express*, in turn, will display that account's Properties dialog box.
4. Within the Properties dialog box, click your mouse on the Security tab. *Outlook Express*, in turn, will display the Security tab.
5. On the Security tab, click your mouse on the Use a digital ID when sending secure messages from: checkbox, placing a checkmark in the box. Then, click your mouse on the Digital ID button and select your digital ID. Finally, click your mouse on the OK button.
6. In the Internet Accounts dialog box, click your mouse on the Close button.

ASSIGNING A DIGITAL SIGNATURE TO YOUR E-MAIL MESSAGE 622

In Tip 621, you learned how to install a digital signature that you download from VeriSign. When you send an e-mail message, you can digitally sign your message using your digital signature. When your recipient receives a message with a digital signature, your recipient can feel confident that the message really came from you (meaning another user did not forge a message claiming to be you) and that your message's contents have not changed since you signed the message.

To digitally sign your message, simply click your mouse on the New Message dialog box Tools menu and choose the Digitally Sign option, placing a checkmark next to the option. Alternatively, you can use the Sign button on the New Message dialog box toolbar to digitally sign the message. After you send a user your digital certificate, the public part of your digital signature, the user can use your certificate to encrypt the message that he or she sends back to you.

623 USING THE OUTLOOK EXPRESS ADDRESS BOOK

When you address a letter that you send via traditional mail, you normally look up your recipient's address in your address book. In a similar way, when you send e-mail messages, you should not have to memorize each of your recipients' e-mail addresses. *Outlook Express* provides an Address Book (also referred to as a Contacts list) within which you can record information about the people to whom you send e-mail. Each time you reply to an e-mail message, *Outlook Express* creates an Address Book entry (if necessary) within which it places your recipient's name and e-mail address. Later, when you send, forward, or reply to a message, you can use the Address Book entries. To use the Address Book entries, click your mouse on the small book-like icon that *Outlook Express* displays next to the To:, Cc:, and Bcc: fields. *Outlook Express*, in turn, will display the Select Recipients dialog box, as shown in Figure 623.

Figure 623 The Select Recipients dialog box.

Within the Select Recipients dialog box, click your mouse on the user to whom you want to send the message and then click your mouse on the To:, Cc:, or Bcc: button. The Select Recipients dialog box, in turn, will copy the user into the corresponding list. After you select the recipients that you desire, click your mouse on the OK button. *Outlook Express*, in turn, will display each of your selected recipients in the appropriate field within your e-mail message.

624 CUSTOMIZING USER PROPERTIES WITHIN YOUR ADDRESS BOOK

In Tip 623, you learned how to use the *Outlook Express* Address Book to select users to whom you want to send an e-mail message. As you have learned, you can also use the Address Book as a contact manager. Within the Address Book, you can store considerable information about an individual, his or her company, and more. For example, Figure 624 shows a user's Properties dialog box. Within the Properties dialog box, you can use the

1001 Internet Tips

various sheets to record the user's address, e-mail address, phone and fax number, home information, company information, and more.

Figure 624 A user's address book Properties dialog box.

To display a user's Properties dialog box, perform the following steps:

1. Within *Outlook Express*, click your mouse on the Tools menu and choose Address Book. Alternatively, you can click your mouse on the *Outlook Express* toolbar Addresses button. *Outlook Express*, in turn, will display the Address Book window.
2. Within the Address Book window, double-click your mouse on the user for whom you want to display the Properties dialog box. *Outlook Express*, in turn, will display the user's Properties dialog box.
3. Within the Properties dialog box, use the sheets to fill in or edit the information that you desire and then click your mouse on the OK button.

PRINTING YOUR ADDRESS BOOK — 625

In Tips 623 and 624, you learned how to use the *Outlook Express* Address Book. If you keep your address book current, you will find that the information it contains makes a useful directory of your friends, clients, and other contacts. In fact, you may want to print a copy of your address book's contents which you store in your briefcase. To print your address book's contents, perform the following steps:

1. Within *Outlook Express*, click your mouse on the Tools menu and choose Address Book. Alternatively, you can click your mouse on the *Outlook Express* toolbar Addresses button. *Outlook Express*, in turn, will display the Address Book window.
2. Within the Address Book window, click your mouse on the File menu Print... option. Alternatively, you can click your mouse on the Address Book toolbar Print button. *Outlook Express*, in turn, will display the Print dialog box.

1001 Internet Tips

3. Within the Print dialog box, select the format you want the Address Book to use to print its entries (Memo, Business Card, or Phone List) and then click your mouse on the OK button.

Note: Within the Print dialog box, you can choose to print only selected contacts or you can print the entire list.

626 CREATING AND USING AN E-MAIL GROUP

If you work in an office or you participate in clubs or organizations, there may be many times when you will find yourself sending e-mail messages to the same group of users. If you are a member of a computer users' group, for example, you might often have messages that you must send to everyone in the group. Rather than forcing you to continually type in each recipient's e-mail address, *Outlook Express* lets you define e-mail groups, within which you can place the addresses of every user you want to receive messages that you send to the group. You might, for example, name your e-mail group PC Users' Group and then assign each group member's e-mail address to the group. To create an e-mail group within *Outlook Express*, perform the following steps:

1. Within *Outlook Express*, click your mouse on the Tools menu and choose the Address Book option. *Outlook Express*, in turn, will display the Address Book window.

2. Within the Address Book window, click your mouse on the File menu and choose the New Group option or click your mouse on the toolbar New button and choose New Group. *Outlook Express*, in turn, will display the Properties dialog box Group tab, as shown in Figure 626.1.

Figure 626.1 The Group tab in the Properties dialog box.

3. Within the Group dialog box, click your mouse on the Group Name field and then type in the name that you desire. Next, click your mouse on the Select Members button.

Outlook Express, in turn, will display the Select Group Members dialog box, as shown in Figure 626.2.

Figure 626.2 The Select Group Members dialog box.

4. Within the Select Group Members dialog box, select each user you want to assign to the group by clicking the Select button for each user, or type the user's e-mail address. Then, click your mouse on the Select button. After you select each of the group members, click your mouse on the OK button.
5. Within the group Properties dialog box, click your mouse on the OK button.
6. Within the Address Book window, click your mouse on the File menu Exit option. *Outlook Express*, in turn, will add the new group name to your address book.

UNDERSTANDING OUTLOOK EXPRESS MESSAGE RULES 627

As you have learned, it is not uncommon for users to receive dozens, if not hundreds, of e-mail messages every day. To help users manage the e-mail messages they receive, *Outlook Express* provides a special tool called Message Rules. Using Message Rules, you can forward the messages that you receive to a different e-mail address (which is convenient when you are traveling), you can also automatically copy the messages that you receive from a specific user into a specific folder, and more. Within the Message Rules dialog boxes, you specify rules that tell the Inbox Assistant how to process specific message types. You might, for example, automatically file copies of all messages you receive from your supervisor into a specific folder.

For the purposes of this and the next few Tips, you will focus on Mail rules. To display the New Mail Rule dialog box, click your mouse on the *Outlook Express* Tools menu. Select Message Rules, then choose Mail from the drop down menu. *Outlook Express*, in turn, will display the New Mail Rule dialog box, as shown in Figure 627. Several of the Tips that follow examine operations that you can perform within the Message Rules dialog boxes.

1001 INTERNET TIPS

Figure 627 The New Mail Rule dialog box.

628 FORWARDING YOUR E-MAIL TO ANOTHER ACCOUNT

In Tip 627, you learned that you can use *Outlook Express* Message Rules to help you manage your electronic mail. For example, if you have multiple Internet accounts (maybe you have one for the office, one for school, as well as a personal account), you may want to create Message Rules to forward copies of your new mail to a different account so you can respond to all your messages from one account.

To create a message rule to forward copies of your e-mail, perform the following steps:

1. Within *Outlook Express*, click your mouse on the Tools menu. Select Message Rules, and choose the Mail option. *Outlook Express*, in turn, will display the New Mail Rule dialog box. (If you have created message rules previously, Outlook Express will respond by displaying the Message Rules dialog box rather than the New Mail Rule dialog box. To access the New Mail Rule dialog box from within the Message Rule dialog box, simply click your mouse on the New button.)

2. Within the New Mail Rule dialog box Select the Conditions for your rule: field, scroll down to the bottom of the list and click your mouse on the For all messages checkbox, placing a check in the box.

3. Within the New Mail Rule dialog box Select the Actions for your rule field, click your mouse on the Forward it to people checkbox, placing a check in the box.

4. Within the New Mail Rule dialog box Rule Description (click your mouse on an undefined value to edit it) field, click your mouse on the Forward it to people link. *Outlook Express*, in turn, will display the Select People dialog box.

1001 INTERNET TIPS

5. Within the Select People dialog box Address: field, type the e-mail address of the account to which you would like to forward your e-mail, as shown in Figure 628.1. Alternatively, you can click your mouse on the Address Book button to select an e-mail recipient or recipients from your address book.

Figure 628.1 Adding an e-mail address to which your e-mail will be forwarded.

6. After you have filled in the Select People dialog box Address: field with an e-mail address, click your mouse on the OK button to close the Select People dialog box. Click your mouse on the OK button to close the New Mail Rule dialog box. *Outlook Express*, in turn, will display the Message Rules dialog box, as shown in Figure 628.2. Notice that your new rule has been added to the rules list and the rule description appears in the Rules Description area.

Figure 628.2 The *Outlook Express* Message Rules dialog box.

7. Within the Message Rules dialog box, click your mouse on the OK button to apply your changes.

Note: *Before the message rule can be applied to your e-mail messages, the messages must arrive in your Inbox folder. If your PC is connected to a local-area network, your network software will likely deliver the messages to your Inbox, which lets the Inbox Assistant forward the messages even if you are out of the office. Otherwise, if you use an online service or Internet service provider to download your messages, you must connect to the Internet and download your messages into your Inbox before the Inbox Assistant can forward your messages as you desire. Tip 629 discusses steps you can perform to let* **Outlook Express** *automatically connect to your online service or provider so it can download your new messages.*

629 SCHEDULING OUTLOOK EXPRESS OPERATIONS WHEN YOU ARE NOT PRESENT

In Tip 628, you learned how to use Message Rules to automatically forward your e-mail to another account—which might be quite convenient when you traveling. As you learned, however, before the Message Rule can work and forward your mail, the mail must arrive in your Inbox, which means *Outlook Express* must first download your messages. If you normally access your e-mail messages by dialing into an online service or Internet service provider, and then use *Outlook Express* to download your messages, you may be able to configure *Outlook Express* to automatically connect to your online service or provider at regular intervals to download (and then to forward) your messages. To direct *Outlook Express* to automatically check for new messages in this way, perform the following steps:

1. Double-click your mouse on the My Computer icon on your Desktop. Windows, in turn, will display the My Computer window. Double-click your mouse on the Dial-Up Networking folder. Windows, in turn, will display the Dial-Up Networking folder. Within your Dial-Up networking folder, you must configure your dial-up settings to remember your password. (Depending on your service or provider, the steps you must perform to allow an automatic login may differ.)

2. Next, within *Outlook Express*, click your mouse on the Tools menu and choose Options. *Outlook Express*, in turn, will display the Options dialog box General tab, as shown in Figure 629.1.

Figure 629.1 The Options dialog box General tab.

1001 Internet Tips

3. On the General tab, click your mouse on the Check for new messages every nn minutes checkbox, placing a checkmark in the box. Then, within the text field, specify the interval at which you want *Outlook Express* to check for messages.

4. Within the Options dialog box, click your mouse on the Connection tab. *Outlook Express*, in turn, will display the Connection tab, as shown in Figure 629.2.

Figure 629.2 The Options dialog box Connection tab.

5. Within the Internet Connections Settings area on the Connection tab, click your mouse on the Change button. *Outlook Express*, in turn, will display the Internet Properties dialog box Connection tab.

6. On the Internet Properties dialog box Connection tab, click your mouse on the Dial whenever a network connection is not present radio button. Windows, in turn, will configure *Outlook Express* and Internet Explorer to dial your Internet provider whenever required.

7. Within the Internet Properties dialog box, click your mouse on the OK button. Within the Options dialog box, click your mouse on the OK button.

After you configure *Outlook Express* to automatically dial and download your messages, you can simply leave *Outlook Express* running, or you can use the Task Scheduler to start *Outlook Express* at specific intervals.

CONTROLLING WHICH MESSAGES OUTLOOK EXPRESS DOWNLOADS FROM YOUR E-MAIL SERVER 630

If you use *Outlook Express* to send and receive e-mail messages from an online service or dial-up account, depending on your connection speed, there may be times when a large message takes a long time to download (up to an hour, depending on the message size). Rather than sitting through large message downloads, you can direct *Outlook Express* not to download the messages from the server or to delete such messages. You might, for example, direct *Outlook Express* not to download any message larger than 1Mb. To create a message rule to delete large messages from the server, perform the following steps:

1. Within *Outlook Express*, click your mouse on the Tools menu. Select Message Rules, then choose the Mail option. *Outlook Express*, in turn, will display the Message Rules dialog box. (If you have not created message rules previously, Outlook Express will respond by immediately displaying the New Mail Rule dialog box.)
2. Within the Message Rules dialog box, click your mouse on the New button. *Outlook Express*, in turn, will display the New Mail Rule dialog box.
3. Within the New Mail Rule dialog box Select the Conditions for your rule: field, scroll down the list and click your mouse on the Where the message size is more than size checkbox, placing a check in the box.
4. Within the New Mail Rule dialog box Select the Actions for your rule: field, click your mouse on the Delete it checkbox, placing a check in the box.
5. Within the New Mail Rule dialog box Rule Description (click your mouse on an undefined value to edit it) field, click your mouse on the size link. *Outlook Express*, in turn, will display the Set Size dialog box.
6. Within the Set Size dialog box Larger than: field, specify a file size limit. *Outlook Express*, in turn, will delete files from the server that are larger than the limit you set, sparing you the extended download times caused by large files.
7. Within the Set Size dialog box, click your mouse on the OK button. Within the New Mail Rule dialog box, click your mouse on the OK button. *Outlook Express*, in turn, will display the Message Rules dialog box. Notice that your new rule has been added to the rules list and the rule description appears in the Rules Description area.
8. Within the Message Rules dialog box, click your mouse on the OK button to apply your changes.

631 SENDING A STANDARD REPLY WHEN YOU ARE AWAY FROM YOUR E-MAIL

In Tip 627, you learned that you can use *Outlook Express* Message Rules to help you manage your e-mail messages. If you are going to be traveling and you want to tell users who send you e-mail that you are away or unavailable, you can create a Message Rule to send a standard reply to every user who sends you a mail message. You might, for example, send a text reply such as:

```
Hello this is Kong, I have received your e-mail message but will be out of
the office until next Friday. If your message is urgent, please call my
co-worker Andrew at 800-555-1212. I will be checking e-mail periodically
and will respond to your message as soon as possible.
```

To direct the Inbox Assistant to send a standard reply to your messages, perform the following steps:

1. Using the Windows 98 Notepad accessory, create a file named *Response.txt* that contains the message text that you want *Outlook Express* to send to each user who sends you an e-mail message. Store the file in a folder on your hard disk, such as the My Documents folder.
2. Within *Outlook Express*, click your mouse on the Tools menu. Select Message Rules, then choose the Mail option. *Outlook Express*, in turn, will display the Message Rules dialog box. (If you have not created message rules previously, Outlook Express will respond by immediately displaying the New Mail Rule dialog box.)

1001 Internet Tips

3. Within the Message Rules dialog box, click your mouse on the New button. *Outlook Express*, in turn, will display the New Mail Rule dialog box.
4. Within the New Mail Rule dialog box Select the Conditions for your rule: field, scroll down to the bottom of the list and click your mouse on the For all messages checkbox, placing a check in the box.
5. Within the New Mail Rule dialog box Select the Actions for your rule: field, scroll down the list and click your mouse on the Reply with message checkbox, placing a check in the box.
6. Within the New Mail Rule dialog box Rule Description (click your mouse on an undefined value to edit it) area, click your mouse on the message link. *Outlook Express*, in turn, will display the Open dialog box.
7. Within the Open dialog box, locate and select the *Response.txt* you created in step 1, as shown in Figure 631. (You may have to change the Files of type setting to instruct *Outlook Express* that you are looking for text files, as shown in the figure). Click your mouse on the Open button to complete the file selection and close the Open dialog box.

Figure 631 The Open dialog box to add a standard response to e-mail when you are away.

8. Within the New Mail Rule dialog box, click your mouse on the OK button. *Outlook Express*, in turn, will display the Message Rules dialog box. Notice that your new rule has been added to the rules list and the rule description appears in the Rules Description area.
9. Within the Message Rules dialog box, click your mouse on the OK button to apply your changes.

Note: *Before the message rule can be applied to your e-mail messages, the messages must arrive in your Inbox folder. If your PC is connected to a local-area network, your network software will likely deliver the messages to your Inbox, which lets the Inbox Assistant forward the messages even if you are out of the office. Otherwise, if you use an online service or Internet service provider to download your messages, you must connect to the Internet and download your messages into your Inbox before the Inbox Assistant can forward your messages as you desire. Tip 629 discusses steps you can perform to let* **Outlook Express** *automatically connect to your online service or provider so it can download your new messages.*

USING E-MAIL STATIONERY

632

If you have been sending and receiving e-mail messages for some time, you have probably realized that one e-mail message looks pretty much like the next. To help you give your e-mail messages some character, *Outlook Express* lets

1001 Internet Tips

you take advantage of e-mail stationery. To accomplish this, e-mail stationery lets you place a graphic image within your e-mail message. For example, Figure 632 shows a message that uses e-mail stationery.

Figure 632 Using stationery to dress up your e-mail messages.

To place stationery within an e-mail message, perform the following steps:

1. Within *Outlook Express*, click your mouse on the New Message button. *Outlook Express*, in turn, will display the New Message dialog box.
2. Within the New Message dialog box, click your mouse on the Format menu. Select the Apply Stationery option, and select a stationery type from the drop down menu.
3. Should you decide to change the stationery, simply select a replacement stationery from the Format menu Apply Stationery sub-menu.

As it turns out, *Outlook Express* lets you use any HTML file as e-mail stationery, which means that if you understand HTML, you can create your own stationery. To select an HTML file as your stationery, perform the following steps:

1. Within *Outlook Express*, click your mouse on the New Mail button. *Outlook Express*, in turn, will display the New Message dialog box.
2. Within the New Message dialog box, click your mouse on the Format menu, move to the Apply Stationery option, and select More Stationery from the drop down menu. *Outlook Express*, in turn, will display the Select Stationery dialog box.
3. Within the Select Stationery dialog box, locate and click your mouse on the HTML file you would like to use as e-mail stationery. *Outlook Express*, in turn, will apply the stationery selection to your e-mail message.

Note: To compose a message using a specific stationery, click your mouse on the down arrow that appears next to the New Mail button on the **Outlook Express** toolbar. **Outlook Express**, in turn, will display a menu of stationery options. After you click your mouse on an option, **Outlook Express** will display a New Message dialog box that includes your selected stationery art.

STARTING NETSCAPE MESSENGER 633

As you learned in Tip 583, one of a computer's most common uses today is to send and receive electronic mail messages. Just as the Netscape Communicator Suite includes the Navigator program that you can use to surf the Web, the Netscape Communicator Suite provides Messenger, shown in Figure 633.1, an e-mail client that you can use to send and receive electronic mail.

Figure 633.1 The Netscape Messenger e-mail and news client.

To start Netscape Messenger, perform the following steps:

1. Click your mouse on the Start menu Programs option and choose Netscape Communicator. Windows 98, in turn, will cascade the Netscape Communicator sub-menu.
2. On the Netscape Communicator sub-menu, click your mouse on the Netscape Messenger menu item. Windows 98, in turn, will launch Netscape Messenger, as shown in Figure 633.2.

Figure 633.2 Starting Netscape Messenger from the Windows 98 Start menu.

1001 Internet Tips

634 Configuring Netscape Messenger to Send and Receive Internet e-mail

Now that you have Netscape Messenger running, you must configure Netscape Messenger to use your account on your Internet service provider's mail server so you can start to send and receive e-mail. Prior to setting up Netscape Messenger to send and receive e-mail, you must have obtained your account and e-mail server information from your Internet service provider. To configure Netscape Messenger to use your e-mail account, perform the following steps:

1. Click your mouse on the Edit menu and choose Preferences. Netscape Messenger, in turn, will open the Preferences dialog box, as shown in Figure 634.1. Note that the configurable options are arranged by category.

Figure 634.1 The Netscape Messenger Preferences dialog box.

2. Within the Category list, expand the Mail & Newsgroups branch if it is not already expanded. Then, click your mouse on Mail Servers.
3. In the Mail Servers area, click your mouse on the Add button. Netscape Messenger, in turn, will open the Mail Server Properties dialog box, as shown in Figure 634.2.

Figure 634.2 Add a new mail server to your configuration using the Mail Server Properties dialog box.

4. Within the Mail Server Properties dialog box Server Name field, type the name of the mail server that your ISP provided. Also, specify the Server Type and User Name provided by your ISP.

5. When you have finished configuring your news server information, click your mouse on the OK button to close the Mail Server Properties dialog box. Then, click your mouse on the OK button to close the Preferences dialog box.

UNDERSTANDING YOUR INBOX AND OTHER FOLDERS — 635

To help you manage the e-mail messages that you send and receive, Netscape Messenger provides you with several folders in which you can store related messages. To start, each time you receive an e-mail message, Netscape Messenger places the message in the Inbox folder, much as someone might place an envelope in your mailbox at home or in your inbox at work. When you send a message, Netscape Messenger places the message into your Unsent Messages folder until Netscape Messenger has had a chance to send the message.

After Netscape Messenger sends your message, it moves the message from the Unsent Messages folder into the Sent folder. Finally, when you delete an e-mail message, Netscape Messenger moves the deleted message into the Trash folder. Figure 635 shows folders within the Netscape Messenger folder list.

Figure 635 The Netscape Messenger folder list.

In Netscape Messenger, you can display a folder's contents by clicking your mouse on the folder's icon in the folder list. In Tip 650, you will learn how to create your own folders to further organize your e-mail messages. As you create your own folders, there may be times when you create subfolders (folders within a folder). To display a folder's subfolders, simply click your mouse on the plus sign that precedes the folder's name within the folder list. Netscape Messenger, in turn, will expand the folder's list of subfolders. To later collapse the expanded folder list, click your mouse on the minus sign that precedes the folder name.

1001 Internet Tips

636 Using the Netscape Messenger Message Toolbar

Like most Windows-based programs, Netscape Messenger provides a Message toolbar that contains icons you can use to simplify common operations. Table 636 depicts the Message toolbar's icons. If Netscape Messenger is not displaying its toolbar, click your mouse on the Netscape Messenger View menu. Select the Show option, then choose Message Toolbar, placing a check next to the Message Toolbar option. Netscape Messenger, in turn, will display the Message Toolbar.

Icon	Description
Get Msg	Directs Netscape Messenger to download messages from your e-mail server and to send messages that are waiting in your Unsent Messages.
New Msg	Creates a new e-mail message.
Reply	Sends a reply message to the current message's author.
Reply All	Sends a reply message to all users who received the current message.
Forward	Forwards the current message to another user.
File	Displays a menu from which you can choose a folder within which Netscape will store the selected message.
Next	Selects the next unread message.
Print	Opens the Print dialog box so you can send the current message to the printer.
Delete	Deletes the current message.
Stop	Stops the current message transfer.

Table 636 The Netscape Messenger toolbar buttons.

637 Composing an e-mail Message within Netscape Messenger

As you have learned, Netscape Messenger can be used as your Internet e-mail client software to send and receive e-mail messages. To create and send an e-mail message, you use the Composition dialog box, as shown in Figure 637.

1001 Internet Tips

Figure 637 The Netscape Messenger Composition dialog box.

In the Composition dialog box, you can specify the e-mail address of each user to whom you want to send the message, you can type a single-line Subject entry that summarizes the message subject, and then you can type the message text.

To send an e-mail message within Netscape Messenger, perform the following steps:

1. Within Netscape Messenger, click your mouse on the toolbar New Msg button or select the Message menu New Message option. Netscape Messenger, in turn, will display the Composition dialog box, as shown in Figure 637.
2. Within the Composition dialog box, click your mouse on the To: field and type in your recipient's e-mail address. Tip 638 discusses the Cc: and Bcc: options which you can use to send courtesy copies of your message to other users.
3. Within the Subject: field, type a one-line message that briefly describes the message contents.
4. Within the message text field, type your message and then click your mouse on the toolbar Send button or click your mouse on the File menu Send Now option. Netscape Messenger, in turn, will move your message into the Unsent Messages folder (and then to the Sent folder after the message has been delivered to the mail server). To direct Netscape Messenger to immediately send your message, click your mouse on the toolbar Get Msg button or select the File menu and choose Get New Messages.

UNDERSTANDING THE CC AND BCC FIELDS　　638

As you learned in Tip 637, when you send an e-mail message, you specify the e-mail address of your message recipients within the To: field. You can also choose to courtesy copy other recipients using the Cc: option or the Bcc:

option. The letters Cc are an abbreviation for courtesy copy. When you send e-mail messages, there will be many times when you are sending a message to a specific user, but you also want other users to receive a courtesy copy of the message. For example, suppose that you are sending a note to your project leader that tells him or her that you need to schedule a meeting with the team to discuss the budget. In this case, you would put the project leader's e-mail address within the To: field and you would courtesy copy the team members using the Cc: option.

In a similar way, there may be times when you want to send a courtesy copy of your message to a user and you do not want other recipients to know that you have courtesy copied that user. In such cases, you can use the blind courtesy copy option (Bcc:) to send the message to that user. When your message recipients view the message header to see who received the message, users to whom you blind copied the message will not appear in the list of recipients. You might, for example, use the Bcc: option to notify your company's accounting director that you will be holding the budget meeting. When your team receives your message, they will be unaware that you have also sent a copy to the accounting director.

To send a courtesy copy to an e-mail recipient, perform the following steps:

1. Within the Composition window, address your message to your primary recipients as you would normally. Then, to courtesy copy a user, click your mouse in the blank field directly below the To: button. Netscape Messenger, in turn, will display an additional To: button, as shown in Figure 638.

Figure 638 *The Netscape Messenger Composition window displaying an additional To: button.*

2. Click your mouse on the second To: button. Netscape Messenger, in turn, will display a menu from which you can choose the Cc: option.
3. Choose the Cc: option from the menu and then type the e-mail address of the recipient you wish to courtesy copy in the field directly to the right.
4. After you have completed addressing and typing your message, click your mouse on the Send button to deliver the message.

1001 Internet Tips

639 SPELL CHECKING YOUR E-MAIL MESSAGE

Before you send an e-mail message using Netscape Messenger, you might want to take time to spell check your message text. To start spell checking your current message, in the Composition dialog box, click your mouse on the Tools menu and choose the Check Spelling option or click your mouse on the Spelling button on the toolbar. If the spell checker encounters an error within your message, Netscape Messenger will display the Check Spelling dialog box, as shown in Figure 639, in which Netscape Messenger highlights the error and displays suggested corrections.

Figure 639 The Netscape Messenger Spelling dialog box.

Within the Check Spelling dialog box, select the Ignore button if your word is spelled correctly (or the Ignore All button if the word appears many times throughout the document). Likewise, if the Check Spelling dialog box provides a correction that you wish to use, click your mouse on the appropriate selection and then click your mouse on the Replace button (or the Replace All button to change the word throughout the document).

Note: If you want the spell checker to add your word to its dictionary, prior to clicking the Ignore button, click your mouse on the Learn button. The spell checker, in turn, will add the word to the dictionary.

640 SELECTING E-MAIL MESSAGE RECIPIENTS FROM YOUR ADDRESS LIST

If you are like many users, you may have a Rolodex or address book on your desk that contains names, addresses, and phone numbers for your key contacts. Within Netscape Messenger, you can store your contact information within an electronic Address Book. Later, when you want to send an e-mail message to a user, you can select your recipients from your Address Book which will eliminate the need to look up or memorize each user's e-mail address. If you examine the Composition dialog box (shown in Figure 637), you will find an Address button located on the Message Toolbar. If, as you are addressing your e-mail message, you click your mouse on the Address icon, Netscape Messenger, in turn, will display the Select Addresses dialog box, as shown in Figure 640, from which you can select the users to whom you want to send a copy of your message.

1001 Internet Tips

Figure 640 The Netscape Messenger Select Addresses dialog box.

To select a recipient for your message, click your mouse on the user's name within the recipient list and then click your mouse on the To:, Cc:, or Bcc: buttons to assign the user to the corresponding field. After you select the entries you desire, click your mouse on the OK button. Netscape Messenger, in turn, will return you to the Composition dialog box, within which you can complete and then send your message.

641 READING A NEW MESSAGE

When you receive an e-mail message, Netscape Messenger will place the message within your Inbox folder. To display the Inbox folder's contents, click your mouse on the Inbox folder icon within the Netscape Messenger folder list.

Within the Inbox folder, Netscape Messenger will highlight your unread messages using a bold typeface. To read an e-mail message within Netscape Messenger, click your mouse on the message within the message list. Netscape Messenger, in turn, will display the message text in the preview frame that usually appears near the bottom of your window. After you read a message, Netscape Messenger will change the bolded message Subject line in the message list to standard type to indicate that you have read the message.

Note: In Tip 650, you will learn how to create your own folders within Netscape Messenger that you can use to organize your e-mail messages. To view a message within any Netscape Messenger folder, simply click your mouse on the folder icon within the Netscape Messenger folder list to select the folder, and then click your mouse on the message you desire within the folder's message list.

PRINTING YOUR CURRENT E-MAIL MESSAGE 642

As you view an e-mail message within Netscape Messenger, there will be many times when you will want to print a copy of the message's contents. To print the current message (the contents of which you can currently read on your screen display), perform the following steps:

1. Click your mouse on the Netscape Messenger File menu and choose the Print option. Netscape Messenger, in turn, will display the Print dialog box.
2. Within the Print dialog box, make any necessary changes and then click your mouse on the OK button to send the print job.

To print a message that is not the currently displayed message within Netscape Messenger, perform the following steps:

1. Within the Netscape Messenger message list, right-click your mouse on the message you desire. Netscape Messenger, in turn, will display the context sensitive pop-up menu.
2. From the pop-up menu, select the Print Message option. Netscape Messenger, in turn, will open the Print dialog box .
3. Within the Print dialog box, make any necessary changes and then click your mouse on the OK button to send the print job.

FORWARDING AN E-MAIL MESSAGE 643

As you read through an electronic mail message, there may be times when you will want to forward a copy of the message to another user. To forward the current e-mail message within Netscape Messenger, perform the following steps:

1. If the message you want to send is not the current message (the contents of which you can view within the Netscape Messenger window), click your mouse on the message within the message list to select the correct message.
2. On the Netscape Messenger Message toolbar, click your mouse on the Forward button (or select the Forward option from the Message menu). Netscape Messenger, in turn, will display the Composition window with the words Fwd: Message Subject in the title bar.
3. Within the Composition window's To: field, type in the e-mail address (or addresses separated by semicolons) of the recipient or recipients to whom you want to forward the message.
4. Within the message box, you may want to type a short message that will accompany the message to the recipient.

5. When you are ready to send the message, click your mouse on the toolbar Send button or select the File menu Send Now option.

644 REPLYING TO AN E-MAIL MESSAGE

One of the reasons users often become buried with e-mail messages is that it seems that each message he or she receives requires a response which, in turn, generates a response from another user. To respond to a message within Netscape Messenger, you have two choices. First, you can reply back to just the author (sender) of the message, or, if the message was sent to you and several other users, you can reply to all of the recipients of the initial message, excluding those recipients who may have been blind courtesy copied because you will have no way of knowing who was blind copied.

To reply to an e-mail message, perform the following steps:

1. Within Netscape Messenger, click your mouse on the toolbar Reply button or Reply All button, depending on whether or not you want to reply only to the author or to all of the recipients of the message. Netscape Messenger, in turn, will display a Composition window that includes the original message. Netscape Messenger will fill in the To: and Cc: fields for you, depending on whether you are replying to the author or to all recipients.
2. Within the Composition window, use the To:, Cc:, or Bcc: fields to include the e-mail addresses of everyone to whom you want to send the message. Note that you can add additional recipients if you like.
3. Click your mouse within the Composition dialog box's message field and type your reply. Then, click your mouse on the Send button to send your message.

645 SORTING YOUR E-MAIL MESSAGES

Sometimes you might receive such a large number of e-mail messages that your Inbox becomes unmanageable and your messages difficult to organize. When your Inbox folder becomes cluttered with an excessive number of messages, you may want to create additional folders within the Netscape Messenger folder list to group and organize related messages, as discussed in Tips 650 and 651. Next, if you are looking for a specific message, you can direct Netscape Messenger to sort your messages by the sender, date and time your message was received, or the subject, the message attachment, or even the message priority.

When you are looking for messages from a specific user, for example, you may find it convenient to sort your messages by sender. To sort your messages within Netscape Messenger, select the View menu. Select the Sort option, then choose a sort option from the drop down menu shown in Figure 645. Netscape Messenger, in turn, will sort your message list by the criteria you selected.

1001 Internet Tips

Figure 645 The Netscape Messenger Sort sub-menu.

Finding a Specific e-mail Message 646

As the number of e-mail messages you receive increases, there may be times when you cannot find a specific message. In such cases, you can use the Search Messages dialog box, as shown in Figure 646. To open the Search Messages dialog box, simply click your mouse on the Netscape Messenger Edit menu and choose Search Messages.

Figure 646 The Netscape Messenger Search Messages dialog box.

Within the Search Messages dialog box, you can use the drop-down lists to specify to search for messages from a certain user, or with a certain word in the Subject line, or any of a number of given criteria. To further refine your message search, you can click your mouse on the More button to specify additional search criteria.

Lastly, using the dialog box Search for items in drop-down list, you can specify the folder within which you want Netscape Messenger to search for your messages.

1001 Internet Tips

After you specify the settings you desire, click your mouse on the Search button. Netscape Messenger, in turn, will display a list of matching messages at the bottom of the dialog box. To view a message's contents, double-click your mouse on the message within the dialog box's list.

647 Attaching a File to an e-mail Message

As you work, there will be times when you will want to send documents or pictures along with your e-mail messages, and files such as a word processing document, a spreadsheet, or a digital picture to another user. In such cases, you can use Netscape Messenger to attach the file to an e-mail message. Later, when your recipient receives your e-mail message, he or she can view or save your attached file. To attach a file to an e-mail message, perform the following steps:

1. Within Netscape Messenger, click your mouse on the New Msg button. Netscape Messenger, in turn, will display the Composition dialog box.
2. Within the Composition dialog box, address your message, add a message subject, and type your message text telling your recipient that you have attached a document.
3. Click your mouse on the Composition dialog box Attach toolbar button and choose the File option from the menu. Netscape Messenger, in turn, will display the Enter file to attach dialog box, as shown in Figure 647.1.

Figure 647.1 The Enter file to attach dialog box.

4. Within the Enter file to attach dialog box, locate the folder that contains the file that you want to attach, click your mouse on the file, and then click your mouse on the Open button. Netscape Messenger, in turn, will display your attached document in the Attach field, as shown in Figure 647.2.

Note: *For your message recipient to view your document, in most cases, the recipient must have the software that you used to create the document. For example, if you send the recipient a Word document, to view the document, the recipient must have Microsoft Word on his or her system or at least some application that can open Word files.*

Figure 647.2 A document file attached to an e-mail message.

Note: *Drag-and-drop will also work for attaching a file to an e-mail message. Simply locate the file you wish to attach using Windows Explorer and then click with your mouse and drag the file into the e-mail message's attached files area.*

VIEWING OR SAVING A FILE ATTACHMENT 648

In Tip 647, you learned how to attach a document, such as a word-processing document, a spreadsheet, or a graphic to an e-mail message. Just as there may be times when you attach documents to the messages that you send to other users, there will be times when users send attached documents to you. When you receive an e-mail message with an attached document, Netscape Messenger will display a paper-clip icon, as shown in Figure 648.1.

If you click your mouse on the paper-clip icon, Netscape Messenger will display the document name or will list multiple document names, depending on the number of documents the sender attached, as shown in Figure 648.2.

If you double-click your mouse on the document name, Netscape Messenger will start the program that the sender used to create the document (provided you have the program installed on your system) and will load the document for you to view or edit. If you simply want to save the document to a file on disk, right-click your mouse on the file's icon at the bottom of the preview pane and choose Save Attachment As from the pop-up menu. Netscape Messenger, in turn, will display the Save As dialog box, within which you can select the folder in which you would like to store the file and then you can specify the filename for the document file you are saving.

1001 Internet Tips

Figure 648.1 Netscape Messenger uses a paper-clip icon to indicate an attached document.

Figure 648.2 Netscape Messenger displaying the names of attached files.

649 DISPLAYING ONLY UNREAD MESSAGES

If you receive a large number of e-mail messages, it may not take long before your Inbox folder fills up with so many messages that you find it difficult to locate specific messages. In fact, there may be times when you have difficulty locating the e-mail messages you have not yet read. To help you locate your unread messages, you can direct Netscape Messenger to display only your unread messages by clicking your mouse on the View menu, select Messages, and choose Unread from the drop down menu. Netscape Messenger, in turn, will display only your unread messages.

Later, if you want to view all your messages, click your mouse on the View menu, select Messages, and choose All from the fly-out menu.

CREATING YOUR OWN E-MAIL FOLDERS 650

As you have learned, when you receive a new e-mail message, Netscape Messenger places your message in the Inbox folder. If you receive a large number of e-mail messages, you may find that your Inbox folder becomes difficult to manage. In such cases, you can create mail folders within Netscape Messenger in which you can store related messages. You might, for example, create a folder for Work, another for Publishing, one for Friends messages. Figure 650.1, for example, shows a Netscape Messenger folder list that contains a variety of folders.

Figure 650.1 A Netscape Messenger folder list including several user-created folders used for organizing e-mail messages.

To create a folder within Netscape Messenger, perform the following steps:

1. Click your mouse on the Netscape Messenger File menu and choose New Folder. Netscape Messenger, turn, will display the New Folder dialog box, as shown in Figure 650.2.

Figure 650.2 The Netscape Messenger New Folder dialog box.

2. Within the New Folder dialog box Name field, type a name for your new folder. Next, click your mouse on the Create as subfolder of: drop-down list and select the folder within which you would like to place your new folder. Finally, click your mouse on the OK button. Netscape Messenger, in turn, will add your new folder to the folder list.

651 Moving e-mail Messages into Different Folders

In Tip 650, you learned how to create your own folders in Netscape Messenger, within which you later store related messages. To move a message to a specific folder in Netscape Messenger, simply click and hold your mouse on the message and drag the message onto the folder in which you would like to store the message. When you release the mouse button, Netscape Messenger will move your message into the destination folder you have chosen. To move multiple messages in one step, simply select messages just as you would select files within Windows Explorer. (Hold down the CTRL key as you click your mouse on each message or hold down the SHIFT key to select consecutive messages.)

To copy a message to a different folder, simply hold down your keyboard's CTRL key as you perform the drag-and-drop operation.

Note: *Netscape Messenger also provides Edit menu options that you can use to move or copy a selected message to a folder. In most cases, however, you should find simply dragging and dropping messages into the folders that you desire is a fast way to move or copy messages.*

652 Emptying Your Trash Folder

After you have read and no longer need an e-mail message, you can delete the message and reduce the clutter within your Inbox. To delete a message, simply click your mouse on the message to select it, Netscape Messenger, in turn, will highlight the message. Then, click your mouse on the Delete button or press your keyboard's DEL key. Alternatively, you can drag a message from your Inbox (or some other Netscape Messenger folder) and drop it on the Trash folder.

When you delete an e-mail message, Netscape Messenger does not delete the message from your system. Netscape Messenger moves the message from its current folder into the Trash folder—much as Windows 98 moves the files that you delete into the Recycle Bin. Should you later decide that you need the message's contents, you can move the message out of the Trash folder back into the folder that you desire. To permanently delete messages from your Trash folder, perform the following steps:

1. Within Netscape Messenger, click your mouse on the Trash folder. Netscape Messenger, in turn, will display the list of messages you have previously deleted.
2. Within the list of deleted messages, select the messages you want to permanently delete. (You can hold down your keyboard CTRL key as you click your mouse on the messages, you can select the Edit menu Select All option, or you can hold down your keyboard SHIFT key and use your arrow keys or mouse to highlight the messages you desire.) After you select the messages you want to delete, click your mouse on the toolbar's Delete button. Netscape Messenger, in turn, will permanently delete the messages.

Alternatively, you can click your mouse on the Netscape Messenger File menu and choose the Empty Trash on Local Mail option.

Note: *You might want to delete messages from your Trash folder on a regular basis. By deleting the messages, you free up disk space the messages consume. In addition, if you work in an office where other users may have access to your system, you prevent other users from viewing messages you have previously deleted.*

CUTTING AND PASTING MESSAGE TEXT 653

As you read or compose an e-mail message, there may be times when you will want to copy text from one message that you can then paste into a second message. To start, you must first select the text you want to copy, by either holding down your keyboard's SHIFT key as you use your keyboard arrow keys to highlight the text, or by holding down your mouse-select button as you drag your mouse pointer over the text. As you select text within a message, Netscape Messenger will highlight your selected text using reverse video. After you select the text that you desire, click your mouse on the Edit menu Copy option. Then, click your mouse within the message into which you want to paste the text and position the cursor to the text's starting position. Finally, select the Edit menu Paste option to place the text into the message.

Note: *If you want to select the entire message text for a cut-and-paste operation, click your mouse within the message that contains the text and then select the Edit menu Select All option.*

INITIATING A SEND AND RECEIVE OPERATION 654

By default, Netscape Messenger checks for new messages every 15 minutes. Further, as you have learned, when you first send an e-mail message, Netscape Messenger may place your message in its Outbox until it has time to send the message. By clicking your mouse on the Get Msg button, or by selecting the File menu Get New Messages option, you can direct Netscape Messenger to immediately check for new messages and to immediately send messages that reside in your Outbox. When you initiate a Get Messages operation, Netscape Messenger will display the Netscape Messenger Getting New Messages dialog box, as shown in Figure 654, which you can use to monitor the status of your system's send and receive operation.

Figure 654 Monitoring e-mail send and receive operations within the Netscape Messenger Getting New Messages dialog box.

655 ASSIGNING A PRIORITY TO YOUR E-MAIL MESSAGE

Today, it is not uncommon for users to receive dozens, if not hundreds, of e-mail messages each day. When you send an e-mail message to another user, Netscape Messenger lets you assign a priority (Lowest, Low, Normal, High, or Highest) to the message. When a user receives the message, his or her e-mail software may display a priority flag, depending on the capabilities of the e-mail software. Netscape Messenger will display a flag in the message list Priority column point for high-priority messages, as shown in Figure 655.

Figure 655 Netscape Messenger displays priority flags in the message list Priority column.

To help manage their e-mail, some users will sort their messages by priority. (Users may be unhappy with you if you send them messages marked as high-priority, the contents of which really do not merit the user's urgent response.) To assign a priority to an e-mail message you are about to send, within the Netscape Messenger Composition window, click your mouse on the Priority drop-down list and choose a priority level. Then address, compose, and send the message as you normally would.

656 USING THE NETSCAPE MESSENGER ADDRESS BOOK

When you address a letter that you send via traditional mail, you normally look up your recipient's address in your address book. In a similar way, when you send e-mail messages, you should not have to memorize each of your recipient's e-mail addresses. Netscape Messenger provides an Address Book within which you can record information about the users to whom you send e-mail. You can add entries to your Address Book. Later, when you send, forward, or reply to a message, you can use the Address Book entries to address messages. To use the Address Book entries, click your mouse on Netscape Messenger's Communicator menu and choose Address Book. Netscape Messenger, in turn, will display the Address Book dialog box, as shown in Figure 656.

1001 Internet Tips

Figure 656 The Address Book dialog box.

Within the Address Book dialog box, click your mouse on a user (or select multiple users) to whom you want to send the message and then click your mouse on the New Msg button. Netscape Messenger, in turn, will open a new Composition window with that user's e-mail address in the To: field. Add a subject line and compose your message as your normally would, and then click your mouse on the Send button to deliver the message.

CUSTOMIZING USER PROPERTIES WITHIN YOUR ADDRESS BOOK 657

In Tip 656, you learned how to use the Netscape Messenger Address Book to select users to whom you want to send an e-mail message. You can also use the Address Book as a contact manager. Within the Address Book, you can store considerable information about an individual, his or her company, and more. For example, Figure 657 shows a dialog box titled Card for Andy Wolfe. Within the Card dialog box, you can use the various tabs to record a user's address, e-mail address, phone and fax number, home information, company information, and so on.

Figure 657 A user's address book entry within Netscape Messenger's Address Book.

1001 Internet Tips

To display a user's Card for the Username dialog box, perform the following steps:

1. Within Netscape Messenger, click your mouse on the Communicator menu and choose Address Book. Netscape Messenger, in turn, will display the Address Book window.
2. Within the Address Book window, double-click your mouse on the user for whom you want to display the Card for the Username dialog box. Netscape Messenger, in turn, will display the user's Card.
3. Within the Card for the Username dialog box, use the tabs to fill in or edit the information that you desire and then click your mouse on the OK button.

658 INSERTING A GRAPHIC INTO AN E-MAIL MESSAGE

In many cases, your e-mail messages will consist of a text message and possibly an attached document. Netscape Messenger, however, will let you insert a graphics file within an e-mail message. Figure 658.1, for example, shows an e-mail message that contains pictures and text.

Figure 658.1 An e-mail message that contains a graphics image. Notice that Netscape Messenger displays graphics within the e-mail message.

To insert a graphic into your current e-mail message, perform the following steps:

1. Within your Composition dialog box, click your mouse on the Insert menu and choose the Image option. Netscape Messenger, in turn, will open the Image Properties dialog box.
2. Within the Image Properties dialog box, click your mouse on the Choose File button. Netscape Messenger, in turn, will display the Choose Image File dialog box. Select the graphic file you would like to insert into the e-mail message, and then click your mouse on the OK button. Netscape Messenger, in turn, will display the file name in the Image location field within the Image Properties dialog box, as shown in Figure 658.2.

Note: *Experiment with the other options within the Image Properties to control image display, size, and positioning.*

Figure 658.2 The Image Properties dialog box with an image selected within the Image location field.

3. After you have selected your image and made any desired changes to the alignment, wrapping, dimension, and spacing options, click your mouse on the OK button to add the image file to your composition.
4. Address the message, add subject line text, and type your message as you like. Then, click your mouse on the Send button to deliver the message with its inserted file to the recipient or recipients you have specified.

UNDERSTANDING COOKIES 659

When you surf sites on the Web, there are times when the sites you visit want to store information on your computer. For example, the site might record the date and time you visited or it might record information about products you examined. By recording such information about you on your PC, the next time you visit the site, it can pull up the information and hopefully use it to provide you with better service. Users refer to the information that a Web site stores on your disk as an *Internet cookie*. Although many sites use cookies to provide you with better service, the problem with cookies is that most users do not know that the site is creating the cookie on their disk. The use of cookies is very common and, in most cases, completely harmless. Although cookies are harmless, for the most part, you should be aware of the fact that cookies are being used and stored on your hard disk.

VIEWING THE CACHED INTERNET OBJECTS STORED ON YOUR HARD DISK BY INTERNET EXPLORER 660

Internet Explorer stores temporary files within folders on your hard drive to improve the browser's performance the next time you view a particular Web page. The browser will use the stored or cached Web objects to load and display the Web page faster. Cookies are also stored within the temporary cache directories on your hard drives. You can use Windows 98's Explorer to view the cached files and cookies stored on your hard drive.

If you would like to view the cached files and cookies stored on your hard disk by Internet Explorer, perform the following steps:

1001 INTERNET TIPS

1. Within the Windows Explorer, locate your Windows installation folder (usually C:\Windows). Expand the Windows folder and locate the Temporary Internet Files folder (usually C:\Windows\Temporary Internet Files).

2. Within the Windows Explorer's folder list, click your mouse on the Temporary Internet Files Folder. Windows Explorer, in turn, will display the folder contents in the contents pane, as shown in Figure 660.

Figure 660 View cached Web files and cookies stored on your hard disk.

3. You can use the Explorer window's scroll bar to move up and down within the file list to view the temporary Internet files and cookies that have been stored on your hard drive.

661 VIEWING THE CACHED INTERNET OBJECTS STORED ON YOUR HARD DISK BY NETSCAPE MESSENGER

Netscape Messenger stores temporary files within folders on your hard drive to improve the browser's performance the next time you view a particular Web page. The browser will use the stored or cached Web objects to load and display the Web page faster. Cookies are also stored within the temporary cache directories on your hard drives. You can use Windows 98's Explorer to view the cached files and cookies stored on your hard drive.

If you would like view the cached files and cookies stored on your hard disk by Netscape Messenger, perform the following steps:

1. Within the Windows Explorer, locate your Program Files folder (usually C:\Program Files). Expand the Program Files folder and locate the Netscape sub-folder, the folder in which the Netscape Communicator Suite has been installed (usually C:\Program Files\Netscape).

1001 Internet Tips

2. Expand the Netscape folder and locate the Users sub-folder. Within the Users sub-folder, expand the sub-folder which corresponds with your username (usually C:\Program Files\Netscape\Users*username*). Within each *username* folder, you will find a cache sub-folder. It is within the cache folder that Netscape stores cached Internet objects.

3. Within the Windows Explorer folder list, click your mouse on the cache sub-folder (usually C:\Program Files\Netscape\Users*username*\cache). Windows Explorer, in turn, will display the folder contents in the contents pane, as shown in Figure 661.

Figure 661 The cache sub-folder where Netscape holds your cache files.

4. You can use the Explorer window's scroll bar to move up and down within the file list to view the cached Internet files and cookies that have been stored on your hard drive.

CONTROLLING YOUR COOKIES WHILE USING INTERNET EXPLORER 662

Within Internet Explorer, you can use the Internet Properties dialog box Security tab to control how your browser handles cookies. To start, you may want your browser simply to accept the cookies with no questions asked. Second, you can direct your browser to prompt you before it accepts or denies a cookie, or you can simply disable all cookies.

To control how Internet Explorer handles cookies from Internet sites, perform the following steps:

1. Click your mouse on the Start menu. Select Settings and choose Control Panel. Windows 98, in turn, will open your Control Panel window.

2. Within the Control Panel window, double-click your mouse on the Internet icon. Windows 98, in turn, will display the Internet Properties dialog box.

1001 Internet Tips

3. Within the Internet Properties dialog box, click your mouse on the Security tab. Windows 98, in turn, will display the Internet Properties dialog box Security tab.

4. On the Security tab, click your mouse on the Internet zone icon and then click your mouse on the Custom Level button. Windows 98, in turn, will display the Security Settings dialog box for the Internet Zone.

5. Within the Settings dialog box Settings list, scroll down until you see the Cookies options, as shown in Figure 662.

Figure 662 Setting Cookies options for Internet Explorer.

6. Click your mouse on the Cookies setting that you desire and then click your mouse on the OK button. Then, click your mouse on the OK button to close the Internet Options dialog box.

663 CONTROLLING YOUR COOKIES WHILE USING NETSCAPE MESSENGER

Within Netscape Messenger, you can use the Preferences dialog box Advanced Category to control how your browser handles cookies. To start, you may want your browser simply to accept the cookies with no questions asked. Second, you can accept only cookies that get sent back to the originating server, or you can simply disable all cookies. You can also direct your browser to prompt you before it accepts or denies a cookie.

To control how Internet Explorer handles cookies from Internet sites, perform the following steps:

1. Within Netscape Messenger, click your mouse on the Edit menu and choose the Preferences option. Messenger, in turn, will display the Preferences dialog box.

2. Within the Preferences dialog box, click your mouse on the Advanced category. Messenger, in turn, will display the Advanced category options, as shown in Figure 663.

3. Within the Cookies area of the Preferences dialog box, click your mouse on the Cookies setting that you desire and then click your mouse on the OK button.

Figure 663 Setting Cookie options for Netscape Messenger.

Fun on the Internet — 664

While there is much on the Internet that is serious and businesslike, there is much fun to be had on the Internet as well. Users play thousands of games on the Internet. Some of the games are traditional games like chess, hearts, and backgammon. Some of the games are not so traditional, such as Quake, a shoot'em up game. If you want to play chess at two in the morning, you have a good chance of finding another user on the Internet who is up and ready to play at that time as well. The Internet is a way to communicate and that includes communicating to play as well as communicating to learn or buy. The next time that you find yourself in need of a good game of hearts in the wee hours of the morning, or during more civil hours as well, turn on your computer and hit the Internet.

Playing Chess and Other Board Games by e-mail — 665

A low-tech way that you can play a game over the Internet is to use e-mail. Many users have played games like chess or Diplomacy, a board game based on World War I by The Avalon Hill Game company, by mail. Each player will mail in the move that he or she makes and then the other player or players will mail a move back and so on. With e-mail, you can play the game in much the same way e-mailing a move back and forth between players. The one advantage that e-mail has over normal mail is that you can play a game at an almost normal pace if both of the players are online at the time. With a chat session you could play a game in real time. Many users find it fun to play a game by mail, be it e-mail or otherwise, because it offers time to think about all the different options. In board games like Diplomacy, one player will act as a collector for all the moves and post the outcomes, sometimes posting the moves to a Web page so all the players can see the game board. You may find that playing games by e-mail will let you play with old friends that have moved away.

666 UNDERSTANDING MUDs, MOOs, MUSHs, AND SUCH

Some of the first games that were played on the Internet were Multiple User Dungeons, or MUDs. MUDs are, in general, role-playing games where you take on the persona of a character while you are playing the MUD. A MUD is similar in concept to the role-playing game Dungeons and Dragons. A MUD will have a server where you and other MUD players will log into and interact with each other. The MUD program will create a virtual environment around the character that you are playing in the MUD and you can then interact with that environment. You can look at things and fight with monsters and other players in the MUD. It is a complex setting where hundreds of users all may be interacting with each other in the virtual environment of the MUD. As MUDs developed, other versions of the MUD theme were developed which became known as MOOs, MUSHs, and so on. They are each different in how they work but they all have the same basic principle behind them: make an environment in which multiple users can interact often in a fantasy role-playing setting. In the past, MUDs were only accessed by using a Telnet client, but as the MUD servers developed so did MUD clients. A MUD client is a program that is designed to work with MUD servers and provides extra functions that you would not get in a normal telnet client. The MUD client still uses the Telnet protocol but the client has other features that would only be used in a MUD, such as a place to keep notes about other players and a mapping function. MUDs are a way to play a role-playing game over the Internet with many other users in a virtual environment.

667 FINDING A MUD THAT YOU CAN PLAY

The best way to find a MUD would be to use a search site like the Yahoo site, at *www.yahoo.com*. If you search for MUDs at the Yahoo site, the search engine will display links to many MUD Web pages. Click your mouse on the Recreation>Games>Computer Games>Internet Games>MUDs link and Yahoo will display the MUDs Web page, shown in Figure 667, which will list many MUDs that you can join.

Figure 667 The MUD link Web page on Yahoo.

Click your mouse on any of the MUDs listed to see the home page for the MUD. On that home page, you will find information about the style of MUD that you are about to join, information about how the MUD works, and information on how to join the MUD. You can use the information on the MUD's home page to join the MUD.

LOGGING INTO A MUD 668

You have found the MUD that you wish to play and now you want to log into the MUD to start playing. You will need to connect to the MUD server using a Telnet client or using a MUD client. The home Web page for the MUD should give you an address for connecting to the MUD server or a link on the Web page that will connect you to the MUD server, as shown in Figure 668.

Figure 668 The home page for a MUD with a link to log into the MUD. The link is the door picture.

When you click your mouse on the link to the MUD, your Telnet client will start and you will be able to log into the MUD. After you have logged into the MUD, you can start playing your character. How characters are created and the rules to the MUD change with every MUD so it is strongly recommended that you read all the information on the MUD's home page.

BASIC COMMANDS IN A MUD 669

After you have entered a MUD, there are some basic commands that you can use to move around and work in the MUD. You move around the MUD by typing different directions, such as N for north and SE for southeast. You can look around you by typing look, and you can talk by typing tell and what you want to say. You get something by typing get and you wear something by typing wear. The MUD is all character-based, as in typing, and most of the commands are simple English commands. The most important command is Help, as most MUDs have an

extensive Help system. You can use the Help system on the MUD to help you find out all the commands that are specific to the MUD in which you are playing. If you are new to MUDs, you should plan on looking at the Help files on the MUD you are playing, as it will give you more information about what you can do in a MUD. Each MUD has a slightly different set of commands, so when you start, take a look at the Help files in the MUD by using the Help command.

670 LOOKING AT THE Z MUD CLIENT

The Z MUD client is a program that takes the place of using Telnet when connecting to a MUD. The Z MUD client has a graphical interface that you can use to connect to a MUD, as shown in Figure 670.

Figure 670 The Z MUD client program graphical interface.

From the Z MUD client, you can connect to a MUD server using a character that you have created with the Z MUD program. The Z MUD client will connect to the MUD and present a Telnet-like screen for you to use in working with the MUD. The Z MUD client is found at *www.zuggsoft.com*, or at many program download sites, such as *www.tucows.com*. Using a client program can aid you in your MUD journeys.

671 THE MSN GAME ZONE

The MSN Game Zone is a Web site where you can play many different types of games against real users on the Internet. You will need to join the MSN Game Zone the first time that you visit the site, at *zone.msn.com*, by filling out information in a Join MSN Game Zone form. After you have joined the MSN Game Zone, you will go to the MSN Game Zone home page, as shown in Figure 671, where you play not only different board and card games but you can play multi-player games like Rainbow Six and Age of Empires.

1001 Internet Tips

To play a game, click your mouse on the type of game you would like to play. MSN, in turn, will ask you to sign in if you are not already connected to the Game Zone.

Figure 671 The MSN Game Zone home page.

Note: *You can sign up for a free Game Zone account from the sign in dialog box by clicking your mouse on the Cancel button.*

After you connect to the Game Zone, you will see a list of game rooms in which you can play your game of choice. The rooms are listed by skill level so you can play a game with users that are at your skill level. When you pick a game room in which to play, a program will download to your computer to run the game, if this is the first time you have played the game you have chosen, and display the game room. You may need to answer a dialog box asking if it is OK to download the program to your computer. You can join a game by clicking your mouse on an empty slot, usually an empty chair, and then joining the game. You can leave a game by closing the game window.

GAMES THAT YOU CAN PLAY ACROSS THE INTERNET — 672

There are many games that you can buy that have the ability to be played across the Internet. The type of games that you can play on the Internet range from strategy games, like Age of Empires, to shoot'em up games, like Quake. To find other users to play online, you can go to Web pages dedicated to the game you want to play, such as *www.planetquake.com* for the Quake online game you have been looking for, or you can go to game Web sites like the MSN Game Zone at *www.zone.msn.com*. At the MSN Game Zone, you can play Age of Empires with other users across the Internet by going to the Age of Empires room, as shown in Figure 672, and joining a game.

1001 Internet Tips

Figure 672 A game room at MSN Game Zone for playing Age of Empires the Rise of Rome Expansion.

After you join a game from a game room, you will be playing with other users on the Internet and not the computer. Playing real users on the Internet can add exciting new challenges to a game you have mastered playing just the computer.

673 CHECKING YOUR LOTTERY NUMBERS ON THE WEB

You can check your lottery numbers online by using the Lottery USA Web site. The Lottery USA home page, shown in Figure 673, can be found at *www.lotteryusa.com*.

Figure 673 The Lottery USA home page where you can check state lotteries online.

1001 INTERNET TIPS

To check the results of the lottery, click your mouse on the link for the state lottery in which you have a ticket. The Lottery USA site, in turn, will display the winning numbers for the most recent drawing for the jackpot for that state's various lotteries. You can also check the results of previous drawings for the past year. The Lottery USA site is a quick place to see the results of lotteries all over the country.

USING THE GAMES AT YAHOO! — 674

The Yahoo! Games site is a good place to play board and card games with other users on the Internet. The Yahoo! games Web page, shown in Figure 674, can be found at *games.yahoo.com*.

Figure 674 The Yahoo Games main Web page.

If you are new to Yahoo! Games, then you must sign up with Yahoo! Games before you can start to play any games. When you click your mouse on a game you would like to play and then click your mouse on the Sign me up! Link, Yahoo!, in turn, will display the Yahoo Sign up! form. You will fill out a short form where you will pick a login name and a password, fill out information for your account, and then click your mouse on the Submit this Form button. The Yahoo! Games site, in turn, will display the Welcome to Yahoo! Web page and send you an e-mail explaining your Yahoo account. Click your mouse on the Go to Yahoo! Games link to return to the Web page of the game that you selected earlier. To start playing a game after you have selected a game and signed in, (if you just created your account you are signed in already) select a game room in which to play a game at your level of play. When you pick a game room, a Java applet, a small program, will be downloaded if this is the first time you play the game. Next, the Java applet will start the game you are playing. The Java applet is used to control the game you are playing at Yahoo! Games. In the game room, you will see different games being played. Each game that is being played is called a table. If the table has room for a new player, you can join the game. If you are not ready to play, you can watch the game. Also, you can watch a game if there is no room for you to join. If you like to play board games or card games, you can find a player at Yahoo! Games.

1001 Internet Tips

675 Computer Gaming at www.happypuppy.com

The Happy Puppy Web site is a Web site dedicated to computer games. The home page for Happy Puppy Web site is a starting point for getting information on various computer games, as shown in Figure 675.

Figure 675 The Happy Puppy home page.

The Navigation bar on the left hand side of the page has links to different areas of the Happy Puppy site. The Computer Games area offers computer games that you play on your PC or Mac computer. The Console Games area has games that you play on a system, such as Nintendo or Play Station. The Hints & Cheats area has help and cheat codes on how to play many of the popular computer games as well as some of the more obscure games. The Pawprint Press area has the latest news on the computer game world. The Biz area has information about working in the computer gaming industry, not to be confused with the gaming industry.

676 Sending Electronic Cards with Message Mates

The Message Mates Web site has many different types of electronic greeting cards that you can send to your friends and relatives. To send a Message Mate greeting card, type *www.messagemates.com* in your browser and hit the ENTER key. Your browser, in turn, will display the Message Mates Web page. Select the type of message that you want to send, such as a birthday card or get well card. You will find three buttons below each message. Click the middle button that looks like an envelope. The Message Mates site, in turn, will display the Send a Message Mate Web page, as shown in Figure 676.

1001 Internet Tips

Figure 676 The Message Mates send a Message Mate Web page.

You can either use a pre-defined message or create a message of your own to send with the electronic card. Enter your name and e-mail address as well as the e-mail address of up to five other people to whom you want to send an electronic card. After you have entered all of the information, click your mouse on the Send Now button. The Message Mates site, in turn, will display a Web page that confirms the card was sent. After the electronic card has been sent, the people you sent the electronic card to will receive an e-mail telling them that they have received a Message Mates card, along with instructions on how to retrieve it. The nice thing about Message Mates is that if you forgot to send a card to your mom, you can send an electronic card that will reach her the same day you send it. The Messages Mates Web site has electronic cards to meet most every need.

677 SENDING ELECTRONIC CARDS WITH BE MINE

The Be Mine Greetings Web site is a romance Web site that is dedicated to putting romance on the Internet. The Be Mine Web site has links to many Web pages related to romance, as well as an extensive number of romantic electronic cards. To send a romantic card from the Be Mine Web site, type *www.bemine.com* in your browser and hit the ENTER key. Your browser, in turn, will display the Be Mine Web page. Select the Card Galleries link. The Be Mine Web site, in turn, will display the Be Mine Greeting Card Galleries, as shown in Figure 677.1.

The numbers under each Gallery heading are links to Web pages that have several different types of greeting cards on the Web page. Click your mouse on a number to see a group of cards that you can create to send. The Be Mine Web site, in turn, will display the card gallery that you selected, as shown in Figure 677.2.

Figure 677.1 The Be Mine Greeting Card Galleries Web page.

Figure 677.2 The number two card gallery on the Be Mine Web site.

To select a card type, click your mouse on the radio button under the card type you like. You must scroll down the Web page to see the other options available to select for your electronic card. Next, to pick a background for your electronic card, click your mouse on the radio button under the type of background that you want on your card. You have a choice of using either a watermark type background or a left side border background but you cannot use both. If you select a watermark type background and then select a left border background, the watermark background will be unselected. After you have selected your background, select the color of the text and the heading that you want for your card. You can then add a sound file to be played when the user retrieves his or her electronic card but this will slow the download of the card when the user tries to retrieve the card. Lastly, you will fill in the user's name and e-mail address and your name and e-mail address, along with a message that you want to send with the electronic card. After you have completed the selection and sending information, you can send your card by clicking your mouse on the Just Send It! button. The Be Mine Web site, in turn, will send the user to whom you sent the card an e-mail with information on how to retrieve the electronic card. The Be Mine Web site is a site for those with romance on the mind.

1001 Internet Tips

Finding Campgrounds on the Web 678

A helpful site for campground information on the Internet is the Camping-USA Web site at *www.camping-usa.com*. The Camping-USA Web site maintains a wealth of information about camping, not the least of which is its National Campground Directory. The National Campground Directory Web page has a map of the continental U.S. marked with red dots to show the location of campgrounds, as shown in Figure 678.

Figure 678 The Camping-USA National Campground Directory Web page.

To display the Camping-USA National Campground Directory Web page, type *www.camping-usa.com* in your browser and then hit the ENTER key. Your browser, in turn, will display the Camping-USA Web page. Click your mouse on the National Campground Directory link. Your browser, in turn, will display the National Campground Directory Web page. Click your mouse at a location on the map of the Continental U.S. that is close to where you want to camp. The Camping-USA Web site, in turn, will display a listing of many of the campgrounds in the vicinity of the location you chose. When you find the campground you wish to visit, click your mouse on the Lookup on Switchboard.com link to look for the phone number of the campground. The Camping-USA provides a quick and easy method for finding a campground for your next camping trip.

Visiting National Parks on the Web 679

The National Parks Service maintains a Web site on the Internet for you to get information about the different national parks at *www.nps.gov*. You can get information about any of the national parks in the United States by going to the National Parks Service Web page and clicking your mouse on the Visit Your Parks link. Your browser, in turn, will display the Visit Your National Parks Web page, as shown in Figure 679, which has information about all of the national parks, including maps and fees.

1001 Internet Tips

Figure 679 The Visit Your National Parks Web page maintained by the National Parks Service.

The Find a Park section of the Visit Your National Parks page has links to find information about the different national parks. There is also a link to a listing of the different state park agencies where you can get information on a state park in a particular state. The National Parks Service Web site is a great source of information about any of the national parks that you might visit.

680 MAKING RESERVATIONS FOR A NATIONAL PARK ON THE WEB

You can reserve a camping space at several of the national parks right on the Web. To make your reservation for a national park on the Web, go to the National Parks Service Reservation Web site, shown in Figure 680, at *reservations.nps.gov*.

To make a reservation, scroll down the National Parks Service Reservations Web page to see if the national park that you are going to visit is listed. You cannot make reservations for all national parks from the reservation page as some of the parks handle the allocation of camping spaces locally or on a first come first serve basis. If you find the national park listed that you want to make a reservation for, perform the following steps:

1. Click your mouse on Click Here to start Reservation. The reservation site, in turn, will display a map and a drop-down box of the different national parks to which you can make a reservation online.

2. Click your mouse on the location of the national park. The reservation site will display the Web page for the national park you have selected. If you hover your mouse over a park site on the map, the name of the national park will be displayed. You can also use the drop-down list to pick the name of the park and click your mouse on the Go to Park button.

3. The Park Web page will have a drop-down list of all the camp locations in the park. Pick the camp location for which you wish to make a reservation. The reservation site, in turn, will display the camp site page. If you are not sure about what camp site in the park you want,

the Park Web page has a link to a map of the park to help you pick. You may need to click your mouse on the Go To Camp button or the Go To Tour button.

Figure 680 The National Parks Service Reservation Web site.

4. On the camp site Web page, you can pick the date that you want to arrive at the park. The camp site Web page will also list all the restrictions for the camp site that you have selected. If you accept the restrictions of the camp site, use the drop-down box to select your check in date and click your mouse on the Accept Restrictions, Check Availability button. The reservation site, in turn, will display the reservation status of the camp site for your selected days. If you have picked times when the park is not open, you will not get the next set of steps but must pick new dates or cancel.

5. Use the appropriate drop-down lists to select the number of days that you will be staying and the number of people that will be staying. After you have completed the information for the page, click your mouse on the Start Reservation Process button. If you are a first time user of the National Parks Reservation System, you will need to fill out a personal information form. If you have used the National Parks Reservation System but have not used the Online system (this Web site), then you will need your customer number to fill out some personal information to match records. If you have used this Web site before, then you know what to do. If you have never used this system before, fill in your personal information in the secure Web page and click your mouse on the Submit button. The reservation site, in turn, will display the discount Web page.

6. Select the type of discount card that you have, none is a choice, and click your mouse on the Submit button. The reservation system, in turn, will display the Charge Information Web page.

7. Enter your credit card information and click your mouse on the Submit button. The reservation site, in turn, will display the cancellation policy.

8. Click your mouse on the Accept button if you agree with the cancellation policy. The reservation site, in turn, will display your reservation information.

You now have a reservation for a national park campground.

681 FINDING PARENTING TIPS ON THE WEB

The Web site *www.parentsoup.com* is a good resource of information for parents and parents to be. The Parent Soup home page has links to many Web pages with information about all stages of parenting, as shown in Figure 681.

Figure 681 The Parent Soup home page.

The different communities of the Parent Soup site target parents of children in different stages of development and cover pre-adolescence years through the teen-age years. The site has many chats where you can ask questions of other parents and several advice column Web pages as well. If you are already a parent or just starting on the road to parenthood, the Parent Soup site has plenty of information for you.

682 USING THE INTERNET FOR TEACHING AND TEACHERS

Despite the press about the dangers of the Internet, the Internet is an excellent resource for extending your learning. The origins of the Internet were to allow the free exchange of information between universities and research labs. As the Internet grew in the 80s and 90s, the goal of the free exchange of information was still central to the development of the Internet. It may seem that the goal of the free exchange of information and learning is lost in all the commercial aspects that have developed on the Internet, but the goal of the exchange of information is still a core part of the Internet. The Internet is a resource for learning that knows no boundaries of religion, race, sex, or nationality. Through the Internet, you can take your students, either in your classroom or in your home with your own children, and expose them to information about every culture on the planet as well as to much that is not of this planet. The Internet is a place where students can learn at their own pace and in their own style. You can provide your students with numerous information on any topic by showing them the tools of the Internet. When you provide the tools to gather information, your students' curiosity can travel where it will. It is true that the Internet has some inappropriate material but, when used with responsibly, the Internet can provide boundless information for your students.

Getting Your Classroom Online 683

Probably the first challenge that you will face is getting your classroom online. This is becoming less of a concern as there are being made available to many schools grants, both from government and private industry, to bring technology into the classroom. The first step that you should take is to find someone in your local school system that has experience writing grant requests. You may even find that your school district has a full-time grant writer. The next step is to use the Internet itself to search for possible technology grants by using the different search engines. You should also check educational publications for listings of different grants. Of course, getting the computer equipment is only part of the battle. You must also get your school connected to the Internet. Getting connected may not be as difficult as you might think as many telephone utilities have it written in their charter that they provide cheap or even free Internet access to schools and public libraries. A source for getting your school connected to the Internet is the Consortium for School Networking at *www.cosn.org*. After you know how you will pay for the equipment and connection, you need to get the approval of the administration for your plan. Most educators see the benefits of having the classroom connected to the Internet but it still may take some work to get your administration behind your plan. The best thing to do is to be prepared when you present your plan to bring your classroom online. Show how the equipment will be paid for and how the connection will be supplied. You should have a few sample lesson plans that show how the Internet in the classroom will improve the learning of your students. You should also expect to answer questions about protecting the children from the inappropriate parts of the Internet, such as pornography, hate groups, and so on. You should have an acceptable use policy for student use of the Internet and consequences if students violate the acceptable use policy. Being prepared when you present your plan to bring your classroom into the Internet age will help you achieve your goal.

Internet Technologies to Use in the Classroom 684

The Internet is made up of many different technologies that let you communicate with other users. In the classroom, you will primarily use two technologies. The World Wide Web is a technology that easily lends itself to the classroom with the wealth of information that it has available. The other main technology that you may find yourself using is e-mail. Giving your students an e-mail account will let them interact with you in a less intimidating environment and will also let them interact with students from other places as well. In the past, users in educational settings commonly used Internet technologies like Gopher and Telnet, but the World Wide Web has almost completely replaced both of these technologies. Users use the File Transfer Protocol (FTP) on a regular basis to download files from the Internet but would most likely not use it in an interactive classroom setting. As you start to work with your lesson plans, look for opportunities that you can use to enhance your lessons with the use of the Internet.

A Teacher FTP Site 685

The Internet is full of education programs that are created by users who are willing to share their programs with you. A good FTP site to find education software is the CD-ROM FTP site. At the FTP address of *ftp.cdrom.com1*, in

the directory pub, you will find many different categories of software that you can download and use. Some of the categories are not appropriate for the classroom but there is some good educational software as well.

If you are a math or science teacher, you may be interested in exploring two directories under the pub directory, *math* and *MacSciTech*, the Macintosh Scientific and Engineering Users Association archives. The full URL to the *MacSciTech* directory is *ftp.cdrom.com/pub/MacSciTech*. Under the *MacSciTech* directory, you will see many different topic-named directories in which you can find many programs for the Macintosh that you can use in your classroom. The *math* directory has several subdirectories, *ed*, *hp48g*, and *utk*, which have programs and other materials that you can use in your classroom. In the *math* directory, there are some files that are not just for math but could be used in other subject areas. Many of the programs will work on DOS computers so that if you are not able to work with the latest equipment, you can still bring learning software into your classroom.

The second area to look for good educational software is under the *mac*, *win3*, or *win95* directories, depending on if you are using the Macintosh operating system, the Windows 3.1 or 3.11 operating system, or the Windows 95 operating system. Under the *mac* directory, refer to the *umich/misc* directory to see programs to use in the classroom. Under either of the Windows directories, you will find not only directories that are subject specific, such as math or music, but also a directory dedicated to education (the *edu* directory). In any of these directories, you will find many programs to use in your classroom.

You may want to look around the CD-ROM FTP site for other directories and programs that you may find fun for your own entertainment. The CD-ROM FTP site has a gold mine of programs that you can use in your classroom and for your own enjoyment.

686 Finding Web Sites for Use in the Classroom

The World Wide Web is full of many excellent Web sites to use in your classroom. The problem is finding the good educational Web sites in the sea of information and commercialization that has become the World Wide Web. One place that you will be able to find educational sites on the Web will be in sources, such as this book and other books, that are guides to the Internet. A second good source of educational Web sites is in teaching-related magazines, such as the National Teachers of Mathematics Journal or the NEA member's magazine where there are articles and information boxes that list Web sites that you can use in the classroom. A third area to find Web sites for use in the classrooms is the Web sites for cable educational channels and educational magazines. For example, the Discovery channel maintains a Web site at *www.discovery.com* and the Discover magazine maintains a Web site at *www.discover.com*. They provide good starting points to find other sites of interest. A fourth area is your peers. Find out what other teachers are using on the Internet and use the same sites. A fifth method that you can use to find sites on the Web is to search on the Web for the topic you are going to teach by using a search engine. If you find other sources that offer beneficial Web sites to use in the classroom, you should pass the information on to your fellow teachers.

687 Working the Internet into a Lesson Plan

When you are ready to work the Internet into your lesson plan, you will need to consider several matters. First, your should determine if the use of the Internet will help your lesson. It is important to note that using the Internet will not enhance every lesson. The Internet is an amazing tool that can help your students to learn, but it is not always

the best way to teach a topic and it may distract from the learning. Next, you need to define your goal in using the Internet in your lesson plan and determine how to grade the students' work. If your use of the Internet is to be successful, you must clearly define what the students are to do and you must be able to determine if they have completed the assigned tasks. You must also plan the steps that the students are to take when they are working on the Internet. You should try the project before the students do it in class. You should do this trial run no more than a few days before the lesson as the Internet changes very quickly and what worked well during the summer may fail completely in November when you use the lesson. You should also use this trial run to set strict time lines for the students to complete the tasks so they do not get off track and start surfing the Internet. If you have all this information in place when you use your lesson, then your students should have a great Internet learning experience.

CITING MATERIAL FROM THE INTERNET — 688

When students get information from the Internet for use in a report, they must cite their source. To cite material from the Internet, your students can refer to copyrighted information provided by Janice Walker (*jwalker@shuma.cas.usf.edu*) of the University of South Florida in the MLA-Style Citations of Electronic Sources style sheet. The basic form of a cite is:

Author's Last Name, First Name. Title of Work. *Title of Complete Work.* [protocol and address] [path] (date of message or visit).

Examples:

WWW:

Wolfe, Andrew. *Cool stuff on the Web.* The Wolfe Home Page. *http://www.alpine.net/~andreww/cool/ coolstuff.htm* (5 Jan. 1999).

E-mail:

Malone, Bill. "New Tips About the Web." Personal e-mail (3 May 1999).

Newsgroups:

Smith, Jim. "Questions about Reality." *alt.fake.newsgroup* (7 May 1999).

Note that in the E-mail and Newsgroup citations, the Subject line from the e-mail or newsgroup post is placed in the quotation marks. If you need more information about citing electronic media, you should refer to Janice Walker's Style sheet, at *www.cas.usf.edu/english/walker/mla.html*, from which the information in this Tip was drawn.

BROWSING ENCYCLOPEDIAS ONLINE — 689

The Internet can bring much of the information that you would have had to go to a library for right to your home computer. You can search an encyclopedia online, using, for example, the Encyclopedia Britannica online site at *www.eb.com*, as shown in Figure 689.

1001 Internet Tips

Figure 689 The Encyclopedia Britannica's home Web page.

The Encyclopedia Britannica is a subscription site where you must have a username and password to use the site. You can receive a trial membership to use the site for thirty days. The Britannica site is completely searchable and has links to other sites on the Internet. The Britannica site also has a dictionary so you can look up the meaning of words as well as look up topics in the encyclopedia.

690 MANAGING YOUR STUDENTS ONLINE

The key to managing your students online is to have and communicate a clear expectation of what they are to do when they are online. This expectation should include what types of Web sites the students should be viewing and suggestions of Web sites that they may start using in their work online. You should also keep a time limit for the search that your students are making so the online lesson does not become free Web browsing time. It is also a good plan that you have an acceptable use policy that each student and their parents must sign. The acceptable use policy should state what types of Web browsing are considered acceptable and that any other use of the school's Internet connection is unacceptable. The acceptable use policy should state clear consequences for students who break the acceptable use policy. Of course, you should always supervise students while they are online. While it is possible that a student can hit an inappropriate

site by mistake, the student should know the site is inappropriate and leave the site immediately. Through the use of clear goals, strict time limits, known consequences for inappropriate behavior while online, and supervision of students while they are online, you should have few problems with your online lessons.

GIVING YOUR STUDENTS INTERNET PROJECTS — 691

A method that you can use to include the Internet in your lesson plans is to use Internet-based projects. You can assign a project that would require your students to use the Internet to find information. Your Internet project can be classroom-based or you can assign it to be completed as a homework project. You can give your students more freedom in how to search the Internet as they will have more time they can use to gather information for their project. An Internet project where your students will search the Internet independently will require you to plan ahead so that all students can be included in the project. The first part of an Internet-based project that you must develop is a lesson on how to search for information on the Internet as some students may not have experience using the Internet to find information. You must also have alternatives for students that do not have computers or Internet connectivity at home to be able to get access to the Internet. Many public libraries now have public access to the Internet so that students who do not have Internet access can use the public library to complete a project. You may also have a computer lab that is open before or after school that students can use for their Internet access. If you give your students a lesson on how to conduct the search requirements for your Internet-based project and ensure all students have access to the Internet, you may find that giving your students extra time to collect information will produce great returns.

CREATING YOUR OWN CLASS WEB SITE — 692

A project that can be very stimulating to your students, while not requiring an Internet connection, is to have your students build a Web site about a topic they are studying. If you can set up a computer in your classroom that you can use to host your Web site, you can have your students create a Web site for a class project. If your school has its own Web server or if you can get a local ISP to donate some Web space, you can publish the students' work on the Internet. Having your class create its own Web site will require some direction from you to give the students the basic design of the Web site. However, the more freedom you give to the students to design the Web site the more they will be actively involved in the project. You will also need some experience at creating Web pages but you may find that some of your students can provide that experience for you. Some of your students may already be experienced Web site designers and would be able to aid the class Web project by creating the Web pages. If you can then publish your Web site on the Internet, not only will your students have learned new information in creating the Web site but also they will now be helping other classes by increasing the information that is on the Internet.

693 DEVELOPING AN INTERNET EXCHANGE WITH OTHER SCHOOLS

A project that is an Internet twist on an old class project is a mail exchange with other schools. The Internet twist is that you use e-mail to exchange letters with the students in the other schools and you can use a Web site to post information about the schools and regions in which the schools are located. Using the Internet for your school exchange can add a personal touch to your study of a different region. You can also do projects other than the pen pal type of mail exchange. For example, have your students exchange local news or describe what the weather is like where they are living. You can have your students describe important town events, anything that has the students thinking about the world around them and learning about the world around other people. Contacting a school in a different region to exchange e-mail messages can add a new dimension to your lessons about that area of the world.

694 USING MAILING LISTS FOR EDUCATION

You can use mailing lists to get information or to send questions to other teachers. When you use a mailing list, you will send an e-mail to a list server asking to subscribe to the list. After you subscribe to a mailing list, you will receive e-mail messages from the mailing list and you can send e-mail messages to a mailing list server that will send them to all the members on the mailing list. Many different groups maintain mailing lists for their members. If you belong to any of the educator professional groups, check with your professional organization to see if they maintain a mailing list that you can join. Professional magazines are good sources of mailing lists. You can also use the AskERIC resources, discussed in Tips 696 and 697, to get information about different education-related mailing lists. Mailing lists have become a private use means of communicating with people who are members of a group. Many public mailing lists still exist but they are growing smaller in number. Some of the organizations that you already belong to may maintain a mailing list that you can join.

695 NEWSGROUPS FOR TEACHERS

There are many newsgroups that are specific for teachers. To find a newsgroup for teaching, use your newsreader to perform a search of the newsgroups. The first area that you should search for a newsgroup is the K12 newsgroups by entering k12 in the newsreader search. The K12 newsgroups are for teachers of the Kindergarten through 12th grade. There are many different newsgroups in the K12 newsgroup category, some dealing with just one subject area and others that are for general discussion. After you have looked at the K12 newsgroups, you should check for newsgroups with school in the title. When you search for school, you will get many unrelated hits and so you may need to page through a list of many different newsgroups with the word school in the title to find a newsgroup of interest. You should also do a search of the newsgroups with the word education in the title. You will find that the

K12 newsgroups are stable and do not change but you will find the newsgroups with school and education in the titles will change from time to time.

UNDERSTANDING AskERIC — 696

AskERIC is an Internet-based clearing house of information about education. The AskERIC home page at *ericir.syr.edu*, as shown in Figure 696, has links to the different resources of the AskERIC system.

Figure 696 The AskERIC home page.

The AskERIC Question and Answer Service is a service where you can send a question about an educational topic and an AskERIC topic specialist will e-mail you a response with links to Internet resources and AskERIC documents. The AskERIC Virtual Library contains educational resources including lesson plans, AskERIC Info Guides, archives of mailing list messages, and much more. The Search the AskERIC Database is a database of almost a million different abstracts of documents and journal articles dating back to the mid-60s. The AskERIC Web site has been called, by some users, one of the most important educational resources.

WORKING WITH THE AskERIC VIRTUAL LIBRARY — 697

The AskERIC Virtual Library is a resource that every teacher and parent should visit. The AskERIC Virtual Library holds information that can supplement any teaching plan. The main Web page for the AskERIC Virtual Library, as shown in Figure 697, has links to the different categories of the library.

Figure 697 *The AskERIC Virtual Library Web page.*

The AskERIC Virtual Library has links to resources that can help you in the classroom. The Lesson Plans link has over a thousand lesson plans covering all of the K12 grades. The AskERIC InfoGuides give you information about the latest topics in education. The Television Series Companion Materials page has links to many of the educational television Web sites. The More Education Resources page has links to many education-related Web sites. The list just goes on. The AskERIC site is a must visit site for any educator.

698 LOOKING AT PROJECT GUTENBERG

The Project Gutenberg Web site, at *promo.net/pg*, is a place where you can get many of the great literary works to read on your computer. The home page of the Project Gutenberg has links to search for books by title and by author, as shown in Figure 698.

Figure 698 *The Project Gutenberg home page.*

You can download the entire text of any of the vast number of Public Domain works of literature that are present at the Project Gutenberg site. The Project Gutenberg site stores all the novels in electronic text (e-text) format so that you can search the book. If you want to curl up with the text of H.G. Wells, *The War of the Worlds*, or search for the color of Dorothy's slippers in the *Wizard of OZ*, then all you need to do is point your browser to the Project Gutenberg site and download the e-text.

LOOKING AT CIA PUBLICATIONS 699

The CIA maintains a Web site on the Internet where they publish several collections of facts about the world, including the CIA World Fact Book and information about the heads of states of foreign governments, as shown in Figure 699.

Figure 699 The Web page for the CIA World Fact Book.

The CIA publications Web page is at *www.cia.gov/cia/publications/pubs.html*. The World Fact Book and the Chiefs of State books are great sources of information about other countries of the world. If you ever need to know how many miles of roads are in Angola or the current chief of state for the Union of Burma, then the CIA Publications page is the place to look.

LEGAL INFORMATION ON THE INTERNET 700

The Internet can be a good source of information on legal matters. You can search for information about laws and about lawyers, about product recalls and ongoing class action suits that you may be able to join. The Internet has information you can use to better educate yourself about the laws that affect you and your family. You can also find information about the lawyer that may be handling your case. The Internet can be a beneficial source of information to keep you from being duped about the law.

1001 Internet Tips

701 Looking at the LawOffice.com Web Site

The LawOffice.com Web site, at *www.lawoffice.com*, offers help to both the legal professional and the average person on the street. You can use the LawOffice.com Web site to help you find a lawyer or to research a legal topic. The LawOffice.com Web site home page, as shown in Figure 701, has links that help you locate a lawyer in your city or to find information about a topic of law.

Figure 701 The LawOffice.com Web site home page.

From the LawOffice.com Web site, you can search for a lawyer in your city based on different areas of law practice. The Law Pathfinders is a search page in the LawOffice.com Web site that you can use to find information about many different legal topics. You can use the Law Tools section of the LawOffice.com Web site to assist you in legal research. You can use the LawOffice.com Web site to answer many questions about the law in the United States.

702 Looking at the FindLaw Web Site

The FindLaw Web site at *www.findlaw.com*, as shown in Figure 702, is a Web site dedicated to searching different areas of the Internet for information about existing laws and current court cases.

The FindLaw home page has links to many different Internet resources for finding the text of current laws. You can also use the FindLaw Web site to do research on the different court decisions that have been made about laws that are on the books in both State and Federal courts. The FindLaw Web site is a strong starting point for any legal research that you may be interested in conducting.

Figure 702 The FindLaw Web site home page.

LOOKING AT THE HIEROS GAMOS WEB SITE

703

The Hieros Gamos Web site, as shown in Figure 703, is at *www.hg.org* and is a good starting point on the Internet for searches about international laws and governments.

Figure 703 The Hieros Gamos Web site home page.

1001 Internet Tips

The Hieros Gamos site has many links to information about foreign government and legal information dealing with both international laws and laws in the United States. The Hieros Gamos is a good site to use in legal research that requires information about countries other than the United States.

704 GETTING FINANCIAL NEWS ON THE INTERNET

Many of the financial news services also have a presence on the Internet like the CNNfn Web site from the CNN Financial News Network, as shown in Figure 704.

Figure 704 The CNNfn Web site home page.

At the CNNfn Web site at *www.cnnfn.com* you can read the latest financial news or get stock quotes on stocks that are trading on many of the stock markets. You can use Web sites like CNNfn to keep up on the business world from your Desktop without having to read a newspaper or turn on a television.

705 GETTING DETAILED FINANCIAL INFORMATION ABOUT PUBLICLY TRADED COMPANIES

You can get detailed financial information filed with the Securities Exchange Commission about publicly traded companies using a Web site such as Edgar-online at *www.edgar-online.com*, as shown in Figure 705.

You can use the Edgar-online site to get copies of the different SEC filings from companies right from your computer. You must register with Edgar-online before you can start to receive the SEC filings from the Edgar-online

Web site. The Edgar-online site has a free registration service with limited access to the SEC filings that the Edgar-online service provides or you can pay for a premium service that gives you access to a greater number of SEC filings and more current filings as well. The Edgar-online Web site can give you very detailed information about companies that are publicly traded on a stock exchange that must file reports with the SEC.

Figure 705 The Edgar-online Web site home page.

SHOPPING ON THE INTERNET 706

The Internet has become a market place to the world which means you can buy a wide variety of goods and services on the Internet. Shopping on the Internet is not just limited to computer products and books. You can buy everything from your weekly groceries to a new car. You can also use the Internet just to research a purchase. You can get information about houses that are for sale and then get information about the latest mortgage rates. The Internet is a good place to research any purchasing plans that you may have.

LOOKING FOR A HOME ONLINE WITH A REAL ESTATE COMPANY 707

If you are planning to buy a home, you can find a wealth of help online. A good place to start looking for help on buying real estate is to visit the home pages of the major real estate broker companies, such as Century 21, as shown in Figure 707.

1001 INTERNET TIPS

Figure 707 The home page for the Century 21 Web site.

At the Web site of the major real estate brokers, you will find help on your real estate questions. The major real estate brokers are also helpful if you are relocating to a different area, as they often have home listings from many different areas. When you are just starting to look for a home, you will find the Web sites of the major real estate brokerage companies to be very helpful.

708 LOOKING AT THE RELOCATE AMERICA.COM WEB SITE

If you are relocating somewhere in the United States or Canada, the Relocate America.com Web site, as shown in Figure 708, can be a great help.

Figure 708 The Relocate America.com Web site home page.

The Relocate America.com Web site is located at *www.relocateamerica.com* and contains many links to Web pages that will help you with a move across the country or just across your town. The Relocate America.com site has links to information about the community to which you will be moving. You can find information about schools and community activities. You can also get the name of a real estate broker in the area to which you will be moving. The Relocate America.com site also has links to information about mortgage rates and mortgage calculators so you can determine the amount of mortgage you can afford. The Relocate America.com site is helpful in finding information about a community to which you are thinking of moving.

FINDING A REAL ESTATE BROKER ONLINE 709

You can find a real estate broker online by using the 1 Real Estate Road Web site at *www.1realestate.com*, as shown in Figure 709.

Figure 709 The 1 Real Estate Road Web site home page.

The 1 Real Estate Road Web site has the names of real estate agents from all over the United States. While the list can be limited for some states, if you need to find a real estate agent in a state where you do not know any real estate agents, the 1 Real Estate Road Web site can give you a start.

LOOKING AT THE FANNIE MAE WEB SITE 710

You can use the Fannie Mae Web site to help you find lending options when you are buying a home. The Fannie Mae Web site at *www.fanniemae.com*, as shown in Figure 710, has links to homes that are for sale and to information for homebuyers.

1001 Internet Tips

Figure 710 The Fannie Mae Web site home page.

The For Sale link on the Fannie Mae Web site has homes that the Fannie Mae corporation is listing as well as links to information on buying Fannie Mae listed homes. Fannie Mae is a nationwide company that can help you find a home when you are moving to a new location.

711 LOOKING AT ONLINE MORTGAGES

You can shop and even apply for a mortgage loan online. There are may sites that are devoted to the home mortgage business on the Internet, such as the E-Loan Web site at *www.eloan.com*, as shown in Figure 711.

Figure 711 The home page for the E-Loan Web site.

The E-Loan Web site has information about loan rates and the many different loan products that you can use to buy a home. With the E-Loan site, you can use loan calculators to find what your monthly payments will be or how much of a home loan you can afford as well as what the current rates are for home mortgages. You can also compare a mortgage that you have to what you can currently get for mortgage financing. After you have found all the information that you need, you can even apply for a mortgage online.

LOOKING AT THE HOUSING AND URBAN DEVELOPMENT WEB SITE 712

You can use the Housing and Urban Development Web site to find a wealth of consumer information and listings of homes that are being sold by different government agencies and other organizations at *www.hud.gov*, as shown in Figure 712.

Figure 712 The home for the Housing and Urban Development Web site.

The Housing and Urban Development Web site can provide you with information about different government programs to assist you in buying a home. The HUD Web site also has links to the Web sites of other government agencies that are selling homes for many different reasons. You can also get information about government regulations that govern the sale of homes.

LOOKING AT THE NEVILLE LOG HOME WEB SITE 713

If you are looking for a more rustic looking home, you can visit Web sites that deal with specialty styles such as Neville Log Homes at *www.nevilog.com*, as shown in Figure 713.

Figure 713 The home page for the Neville Log Homes Web site.

The Neville Log Homes Web site is an example of the type of information you can find when you are looking for something other than the ordinary home on the Internet. The Neville Log Homes Web site has information on the types of Neville Log Homes you can have built and the different floor plans available. You can use the Web site to decide if you need to get further information or look elsewhere for your special home.

714 SETTING UP YOUR VACATION ONLINE

You can do much of the legwork for planning your next vacation online. The Internet is a good place to find what options you have for the type of vacation that you want to take. At many Web sites, you can take a virtual tour of your vacation location choices to help decide if you have found your perfect vacation spot. The Internet can also help you in making all the necessary reservations for your vacation and it lets you compare prices for transportation and accommodations.

715 PLANNING A VACATION TO BIG SKY ON THE INTERNET

The Big Sky Resort Web site will give you the information awkward you leave which you need to make your plans for your Big Sky vacation. The Big Sky Web site is at *www.bigskyresort.com,* as shown in Figure 715.

At the Big Sky Web site, you can get information about the different types of activities that are available for you in the seasons that the resort is open. For example, in the winter you can plan all your ski activities for your stay. You can also make your reservations online for your vacation. If you are not sure how to get to Big Sky, the Big Sky Web site has a map and directions.

1001 INTERNET TIPS

Figure 715 *The Big Sky Resort Web site home page.*

716 PLANNING A TRIP TO GO SKIING IN VAIL

If you are interested in taking a vacation to the Rockies, then the Vail Web site at *www.snow.com* provides helpful information, as shown in Figure 716.

Figure 716 *The home page for the Vail Ski Resort Web site.*

1001 INTERNET TIPS

Like the Big Sky Web site, you can get information about summer or winter vacations at Vail. You can also make your reservations online for your vacation. If you plan to go to Vail often, you can also buy your season ski lift pass using the Vail Web site.

717 PLANNING A TRIP TO DISNEY ONLINE

The Internet can help you with your Disney vacation plans when you visit the Disney Web site at *Disney.com*, as shown in Figure 717.

Figure 717 The home page for the Disney Web site.

Click your mouse on the Vacations link at the *Disney.com* home page to display the Vacation Web page. On the Vacation Web page, you will find many useful links including one that lets you plan your Disney vacation to any of the three Disney theme parks—Walt Disney World, Disneyland, and Disneyland Paris. You can also get information about the different special events that the Disney theme parks are presenting. After you have planned your vacation, you can even book your vacation plans online at the *Disney.com* Web site.

718 BOOKING TRAVEL WITH EXPEDIA

You can make all of your travel arrangements using the Expedia Web site at *www.expedia.com*, as shown in Figure 718.

The Expedia site will assist you in finding vacation and cruise packages for your next vacation. You can also use the Expedia Web site to search for different airline flights to fly to your destination, whether on business or on vacation. The Expedia site can help you book hotel and car reservations for your trip as well. The Expedia Web site also will give you directions to get to a location using Expedia Maps. In short, the Expedia Web site can help you with all aspects of your travel planning.

1001 INTERNET TIPS

Figure 718 The Expedia Web site home page.

TAKING A VIRTUAL TOUR OF A COLLEGE CAMPUS 719

The CampusTours Web site offers information about colleges or universities you might be interested in attending by letting you tour a college campus from home. The CampusTours Web site is at *www.campustours.com*, as shown in Figure 719.

Figure 719 The home page of the CampusTours Web site.

At the CampusTours Web site, you can view pictures and live video from many college campuses in the United States. The CampusTours Web site has links to the home pages of universities and colleges where you can get more

information about the schools to help you decide if you want to visit a college. The CampusTours site also has links to many Web sites to help you learn about college life as well as links to different financial aid Web pages to help you pay tuition.

720 FINDING COLLEGE CLASSES OFFERED ONLINE

You can find many college classes that are offered to you online. The LifeLongLearning Web site at *www.lifelonglearning.com*, as shown in Figure 720, has links to hundreds of classes that you can take over the Internet.

Figure 720 The home page for the LifeLongLearning Web site.

The LifeLongLearning Web site also has information to help adult students that have not taken college classes in a long time as well as adult students taking college classes for the first time. You can return to college without leaving your home by taking college classes over the Internet by using the LifeLongLearning Web site to help you find the college class you want to take.

721 GOING TO THE WESTERN GOVERNORS UNIVERSITY

The Western Governors University at *www.wgu.edu*, as shown in Figure 721, is an alternative to the traditional college for getting a degree.

The Western Governors University uses a competency-based degree system where you get credit for your real world experiences. You earn your degree or certificate by demonstrating your skill and knowledge level and not by having accumulated college credits. The Western Governors University is designed to be easy for you to attend, even if you do not live near a college or university, as it does not require you to go to a physical building or campus to take your classes. The Western Governors University also offers flexibility for people with schedules

1001 INTERNET TIPS

that make it difficult to attend a normal college. The Western Governors University is an innovative method of getting a college degree or a certificate.

Figure 721 The home page for the Western Governors University Web site.

722 LOOKING AT COLLEGES THAT HAVE ONLINE DEGREE PROGRAMS

You can make use of an online college to get your degree from home. A good example of a college that has a degree program course of study that it offers online is the University of Phoenix. The University of Phoenix at *onl.uophx.edu*, has several online degree programs, as shown in Figure 722.

Figure 722 The home page for the University of Phoenix Online Degree Program Web site.

1001 Internet Tips

The University of Phoenix offers several undergraduate and graduate programs of course work. You take a course of study to lead to a degree much as you would in a traditional college but you do it over the Internet. The University of Phoenix is not the only college that is offering degree programs over the Internet. Many traditional colleges and universities are starting to offer selected degree programs.

723 BUYING YOUR GROCERIES ONLINE

You can buy almost anything online, including your groceries. You may be able to find a company that will deliver groceries to your home, such as HomeRuns in the Boston area. The HomeRuns Web site can be found at *www.homeruns.com*, as shown in Figure 723.

Figure 723 The home page for the HomeRuns Web site.

You can search for groceries and your home town in an Internet search engine to see if there is an online grocery store near you. The HomeRuns Web site has all the features of your local grocery store right down to the butcher, whom you can ask for a special cut of meat. The HomeRuns Web site will take your order and then a HomeRuns delivery person will bring your groceries to your home. You can give the delivery person coupons and return bottles that the company will credit to your account. You can do all of your grocery shopping on the Web at a price that is comparable to your local grocery store.

724 FINDING A RESTAURANT ONLINE

As you learned in the previous Tip, you can buy your groceries online. If you do not want to cook, you can order take out at *www.food.com*, as shown in Figure 724.

Figure 724 The home page for the Food.com Web site.

In many cities in the United States, you can order your food for delivery or take-out from a restaurant in your local area. The *Food.com* Web site will store information about your eating habits so when you order, the restaurant staff will already know how to prepare your food. The *Food.com* Web site also will let you order your food in advance so you do not have to wait for your order to be cooked. *Food.com* makes ordering in much easier.

BUYING TOYS ONLINE 725

You can avoid the Christmas rush this year in the toy store by buying your children's toys online at eToys, at *www.etoys.com*, as shown in Figure 725.

Figure 725 The home page for the eToys Web site.

1001 Internet Tips

The eToys site will help you make all of your toy purchases and will wrap the toys and ship them for you, too. You can search the eToys site for a toy by price, age group, brand, and so on. You can direct the eToys Web site to store information about birthdays and other events to remind you when you need to shop for a toy. You can do all of your toy shopping at eToys at prices that will make you appreciate not having to drive to toy stores any more.

726 SHOPPING FOR YOUR NEXT CAR ONLINE

The next time you go shopping for a car, you can be better prepared to make a deal by using the Internet to get information on the car you are going to buy. You can use the Internet to find the real dealer cost of a car and not what the dealer tells you the dealer pays. You can also use the Internet to find the value of a car. You can even use the Internet to purchase a car online. When you do research on the Internet about a new car, you can find information that will help you make a great deal on your next new car.

The next several Tips discuss how to use the Internet in various ways to shop for your next new car.

727 FINDING THE VALUE OF YOUR OLD CAR

You can use the Internet to find the current value of the car you are going to use as a trade for a new car. By knowing the fair market value, you can tell if you are getting the full amount on your trade. You can use the Kelly Blue Book Web site to get a suggested value of your car if you use it as a trade-in, as shown in Figure 727.

Figure 727 Using the Kelly Blue Book Web site to find the trade-in value of a car.

1001 Internet Tips

To find the value of your trade-in, go to the Kelly Blue Book Web site at *www.kbb.com* and perform the following steps.

1. From the Kelly Blue Book home page, click your mouse on the Used Car Values Link. The Kelly site, in turn, will display the Used Car Values Web page.
2. Click your mouse on the TRADE-IN link. The Kelly site, in turn, will display the Select a Year Web page.
3. Click your mouse on the year of your car. The Kelly site, in turn, will display the Select a Make Web page.
4. Click your mouse on the make of your car. The Kelly site, in turn, will display the Select a Model Web page.
5. Click your mouse on the Model of your car. The Kelly site, in turn, will display the Options Web page.
6. Click your mouse on each option that your car has and fill in the mileage and your zip code information. You will also need to select the condition of your car. After you have completed all the information, click your mouse on the Submit button. The Kelly site, in turn, will display the Blue Book Trade-In Report.

You now have a value to use as a benchmark for the trade-in you are offered by a dealer for your car. This value may be different than what you are offered by the dealer, but it should give you a starting point for evaluating what you are being offered in trade for your car.

FINDING THE PRICE OF A NEW CAR BEFORE YOU SEE A CAR DEALER — 728

You can also use the Kelly Blue Book Web site to find the price of a new car before you step into the dealer show room, as shown in Figure 728.

Figure 728 The price of a new car as suggested from the manufacturer.

1001 Internet Tips

To find the price of a new car, go to the Kelly Blue Book Web site at *www.kbb.com* and perform the following steps:

1. Click your mouse on the New Car Pricing link. The Kelly site, in turn, will display the Enter Your Zip Code Web page.
2. Enter your Zip Code in the text box and click your mouse on the Continue button. The Kelly site, in turn, will display the Select a Category Web page.
3. Click your mouse on the type of new car or truck that you want. The Kelly site, in turn, will display the Select a Make Web page.
4. Click your mouse on the make of car or truck that you want. The Kelly site, in turn, will display the Make Web page listing the different models for the category that you selected.
5. Click your mouse on the model that you want. The Kelly site, in turn, will display the Model Web page.
6. Click your mouse on the type of model you want, such as a DX or LX model or a two-wheel or four-wheel drive. The Kelly site, in turn, will display the New Car Pricing information for your selection.

You can look at the base price of the new car you want as well as the price of the model with all of the options.

729 LOOKING AT THE SAFETY OF YOUR CAR

You can find information on how well you car will perform if you are involved in an automobile accident. The Crashtest.com Web site provides data about many makes of cars, including data for models going back to the early eighties and seventies, as shown in Figure 729.

Figure 729 The crash test results for different models of Honda cars.

At Crashtest.com, you can see how well your car, or the car that you are going to buy, will protect you in a car crash. Click your mouse on the name of the manufacturer of the car you are interested in reviewing. The Crashtest.com Web site will display information about how well the car performed in crash tests.

Using an Online Loan Calculator 730

One of the most important questions about buying a new car is how much the new car loan is going to cost you each month. You can use an online loan calculator help you determine how much you will need to pay each month for your new car loan. You can use the Snap.com loan calculator, as shown in Figure 730, to calculate a car loan or a car lease if you have all the information from the dealer about your car.

Figure 730 The Snap.com loan/lease calculator.

To display the Snap.com loan/lease calculator, go to the Snap.com home page at *www.snap.com*. Click your mouse on the Autos link on the left hand side of the Web page. The Snap.com Web site, in turn, will display the Snap Autos Web page. Click your mouse on the Loan/Lease Calculator link on the right hand side of the Web page under the Essential Tools section. The Snap.com Web site, in turn, will display the Loan/Lease calculator page. Enter the required and optional information from your dealer and click your mouse on the Loan Only, Lease Only, or Both button. The Snap.com Web site, in turn, will display the monthly payment for your car loan or lease.

Shopping for a Loan Online 731

You can use the Internet to help you find a loan that is right for you and your finances. The LendingTree.com Web site at *www.lendingtree.com*, as shown in Figure 731, will return several loan offers to you after you have filled out a questionnaire about yourself.

1001 Internet Tips

Figure 731 The LendingTree.com Web site home page.

The LendingTree.com Web site will help you look for several different types of loans, including a new or used car loan. You will need to fill out an electronic questionnaire about your personal information, your work, and your finances. The LendingTree site will then send you up to four loan offers within two business days.

732 Looking at the Car Connection Web Site

The Car Connection Web site, as shown in Figure 732, is dedicated to the automobile and has a wealth of information about new cars and trends in the automotive industry.

Figure 732 The Car Connection Web site home page.

If you have a love of cars, you will find many hours of enjoyment at The Car Connection Web site.

733 Using Surplus Auction

You can buy computer equipment, sometimes at a great savings, by placing bids for the equipment at the Surplus Auction Web site at *www.surplusauction.com*, as shown in Figure 733.

Figure 733 The Surplus Auction Web site home page.

The Surplus Auction Web site is now run by Egghead.com but is still found at the Surplus Auction Web address. At Surplus Auction, you can place a bid on an item that is being sold. If your bid wins the auction, the item is yours. There is no set ceiling price for an item. The bidding will start at a set price but the bidding will go as high as someone is willing to pay for the item. The bidding may go over the market value of an item that is for sale or the bidding may be low and you will be able to buy an item for sale that is much below what you would pay for the item in a store. The site, as the name suggests, is an auction and the price of the items being sold is determined by how much the bidders on that day are willing to pay.

734 Setting Up Your Account at Surplus Auction So You Can Bid

To start bidding on Surplus Auction, you will need to set up an account with Surplus Auction. To create your account at Surplus Auction, perform the following steps:

1. Click your mouse on the Sign Up To Bid button on the Surplus Auction Web site home page. The Surplus Auction Web site, in turn, will display the Sign Up to Bid Web page, as shown in Figure 734.

2. Fill in the form with your personal information and click your mouse on the SUBMIT button. The Surplus Auction Web site, in turn, will display the You're ready to bid page.

1001 Internet Tips

You will need to remember your account number and password to place a bid on an item that is being sold.

Figure 734 The Sign Up to Bid Web page at the Surplus Auction Web site.

You should protect your account number and password because if someone were to get your account number and password, they could place bids as if they were you. Now that you have an account number, you can go to the Surplus Auction home page and start bidding on items that you are interested in purchasing.

735 PLACING A BID AT SURPLUS AUCTION

After you are set up with your account, you can start bidding at Surplus Auction. You will need to go to one of the auctions to find something on which you want to bid. You can find items to bid on by clicking your mouse on the links to different products categories. After you find an item you are interested in bidding on, click your mouse on the item to get information about the item. If you are still interested in bidding on the item after reading the information about the item, click your mouse on the Place Your Bid button. The Surplus Auction Web site, in turn, will display the Place Your Bid Web page. On the Place Your Bid page, enter the account number and password you created when you signed up to bid (see Tip 734, "Setting Up Your Account at Surplus Auction So You can Bid") and click your mouse on the Go button. The Surplus Auction Web site, in turn, will display the Place a Bid Web page where you can enter your bid amount, as shown in Figure 735.

The Place a Bid Web page will display the minimum required bid at that point in the auction. If there is more than one item in the auction, you can bid for more than one of the items. Be careful about how high you bid and for how many items you bid because once you click your mouse on the Submit Bid, you may have just purchased the item. Once you enter a bid, you cannot pull the bid back. You can only increase your bid if you are outbid. After you have checked your bid and are ready to submit, click your mouse on the Submit Bid button. The Surplus Auction Web site, in turn, will display the Bid Acknowledgement Web page. You now just need to check your bid from time to time to see if you still have one of the winning bids for the item. If someone else outbids you, you can increase your bid. When the auction closes, if you are still one of the top bidders you will have purchased the item on which you were bidding.

1001 INTERNET TIPS

Figure 735 The Surplus Auction Place a Bid Web page.

CHECKING ON YOUR BID 736

After you have placed your bid, you can easily check on your bid by clicking your mouse on the Your Bid Status button on any of the Surplus Auction Web pages. The Your Bid Status Web page will require that you log in to the page where you will enter your account number and password for the Surplus Auction Web site. After you have entered your account number and password, click your mouse on the Check Bid Status button. The Web site, in turn, will display the status of your bids on current auctions and bids on auctions that have closed in which you placed bids, as shown in Figure 736.

Figure 736 The Bid Status Web page for bids on items at Surplus Auction.

1001 Internet Tips

If one of your bids is bumped, you can click your mouse on the Auction Lot Number link to go to the product page and place a new bid at a higher price if you still want to bid on the item.

737 Looking at the Amazon.com Web Site

A great Web site that you can use for all of your shopping needs is the Amazon.com Web site at *www.amazon.com*, as shown in Figure 737.

Figure 737 The Amazon.com site home page.

The Amazon.com Web site offers everything from books, the first product that the Amazon.com Web site offered, to power tools. The Amazon.com Web site is quickly becoming the department store of the Internet.

738 Looking at an E-Bank on the Web

As the World Wide Web becomes safer to conduct business on, the Web electronic banks are becoming more popular. One Web-based bank is the CompuBank Online bank, as shown in Figure 738.

CompuBank is a full service bank that you access via the Internet. You can transfer money, check on your balances, and view your account history. The CompuBank is regulated by the federal government and is insured by the FDIC. You can use the CompuBank as you would any other bank.

1001 INTERNET TIPS

Figure 738 *The home page for the CompuBank Web site.*

WORKING WITH A TRADITIONAL BANK ONLINE 739

You can also use the Internet to work with your bank account even if your account is with a traditional bank, such as Wells Fargo Bank, as shown in Figure 739.

Figure 739 *The home page for the Wells Fargo Bank Web site.*

You can use your bank's online Web site to do many of the normal things that you would go into a branch bank to complete. With some banks, you can even complete all of your banking online. You can use a traditional bank with a strong online presence to get the feel of using online banking while still having a local branch to use if you need to do business person to person.

740 BUYING STOCK ONLINE

There are many new stock-trading companies on the Internet today. One Web site that you can use to keep track of your stocks is the e-Trade Web site, as shown in Figure 740.

Figure 740 The e-Trade Web site home page.

You can use the e-Trade Web site to research new stocks and view information about the fanancial markets. If you have an account with e-Trade, you can also buy and sell stocks on the many stock markets. The e-Trade Web site is a great example of an investment brokerage house that is online.

741 HEALTH ON THE INTERNET

You can use the Internet to find a world of information about medical news and new treatments. You should, however, be careful about any information that you get from the Internet. While the Internet is full of information,

there are many people spreading bad information. As you use the Internet to find medical information, you should always verify whatever you learn from the Internet. Use the information on the Internet to help you understand more about medicine but your doctor's advice should always be the advice you trust first.

742 LOOKING AT THE ONHEALTH WEB SITE

At the Onhealth Web site, at *www.onhealth.com*, you can find information on many topics about your health and staying healthy. The Onhealth Web site has news stories about health as well as many advice columns, as shown in Figure 742.

Figure 742 The home page for the Onhealth Web site.

The Onhealth Web site has links to information about dieting to migraines to your baby's health. The Onhealth Web site also has a shopping site where you can buy a large variety of health-related products.

743 LOOKING AT THE MEDICINENET WEB SITE

The MedicineNet is a good Web site to visit if you have any questions about your health. You can use the MedicineNet home page, at *www.medicinenet.com*, as a starting point to look up information about many medical topics. The MedicineNet home page has links to reference information about medications, diseases, tests, and much more, as shown in Figure 743.

1001 INTERNET TIPS

Figure 743 The MedicineNet Web site home page.

744 LOOKING AT THE INTELIHEALTH WEB SITE

The InteliHealth Web site is produced in conjunction with Johns Hopkins Health and is a good source of information about health issues. The home page of InteliHealth, shown in Figure 744, can be found on the Web at *www.intelihealth.com*.

Figure 744 The InteliHealth Web site home page.

The InteliHealth Web site also provides a search engine for you to search for information on different medical terms.

GETTING INFORMATION ABOUT YOUR MEDICATIONS 745

You can use the PharmInfo Net Web site, shown in Figure 745, to get information about prescription and over the counter drugs.

Figure 745 The home page for the PharmInfo Net Web site.

If you have questions about a drug that you are taking, you can get reference information about the drugs at the PharmInfo Net Web site. The PharmInfo Net Web site has links to articles written about different drugs as well as Press Release information given by companies when a new drug is released.

LOOKING AT THE MSNBC WEB SITE 746

The MSNBC Web site, shown in Figure 746, is a Web-based news show that you can use to view the top stories of the day.

As the name suggests, the MSNBC Web site is a combined effort of Microsoft and the NBC television network. When you first go to the MSNBC Web site, you may be asked to enter your zip code and up to three stock ticker symbols so that your MSNBC home page will be personalized to you. After your zip code, you will see your local weather and news as well as the national headlines. The MSNBC is a Web site that will help keep you informed.

1001 Internet Tips

Figure 746 *The home page for the MSNBC Web site.*

747 LOOKING AT USA TODAY ON THE WEB

If you like the USA Today newspaper, then you will enjoy being able to read USA Today in your Web browser, as shown in Figure 747.

Figure 747 *The USA Today Web site home page.*

You can find USA Today on the Web at *www.usatoday.com*. The USA Today Web site has many of the main stories that you see in the newsprint version of the paper. You can get a quick update on the top stories of the day for both the nation and the world by visiting the USA Today Web site.

READING BUSINESS WEEK ON THE WEB — 748

If you are looking for business news, then the Business Week magazine Web site, shown in Figure 748, has the day's big business news.

Figure 748 The home page for the Business Week Web site.

You will find the Business Week Web site at *www.businessweek.com*. The sections of the Business Week Web site that are marked with a red BW symbol can only be viewed if you subscribe to the Business Week Web site. If you already subscribe to the Business Week magazine, then it is free for you to subscribe to the Business Week Web site. If you do not subscribe to Business Week magazine, then you can subscribe to the magazine and get your free access to the Web site. To subscribe to the Business Week magazine and the Web site, or if you already get the magazine and just need to subscribe to the Web site, click your mouse on the Subscribe Now link at the top of the Business Week home page.

READING THE WALL STREET JOURNAL ON THE WEB — 749

The Wall Street Journal has been standard reading for the business and investing world for decades. You can now read the Wall Street Journal on the Web, as shown in Figure 749, as well as have the paper delivered to your work or home.

1001 INTERNET TIPS

Figure 749 *The Front Section Web page of the subscriber's area of the Wall Street Journal on the Web.*

The Wall Street Journal Interactive Edition, as the Web site is called, is a subscription service. You must pay to have access to the content of the Wall Street Journal Web site. If you subscribe to the Wall Street Journal Web site, you will receive the latest business news. If you are already a subscriber to the Wall Street Journal paper, then you can get a discount for the Wall Street Journal Web site but your access to the site will still cost you a fee.

750 LOOKING AT THE ABC NEWS WEB SITE

The ABC News Web site is a good source for late breaking news. The home page of the ABC News Web page, shown in Figure 750, has links to many late breaking news stories.

Figure 750 *The home page to the ABC News Web site.*

You can keep up on all the news at the ABC News Web site at *www.abcnews.go.com*. When you use the ABC News Web site, you can stay on top of events in the world around you.

LOOKING AT THE CNN WEB SITE 751

The CNN Web site, as shown in Figure 751, is devoted to the constant flow of up-to-date news information in much the same manner as the CNN cable channel.

Figure 751 The CNN Web site home page.

You can view the CNN Web site at *www.cnn.com*. At the CNN Web site, you will find the headline news stories that you would see on the CNN cable channel. The CNN news channel also gives links to news stories to get more in-depth information. You can keep up on the latest news of the day from CNN from your desktop by using the CNN Web site.

LOOKING AT THE ESPN WEB SITE 752

If you want to get your sports information online, then the ESPN Web site, as shown in Figure 752, is the place that you should direct your browser.

The ESPN Web site, at *www.espn.go.com*, has all the information you could ever need on your favorite teams or your favorite sport. You can view team line-ups, team standings, score reports, and information about many other sports besides the big team sports. You can find everything from golf results to the Winston Cup standings.

1001 Internet Tips

Figure 752 The ESPN Web site home page.

753 CHECKING THE WEATHER ON THE WEB

You can get the weather forecast for your local area or the places to which you are traveling any time of the day by going to the Weather Channel Web site, as shown in Figure 753.

Figure 753 The Weather Channel Web site home page.

To find the local weather in the United States, enter the zip code for the area in which you are interested into the Local Weather section and click your mouse on the go! button. The Weather Channel Web site, in turn, will display the current weather for your location as well as the five-day forecast. You can also enter the city name for which you want the local weather but you may need to choose from a list of cities that have the same name before you can get the forecast. You can also use the Weather Channel Web site to get national weather maps and traveler's reports.

754 LOOKING AT THE WHITEHOUSE WEB SITE

The Whitehouse maintains a Web site on the Internet at *www.whitehouse.gov*, as shown in Figure 754.

Figure 754 The home page for the Whitehouse Web site.

You should note that the Web address for the Whitehouse ends in .gov and not .com. The Whitehouse Web site has the text of speeches and proclamations that the President has made. The Whitehouse Web site is a great starting point for almost any search for information that is available through the government. You can also take a virtual tour of the Whitehouse where you can see pictures of different rooms in the Whitehouse.

755 USING THE INTERACTIVE CITIZENS' HANDBOOK

In addition to the Whitehouse Website, the Interactive Citizens' Handbook provides information regarding the federal government, as shown in Figure 755.

You get to the Interactive Citizens' Handbook by going to the Whitehouse Web sites (see Tip 754). Scroll down the Web page and click your mouse on the Interactive Citizens' Handbook link. The Interactive Citizens' Handbook has links to many different Web sites that you can use to get information about the United States government, as well

1001 INTERNET TIPS

as links to government search engines and to various government agencies. The Handbook Web page also has links to the different branches of the government.

Figure 755 The Interactive Citizens' Handbook Web page from the Whitehouse Web site.

756 LOOKING AT THE THOMAS WEB SITE

The Thomas Web site, as shown in Figure 756, is a service provided by the Library of Congress to provide information to the public about current and past legislation in the United States Congress.

Figure 756 The home page for the Library of Congress Thomas Web site.

The Thomas Web site is at the Web address of *www.Thomas.loc.gov*. At the Thomas Web site, you can obtain text, summaries, and the status of current legislation before Congress. You can also find information about the different Congressional committees and their schedules or use the Thomas Web site to view the Congressional Record.

FINDING LEGISLATION BY WORD OR PHRASE ON THE THOMAS WEB SITE — 757

You can use the Thomas Web site to search the current Congress for legislation by using a search word or phrase. To make a search of the Thomas Web site for legislation by a word or phrase, perform the following steps:

1. Go to the Thomas home page (see Tip 756) and enter your search word or phrase in the By Word/Phrase text box at the top of the Web page. Next, click your mouse on the Search button. The Thomas site, in turn, will display the search results Web page, as shown in Figure 757.

Figure 757 The search results Web page from a search of the Thomas Web site for a bill before Congress.

2. Click your mouse on the Bill number link next to the description of the bill in which you are interested. The Thomas Web site, in turn, will display the Bill Table of Contents Web page.
3. In the Bill Table of Contents Web page, you can click your mouse on any of the section headings to view the text of the bill in that section.

The Table of contents Web page also has links to references to a bill in the Congressional Record and the Committee Reports on the bill. There is also a link to a summary and status of a bill. If you want to read the full text of a bill, you can have the full text displayed by clicking your mouse on the Full Display link or have the PDF file (see Tip 210, "Working with PDF Files"), downloaded to your computer. You may need to look at several different bills from the search results page to find the exact bill for which you are looking.

1001 INTERNET TIPS

758 — FINDING LEGISLATION BY BILL NUMBER ON THE THOMAS WEB SITE

You can use the number of a bill to search the Thomas Web site for its text and status by performing the following steps:

1. Go to the Thomas home page (see Tip 756, "Looking at the Thomas Web Site") and enter the number of the bill in the By Bill Number text box at the top of the Web page. Next, click your mouse on the Search button. The Thomas site, in turn, will display the Bill Table of Contents Web page, as shown in Figure 758.

Figure 758 The Bill Table of Contents Web page for a bill before Congress on the Thomas Web site.

2. On the Bill Table of Contents Web page, you can click your mouse on any of the section headings to view the text of the bill in that section. The Bill Table of Contents Web page also has links to references to the bill in the Congressional Record and the Committee Reports on the bill.

You can also get the full text of the bill in PDF format or as plain text in your Web browser. If you are given a bill number or the number of a bill is referenced, you can use the number of the bill to take you straight to the Bill Table of Contents page on the Thomas Web site.

759 — LOOKING AT THE MOST RECENT ISSUE OF THE CONGRESSIONAL RECORD

The Congressional Record is the record of the activities of Congress. To review the most recent issue of the Congressional Record, click your mouse on the Most Recent Issue link under the Congressional Record heading on the Thomas home page. The Thomas Web site, in turn, will display the different days that the most recent issue of the Congressional Record covers, as shown in Figure 759.

You can click your mouse on any of the links to see information on the different daily activities of the House of Representatives or the Senate.

Figure 759 A most recent issue of the Congressional Record Web page.

LOOKING AT THE VOTING RECORD FOR ROLL CALL VOTES ON LEGISLATION 760

To view the results of roll call votes in either the House of Representatives or in the Senate, click your mouse on the House link or the Senate link under the Roll Call Votes section on the home page of the Thomas Web site. Your Web browser, in turn, will display a Web page listing the different sessions of Congress for either the House of Representatives or the Senate, depending on which link you clicked your mouse. Next, click your mouse on the session of Congress in which you are interested. Your browser, in turn, will display the Roll Call Votes Web page for the House, as shown in Figure 760, or the Senate, again depending on which link you clicked your mouse on the Thomas home page.

You can then click your mouse on the Roll number to see the voting record on the bill for the different members of Congress.

Figure 760 The U.S. House of Representatives Roll Call Votes Web page.

1001 Internet Tips

761 Looking at the House of Representatives Web Site

You can find information about the House of Representatives by going to the House of Representatives Web site, as shown in Figure 761.

Figure 761 *The home page of the House of Representative's Web site.*

The Web address for the House of Representatives is *www.house.gov*. You can use the House Web site to find information about the different Congressional Committees, as well as the different leadership offices of the House. The House Web site also has a listing of the members of the House of Representatives.

762 Looking at the Senate Web Site

You can find information about the United States Senate by going to the Senate Web site at *www.senate.gov*, as shown in Figure 762.

You use the Senate Web site to find information about the different Senate committees, as well as a schedule for Senate Committee hearings. The Senate Web site also has information about the different leadership offices of the Senate and information about the manner in which the Senate operates.

Figure 762 The home page for the United States Senate Web site.

FINDING THE HOME PAGE OF A MEMBER OF CONGRESS 763

You can easily find the home page of a member of Congress by going to the home page for the division of Congress the person is a member of and using the members' directory. To find the Web page of a member of the House of Representatives, perform the following steps:

1. Go to the home page for the House of Representatives (see Tip 761, "Looking at the House of Representatives Web Site") and click your mouse on the House Directory link. The House Web site, in turn, will display the Member and Committee Information Web page.
2. Scroll down to the U.S. House of Representatives Links section and click your mouse on the Members Web Page. The House Web site will display the U.S. House of Representatives Member Office Web Services Web page, as shown in Figure 763.1.
3. Click your mouse on the name of the member of the House whose Web page you wish to view. The House Web site, in turn, will display the Web page of the member of the House whose name on which you clicked your mouse. You can also search for members' Web pages by state if you do not know the name of the representatives for a given state.

1001 Internet Tips

Figure 763.1 The U.S. House of Representatives Member Office Web Services Web page.

To find the Web page of a member of the Senate, perform the following steps:

1. Go to the home page for the Senate (see Tip 762, "Looking at the Senate Web Site") and click your mouse on the drop-down list in the Connect with your senators section to select the state of the Senator in whom you are interested. After you have selected the state, click your mouse on the Go button. The Senate Web site, in turn, will display the senators for your state, as shown in Figure 763.2.

Figure 763.2 The Senate home page after a search for the senators from a state.

2. Click your mouse on the name of the senator in whom you are interested. The Senate Web site, in turn, will display the Web page for the senator on whose name you clicked your mouse.

You can then use the Congress member's Web page to view any information that the member of Congress presents and also how to contact the member of Congress.

LOOKING AT A SUPREME COURT WEB SITE 764

The Legal Information Institute Supreme Court Collection Web site, as shown in Figure 764, is hosted by Cornell University.

Figure 764 The Legal Information Institute's Supreme Court Collection Web site.

You can use the Supreme Court Collection Web site to find information about recent Supreme Court decisions as well as important historic decisions. The Supreme Court Web site also contains a list of orders in pending cases. You can use the Supreme Court Collection Web site as a starting point for any search of Supreme Court activity.

LOOKING AT STATE AND LOCAL GOVERNMENTS ON THE WEB 765

You can find many state and local governments on the Web. The easiest way to find the Web address for your local or state government is to contact your local city hall or Secretary of State's office and ask for the Web address. You can also use a Web search engine to search for the name of your local town or your state name to find the Web page for the government. A third method that may work is to type the name of the state or local government for which you are looking. A good example is the Reno, Nevada, Web site, as shown in Figure 765, which is at the Web address *www.reno.gov*.

A fourth method for finding a state government's Web site is using the State Search Web page of the National Association of State information Resource Executives, at the Web address *www.nasire.org/stateSearch/*. You will find that your state or local government's Web site offers a wealth of information to you.

1001 Internet Tips

Figure 765 The City of Reno, Nevada, Web site home page.

766 LOOKING AT THE NASA WEB SITE

The NASA Web site, as shown in Figure 766, at the Web address of *www.nasa.gov*, is the site to visit if you are fascinated by the stars.

Figure 766 The NASA Web site home page.

You can find information about many of the NASA missions, including pictures taken by different space probes and the Hubble Space Telescope. The NASA site is also a helpful education tool for children at the NASA for Kids Web page at *www.nasa.gov/kids.html*. The NASA site is full of interesting Web pages about space and the human exploration of space.

Note: *This is a government Web site so the Web address ends in .gov, not .com. The **www.nasa.com** Web address is NOT the NASA Web site.*

767 LOOKING AT THE DEPARTMENT OF EDUCATION WEB SITE

You can use the Department of Education's Web site, as shown in Figure 767, to find information about many topics dealing with the educational system in the United States.

Figure 767 The United States Department of Education Web site home page.

The Web address for the Department of Education is *www.ed.gov*. The Department of Education Web site is an excellent place to find information about the strengths and problem areas in the educational system in the United States. You can also find information to help parents improve their child's education. The Department of Education has a wealth of information about financial aid for families planning for ways to pay for a college education.

768 LOOKING AT THE FEDWORLD WEB SITE

You can use the FedWorld Web site, as shown in Figure 768, as a central point of access to information about and from the Federal Government.

1001 Internet Tips

Figure 768 The FedWorld Web site home page.

The Web address for the FedWorld Web site is *www.fedworld.gov*. The FedWorld serves as a repository of information, a search engine for Web sites of the federal government, and links to other government Web sites. At the FedWorld Web site, you can find and download information that you need from the Federal Government for both your personal use and for business use.

769 UNDERSTANDING SHAREWARE

You can download many types of software from the Internet to your computer. One type of software that you can download from the Internet is shareware. Shareware does not refer to what the program does or what operating system that the program runs on, but refers to whether and when you pay for the program after it is downloaded. If you download shareware, you can use the software for a trial time period after which you should send money to the program creator to continue to use the program. The idea behind shareware is that you can try the program before you buy the program. If you do not find the program useful, then you can delete the program off of your system and not pay for the program. If you want to continue to use the program, then you should pay for the program. Some of the shareware programs will stop working after a specified period of time or will place a message in the program reminding you to register and pay for your program. Some of the shareware is created on the honor system where there is a time period that you can test the program and you are trusted to either delete the program at the end of the trial time period or pay for the program if you are going to continue to use it.

770 UNDERSTANDING FREEWARE

Freeware, as the name suggests, is free programs. You do not have to pay for freeware after you download a program and start to use it. While you may believe that you get what you pay for, there are many very good freeware programs

that you can download from the Internet. Freeware programs are available for many reasons. Some individuals just want to be helpful and offer the program to anyone that wants to use the program. Others offer programs as freeware because they do not want to support the program, as would be expected if the program were purchased. Most freeware is offered as is, meaning that you are not entitled to any support for the program. While you may find users in news groups that may help you with a freeware program, no one is obligated to help you because you purchased the program from them. Many freeware programs are useful and at the price you usually cannot go wrong.

GOING TO SHAREWARE.COM FOR SOFTWARE 771

You can find a staggering number of programs to download at the Shareware.com Web site, as shown in Figure 771.

Figure 771 The home page for the Shareware.com Web site.

The Web address of the Shareware.com Web site is *www.shareware.cnet.com*. You can use the search engine at the Shareware.com Web site or you can browse categories of software, such as business applications or games. You can find almost any type of program at the Shareware.com Web site.

GOING TO THE DOWNLOAD.COM WEB SITE 772

The Download.com Web site, as shown Figure 772, is the sister site to the Shareware.com Web site.

The Web address of the Download.com Web site is *www.download.cnet.com*. The Download.com Web site has some of the same programs as the Shareware.com Web site but also has many freeware programs as well. You will find a similar set of available downloads at the Download.com Web site as the Shareware.com Web site. You can browse the Download.com Web site by the type of program that you are planning to download. The Downlaod.com Web site has a vast number of programs to be downloaded.

1001 Internet Tips

Figure 772 *The Download.com Web site home page.*

773 LOOKING AT THE TUCOWS.COM WEB SITE

The Tucows Web site, as shown in Figure 773, is a shareware and freeware download site that has programs of almost every type.

Figure 773 *The Tucows Web site home page.*

The Web address for the Tucows Web site is *www.tucows.com*. The Tucows Web site has many copies of the Web site in different locations around the globe. You will get better download speeds if you click your mouse on the region

of the world that you are in and pick a copy, or mirror, of the Tucows Web site that is closest to your location. The Tucows Web site is ordered by the type of operating system that you are using. Thus, if you are using the Windows 98 operating system, you would click your mouse on the Windows 98 link. After you are in the section of the Tucows Web site that is for your operating system, you can browse the programs that you can download from the Tucows Web site by the type of program that you need. The Tucows Web site is one of the largest collection of shareware and freeware programs that you can use to download programs.

Finding Other Download Sites 774

Many other sites exist on the Internet from which you can download shareware and freeware programs. One place that you should look to download programs from is your Internet Service Provider (ISP). Many ISPs have their own shareware and freeware download Web site. You can contact your IPS to ask if the ISP has a Web site where you can download programs and get the Internet address. You can also download programs from many different FTP sites on the Internet. The FTP sites are not as easy to use as the Web-based download sites, but they also have large collections of programs that can be downloaded. You can also search for program names to find download sites for a specific program.

Understanding the Java Platform 775

The Java platform is a technology that is being developed by Sun Microsystems. The Java platform is a programming language and a computer environment in which Java programs can be run. The goal of Sun in making Java is to provide an environment where the same program can be run regardless of the computer hardware that is running the Java program. Traditional programs need to be recreated for different types of computer equipment so that a program that is created for the Macintosh operating system cannot be run on a Windows operating system computer. By making a program that can run on any computer equipment, you will only need to create your program once and then anyone can run the program on his or her system even if that system is different from the computer system on which you created your program. To let a Java program run, you need to have a Java environment on your computer. Most browsers now have a Java environment built into the browser. The two browsers discussed in this book have Java environments built into the browser. With the Java environment on your system, you can run any Java program. The Java environment must be created for each computer system but after the environment is created, any Java program can run in that environment. The Java platform is a program environment that is independent of the computer system on which the Java program is running.

Understanding Applets 776

An applet is a program that is executed inside another program. Java programs often take the form of an applet and not a full application. Java applets are executed in a Java environment, as discussed in Tip 775, and not on a specific computer operating system. The Java environment that executes Java applets is called the Java Virtual Machine. Your browser, if it is a current version of your browser, has a Java Virtual Machine built in to the browser. You will most

likely encounter Java applets as programs that are downloaded to your computer and then run in the Java Virtual Machine in your Web browser.

777 UNDERSTANDING JAVASCRIPT

You may have seen Web pages that change, depending on what actions you take when viewing the Web page. Almost all Web pages created now fall into this category. Such a Web page can take the form of search pages, order form pages, calculator Web pages, and so on, where the Web page has different content based on some action you took when you viewed the Web page. You can create active pages by using special programs that run on a Web server, by using special programs that run in a Web browser (a Java applet, for example), or by using a script in a Web page.

A script language is a program language that is interpreted by your Web browser into a program that a computer can run at the time the browser downloads the script. All current Web browsers have script interpreters built into the browser, in a similar manner to the Java Virtual Machines discussed in Tip 776. One script language that you can use is the JavaScript language. The JavaScript language was created by Netscape to let Web page developers create Web pages that would process information that you enter into a Web page on your computer by your browser. If your Web browser processes information that you enter into a Web page, instead of having the Web server process all information that you enter into a Web page, you will get a much quicker response because your computer is usually not as busy as a Web server. You can use JavaScript to create Web pages that can take user input and then process the user input. Microsoft also has a proprietary script language, similar to JavaScript, that is called Jscript.

778 LEARNING TO WRITE JAVASCRIPT

You can use the Web to help you learn to write JavaScript. CNET maintains a Web site called JavaScript for Beginners, as shown in Figure 778.

Figure 778 The JavaScript for Beginners Web page.

You can find JavaScript for Beginners at the Web address *www.builder.com/Programming/Javascript/* where you can start learning about JavaScript. The JavaScript for Beginners is a tutorial that steps you through the creation of a Web page form that is created using JavaScript.

LEARNING TO WRITE JAVA PROGRAMS AND APPLETS — 779

You can start learning how to write Java programs and applets by going to the Java Tutorial Web site, shown in Figure 779, which is maintained by Sun Microsystems.

Figure 779 The Sun Microsystems Java Tutorial Web page.

The Web address for the Java Tutorial is *http://java.sun.com/docs/books/tutorial/index.html*. The Java Tutorial will step you through the creation of both Java applets and Java applications. Before you can use the Java Tutorial, you will need to download the Java Software Development Kit at the Web address of *http://java.sun.com/products/jdk/1.2/*. The Java Software Development Kit is a free download from Sun. After you have the Java Software Development Kit, you can start using the Java Tutorial to learn about writing Java code.

LOOKING AT THE JAVASCRIPT PLANET WEB SITE — 780

A good resource for JavaScript on the Web that you can use is the JavaScript Planet Web site, shown in Figure 780, at the Web address *www.js-planet.com*.

The JavaScript Planet Web site has hundreds of Java scripts that you can look at and download to help you better understand how to use JavaScript in your Web pages. The JavaScript Planet Web site also has JavaScript tutorials to help teach you how to use JavaScript to create interactive Web pages.

1001 INTERNET TIPS

Figure 780 *The JavaScript Planet Web site home page.*

781 LOOKING AT THE JAVASCRIPT SOURCE WEB SITE

You can use the JavaScript Source Web site, as shown in Figure 781, to help you create Web pages with JavaScript.

Figure 781 *The home page for the JavaScript Source Web site.*

The JavaScript Source Web site is at the Web address *http://javascript.internet.com*. The JavaScript Source Web site has many JavaScript examples that you can copy into your Web pages for free. You not only can use the JavaScripts in your Web pages but you can also use the examples to see what can be done with a JavaScript to help you create your own JavaScripts. The JavaScript Source Web site also has a help forum that you can use to get help from other JavaScript users. The JavaScript Source Web site is an excellent source of information for the experienced and beginner JavaScript user.

LOOKING AT THE DOC JAVASCRIPT WEB SITE 782

When you visit the Doc JavaScript Web site, shown in Figure 782, you will get a daily tip on creating JavaScript for your Web pages.

Figure 782 The Doc JavaScript Web site home page.

The Doc JavaScript Web site is a helpful resource for JavaScript writers. In addition to the daily tip on JavaScript, the Doc JavaScript Web site has many articles about methods of writing JavaScript and types of JavaScripts that you can produce. The Web address for the Doc JavaScript Web site is *http://www.docjs.com*. You can visit the Doc JavaScript Web site on a daily basis and get some new information to use every time.

LOOKING AT THE JAVA WORLD WEB SITE 783

You can use the Java World Web site, shown in Figure 783, to stay up to date on the latest Java news and find many Java programming resources.

Figure 783 The Java World Web site home page.

The Java World Web site is at the Web address *http://www.javaworld.com*. The Java World Web site is not only a news source for Java but also has many articles on how to use the latest developments in the Java programming language. You will also find many Java tips and tricks at the Java World Web site. You can find a large amount of information to help you with your Java projects.

784 LOOKING AT THE JAVA CENTRE WEB SITE

You can use the Java Centre Web site, shown in Figure 784, as a resource to help you find ready-made Java applets that you can use in your Web pages.

Figure 784 The Java Centre Web site home page.

The Java Centre Web site is at the Web address *http://www.java.co.uk*. The Java Centre Web site has a large listing of applets that you can download in the Javarama Gallery. The Java Centre Web site also has a discussion list that you can use to talk to other Java developers as well as other good Java resources. You will find a lot of help for your Java project at the Java Centre Web site.

Understanding the Common Gateway Interface — 785

The Common Gateway Interface (CGI) is a standard for having a Web server exchange information and Web content with other programs. One of the first uses of the CGI standard was to have a database store and retrieve information that is displayed in a Web page. The exchanging of information between a Web page and a database is still one of the most common uses of the CGI standard. CGI is a standard and not a programming language with which you would create Web applications. You can create a CGI program in many different programming languages, such as the C/C++ programming language. You can also create CGI scripts using many different scripting languages, such as the Perl script language. You can use the CGI standard to develop a connection between your Web server and another program.

Looking at the CGI101.com Web Site — 786

You can use the CGI101.com Web site, shown in Figure 786, as a resource for you to learn more about using CGI in your Web site.

Figure 786 The CGI101.com Web site home page.

The CGI101.com Web site is at the Web address *http://www.cgi101.com*. You will find a tutorial on CGI, as well as many other resources dealing with CGI, at the CGI101.com Web site. The CGI101.com Web site has sample scripts that you can use as examples in the creation of your own CGI scripts and applications. You can also find

many links to other CGI resources on the Internet on how to create CGI scripts and applications. The CGI101.com Web site is a good starting point for you to learn about CGI.

787 LOOKING AT THE CGI RESOURCE WEB SITE

An excellent resource that you can use to learn about the CGI standard is the CGI Resource Web site, shown in Figure 787.

Figure 787 The CGI Resource Web site home page.

The Web address of the CGI Resource Web site is *http://www.cgi-resources.com*. You will find a large repository of CGI scripts and programs written in many different programming and script languages. The CGI-Resources Web site also has a documentation section that is useful to beginners and experts alike. You will also find links to books and articles about CGI and about using CGI in Web sites. The CGI Resource Web site is a beneficial resource for any user of the CGI standard.

788 UNDERSTANDING SERVER SIDE INCLUDES

You can use a server side include to include the output of a program, script, or a different file in a Web page. The server side include is helpful in including a file that has text that you want to have displayed on every Web page in your Web site, such as a copyright notice in a page footer. You can also use the server side include to have the output of a program or script be added to a Web page before the Web page is sent to the client browser. Server side includes are useful in letting you have repetitive text and program and script output added to Web pages before the Web page is sent to the client browser.

789 Understanding VBScript

You can use VBScript in your Web pages to make the Web pages change based on actions taken by the user viewing the Web page. When you add a script to a Web page, you are making your Web pages interactive with the user viewing the Web page. The Web browser of the client must have a VBScript interpreter in order for the VBScript in your Web pages to work. The Microsoft Internet Explorer Web browser has a VBScript interpreter but many Web browsers do not yet have VBScript interpreters. As a Web developer, you may provide a non-VBScript Web page to users that may view your Web pages with a Web browser that cannot use VBScript. The VBScript language was developed by Microsoft and is a subset of the Microsoft Visual Basic. If you have learned the Basic programming language, you will be able to pick up and use VBScript very quickly. If you are not familiar with the Basic programming language, you will still find the VBScript an intuitive and easy scripting language to learn. You can quickly learn the VBScript language to help you make dynamic Web pages and to create Web-based applications.

790 Looking at the Microsoft VBScript Web Page

You can use the Microsoft VBScript Web page, shown in Figure 790, to get information about VBScript, or to find a VBScript tutorial, samples, and other downloads.

Figure 790 The Microsoft VBScript Web page at the Microsoft Developer Network Web site.

The Web address for the VBScript overview Web page is *http://msdn.microsoft.com/scripting/vbscript/default.htm*. You can use the Documentation link on the right hand side of the Web page to learn more about the VBScript language. The VBScript Web page also has a link to samples where you can study examples of working VBScripts to help you better understand the VBScripting environment.

791 Understanding ActiveX

ActiveX is a term that Microsoft uses for a related group of technologies and programming methodologies. An ActiveX type program uses an object model to let one program interact with a second program. The ActiveX technology is used to support Microsoft's Component Object Model (COM) of programming. When you create an ActiveX COM object, you are creating a program that is used by other programs to perform some function. The COM object that you create using the ActiveX technologies is called an ActiveX control. You can write ActiveX controls in many different programming languages, such as C++, Visual Basic, PowerBuilder, and in scripting languages such as VBScript. You can create ActiveX controls in your Web pages that will interact with a user's browser. The ActiveX technology is becoming a fundamental part of Microsoft's software design philosophy. You can make use of ActiveX to enhance your Web pages.

792 Understanding Active Server Pages

Active Server Pages are a Microsoft technology that supports the creation of dynamic Web pages. You can create a Web page as an Active Server Page by using a scripting language, like Visual Basic. While Active Server Pages are a Microsoft technology, you can use the Active Server Page technology on platforms other than Windows and Microsoft Internet Information Servers. There are many Web sites on the Web that are devoted to Active Server Page development, such as the ASP Zone Web site, as shown in figure 792, at the Web address *http://www.asp-zone.com*.

Figure 792 The ASP Zone Web site home page.

You can use the Active Server Page technology to create Web applications where your Web pages interact with other programs, such as databases.

UNDERSTANDING PERL 793

Perl is a programming language that you can use to create Web applications and CGI scripts. The Perl language has as its origins the C language and a number of Unix utilities. You can use the Perl language to manipulate text documents, do system management tasks, access databases, and create Web applications. You can use the Perl Web site, shown in Figure 793, at *http://www.perl.com*, to help you develop Perl programs.

Figure 793 The Perl Web site home page.

The Perl programming language is becoming one of the most popular languages for writing CGI programs and other Web programs.

LOOKING AT THE NATIONAL CENTER FOR SUPERCOMPUTING APPLICATIONS PERL TUTORIAL 794

You can use the National Center for Supercomputing Applications (NCSA) Perl Tutorial Web site, shown in Figure 794, to learn how to write Perl programs.

The Web address for the tutorial is *http://www.ncsa.uiuc.edu/General/Training/PerlIntro/*. The NCSA Web site will help you learn how to create basic Perl programs. You should have some basic programming experience before you

use the Perl tutorial. After you have learned how to write Perl programs, you can use Perl to create Web applications that interact with databases, text files, and so on.

Figure 794 The Perl Tutorial Web site hosted by the National Center for Supercomputing Applications.

795 UNDERSTANDING PYTHON

Python is a programming language that you can use to create Web applications. You can learn more about Python by going to the Python Web site, as shown in Figure 795, at *http://www.python.org*.

Figure 795 The home page for the Python Web site.

The Python language is a fairly recent programming language and is gaining popularity with many Web programmers. The Python language is powerful language and is flexible to use. You can use the Python language on many different computer operating systems, such as Windows, Unix, Macintosh, and so on. The Python language is useful in creating CGI Web applications.

LOOKING AT A PYTHON TUTORIAL 796

You can use a Web-based Python tutorial, as shown in Figure 796, to help you learn how to program in the Python language.

Figure 796 A Web-based Python programming tutorial.

The Web address for the Python Tutorial is *http://www.lut.fi/man/python/python-tut/tut.html*. You can use the tutorial to learn the Python languages to develop Web-based applications. The tutorial will take you through basic python programming to more advanced Python programming topics.

UNDERSTANDING PUSH TECHNOLOGIES 797

Push technologies differ from the standard information retrieval you are used to on the Internet in that push technologies push data to your browsers. You are probably familiar with browsing Internet locations and retrieving information you are interested in by using a common tool like a Web browser. Push technologies deliver data automatically to the user and once set up, you need only to view the information.

One of the most common and popular push services is PointCast *http://www.pointcast.com*. See Tip 525 for a discussion and description of PointCast.

798 Understanding HyperText Markup Language (HTML)

You will use HyperText Markup Language (HTML) to create Web pages. HTML is a scripting language that describes how text should be formatted in a Web page. HTML is also used to place graphics and other objects, such as forms, tables, and so on, into a Web page in a formatted manner. The great strength of HTML is that HTML is a scripting language that is totally independent of the computer in which the HTML Web page is going to be displayed. HTML started out as a method for scientists to be able to share research information but quickly grew to be the primary method of placing information on the Internet. The language of the World Wide Web is HTML. You can view HTML by clicking your mouse on the View menu item in your Internet Explorer browser and selecting the Source menu item. Internet Explorer, in turn, will display the HTML source of the Web page that you are viewing. All Web pages are created using HTML.

799 Understanding Dynamic HyperText Markup Language (DHTML)

You can use Dynamic HyperText Markup Language (DHTML) to create Web pages that change when users interact with the Web page. The Web page is dynamic or changing its content based on actions from the user or programmed behavior from the Web page developer. DHTML is not a language but a combination of Web technologies. You would use HTML and scripting as well as extensions to the HTML language to create DHTML Web pages. Microsoft is advocating DHTML as the next big technology on the Internet and Netscape is working with DHTML as well. Dynamic Web pages will be more common on the Web as the technologies that make up DHTML develop.

800 Understanding Extensible Markup Language (XML)

You use a markup language to describe how information should look when the information is displayed or how information should be handled when the information is exchanged between different systems. HTML (see Tip 798) is a markup language that has a set of descriptions that you can use to describe how a document should be displayed in a Web browser. Extensible Markup Language (XML) is like HTML in that XML is used to describe how information should be displayed but XML does not have a single set of descriptions that you are limited to. You can customize the XML markup language to fit your needs, hence the extensible part of the name XML. If you have a special way that information needs to be displayed on your Web pages, you can use XML to describe your documents in a customized manner that you would not easily be able to do with just the HTML language. XML is a method for presenting information on the Internet or of exchanging electronic information.

Using the Windows Internet Naming Service (WINS) — 801

A term that you might hear floating around your office is the term WINS, an acronym for Windows Internet Naming Service. As you have learned, computers that communicate on a network by using the TCP/IP suite of protocols each require a unique TCP/IP (IP) address. On a TCP/IP network, when a user specifies a domain name like *www.microsoft.com*, programs will use a Domain Name Service or DNS server to resolve or match the domain name to an IP address. In a similar way, if your network runs the NetBIOS protocol on top of TCP/IP, your network may use a similar naming service to resolve NetBIOS computer names to a corresponding TCP/IP address. See Tip 802, "Understanding NetBIOS," for a discussion of NetBIOS computer names.

In general, WINS software is a service that runs on a Windows NT server that resolves a NetBIOS computer name into an IP address. Most users will not have to worry about the WINS software. Instead, the network administrator will configure the WINS settings on both the WINS server and on the client computers that will use the WINS server. Users can then access other computers on the network by referring to the computer's NetBIOS computer name. Users will also be able to run applications written to use the NetBIOS interface specification.

Understanding NetBIOS — 802

NetBIOS is a standard interface that client server applications use to communicate over a network. Simply put, NetBIOS is one of the methods that applications can use to communicate over a network when part of the application runs on the client computer and part of the application runs on the server computer. More technically, the NetBIOS interface is a standard application programming interface (API) for client/server applications to submit network input/output and control directives to lower level network protocol software. NetBIOS is a networking term that you might hear in conversations about LANs, WANs, and the Internet.

As discussed in Tip 801, "Using the Windows Internet Naming Service," and expanded upon in Tip 803, "What Are NetBIOS Computer Names?," NetBIOS is the protocol responsible for network name registration and network session management, among other things. For you as a user of a network, quite simply, NetBIOS lets you access network computers, services, and applications using friendly names instead of more complicated unique identifiers.

What Are NetBIOS Computer Names? — 803

When you install Windows 98, you must name your computer with a unique 15-character computer name. That means your computer name cannot be the same as any other computer on your network. If you are working on a home computer and just dialing into an Internet Service provider to connect to the Internet, you stand very little chance of having a problem with duplicating a computer name because you will not be using NetBIOS application much, if at all. NetBIOS computer names really come into play when your computer is connected to your company's network.

1001 Internet Tips

As you have learned, one of the roles of the NetBIOS protocol is to uniquely identify computers and services on a network. If you have ever installed a Microsoft Windows operating system onto a computer, you may remember that the setup program prompted you for a unique computer name for that machine. That unique computer name is called a NetBIOS computer name. A NetBIOS name is a unique 16-byte identifier used to name any NetBIOS resource on a network, one such type of resource being a computer. The term 16-byte means 16 characters, 15 characters of which are used for the computer name and a 16th (hexadecimal) character identifying the type of NetBIOS resource. On a simpler level, you must identify your computer on the LAN with a unique computer name so that network communications between computers on the LAN will work without a problem.

804 Understanding Dynamic Host Configuration Protocol

As discussed in Tips 73-79, each computer on a TCP/IP network (like the Internet) must be configured with a unique numerical address called an IP address. As you learned, these IP addresses are actually 32-bit binary numbers but you usually see them in the form of their decimal representation, such as: 208.136.52.65.

It is usually the responsibility of your Internet Service provider or, in the case of your work LAN, your network administrator, to ensure that each computer is configured with a unique IP address. You can imagine that this is a difficult task when you consider that hundreds, if not thousands, of users dial in to your ISP each day. Further, depending upon the size of your company's network, your network administrators could have many personal computers to manage as well. It quickly becomes difficult not only visiting each machine to "statically" assign a unique IP address, but also maintaining the list of IP addresses that have been assigned. The administrative overhead of managing static IP addresses quickly becomes a problem.

Dynamic Host Configuration Protocol (DHCP) was defined by the Internet community to take the place of static IP address assignment. The DHCP server is configured by an administrator with a scope or range of IP addresses that the server makes available for lease by DHCP client computers. To obtain a lease from a DHCP server, you simply configure the TCP/IP on your Windows 98 computer to obtain an IP address automatically, as shown in Figure 804.1. By the same token, if you dial into an ISP, you will configure your dial-in connection to obtain an IP address automatically, as shown in Figure 804.2. These tasks are usually performed by or under the direction of your ISP or your system administrator.

Figure 804.1 A Windows 98 machine configured to obtain an IP address automatically on the LAN.

Figure 804.2 A Windows 98 Dial-up Networking connection configured to obtain an IP address automatically.

Once the server and client are set, each time a new DHCP client boots up (or dials-in), the client initializes a limited version of TCP/IP and broadcasts to get an IP address from the DHCP server. The server responds with an available IP address from its scope which is then used by the client and recorded by the server in the server's DHCP database.

ASSIGNING DHCP SCOPE OPTIONS — 805

As you learned in Tips 81, 82, and 801, in order for computers to communicate effectively and efficiently over a TCP/IP network, they must have a configured Domain Name System (DNS) server and Windows Internet Name Service (WINS) server to handle name resolution tasks. You also learned in Tip 804 that administrators can set up Dynamic Host Configuration Protocol (DHCP) servers to handle the assignment of unique TCP/IP addresses to all of the computers on the network. It does not make sense to assign the TCP/IP address automatically and then go to each computer to configure that computer's WINS server address or DNS server address that the computer will use. For this reason, DHCP servers let administrators configure Scope Options. As you might guess, two of the configurable scope options that an administrator can specify are WINS server address, and DNS server address among many others. Thus, when a DHCP client computer leases a TCP/IP address, it gets all of the necessary scope options that the administrator has specified along with the lease.

UNDERSTANDING FIREWALLS — 806

The term firewall is commonly used to describe network hardware or software used to restrict or deny entry to an organization's network from the Internet. In general, firewalls provide the capability to secure your network from attack at several levels of the OSI reference model.

Firewalls also provide some mechanism for notifying the administrator of an intrusion or anomalous strings of network traffic. Firewalls may also provide logging capabilities so network administrators can track the traffic in and out of the network.

807 USING A PROXY SERVER TO ACCESS THE INTERNET

As you have learned, more and more companies are connecting their internal networks to the Internet for many reasons—to expose the company Web site to the Internet, to let employees access the network resources from the Internet, to access Internet resources from within the company LAN, and more. Some of the biggest issues these organizations face as they extend their networks to the Internet are security, cost of bandwidth to the Internet, and management of TCP/IP addresses for use on the Internet. Proxy server products typically address each of these issues.

Many proxy server products offer firewall security (described in Tip 806), content caching (see Tip 809), IP address aggregation, and access management tools. IP address aggregation means that the proxy server will use one valid, registered IP address to serve the requests of all of your LAN-connected personal computers, even though you will probably use unregistered or private IP addresses on your LAN-based PCs. By virtue of using the proxy server, one valid IP address is used to serve a whole body of unregistered, private IP addresses. This proxy server capability helps you get around the cost of leasing valid IP addresses, and also serves to alleviate the problem of running out of IP addresses in your limited 32-bit IP address number scheme. See Tip 861 which discusses TCP/IP in more detail.

If you are using a PC that is connected to a local-area network, your network may use such a proxy server to make that connection to the Internet. A proxy server sits as a gateway between the Internet and the computers within your local-area network and provides the services described above. When your computer performs an Internet-based operation (such as viewing a Web site), your browser (client) will send its request to the proxy server which, in turn, will forward the request to the Internet on behalf of the client. When the system across the Internet sends back your response, it will send the response to the proxy server which, in turn, will send the information back to your system. You can think of a proxy server as a caching firewall protecting your network from attack via the Internet.

808 UNDERSTANDING THE FEATURES AND BENEFITS OF MICROSOFT PROXY SERVER 2.0

Microsoft entered the proxy server market initially with its Proxy Server 1.0 product. Since then, Microsoft has released a new and much improved proxy server product in Proxy Server version 2.0. Proxy Server 2.0 provides firewall services and a Web cache server designed to secure your network from attack from the Internet while improving Internet browsing response time and efficiency for your LAN users. Proxy server lets your LAN users make Internet requests just as if they were directly connected to the Internet, but also blocks unauthorized access to your LAN from the Internet.

The specific services that Proxy Server 2.0 provides are described in the following Tips.

809 UNDERSTANDING PROXY SERVER 2.0 CONTENT CACHING

With version 2.0, Microsoft Proxy Server introduced the capability to create a network of distributed and hierarchical caching servers to deliver excellent Internet request response performance to your LAN. Distributed and hierarchical means that proxy servers throughout your corporation's enterprise can be configured to work together in a chain beginning at the most remote sub-network and ending at a gateway proxy server through which requests go

out onto the Internet. The net effect is that the proxy servers work together to answer Internet requests to make sure LAN users get the quickest response possible.

Content caching proxy servers can reside in branch offices, at the departmental level within enterprises, or at the ISP Points of Presence (POPs). The proxies can be configured together in a chain allowing for Internet requests to be serviced by an upstream proxy's cache rather than hitting one proxy and then going out onto the Internet. In doing so, a Proxy server 2.0 chain provides the best opportunity for a request to be answered from cache.

Microsoft Proxy Server 2.0 also lets administrators configure Proxy arrays made up of several Proxy servers logically combined to service requests. Proxy arrays let administrators scale Proxy servers to accommodate a growing enterprise network. Proxy Server 2.0 delivers distributed caching and cache arrays using a new technology called Cache Array Routing Protocol (CARP). With CARP, Microsoft Proxy Server 2.0 improves the performance of distributing requests across multiple servers in a Proxy server array.

UNDERSTANDING THE PROXY SERVER 2.0 PASSIVE CACHING 810

As you learned in Tip 809, Microsoft Proxy Server performs content caching to reduce the number of content requests that have to be served by a site on the Internet. The idea behind caching is that the proxy server machine, which is physically much closer to the end user on the network relative to Internet sites, can serve the request faster and more efficiently if it maintains copies of Web content that users request frequently.

Microsoft proxy servers perform two types of content caching, passive caching and active caching. (Active caching is described in detail in Tip 811.) As a user on the LAN requests a Web resource like, for example, *http://www.jamsapress.com/ default.htm*, that user's request is channeled through the proxy server and out onto the Internet for service. The proxy server actually makes the request to the Internet site on behalf of the end user, hence the name proxy. As that request is returned to the user, it passes back through the proxy server onto the LAN and back to the user's computer.

The term passive caching refers to the proxy server's involvement in getting an object into cache. As requested data passes back through the proxy server to a requesting user, the proxy server saves a copy of the data in its cache. The next time the user, or any other user on the LAN, accesses the same Web resource, the proxy server will check its cache to see if it can serve the request from cache instead of sending the request out onto the Internet. This process is called passive caching. The proxy server passively saves copies of data as users request the data. Compare this passive process to active caching, discussed in Tip 811.

The proxy server also makes sure that users retrieve the most up-to-date copy of a requested object. As the proxy server services a request, it first checks its cache for the requested object (in this case, a Web page). If the object is found in cache, the proxy server checks the last changed time stamp of the item in cache against the last changed time stamp of the actual Internet object to see if the item has changed. If the object has not changed, the proxy server delivers the cached object back to the requesting user. If the object has changed, the proxy server retrieves a new copy of the requested object from the Internet, stores a copy in cache, and forwards the new object on to the end user.

UNDERSTANDING THE PROXY SERVER 2.0 ACTIVE CACHING 811

As you learned in Tips 809 and 810, Microsoft Proxy Server performs content caching to reduce the number of content requests that have to be served by a site on the Internet. The idea behind caching is that the proxy server

1001 Internet Tips

machine, which is physically much closer to the end user on the network relative to Internet sites, can serve the request faster and more efficiently if it maintains copies of Web content that users request frequently.

Microsoft proxy servers perform two types of content caching, passive caching and active caching. (Passive caching is described in detail in Tip 810.) As a user on the LAN requests a Web resource like, for example, *http://www.jamsapress.com/default.htm*, that user's request is channeled through the proxy server and out onto the Internet for service. The proxy server actually makes the request to the Internet site on behalf of the end user, hence the name proxy. As that request is returned to the user, it passes back through the proxy server onto the LAN and back to the user's computer.

Unlike its role in passive caching, in which the proxy server plays a minor role in building the cache, in active caching the proxy server actually generates Internet requests itself in order to freshen objects in it's cache. During times of low network and proxy server utilization, the proxy server will analyze its cache and make requests to Internet sites to retrieve up-to-date copies of cached objects. The proxy server makes a determination of what items are accessed most frequently by network users and pre-loads the cache with current copies of those objects from the Internet. Thus, the proxy server actively maintains current copies of items in its cache. Compare this active process to passive caching, discussed in Tip 810.

The proxy server also makes sure that users retrieve the most up-to-date copy of a requested object. As the proxy server services a request, it first checks its cache for the requested object. If the object is found in cache, the proxy server checks the last changed time stamp of the item in cache against the last changed time stamp of the actual Internet object to see if the item has changed. If the object has not changed, the proxy server delivers the cached object back to the requesting user. If the object has changed, the proxy server retrieves a new copy of the requested object from the Internet, stores a copy in cache, and forwards the new object on to the end user.

812 UNDERSTANDING THE PROXY SERVER 2.0 WEB PROXY SERVICE

As you learned in Tips 809-811, Microsoft Proxy Server 2.0 performs content caching to increase the efficiency of Internet access for your LAN users. As your users browse the Internet through the proxy server, the proxy server adds a copy of much of the content to its cache. The proxy server also performs active caching during periods of low utilization. This process greatly enhances the apparent speed and performance of browsing the Internet.

The Web Proxy service component is the Proxy Server 2.0 service that is responsible for caching and delivering HyperText Transfer Protocol (HTTP) content (Web content) and File Transfer Protocol (FTP) content to network users running the Transport Control Protocol/Internet Protocol (TCP/IP).

813 UNDERSTANDING THE PROXY SERVER 2.0 WINSOCK PROXY SERVICE

As you learned in Tips 809-811, Microsoft Proxy Server 2.0 performs content caching to increase the efficiency of Internet access for your LAN users. As your users browse the Internet through the proxy server, the proxy server adds a copy of much of the content to its cache. The proxy server also performs active caching during periods of low utilization. This process greatly enhances the apparent speed and performance of browsing the Internet.

The Winsock Proxy service component is the Proxy Server 2.0 service that supports Windows Sockets-based applications (such as Telnet or RealAudio) for network users running the Transport Control Protocol/Internet Protocol

(TCP/IP) or Internetwork Packet Exchange/Sequenced Packet Exchange (IPX/SPX). The Winsock Proxy service lets LAN users running the IPX/SPX protocol access the Internet without having TCP/IP on their computers.

Understanding the Proxy Server 2.0 SOCKS Proxy Service — 814

Microsoft Proxy Server 2.0 also includes a SOCKS Proxy service to support SOCKS clients. SOCKS proxy is a cross-platform communications mechanism that allows secure client and server intercommunication. The SOCKS Proxy service lets non-Windows clients use Microsoft proxy servers to access the Internet and use a variety of Windows Sockets applications. The SOCKS Proxy service uses TCP/IP and can be used for Telnet, FTP, Gopher, and HTTP.

Much as the Winsock Proxy service acts as a go-between between Windows clients and Internet servers, the SOCKS Proxy service acts a middleman between non-Windows clients and Internet servers.

Note: *The SOCKS Proxy service does not support applications that rely on the User Datagram Protocol (UDP).*

Using Proxy Server 2.0 as a Firewall — 815

In Tip 806, you learned about the function of firewalls on your network. Microsoft Proxy Server 2.0 provides firewall security to prevent unauthorized access to your network from the Internet. Because the proxy server is the single point of entry to your network, it is inherently more secure that connecting all of your computers directly to the Internet. A proxy server computer has two network interface cards, one that connects to your corporate network and one that connects to the Internet. The two separate network cards serve to physically isolate your network from the Internet. The Proxy Server software connects the two networks but also processes and filters all traffic between the two networks.

Proxy Server 2.0 is the first Microsoft proxy server product that provides filtering at the packet level. In other words, you can block or enable the passing of certain packet types as needed. For example, you could block the transfer of File Transfer Protocol (FTP) packets if it was determined that this type of traffic was not needed on your network.

Using Netscape Navigator with a Proxy Server to Access the Internet — 816

If your network uses a proxy server, you might have to configure Netscape Navigator to use the proxy server. That is to say, if your gateway to the Internet is a proxy server, you might have to tell your browser that it will be making requests through a proxy server so the browser will perform correctly when making Internet requests.

Before you change the configuration of your browser software, you may want to consult with your network administrator or your Internet service provider.

1001 Internet Tips

To manually configure Netscape Navigator to use a proxy server, perform the following steps:

1. To start Netscape Navigator, click your mouse on the Start Menu. Move to Programs, then to Netscape Communicator, and choose Netscape Navigator. Windows 98, in turn, will launch Netscape Navigator.
2. Within Netscape Navigator, click your mouse the Edit menu and choose Preferences. Netscape Navigator, in turn, will display the Preferences dialog box.
3. Within the Preferences dialog box's Category area, click your mouse on the plus sign next to the Advanced option to expand Advanced.
4. Beneath Advanced, click your mouse on Proxies to display the proxy configuration options. Navigator, in turn, will display three radio buttons that you can use to configure Navigator's proxy options.
5. Click you mouse on the Manual proxy configuration radio button and then click your mouse on the View button. Navigator, in turn, will display the Manual Proxy Configuration dialog box.
6. Within the Manual Proxy Configuration dialog box, type in the IP addresses and port numbers for the proxy server or servers used for each of the respective Internet services.

Note: Consult your network administrator or Internet service provider to obtain the correct IP addresses and port numbers for the proxy server or servers on your network. You can use the Exceptions area at the bottom of the Manual Proxy Configuration dialog box to specify any sites you might access without using a Proxy server, for example, an internal Web server on your company's LAN.

7. After you have entered the appropriate IP addresses and port numbers and any exceptions, click your mouse on the OK button to close the Manual Proxy Configuration dialog box. Then, click your mouse on the OK button to close the Preferences dialog box.

817 USING INTERNET EXPLORER WITH A PROXY SERVER TO ACCESS THE INTERNET

If your network uses a proxy server, you might have to configure Internet Explorer to use the proxy server. That is to say, if your gateway to the Internet is a proxy server, you might have to tell your browser that it will be making requests through a proxy server so the browser will perform correctly when making Internet requests.

Note: Before you change the configuration of your browser software, you may want to consult with your network administrator or your Internet service provider.

To manually configure Internet Explorer to use a proxy server, perform the following steps:

1. To start Internet Explorer, double-click your mouse on the Internet Explorer icon on your Desktop. Windows 98, in turn, will launch Internet Explorer.
2. Within Internet Explorer, click your mouse on the Tools menu and choose Internet Options. Internet Explorer, in turn, will display the Internet Options dialog box.
3. Within the Internet Options dialog box's Category area, click your mouse on the Connections tab.
4. On the Connections tab, click your mouse on the LAN Settings button. Internet Explorer, in turn, will display the Local Area Network (LAN) Settings dialog box.

5. Within the Local Area Network (LAN) Settings dialog box, click your mouse on the Use a proxy checkbox, placing a check in the box.

6. In the appropriate fields, specify the address of the proxy server and the port number. These numbers will be provided by your network administrator. If instructed to do so by your administrator, click your mouse on the Advanced button and specify the server information for each individual services. Then, click your mouse on the OK button to close that dialog box.

7. After you have entered the appropriate IP addresses and port numbers and any necessary advanced options, click your mouse on the OK button to close the Local Area Network (LAN) Settings dialog box.

ALLOWING A SERVER TO CONFIGURE YOUR INTERNET EXPLORER SETTINGS — 818

If you are using a PC that is connected to a local-area network, your network administrator may have specified software on the network that you can use to configure the Internet Explorer. If your network administrator tells you to use a server to configure your Internet Explorer settings, perform the following steps:

1. Click your mouse on the Start menu Settings button and choose Control Panel. Windows 98, in turn, will open your Control Panel window.

2. Within the Control Panel window, double-click your mouse on the Internet icon. Windows 98, in turn, will display the Internet Properties dialog box.

3. Within the Internet Properties dialog box, click your mouse on the Connection tab. Windows 98, in turn, will display the Internet Properties dialog box Connection sheet.

4. Within the Connection sheet, click your mouse on the LAN Settings button. Windows 98, in turn, will display the Local Area Network (LAN) Settings dialog at the top of which you will find the Automatic Configuration area.

5. Within the Automatic Configuration area, click your mouse on the Use automatic configuration script checkbox, placing a check in the box. Then, type in the address of the script file that your network administrator has created and made available over the network (your network administrator will tell you what this address is) and then click your mouse on the OK button. (If you are running your browser, you can apply the changes immediately by clicking your mouse on the Refresh button.)

6. Within the Internet Properties dialog box, click your mouse on the OK button.

DIFFERENTIATING BETWEEN AN INTRANET AND THE INTERNET — 819

Tips 1-14 of this book describe the makeup and history of the Internet in detail. You may have heard of the term intranet and wondered how it compares to the *Big I*, the Internet. The answer is quite simple. You create an intranet when you set up Internet-like services, such as a Web server on your internal corporate network. To put it another way, when you use Web technologies like Internet Information Server, described in Tips 821-825, to make information available on your internal network, you call it an intranet. Intranet information is not exposed for view by

Internet users who are not part of your company. No special technology applies to an intranet, it is just a term to describe the use of Internet technologies on your internal company network.

Tip 820 discusses some of the decisions you must make as you are setting up your intranet sites and then points you to the Tips in this book that will help you get started.

820 SETTING UP YOUR INTRANET

This Tip is included to further clarify the meaning of the term intranet and to tie together all of the products you could use to set up your intranet. After you decide on the content your intranet site will deliver, you can begin to develop the site. Developing the site means choosing an application, such as Microsoft FrontPage (see Tips 545-581) to develop and manage the Web site.

Next, you must choose a server product to be used to host the site. You can use Microsoft Internet Information Server or Peer Web Services, depending on the number of users who will access the site and the operating system on the Web server computer. On Windows NT Server, the Internet Information Server product is the software you can use to set up a corporate intranet site (see Tips 821-825). You can use Peer Web Services (a subset of the Internet Information Server services designed for NT Workstation) on your NT Workstation computers for the purpose of Web site development or even for hosting a small workgroup intranet site. You can install and use Personal Web Server on your Windows 98 machine for developing Web sites on your Windows 98 computer. See Tips 523 to 531 to utilize Personal Web Server.

After you make these key decisions about setting up your intranet, site you need only build the site and then direct your corporate users to the site.

821 USING MICROSOFT INTERNET INFORMATION SERVER (IIS)

Microsoft Internet Information Server (IIS) 4.0 is a network file and application server that operates on Windows NT 4.0 Server (and soon Windows 2000 Server). IIS is fully integrated with NT Server 4.0 and takes advantage of the NT operating system foundation for security, scalability, and reliability. IIS provides the ground floor services for building and Internet or intranet presence. IIS also integrates with other Microsoft BackOffice products that run on NT, such as Microsoft SQL Server, Microsoft Exchange Server, and Microsoft Proxy Server. IIS also supports expansion and development by letting programmers develop sophisticated Web solutions using Microsoft Visual Basic, VBScript, JScript, and Java components. IIS also supports Common Gateway Interface (CGI) and Internet Server Application Programming Interface (ISAPI) extensions and filters. (See Tips 785-787 for information about CGI).

Microsoft Internet Information Server 4.0 includes services that support key Internet industry standards. For example, IIS supports the HyperText Transfer Protocol (HTTP) standard with its WWW (World Wide Web) Service, the File Transfer Protocol (FTP) standard with its FTP Service, and the Network News Transfer Protocol (NNTP) standard with its NNTP service. In other words, IIS can be a Web server, an FTP server, and a News or NNTP server.

Tips 822-825 describe the key Internet Information Server services and each service's function.

Understanding the IIS WWW Service 822

In Tip 821, you were introduced to the Microsoft Internet Information Server 4.0 and its key components. One of the key components of IIS is the WWW (World Wide Web) Service or Web Service. The WWW Service supports the HyperText Transfer Protocol (HTTP) standard which is the service that lets you publish content to the Internet. As you have learned, the Web is the most popular and graphical service on the Internet.

Whether you choose to publish a Web site on the Internet or on your intranet, the software (IIS) and the principles are the same. Essentially, you place Web site files in folders on your Web server running IIS and clients can view those HTML documents and graphics in a Web browser that makes a connection to TCP port 80 (as defined in the HTTP standard) on your Web server machine.

The Microsoft Internet Information server will let you host multiple Web sites on a single server, making IIS a viable alternative for Internet service providers that provide Web hosting services.

Understanding the IIS FTP Service 823

In Tip 821, you were introduced to the Microsoft Internet Information Server 4.0 and its key components. One of the key components of IIS is the File Transfer Protocol (FTP) Service. The FTP Service supports FTP, the long-standing industry standard protocol used for transferring files between computers on a TCP/IP-based network or Internetwork. (Tips 117-168 discuss FTP in detail.)

Just as you can use IIS to host multiple Web sites, you can also host multiple FTP sites on a single IIS computer. FTP remains very popular because it is the most efficient method to use, considering network traffic, to download or upload files from one computer to another on the Internet.

Understanding the IIS NNTP Service 824

In Tip 821, you were introduced to the Microsoft Internet Information Server 4.0 and its key components. One of the key components of IIS is the Network News Transfer Protocol (NNTP) Service. The NNTP Service lets you use your IIS as a commercial grade news hosting server. As you learned in Tips 268-294, NNTP or newsgroups remain a useful tool for sharing information over the Internet. Probably the best feature of newsgroups is that they let you maintain a threaded discussion without having to use e-mail and clog your inbox with a series of different versions of the same discussion.

Internet Information Server's NNTP service supports numerous standard file formats commonly used for posting to newsgroups, including:

- MIME—Multipurpose Internet Mail Extension
- HTML—Hypertext Markup Language

- GIF—Graphics Interchange Format
- JPEG—Joint Photographic Experts Group

With such extensive support, users can post text documents and graphics to the newsgroups hosted on your Internet Information Server computer.

825 UNDERSTANDING MICROSOFT INDEX SERVER 2.0

As you have browsed the World Wide Web, you have probably noticed that many sites on the Web provide a built-in capability to do keyword searches of the content of that Web. As Web sites grow with the addition of more and more useful information, it becomes imperative that Web visitors have a method available to search the Web for specific information they require. Microsoft Index Server 2.0, an accompanying product of IIS, provides the necessary tools for indexing and then querying Web sites.

Index Server 2.0 indexes the contents and properties of documents on your IIS 4.0 Web sites. Index Server can even index formatted documents included in your Web. For example, if you include several Microsoft Word files or Microsoft Excel files in your Web site, Index Server can index the properties and contents of those files because it has built in content filters for many document types. Index Server can also follow an Object Linking and Embedding (OLE) link to index linked documents.

Finally, Index Server works automatically. After it is installed, Index Server will index all files on your IIS Web site and update those indexes as content changes. Index Server requires little, if any, maintenance and administration.

826 UNDERSTANDING THE APACHE WEB SERVER

The Apache software is Web server software that will let your computer respond to requests for Web pages from Web browsers. The Apache Software Foundation maintains the Apache Web Server software. The Apache Group is a group of volunteers around the world communicating on the Internet. The Apache Software Foundation freely distributes the Apache Web Server and you can use it at no cost. A group of programmers developed the Apache Web Server software, creating patches, fixes to software, to an existing Web server program. The group used so many patches, they started calling their new Web server program A PAtCHy Web server. The name stuck, although the spelling changed. Today, the Apache Web Server program is a coherent robust program that the Apache Group updates and maintains. At last count, it has been estimated that the Apache Web Server is the most used Web server program on the Internet. Estimates by independent monitors of the Internet show more Web sites use the Apache Web server on the Internet than all other Web server programs combined.

827 OBTAINING THE APACHE WEB SERVER SOFTWARE

You can obtain the Apache Web server software from the Apache Web site at *www.apache.org*. At the Apache Web, site you will find information about the Apache Web server and the Apache software. The Web site also provides a

1001 INTERNET TIPS

list of Web sites that mirror the Apache Web site. You will most likely get better performance by choosing a mirror site that is closer to you geographically. There is usually less traffic on the mirrored sites and a site that is close to you is more likely to have faster network connections to you. If you are getting slow response times as you look at the Apache Web site, you may want to try a different mirror of the Web site. After you have found an Apache mirror that you are going to work with, you should go to the download page to download the Apache software. You can download the Apache software in two main forms, source code and binary. If you download the source code, you must have a compiler, a program that turns source code into a program, to make the Apache program work. You will most likely want to go to the Binaries directory and then to the win32 directory, if you are planning to install Apache on your Windows computer. You should then download the apache_1_3_6_win32.exe program. The program that you are downloading from the Apache Web site is an installations program that you will use to set up your Apache Web Server. The Apache site or a mirror of the Apache site is the best place to download the most current release of the Apache software.

INSTALLING THE APACHE WEB SERVER SOFTWARE 828

Now that you have the Apache software installation program, the next step is to install the Apache Web Server on your computer system. Use Windows Explorer to display the directory to which you downloaded the Apache software. To install the software, perform the following steps:

1. Double-click your mouse on the appache_1_3_9_win32.exe program to start the Apache installation program. The install program, in turn, will start and will ask you to confirm that you wish to install the Apache software.

Note: The Apache software is constantly being updated so the version number of the file you download at the Apache Web site may be different.

2. Click your mouse on the Yes button. The installation program, in turn, will start the installation and display the Apache Software License Agreement, as shown in Figure 828.

Figure 828 The first screen in the Apache installation, the License Agreement dialog box.

3. Click your mouse on the Yes button if you agree to the Apache License.
4. The installation program, in turn, will display a warning that the Apache code for the Windows platform is still being developed and that the Windows Apache is not as stable as the Apache for the Unix platform. If you still want to install the Apache software, click your mouse on the Next button.
5. The installation program, in turn, will display the Destination Directory dialog box. For most installations, the default directory should be the correct place to install the Apache software. Click your mouse on the Next button.
6. The installation program, in turn, will display the Setup Type dialog box. For most installations, the Typical install should be the correct installation type. Click your mouse on the Typical radio button and then click your mouse on the Next button.
7. The installation program, in turn, will display the Select Program Folder dialog box. The default should be the correct option for most installations of the Apache software. Click your mouse on the Next button.
8. The installation program, in turn, will install the Apache program and display the Setup Complete dialog box. Click your mouse on the Finish button to complete the installation of the Apache software.

You should now have the Apache software installed on your computer system.

829 SETTING THE HOST NAME FOR YOUR COMPUTER

Before you can start using your Apache Web Server, you must set the host name of the computer that you are using as the Web server. To set the host name of Windows 98 computers you must first display the network properties. To display the network properties, perform the following steps:

1. Click your mouse on the Start button. Windows, in turn, will display the Start menu.
2. Click your mouse on the Settings option. Windows, in turn, will display the Settings sub-menu.
3. Click your mouse on the Control Panel option. Windows, in turn, will display the Control Panel window.
4. Double-click your mouse on the Network icon. Windows, in turn, will display the Network Properties dialog box, as shown in Figure 829.
5. On the Configuration tab, click your mouse on the TCP/IP option in the list box. You may need to scroll down through the items listed in the list box and you may find more than one listing of TCP/IP. Select the first occurrence of TCP/IP, even if other items are listed on the same line. Windows 98, in turn, will highlight the TCP/IP item in the list box. You may get a warning message about changing the configuration. This is normal and you can click your mouse on the OK button.
6. Click your mouse on the Properties button. Windows 98, in turn, will display the TCP/IP Properties dialog box.
7. Click your mouse on the DNS Configuration tab. Windows 98, in turn, will display the DNS Configuration Properties sheet.
8. If the sheet is not enabled, click your mouse on the Enable radio button and then enter your host name in the Host text box. Click your mouse on the OK button on all the dialog boxes as they are displayed.

Figure 829 The Network Properties dialog box.

The host name for your computer is now set.

UNDERSTANDING THE HTTPD.CONF FILE 830

The Apache Web server comes from the Unix world where you use entries in a text file to control most programs. You use the *HTTPD.Conf* file to configure your Apache Web Server to control how it will operate. You can edit the *HTTPD.Conf* file in any text editor, such as Notepad. You will find the *HTTPD.Conf* file in the conf subfolder. Use Windows Explorer to navigate to the Program Files folder on your hard drive, go to the Apache Group folder, then go to the Apache folder to find the conf folder, as shown in Figure 830.

Figure 830 The Apache Web Server conf folder where the HTTPD.Conf file is located.

The conf folder holds other configuration files that you can use to change how your Apache Web Server will work. The documentation explains all of the different settings of the different configuration files but you should only attempt to edit your configuration files if you understand what each change will do to your Apache Web Server.

831 STARTING THE APACHE WEB SERVER

To start your Apache Web Server, you should have set the Host Name of your computer (see Tip 829) and restarted your computer. You can start the Apache Web Server by performing the following steps:

1. Click your mouse on the Start button. Windows 98, in turn, will display the Start menu.
2. Place your mouse on the Program option, Windows 98, in turn, will display the Programs menu.
3. Place your mouse on the Apache Web Server option. Windows 98, in turn, will display the Apache Program menu.
4. Click your mouse on the Start Apache as console app option. Windows 98, in turn, will open a MS-DOS Prompt window and show Apache/1.3.6 (Win32) running. The 1.3.6 may be different depending on what version of Apache you are using.
5. Click your mouse on the Minimize button, located in the upper right corner of the MS-DOS prompt window to minimize the window to the Start Bar.

The Apache program is now running on your computer and waiting for requests from your Web pages. The other option to start the Apache Web Server as a service is for use on a Windows NT operating system and should not be used when you are running Apache on a Windows 98 computer.

832 UNDERSTANDING THE FOLDER STRUCTURE OF THE APACHE DIRECTORY

The Apache Web Server stores all of its important files in the folders under the Apache directory. You can build your Web site by creating and linking Web pages together and storing them in the *htdocs* folder. The *htdocs* folder is the folder just below the conf folder shown in Figure 830. You can use the icons in the icons folder to create Web pages. The Apache Web Server uses the *cgi-bin* folder to store special Web programs. The bin folder and the modules folders hold the Apache Web Server program files. You can see the address of the computers that have connected to your Web site by viewing the logs in the logs folder. The conf folder was discussed in Tip 830. The folders under the Apache folder hold all the pieces that will make up your Apache Web site.

833 TESTING YOUR APACHE WEB SERVER

You can test your Apache Web server by performing the following steps.

1. Start your Web browser.

2. In the address box, enter the Host Name that you set for your computer in Tip 829 and press the ENTER key.

Your browser will display the Web page shown in Figure 833 or the Web page that you placed in the *htdocs* folder with the file name *index.html*.

Figure 833 The default Apache Web Server page that is displayed if your Apache Web Server is working.

The first page of your Web site should be called *index.html* when you are using the Apache Web Server. You will know your Apache Web Server is working if your browser displays the Web page shown in Figure 833 or your own *index.html* page.

ADDING MEMORY TO YOUR APACHE WEB SERVER 834

You can improve the performance of your Apache Web Server by adding memory to your computer. The Apache Web Server uses additional memory to store Web pages that are being used in memory instead of on the hard disk. It is much quicker to have a Web page that is being used be stored in memory than on the hard disk. The more memory that you have installed in the computer that you are using as your Web server, the faster your Web server will perform.

DISPLAYING YOUR TCP/IP ADDRESS CONFIGURATION WITH IPCONFIG 835

When you connect to an Internet Service Provider, the ISP will provide you with an IP address. Depending on the programs that you run, there may be times when you must know your IP address. Within Windows 98, you can use the IPCONFIG command to display your system's current IP address, as shown in Figure 835.

The IPCONFIG command will display information about all network interfaces on your computer. If your

computer has multiple network interfaces, such as a network card for a LAN and a modem, the IPCONFIG command will display multiple sections.

Figure 835 *Using the IPCONFIG command to display your system's IP address.*

To use the IPCONFIG command to display your system's IP address, perform the following steps:

1. Click your mouse on the Start menu Run option. Windows 98, in turn, will display the Run dialog box.
2. Within the Run dialog box, type in COMMAND and press ENTER. Windows 98, in turn, will open an MS-DOS window.
3. Within the MS-DOS window, type IPCONFIG and press ENTER. Windows 98, in turn, will run the IPCONFIG command, which displays your IP address.
4. To later close the MS-DOS window, type EXIT at the system prompt and press ENTER.

836 DISPLAYING YOUR TCP/IP ADDRESS CONFIGURATION WITH *WINIPCFG*

In Tip 835, you learned how to use the IPCONFIG command from your system prompt to display your system's current IP address. This is a command line interface where you will type commands at the MS-DOS command prompt, but Windows provides a Windows-based program to show your IP address. Within Windows 98, you can run the *WinIPcfg* (Windows IP-address Configuration command) program to display information about your Internet connection, as shown in Figure 836.1.

Figure 836.1 *Displaying your system's Internet settings using the **WinIPcfg** program.*

Within the WinIPCfg's IP Configuration window, you can click your mouse on the More Info >> button to display the advanced IP Configuration information window, as shown in Figure 836.2.

Figure 836.2 Displaying advanced WinIPcfg information.

To run the WinIPcfg program, perform the following steps:

1. Click your mouse on the Start menu Run option. Windows 98, in turn, will display the Run dialog box.
2. Within the Run dialog box, type WinIPcfg and press ENTER. The WinIPcfg command will display the IP Configuration window, as shown above in Figure 836.1.

RELEASING YOUR SYSTEM'S IP ADDRESS — 837

If you are on a corporate Local Area Network (LAN), you may be getting the IP address for your computer automatically from a special computer on your LAN. If you are obtaining your address automatically on your network, then you can use the IPCONFIG command to perform other functions. At times you may need to get a new IP address for your computer due to some change in the way your LAN is configured. Before you can obtain a new address for your computer on your LAN, you need to release the address you are currently using. Within Windows 98, you can use the IPCONFIG command with the Release switch to release your IP address, as shown in Figure 837.

The IPCONFIG command will report the current IP address of all the network interfaces that are on your system after you have released the IP address of an interface. When you release an IP address from your system, the IP address on the interface will be set to all zeros.

1001 Internet Tips

Figure 837 Using the IPCONFIG command to release your computer's IP address.

To use the IPCONFIG command to release your system's IP address, perform the following steps:

1. Click your mouse on the Start menu Run option. Windows 98, in turn, will display the Run dialog box.
2. Within the Run dialog box, type in COMMAND and press ENTER. Windows 98, in turn, will open an MS-DOS window.
3. Within the MS-DOS window, type IPCONFIG /release *n* and press ENTER. Windows 98, in turn, will run the IPCONFIG command, which releases your IP address. The *n* in the IPCONFIG /release *n* command is the number of the interface from which you want to release the IP address. You can also use the word *all* to release all IP addresses on all interfaces on your system. When you run just the IPCONFIG command, a listing of your network cards will be displayed and each card will have a number. You should replace *n* with the number of the card from which you want to release the IP address.
4. Later, to close the MS-DOS window, type EXIT at the system prompt and press ENTER.

You can also use the WinIPcfg command, discussed in Tip 836, to release an IP address from your system. Within the WinIPcfg command's IP Configuration window, click your mouse on the Release or the Release All buttons. You should not need to use the release command if you are just dialing into an ISP.

838 RENEWING YOUR SYSTEM'S IP ADDRESS

In Tip 837, you learned how to release your IP address. To be able to work on your network after you have released your IP address, you must obtain a new IP address. You use the IPCONFIG command to renew your IP address. The IPCONFIG command also works if your system is obtaining its IP address automatically. You can renew the amount of time that you can use your current IP address. You will need to use the IPCONFIG command to get a new IP address if you have released your IP address using the IPCONFIG command (see Tip 837, "Releasing Your Systems IP Address"). Within Windows 98, you can use the IPCONFIG command with the renew switch to obtain a new IP address, as shown in Figure 838.

1001 Internet Tips

Figure 838 Using the IPCONFIG command with the renew switch to obtain an IP address.

The IPCONFIG command will report the IP address of all network interfaces including the new IP address that you just obtained.

To use the IPCONFIG command to obtain a new IP address for your system, perform the following steps:

1. Click your mouse on the Start menu Run option. Windows 98, in turn, will display the Run dialog box.
2. Within the Run dialog box, type in COMMAND and press ENTER. Windows 98, in turn, will open an MS-DOS window.
3. Within the MS-DOS window, type IPCONFIG /renew *n* and press ENTER. Windows 98, in turn, will run the IPCONFIG command, which will obtain an IP address. The *n* in the IPCONFIG /renew *n* command is the number of the interface from which you want to release the IP address. You can also use the word *all* to release all IP addresses on all interfaces on your system. When you run just the IPCONFIG command, a listing of your network cards will be displayed and each card will have a number. You should replace *n* with the number of the card for which you want to renew the IP address.
4. Later, to close the MS-DOS window, type EXIT at the system prompt and press ENTER.

After you have obtained an IP address with the IPCONFIG command, your computer will be ready to work on your network. You can also renew your IP address using the WinIPcfg command discussed in Tip 836. Within the WinIPcfg command's IP Configuration dialog box, click your mouse on the Renew or Renew All button to renew your IP address.

USING IPCONFIG WITH THE /ALL SWITCH 839

As you learned in Tip 835, the IPCONFIG command will display your system's IP address. You also learned that the WinIPcfg command will also display your system's IP address and display more information when you use the More Info >> button in the IP Configuration window. You can also get the IPCONFIG command to display more information by using the */all* switch, as shown in Figure 839.

1001 Internet Tips

Figure 839 Using the IPCONFIG command to view more information about your system's IP configuration.

Some of the information may scroll off of the screen when you use the /all switch.

To use the IPCONFIG command with the /all switch to display your system's IP address and other information, perform the following steps:

1. Click your mouse on the Start menu Run option. Windows 98, in turn, will display the Run dialog box.
2. Within the Run dialog box, type in COMMAND and press ENTER. Windows 98, in turn, will open an MS-DOS window.
3. Within the MS-DOS window, type IPCONFIG /all and press ENTER. Windows 98, in turn, will run the IPCONFIG command which displays your IP address and other information.
4. Later, to close the MS-DOS window, type EXIT at the system prompt and press ENTER.

The IPCONFIG command with the /all switch is a quick method to get information about your system's IP address.

840 USING THE IPCONFIG COMMAND WITH THE /BATCH SWITCH

When you ran the IPCONFIG command with the /all switch, you may have had some of the information run off the screen. Perhaps you would like to see all of the information. You may want to send a user the output of your IPCONFIG command to help you find a problem with your computer system. The /batch switch is a good method to get a copy of the output of the IPCONFIG command. The IPCONFIG command */batch* switch will write the output of the IPCONFG command to a text file, as shown in Figure 840.1.

You will not see any output to your screen because the command will write all of the information to a text file. You can use any text editor such as Notepad to view the output from your IPCONFIG command, as shown in Figure 840.2.

1001 Internet Tips

Figure 840.1 The IPCONFIG /all command with the /batch switch directs the output to the text file ip.txt.

Figure 840.2 Viewing the output from IPCONFIG using the Notepad program.

You could attach this text file to an e-mail message and send it to support personnel to help you in troubleshooting a problem with your system.

To write the output of the IPCONFIG command to a text file, perform the following steps:

1. Click your mouse on the Start menu Run option. Windows 98, in turn, will display the Run dialog box.

2. Within the Run dialog box, type in COMMAND and press ENTER. Windows 98, in turn, will open an MS-DOS window.

1001 Internet Tips

3. Within the MS-DOS window, type IPCONFIG /batch *filename* and press ENTER. Windows 98, in turn, will run the IPCONFIG command, which writes your IP address to a file. Replace the *filename* word in the command with the name of the file to which the IPCONFIG command is to write its information.
4. To close the MS-DOS window, type EXIT at the system prompt and press ENTER.

841 UNDERSTANDING THE ADDRESS RESOLUTION PROTOCOL

If your computer is on a LAN and uses the TCP/IP protocol, it is also using the Address Resolution Protocol (ARP). Your computer, at the lowest level on a LAN, uses a Media Access Control (MAC) address to communicate with other computers that are on the same LAN. Using the MAC address to communicate will work only for computers that are on the same physical LAN. At a higher level, your computer uses an IP address to communicate with other computers. An IP address is more general and can be used by your computer to connect to other computers both on your LAN and on the Internet. All communication on your LAN uses MAC addresses and your computer uses another computer's IP address to set up communication with the other computer. Therefore, in order to communicate, your computer must translate an IP address to a MAC address. The protocol that makes that translation is the Address Resolution Protocol. The ARP translates IP addresses to MAC addresses for your computer. After your computer maps an IP address to a MAC address, your computer will keep that address mapping in a table. Your computer makes the table so that your computer does not have to find the address mappings each time it tries to communicate with a computer. The table that your computer makes will keep address mappings for short periods of time and then drop them. This table is called the ARP table and you can work with that table to troubleshoot your computer. You use the *arp* command to work with the ARP table. The *arp* command has several switches that modify how it operates. The next three Tips discuss the *arp* command.

842 DISPLAYING THE ARP TABLE ON YOUR COMPUTER

The first *arp* command switch that you should work with is the *–a* switch, which directs the *arp* command to display (the arp table), as shown in Figure 842. Note that the *arp* command uses a hyphen(-) to show a switch and not a slash(/) like most Windows 98 command prompt commands.

Figure 842 Using the arp command to display the ARP table.

To run the *arp* command, perform the following steps:

1. Click your mouse on the Start menu Run option. Windows 98, in turn, will display the Run dialog box.
2. Within the Run dialog box, type in COMMAND and press ENTER. Windows 98, in turn, will open an MS-DOS window.
3. Within the MS-DOS window, type ARP -a and then press ENTER. Windows 98, in turn, will run the *arp* command, which displays your network statistics.
4. To close the MS-DOS window, type EXIT at the system prompt and press ENTER.

If you have more than one network interface on your computer, you should specify for which interface the *arp* command is to display the ARP table. You will specify the network interface by using the –*N* switch with the *arp* command so that your command will look like the following:

```
>arp -a -N 10.0.1.54 <ENTER>
```

When you use the –*N* switch, you must specify the IP address of the network interface for which you want the listing of the ARP table.

ADDING AN ENTRY INTO THE ARP TABLE 843

You can add entries to the ARP table with the *arp* command's –*s* switch. The ARP table contains dynamic entries, meaning that the computer determines what MAC address translates to the IP address to which your computer is trying to connect and builds a table of arp entries on the fly. A dynamic ARP table entry in a Windows 98 computer will stay in the ARP table for, at most, ten minutes and then the entry is dropped from the ARP table by the computer. The computer will need to determine the MAC address for an IP address again as if it were the first connection to that IP address. If you want to make an entry stay in the ARP table until the next time you reboot the computer, you must manually add the entry to your computer's ARP table, as shown in Figure 843.

Figure 843 Using the arp command to add an entry to the ARP table.

1001 Internet Tips

To run the *arp* command, perform the following steps:

1. Click your mouse on the Start menu Run option. Windows 98, in turn, will display the Run dialog box.
2. Within the Run dialog box, type in COMMAND and press ENTER. Windows 98, in turn, will open an MS-DOS window.
3. Within the MS-DOS window, type arp –s ip_address MAC_address and then press ENTER. Windows 98, in turn, will run the *arp* command, which adds the entry to the ARP table on your computer.
4. To close the MS-DOS window, type EXIT at the system prompt and press ENTER.

If you have more that one network interface, you will need to specify to which interface's ARP table the new ARP entry should be added. The –N switch is used to specify an interface's ARP table that you are going to modify.

844 DELETING AN ENTRY FROM THE ARP TABLE

When you add entries into your computer's ARP table, you may find that because you made a typo, or for some other reason, you need to remove an entry from the ARP table. You delete entries from the ARP table by using the *arp* command with the *–d* switch, as shown in Figure 844.

*Figure 844 Using the **arp** command to delete an entry from the ARP table.*

To run the *arp* command, perform the following steps:

1. Click your mouse on the Start menu Run option. Windows 98, in turn, will display the Run dialog box.
2. Within the Run dialog box, type in COMMAND and press ENTER. Windows 98, in turn, will open an MS-DOS window.
3. Within the MS-DOS window, type arp –d ip_address and then press ENTER. Windows 98, in turn, will run the ARP command, which deletes the entry from your computer's ARP table.
4. To close the MS-DOS window, type EXIT at the system prompt and press ENTER.

As you do when viewing the ARP table and adding to the ARP table, you can use the –*N* switch to specify a network interface if you have more than one network interface. When you use the –*N* switch you must specify the IP address of the network interface for which you want the listing of the ARP table.

Understanding the ROUTE Command 845

As you have learned, when you send a message across the Internet, your message may travel through many computers. Depending on the network traffic, the route that your message takes may differ from one day to the next. Special computers on the Net, called routers, determine the path your message travels. In general, you can think of a router as a network traffic cop that directs a message between systems.

To perform their traffic routing, network routers keep tables of routing information, which help them monitor network traffic. If you are a network administrator, there may be times when you will need to customize router tables. In such cases, you can use the *route* command. The *route* command lets you view and change the route tables on your Windows 98 computer. In general, you should never need to change your routing table but if you should or are told that you need to by technical support personnel, you will use the *route* command.

Understanding ROUTE PRINT 846

The first option you may use with the *route* command is the print option. The print option will display the current routing table that your system is using to route your network traffic, as shown in Figure 846.

*Figure 846 Using the **route** command to display the routing table.*

Note that you type the word *print* with no slash or hyphen.

To run the *route* command with the print option, perform the following steps:

1. Click your mouse on the Start menu Run option. Windows 98, in turn, will display the Run dialog box.

1001 Internet Tips

2. Within the Run dialog box, type in COMMAND and press ENTER. Windows 98, in turn, will open an MS-DOS window.

3. Within the MS-DOS window, type route print and then press ENTER. Windows 98, in turn, will run the Route command to display the routing table for your system.

4. To close the MS-DOS window, type EXIT at the system prompt and press ENTER.

847 USING THE ROUTE COMMAND TO ADD A ROUTE

You can use the *route* command to add a route to the routing table, as shown in Figure 847. The *route* command will add an entry to your system's routing table. It will not add any physical routes to your network or change the routing table on other systems.

Figure 847 Using the **route** *command to add an entry to a routing table.*

To run the *route* command to add a route, perform the following steps:

1. Click your mouse on the Start menu Run option. Windows 98, in turn, will display the Run dialog box.

2. Within the Run dialog box, type in COMMAND and press ENTER. Windows 98, in turn, will open an MS-DOS window.

3. Within the MS-DOS window, type route add *Network_address* mask *subnet_mask gateway_address* metric *metric_value* and then press ENTER. Windows 98, in turn, will run the *route* command to change your system's network router tables.

4. To close the MS-DOS window, type EXIT at the system prompt and press ENTER.

The *Network_address* and the *subnet_mask* are used by the computer to describe the network to which you are creating a route (see Tip 861). The *gateway_address* is the address of the router on your LAN and the *metric_value* is how many networks the traffic will go through to get to the network to which you are creating the route.

Understanding ROUTE DELETE

848

You may also need to delete a route from your routing table due to the route being invalid or the route no longer being open to your system. You can use the *route* command to delete a route, as shown in Figure 848.

*Figure 848 Using the **route** command to delete a route.*

To run the *route* command to delete a route, perform the following steps:

1. Click your mouse on the Start menu Run option. Windows 98, in turn, will display the Run dialog box.
2. Within the Run dialog box, type in COMMAND and press ENTER. Windows 98, in turn, will open an MS-DOS window.
3. Within the MS-DOS window, type route delete *Network_address* and then press ENTER. Windows 98, inturn, will run the *route* command to delete the route in your system's network router tables.
4. To close the MS-DOS window, type EXIT at the system prompt and press ENTER.

The *Network_address* in the route delete command is an IP address of a computer on the subnet that you want to delete from.

Understanding ROUTE CHANGE

849

You may need to change a route in your system's routing table if, when the route was added to the table, it was added with incorrect routing information. You use the *route* command with the change option to change some part of an entry in your system's routing table, as shown in Figure 849.

1001 Internet Tips

*Figure 849 Using the **route** command to change an entry in your system's routing table.*

To run the *route* command to change a route, perform the following steps:

1. Click your mouse on the Start menu Run option. Windows 98, in turn, will display the Run dialog box.
2. Within the Run dialog box, type in COMMAND and press ENTER. Windows 98, in turn, will open an MS-DOS window.
3. Within the MS-DOS window, type route change *Network_address* mask *subnet_mask gateway_address* metric *metric_value* and then press ENTER. Windows 98, in turn, will run the *route* command to change your system's network router tables.
4. To close the MS-DOS window, type EXIT at the system prompt and press ENTER.

In Tip 847, you learned to add a route to your system's routing table. The parameters to the change command are the same as the add option of the route command. In the change option of the *route* command, you are changing an existing route and not adding a new route as you do in the add option.

850 UNDERSTANDING TRACERT

When you send a file across the Internet, your computer most likely does not have a direct connection to the computer to which you are sending the file. As with most Internet connections, as your file travels across the Internet it takes a route through several other computers to get to its final destination. The path that your file takes can be by an indirect route. The *tracert* command in Windows 98 will show you each step that a connection to a remote computer takes to get to the remote computer. Each step that a connection takes to connect to a remote computer is called a hop. When you trace a connection to a computer in Houston, you may find that the connection goes through San Francisco, then to Salt Lake, then to Dallas before the connection to the computer in Houston is made, as shown in Figure 850.

As shown in Figure 850, the *tracert* command gives the time it takes to make each hop of a connection, which you can use to determine where your Internet connection is slowing down.

*Figure 850 Tracing the route that a connection to a computer in Houston takes with the **tracert** command.*

USING TRACERT WITHOUT HOST NAMES BEING RETURNED 851

As you learned in Tip 850, the *tracert* command displays the route that a connection across the Internet takes to get to a remote computer system. You may also have noticed that the *tracert* command tries to resolve each host name for each hop in the route. You can disable the *tracert* command's host name look-up, in order to speed up its execution, by using the *–d* switch, as shown in Figure 851.

*Figure 851 Using the **tracert** command with host name resolution disabled.*

1001 INTERNET TIPS

To run the *tracert* command, perform the following steps:

1. Click your mouse on the Start menu Run option. Windows 98, in turn, will display the Run dialog box.
2. Within the Run dialog box, type in COMMAND and press ENTER. Windows 98, in turn, will open an MS-DOS window.
3. Within the MS-DOS window, type tracert –d <hostname or Ipaddress> and press ENTER. Windows 98 will run the *tracert* command.
4. To close the MS-DOS window, type EXIT at the system prompt and press ENTER.

By using the *–d* switch, you can speed the tracing of the route that your connection takes to a remote computer, but, as shown in Figure 851, all other information is retained in the output from the *tracert* command.

852 SETTING THE MAXIMUM NUMBER OF HOPS THE TRACERT COMMAND WILL TAKE TO CONNECT

You can configure how many hops the *tracert* command will track as it traces a route to a remote computer. The *tracert* command will, by default, only take 30 hops to trace a route to a remote computer. You can use the *tracert* command's *–h* switch to configure how many hops it will use in a route trace, as shown in Figure 852.

*Figure 852 Using the –h switch to the **tracert** command to limit the number of hops that the **tracert** command will use.*

To run the *tracert* command, perform the following steps:

1. Click your mouse on the Start menu Run option. Windows 98, in turn, will display the Run dialog box.
2. Within the Run dialog box, type in COMMAND and press ENTER. Windows 98, in turn, will open an MS-DOS window.
3. Within the MS-DOS window, type *tracert –h* <number_of _hops> <hostname or Ipaddress> and press ENTER. Windows 98, in turn, will run the *tracert* command. If the route is longer than the number of hops that you limit the trace to, the *tracert* program will stop the trace after the specified number of hops.
4. To close the MS-DOS window, type EXIT at the system prompt and press ENTER.

The *–h* switch to the *tracert* command is used to limit the number of hops that the *tracert* command will take to trace a route to a remote computer.

1001 INTERNET TIPS

853 LISTING COMPUTERS THAT THE TRACERT COMMAND MUST PASS THROUGH CONNECTING TO A REMOTE COMPUTER

With the *tracert* command, you can list routers that must be used in the route that your connection to a remote computer will use. This command will test if your connection to a computer can go through a specific router and still get to the connection's destination. When you use the *tracert* command to test routes through certain routers, you must list the routers that your connection must pass through but the connection may pass through other routers as well. If one of the routers that you list is not working, then your *tracert* command will not work.

To run the *tracert* command to list some of the routers to use, perform the following steps:

1. Click your mouse on the Start menu Run option. Windows 98, in turn, will display the Run dialog box.
2. Within the Run dialog box, type in COMMAND and press ENTER. Windows 98, in turn, will open an MS-DOS window.
3. Within the MS-DOS window, type *tracert –j* <list of routers> <hostname or IP address> and press ENTER. Windows 98, in turn, will run the *tracert* command.
4. To close the MS-DOS window, type EXIT at the system prompt and press ENTER.

You can use the *tracert* command where you list the path in specific troubleshooting problems.

854 CHANGING THE TIME THAT THE TRACERT COMMAND WILL WAIT FOR A REPLY

The *tracert* command can help you troubleshoot time-related connection problems. The *tracert* command's *–w* switch lets you set the time that the *tracert* utility will wait for a response from a router. The *tracert* command with the *–w* switch is shown in Figure 854.

*Figure 854 Using the **tracert** command with different wait times.*

To run the *tracert* command with different wait times, perform the following steps:

1. Click your mouse on the Start menu Run option. Windows 98, in turn, will display the Run dialog box.
2. Within the Run dialog box, type in COMMAND and press ENTER. Windows 98, in turn, will open an MS-DOS window.
3. Within the MS-DOS window, type *tracert –w* <wait time in milliseconds> <hostname or IP address> and press ENTER. Windows 98, in turn, will run the *tracert* command.
4. To close the MS-DOS window, type EXIT at the system prompt and press ENTER.

855 UNDERSTANDING INTERNET NAME SERVER LOOK-UPS

As you have learned, the Internet uses IP address numbers, rather than names, for two computers to communicate. You also learned in Tips 80 and 81 that the names used on the Internet must be converted to IP addresses by a system called the Domain Name System (DNS). You may at times need to look up an Internet name in the DNS to see the address that is being used for that name. There are several name look-up utilities that you can use but they all have the same result: they look up a name in the DNS and return an IP address. Name look-up is different from programs that use name resolution, like the *ping* command, in that just the name is being looked up and no connection is being made to the computer. You will use a name look-up program to verify that the IP address for your Internet domain name is correct.

856 INSTALLING THE NS-BATCH PROGRAM

The NS-Batch program is used to make it easy to resolve the DNS name for a large number of IP addresses that are listed in a log file of IP addresses that requested Web pages created by a Web server. The NS-Batch program will also resolve DNS names interactively using a windows type program. The NS-Batch program is a free program and will do both name-to-IP address and IP address-to-name DNS resolution. To install the NS-Batch program, perform the following steps:

1. Create a directory on your hard drive called Nslookup.
2. Copy all of the files in the NS-Batch directory on the CD-ROM that accompanies this book to the Nslookup directory on your hard drive.

Your Nslookup directory should look like Figure 856.1.

The files that end in *.dll* may be hidden and not visible in your view and you may not see the file extensions. You can set Windows Explorer to show all files to see the *.dll* files and to show file extensions. You can set the option to show all files by using the View menu options item. The NS-Batch program, Nsb-32, is now installed and ready to use. To start the NS-Batch program, double-click your mouse on the Nsb-32 program file in the Nslookup directory that you created earlier. The NS-Batch program, in turn, will start and display the window shown in Figure 856.2.

Figure 856.1 The Nslookup directory after the nsb33-111.zip file has been expanded.

Figure 856.2 The NS-Batch program window.

The NS-Batch program is used to resolve Internet names using the Domain Name System.

LOOKING UP AN INTERNET NAME 857

You can use the NS-Batch program to look up an Internet name. A host name and a domain name make up an Internet name. The program will return the IP address of the computer that is registered with the DNS as having the name you entered, as shown in Figure 857.

To use the NS-Batch program to do a host name look-up, perform the following steps:

1. Start the NS-Batch program, as described in the previous Tip.
2. Enter the Internet name that you want to look up in the Hostname to IP Address text box.

1001 Internet Tips

3. Click your mouse on the Lookup button in the Hostname To IP Address area, the second Lookup button from the top. The NS-Batch program, in turn, will fill in the gray text box to the right of where you entered the host name with the corresponding IP Address. If the name that you are looking up does not exist in the DNS, the NS-Batch program will display Unknown in the gray text box to the right of where you entered the hostname.

Figure 857 Using the NS-Batch program for an Internet name look-up.

858 Doing a Reverse Name Look Up

You can also use the NS-Batch program to find an Internet name when you have just an IP address. When you enter the IP address in the NS-Batch program, the NS-Batch program will do what is called a reverse look-up in the DNS for the Internet name and return the name, as shown in Figure 858.

Figure 858 Using the NS-Batch program for a reverse name look-up.

To use the NS-Batch program to do a reverse name look-up, perform the following steps:

1. Start the NS-Batch program, as discussed in Tip 856.

2. Enter the IP address that you want to look up in the IP Address to Hostname text box.
3. Click your mouse on the Lookup button in the IP Address To Hostname area, the first Lookup button from the top. The NS-Batch program, in turn, will display the corresponding Internet name in the gray text box to the right of where you entered the IP address. If the IP address that you are looking up does not exist in the DNS, the NS-Batch program will display NotFound in the gray text box to the right of where you entered the IP address.

Not all computers that are part of the DNS register a reverse name look-up. You may be able to ping an IP address number but not be able to do a reverse look-up on that IP address number.

DIFFERENT TYPES OF INTERNET NAMES — 859

The NS-Batch program only looks up two types of Internet names. The two types of names that NS-Batch uses are host name and conical name, also called a cname, but there are other types of names. The host name of a computer is the computer name and a cname is an alias for the host name, an electronic AKA. There are many other types of DNS names that show who controls an Internet domain and where to send e-mail for an Internet domain. If you need to do advanced troubleshooting with DNS, such as verifying that your e-mail server is listed correctly in the DNS, you may need to find a different DNS look-up tool, such as the nslookup tool included with Windows NT.

LOOKING AT PROTOCOLS — 860

Protocols are the language of the Internet. A protocol is a definition of how one computer will talk to a second computer. A protocol describes what information a computer will send to another computer and in what format that information must be sent so that the receiving computer can correctly interpret it. The Internet has many protocols that are used to make the Internet function. There are protocols for how to send and receive e-mail, protocols on how to send files, and protocols on how to send Web pages, just to name a few. Different programs will use different protocols and some protocols are used by other protocols. In other words, one protocol will depend on another protocol being present in order for it to work. All protocols that are used on the Internet are described by a Request For Comment (see Tip 4). If you want information about a protocol that is the most current and up to date you should visit the RFC Editor search page at *www.rfc-editor.org/rfcsearch.html*. The protocols that make up the Internet make up the formal definition of the Internet.

UNDERSTANDING THE TCP/IP PROTOCOL — 861

The TCP/IP protocol is the fundamental part of the Internet. TCP stands for Transmission Control Protocol and deals with how information is sent to a computer so that all the information will get to the computer and in the right order. TCP is a definition of what computers must do to ensure that all the information being sent across a network is received and in the correct order. TCP defines methods for how computers should resend information that does not arrive at the intended destination. IP stands for Internet Protocol and is the IP in IP address. IP is a

definition of how you address information so that the information can get to a destination without knowing a route prior to the information being sent. IP is like addressing a letter—you put the address on the letter but you do not know by which highway the letter will travel. IP also informs the sending computer if there is no way to get information to a computer because there is no valid route for the address. TCP/IP is the most basic protocol to the Internet and must be installed on your computer if you are going to work on the Internet.

862 INSTALLING THE TCP/IP PROTOCOL ON YOUR WINDOWS 98 COMPUTER

You must have the TCP/IP protocol installed on your computer before you can work on the Internet. In most cases, the TCP/IP protocol will be on your computer already, but you may need to install the TCP/IP protocol yourself. You can check to see if you already have the TCP/IP protocol installed from the Network Properties dialog box. If you need to install TCP/IP on your computer, you will also need to go to the Network Properties dialog box.

To check if your computer has the TCP/IP protocol installed or to start installing the TCP/IP protocol, perform the following steps:

1. Right-click your mouse on the Network Neighborhood icon on your Desktop. Windows, in turn, will display the Network Shortcut menu.
2. Click your mouse on the Properties option. Windows, in turn, will display the Network Properties dialog box.

On the Configuration tab of the Network properties dialog box, look for a protocol icon that looks like a cable and a plug, then look for the TCP/IP label, as shown in Figure 862.1.

Figure 862.1 The Network Properties dialog box with the TCP/IP protocol installed.

If you have only a modem in your computer, you may see only one listing of TCP/IP by itself. In Figure 862.1, the computer has a modem and a network interface card so the TCP/IP protocol is listed twice. Each listing of TCP/IP

1001 INTERNET TIPS

points to the hardware that the TCP/IP settings are related to, as you can have different TCP/IP settings for each network hardware item that you have installed in your computer. If you do see TCP/IP, you do not need to install it. If you do not see TCP/IP listed at all in the Network dialog box, you must install the TCP/IP protocol. To start the installation of the TCP/IP protocol, you must have your Windows 98 installation CD-ROM.

To continue checking if your computer has the TCP/IP protocol installed or to start installing the TCP/IP protocol, perform the following steps:

3. Click your mouse on the Add button. Windows, in turn, will display the Select Network Component Type dialog box.
4. Click your mouse on the protocol icon and then click your mouse on the Add button. Windows, in turn, will display the Select Network Protocol dialog box.
5. Click your mouse on the Microsoft option in the left pane. Next, click your mouse on the TCP/IP option in the right pane. You may need to scroll down in the right pane to display the TCP/IP option. Your Select Network Protocol dialog box should look like Figure 862.2.

Figure 862.2 The Select Network Protocol dialog box.

6. Click your mouse on the OK button. Windows, in turn, will display the Network Properties dialog box.
7. Click your mouse on the OK button on the Network Properties dialog box. Windows, in turn, will display the Copying Files status box. You may be required to insert the Windows 98 CD-ROM in your CD-ROM drive. Insert the CD-ROM and click OK in the Insert Disk dialog box.

Windows will install the TCP/IP protocol. You will need to reboot your computer to have Windows complete the installation process.

CONFIGURING THE TCP/IP PROTOCOL 863

After you have the TCP/IP protocol installed, you may need to configure the protocol. To start the configuration of the TCP/IP protocol, you will need to open the Network Properties dialog box. See Tip 862 for directions to open the Network Properties dialog box. If you have only a modem or the TCP/IP protocol icon

1001 Internet Tips

is pointing to the dial-up adapter, then you should configure your TCP/IP protocol properties from the Dial-Up Networking Properties dialog box. Tips 91-109 explain how to set up dial-up networking. If you have only a network interface card (NIC) adapter or the TCP/IP protocol icon is pointing to the NIC adapter, then you can configure the TCP/IP protocol properties using the Network Properties dialog box. To start configuring the TCP/IP protocol properties, double-click your mouse on the TCP/IP protocol icon with your mouse. Windows, in turn, will display the TCP/IP Properties dialog box shown in Figure 863.

Figure 863 The TCP/IP Properties dialog box.

For most networks, the Obtain an IP address automatically radio button should be selected by default. If you need to configure your TCP/IP settings, you will need to obtain an IP address and subnet mask that is correct for your network from your network administrator. You should also obtain an IP address for your DNS server and an IP address for your default gateway and enter the information, respectively, in the DNS Configuration tab and Gateway tab. The TCP/IP Properties dialog box is used to configure your TCP/IP settings.

864 UNDERSTANDING THE SNMP PROTOCOL

The SNMP protocol is a network management protocol. SNMP stands for Simple Network Management Protocol. SNMP is used to monitor and manage TCP/IP networks and networking hardware. With SNMP, you can monitor your Web servers to see if they are working and what their status is. Using SNMP, you can also set the configuration of servers and routers on your network. The SNMP protocol uses two types of programs, a management program and a client program. You install the management program on your workstation from which you will manage your network. You install the client program on the computer that you want to manage. Most client programs will send alerts to the management program if there is a problem with the computer on which the client is running. If you want more information about the SNMP protocol, you should visit the RFC Editor's search Web page at *www.rfc-editor.org/rfcsearch.html* and search for the keyword SNMP. You will find almost a hundred different RFCs that deal with the SNMP protocol though some of the RFCs have been made obsolete by other RFCs.

Understanding the POP Protocol — 865

E-mail client programs use the POP protocol to retrieve e-mail from an Internet e-mail server. POP stands for Post Office Protocol and the third version is the most current version so you may see the protocol listed as POP3. The POP protocol defines how an e-mail client program will collect e-mail messages from an Internet e-mail server. Almost every e-mail program in use today supports the POP protocol for retrieval of e-mail messages from an e-mail server. When you are configuring your e-mail client to collect e-mail from your e-mail server, you must enter the name or IP address of your POP server. The POP protocol also defines how an e-mail client retrieves mail and does not provide for the sending of e-mail. The sending of e-mail is left to another protocol. If you want more information about the POP protocol, you should visit the RFC Editor's search Web page at *www.rfc-editor.org/rfcsearch.html* and search for the keyword POP3.

Understanding the SMTP Protocol — 866

SMTP stands for Simple Mail Transfer Protocol. The SMTP protocol is used to send e-mail to a computer. Internet e-mail servers will use the SMTP protocol to send blocks of e-mail messages to other e-mail servers on the Internet. Your e-mail client will also use the SMTP protocol to send e-mail to your Internet e-mail server. As the protocol name suggests, the SMTP protocol is used to send e-mail to a server. This is different than the POP protocol where a computer is getting e-mail from a server. The difference between SMTP and POP is that in SMTP a computer is starting to send e-mail, and in POP a computer is starting a retrieval of e-mail. Internet e-mail servers use SMTP only to send e-mail messages to other servers. If you want more information about the SMTP protocol, you should visit the RFC Editor's search Web page at *www.rfc-editor.org/rfcsearch.html* and search for the keyword SMTP.

Understanding the SLIP Protocol — 867

SLIP stands for Serial Line Internet Protocol. The SLIP protocol is a protocol developed in the mid-1980s for making TCP/IP connections between Unix computers using the serial port on both computers. SLIP was most commonly used when the method of connecting two computers together was over telephone lines using modems attached to both computers. The SLIP protocol is below the level of the TCP/IP protocol when you are looking at communications between two computers. You would set up a SLIP connection to a computer and then you would set up a TCP/IP connection. The SLIP protocol has been converted to almost all other operating systems and can be used by Windows 98 to connect to a SLIP host. You can find information about the SLIP protocol on the RFC Editor's page at *www.rfc-editor.org/rfcsearch.html*. The protocol is not used very much as it has been replaced in most computers by the PPP protocol discussed in the next Tip. The SLIP protocol is used to connect to remote computers.

868 UNDERSTANDING THE PPP PROTOCOL

PPP stands for Point to Point Protocol. Like the SLIP protocol, the PPP protocol is used to connect two computers using the serial ports on the computers. As with the SLIP protocol, PPP is geared to working with modems connected to the serial ports of computers as the means of connecting computers. The PPP protocol has several advantages over the SLIP protocol for making connections between two computers over telephone lines. The first advantage of PPP is that it supports compression of the information so that the transmission of data over a PPP connection takes less time as compared to a SLIP connection. PPP also is able to encrypt username and password information used to make the PPP connection between computers. The third advantage that PPP offers is error correction. The PPP protocol is able to detect errors in data being sent over the PPP connection and have the data resent, so that the connection provided by PPP is a more reliable connection when compared to the SLIP protocol.

869 UNDERSTANDING THE PPTP PROTOCOL

PPTP stands for the Point to Point Tunneling Protocol. The PPTP protocol is used to make a connection to a private network through a public network. Many companies use the PPTP protocol to connect remote users to the company's internal network across the Internet. Due to the fact that at each end you are making only a local connection to the Internet, and using the Internet to make the long distance connection the remote network, you save on long distance charges. The PPTP protocol provides a method to connect to the Internet and then, using your connection to the Internet, you can make a connection to a second network that is connected to the Internet. PPTP is a method of implementing a Virtual Private Network and is Microsoft's main VPN solution (see Tip 875 for information on VPN). The PPTP protocol will make use of a public network like the Internet and set up a connection to a computer that is on both the public network and a private internal network. After you have made a PPTP connection to a computer that is connected to your private network across the Internet, your computer will act as though it were connected to the private network directly.

870 UNDERSTANDING THE NNTP PROTOCOL

NNTP stands for the Network News Transfer Protocol. The NNTP protocol is used to transfer newsgroup articles between two computers. In Tips 274 to 294, you learned about using newsgroups. Your newsreader uses the NNTP protocol to download news articles from the news server to your computer. The NNTP protocol is also used to transfer newsgroups between news servers. When you post to a newsgroup, your newsreader makes use of the NNTP protocol to post your article to your news server. The news server that you use also makes use of the NNTP protocol to transfer your post to the newsgroup to other news servers. The NNTP protocol is used to transfer newsgroup articles between your client newsreader and a news server and to transfer newsgroup articles between news servers.

Understanding the HTTP Protocol — 871

HTTP stands for HyperText Transfer Protocol. When you look at a Web page, the Web page is written in part or in its entirety in HyperText Markup Language (HTML). The HTTP protocol is the protocol that transfers the HTML code from a Web server to your Web browser. The HTTP protocol sends the HTML code to your Web browser. The HTTP protocol also has methods for transferring files, graphics, movies, sounds, and many other types of multimedia. The HTTP protocol transfers Web pages from a Web server to your Web browser.

Understanding the ICA Protocol — 872

ICA stands for Independent Computer Architecture. The ICA protocol is used by Citrix WinFrame and the MetaFrame server to connect a Citrix client to a Citrix server (see Tips 372-380). The ICA protocol is not part of the Internet standard protocols but is a protocol that can be used across the Internet. The ICA protocol can be used to connect a Citrix client to a Citrix server over the Internet. The purpose of the ICA protocol is to send the display of a program that is running on a Citrix server to a Citrix client so that the user of the Citrix client can work with programs that are not running on the user's computer. The ICA protocol makes it possible for you to run and use an application that is running on a remote computer as if the application was running on your own computer.

Understanding the RDP Protocol — 873

RDP stands for Remote Desktop Protocol. The RDP protocol is like the ICA protocol in that it lets a user run an application on a remote computer as if the application were running on the user's local computer. The RDP protocol is made by the Microsoft Corporation and is used with the Microsoft Terminal Server. The RDP protocol is usable across the Internet. You can use the RDP protocol to connect and run an application on a Terminal Server as if the application were local to your computer.

Understanding the LDAP Protocol — 874

LDAP stands for Light Directory Access Protocol. The LDAP protocol is used by e-mail client programs to query a directory for information about a user, such as a user's e-mail address. A directory is a computer-based equivalent of a telephone book. Many e-mail server programs support a directory of all the users that the server transfers e-mail for and that directory can be searched to find a user's e-mail address and other information. If you have an e-mail program at work, you have probably made use of an address book in your program. An address book in many e-mail programs makes use of an e-mail server's directory. The LDAP protocol is an Internet standard that lets many different types of e-mail clients use an e-mail server's directory.

875 Using Virtual Private Networks

A Virtual Private Network (VPN) is the process of connecting two private networks over a public network. A VPN can be set up between a single computer and a server to connect the single computer to a private internal network across a public network. A VPN can also be set up between two servers or routers to connect two private networks using a public network. There are several key components to a VPN. The first key part of a VPN is that a connection to a private internal network is being made over a public network. The second key part of a VPN is that the information being transferred to and from the private network is secured from being viewed when it is traveling over the public network. The last component is that a connection to the private network over the public network must be authenticated. There are several methods of creating a VPN by using hardware, software, or both. In a hardware solution, you must have two routers that support encryption so that you can set up an encrypted connection from one router to the other over a public network. A hardware solution is most often used when two private networks are being connected over a public network. You can also use a software solution to create a VPN using different protocols, such as PPTP and Secure IP. Secure IP is a method of encrypting information as the information is placed on the network, and PPTP is a method of making a connection to a private network over an existing connection to a public network.

876 Setting Up a Virtual Private Network with Your ISP

You have several options in setting up a VPN between private networks. If you are trying to connect two local area networks across the Internet then your local ISP may be able to make the connection for you. When you are connecting two LANs together across the Internet, you may want to look at a hardware solution but that requires expensive equipment. A second solution may be provided by your Internet service provider who can use VPN equipment to connect to an ISP that is local to the other LAN that you wish to connect to your network. The ISPs make the secure connection over the Internet and you just connect to the respective ISP that is local to each LAN. Using the ISP to create your VPN connection is usually more cost effective but gives you less control over the type of VPN method being used to connect your networks together. Also, not all ISPs can handle creating VPNs for their customers so you should check with your ISP first to see if they will be able to help you set up a VPN. Even if you use your own equipment to create a VPN between two networks over the Internet, your ISP will need to be involved, as you may need a constant connection to the Internet. You may need to upgrade your existing connection to your ISP, for example, change from analog dial-in to ISDN, to increase bandwidth to accommodate the increased demands of maintaining a VPN. Your ISP may be able to set up a VPN for you or help you create your own VPN between two private LANs in your company.

877 Understanding How Point-to-Point Tunneling Works in Windows 98

The Point-to-Point Tunneling Protocol, PPTP, provides the capability to connect two computers together using the Internet public network as if it were a private network connection. PPTP is a form of making a Virtual Private Network. The concept of PPTP is similar to the concept of Dial-up Networking. In Dial-up Networking, you are

using a telephone line to make a connection to a computer, and in PPTP, you are using an existing network connection to make a connection to a computer. Unlike the hardware or ISP Virtual Private Networks used to connect LANs together (see Tip 876), PPTP is usually used to connect two computers together or to connect a single computer to a private network. When using PPTP with Windows 98, you must make a Dial-Up Networking connection to your ISP (see Tip 113). After you have a connection to the Internet, you can then set up your VPN with PPTP. You will make a second connection to your private network using Dial-Up Networking, but you will make the connection using the Microsoft VPN Adapter instead of your modem, as shown in Figure 877. (See Tip 116 for creating this connection.)

Figure 877 A Dial-Up networking Make New connection dialog box set up for use with the Microsoft VPN Adapter.

When network activity is sent to the VPN adapter, Microsoft VPN resends the data to the Dial-Up adapter and though the modem connection to the Internet. All network traffic that is sent to your company's internal private network will be sent to the VPN adapter. The VPN adapter, in turn, will encapsulate the information and send it through the Internet to your company's VPN server which will, in turn, un-encapsulate the information and send it on to the internal private network. The company's VPN server will do the same process to send information back to your computer as your computer used to send information to the company's VPN server. It is this encapsulation that makes the connection between your computers and the computer on your company's internal private network seem as if they are on the same network even though the Internet is between the two computers. The Point-to-Point Tunneling Protocol encapsulates information so that it can be sent across a public network to a computer that can receive the PPTP information and resend the information on an internal private network.

UNDERSTANDING USING PPTP TO CONNECT TO YOUR COMPANY'S INTERNAL PRIVATE NETWORK — 878

As you learned in Tip 877, you can use Windows 98 to make a connection to your company's private network using the Microsoft VPN Adapter. However, there are other steps that must be completed before you can make this connection. Your company must have set up a server that is connected to both your company's internal private network and to the Internet. The server that is connected to the private and the public networks will be your connection to the private network from the public network. The server must also have a PPTP protocol installed that is compatible with Microsoft's PPTP protocol that is installed when you install the Microsoft VPN Adapter. Your network administrator should be able to tell you if your company supports using the Microsoft VPN Adapter to connect to your company's private network across the Internet. To make a VPN connection to your company's internal private network across the Internet, you must have VPN software on your computer and VPN software on a server at your company to receive your connection.

1001 Internet Tips

879 Installing the Microsoft VPN Adaptor

In Tip 112, you learned how to create a virtual private network connection using the Windows 98 Make New Connection Wizard. If, however, the Wizard does not display the Microsoft VPN Adapter option, you must first install network software for the adapter by performing the following steps:

1. Click your mouse on the Start button. Windows 98, in turn, will display the Start menu.
2. Within the Start menu, select the Settings menu Control Panel option. Windows 98, in turn, will open the Control Panel window.
3. Within the Control Panel, double-click your mouse on the Network icon. Windows 98, in turn, will display the Network dialog box.
4. Within the Network dialog box, click your mouse on the Add button. Windows 98, in turn, will display the Select Network Component Type dialog box.
5. Within the Select Network Component Type dialog box, click your mouse on the Adapter option and then click your mouse on the Add button. Windows 98, in turn, will display the Select Network Adapters dialog box.
6. Within the Select Network Adapters dialog box Manufacturers list, click your mouse on the Microsoft option.
7. Within the Select Network Adapters dialog box Network Adapters list, click your mouse on the Microsoft Virtual Private Networking Adapter option and then click your mouse on OK. Windows 98, in turn, will install software to support the adapter.
8. Restart your system for your software installation to take effect.

880 Understanding IPSec

When you are using a VPN across the Internet, there is the concern that the information you are sending over the Internet can be snooped by your competition or changed by someone who wants to harm your system. Several methods are available to protect your information as it crosses the Internet and all of them involve some type of encryption. One method that you can use to encrypt information that crosses the Internet is to use the IPSec protocol. IPSec stands for Internet Protocol Security and is a way of encrypting information at a low level in the computer system so that programs do not need to do any special handling of information. The IPSec protocol is done at a low level of the networking system so that the user does not need to be aware of any change in how he or she uses the computer. IPSec is a new protocol that you can use to encrypt your data on a VPN. To make use of

IPSec, you will need to get an IPSec software package to install on your computer system. IPSec is a low-level method of protecting information as it crosses the Internet.

E-MAILING YOUR CELLULAR PHONE — 881

Many of the new cell phones are able to do what is called text messaging, where text is displayed on the cell phone screen. You can have individuals e-mail your cell phone number at your cell phone provider's Internet address, such as *7755551212@att.phone.com*. It is often easier to drop someone an e-mail to his or her cell phone than to interrupt the person while he or she is in a meeting or otherwise unable to answer your cell phone call. Most cell phones can only accept small e-mail messages, only a few lines of text, so you must keep your messages short. The use of text messaging in the past was available only when you called an operator who would then type in the message to the pager system, but with the new text messaging systems letting users receive e-mail on the cell phone screen, you can send a quick e-mail message rather than bother someone with a phone call.

SENDING AN E-MAIL TO YOUR PAGER — 882

You can send e-mail to a person's pager if the pager supports text messaging. Instead of having to call the pager service to leave a message, you can send an e-mail message to the person's pager directly. Some of the older text messaging pager services do not support sending e-mails to pagers, but almost all services have started to support the use of e-mail to send a text page. The amount of information that you can send to a text pager changes, depending on the service that supports the pager. The e-mail address that you use is often the pager number or a user name, such as *jsmith23@pager.service.com*. You can save time if all you need to do is send a quick message if you just e-mail a pager text message rather than call the person's pager service and wait to give a message to someone at the pager service who will send the message to a pager.

SENDING MESSAGES FROM YOUR PAGER — 883

There is a new type of pager that not only receives e-mail but is able to send a response to an e-mail message as well. You can receive an e-mail and then, on a small attached keyboard, send a reply to the e-mail message that you just received. The new pagers that let you send and receive e-mail make it possible for you to stay in touch through e-mail without the need to carry a laptop around with you.

884 USING A CELL PHONE TO CONNECT YOUR LAPTOP

Some of the new cell phones that you can purchase support connecting the cell phone to a modem PC Card in your laptop computer. While the speed that you can transfer data through your cell phone will usually not be as high as the speed that you transfer data through a normal telephone line, it still will provide connectivity when you are away from the office. You must have both a cell phone and a modem card that support sending data over a cell phone. When you connect your laptop to your office or an ISP through a cell phone, you must attach a special cable that will connect to a data port in your cell phone and to the modem card in your laptop computer. The use of a cell phone to connect your laptop to your office or your ISP can keep you connected in the most remote of areas.

885 USING OTHER OPTIONS TO CONNECT WHEN YOU ARE AWAY

If you are in an airport and you do not want to use a cell phone to connect to the Internet, you have some other options. One possibility that you may have in many airports is that most public pay telephones now have data ports you can use to connect your laptop to the telephone for the purpose of dialing your office or your ISP. You connect your laptop to the pay phone in much the same way that you can use a data port on a telephone in a hotel room. You must use a calling card or call a toll free number and then you would be able to connect your laptop to the Internet while you are at the airport.

A second option that you have is to use an acoustic coupler to connect to the Internet. An acoustic coupler is a device that attaches to the earpiece and the mouthpiece of a phone. The acoustic coupler will generate and send sound signals that a modem would through the mouthpiece of the phone and receive the sound signals through the earpiece. You will get very slow data transfer through an acoustic coupler but you will get connected. The most common reason that you would use this type of connection to the Internet is to in receive and send small amounts of data, such as e-mail messages. The use of acoustic couplers was how you used to connect your computer over the phone lines in the early days of home computer use.

886 CONNECTING TO THE INTERNET WITH YOUR PERSONAL DIGITAL ASSISTANT

Many of the Personal Digital Assistants, PDAs, let you connect to the Internet. A PDA is a small electronic device that holds in electronic form your appointments, phone numbers, notes, and many other personal productivity programs. Depending on the type of PDA you are using, you may be able to connect to the Internet directly or you may need to connect your PDA to a computer system first and then to the Internet through the computer system. After your PDA is connected to the Internet, you can access many of the features of the Internet that you can use from your full computer system. Many of the PDAs in use have software pre-installed or let you install software that can make use of many aspects of the Internet including e-mail, the World Wide Web, Telnet, and so on.

887. Getting Web Pages on the Internet to View on Your Personal Digital Assistant

You can use your PDA to receive Web pages that you can view offline when you are not connected to the Internet. Avant Go makes a software add-in for your PDA that will download Web pages to your PDA when you synchronize your PDA with your computer. When you synchronize a PDA, you are downloading your e-mail, your electronic calendar, Web pages, and so on, on to your PDA from your Desktop computer. The Avant Go Web page, as shown in Figure 887, at *avantgo.com*, has links to the software that you must install on your computer and on your PDA.

*Figure 887 The Avant Go home Web page at **avantgo.com**.*

You will download the software for the type of PDA that you have. The Avant Go Web site will step you through the set up of the Avant Go software so that you will be able to download Web pages to your PDA that you can view later when you are not connected to the Internet.

888. Sending and Receiving e-mail with Your Personal Digital Assistant

In most PDAs, you can have your e-mail downloaded to the PDA when you synchronize your PDA with your e-mail software on your computer. When you synchronize a PDA, you are downloading your e-mail, your electronic calendar, Web pages, and so on, onto your PDA from your Desktop computer so that you have a copy on both your Desktop computer and on your PDA. When the e-mail is downloaded to your PDA, you can then view the e-mail while you are away from your computer. As you are viewing your e-mail on your computer, you can reply to an e-mail that you are reading and send the reply. You can also create new e-mail to a user and send the e-mail message on your PDA while you are not connected to your computer. The next time that you synchronize your PDA with

your computer, the e-mail that you had sent, both the new e-mail and the replies to e-mail you had received, on your PDA will be transferred to your computer and sent to the different e-mail recipients. By using your PDA, you can write e-mail while you are standing in line, waiting for a customer, or at any time, and then have the e-mail be sent out as soon as you synchronize your PDA.

889 UNDERSTANDING HOTMAIL

Hotmail is an e-mail service that you can use to send and receive e-mail from your Web browser. To access a Hotmail e-mail account, you must have a connection to the Internet. You will not need to connect to a special e-mail server, you just use any connection to the Internet with a Web browser and view the Hotmail Web page to connect to your e-mail. You can use the MSN Web site to connect to the Hotmail e-mail server at *www.msn.com* (see Tip 890 to learn how to get your free Hotmail account).

The use of a total Web based e-mail account is quite convenient as you can access your e-mail from any location with a connection to the Internet and a Web browser. You can borrow another user's computer and quickly point the Web browser on the computer that you are borrowing to the Hotmail Web page and you will have your e-mail without making any special connections or installing any software on the computer. There is no need for you to make a new connection to get your e-mail, you just use any existing connection to the Internet and a Web browser. Hotmail, by using the World Wide Web as your method for accessing your e-mail account, makes your e-mail available to you even when you are away from your own computer.

890 GETTING A HOTMAIL ACCOUNT

To get your Hotmail account, you will need to go to the MSN home Web page at *www.msn.com*. Click your mouse on the Free e-mail button, as shown in Figure 890, to sign up for a Hotmail e-mail account.

Figure 890 The MSN home Web page with the free e-mail button used to sign up for a Hotmail e-mail account.

On the MSN Hotmail Web page, click your mouse on the Sign Up Now link. The Hotmail Web site, in turn, will display the Hotmail Terms of Service Web page. After you have read the terms of your new Hotmail account and you

agree with them, click your mouse on the I Accept button. The Hotmail Web site, in turn, will display the Hotmail Registration Web page. Complete the Hotmail registration and click your mouse on the Sign Up button. The Hotmail Web site, in turn, will display the Hotmail Sign Up Successful Web page. Your Hotmail account is ready to use.

LOGGING INTO YOUR HOTMAIL ACCOUNT 891

To log into your Hotmail account, go to the MSN Web page at *www.msn.com*. On the MSN Web page, enter your login name and password within the e-mail section of the Web page, as shown in Figure 891.1.

Figure 891.1 The login section of the MSN Web page for Hotmail.

After you have entered your login information, click your mouse on the ENTER button. The Hotmail Web site, in turn, will display your Hotmail Inbox Web page, as shown in Figure 891.2.

Figure 891.2 The Hotmail Inbox Web page after you login to your Hotmail account.

1001 Internet Tips

892 VIEWING E-MAIL THAT YOU RECEIVE

After you have logged into your Hotmail e-mail account, you can view e-mail you have received. To view an e-mail, click your mouse on the link in the From column for the e-mail you wish to read on the Inbox Web page. When you click your mouse on the link to an e-mail message, the Hotmail Web site will display your e-mail message as a Web page, as shown in Figure 892.

Figure 892 Viewing an e-mail message that has been sent to your Hotmail account.

To return to the Inbox to read other messages click your mouse on the Inbox link. If you want to read the next message click your mouse on the Next link or to read the previous message click your mouse on the previous link. You will view your e-mail messages in Hotmail by clicking your mouse on the link to the e-mail message in the From column on the Inbox Web page.

893 SENDING AN E-MAIL WITH YOUR HOTMAIL ACCOUNT

To send an e-mail message with your Hotmail account, you should go to your Hotmail Inbox. From the Inbox Web page, click your mouse on the Compose link. The Hotmail Web site, in turn, will display the Compose Web page. Fill in the information in the Compose Web page, as shown in Figure 893.

Enter the e-mail address of the user that you are sending the e-mail message to, enter a subject, and enter the text of your message. After you have completed the Compose Web page, click your mouse on the Send button. The Hotmail Web site, in turn, will display the Sent Message confirmation Web page. Click your mouse on the OK button. The Hotmail Web site, in turn, will display the Hotmail Inbox Web page and the e-mail message will have been sent.

1001 INTERNET TIPS

Figure 893 The Compose Web page used to send e-mail messages in Hotmail.

SENDING ATTACHMENTS WITH YOUR HOTMAIL ACCOUNT 894

To send an attachment with your e-mail message, start to compose a message as described in the previous Tip. From the Compose Web page, click your mouse on the Attachment button. The Hotmail Web site, in turn, will display the Attachments Web page, as shown in Figure 894.

Figure 894 The Hotmail Attachments Web page used to attach files to your e-mail messages.

1001 INTERNET TIPS

You can use the Browse button to browse your computer for the file to attach. Windows, in turn, will open a Choose File dialog box. Select a file from your computer and click your mouse on the Open button. The Hotmail Web site, in turn, will display the file you chose in the Attach File field. Click your mouse on the Attach to Message button to attach the file. The Hotmail Web site, in turn, will clear the Attach File field and display the file name you chose in the Message Attachments box at the bottom of the screen. You can continue to attach files until you have attached all the files to the e-mail that you want to attach. You cannot attach more than 1,000 KB of files to one e-mail message. After you have attached all the files, click your mouse on the Done button and then send the e-mail message as normal.

895 REPLYING TO HOTMAIL E-MAIL MESSAGES.

You will use the Reply Web page to reply to e-mail messages sent to you at your Hotmail account. To reply to an e-mail message from your Hotmail account, view the e-mail message (see Tip 892). After you have read the e-mail message, click your mouse on the Reply link. The Hotmail Web site, in turn, will display the Reply Web page, as shown in Figure 895.

Figure 895 The Hotmail Reply Web page used to reply to Hotmail e-mail messages.

Hotmail will fill in the To:, Subject:, and the original message text for you. You can add text to the message and then send the e-mail back to the original sender.

896 DELETING E-MAIL MESSAGES FROM YOUR HOTMAIL ACCOUNT

When you have finished with an e-mail message in your Hotmail account, you can delete it. To delete an e-mail message, click your mouse in the box next to the message that you want to delete. The Hotmail Web site, in turn, will place a checkmark in the box, as shown in Figure 896.

Figure 896 The Hotmail Inbox with messages marked for deletion.

After you have checked all the e-mail messages that you want to delete, click your mouse on the Delete button. The Hotmail Web site, in turn, will delete the checked messages.

CREATING ADDRESS NICKNAMES 897

You can use Hotmail Nicknames as shortcuts to e-mail addresses for users that you send e-mail messages to on a regular basis. By using Hotmail Nicknames, you can quickly address your e-mails. To create a Nickname, click your mouse on the Addresses link from the Hotmail Inbox Web page. The Hotmail Web site, in turn, will display the Addresses Web page. The Hotmail Addresses Web page, as shown in Figure 897, will list all the Nicknames you have in your Hotmail account.

Figure 897 The Hotmail Addresses Web page used to create Hotmail Nicknames.

You can create Hotmail Nicknames for individuals by clicking your mouse on the Create New link next to the Individuals heading. The Hotmail Web site, in turn, will display the Create Individual Nickname Web page. Within the Create Individual Nickname Web page, you assign a nickname and can fill in optional information such as the user's e-mail address, mailing address, phone number, and so on. Click your mouse on either of the OK buttons at the top and bottom of the Create Individual Nickname Web page. The Hotmail Web site, in turn, will update your list of individuals on your Addresses Web page.

1001 INTERNET TIPS

You can create a Nickname for a group by clicking your mouse on the Create New link next to the Group heading on the Addresses Web page. The Hotmail Web site, in turn, will display the Create Group Nickname Web page. Within the Create Group Nickname Web page, enter a nickname and a list of e-mail addresses to associate with the nickname.

898 CREATING HOTMAIL FOLDERS

You can organize your Hotmail e-mail into folders that you create in your Hotmail account. To create a Hotmail Folder, click your mouse on the Folder link from the Hotmail Inbox Web page. The Hotmail Web site, in turn, will display the Folders Web page. The Hotmail Folders Web page, as shown in Figure 898, will have four standard Hotmail Folders: Inbox, Sent Messages, Drafts, and Trash Can, and any folders that you have created.

Figure 898 The Hotmail Folders Web page used to organize your e-mail messages.

To create a new folder to store your e-mail messages, click your mouse on the Create New link next to the Folder heading. The Hotmail Web site, in turn, will display the Create Folder Web page. Enter a folder name in the New Folder Name field, then click your mouse on the OK button. The Hotmail Web site, in turn, will create the folder in your Hotmail account.

899 MOVING E-MAIL TO HOTMAIL FOLDERS

After you have created folders, you can organize your e-mail by moving e-mail in your Inbox to your folders. To move an e-mail to a folder, click your mouse in the checkbox next to the e-mail to select the ones you want to move to a folder. Next, select the folder to which you want to move the e-mails by clicking your mouse on the drop-down list next to the Move To button, as shown in Figure 899.

After you have selected the folder to which you are going to move your e-mail, click your mouse on the Move To button. The Hotmail Web site, in turn, will remove the e-mail messages from the current Hotmail folder and place the e-mail messages in the folder that you selected.

Figure 899 The Folder Move To drop-down list used to move e-mail to different folders.

LOOKING AT HOTMAIL OPTIONS 900

The Hotmail Options Web page is where you can configure how your Hotmail account will work. The Hotmail Options page, as shown in Figure 900, has links to configure Web pages.

Figure 900 The Hotmail Options Web page used to configure your Hotmail account.

You will use the links to configure the different areas of your Hotmail account. To change your personal information, click your mouse on the Personal link. To have your Hotmail account get e-mail messages from other Post Office Protocol or POP e-mail accounts, click your mouse on the POP link, and so on.

901 Understanding Juno Mail

Juno is an Internet Service provider that has different levels of service that you can subscribe to. Unlike most Internet service providers, if you want to have only e-mail service you do not need to get a full Internet account. Juno will provide an e-mail account to you free of charge. With you can only receive and send e-mails. The free Juno e-mail account does not give you access to the World Wide Web or any other Internet type of access. The Juno free e-mail account does not even require you to have access to the Internet, unlike Web-based free e-mail providers such as Hotmail. Juno has 1,000 different local phone numbers covering almost all of the United States. The Juno e-mail is truly free for most users as you do not need to pay for the e-mail account, the Internet access, or the phone call. All that you need to do is download the Juno mail software to use the Juno e-mail.

902 Getting the Juno Mail Software

To use Juno mail, you will need to download the Juno mail software from the Juno Web site. You can download the Juno e-mail from any connection that you can find to the World Wide Web. You do not have to have your computer connected to the Internet to get the Juno mail software. You can download the software from the Internet at work or a friend's home and put the software on a floppy disk to install on your computer at home. To download the Juno mail software, go to the Juno Web site at *www.juno.com* and click on the Get Free Juno E-mail! link. At the Free E-mail page, click your mouse on the Download Now link to download the full version of Juno. You have other download options as well and you will need to pick the method of obtaining the software that fits your needs. If you can download to your computer, as mentioned above, you can get the latest software by directly downloading the software. If you cannot download to your computer, you will need to download an older version of the software that fits on a floppy disk and install the software from a floppy disk to your computer.

Note: At the bottom of the page you will see a link that lets you download a version of Juno that will fit on a floppy.

The other available option if you cannot download to your computer is to order the software on a CD from Juno from the download page and the CD will be mailed to you. After you have a version of the Juno mail software, you can start using Juno mail.

The installation varies depending on the version of the Juno mail software you download. You will need to start the Juno installation program and follow the installation program instructions to install the software on you computer. If you have doubts about what installation option you should pick, select the default installation selection, as it will work for most installations. After the installation, you will need to create your new Juno e-mail account. You will set-up your Juno e-mail account by configuring your computer to run the Juno software and then providing information about yourself and picking a telephone number to use to dial into the Juno e-mail system.

The dialog boxes are clearly explained at each step of the installation program used by the different versions of the Juno mail software. Juno provides free e-mail accounts for the same reason network TV provides free TV programs—they make money from advertising. The account setup program will give you a survey to target the advertising that you will see when using your Juno mail account. The survey will be about sixteen dialog boxes long and should take about 10 to 15 minutes and is a mandatory part of the installation. After you have completed all of the account setup, information you will be ready to use the Juno e-mail account that you created.

903 Sending a New e-mail with Juno

To send e-mail with your free Juno e-mail account you must first start the Juno e-mail program. If you used all default options on the installation of the Juno software, you can start the Juno e-mail account by double-clicking your mouse on the Juno shortcut on your Desktop. The Juno program will start and display the Welcome to Juno dialog box in which you enter your Juno login name and the password that you chose when you installed the program.

Note: *After entering your login and password, you may have to click your mouse on the e-mail button*

The Juno program, in turn, will display some advertisements. You can click your mouse on an option to dismiss the ads or click your mouse on an option to receive more information about the advertised product. After the Juno program displays the ads, it will display the Check for New Mail dialog box. Click your mouse on the Yes button. The Juno program, in turn, will display the get new mail status screen, connect to the Juno system, and retrieve any new mail you may have on the Juno system. After the Juno program has completed the mail retrieval, click your mouse on the Close button.

After the Juno program is running, click your mouse on the Write tab in the Juno program to send an e-mail. Enter the e-mail address of the user to whom you are sending e-mail and enter your e-mail message, as shown in Figure 903.

Figure 903 *The Juno program Write screen.*

After you have completed your e-mail message, click your mouse on the Send Mail button. The Juno program, in turn, will display the Send Mail dialog box. You can choose to send your e-mail immediately or to place your e-mail in the Outbox to be sent the next time you check for e-mail or when you close the program. The Juno program will connect to the Juno system if you send the e-mail immediately and send the e-mail. You should use the Write screen to send e-mail.

904 Receiving e-mail with Juno

To read e-mail with your free Juno e-mail account, you will need to start the Juno e-mail program. If you used all default options on the installation of the Juno software, you can start the Juno e-mail account by double-clicking

1001 Internet Tips

your mouse on the Juno shortcut on your Desktop. The Juno program will start and display the Welcome to Juno dialog box in which you enter your Juno login name and the password that you entered when you installed the program. The Juno program, in turn, will display some advertisements.

Note: *After entering your login and password, you may have to click your mouse on the e-mail button.*

You can click your mouse on an option to dismiss the ads or click your mouse on an option to receive more information about the advertised product. After the Juno program has displayed the ads, it will display the Check for New Mail dialog box. Click your mouse on the Yes button. The Juno program, in turn, will display the get new mail status screen, connect to the Juno system, and retrieve any new mail you may have on the Juno system. After the Juno program has completed the mail retrieval, click your mouse on the Close button. To read your e-mail, click your mouse on the Read tab and then click your mouse on the message that you wish to read, as shown in Figure 904.

Figure 904 *The Juno mail program Read screen.*

You can check for new mail after you have started the Juno mail program by clicking your mouse on the Get New Mail button. The Juno program, in turn, will connect to the Juno system and retrieve any mail on the Juno system for you.

905 Using Juno to Send Attachments and Browse the Web

The free e-mail account from Juno mail is a limited e-mail account. The basic account that Juno provides free of charge will only send and retrieve e-mail. You cannot send or receive file attachments with your e-mails. If you wish to send and receive file attachments, you can pay a small fee for a Juno Gold account. For a higher monthly fee, you can get a Juno Web account which will give you access to the World Wide Web much like any account with an Internet Service provider.

906 Having a Private e-mail Account

Juno mail (see Tip 901) provides a convenient method for you to have a private e-mail account for your use at home that has no charge to you. It is a good practice to have your own e-mail account at home that you can use for

personal e-mail that is separate from your work e-mail account. You should have a personal e-mail account that is separate from your work e-mail account for several reasons. Some companies have a policy on the use of the e-mail system that is owned by the company, much like not letting a user make personal calls on company telephones. The other reasons concern legal aspects of who owns e-mail on a computer. If you are doing some type of business using your company's e-mail system, the company could claim that you used company equipment to make money, therefore the company is entitled to any revenue generated by company equipment. Also, if you have personal information in your e-mail account at work, your company may claim that if information is on company equipment the company is entitled to read and use that information. There have been several court cases that question whether or not a company can claim that e-mail on company equipment is company property. Even though you may be able to defend the privacy of your e-mail on company equipment, it is always easier to just have your own e-mail account so there is no question about e-mail ownership.

USING THE WINDOWS 98 ADDRESS TOOLBAR 907

A new toolbar feature of Windows 98 is the Address Toolbar. You can use the Address Toolbar to access Web sites, files and folders on your hard disk, or network resources. To turn on the Address Toolbar, perform the following steps:

1. Point your mouse to an empty area of the Windows Taskbar and click on your right mouse button. Windows 98, in turn, will display the context sensitive pop-up menu.
2. On the pop-up menu, move your mouse cursor to the Toolbars option. Windows 98, in turn, will display the Toolbar's fly-out menu, as shown in Figure 907.1.

Figure 907.1 The Toolbar's fly-out menu on the Taskbar's context sensitive pop-up menu.

3. From the Toolbar's fly-out menu, select the Address option. Windows 98, in turn, will add the Address Toolbar to the Taskbar, as shown in Figure 907.2.

Figure 907.2 The Address Toolbar on the Windows 98 Taskbar.

You can now use the Address Toolbar just as you would use the Address field within the Internet Explorer, as discussed in Tip 913. Simply type in the address of a Web site you would like to view, and Windows 98 will open up your Web browser and load the Web site. You can also use the Address Toolbar to access resources like files and

folders on your disk drives. For example, you can type in the path to a folder on your C: drive, like C:\My Documents, and Windows 98 will respond by opening that folder, as shown in Figure 907.3.

Figure 907.3 Accessing a folder on the hard drive by using the Address Toolbar.

908 ADDING THE LINKS TOOLBAR TO THE WINDOWS 98 TASKBAR

In Tip 907, you learned how to turn on and use the Address Toolbar. Windows 98 also provides a Links Toolbar with pre-configured shortcuts for accessing popular locations on the Web. To turn on the Links Toolbar, perform the following steps:

1. Point your mouse to an empty area of the Windows Taskbar and click on the right mouse button. Windows 98, in turn, will display the context sensitive pop-up menu.
2. On the pop-up menu, move your mouse cursor to the Toolbars option. Windows 98, in turn, will display the Toolbar's fly-out menu, as described in Tip 907.
3. From the Toolbar's fly-out menu, select the Links option. Windows 98, in turn, will add the Links Toolbar to the Taskbar, as shown in Figure 908.

Figure 908 The Windows 98 Links Toolbar.

909 STARTING INTERNET EXPLORER

As you have learned, to surf sites on the World Wide Web, you must use special browser software. To help you take full advantage of the Web, Microsoft includes the Internet Explorer, shown in Figure 909.1, that you can use to view sites on the Web.

1001 Internet Tips

Figure 909.1 Windows 98 includes the Internet Explorer with which you can surf the Web.

To start the Internet Explorer, perform the following steps:

1. Click your mouse on the Start menu Programs option and choose the Internet Explorer. Windows 98, in turn, will cascade the Internet Explorer sub-menu.
2. Within the Internet Explorer sub-menu, click your mouse on the Internet Explorer option. Windows 98, in turn, will open the Internet Explorer window, previously shown in Figure 909.1. Alternatively, you can double-click your mouse on the Internet Explorer icon on the Desktop.

Within the Internet Explorer, you can view a Web site's contents by clicking your mouse on the Address field and then typing in the site's Web address. If your PC is not currently connected to the Net and you type in the address of a site on the Web, Windows 98 will start the software that you use to dial into your online service or Internet Service provider. After you connect to the Net, the Internet Explorer will display the Web site's contents.

Note: To simplify your access to the Internet Explorer, Windows 98 displays an icon within the Taskbar upon which you can click your mouse to start the program, as shown in Figure 909.2. If your system does not display the Internet Explorer's Taskbar icon, right-click your mouse on the Taskbar and select the pop-up menu Toolbars submenu Quick Launch option.

Figure 909.2 Launching Internet Explorer 5.0 from the Windows 98 Taskbar.

USING THE INTERNET EXPLORER TOOLBARS 910

Like all Windows-based programs, the Internet Explorer provides toolbars with buttons you can use to help simplify common tasks. However, unlike some other programs that provide one toolbar, the Internet Explorer provides four toolbars. To display the Internet Explorer toolbars, click your mouse on the View menu Toolbars option and then click your mouse on the toolbar you desire, placing a checkmark next to the option. Figure 910 displays the

1001 Internet Tips

Internet Explorer's Standard Buttons toolbar, which you can use to move forward or backward between sites you have previously displayed, to refresh the current site, to stop a Web site download, to search for information on the Web, to print the current Web site's content, and more.

Figure 910 *The Internet Explorer's Standard Buttons toolbar.*

In Tips 912 and 913, you will learn how to use the Internet Explorer's Address Bar and Links toolbar.

911 CONFIGURING YOUR INTERNET SETTINGS

Today, most users make extensive use of a Web browser and an e-mail program. As you will learn, Windows 98 also provides software you can use to chat with other users across the Net and to hold meetings. To help you configure the Internet settings that a variety of these programs will use, Windows 98 provides the Internet Properties dialog box, as shown in Figure 911.

Figure 911 *The Internet Properties dialog box.*

Several of the Tips that follow examine the Internet Properties dialog box in detail. To display the Internet Properties dialog box, perform the following steps:

1. Click your mouse on the Start menu Settings button and choose Control Panel. Windows 98, in turn, will open the Control Panel window.
2. Within the Control Panel window, double-click your mouse on the Internet Options icon. Windows 98, in turn, will display the Internet Properties dialog box.

Note: In addition to performing the steps this Tip presents to display the Internet Properties dialog box, you can also select the Tools menu Internet Options choice within the Internet Explorer to display the dialog box. Note that when you open the dialog box as described here, Windows calls the dialog box Internet Options instead of Internet Properties.

Configuring the Links Toolbar 912

In Tip 908, you learned how to add the Links toolbar to the Windows 98 Taskbar. The Links toolbar is also available within Internet Explorer, as you learned in Tip 910. You will find that the Links toolbar is already configured with a number of Web links, but the real power of the Links toolbar is that you can add your own favorite links to the toolbar.

It is no mistake that the Links toolbar is located next to the Address bar within Internet Explorer. To add a Web address to your Links toolbar, perform the following steps:

1. Within Internet Explorer, type the address of a Web site in the Address field, as discussed in Tip 913. Internet Explorer, in turn, will load the Web page.
2. To add the Web page to your Links toolbar, simply point to the small icon to the left of the Web address on the Address bar and click and drag the icon onto the Links toolbar. Internet Explorer, in turn, will add the Web site's link to the Links toolbar, as shown in Figure 912.

Figure 912 The Jamsa Press Web link has been added to the Links toolbar.

Note: If you have added the Links toolbar to the Windows 98 Taskbar, as described in Tip 908, you will notice that it remains in synchronization with the Internet Explorer Links toolbar as you add and remove Web links.

1001 Internet Tips

913 — Using the Internet Explorer's Address Bar

In Tip 909, you learned how to start the Microsoft Internet Explorer. Within the Internet Explorer, you select Web sites by typing a Web address within the Address field, as shown in Figure 913.

Figure 913 Using the Address field to type a Web address.

You can get started surfing the Web by trying the addresses shown in Table 913.

Site	Address
Microsoft	www.microsoft.com
Jamsa Press	www.jamsapress.com
ESPN	espn.go.com
Excite	www.excite.com
Business Week	www.businessweek.com
Mr. Showbiz	mrshowbiz.go.com
Netscape	www.netscape.com
Yahoo	www.yahoo.com
Wall Street Journal	www.wsj.com
MSNBC	www.msnbc.com

Table 913 Sites to visit on the World Wide Web.

914 — Searching by Using the Address Field

As you learned in Tip 913, you use Internet Explorer's Address field on the Address bar to specify the Internet site you would like to browse. Internet Explorer's Address field can also be used to search the Web for topics of interest. To use the Address field to perform a search, simply type the word or words you are searching for in the Address field. Internet Explorer, in turn, will reply with Search for your topic, as shown in Figure 914.

As shown in Figure 914, Web auctions has been typed in the Address field and Internet Explorer responds with Search for Web auctions. You can hit the ENTER key on your keyboard or click your mouse on the Search for 'Web auctions' phrase on the list that drops down from the Address field to begin the Web search for the topic you have typed into the Address field. Internet Explorer, in turn, will display search results for your phrase.

1001 INTERNET TIPS

Figure 914 Using the Address field to search for topics on the Web.

By default, Internet Explorer uses the MSN Web Search site for autosearching via the Address Bar. Tip 915 discusses setting your own advanced search options within Internet Explorer.

CONFIGURING ADVANCED SEARCH OPTIONS 915

After gaining some experience in searching the Web using Internet Explorer, you may find that you would like to change or refine some of Internet Explorer's search options. To customize your search settings, perform the following steps:

1. On the Standard Buttons toolbar, click your mouse on the Search button (if it is not already depressed). Internet Explorer, in turn, will display the Explorer Bar's Search window along the left side of the Internet Explorer window.

Note: The Explorer Bar is discussed in detail in Tip 917.

2. Within the Explorer Bar's Search window, click your mouse on the Customize button, as shown in Figure 915. Internet Explorer, in turn, will display the Customize Search Settings dialog box.

Figure 915 The Customize button within the Explorer Bar's Search window.

1001 Internet Tips

3. Within the Customize Search Settings dialog box, you can edit the various categories to configure each type of Internet search service. To configure Autosearch settings, click on the Autosearch settings button at the bottom left corner of the Customize Search Settings dialog box. Internet Explorer, in turn, will display the Customize Autosearch Settings dialog box, within which you can choose a search provider to be used for Address bar searches, as discussed in Tip 914.

4. After you have chosen a search provider for address bar searches, click the OK button to close the Customize Autosearch Settings dialog box. Internet Explorer, in turn, will return you to the Customize Search Settings dialog box.

5. After you have finished configuring your search options in the Customize Search Settings dialog box, click the OK button to apply your changes.

916 SEARCHING FOR TEXT ON THE CURRENT PAGE

In Tip 470, you learned how to use a search engine to locate sites on the Web that discuss specific topics. As you are viewing a site's contents within the Internet Explorer, there may be times when you will want to search the current document for specific information (some Web pages can actually become quite long). To search the current Web page for specific words or phrases, perform the following steps:

1. In Internet Explorer, click your mouse on the Edit menu and choose the Find (on This Page) option (alternatively you can press CTRL-F on the keyboard). Internet Explorer, in turn, will display the Find dialog box, as shown in Figure 916.

Figure 916 The Internet Explorer Find dialog box.

2. Within the Find dialog box, type in the word or phrase for which you would like to search in the Find what: field and then click your mouse on the Find Next button. If the Internet Explorer finds your text on the current page, it will move your view to that portion of the page and highlight the text for which you have searched. If the search fails, Internet Explorer will display a dialog box telling you that it has finished searching the document.

If the page contains multiple occurrences of the word or phrase, you can click your mouse on the Find dialog box Find Next button to move through each occurrence.

Note: You can use the Find dialog box's Match whole word only checkbox and the Match case checkbox to further refine your search. You can also choose the search Up or Down button from the current cursor location on the page by using the Up and Down radio buttons in the Direction area of the Find dialog box

1001 Internet Tips

Using the Explorer Bar 917

As discussed in Tip 915, Internet Explorer provides a special Explorer Bar that the Internet Explorer displays along the left-hand side of its window. You can use the Explorer Bar to search the Internet, view your Favorites folder, view your History list that lists the sites you have recently visited, as well as a Folders list you can use to browse the resources available on your computer or on the network to which your computer is connected. Figure 917, for example, shows the contents of the Favorites folder within the Explorer Bar.

Figure 917 Using the Explorer bar to access your Favorites folders.

To display the Internet Explorer's Explorer Bar, click your mouse on the View menu and move to the Explorer Bar menu item. Internet Explorer, in turn, will cascade the Explorer Bar menu within which you can select the option that corresponds to the contents you want to display.

Note: *Within the Explorer's Standard Buttons toolbar, you can click your mouse on the Search, Favorites, or History button to display the corresponding item within the Explorer Bar. To close the Explorer Bar, you can click your mouse on the Close button that appears at the top right-hand corner of the Explorer bar.*

1001 Internet Tips

918 — Adding the Current Site to Your Favorites Folder

As you use Internet Explorer to view sites on the Web, you might come across sites that you will want to visit again. You might, for example, want to visit the Microsoft site on a regular basis to stay current on Windows 98, or you may want to use the Go Network search engine on a regular basis to search the Web for specific content. To make it easy for you to revisit a site in the future, Windows 98 provides a Favorites folder within which you can add links to your favorite sites. Later, when you want to revisit the site, you can click your mouse on Internet Explorer's Favorites menu and then click your mouse on the site's link. Figure 918.1, for example, shows an extensive Favorites menu within the Internet Explorer.

Figure 918.1 Using the Internet Explorer Favorites menu, you can quickly select one of your favorite sites to visit.

To add sites to your Favorites menu, perform the following steps:

1. First, access the Web site by typing the address to the site in Internet Explorer's Address field and then hit the ENTER key (see Tip 913). Internet Explorer, in turn, will display the site.
2. Click your mouse on the Internet Explorer Favorites menu and choose the Add to Favorites menu item right at the top of the menu. The Internet Explorer, in turn, will display the Add Favorite dialog box, as shown in Figure 918.2.
3. Note that the Web page's title is shown in the Name field within the Add Favorite dialog box. If you would like to modify or change the name, click your mouse in the Name: field and then

type in the name you want the Favorites menu to display for the current site. Then, click your mouse on the OK button. The Internet Explorer, in turn, will add the site to the Favorites menu.

Figure 918.2 The Add Favorite dialog box.

Note: *If you view the Internet Explorer Favorites menu, you will find that the menu provides several folders within which you can organize your sites.*

If you want the Internet Explorer to place the current site within a specific folder, perform the following steps:

1. Click your mouse on the Internet Explorer Favorites menu and choose Add to Favorites. The Internet Explorer, in turn, will display the Add Favorite dialog box, as shown in Figure 918.2.
2. Within the Add Favorite dialog box, click your mouse on the Name: field and then type in the name you want the Favorites menu to display for the current site.
3. Within the Create in area's folder list, click your mouse on a specific folder to choose a location in which you would like to place your shortcut. After you have selected a folder location for the short cut, click the OK button to complete the operation.

Note: *If you do not see the Create in area's folder list within the Add Favorite dialog box, click on the Create in << button to expand the dialog box and display the Create in area's folder list. If you would like to add a new folder to the folder list, simply click on the New Folder... button and specify a name for your new folder in the Create New Folder dialog box. See Tip 920 for more information on organizing your Favorites folder.*

SELECTING SITES USING THE INTERNET EXPLORER FAVORITES BAR — 919

In Tip 918, you learned how to add a site to the Internet Explorer Favorites menu. After you add a site to the Favorites menu, you can select the site from Internet Explorer's Favorites menu to browse the site. In addition to selecting the site from the Favorites menu, you can also direct the Internet Explorer to display the Favorites menu within its Explorer Bar, which the Internet Explorer will display along the left-hand side of its window, as shown in Figure 919.

1001 Internet Tips

Figure 919 Displaying the Favorites menu in the Internet Explorer Bar.

To display the Favorites menu within the Internet Explorer Bar, click your mouse on the View menu Explorer Bar option and choose Favorites or click your mouse on the Favorites button found on the toolbar.

920 Organizing Your Favorites Folder

In Tip 918, you learned how to add a Web site to the Internet Explorer Favorites menu. As you learned, when you add a site to the Favorites menu, you can add the site as an upper-level entry within the menu or you can place the site within a folder that appears within the menu. As the number of sites you add to the Favorites menu increases, you may eventually want to remove a site or move a site into a specific folder. To organize the sites that appear on the Favorites menu, perform the following steps:

1. Within the Internet Explorer, click your mouse on the Favorites menu and choose the Organize Favorites option. The Internet Explorer, in turn, will display the Organize Favorites dialog box, as shown in Figure 920.1.

2. To remove a site from the Favorites menu using the Organize Favorites dialog box, click your mouse on the site's entry and then click your mouse on the Delete button. The Internet Explorer, in turn, may display the Confirm File Delete dialog box asking you to confirm the operation. Click your mouse on the Yes button to confirm the deletion. Windows, in turn, will move the shortcut to the Recycle Bin.

Figure 920.1 The Organize Favorites dialog box.

3. To move a site into a specific Favorites menu folder, click your mouse on the site and then click your mouse on the Move to Folder button. Internet Explorer, in turn, will display the Browse for Folder dialog box, as shown in Figure 920.2.

Figure 920.2 The Browse for Folder dialog box.

4. Within the Browse for Folder dialog box, click your mouse on the folder into which you want to move the site's shortcut and then click on the OK button.
5. Within the Organize Favorites dialog box, click your mouse on the Close button.

VIEWING A WEB PAGE'S SOURCE CODE 921

In previous Tips, you have learned to create Web pages using a variety of tools. You also learned that you, as a Web designer, ultimately use Hypertext Markup Language (HTML) to create those Web pages.

1001 INTERNET TIPS

As you become more familiar with Web design and HTML, you might find it useful to be able to view the HTML code used to create the pages you browse with Internet Explorer. When you view sites on the Web, you can direct the Internet Explorer to display the current page's HTML codes by selecting the View menu Source option. Internet Explorer, in turn, will open the Notepad text editor and display the HTML source code for the currently loaded site. Figure 921, for example, shows the HTML source code from the Microsoft Web site at *www.microsoft.com*. By examining another site's HTML code, designers can often learn new HTML techniques.

Figure 921 Viewing HTML source code within the Internet Explorer.

922 CHANGING YOUR DEFAULT WEB PAGE

In Tip 909, you learned how to start and use the Internet Explorer to browse sites on the World Wide Web. Each time you start the Internet Explorer, it will connect you to your default Web site. By default, the Internet Explorer will connect you to a default site created by Microsoft. Using the Internet Properties dialog box, you can specify the Web site to which you want the Internet Explorer to connect you each time it starts. For example, you might want the Internet Explorer to automatically display the Go Network site that you can use to search for information on the Web. Likewise, you may want the Internet Explorer to always display your company's Web site. To specify your default Web site, perform the following steps:

1. Click your mouse on the Start menu Settings button and choose Control Panel. Windows 98, in turn, will open the Control Panel window.
2. Within the Control Panel window, double-click your mouse on the Internet Options icon. Windows 98, in turn, will display the Internet Properties dialog box.
3. Within the Home page area on the General tab of the Internet Properties dialog box, click your mouse in the Address: field and type in the Web address of the site you desire, such as *http://www.go.com*, and then click your mouse on the OK button.

Note: Alternatively, you can access the Internet Options dialog box by using the Tools menu within Internet Explorer. Simply select the Tools menu's Internet Options item. Internet Explore, in turn, will open the same Internet Options dialog box discussed above.

923 Cleaning up Temporary Internet Files

If you have spent time surfing the Web, you know that you can spend a considerable amount of time waiting for your system to download files. To improve performance, most Web browsers will store many of the files you download in temporary folders on your hard disk. Should you later revisit the Web site, your browser can use the files it previously downloaded to immediately display the site's contents. (Actually, your browser will contact the Web site to determine if the files it previously downloaded are current. If the files are current, your browser will use them. Otherwise, your browser will download any files that have changed.)

Although storing downloaded Internet files in this way improves your browser's performance, the temporary files consume disk space that you might need to reclaim. In addition, if another user gains access to your system, that user can view the temporary file's contents and determine which sites you have been visiting. Your company, for example, could use the temporary files to prove that you were using the Web for non-business purposes during working hours.

Fortunately, Windows 98 lets you purge (delete) the temporary files when you no longer need them and you can specify how much disk space the temporary files can consume. To purge your temporary Internet files, perform the following steps:

1. Click your mouse on the Start menu Settings button and choose Control Panel. Windows 98, in turn, will open the Control Panel window.
2. Within the Control Panel window, double-click your mouse on the Internet Options icon. Windows 98, in turn, will display the Internet Properties dialog box.
3. Within the Internet Properties dialog box Temporary Internet files area, click your mouse on the Delete Files button. Windows 98, in turn, will display the Delete Files dialog box that prompts you to confirm the file deletion.
4. Within the Delete Files dialog box, click your mouse on the OK button.

If you do not want to purge all the files in your temporary Internet files folders, the following Tip discusses how to view the directory in which the files are kept so you can choose which files to delete.

Note: *Alternatively, you can access the Internet Options dialog box by using the Tools menu within Internet Explorer. Simply select the Tools menu Internet Options item. Internet Explorer, in turn, will open the same Internet Options dialog box discussed above.*

924 Controlling How Windows 98 Manages Temporary Internet Files

In Tip 923, you learned how to use the Internet Options dialog box to purge your temporary Internet files from your disk. Before you delete the temporary files, there may be times when you want to display a listing of files. Or, if you are an employer, you may want to view the Web sites your employees are visiting during working hours. Within the Internet Properties dialog box Temporary Internet files area, you can click your mouse on the Settings button to access the Settings dialog box, as shown in Figure 924. You can use the View Files button to display a list of the temporary Internet files currently stored on your computer. (Within the list, you can double-click your mouse on an entry to view the file's contents.)

1001 Internet Tips

In addition, within the Settings dialog box, you can control how much disk space Windows 98 can allocate for your temporary Internet files and how often, after downloading files, your browser will check for updates to a site's file.

Figure 924 *The Internet Properties dialog box Settings dialog box.*

As you have learned, after your browser downloads files from a Web site, your browser can later display those files' contents again should you visit the Web site a second time. Within the Settings dialog box, you can control how often your browser will check for file updates. For example, if you visit Web sites that change their contents very often (such as every few minutes), you will want your browser to check for new files every time you visit a Web site. If you normally start your browser, view a few sites, and then end your browser, you may want your browser to check for file updates for sites that you have visited since you last started your browser. Likewise, if you do not care to view a site's most current contents, you can direct your browser never to check for new files and to always use its cached file contents if a temporary file is available for the current site.

Within the Settings dialog box Temporary Internet files folder area, you can use the Amount of disk space to use: slider to control how much of your disk Windows 98 will allocate for storing temporary Internet files. To increase or decrease the amount of disk space Windows 98 will allocate for temporary files, use your mouse to drag the slider bar to the right or to the left. After Windows 98 consumes the amount of disk space you allow, Windows 98 will delete your oldest files.

925 MOVING THE FOLDER WITHIN WHICH WINDOWS 98 STORES YOUR TEMPORARY INTERNET FILES

As you have learned, to improve its performance, your browser stores the information it downloads from the Web sites you visit as temporary files within a folder on your disk. By default, your browser will store the files within the *C:\Windows\Temporary Internet Files* folder. However, depending on your needs, there may be times when you will want your browser to store the temporary files at a different location. For example, if you work within an office, many companies store a user's files within folders that reside on a network server. If your browser is storing your temporary files on a network server, you may encounter two problems. First, because your network must transfer each file you download to the server, your temporary Internet files can consume considerable network bandwidth (which will slow down other network operations) and may consume considerable space on the server's hard disk. Second, because the files now reside on a network server, your network administrator may be able to view the file's contents to determine which Web sites you visit.

1001 Internet Tips

To change the location at which your browser will store your temporary Internet files, perform the following steps:

1. Click your mouse on the Start menu Settings button and choose Control Panel. Windows 98, in turn, will open the Control Panel window.
2. Within the Control Panel window, double-click your mouse on the Internet Options icon. Windows 98, in turn, will display the Internet Properties dialog box.
3. Within the Internet Properties dialog box Temporary Internet files area, click your mouse on the Settings button. Windows 98, in turn, will display the Settings dialog box.
4. Within the Settings dialog box, click your mouse on the Move Folder button. Windows 98, in turn, might display a Warning! dialog box that tells you to move your temporary files, it must delete your subscription data (which means you must re-subscribe later). Click your mouse on the OK button. Windows 98, in turn, will display the Browse for Folder dialog box.
5. Within the Browse for Folder dialog box, click your mouse on the folder you desire and then click your mouse on the OK button.

Note: *Alternatively, you can access the Internet Options dialog box by using the Tools menu within Internet Explorer. Simply select the Tools menu's Internet Options item. Internet Explorer, in turn, will open the same Internet Options dialog box discussed above.*

CONFIGURING INTERNET EXPLORER'S COLOR UTILIZATION 926

Like Windows 98, Internet Explorer is customizable. If you spend a considerable amount of time surfing the Web, you may want to customize your browser's color settings. To specify your browser colors, perform the following steps:

1. Click your mouse on the Start menu. Select the Settings option and then choose Control Panel. Windows 98, in turn, will open the Control Panel window.
2. In the Control Panel window, double-click your mouse on the Internet Options icon. Windows 98, in turn, will display the Internet Properties dialog box.
3. In the Internet Properties dialog box, click your mouse on the Colors button located in the lower left-hand corner of the General tab. Windows 98, in turn, will display the Colors dialog box, as shown in Figure 926.

Figure 926 The Colors dialog box.

1001 Internet Tips

4. In the Colors dialog box, you can specify the colors your browser uses for its background color and for text display. By default, the browser will use the current Windows 98 color scheme. To select your own color settings, click your mouse on the Use Windows colors checkbox to remove the checkmark. Then, click on the Text or Background buttons to specify the colors you desire.

5. In the Colors dialog box, you can also specify the colors you want your browser to use to display links you can visit as well as links you have visited. In addition, you can choose a color you want your browser to use when you hold your mouse over a link (hover over the link).

6. After you select the colors you desire, click your mouse on the OK button to put your changes into effect. Then, click your mouse on the OK button to close the Internet Properties dialog box.

927 CONFIGURING INTERNET EXPLORER'S FONT UTILIZATION

If you use your browser on a regular basis, there may be times when you will want to customize the browser's font usage (you might, for example, select a larger bolder font that you find easier to read). To customize your browser's font settings, perform the following steps:

1. Click your mouse on the Start menu. Select the Settings option and then choose Control Panel. Windows 98, in turn, will open the Control Panel window.

2. In the Control Panel window, double-click your mouse on the Internet Options icon. Windows 98, in turn, will display the Internet Properties dialog box.

3. Within the Internet Properties dialog box, click your mouse on the Fonts button located in the lower part of the General tab. Windows 98, in turn, will display the Fonts dialog box, as shown in Figure 927.

Figure 927 The Fonts dialog box.

4. Within the Fonts dialog box, you can specify the Language script that you desire as well as the specific fonts your browser will use for Web page font and Plain text font operations.

5. After you select your font settings, click your mouse on the OK button to apply your changes. Then, click your mouse on the OK button to close the Internet Properties dialog box.

1001 Internet Tips

CONTROLLING INTERNET EXPLORER'S LANGUAGE SUPPORT — 928

Depending on the Web sites that you visit, you may encounter sites whose content is based on a different language. Fortunately, using the Language Preferences dialog box shown in Figure 928, you can add software that will let your browser support multiple language attributes. To access the Language Preferences dialog box, simply click your mouse on the Languages button at the bottom of the General tab in the Internet Properties dialog box.

Figure 928 The Language Preferences dialog box.

Within the Language Preferences dialog box, you can add other languages you want your browser to support. By default, when you visit a Web site, your browser will prioritize the languages in the order they appear within the Language list. To change a language's priority, click your mouse on the language within the list and then click your mouse on the Move Up or Move Down button. To add a language to the list, click your mouse on the Add button. Windows 98, in turn, will display the Add Language dialog box, from which you can select the language that you would like to add. After you make your changes within each dialog box, click your mouse on the OK button to put your changes into effect. Then, click your mouse on the OK button to close the Internet Properties dialog box.

USING HISTORY TO ACCESS PREVIOUSLY VIEWED WEBS — 929

To make it easier for you to revisit sites across the Web, your browser keeps a history (a list) of the sites you visit. If you want to revisit a site, you can simply click your mouse on the Toolbar's History button to view the History list in Internet Explorer's Explorer Bar. (For more information about the Explorer Bar, see Tip 917.) The Explorer Bar History list groups sites you have visited by day and week. For example, Figure 929 shows the Internet Explorer's History Explorer Bar view from which you can click your mouse on the site you want to revisit.

1001 INTERNET TIPS

Figure 929 Selecting a site to revisit from the Internet Explorer's Explorer Bar History list.

930 CLEARING YOUR HISTORY FOLDER

Within the Internet Properties dialog box, you can clear (erase) the current history list and specify the number of days for which Windows 98 will maintain a site's hyperlink entry within the history list. If you use a browser at work, you may want to clear your history list at the end of each day so your employer cannot use the list to track the Web sites you visit during your working hours. To clear your history list, perform the following steps:

1. Click your mouse on the Start menu. Select the Settings option and then choose Control Panel. Windows 98, in turn, will open the Control Panel window.
2. In the Control Panel window, double-click your mouse on the Internet Options icon. Windows 98, in turn, will display the Internet Properties dialog box.
3. In the History area on the General tab of the Internet Properties dialog box, click your mouse on the Clear History button. Windows 98, in turn, will display a dialog box asking you to confirm the history list deletion. Click your mouse on the OK button. Windows 98, in turn, will delete all of the History information that has been stored.

Note: Tip 931 discusses setting the number of days that Windows 98 will maintain a link to a site in the History list.

931 CONFIGURING YOUR HISTORY FOLDER

As you learned in Tip 930, you can clear the contents of the Internet Explorer History list. Further, you can specify the number of days an entry will remain in the History list before it is automatically deleted. To specify the number of days for which Windows 98 will maintain a site within the History list, perform the following steps:

1. Click your mouse on the Start menu. Select the Settings option and then choose Control Panel. Windows 98, in turn, will open the Control Panel window.
2. In the Control Panel window, double-click your mouse on the Internet Options icon. Windows 98, in turn, will display the Internet Properties dialog box.
3. In the History area on the General tab of the Internet Properties dialog box, click your mouse on the Days to keep pages in history field and type in the number of days you desire. Alternatively, you can use the increment/decrement buttons to adjust the number of days to keep pages in the history. The Days to keep pages in history value can range from 0 to 999 days. When you have set the desired number of days, click your mouse on the OK button to apply your changes and close the dialog box.

UNDERSTANDING YOUR BROWSER'S SECURITY ZONE SETTINGS 932

As you surf sites across the World Wide Web, there will be times when a site may want to download software onto your system that the site uses to play music, play back video or animations, or to perform other specific tasks. To avoid computer viruses or other damage or invasion of privacy, you may not want to download programs from sites on the Web, particularly from sites whose contents you do not know or trust.

Note: *Generally, you can feel safe downloading software from a reputable company's Web site, such as Microsoft, Netscape, VeriSign, or even your computer manufacturer.*

To help you prevent a site from downloading software that may damage your system, Windows 98 lets you take advantage of security zones. Each security zone lets your browser perform different operations based on the zone's security level. Within your Trusted sites zone, for example, your browser can download and install software. From other zones, however, you might disable software-download operations or require that your browser prompt you before it downloads software. To manage your security-zone settings and the sites that you place in each zone, you will use the Internet Properties dialog box Security tab, as shown in Figure 932.

Figure 932 The Internet Properties dialog box Security tab.

On the Security tab, you can see that Windows 98 defines four security zones. If you click your mouse on one of the icons that represents a security zone, you can adjust the security level for that zone and also view site information for the sites included in that zone. Table 932 briefly describes each of the four Security zones defined for use by Internet Explorer.

Zone	Description
Local intranet zone	Contains a list of sites that reside within your company's intranet
Trusted sites zone	Contains a list of sites that you trust not to damage your system
Internet zone	Contains the majority of sites across the Web—sites you have not assigned to other zones
Restricted sites zone	Contains a list of sites that may potentially download damaging software

Table 932 Windows 98 Internet security zones.

The Internet zone is a catchall zone that your browser will use for all sites that you have not specifically assigned to a different zone. Within each zone, you can define the level of operations that your browser can perform for the zone's sites. Several of the Tips that follow examine security-zone operations in detail.

933 CONTROLLING AN INTERNET ZONE'S SECURITY SETTINGS

In Tip 932, you learned that Windows 98 lets you assign Web sites to different security zones. Later, when you surf the Web, your browser will use the zone settings to determine which operations it can perform for a specific site. To assign security settings to an Internet zone, perform the steps:

1. Click your mouse on the Start menu. Select the Settings option and then choose Control Panel. Windows 98, in turn, will open the Control Panel window.
2. In the Control Panel window, double-click your mouse on the Internet Options icon. Windows 98, in turn, will display the Internet Properties dialog box.
3. Within the Internet Properties dialog box, click your mouse on the Security tab. Windows 98, in turn, will display the Security tab.
4. On the Security tab, click your mouse on the icon that represents the zone for which you want to assign security settings. Next, using the security level slider buttons, choose the level of security you want your browser to enforce for the corresponding zone and then click on the OK button to apply your changes.

As you become more comfortable with Security settings, you can define your own security settings by clicking your mouse on the Custom Level button and then setting your own individual security options. For example, you can enable or disable the browser's ability to download plug-ins, ActiveX controls, Java applets, and so on.

934 ADDING A WEB SITE TO A SECURITY ZONE

In Tip 932, you learned that Windows 98 provides security zones that you can use to control how your browser performs software-download operations as you surf sites on the World Wide Web. In Tip 933, you learned how to

define each zone's security settings. If there are Web sites that you visit on a regular basis, you may want to add those sites to specific security zones. For example, you might add the Microsoft Web site to a trusted zone. To add a Web site to a specific Internet security zone, perform the following steps:

1. Click your mouse on the Start menu. Select the Settings option and then choose Control Panel. Windows 98, in turn, will open the Control Panel window.
2. In the Control Panel window, double-click your mouse on the Internet Options icon. Windows 98, in turn, will display the Internet Properties dialog box.
3. Within the Internet Properties dialog box, click your mouse on the Security tab. Windows 98, in turn, will display the Security tab.
4. On the Security tab, click your mouse on the zone icon that represents the zone to which you want to assign the Web site.

Note: *You cannot add sites to the Internet Zone, it is the catchall zone to which all sites belong until you assign the sites to a different zone.*

5. After you select the zone you desire, click your mouse on the Sites button. Windows 98, in turn, will display the dialog box specific to the zone, within which you can add a site's Web address. After you add the site, click your mouse on the OK button.
6. In the Internet Properties dialog box, click your mouse on the OK button to apply your changes.

INSTALLING MICROSOFT WALLET 935

If you have used the Internet to shop, you have undoubtedly typed in credit card and shipping information that you then sent across the Internet to a Web site. Normally, when you send such information, you do so using a secure connection and your credit card information is relatively safe. To simplify (and to further secure) your credit card use while shopping on the Internet, Internet Explorer provides Microsoft Wallet, a software component you can use to store your credit card and shipping information. Later, when you shop, you can use the information Microsoft Wallet contains to easily pass your credit card and shipping information to Web sites across the Internet.

Note: *No user or application can see the information without your permission.*

If another user gains access to your system, the user must specify your wallet password before the user can view or use your data. The Microsoft Wallet software will work with a variety of programs that support the Personal Information Exchange (PFX) standard.

Before you can use the Microsoft Wallet, you must install the software on your system. To install Microsoft Wallet, perform the following steps:

1. Click your mouse on the Start menu. Select the Settings option and then choose Control Panel. Windows 98, in turn, will open the Control Panel window.
2. In the Control Panel window, double-click your mouse on the Add/Remove Programs icon. Windows 98, in turn, will display the Add/Remove Programs Properties dialog box.
3. Within the Add/Remove Programs Properties dialog box, click your mouse on the Windows Setup tab. Windows 98, in turn, will display checkboxes used to install or uninstall Windows 98 components.

1001 Internet Tips

4. Within the Windows 98 component list, click your mouse on the Internet Tools checkbox and then click your mouse on the Details button. Windows 98, in turn, will display the Internet Tools dialog box.

5. Within the Internet Tools dialog box, click your mouse on the Microsoft Wallet checkbox, placing a checkmark within the box. Then, click your mouse on the OK button.

6. Within the Add/Remove Programs Properties dialog box, click your mouse on the OK button. Windows 98, in turn, will respond by copying and installing the Microsoft Wallet program.

Note: *You might be prompted for your Windows 98 installation CD-ROM.*

In Tip 936, you will learn how to use the Microsoft Wallet to store your credit card and shipping information.

936 STORING YOUR CREDIT CARD INFORMATION IN MICROSOFT WALLET

In Tip 935, you learned how to install the Microsoft Wallet software that you can use to store your credit card and shipping information for the purposes of shopping over the Internet. To record your credit card information within the Wallet, perform the following steps:

1. Click your mouse on the Start menu. Select the Settings option and then choose Control Panel. Windows 98, in turn, will open the Control Panel window.

2. In the Control Panel window, double-click your mouse on the Internet Options icon. Windows 98, in turn, will display the Internet Properties dialog box.

3. In the Internet Properties dialog box, click your mouse on the Content tab. Windows 98, in turn, will display the Content tab of the Internet Properties dialog box.

4. On the Content tab, click your mouse on the Wallet button. Windows 98, in turn, will display the Payment Options dialog box.

5. In the Payment Options dialog box, click your mouse on the Add button. Windows 98, in turn, will display a menu of credit card options, as shown in Figure 936.

Figure 936 *The Payment Options credit card list.*

1001 Internet Tips

6. On the pull-down credit card list, click your mouse on the credit card type you desire. Windows 98, in turn, will start the Add a New Credit Card Wizard, which will walk you through the steps you must perform to enter your credit card and billing address information.

7. After you have completed the steps outlined by the Add a New Credit Card Wizard, click your mouse on the Close button to close the Payment Options dialog box.

8. Within the Internet Properties dialog box, click your mouse on the OK button to apply your changes.

CONFIGURING YOUR PROFILE INFORMATION FOR USE WHILE BROWSING THE WEB — 937

In Tips 935 and 936, you learned how to install and configure Microsoft Wallet using the Content tab of the Internet Properties dialog box. You can also use the Microsoft Profile Assistant on the Content tab to edit your Profile information. Your Profile information is personal information such as name, address, and telephone information that you can share when a Web site requests information from its visitors. To record your Profile information for use by Internet Explorer, perform the following steps:

1. Click your mouse on the Start menu. Select the Settings option and then choose Control Panel. Windows 98, in turn, will open the Control Panel window.

2. In the Control Panel window, double-click your mouse on the Internet Options icon. Windows 98, in turn, will display the Internet Properties dialog box.

3. In the Internet Properties dialog box, click your mouse on the Content tab. Windows 98, in turn, will display the Content tab of the Internet Properties dialog box.

4. On the Content tab, click your mouse on the My Profile button. Windows 98, in turn, will display the Main Identity Options dialog box.

5. Within the Main Identity Options dialog box, click your mouse on the Name tab and type your name and address in the appropriate fields, as shown in Figure 937.

Note: *Configure other information on the remaining tabs in the Main Identity Properties dialog box as needed.*

6. When you have finished entering information into the Main Identity Options dialog box, click your mouse on the OK button.

Figure 937 *The Main Identity Options dialog box.*

1001 Internet Tips

938 — Specifying the Programs Internet Explorer Will Use for Each Internet Service

Using Internet Explorer and its accompanying tools, you can view Web sites or newsgroups, send and receive electronic mail, and even perform an Internet call. When you perform any of these operations, Internet Explorer, in turn, will run a second program, such as Microsoft Outlook Express or NetMeeting, to perform the operation. Using the Internet Properties dialog box Programs tab, shown in Figure 938, you can specify which program your browser will run to perform these operations.

Figure 938 The Internet Properties dialog box Programs tab.

On the Programs tab, click your mouse on the pull-down list that corresponds to the operation for which you want to assign a new program and select the program you desire.

In addition to using the Programs tab to specify the programs your browser will launch for Internet operations, you can also use the Programs tab to specify the applications you want the browser to launch for your calendar and contact management tasks.

939 — Configuring Internet Explorer to Check to See If It Is the Default Browser

As you browse the Web and become more familiar with Internet technologies, you might install additional Internet-related software to try out. If you install another Web browser in addition to Internet Explorer, you can configure Internet Explorer to check to see if it is the default browser. If configured to do so, Internet Explorer will check to see if it is the default browser, and as such, will launch whenever you click your mouse on a Web link in another document, on your active Desktop, or typed into your Address Toolbar.

To configure Internet Explorer to check to see if it is the default Web browser, perform the following steps:

1. Click your mouse on the Start menu. Select the Settings option and then choose Control Panel. Windows 98, in turn, will open the Control Panel window.

2. In the Control Panel window, double-click your mouse on the Internet Options icon. Windows 98, in turn, will display the Internet Properties dialog box.

3. Within the Internet Properties dialog box, click your mouse on the Programs tab. Windows 98, in turn, will display the Programs tab.

4. Near the bottom of the Programs tab, click your mouse on the checkbox directly to the right of the words Internet Explorer should check to see whether it is the default browser. Click the OK button to apply your changes and close the Internet Properties dialog box.

CONFIGURING INTERNET EXPLORER'S ACCESSIBILITY OPTIONS 940

Within the Windows 98 Control Panel, you can use the Accessibility Options applet to configure the operating system to accommodate users who are mobility, hearing, or visually impaired. For example, you might select a high-contrast screen display to make it easier for a user to view the screen contents. As you surf sites on the Web, there may be times when a site's HTML file specifies specific colors, font styles, or font sizes that you find difficult to read. Depending on your needs, you may want your browser to ignore the site's settings—so that you find the site's content easier to view. To control your browser's accessibility settings, perform the following steps:

1. Click your mouse on the Start menu. Select the Settings option and then choose Control Panel. Windows 98, in turn, will open the Control Panel window.

2. In the Control Panel window, double-click your mouse on the Internet Options icon. Windows 98, in turn, will display the Internet Properties dialog box.

3. On the Internet Properties dialog box General tab, click your mouse on the Accessibility button. Windows 98, in turn, will display the Accessibility dialog box, as shown in Figure 940.

Figure 940 *Internet Explorer's Accessibility dialog box.*

4. In the Accessibility dialog box, you can choose to ignore colors, font styles, and font sizes specified on Web pages. You can also specify that Internet Explorer will use your own style-sheet.

Note: *A Style Sheet is used to specify the default font style, size, colors, and backgrounds for text and headings for pages viewed in Internet Explorer.*

1001 INTERNET TIPS

941 CONFIGURING INTERNET EXPLORER'S ADVANCED BROWSER SETTINGS

Several of the Tips in this section of the book examine specific operations you can perform to configure Internet Explorer and its associated applications. This Tip examines the Internet Properties dialog box Advanced tab, as shown in Figure 941. On the Advanced tab, you can control specific browser settings, which HTTP protocol your browser uses, how your browser handles Java programs you encounter on the Web, and much more.

Figure 941 The Internet Properties dialog box Advanced tab.

To further customize your Internet program settings using the Advanced tab, perform the following steps:

1. Click your mouse on the Start menu. Select the Settings option and then choose Control Panel. Windows 98, in turn, will open the Control Panel window.
2. In the Control Panel window, double-click your mouse on the Internet Options icon. Windows 98, in turn, will display the Internet Properties dialog box.
3. Within the Internet Properties dialog box, click your mouse on the Advanced tab. Windows 98, in turn, will display the Advanced tab.

In the following Tips, you will learn to configure some of the specific areas on the Advanced tab of the Internet Properties dialog box.

942 CONFIGURING INTERNET EXPLORER'S ADVANCED MULTIMEDIA SETTINGS

As you learned in Tip 941, you can use the Advanced tab of the Internet Properties dialog box to configure specific advanced browser settings, such as which HTTP protocol your browser will use, how your browser handles Java programs you encounter on the Web, and much more.

1001 INTERNET TIPS

The Multimedia options area of the Advanced tab, shown in Figure 942, controls how Internet Explorer handles multimedia files that are made available by Web sites you browse. From time to time, you may find that Web sites with extensive multimedia content are loading much too slowly for your liking. You can use the Advanced tab multimedia options to turn off downloading of various multimedia content, such as sounds and animations.

Figure 942 The Multimedia settings area of the Advanced tab in the Internet Properties dialog box.

CONFIGURING INTERNET EXPLORER'S JAVA VIRTUAL MACHINE — 943

As you learned in Tip 941, you can use the Advanced tab of the Internet Properties dialog box to configure specific advanced browser settings, such as which HTTP protocol your browser will use, how your browser handles Java programs you encounter on the Web, and much more. One such configurable option is the Java Virtual Machine or Java VM. The checkboxes found under the Java VM heading let you configure how Internet Explorer handles Java applets downloaded to your browser. For example, you can configure Internet Explorer to log all Java program activity. In doing so, you can use the logged information to verify that the applets are safe and your system is secure, as well as troubleshoot applets that appear to run incorrectly. There are also Java VM settings specifically for developers of Web-based applets.

PRINTING BACKGROUND COLORS AND IMAGES — 944

In your browser, you can print a Web page's contents by selecting the File menu Print option or by clicking your mouse on the Printer icon on the Standard Buttons toolbar. By default, to make your printouts easier to read, your browser does not print background graphics or colors that appear on the Web page. Instead, your browser will print the Web site text and graphics images that appear within the text. For example, if the site displays its text on a yellow

1001 Internet Tips

background, your browser, by default, does not print the yellow background. To direct your browser to print a site's background color or background image, perform the following steps:

1. Click your mouse on the Start menu. Select the Settings option and then choose Control Panel. Windows 98, in turn, will open the Control Panel window.
2. In the Control Panel window, double-click your mouse on the Internet Options icon. Windows 98, in turn, will display the Internet Properties dialog box.
3. Within the Internet Properties dialog box, click your mouse on the Advanced tab. Windows 98, in turn, will display the Internet Properties dialog box Advanced tab, as shown in Figure 944.

Figure 944 The Internet Properties dialog box Advanced tab.

4. Within the Advanced sheet, click your mouse on the Print background colors and images checkbox, placing a checkmark within the box. Then, click your mouse on the OK button to apply your changes.

945 Using the Internet Connection Wizard to Get You Connected

To help you get connected to the Internet, Windows 98 provides the Internet Connection Wizard. Using the Wizard, you can configure your PC to use an Internet Service provider to access the Internet using your modem and phone lines or using a local-area network (LAN) connection. If you are connected to a local-area network that will provide you with Internet access, you should have your network administrator assist you in configuring your network settings. (Your system may already be ready to access the Internet.) If you want to configure your system to use a new or existing Internet Service Provider account, perform the following steps:

1. Click your mouse on the Start menu. Select the Settings option and then choose Control Panel. Windows 98, in turn, will open the Control Panel window.
2. In the Control Panel window, double-click your mouse on the Internet Options icon. Windows 98, in turn, will display the Internet Properties dialog box.

1001 Internet Tips

3. Within the Internet Properties dialog box, click your mouse on the Connections tab. Windows 98, in turn, will display the Internet Properties dialog box Connection tab.

4. On the Connections tab, click your mouse on the Setup button. Internet Explorer, in turn, will launch the Internet Connection Wizard. Figure 945 displays the Internet Connection Wizard welcome screen.

Figure 945 The Windows 98 Internet Connection Wizard.

5. In the Internet Connection Wizard welcome dialog box, click your mouse on the radio button that corresponds to the account type you want to connect (a new account, an existing account, or a manual or LAN configuration). Then, click your mouse on the Next button. The Wizard, in turn, will display a series of dialog boxes that will guide you through the process of setting up the account.

If you are creating a new account, the Internet Connection Wizard can download a list of Internet Service providers available within your area code. From this list, you can sign up for Internet access using one of the specified providers.

Note: *You can click your mouse on the Tutorial button on the Internet Connection Welcome screen to launch a tutorial that will teach you the basics of Internet use and connecting to the Internet.*

SELECTING A MODEM OR LOCAL-AREA NETWORK INTERNET CONNECTION 946

To access the Internet, users usually connect their PC to the Internet through an Internet Service Provider using a modem and phone lines or through a connection on their local-area network (LAN). Before you can access the Internet, you must tell Windows 98 how you will connect your PC to the Internet. In Tip 945, you learned how to use the Internet Connection Wizard to simplify the process of configuring a connection to the Internet. You can also use the Internet Properties dialog box Connections tab, shown in Figure 946.1, to select and configure a dial-up connection or to configure a LAN connection manually.

If you are using a modem to connect to the Internet, you can click your mouse on the Connections tab's Settings button to configure your dial-up connection settings, as shown in Figure 946.2.

1001 INTERNET TIPS

Figure 946.1 The Internet Properties dialog box Connections tab.

Figure 946.2 The Dial-Up Settings dialog box that can be used to configure your dial-up connection.

Within the Dial-Up Settings dialog box, you can specify the username and password you use to connect to your Internet Service provider as well as other configurable options. See Tip 808 for a discussion of proxy servers. See Tip 112 for a discussion of Dial-Up Networking options.

Note: If you must change the number Windows 98 dials for your provider, you can select the provider within the Connections tab Dial-Up Settings pull-down list and click your mouse on the Settings button. Windows 98, in turn, will display the Settings dialog box. Click your mouse on the Properties button. Windows 98, in turn, will display the Properties dialog box for your connection within which you can change the phone number and other settings.

947 STOPPING A WEB SITE DOWNLOAD

As you surf the Web, there may be times when, after you initiate a Web site's download, you decide that you no longer want to view the site's contents, meaning you want to stop the download of the site possibly because you

1001 INTERNET TIPS

selected the site by mistake or because the site is taking too long to download. To direct Internet Explorer to stop downloading a site, click your mouse on the Standard Buttons toolbar Stop button or press your keyboard's Esc key.

After the Internet Explorer stops the download operation, you can type a different address in the Internet Explorer's Address field to continue surfing the Web. Should you stop a download and then decide you would like to resume the download, you may be able to restart the download by simply clicking your mouse on the Standard Buttons toolbar Refresh button or by pressing the F5 function key.

Note: *If you initiated the download of the site by clicking a link and the new Web site's address has not yet appeared in the Address bar's Address field, the Refresh button or F5 key may not reload the new site, but rather, refresh the previous site you were viewing.*

OPENING A NEW INTERNET EXPLORER WINDOW 948

As you traverse sites on the Web, there may be times that you find a site that contains some of the information that you need, but you still want to continue your search. In such cases, you can use the Internet Explorer's File menu New option and then choose Window to open a second window, within which you can continue your search while you leave your first site's contents in view. For example, Figure 948 shows two Internet Explorer windows. When you are done with either window, you can select that window's File menu Close option to close the window or simply click your mouse on the window's Close button.

Figure 948 *Using multiple Internet Explorer windows to surf the Web.*

949 REFRESHING THE CURRENT PAGE

When you view sites on the Web, there may be times when, due to an error, or because you previously stopped the site's download, Internet Explorer does not download the entire site's text or graphics. Or you may want to re-load the page to view any changes that may have occurred since you first loaded it into your browser. In such cases, you can restart the download operation or refresh the page by clicking your mouse on the Standard Buttons toolbar Refresh button or by pressing the F5 function key on your keyboard. When you refresh a Web site in this way, the Internet Explorer will only download the files it previously failed to download or content that has changed since you performed the last download operation.

As you learned in Tips 923 and 924, when you download a site's contents, Internet Explorer stores some of the content in temporary files on your hard disk. If you later revisit the site, the Internet Explorer will use the previously downloaded contents, which improves the speed with which Internet Explorer can display the site's contents. Depending on your system's Internet settings, Internet Explorer may not check whether the site's contents have changed since your previous download operation. By refreshing the page as described above, you can direct Internet Explorer to test whether or not the site's contents have changed and, if so, to download the updated content.

950 SENDING THE CURRENT WEB SITE TO AN E-MAIL RECIPIENT

As you surf the Web, there may be times when you encounter a site, the contents of which you would like another user to see. In such cases, you can e-mail the current page or a link to the current page to another user right from within Internet Explorer. To send the current page or a link to the current page to an e-mail recipient, perform the following steps:

1. Within the Internet Explorer, click your mouse on the File menu and move your cursor to the Send option. The Internet Explorer, in turn, will cascade the Send sub-menu, as shown in Figure 950. Alternatively, you can click your mouse on the Standard Buttons toolbar Mail button to cascade a similar menu.

Figure 950 Cascading the Internet Explorer Send sub-menu.

2. On the Send sub-menu, select the Page by Email option to send the contents of the current page to another user. Alternatively, select the Link by E-mail option to send a link (the site's Web address) to the Web site to an e-mail recipient. The Internet Explorer, in turn, will compose an e-mail message using Outlook Express (or the e-mail program you have configured your system to use) that you can then address and send to the recipient or recipients that you desire.

Understanding HTTP 1.1 in Internet Explorer — 951

As you learned in Tip 941, you can use the Advanced tab of the Internet Properties dialog box to configure specific advanced browser settings, such as which HTTP protocol your browser will use, how your browser handles Java programs you encounter on the Web, and much more.

The HTTP 1.1 settings area of the Advanced tab shown in Figure 951 controls whether or not Internet Explorer will attempt to use the HyperText Transfer Protocol (HTTP) 1.1 protocol when connecting to Internet Web sites. Many sites on the Web still use the HTTP 1.0 protocol. It follows that if you encounter problems browsing a particular Web site, you might try unchecking the Use HTTP 1.1 checkbox on the Internet Properties Advanced tab to see if the Web site will load successfully.

Figure 951 Viewing the HTTP 1.1 setting on the Advanced tab of the Internet Properties dialog box.

Likewise, many proxy servers are based on the HTTP 1.0 protocol and therefore may not work well with a browser configured to use the HTTP 1.1 protocol. You can check or uncheck the Use HTTP1.1 through proxy connections checkbox to configure whether or not your browser will use the HTTP 1.1 protocol when accessing Web sites through a proxy server.

Using Internet Explorer's Radio Toolbar — 952

Internet Explorer's Radio Toolbar lets you listen to broadcast radio stations and Internet-only radio stations via your Web browser. You can choose from a variety of station categories such as Sports, Talk Radio, International, and

1001 INTERNET TIPS

Christian Contemporary, to name just a few, through your computer while you browse the Web. The Radio Toolbar is available in Internet Explorer after you have installed the Windows Media Player. Fortunately, a version of the Windows Media Player is included with Internet Explorer. Tip 464 discusses the Windows Media Player. To turn on the Radio Toolbar within Internet Explorer, click on the View menu. Move your mouse cursor to Toolbars, and select Radio from the Toolbars fly-out menu. Internet Explorer, in turn, will respond by displaying the Radio Toolbar, as shown in Figure 952.1.

Figure 952.1 Internet Explorer's Radio Toolbar.

After you have turned on the Radio Toolbar, you can choose a radio station to listen to by performing the following steps:

1. Within Internet Explorer, click your mouse on the Radio Toolbar's Radio Stations drop-down menu and choose Radio Station Guide. Internet Explorer, in turn, will open the WindowsMedia.com Web site (*http://windowsmedia.microsoft.com/radio/radio.asp*) in your browser, as shown in Figure 952.2.

Figure 952.2 The WindowsMedia.com audio-video guide Web site.

2. From the WindowsMedia.com Web site, choose one of the four radio buttons which display options for finding your favorite radio station. After you choose a radio button,

1001 Internet Tips

Internet Explorer, in turn, will display a drop down list of radio stations that correspond to your category.

3. Within the radio station list, choose your radio station by clicking your mouse on the radio button to the left of the radio station you would like to listen to. Next, click your mouse on the Listen Now! link to the right of the radio station listing. Internet Explorer, in turn, will open the radio station's Web page (in many cases, a Broadcast.com Web page) and the radio station will start playing through your sound card and speakers.

Note: As you try different radio stations using the Radio Toolbar, you can add your favorite stations to your favorites list. The Radio Toolbar will also store a 'most recently used' list of the radio stations you have accessed recently, as shown in Figure 952.3.

Figure 952.3 The list of the radio stations you have accessed recently stored on the Radio Stations drop-down list on the Radio Toolbar.

EMPTYING THE TEMPORARY INTERNET FILES FOLDER WHEN THE BROWSER IS CLOSED — 953

As you have learned, to improve its performance, your browser stores some of the information it downloads for the sites that you visit on the Web as temporary files within folders on your hard disk. Should you later revisit a site, your browser can quickly display the site by using the temporary files it has retained for that site. In Tip 923, you learned how to purge the temporary Internet files from your disk. If you are using a browser at work, and you do not want another user to determine the sites you visit by examining your temporary Internet files, you can direct your browser to delete its temporary files each time you close the browser window. To direct your browser to delete its temporary files each time you close the browser window, perform the following steps:

1. Click your mouse on the Start menu. Select the Settings option and then choose Control Panel. Windows 98, in turn, will open the Control Panel window.
2. In the Control Panel window, double-click your mouse on the Internet Options icon. Windows 98, in turn, will display the Internet Properties dialog box.
3. Within the Internet Properties dialog box, click your mouse on the Advanced tab. Windows 98, in turn, will display the Internet Properties dialog box Advanced tab.
4. On the Advanced tab, scroll down to the Security section on the list and click your mouse on the Empty Temporary Internet Files folder when browser is closed checkbox, placing a check mark within the box. Then, click your mouse on the OK button to apply your changes.

1001 Internet Tips

954 Getting Help in Internet Explorer

Like other Windows applications you are probably familiar with, Internet Explorer is packaged with a sophisticated set of help information. From time to time, you might want to research a problem or learn how to perform a specific task within Internet Explorer. You can access help at any time within Internet Explorer by using the Help menu, as shown in Figure 954.1. This Tip and the Tips to follow will discuss the different types of help you can access.

Figure 954.1 *The Internet Explorer Help menu.*

The Contents and Index option found on the Help menu provides a quick method to search for hints and to solve problems within Internet Explorer (see Figure 954.1). Select the Contents and Index option from the Internet Explorer Help menu to open the Microsoft Internet Explorer Help dialog box, as shown in Figure 954.2.

Figure 954.2 *The Microsoft Internet Explorer Help dialog box.*

Within the Help dialog box, you will notice three tabs: a Contents tab, an Index tab, and a Search tab. The Contents tab lets you browse through help as if you were looking through the contents pages of a book. When you

find a topic that you would like to view, you can simply double-click you mouse on that topic heading to open that topic into the viewing pane on the right sight side of the dialog box. The Index tab of the Help dialog box provides you with the capability to search an Index of all of the Help documentation. Finally, the Search tab of the Help dialog box provides an extended search tool that lets you search all of the help text for keywords you specify.

TAKING THE WEB TUTORIAL 955

As you learned in Tip 954, Internet Explorer provides help materials for you in many forms. From the Internet Explorer Help menu, you can choose the Tour option to open a Web-based Internet Explorer tour page *(http://www.microsoft.com/windows/ie/tour)*, as shown in Figure 955. From the Internet Explorer tour Web page, you can launch a Web-based tutorial that will teach you about the basics of the Internet and using Internet Explorer to browse content on the Internet. The Tour Web Page also provides links to information for those users who have upgraded from Internet Explorer 4 to Internet Explorer 5.

Figure 955 The Microsoft Internet Explorer 5 Tour Web site.

GETTING SUPPORT FROM MICROSOFT ONLINE 956

As you learned in Tip 954, Internet Explorer provides help materials for you in many forms. From the Internet Explorer Help menu, you can choose the Online Support option to open a Web-based technical support page that gives you access to a variety of information types and topics *(http://www.microsoft.com/support)*, as shown in Figure 956. The Microsoft Product Support Services Web site is your inside track to Microsoft support professionals, online product support, and downloadable resources, to mention just a sample of the information available.

1001 Internet Tips

Figure 956 The Microsoft Product Support Services Web site.

Note: *Tip 957 teaches you how to search for help on a product-by-product basis using the Support Services Web site.*

957 GETTING SUPPORT FOR A SPECIFIC MICROSOFT PRODUCT

After you have accessed the Microsoft Product Support Services Web site, you might notice a link on the left side of the main page called Support by Product. Clicking your mouse on the Support by Product link takes you to a Web page that organizes help on a product-by-product basis. To get help, choose your product from a drop-down list, as shown in Figure 957.1.

To access a help Web site for a specific Microsoft product, simply select the product you desire from the Select a Microsoft product drop-down list. Then, click your mouse on the Go button directly to the right of the list field. Internet Explorer, in turn, will display an Online Self-Help registration opening page, as shown in Figure 957.2, from which you can select the type of help you need and even register for specific services from Microsoft.

In short, you can select No-charge Assisted Support or you can select Paid Assisted Support services for your product, depending upon your needs. Please read the instructions on the Online Self-Help page carefully to ensure you are getting the type of service you need and expect.

1001 INTERNET TIPS

Figure 957.1 Searching for help on a specific Microsoft product.

Figure 957.2 The Microsoft Online Self-Help Web site's registration selection page.

1001 Internet Tips

958 Printing a Web Page within Internet Explorer

Often, after you locate the information you desire at a Web site, you will want to print the site's contents so you can have a hard copy of the information. To print the current site's content within the Internet Explorer, select the File menu Print option. The Internet Explorer, in turn, will display the Print dialog box, as shown in Figure 958.

Figure 958 Internet Explorer's Print dialog box.

For many sites, you can simply click your mouse on the Print dialog box OK button to print the site's contents. However, if the current site uses frames, you can use radio buttons that appear within the Print Frames area in the Print dialog box to control how the Internet Explorer prints each frame's contents. First, the Internet Explorer can simply print the site just as it appears on your screen—showing the separate frames. Or, you can direct the Internet Explorer to only print the current frame's contents or to print each frame's contents individually. After you select the radio button that corresponds to the frame format you desire, click your mouse on the Print dialog box OK button.

959 Turning on the Internet Explorer "Tip of the Day"

As you learned in Tip 954, Internet Explorer provides help materials for you in many forms. From the Internet Explorer Help menu, you can choose the Tip of the Day option to open a small frame at the bottom of your browser window that displays a different Internet Explorer help Tip each day. Figure 959 shows the Tip of the Day frame at the bottom of the Internet Explorer window.

Note: The Next Tip link at the right side of the Tip of the Day frame lets you page through additional Internet Explorer Tips.

1001 INTERNET TIPS

Figure 959 *The Internet Explorer Tip of the Day frame.*

960 UPDATING YOUR SOFTWARE WITH WINDOWS UPDATE FROM MICROSOFT

From time to time, Microsoft releases software fixes and updates to programs that you might have installed on your computer. To make it easy for you to get the updates you need, Microsoft distributes the updates and fixes via a Microsoft Update Web site. You might find a shortcut on your Windows 98 Start menu called Windows Update, as shown in Figure 960.1, which, if selected, will take you right to the Microsoft Windows Update Web site shown in Figure 960.2.

Figure 960.1 *The Windows Update shortcut on the Windows 98 Start menu.*

1001 Internet Tips

If you do not find a link to the Microsoft Windows Update Web site on your Windows 98 Start menu, you can launch Internet Explorer and type the address of the Web site into the Internet Explorer address field. To access the Microsoft Windows Update, type *http://windowsupdate.microsoft.com* into the Address field of your browser. To download and install the latest Microsoft product updates for your computer, click your mouse on the product updates link on the Microsoft Windows Update Web page, as shown in Figure 960.2.

Figure 960.2 The product updates link on the Microsoft Windows Update Web page.

As your browser loads the product updates Web page, the Web site will check your machine to find out what updates are available for your computer's software. After displaying a security warning, your browser will display the Select Software page showing a list of software you can download and install to update your computer. Simply click your mouse to place a check in the checkboxes next to the updates you want to install. When you have chosen the software you want to install, click your mouse on the Download button at the upper right corner of the page. Internet Explorer and the Update Web site, in turn, will display a confirmation checklist that lets you confirm your choices. You can choose to view further instructions by clicking the View Instructions button. You can start the download by clicking your mouse on the Download button, or you can click your mouse on the Back button to return to the page containing the list of all available software.

When you click your mouse on the Download, button the Update Web site will display a License and Non-Disclosure agreement which you must accept before the download will occur. Clicking your mouse on the Accept button begins the downloading and installation of all chosen updates.

Note: *To be informed regarding your new software installation as well as the license agreements involved, please read all of the accompanying documentation on the Microsoft Windows Update page.*

961 Using Netscape Communicator

Communicator is Netscape Communications Corporation's suite of Internet client software designed for browsing the Web, sending and receiving e-mail, using discussion groups (newsgroups), composing and editing Web pages, conferencing, and accessing channels. The tool in the suite that you have probably heard most about or are most familiar with is Netscape Navigator, the Web browser. Netscape Navigator is Netscape's competing product for Microsoft Internet Explorer, discussed in Tips 909-960. The remaining Tips in the book introduce you to the use of Netscape's Communicator suite of Internet Tools, the most popular of which is Netscape Navigator, shown in Figure 961.

Figure 961 Netscape's Web browser, Netscape Navigator.

962 Installing Netscape Communicator

As with any software, the first step in installing the software is obtaining the setup files. In this Tip, you will learn how to download the latest Netscape Communicator software from Netscape's Web site and then install it on your system.

1001 Internet Tips

Note: *To download the software from Netscape's Web site, you must have a working connection to the Internet and a working Web browser. The browser illustrations in this Tip are actually screen captures of an older version of Netscape Navigator.*

To download and install Netscape Communicator, perform the following steps:

1. After you have connected to your Internet service provider and launched your Web browser, type the Web address of Netscape's Web site (*http://www.netscape.com*) in the browser's Address field and then hit the ENTER key. (Note that in this case you are using an older version of Netscape Navigator in which the address field is called the Netsite field.) Your browser, in turn, will display the Netscape Netcenter home page.

2. To begin the download of the Netscape Communicator software, you must locate the link to the software. In Figure 962.1, notice the Download link directly to the left of the words Netscape Netcenter in the title of the Web page.

Figure 962.1 The Netscape Netcenter home page with links to download the latest version of the Netscape Communicator software.

3. From the download page, select the link that corresponds to your operating system and current browser. For example, if your operating system is Windows 98 and this is the only version of Netscape Communicator you have installed to date, that is to say you do not have a previous version installed, click your mouse on the link that corresponds to the full Windows 98 version of Netscape Communicator. Your browser, in turn, will take you to the SmartDownload Communicator page that corresponds to the version of the software you chose.

4. From the SmartDownload Communicator page, choose a download location (if you like) and click your mouse on the Download button. Your browser, in turn, will present you with a file save dialog box within which you must choose a location to store the installation executable file. You might want to save the file to your Desktop to make it easy to locate and use in step five below.

1001 Internet Tips

Note: *The file you save to disk is a small executable that starts the SmartDownload.*

5. After the SmartDownload file download is complete, locate that file (on your Desktop, if that is where you chose to save it) and double-click your mouse on the file to begin the SmartDownload. Windows 98, in turn, will display the SmartDownload windows, as shown in Figure 962.2.

Note: *The download can easily take an hour or more depending on the speed of your connection to the Internet.*

Figure 962.2 The Netscape SmartDownload progress window displays the progress of your software download.

6. When the download is complete, SmartDownload will display a Download successful dialog box like the one shown in Figure 962.3. Within the Download successful dialog box, click your mouse on the Install button to launch Netscape Communicator 4.61 setup. Netscape setup, in turn, will extract some files and then display the Setup welcome screen.

Figure 962.3 The Download successful dialog box indicates that the installation files have been successfully copied to your machine.

7. On the Netscape Communicator 4.61 Setup welcome screen, click your mouse on the Next button to continue setup. Setup, in turn, will display the Software License Agreement dialog box.

8. Within the Software License Agreement dialog box, scroll down to read the license agreement. When you have finished, and if you agree and want to continue the installation, click your mouse on the Yes button. Setup, in turn, will display the Setup Type dialog box.

1001 Internet Tips

9. Within the Setup Type dialog box, choose the type of installation you prefer. Most users simply select the Typical option. If you are an advanced user and wish to customize your installation, you can choose the Custom option. After you have chosen your installation type, click your mouse on the Next button to continue. Setup, in turn, will display the Netscape Desktop Preference Options dialog box.

10. Within the Netscape Desktop Preference Options dialog box, choose the Preference options you prefer. When you are finished, click your mouse on the Next button to continue. Setup, in turn, will display the Select Program Folder dialog box.

11. From the Select Program Folder, choose the Start menu folder into which you want Setup to place the Netscape Communicator shortcuts. Usually the Default folder is fine. When you have made your choice, click your mouse on the Next button to continue. Setup, in turn, will display a summary of the setup choices you made using the Setup Wizard. Click your mouse on the Install button to accept your choices and begin the file copy.

After Setup has finished installing files and modifying the operating system, you will be prompted to restart your computer and then you will be ready to use the Netscape Communicator software.

963 JOINING NETSCAPE'S NETCENTER

After you complete the installation of Netscape Communicator and you have launched the software, you might browse the Netscape Netcenter Web site and notice a plethora of free services, like a free Web page or free e-mail, offered by Netscape. Near the bottom of the Netscape Netcenter Web site, you might notice a link titled Become a Member, as shown in Figure 963.

Figure 963 The Become a Member link on the Netscape Netcenter Web site.

1001 INTERNET TIPS

Clicking your mouse on the Become a Member link loads the Become a Member page that starts the process of registering you for a variety of free services from Netscape. On the Become a Member page, simply click your mouse on the large JOIN NOW! link to open a form with which you can register yourself as a Netscape Netcenter member. Simply fill out the Netcenter Registration form by following the instructions on your screen to take advantage of the services offered by Netscape Netcenter.

TURNING TOOLBARS ON AND OFF 964

Like all Windows-based programs, Netscape Navigator provides toolbars with buttons you can use to help simplify common tasks. However, unlike some other programs that provide one toolbar, Netscape Navigator provides four toolbars: the Navigation Toolbar, the Location Toolbar, the Personal Toolbar, and the Floating Component Bar. To turn toolbars on and off, click your mouse on the View menu and move to the Show option. Then, click your mouse on the toolbar you desire. Placing a checkmark next to the toolbar choice turns that toolbar on, and removing the checkmark next to a toolbar option turns that toolbar off. Figure 964 displays Netscape Navigator's Show option on the View menu which you can use to control the display of Netscape Navigator's toolbars.

Figure 964 Netscape Navigator's View menu Show option which you can use to control the display of Navigator's toolbars.

As an alternative to using the View menu, you can control the display of Netscape Navigator's toolbars by clicking your mouse on the vertical tab to the left of each toolbar. When the toolbar is hidden, the tab appears horizontally below the other visible toolbars. To display the toolbar again, you can simply click your mouse on the horizontal tab.

Note: Using the View Menu's Show option completely hides a toolbar, including its horizontal tab.

In the next few Tips, you will learn how to use the Netscape Navigator toolbars.

UNDERSTANDING THE PERSONAL TOOLBAR 965

In Tip 964, you learned about Navigator's toolbars and how to turn toolbars on and off within Netscape Navigator. The Personal Toolbar is one of the toolbars you might find yourself using frequently. You will find that the Personal Toolbar, like Internet Explorer's Links toolbar, is already configured with a number of Web links, but the real power of the Personal Toolbar is that you can add your own favorite links to the toolbar.

1001 INTERNET TIPS

It is no mistake that the Personal Toolbar is located next to the Address bar within Internet Explorer. To add a Web address to your Personal Toolbar, perform the following steps:

1. Within Navigator's Location/Netsite field, type the address of a Web site you would like to browse and press the ENTER key. Navigator, in turn, will load the Web page.
2. To add the Web page to your Personal Toolbar, simply point to the small icon to the left of the word Netsite near the Netsite field and click your mouse and drag the icon onto the Personal Toolbar. Navigator, in turn, will add the Web site's link to the Personal Toolbar, as shown in Figure 965.

Figure 965 *The ESNP.com Web link has been added to the Personal Toolbar.*

966 USING THE NAVIGATION TOOLBAR

Navigator's primary toolbar, the Navigation Toolbar, appears near the top of the Navigator window just below the menu bar. Figure 966 displays the Navigation Toolbar, which you can use to move forward or backward among sites you have previously displayed, to refresh the current site's content, to stop a Web site download, to search for information on the Web, to print the current Web site's content, and more.

Figure 966 *Netscape Navigator's Navigation Toolbar.*

967 USING THE LOCATION TOOLBAR

In Tip 913, you learned how to use Internet Explorer's Address Bar to select Web sites to browse by typing a Web address within the Address field. The Netscape Navigator browser provides the same functionality in the form of the Location Toolbar. To browse to a particular Web site within Netscape Navigator, you simply type the Web address into the Netsite field and press the ENTER key, as shown in Figure 967.

1001 Internet Tips

Figure 967 Using the Netsite field on the Location Toolbar to browse to a Web site.

You can get started surfing the Web by trying the addresses listed in Table 967.

Site	Address
Netscape	www.netscape.com
Jamsa Press	www.jamsapress.com
ESPN	espn.go.com
Excite	www.excite.com
Business Week	www.businessweek.com
Mr. Showbiz	mrshowbiz.go.com
Netscape	www.netscape.com
Yahoo	www.yahoo.com
Wall Street Journal	www.wsj.com
MSNBC	www.msnbc.com

Table 967 Sites to visit on the World Wide Web.

USING THE COMPONENT BAR — 968

One of the four toolbars included with Netscape Navigator and discussed in Tip 964 is the Component Bar. The Component Bar provides you with a set of buttons that launch each of the applications in the Netscape Communicator suite. From the Component Bar, you can quickly start Navigator, go to your Inbox, peruse newsgroups, open your Address Book, and launch Page Composer (to create your own Web pages). Figure 968 displays the Netscape Communicator Component Bar.

Figure 968 The Netscape Communicator Component Bar, from which you can launch the Communicator applications.

1001 Internet Tips

969 Searching with the Netsite Field

As you learned in Tip 967, you use Navigator's Netsite field on the Location Toolbar to specify the Internet site you would like to browse. You can also use Navigator's Netsite field to search the Web for your topics of interest. Netscape's developers term the process of searching using the Netsite field as Smart Browsing. Smart Browsing attempts to find an exact match for the keyword or words you type, but in the event that Smart Browsing cannot find an exact match, it returns a search results page. To use the Netsite field to perform a search, simply type the word or words you are searching for in the Netsite field and then type the ENTER key to initiate the search. Navigator, in turn, will display a site that matches your keyword or phrase or Navigator will display a search results page, as shown in Figure 969 if Smart Browsing does not find an exact match.

Figure 969 A search results page resulting from using the Netsite field to search for topics on the Web.

As you can see in Figure 969, Navigator has responded with a page titled Search Results for audio files that includes links to sites, the contents of which match the search criteria audio files.

Note: *By default, Netscape Navigator uses the Netscape Search Web site for Smart Browsing via the Location Toolbar.*

Searching for Text on the Current Page 970

In Tip 470, you learned how to use a search engine to locate sites on the Web that discuss specific topics. When you view a site's contents within Netscape Navigator, there may be times when you will want to search the current document for specific information (some Web pages can become quite long). To search the current Web page for information, perform the following steps:

1. Within Netscape Navigator, click your mouse on the Edit menu and choose the Find in Page option. Netscape Navigator, in turn, will display the Find dialog box, as shown in Figure 970.

Figure 970 The Netscape Navigator Find dialog box.

2. Within the Find dialog box, type in the word for which you want Netscape Navigator to search the current page and then click your mouse on the Find Next button. (Netscape Navigator will search only the current page. It will not search pages that correspond to links on the current page.) If Netscape Navigator finds your text, it will, in turn, highlight the text within the page. Otherwise, Netscape Navigator will display a dialog box stating Search String Not Found!

If the page contains multiple occurrences of the word or phrase, you can click your mouse on the Find dialog box Find Next button to move through each occurrence.

Setting Netscape Communicator Preferences 971

As you become more familiar with Navigator and the Communicator suite, you may find that you want to customize Navigator and the other programs in the suite to better suit your needs. To help you configure the browser and other program settings that the Communicator suite will use, Navigator provides the Preferences dialog box, as shown in Figure 971.

Several of the Tips that follow examine the Preferences dialog box in detail. To display the Preferences dialog box, within Netscape Navigator, click your mouse on the Edit menu and choose the Preferences menu option. Navigator, in turn, will open the Preferences dialog box shown in Figure 971.

Figure 971 The Netscape Communicator Preferences dialog box.

Note: *In addition to performing the steps this Tip presents to display the Preferences dialog box, you can also select the Edit menu Preferences options within the other applications in the Communicator suite to display the Preferences dialog box.*

972 CONFIGURING APPEARANCE OPTIONS

Like competitor Internet Explorer, Navigator is extremely customizable. For example, you can customize the colors your browser uses, the fonts your browser displays, and the default start page that appears when you launch the browser. This Tip will teach you how to configure your browser's appearance options. To specify your browser appearance options, perform the following steps:

1. Within Navigator, click your mouse on the Edit menu and choose the Preferences option. Navigator, in turn, will display the Preferences dialog box.

2. In the Preferences dialog box, expand the Appearance option in the Category list. Navigator, in turn, will display the Appearance options in the Preferences dialog box, as shown in Figure 972. You can use the On startup, launch area to specify which applications in the Communicator suite will actually start up when you launch Communicator. Within the Show toolbars as area of the Preferences dialog box, you can specify how toolbar buttons will appear within the Communicator applications: with pictures and text, with pictures only, or with text only.

Figure 972 Configuring the Appearance option in the Preferences dialog box.

1001 Internet Tips

After you have made your configuration selections, you can click your mouse on the OK button to apply your changes.

Note: *If you make changes to the On startup, launch area, those changes will take effect the next time you start Communicator.*

Configuring Navigator's Color Utilization 973

Like Internet Explorer, you can customize Navigator's color utilization to suit your needs. If you spend a considerable amount of time surfing the Web, you may want to customize your browser's color settings. To specify your browser colors, perform the following steps:

1. Within Netscape Navigator, click your mouse on the Edit menu and choose the Preferences option. Navigator, in turn, will display the Preferences dialog box.
2. In the Preferences dialog box, expand the Appearance option in the Category list and click your mouse on the Colors option. Navigator, in turn, will display the Colors options in the Preferences dialog box, as shown in Figure 973.

Figure 973 The Colors category in the Preferences dialog box.

3. Using the Colors options in the Preferences dialog box, you can specify the colors your browser uses for its background color and for text display. By default, the browser will use the current Windows 98 color scheme. To select your own color settings, click your mouse on the Use Windows colors checkbox to remove the checkmark. Then, click your mouse on the Text or Background buttons to specify the colors you desire.
4. In the Colors dialog box, you can also specify the colors you want your browser to use to display links you can visit as well as links you have visited. In addition, you can choose to have your browser underline links by placing a checkmark in the Underline links checkbox.
5. After you select the colors and links options you desire, click your mouse on the OK button to apply your changes and close the Preferences dialog box.

974 CONFIGURING NAVIGATOR'S FONT UTILIZATION

If you use your browser on a regular basis, there may be times when you will want to customize the browser's font usage. (You might, for example, select a larger, bolder font that you find easier to read.) To customize your browser's font settings, perform the following steps:

1. Within Netscape Navigator, click your mouse on the Edit menu and choose the Preferences option. Navigator, in turn, will display the Preferences dialog box.
2. In the Preferences dialog box, expand the Appearance option in the Category list and click your mouse on the Fonts option. Navigator, in turn, will display the Fonts customization options in the Preferences dialog box, as shown in Figure 974.

Figure 974 The Fonts category in the Preferences dialog box.

3. Using the Fonts options in the Preferences dialog box, you can specify the font character set that you desire as well as the specific fonts your browser will use for variable and fix-width font operations. In addition, you can choose the font size that you prefer.
4. After you select the fonts options you desire, click your mouse on the OK button to apply your changes and close the Preferences dialog box.

975 CONFIGURING THE WEB PAGE NAVIGATOR STARTS WITH

When you launch your browser, regardless of whether you use Navigator or Internet Explorer, your browser typically loads a Web page. You can configure the Web page that Navigator will load when it starts. To specify the Web page Navigator starts up with, perform the following steps:

1001 Internet Tips

1. Within Netscape Navigator, click your mouse on the Edit menu and choose the Preferences option. Navigator, in turn, will display the Preferences dialog box.
2. In the Preferences dialog box, click your mouse on the Navigator Category option. Navigator, in turn, will display the Navigator customization options in the Preferences dialog box, as shown in Figure 975.1.

Figure 975.1 The Navigator category in the Preferences dialog box.

3. Within the Navigator Starts with area of the Navigator Category options, you have three choices from which you can choose: Blank page, Home page, and Last page visited. Click your mouse on the Radio button next to the Navigator starts with option you desire.

Note: *If you choose the Blank page option, upon startup, Navigator will load a blank page, as shown in Figure 975.2. If you choose the Home page option, upon startup, Navigator will display the Web page specified in the home page area of the Preferences dialog box (see Tip 976 to learn how to set the home page in the home page area of the Preferences dialog box). If you choose the Last page visited option, upon startup, Navigator will attempt to load the last page you viewed during your previous browsing session.*

Figure 975.2 Navigator launched with a blank page displayed.

1001 Internet Tips

4. After you select the Navigator starts with option you desire, click your mouse on the OK button to apply your changes and close the Preferences dialog box.

976 CHANGING YOUR DEFAULT HOME PAGE

Tip 975 discussed configuring the Web page Navigator loads when it starts. If you chose to have Navigator start with a home page in Tip 975, you might want to change your home page from time to time. Basically, you can choose to have any available Web page on the Internet as your default home page when Navigator starts. To specify the Web page with which Navigator starts, perform the following steps:

1. Within Netscape Navigator, click your mouse on the Edit menu and choose the Preferences option. Navigator, in turn, will display the Preferences dialog box.
2. In the Preferences dialog box, click your mouse on the Navigator Category option. Navigator, in turn, will display the Navigator customization options in the Preferences dialog box, as shown previously in Figure 975.1.
3. Within the Navigator Starts with area of the Navigator Category options, make sure that you have chosen the Home page option. Then, in the home page area's Location field, you can type the address of the Web page you would like Navigator to load whenever you start the program. Alternatively, you can click your mouse on the Use Current Page button to set the page that is currently displayed in the browser as your home page. Also, you can click your mouse on the Browse button to browse your file system for a Web page to use as your home page.
4. After you select the Home page option you desire, click your mouse on the OK button to apply your changes and close the Preferences dialog box.

977 CLEARING NAVIGATOR'S HISTORY LIST

Within Navigator's Preferences dialog box, you can clear (erase) the current history list and specify the number of days for which Navigator will maintain a site's hyperlink entry within the history list. If you use a browser at work, you may want to clear your history list at the end of each day so your employer cannot use the list to track the Web sites you visit during your working hours. To clear the contents of your history list, perform the following steps:

1. Within Netscape Navigator, click your mouse on the Edit menu and choose the Preferences option. Navigator, in turn, will display the Preferences dialog box.
2. In the Preferences dialog box, click your mouse on the Navigator Category option. Navigator, in turn, will display the Navigator customization options in the Preferences dialog box, as shown previously in Figure 975.1.
3. Within the History area of the Navigator Category options, click your mouse on the Clear History button. Navigator, in turn, will display a dialog box asking you to confirm the history list deletion. Click your mouse on the OK button. Navigator, in turn, will delete all of the history information that has been stored.

1001 Internet Tips

Note: *Tip 978 discusses setting the number of days that Windows 98 will maintain a link to a site in the History list.*

Note: *Refer to Tip 993 to learn how to use your History folder to access Web sites you have previously viewed.*

Configuring Navigator's History List — 978

As you learned in Tip 977, you can clear the contents of the Navigator history list. Further, you can specify the numbers of days an entry will remain in the history list before Netscape Navigator automatically deletes it. To specify the number of days for which Navigator will maintain a site within the history list, perform the following steps:

1. Within Netscape Navigator, click your mouse on the Edit menu and choose the Preferences option. Navigator, in turn, will display the Preferences dialog box.

2. In the Preferences dialog box, click your mouse on the Navigator Category option. Navigator, in turn, will display the Navigator customization options in the Preferences dialog box, as shown previously in Figure 975.1.

3. Within the History area of the Navigator Category options, click your mouse in the Pages in history expire after field and type in the number of days you would like Navigator to store Web sites in the history list before it automatically deletes them. When you have finished making your changes, click your mouse on the OK button to apply your changes and close the Preferences dialog box.

Note: *Refer to Tip 993 to learn how to use your History folder to access Web sites you have previously viewed.*

Clearing Navigator's Location Bar History — 979

In Tip 977, you learned how to clear the contents of the Navigator history list. Navigator also maintains a Location Bar history, shown in Figure 979.1, which records the Web sites you have typed into the Netsite field within Navigator.

To clear the contents of your Location Bar history list, perform the following steps:

1. Within Netscape Navigator, click your mouse on the Edit menu and choose the Preferences option. Navigator, in turn, will display the Preferences dialog box.

2. In the Preferences dialog box, click your mouse on the Navigator Category option. Navigator, in turn, will display the Navigator customization options in the Preferences dialog box, as shown previously in Figure 975.1.

3. Within the Location Bar History area of the Navigator Category options, click your mouse on the Clear Location Bar button. Navigator, in turn, will display a confirmation dialog box, shown in Figure 979.2, notifying you that the operation will remove all the items in the location bar drop-down list. Click your mouse on the OK button to complete the operation.

1001 Internet Tips

Figure 979.1 Netscape Navigator's Location Bar history drop-down list.

Figure 979.2 Confirming that you want to clear the contents of the Location Bar drop-down list.

 4. Within the Preferences dialog box, click your mouse on the OK button to apply your changes and close the Preferences dialog box.

1001 Internet Tips

Configuring Mail and Newsgroups Options — 980

As you learned in Tip 971, you can use Communicator's Preferences dialog box to fine-tune settings for all of the programs in the Communicator suite to better suit your needs. The Mail & Newsgroups category option, shown in Figure 980, provides you with the tools you need to configure all of Communicator's messaging options.

Figure 980 The Mail & Newsgroup category options within Navigator's Preferences dialog box.

To open Navigator's Preferences dialog box and begin configuring messaging options, perform the following steps:

1. Within Netscape Navigator, click your mouse on the Edit menu and choose the Preferences option. Navigator, in turn, will display the Preferences dialog box.
2. In the Preferences dialog box, expand the Mail & Newsgroups option in the Category list. Navigator, in turn, will display the Mail & Newsgroups customization options in the Preferences dialog box, as shown in Figure 980.
3. To help you in making configuration changes in the Mail & Newsgroups category, refer to Table 980 for a description of each of the sub-categories.

Category Option	Use this option to:
Mail & Newsgroups	configure general settings for Mail and Newsgroup
Identity	set your name, email address, and signature file
Mail Servers	specify servers used for your e-mail
Newsgroup Servers	specify your servers for reading network news
Addressing	specify settings for addressing messages
Messages	choose settings for messages
Window Settings	configure your window layout

Table 980 Communicator's Mail & Newsgroup configuration options. (continued on next page)

1001 Internet Tips

Category Option	Use this option to:
Copies and Folders	specify settings for handling messages, copies, drafts, and templates
Formatting	specify settings for message formatting
Return Receipts	specify settings for requesting or returning message receipts
Disk Space	manage the amount of disk space used by messages

Table 980 *Communicator's Mail & Newsgroup configuration options. (continued from previous page)*

Note: *Before making changes to your Mail & Newsgroup category options, you may want to consult with your Internet service provider or your network administrator (if you are using Navigator on a personal computer connected to a Local Area Network).*

981 CONFIGURING ROAMING ACCESS OPTIONS

Roaming Access lets you launch Communicator with the same configured preferences, bookmarks, cookies, and other items, regardless of which computer you use. That is to say, when you are away from your desk, working at a co-worker's computer, or working from home, you can see your same settings. To set up Roaming Access, perform the following steps:

1. Within Netscape Navigator, click your mouse on the Edit menu and choose the Preferences option. Navigator, in turn, will display the Preferences dialog box.

2. In the Preferences dialog box, click your mouse on the Roaming Access Category option. Navigator, in turn, will display the Roaming Access setup options in the Preferences dialog box.

3. Within the Roaming Access setup area, click your mouse on the Enable Roaming Access for this profile checkbox to place a check in the box. In the User Name field, type your user name that Communicator will use when retrieving your user profile from the Roaming Access server.

4. You may want to select Remember my Roaming Access password to avoid having to type your password each time you connect from another computer.

Note: *To use Roaming Access, you must be able to connect to a LDAP directory server or an HTTP server on which you can store your personal information. Consult your Internet service provider or your system administrator to find out if you can use IMAP.*

5. After you have turned on Roaming Access and specified your user name, you must configure your Roaming Access server. To do so, within the Preferences dialog box Category list, click your mouse on the Server Information sub-category of Roaming Access, as shown in Figure 981.1. Configure your server options as assigned by your Internet service provider or system administrator.

6. After you have configured your Roaming Access server options, you might want to configure which items Communicator will store with your Roaming Access information. To do so, within the Preferences dialog box Category list, click your mouse on the Item

Selection sub-category of Roaming Access, as shown in Figure 981.2. Within the Item Selection sub-category dialog box, you can select the user profile items you would like to include in your Roaming Access profile.

7. After you are finished configuring your Roaming Access options, click your mouse on the OK button to apply your changes and close the Preferences dialog box.

Figure 981.1 Configuring Communicator to use a Roaming Access server.

Figure 981.2 Configuring Roaming Access items that Communicator will include in your Roaming Access profile.

CONFIGURING COMPOSER OPTIONS 982

Netscape Composer is Netscape's what-you-see-is-what-you-get (WYSIWYG) hypertext markup language (HTML) editor, as shown in Figure 982.1. Composer lets you edit Web pages without doing HTML programming. You can

1001 INTERNET TIPS

simply format the Web page text and graphics much as you would format a document within a Word processor like Microsoft Word.

Like other Communicator applications, Composer requires some configuration work in order to use it most effectively. For example, you may want to configure Composer to use a certain external HTML editor like Windows Notepad, or you might want to configure Composer to publish Web pages to a certain location, like your own personal Web site stored on your Internet service provider's server. To configure Composer, perform the following steps:

Figure 982.1 Netscape Composer—a WYSIWYG HTML editor.

1. Within Netscape Navigator, click your mouse on the Edit menu and choose the Preferences option. Navigator, in turn, will display the Preferences dialog box.
2. In the Preferences dialog box, click your mouse on the Composer Category option. Navigator, in turn, will display the Composer setup options in the Preferences dialog box, as show in Figure 982.2.
3. Within the Composer setup area, you can specify an Author Name that Composer will associate with Web pages as you create them. You can specify a program to use as an HTML editor and a program to use as an Image editor. Finally, you can specify how Composer deals with font sizing within your Web pages.
4. After you are finished configuring your Composer options, click your mouse on the OK button to apply your changes and close the Preferences dialog box.

1001 INTERNET TIPS

Figure 982.2 Setting Composer options within the Communicator Preferences dialog box.

CONFIGURING COMPOSER PUBLISHING OPTIONS 983

As you learned in Tip 982, Netscape Composer is Netscape's what-you-see-is-what-you-get (WYSIWYG) hypertext markup language (HTML) editor. With HTML editors, you typically create Web pages and then copy or publish them to servers that make the content available on the Internet. You can configure Composer with default Web locations to which you can publish the pages you create. These Web locations are usually servers stored at your Internet service provider's facility and made available, or rather, are reachable by users browsing the Internet. To configure Composer's Publishing options, perform the following steps:

1. Within Netscape Navigator, click your mouse on the Edit menu and choose the Preferences option. Navigator, in turn, will display the Preferences dialog box.
2. Within the Preferences dialog box, expand the Composer Category option and click your mouse on the Publishing sub-category option. Navigator, in turn, will display the Publishing setup options in the Preferences dialog box, as shown in Figure 983.
3. Within the Publishing setup area, you can specify how Composer deals with links and images when saving or publishing Web pages to their Internet locations and you can specify addresses to your default publishing location, meaning the Web address of your Web site location.

Note: You can obtain the correct publishing location addresses from your system administrator or from your Internet service provider.

1001 Internet Tips

Figure 983 Setting Publishing options within the Communicator Preferences dialog box

4. After you are finished configuring your Publishing options, click your mouse on the OK button to apply your changes and close the Preferences dialog box.

984 CONFIGURING ADVANCED OPTIONS

By configuring Advanced options within Communicator's Preference dialog box, you make changes that, in many cases, affect the entire suite of products. For example, you can control how images load, whether or not Java applications can run, or how your Netscape programs deal with Cookies. To configure Communicator Advanced options, perform the following steps:

1. Within Netscape Navigator, click your mouse on the Edit menu and choose the Preferences option. Navigator, in turn, will display the Preferences dialog box.
2. Within the Preferences dialog box, click your mouse on the Advanced Category option. Navigator, in turn, will display the Advanced setup options in the Preferences dialog box.
3. Use the checkboxes and radio buttons to select or deselect advanced options. Advanced options you can configure include automatic image loading, enabling or disabling Java and JavaScript, enabling or disabling style sheets, and whether or not Navigator sends your e-mail address as an anonymous password when you access an FTP site. (FTP sites are discussed in Tips 117-168). You can also configure the manner in which Communicator programs handle Cookies. Refer to Tip 659 for a description of cookies.

4. After you are finished configuring your Advanced options, click your mouse on the OK button to apply your changes and close the Preferences dialog box.

CLEANING UP TEMPORARY INTERNET FILES 985

If you have spent time surfing the Web, you know that you can spend a considerable amount of time waiting for your system to download files. To improve performance, most Web browsers will store many of the files you download in temporary folders on your hard disk. Should you later revisit the Web site, your browser can use the files it previously downloaded to immediately display the site's contents. (Actually, your browser will contact the Web site to determine if the files it previously downloaded are current. If the files are current, your browser will use them. Otherwise, your browser will download any files that have changed.)

Although storing downloaded Internet files in this way improves your browser's performance, the temporary files consume disk space that you might need to reclaim. In addition, if other users gain access to your system, they can view the temporary file's contents and determine which sites you have been visiting. Your company, for example, could use the temporary files to prove that you were using the Web for non-business purposes during working hours.

Fortunately, Communicator lets you purge (delete) the temporary files when you no longer need them and you can specify how much disk space the temporary files can consume. To purge your temporary Internet files, perform the following steps:

1. Within Netscape Navigator, click your mouse on the Edit menu and choose the Preferences option. Navigator, in turn, will display the Preferences dialog box.
2. Within the Preferences dialog box, expand the Advanced Category option and then click your mouse on the Cache sub-category option. Navigator, in turn, will display the cache setup options in the Preferences dialog box.
3. Within the Cache configuration area shown in Figure 985, you will notice that Communicator provides both a Memory Cache and a Disk Cache. Click your mouse on the Clear Memory Cache button to delete information cached in memory. Communicator, in turn, will display a confirmation dialog box asking you to confirm that you want to remove files from the memory cache. Click your mouse on the OK button to complete the operation.
4. To clear the Disk Cache, click your mouse on the Clear Disk Cache button to delete files cached on your hard disk. Communicator, in turn, will display a confirmation dialog box asking to confirm that you want to remove files from the disk cache. Click your mouse on the OK button to complete the operation.
5. After you are finished clearing Communicator's Memory Cache and Disk Cache, within the Preferences dialog box click your mouse on the OK button to close the Preferences dialog box.

1001 Internet Tips

Figure 985 Communicator's Cache configuration options.

Tip 986 discusses configuring the size of the memory and disk cache as well as configuring how frequently pages from the cache are compared to their corresponding files on the Internet to test freshness.

986 Configuring Navigator's Cache

In Tip 985, you learned how to use Communicator's Preferences dialog box to purge your temporary Internet files from Memory Cache and Disk Cache. As you become more experienced with Internet technologies, you might decide that you want to adjust how much memory or disk space Communicator can allocate for your temporary Internet files and how often, after downloading files, your browser will check for updates to a site's file.

As you have learned, after your browser downloads files from a Web site, your browser can later display those files' contents again should you visit the Web site a second time. Within the Preferences dialog box, you can control how often your browser will check for file updates. For example, if you visit Web sites that change frequently (such as every few minutes), you will want your browser to check for new files every time you visit a Web site. If you normally start your browser, view a few sites, and then end your browser, you may want your browser to check for file updates for sites that you have visited since you last started your browser. Likewise, if you do not care if you view a site's most current contents, you can direct your browser never to check for new files and to always use its cached file contents if a temporary file is available for the current site. To configure Communicator's cache settings, perform the following steps:

1. Within Netscape Navigator, click your mouse on the Edit menu and choose the Preferences option. Navigator, in turn, will display the Preferences dialog box.

2. Within the Preferences dialog box, expand the Advanced Category option and then click your mouse on the Cache sub-category option. Navigator, in turn, will display the cache configurations options in the Preferences dialog box, as shown previously in Figure 985.

3. Within the Cache configuration area, use the Memory Cache and Disk Cache fields to configure the amount of memory and the amount of disk space (both measured in kilobytes) Communicator will use for caching Internet content.

4. To configure the frequency with which Communicator checks the Internet for changes to documents you retrieve, select either Once per session, Every time, or Never from the three available choices under the Document in cache is compared to document on network heading.

5. After you have made your changes, click your mouse on the OK button to complete the operation.

CHANGING THE FOLDER THAT NAVIGATOR USES FOR CACHING FILES 987

As you have learned, to improve its performance, Navigator caches the information it downloads from the Web sites you visit as temporary files within a folder on your disk. By default, Navigator will store the files within a folder called C:*Program Files\Netscape\Users*\username*cache*. However, depending on your needs, there may be times when you will want your browser to store the temporary files at a different location. For example, if you work within an office, many companies store a user's files within folders that reside on a network server. If your browser is storing your temporary files on a network server, you may encounter two problems. First, because your network must transfer each file you download to the server, your temporary Internet files can consume considerable network bandwidth (which will slow down other network operations) and may consume considerable space on the server's hard disk. Second, because the files now reside on a network server, your network administrator may be able to view the file's contents to determine which Web sites you visit.

To change the location at which your browser will store your temporary Internet files, perform the following steps:

1. Within Netscape Navigator, click your mouse on the Edit menu and choose the Preferences option. Navigator, in turn, will display the Preferences dialog box.

2. Within the Preferences dialog box, expand the Advanced Category option and then click your mouse on the Cache sub-category option. Navigator, in turn, will display the cache configurations options in the Preferences dialog box, as shown previously in Figure 985.

3. Within the Cache configuration area, type the full path to the new storage folder for cached Internet files in the Disk Cache Folder field. Alternatively, you can use the Choose Folder button just below the Disk Cache Folder field to browse your computer's disks and select a new folder location for the cache Internet files.

4. After you have selected the new cache folder, click your mouse on the OK button to complete the operation.

1001 Internet Tips

988 Adding Bookmarks

As you use Netscape Navigator to browse sites on the Web, you might come across sites that you will want to visit again in the future. You might, for example, want to visit the Netscape site on a regular basis to stay current on new releases of Communicator or you may want to use the Go Network search engine on a regular basis to search the Web for specific content. To make it easy for you to revisit a site in the future, Navigator provides the capability to create bookmarks that link to your favorite sites. Later, when you want to revisit the site, you can click your mouse on Navigator's Communicator, move to the Bookmarks option, and then select your bookmarked site from the Bookmarks fly-out menu. Figure 988 shows the Bookmarks fly-out menu within Navigator.

Figure 988 Using Navigator's Bookmarks menu, you can quickly select one of your favorite sites to visit.

To add sites to Navigator's Bookmarks menu, perform the following steps:

1. Access the Web site by typing the address of the site in Navigator's Netsite field and then press the ENTER key. Internet Explorer, in turn, will display the site.
2. Click your mouse on Navigator's Communicator menu, move to Bookmarks, and then choose Add Bookmark. Navigator, in turn, will add the link to the bottom of the Bookmarks fly-out menu.

If you view the Navigator Bookmarks menu, you will find that the menu provides several folders within which you can find a variety of Bookmarks to popular sites. You can use the folders on the Bookmarks menu to organize

your own bookmarks. To place one of your own bookmarks into an existing Bookmarks folder, perform the following steps:

3. Access the Web site by typing the address to the site in Navigator's Netsite field and then press the ENTER key. Internet Explorer, in turn, will display the site.
4. Click your mouse on Navigator's Communicator menu, move to Bookmarks, and then choose File Bookmark. Navigator, in turn, will cascade the File Bookmark sub-menu.
5. On the File Bookmark sub-menu, select the name of the sub-menu to which you would like to add your link. Navigator, in turn, will add the current Web site to the sub-menu you chose.

ORGANIZING AND DELETING BOOKMARKS 989

In Tip 988, you learned how to add a Web site to the Bookmarks menu within Navigator. As you learned, when you add a site to the Bookmarks menu, you can add the site as an upper-level entry on the menu or you can place the site within a folder that appears on the menu. As the number of sites you add to the Bookmarks menu increases, you may eventually want to remove a site or move a site into a specific folder. To organize the sites that appear on the Favorites menu, click your mouse on the Communicator menu, move to the Bookmarks option, and choose Edit Bookmarks from the Bookmarks fly-out menu. Navigator, in turn, will display the Bookmarks window, as shown in Figure 989.1.

Figure 989.1 The Bookmarks window within which you can rearrange your bookmarks, delete bookmarks, or otherwise reorganize your Bookmarks menu.

1001 Internet Tips

The Bookmarks window displays the Bookmarks for *Your Name* folders and items in a tree-like structure. Within the tree structure, you can click and hold your mouse on items or folders to move them to new locations within the tree structure, thus rearranging your Bookmarks menu. If you want to delete a bookmark, simply click your mouse on the bookmark to select it, and then hit the DELETE key on your keyboard. Alternatively, to delete a bookmark, you can right click your mouse on the bookmark and choose Delete Bookmark from the context menu, as shown in Figure 989.2

Figure 989.2 Deleting a bookmark using a secondary (or right) mouse click.

After you have finished rearranging and reorganizing your bookmarks, you can close the Bookmarks window by clicking your mouse on the File menu and choosing Close.

990 VIEWING A WEB PAGE'S SOURCE CODE

In previous Tips, you have learned to create Web pages using a variety of tools. You also learned that you, as a Web designer, ultimately use HyperText Markup Language or HTML to create those Web pages.

As you become more familiar with Web design and HTML, you might find it useful to be able to view the HTML code used to create the pages you browse with Netscape Navigator. When you view sites on the Web, you can direct Navigator to display the current page's HTML codes by selecting the View menu Page Source option. Navigator, in turn, will open a new window containing the Source HTML code for the Web page you are currently browsing.

Figure 990, for example, shows the HTML source code from the Netscape Web site at *www.netscape.com*. By examining another site's HTML code, designers can often learn new HTML techniques.

Figure 990 *Viewing HTML source code within Netscape Navigator.*

VIEWING A WEB PAGE'S PAGE INFO 991

As you learned in Tip 990, you can view a Web page's source HTML code within Navigator. You can also instruct Navigator to show you what files compose a page, what the page's MIME type is, whether or not the page is cached by Navigator, and the number of characters in the file, to name just a few of the facts you learn about a page. To view a page's information, simply load the page by typing the page address into Navigator's Netsite field and then press the ENTER key on your keyboard. When Navigator has completed loading the page, click your mouse on the View menu and choose the Page Info option. Navigator, in turn, will display a Page Info window like the one shown in Figure 991.

1001 Internet Tips

*Figure 991 The Page Info window for the Netscape Web page at **www.netscape.com**.*

Table 991 briefly describes most of the information you can gather when you view a Web page's information page as described above.

Information Heading	Description
Structure window (the top window)	Lists the URLs of the files and graphics that make up the page
Netsite or Location	The URL of the page or selected file
File MIME type	A code that identifies the file's type for Web browsers.
Source	Indicates whether the page is currently in disk cache or is not cached.
Local cache file	Indicates the name of the corresponding file in the disk cache.
Last Modified	The time when the file was last changed.
Content length	The number of characters in the file.
Expires	The date (if it exists) when the file should be removed from the cache (set by the author of the page).
Charset	Code for the character set the file uses.
Security	Indicates whether the file is encrypted or not.

Table 991 The information you can find within a Web page Information window.

Getting Help in Navigator

992

Like other Windows applications you are probably familiar with, the Netscape Communicator suite is packaged with a sophisticated set of help information. From time to time, you might want to research a problem or learn how to perform a specific task within Communicator. You can access help at any time within Communicator by using the Help menu, as shown in Figure 992.1.

Figure 992.1 The Netscape Navigator Help menu.

The Help Contents menu option, which is found on the Help menu, provides a quick and easy way to search for hints and solve problems within Navigator. Select the Help Contents from the Navigator Help menu to open the NetHelp window, as shown in Figure 992.2.

Figure 992.2 The Navigator NetHelp window.

Within the NetHelp window, you will notice two link buttons in the upper left corner of the window: a Contents link and an Index link. The Contents link lets you browse through Help as if you were browsing a Web page (and, in fact, you are) by clicking your mouse on links. When you find a topic that you would like to view, you can simply click your mouse on that topic heading to open that topic into the viewing pane on the right side of the window. The Index link of the NetHelp Window provides you with the capability to search an Index of all of the Help documentation to find the information for which you are looking.

993 USING THE NAVIGATOR HISTORY WINDOW

In Tips 977 and 978, you learned how to clear your History folder and configure your History folder. To make it easier for you to revisit sites across the Web, Navigator keeps a history (a list) of the sites you visit. If you want to revisit a site, you can simply click your mouse on Navigator's Communicator Menu, move to Tools, and select History from the Tools fly-out menu. Navigator, in turn, will open the History window, as shown in Figure 993.

Figure 993 Netscape Navigator's History list.

The History window lists the Web pages you have visited in order of most recently visited first. You can re-visit a Web page by simply double-clicking your mouse on the page's title in the left most column of the History window. You might also notice that the History window tells you when a page was first visited, last visited, when the page will expire, and how many times you have visited the page.

994 EDITING THE CURRENT PAGE USING COMPOSER

As you learned in Tip 982, Page Composer is Netscape's WYSIWYG HTML editor. You can use Page Composer, or Composer, to which it is sometimes referred, to create your own Web pages and to edit pages that you browse on the

1001 Internet Tips

Internet. You can edit Web pages that you have retrieved from the Internet but, for security reasons, you typically cannot save them back to their original locations on the Internet. However, that does not mean you cannot edit a page and then save it someplace else, like your local hard drive, for example.

Note: *If you do retrieve pages from the Internet for your own personal or business use, be sure that by doing so you are not violating copyright agreements for the pages.*

It may be useful for you as an HTML developer to open Web pages that you find on the Internet into Page Composer to work with the code and learn from what other developers have done. In Tip 990, you learned how to view a Web page's source HTML code. Navigator also provides you with the capability of opening the currently loaded Web page into Page Composer by simply selecting a menu option. To open a Web page into Page Composer, perform the following steps:

1. Access the Web site by typing the address to the site in Navigator's Netsite field and then pressing the ENTER key. Internet Explorer, in turn, will display the Web site.
2. Click your mouse on Navigator's File menu and choose the Edit Page Option. Navigator, in turn, will launch Page Composer and open the Web page into Page Composer. Figure 994 displays the Netscape Web page (*http://www.netscape.com*) opened into Page Composer.

Figure 994 A Web page retrieved from the Internet and opened in Page Composer.

After you have opened a Web page into Page Composer, you can take advantage of Page Composer's WYSIWYG HTML editing capabilities to edit and manipulate the page. Keep in mind that you typically cannot place your edited copy back out on the original Web location, but you can save your changes on your local hard disk. Once again, be careful not to violate any copyright agreements while browsing and editing content on the Internet.

1001 Internet Tips

995 Printing the Current Page

Often, after you locate the information you desire at a Web site, you will want to print the site's contents so you can have a hard copy of the information. To print the current site's content within Netscape Navigator, select the File menu Print option. Navigator, in turn, will display the Print dialog box, as shown in Figure 995.

Figure 995 The Print dialog box within Netscape Navigator.

For many sites, you can simply click your mouse on the Print dialog box OK button to print the site's contents. However, if the current site uses frames, first, before choosing the print command from the File menu, you can click your mouse in a frame to make it the active frame, and then click on Navigator's File menu and choose Print Frame to print the contents of the frame.

996 Stopping the Download of a Web Site

As you surf the Web, there may be times when, after you initiate a Web site's download, you decide that you no longer want to view the site's contents, meaning you want to stop the download of the site possibly because you selected the site by mistake or because the site is taking too long to download. To direct Navigator to stop downloading a site, click your mouse on the Stop button on the Navigation Toolbar or press your keyboard's Esc key.

After Navigator stops the download operation, you can type a different address in the Netsite field to continue surfing the Web. Should you stop a download and then decide you would like to resume the download, you may be able to restart the download by simply clicking your mouse on the Reload button on the Navigation Toolbar.

Reloading the Current Web Page 997

When you view sites on the Web, there may be times when, due to an error, or because you previously stopped the site's download, Netscape Navigator does not download the entire site's text or graphics. Or you may want to reload the page to view any changes that may have occurred since you first loaded the page into your browser. In such cases, you can restart the download operation or refresh the page by clicking your mouse on the Reload button on the Navigation Toolbar or by choosing the View menu's Reload option.

As you learned in Tip 985, when you download a site's contents, Navigator stores some of the content in temporary files in memory and on your hard disk. If you later revisit the site, Navigator will use the previously downloaded contents, which improves the speed with which Navigator can display the site's contents. Depending on your Navigator's Preference settings, Navigator may not check if the site's contents have changed since your previous download operation. By refreshing the page as described above, you can direct Navigator to check whether or not the site's contents have changed and, if so, to download the updated content.

Returning to Your Home Page 998

As you learned in Tip 976, you can configure Navigator to open your favorite Web page by default when you launch the program. Many Web users set their default home page to be a news service page, a Web portal, or other configurable page with information on a variety of topics. Often times this page becomes a valuable information source for the Web user. For that reason, Navigator provides a Home button on the Navigation Toolbar. By clicking your mouse on the Home button on the Navigation Toolbar, you can quickly return to your default home page.

Opening a New Navigator Window 999

As you traverse sites on the Web, there may be times that you find a site that contains some of the information that you need, but you still want to continue your search. In such cases, you can click your mouse on Navigator's File menu, move to the New option, and choose Navigator Window from the New fly-out menu. Navigator, in turn, opens a second window, within which you can continue your search while you leave your first site's contents in view. For example, Figures 999.1 and 999.2 show two Navigator windows. When you are done with either window, you can select the window's File menu Close option to close the window or simply click your mouse on the window's Close button.

Figure 999.1 Using multiple Navigator windows to surf the Web.

Similarly, as shown in Figure 999.2, within Navigator, you can click your right mouse button on a link within the current Web page and choose Open in New Window to open the selected link in a new Navigator window.

Figure 999.2 Opening a link into a new Navigator window using the Context menu.

Using Netscape's Online Reference Library 1000

As you learned in Tip 992, Communicator provides help materials for you in many forms. From the Navigator Help menu, you can choose the Reference Library option, as shown in Figure 1000.1, to open a Web-based reference page (*http://help.netscape.com/products/client/communicator/reflib.html*) as shown in Figure 1000.2. From the Reference Library Web page, you can click your mouse on a variety of links to research topics pertaining to the use of the Netscape Communicator suite and the Internet in general.

Figure 1000.1 The Reference Library option on the Netscape Help Menu.

Figure 1000.2 Netscape's Reference Library Web site.

1001 Internet Tips

1001 Sending the Current Web Site to an e-mail Recipient

As you surf the Web, there may be times when you encounter a site, the contents of which you would like another user to see. In such cases, you can e-mail a link to the current page to another user right from within Navigator. To send the current page or a link to the current page to an e-mail recipient, perform the following steps:

1. Within Navigator, click your mouse on the File menu and choose the Send Page option. Navigator, in turn, will open an e-mail with the Web site's link included in the body of the e-mail, as shown in Figure 1001.

Figure 1001 Mailing a link to a Web site to an e-mail recipient.

2. Within the e-mail window, simply address the message, add a subject line, type any additional text you would like in the body of the message, and then click your mouse on the Send button. Communicator, in turn, will send the message to your e-mail recipient.

Index

1blink.com, using, 493
a switch, using, 253
ABC News, viewing online, 750
access number, for Prodigy, changing, 64
active components, FrontPage 2000,
 using, 570
Active Desktop Components,
 understanding, 512
Active Desktop Gallery, objects,
 installing, 513
active server pages, understanding, 792
ActiveX, understanding, 791
Address Resolution Protocol
 table
 adding entries, 843
 deleting entries, 844
 displaying, 842
 understanding, 841
addresses, e-mail, understanding, 86
all switch, using, 839
All-In-One page, searching with the, 491
altavista.com, using, 478
Amazon.com, viewing, 737
America Online
 Buddy List, introduction, 28
 channels, understanding, 25
 classes, taking, 34
 e-mail, sending, 32
 Favorites List, building, 31
 games, playing on, 36
 Instant Messenger, using, 28
 Kids Only channel, using, 26
 Member Directory, searching, 38
 navigating, 23
 NetFind, using, 24
 reading news on, 37
 searching, 24
 shopping on, 33
 travel reservations, making, 27
 Wall Street information, getting, 39
 Welcome Window, understanding, 35
analog connections, understanding, 18
Apache Web Server
 folder structure, understanding, 832
 HTTPF.conf file, understanding, 830

Apache Web Server
 memory, adding, 834
 software
 installing, 828
 obtaining, 827
 starting, 831
 testing, 833
 understanding, 826
applets
 Java, understanding, 776
 writing, 779
applications
 delivered via World Wide Web,
 understanding, 372
 in NetMeeting, sharing, 408
arc file format, using, 199
Archie
 installing and using, 170
 understanding, 169
archives
 adding files to, 220
 creating, with the tar command, 224
 creating with WinZip, 219
 extracting, with the tar command, 225
 files, extracting from, 222
area code, configuring, 96
arj file format, using, 204
ARPAnet, understanding, 2
AskERIC
 understanding, 696
 virtual library, using, 697
askjeeves.com, using, 484
ASPs, see active server pages,
auctions, on the Internet, 733
avi file format, using, 206
backbone, definition, 3
banking, using the World Wide Web, 738
Basic Rate Interface (BRI), description, 19
batch switch, using, 840
Bcc field, understanding, 591
bin file format, using, 197
bmp files, using, 176
Boolean operations, understanding, 483
Buddy List
 building the, 29

 configuring, 30
 introduction, 28
buddyPhone
 installing, 420
 placing a call with, 421
business, defining yours, on the Web, 536
cab file format, using, 205
cached Internet objects, viewing, using
 Internet Explorer, 660
cached Internet objects, viewing, using
 Netscape Messenger, 661
calling cards, using, with modems, 98
campgrounds, finding,
 using the World Wide Web, 678
cars
 shopping for,
 using the World Wide Web, 726
 used values, finding, 727
Cc field, understanding, 591
cdr file format, using, 185
cellular phones
 laptop connections, 884
 using with e-mail, 881
cgm file format, using, 181
Channel Bar, using, 502
Channel Viewer, using, 503
channels
 America Online, understanding, 25
 AOL Kids Only, using, 26
 as a screen saver, 504
 Channels folder, managing, 505
 contents of, viewing, 501
 properties, changing, 506
 subscriptions, comparing, 500
 viewing, form channel bar, 502
chat rooms
 creating, 326
 entering and leaving, 325
chat server, selecting, 317
chat session, within NetMeeting,
 ending, 401
chatting
 chat server, selecting, 317
 comic personality, selecting, 319
 expression, changing, 324

ignoring users, 320
message macros, using, 322
multiple chats, participating in, 323
rooms
 creating, 326
 entering and leaving, 325
text view, selecting, 327
understanding, 315
user's identity, viewing, 328
using Microsoft Chat, 316
using NetMeeting, 398
whispering, 321
with ICQ, 336
CIA publications, viewing, 699
classes, taking on AOL, 34
classrooms
 online, getting, 683
 using Internet technologies, 684
 Web sites, creating, 692
Clip Art Connection Web site, using, 539
CNN Web site, viewing, 751
college campuses, virtually touring, 719
college classes, finding,
 using the World Wide Web, 720
command line
 exiting, 127
 using, to connect to FTP, 118
commands
 finger, understanding, 263
 tar, using, 223
common gateway interface,
 understanding, 785
communication port, modem,
 understanding, 102
Compuserve
 e-mail, sending, 57
 favorite Places List, building, 56
 forums, using, 59
 navigating, 55
 What's New Window, using, 58
conferences
 CU-SeeMe, connecting to, 388
 holding, using PAL, 312
 NetMeeting, hosting, 396
Congressional members, Web sites,
 finding, 763
Congressional record, viewing most recent,
 using the World Wide Web, 759
connection phone number, for MSN,
 finding, 45
connection profiles, FTP Explorer Program,
 adding new, 155
connections
 analog, understanding, 18

closing, without exiting FTP, 129
dumb terminal, 226
ISDN, understanding, 19
modem, simplifying, 99
multilink modem, using, 111
options while away, 885
T-carrier, understanding, 20
types, understanding, 21
content
 inappropriate,
 viewing by accident, 359
 of the Internet, understanding, 9
cookies
 controlling
 using Internet Explorer, 662
 using Netscape Messenger, 663
 understanding, 659
credit cards, using, on the Internet, 452
ct file format, using, 188
CU-SeeMe
 conferences, connecting to, 388
 configuration, testing, 385
 contact card, creating a new, 386
 Listener, using, 387
 other users, communicating with, 389
 Phone Book, using, 384
 software, configuring, 383
 software and hardware,
 understanding, 382
 understanding, 381
 World Web site, using, 390
database, connecting, to Web sites, 575
debug command, File Transfer Protocol,
 using, 132
default browser, configuring, 939
Default Viewer, MSN, using, 46
default Web pages, changing, 922
degree programs, online, discussing, 722
dejanews.com, using, 480
DHTML, see Dynamic HyperText
 Markup Language,
dialing properties, dialog box, using, 96
dialing schemes, using, 100
Dial-Up Networking, discussion, 112
Dial-Up Server
 turning off, 114
 using, 113
Dial-Up session, remote user,
 disconnecting from a, 115
dib image format, using, 182
digital business card,
 creating and inserting, 605
digital certificates, using,
 with Internet Explorer, 451

digital ID
 getting, from Verisign, 447
 understanding, 446
digital signature
 assigning, 622
 obtaining, 621
 understanding, 443
dir command, using, 120
directories
 File Transfer Protocol, deleting, 147
 multiple on File Transfer Protocol,
 getting, 139
 on FTP sites, creating new, 142
directory, local computer, changing, 136
directory structure, File Transfer Protocol,
 viewing, 144
DNS server, configuring, 82
doc file format, using, 189
Domain Name System (DNS),
 understanding, 81
domain names
 DNS, understanding, 81
 registering, 83
 searching, using Whois, 267
 understanding, 80
DOS commands, running, from FTP, 119
download sites, finding, 774
downloads, stopping, 947
dumb terminal, description, 226
Dynamic Host Configuration Protocol,
scope options, assigning, 805
Dynamic Host Configuration Protocol,
 understanding, 804
Dynamic HyperText Markup Language,
 understanding, 799
e-commerce, introduction, 13
education, using mailing lists for, 694
electronic cards
 sending
 using Be Mine, 677
 using Message mates, 676
electronic mail, see e-mail,
e-mail
 addresses, understanding, 86
 and cellular phones, 881
 attaching a file to, in Pine, 243
 Bcc field, understanding, 591
 Cc field, understanding, 591
 checking
 with Pine, 239
 with Telnet, 235
 composing
 using Netscape Messenger, 637
 using Outlook Express, 590

1001 Internet Tips

Compuserve, sending, 57
deleting with Pine, 240
digital signature, assigning, 622
forwarding, 596
Hotmail, understanding, 889
ICQ service, using, 355
Juno Mail, understanding, 901
monitoring and reading,
 by your employer, 71
new, reading, 594
on MSN, using, 47
Outlook Express
 adding graphics, 606
 assigning priority to, 619
 attaching files, 601
 configuring, 585
 creating folders, 609
 creating offline, 613
 cutting and pasting text, 614
 encrypting, 620
 inserting a Web address, 607
 inserting file text contents, 602
 inserting signatures, 604
 saving file attachments, 603
 sorting, 599
 viewing file attachments, 603
 viewing its properties, 608
playing games using, 665
printing, 595
private accounts, having, 906
Prodigy, checking, 65
recipients, selecting, 593
replying, 597
replying and forwarding with Pine, 242
sending
 on AOL, 32
 to pagers, 882
sending with Pine, 241
specific message, finding, 600
spell checking, 592
stationary, using, 632
understanding and discussing, 583
using with PDAs, 888
e-mail group, creating and using, 626
EmailFerretPRO Search Utility, using, 488
emf file format, using, 180
employers, researching online, 497
encryption
 areas to avoid when using, 449
 key length, understanding, 440
 public key, understanding, 442
 single key, understanding, 441
 understanding, 439
encryption key, creating,

 on Pretty Good Privacy, 455
encryption software, understanding, 448
encyclopedias, browsing online, 689
eps files, using, 178
ESPN Web site, viewing, 752
excite.com, using, 474
exe file format, using, 184
Explorer Bar, using, 917
Extensible Markup Language,
 understanding, 800
f switch, using, 256
Fannie Mae Web site, viewing, 710
Favorite Places List, Compuserve,
 building, 56
Favorites List, building, on AOL, 31
faxing, using the Internet, 422
file, multiple, sending to FTP site, 141
file compression, using LHARC, 203
file formats
 arc, using, 199
 arj, using, 204
 avi, using, 206
 bin, using, 197
 cab, using, 205
 cdr, using, 185
 cgm, using, 181
 ct, using, 188
 dib image, using, 182
 doc, using, 189
 emf, using, 180
 exe, using, 184
 gz, using, 200
 hqx, using, 196
 lha, using, 203
 Microsoft Office, using, 190
 mov, using, 211
 mp3, using, 209
 mpeg, using, 208
 mpg, using, 208
 on the World Wide Web,
 using various, 172
 pcx, using, 191
 pdf, using, 210
 PICT, using, 192
 prn, using, 186
 sea, using, 198
 sit, using, 194
 tga, using, 193
 txt, using, 183
 uu, using, 195
 uud, using, 195
 uue, using, 195
 wav, using, 207
 z, using, 200

 zip, using, 201
 zoo, using, 202
file transfer, completion notification, 126
File Transfer Protocol
 closing a connection,
 without exiting, 129
 command line, exiting, 127
 connecting and disconnecting,
 using FTP Explorer toolbar, 158
 connecting to,
 using the command line, 118
 connecting to a site, 130
 debug command, using, 132
 dir command, using, 120
 directories, deleting, 147
 directory structure, viewing, 144
 DOS commands, running from, 119
 Explorer Program,
 starting and connecting, 154
 file, downloading from, 122
 file properties, viewing, 163
 files
 changing the name of, 146
 deleting from remote host, 131
 getting Help, 135
 glob command, using, 133
 hash command, using, 134
 listing of commands, getting, 145
 literal command, using, 137
 local directory, changing, 136
 log on, changing, 150
 ls command, using, 120
 moving around a site, 128
 multiple directories listing, getting, 139
 multiple files
 deleting, 138
 getting, 140
 sending, 141
 new directories, creating, 142
 option settings, determining, 148
 output, giving less, 151
 quote command, using, 137
 stopping prompts, 143
 trace command, using, 149
 transfer mode, setting, 125
 transferring files to a server, 123
 understanding, 117
 Windows-based program,
 installing, 153
 working a, 121
files
 bmp, using, 176
 deleting from remote host, 131
 downloading, using a Web browser, 171

downloading from an FTP site, 122
eps, using, 178
extracting, 222
File Transfer Protocol,
 changing the name of, 146
gif, using, 173
in NetMeeting,
 sending and receiving, 407
jpeg, using, 174
multiple
 deleting from FTP site, 138
 getting from FTP site, 140
on the local system,
 adding to remote system, 124
png, using, 177
tiff, using, 175
transferring, to an FTP server, 123
wmf, using, 179
financial information, getting, 705
financial news, on the Internet, 704
FindLaw Web site, using, 702
finger command, understanding, 263
finger program
 installing, 264
 using, 265
firewalls
 understanding, 430, 806
 using Proxy Server 2.0, 815
forums, on Compuserve, using, 59
fpArchie, installing and using, 170
freeware
 discussion, 152
 understanding, 770
Friends feature, on MSN, using, 54
FrontPage, introduction, 532
FrontPage 2000
 active components, using, 570
 All Files report, using, 558
 broken hyperlinks report, using, 561
 folder view, using, 557
 formatting toolbar, using, 580
 HTML page view, using, 567
 hyperlink view, using, 560
 hyperlinks, creating, 574
 Internet Explorer, launching from, 556
 multiple Web sites, creating, 564
 navigation view, using, 559
 normal page view, using, 566
 page view, using, 565
 preview page view, using, 568
 server extensions, understanding, 555
 standard toolbar, using, 579
 task view, using, 563
 themes, using, 562
 toolbars, understanding, 578
 understanding, 551
 Web page components, using, 569
 working with text, 573
FrontPage Express
 understanding, 545
 using, 547
FTP, see File Transfer Protocol,
FTP Explorer Program
 command, canceling, 159
 connection profiles, adding new, 155
 creating new directories, using the, 168
 deleting files, 162
 download path, setting, 167
 downloading files, 160
 e-mail address for the, setting, 167
 FTP log, viewing, 166
 icon sizes, changing, 164
 starting and connecting, 154
 toolbar, using, 156
 transfer mode, changing, 165
 uploading files, 161
 view, refreshing, 157
FTP log, FTP Explorer Program, using, 166
games
 at happypuppy.com, 675
 at Yahoo, 674
 on the Internet, finding, 672
 playing by e-mail, 665
 playing on AOL, 36
gif files, using, 173
glob command, File Transfer Protocol,
 using, 133
GNU Project, understanding, 250
GO Network, using, 473
gopher
 Jughead, understanding, 306
 understanding, 301
 Veronica, understanding, 305
 World Wide Web, comparing, 304
gopher client, using a Web browser,
 as a, 302
gopher site, using, 303
goto.com, using, 479
governments, state and local, viewing, 765
graphics
 on the World Wide Web, using, 172
 viewing with,
 Microsoft Photo Editor, 214
groceries, buying online, 723
Guerilla Marketing Online Web site,
 using, 541
gz file format, using, 200
hackers
 protecting from, 429
 understanding, 431
happypuppy.com, games, using, 675
hardware
 CU-SeeMe, understanding, 382
 Internet phone, requirements, 419
hardware settings, modem, controlling, 101
hash command, File Transfer Protocol,
 using, 134
headhunters.com, using, 495
health topics, researching,
 using the World Wide Web, 741
Heiros Gamos Web site, using,
 for legal and government, 703
Help
 File Transfer Protocol, getting, 135
 for Internet Explorer, getting, 954
history
 of the Internet, understanding, 2
 of the World Wide Web,
 understanding, 12
homes
 finding,
 using Relocate America.com, 708
 looking online, 707
host name
 finding, 253
 for a computer, setting, 829
hotbot.com, using, 477
Hotmail
 account
 getting a, 890
 logging into, 891
 address nicknames, creating, 897
 folders, creating, 898
 options, examining, 900
 reading e-mail on, 892
 replying to, 895
 sending e-mail with, 893
 sending file attachments, 894
 understanding, 889
hqx file format, using, 196
HTML, see HyperText Markup Language,
HTML Interactive Tutorial, using, 534
HTTP protocol, understanding, 871
HTTPD.conf file, Apace Web Server,
 understanding, 830
hyperlinks
 understanding, 212
 using, 574
HyperText Markup Language,
 understanding, 798
HyperText Transfer Protocol, see HTTP,
I Seek You, see ICQ,

I switch, using, 257
ICA protocol, understanding, 872
Iconocast Web site, using, 540
Iconographics Design Web site, using, 537
ICQ
 Add/Change Current User sub-menu, using, 342
 advanced mode, understanding, 345
 advanced mode user menu, understanding, 348
 chatting on, 336
 e-mail Service, using, 355
 Enhanced Online Status menu, using, 349
 Follow Me Service, using, 356
 installing, 330
 Invitation Wizard, using, 341
 message archive, using, 357
 messages, sending, 334
 My ICQ Homepage, understanding, 351
 Notes Service, using, 353
 Now button, using, 347
 online status, changing, 338
 Preferences dialog box, using, 344
 Reminder Service, 352
 Security and Privacy dialog box, using, 343
 sending a URL, using, 335
 services, understanding, 350
 starting, 331
 system menu, understanding, 339
 To Do List Service, using, 354
 understanding, 329
 user list information, viewing and changing, 337
 users, adding to, 332
 Web Search Box, using, 346
 White Pages, using, 358
 window display, changing, 333
 menu, understanding, 340
IIS, see Internet Information Server,
images
 inserting, into Web pages, 572
 Open Prepress, using, 187
 pornographic, discussion, 360
inappropriate content, viewing, by accident, 359
Inbox, Outlook Express, understanding, 586
Inbox Assistant, Outlook Express, using, 631
Independent Computer Architecture Protocol, see ICA

Index Server, Microsoft, understanding, 825
information, finding, on the Internet, 465
InfoZoid, using, 492
instant message services, PAL, understanding, 307
Instant Messenger, using, 28
Integrated Services Digital Network connections, understanding, 19
Internet
 accessing, at work, 67
 accessing the, 8
 citing for the, 688
 content of the, understanding, 9
 credit card shopping, 452
 faxing with the, 422
 financial news, finding, 704
 funding the, 7
 games, finding, 672
 having fun on the, 664
 history of the, understanding, 2
 information, finding on the, 465
 intranet, comparing, 819
 introduction, 1
 legal information, on the, 700
 makeup of the, understanding, 3
 MP3 files, finding on the, 371
 protecting children on the, 366
 sending material to co-workers, 72
 software, getting, 152
 sports
 listening on the, 516
 watching on the, 517
 understanding, 1
 use of, company monitoring, 70
 using for teachers, 682
 using while teaching classes, 687
 White Page Directories, using, 498
 World Wide Web, differentiating between, 11
 Yellow Page Directories, using, 499
 zone security settings, controlling, 933
Internet Connection Wizard, using, 945
Internet Content Advisor
 access, controlling, 363
 language settings, specifying, 362
 nudity settings, specifying, 362
 password, controlling, 364
 sex settings, specifying, 362
 understanding, 361
 violence settings, specifying, 362
Internet Domain Name, searching, using Whois, 267
Internet Exchange, developing, 693
Internet Explorer

accessibility options, configuring, 940
Address Bar, using, 913
advanced browser settings, configuring, 941
advanced multimedia settings, configuring, 942
advanced search options, configuring, 915
browsing offline with, 510
Channel Bar, using, 502
Channel Viewer, using, 503
Channels Folder, managing, 505
color utilization, configuring, 926
configuring settings, with a server, 818
cookies, controlling, 662
Explorer Bar, using, 917
Favorites folder, adding to, 918
Favorites folder, organizing, 920
font utilization, configuring, 927
FrontPage 2000, launching, 556
Help, getting, 954
History folder, using, 930
HTTP 1.1, understanding, 951
Java Virtual machine, configuring, 943
language support, controlling, 928
Links Toolbar, configuring, 912
Radio Toolbar, using, 952
starting, 909
temporary files, viewing, 660
Tip of the Day, turning on, 959
toolbars, using, 910
using, with proxy server, 817
using digital certificates with, 451
Web sites, viewing, 549
Internet Information Server
 FTP Service, understanding, 823
 Microsoft, using, 821
 NNTP Service, understanding, 824
 WWW Service, understanding, 822
Internet jump off, understanding, 466
Internet Locator Server, setting up, 416
Internet Marketing Center Web site, using, 544
Internet name, looking up an, using NS-Batch, 857
Internet Name Server Look-Ups, understanding, 855
Internet Name Space, understanding, 81
Internet names, types of, 859
Internet phone, using, with NetMeeting, 417
Internet projects, for students, 691
Internet Protocol
 shortcomings of the, 78

Version 6, understanding, 79
InterProtocol address
 binary numbers, explanation, 74
 classes of, 75
 shortage of, discussion, 77
 understanding, 73
Internet Security Protocol, see IPSec,
Internet Service Provider
 introduction, 8
 online services,
 differentiating between, 17
 server directory, using, 84
 shopping for an, 16
 understanding, 15
 using MSN as your, 43
Internet settings, configuring, 911
Internet telephony, understanding, 418
intranet
 Internet, comparing, 819
 setting up, 820
Invitation Wizard, on ICQ, using, 341
IP address
 host name, finding, 253
 releasing, 837
 renewing, 838
 see Internet Protocol address,
IPCONFIG
 using, 835
 with the /all switch, 839
 with the /batch switch, 840
IPSec, understanding, 880
ISDN Wizard, using, 110
ISPs, see Internet Service Provider,
j switch, using, 261
Java
 applets, understanding, 776
 programs, writing, 779
Java platform, understanding, 775
JavaScript
 learning to write, 778
 understanding, 777
job search
 employers, researching online, 497
 using headhunters.com, 495
 using jobs.com, 496
 using monster.com, 494
jobs.com, using, 496
jpeg files, using, 174
Jughead, understanding, 306
Juno Mail
 software, getting, 902
 understanding, 901
 using, 903
k switch, using, 261

Kelly Blue Book Web site, using, 727
key length, encryption, understanding, 440
LAN connection, selecting, 946
language settings, specifying, 362
LANs, see local area network,
lawoffice.com, using, 701
LDAP protocol, understanding, 874
legal information
 finding
 on the Internet, 700
 using thomas.loc.gov, 757
 FindLaw Web site, using, 702
 Hieros Gamos Web site, using, 703
 Supreme Court, viewing online, 764
legislation, finding,
 using the World Wide Web, 757
lha file format, using, 203
LHARC, using, 203
Light Directory Access Protocol, see LDAP,
Linux
 getting, 247
 understanding, 245
 versions, differences between, 246
Listener, CU-SeeMe, using, 387
literal command, File Transfer Protocol,
 using, 137
loan calculators, online, using, 730
loans, researching online, 731
local area network, understanding, 68
local system file, remote system,
 adding to, 124
lottery numbers,
 checking on the World Wide Web, 673
ls command, using, 120
lycos.com, using, 476
macro viruses, understanding, 433
macros, message macros, using, 322
mailing lists
 finding, 297
 education, using, 694
 newsgroups, comparing, 296
 posting to a, 300
 subscribing to, 298
 understanding, 295
 unsubscribing from, 299
marketing
 Guerilla Marketing Online, using, 541
 Internet Marketing Center Web site,
 using, 544
 NetMarketing Web site, using, 543
 Web Digest, using, 542
masks, subnet, understanding, 76
Media Player, Microsoft, using, 464
medications, researching,

 using the World Wide Web, 745
Member Directory, on AOL, searching, 38
Message Mates, electronic cards, using, 676
messages
 attaching files to, 287
 canceling a posted, 281
 digitally signing,
 using Pretty Good Privacy, 456
 encrypting,
 using Pretty Good Privacy, 457
 forwarding, 285
 inserting a hyperlink, 289
 inserting a picture, 290
 large, sending to newsgroups, 286
 posting to newsgroups, 279
 responding to, using PAL, 311
 responding to a newsgroup, 283
 responding to author only, 284
 sending, using ICQ, 334
 sending, using PAL, 310
 sending, via NetMeeting, 400
 within a newsgroup, finding, 282
meta search engines, using, 490
metacrawler.com, using, 490
MetaFrame server, understanding, 378
Microsoft Chat
 comic personality, selecting, 319
 expression, changing, 324
 message macros, using, 322
 multiple chats, participating in, 323
 personal information, customizing, 318
 specific user, ignoring, 320
 text view, selecting, 327
 user's identity, viewing, 328
 using, 316
 whispering, 321
Microsoft Index Server 2.0,
 understanding, 825
Microsoft Media Player, files, playing, 464
Microsoft Network
 connection phone number, finding, 45
 Default Viewer, using, 46
 e-mail, using, 47
 Friends feature, configuring, 54
 icon, using, 44
 Member Services Page, using, 52
 MSNMember Web page, using, 48
 Services menu, using, 50
 software for, getting, 41
 Support Flash Page, using, 53
 understanding, 40
 Update Page, using, 49
 using as your ISP, 43
 version, updating, 42

Web Communities Page, using, 51
Microsoft Network Home page,
 personalized, configuring, 468
Microsoft Office file types,
 working with, 190
Microsoft Online,
 getting support from, 956
Microsoft Outlook Express, starting, 584
Microsoft Photo Editor,
 viewing graphics with, 214
Microsoft Terminal Server,
 understanding, 377
Microsoft Wallet
 installing, 935
 using, 936
modem, speed, discussed, 18
modem connection, selecting, 946
modem list, removing from, 93
modems
 advanced settings, using, 108
 call preference settings,
 configuring, 106
 calling cards, using, 98
 communication port,
 understanding, 102
 connections, simplifying, 99
 data connection settings,
 customizing, 105
 dialing properties, configuring, 95
 dialing schemes, using, 100
 hardware settings, controlling, 101
 log.txt file, using, 109
 maximum speed setting,
 understanding, 104
 multilink connections, using, 111
 new software, installing, 92
 phone line specific, configuring, 97
 properties, displaying, 94
 removing old, 93
 settings, customizing, 91
 speaker volume, controlling, 103
 troubleshooting, 109
 UART settings, configuring, 107
monster.com, using, 494
mortgages, online, viewing, 711
mov files, using, 211
MP3 files
 finding, 371
 using, 209
MP3 players
 portable, using, 370
 understanding, 367
 WinAmp, using, 368
mpeg files, using, 208

mpg files, using, 208
MSN, see Microsoft Network,
MSN Game Zone, using, 671
MSN Web Search, using, 471
MSNMember Web page, using, 48
MUDs, see Multiple User Dungeons,
 multilink modem connections,
 using, 111
Multiple User Dungeons
 commands, basic, 669
 finding a, 667
 logging into a, 668
 MOOs, understanding, 666
 MUSHs, understanding, 666
 understanding, 666
 Z MUD Client, using, 670
My ICQ Homepage, understanding, 351
My Yahoo Web page, personalized,
 configuring, 467
names
 domain
 registering, 83
 understanding, 80
 usernames, understanding, 87
NASA Web site, viewing, 766
national parks
 reserving,
 using the World Wide Web, 680
 visiting,
 using the World Wide Web, 679
NetBIOS
 computer names, understanding, 803
 understanding, 802
Netcenter, joining, 963
net-etiquette, using, 271
NetMarketing Web site, using, 543
NetMeeting, applications, sharing, 408
NetMeeting
 audio settings, configuring, 404
 call settings, configuring, 404
 calling, using IP address, 397
 calling another user within, 395
 chat, using, 398
 chat session, ending, 401
 collaborating in, 409
 conferences, hosting, 396
 directory service, changing, 394
 ending, 412
 files, sending and receiving, 407
 History screen, using, 410
 Home Page, using, 406
 Internet phone, using as a, 417
 interruptions, preventing, 403
 menus, using, 413

messages,
 sending to one participant, 400
Navigation Bar, using, 414
personal information, setting, 411
software
 getting, 392
 starting, 393
speed dials, creating, 402
toolbars, using, 413
understanding, 391
using with Outlook, 415
video settings, configuring, 404
Web directories on, using, 405
Whiteboard, using within, 399
Netscape
 customizable Web portal, using, 469
 Netcenter, joining, 963
Netscape Communicator
 advanced options, configuring, 984
 bookmarks, adding, 988
 cache, configuring, 986
 current Web page,
 sending as e-mail, 1001
 getting Help, 992
 installing, 962
 Navigation Toolbar,
 understanding, 966
 Personal Toolbar, understanding, 965
 preferences, setting, 971
 toolbars, turning on and off, 964
 using, 961
Netscape Messenger
 Address Book
 customizing, 657
 using, 656
 cached Internet objects, viewing, 661
 configuring, 634
 for a news server, 292
 cookies, controlling, 663
 e-mail
 assigning priorities, 655
 attching files, 647
 composing, 637
 finding a specific, 646
 forwarding, 643
 inserting graphics, 658
 moving folders, 651
 printing, 642
 replying, 644
 sorting, 645
 spell checking, 639
 e-mail attachments,
 viewing or saving, 648
 e-mail folders, creating, 650

e-mail recipients, selecting, 640
e-mail text, cutting and pasting, 654
folders, understanding, 635
Message Toolbar, using, 636
new e-mail, reading, 641
newsgroups
 subscribing to, 293
 unsubscribing to, 294
Trash folder, emptying, 652
Unread messages, displaying only, 649
using, 633
Netscape Navigator, using,
 with proxy server, 816
Netscape Newsreader, starting, 291
Network News Transfer Protocol, see NNTP,
 network security, understanding, 427
networking, virtual private,
 understanding, 116
news, reading, on AOL, 37
news sending format,
 changing to HTML, 288
news server, within Netscape Messenger,
 setting up, 292
NewsFerretPRO Search Utility, using, 489
newsgroup servers, within Outlook Express,
 configuring, 275
newsgroups
 categories, using, 270
 for teachers, 695
 history of, 269
 large messages, sending, 286
 mailing lists, comparing, 296
 messages
 attaching files to, 287
 finding within, 282
 forwarding, 285
 inserting hyperlinks into, 289
 inserting pictures into, 290
 posted messages, canceling, 281
 posting a message to, 279
 posting messages to multiple, 280
 responding to author only, 284
 responding to messages, 283
 subscribing to, 277
 understanding, 268
 unsubscribing from, 278
 using net-etiquette, within, 271
 using passively, 272
 viewing, in Outlook Express, 276
Newsreader, Netscape, starting, 291
newsreaders, using, 273
NNTP protocol, understanding, 870
non-rated sites, access to, controlling, 363
NS-Batch program
 installing, 856
 reverse name look up, performing, 858
nudity settings, specifying, 362
offline items
 channels, making, 509
 Web sites, making, 509
offline Web sites
 synchronizing, 511
 understanding, 507
online chatting, understanding, 315
online degree programs, discussing, 722
online loan calculators, using, 730
online mortgages, viewing, 711
online services
 America Online, navigating, 23
 Compuserve, navigating, 55
 ISPs, differentiating between, 17
 Microsoft Network, navigating, 40
 Prodigy, using, 60
 understanding, 22
online status, ICQ, changing, 338
Open Prepress images, using, 187
OPI images, see Open Prepress images, 187
Outbox folder, Outlook Express,
 understanding, 617
Outlook, using with NetMeeting, 415
Outlook Express
 Address Book
 customizing, 624
 printing, 625
 using, 623
 configuring, for e-mail, 585
 Deleted Items Folder
 emptying, 611
 emptying upon exit, 612
 digitally signing messages,
 using Pretty Good Privacy, 456
 downloads, controlling, 630
 e-mail
 adding graphics, 606
 assigning priority to, 619
 composing within, 590
 creating offline, 613
 encrypting, 620
 forwarding, 596
 inserting a file, 601
 inserting a Web address, 607
 inserting file text contents, 602
 inserting signatures, 604
 printing, 595
 replying, 597
 saving file attachments, 603
 sorting, 599
 viewing file attachments, 603
 e-mail folders
 creating, 609
 moving into, 610
 e-mail group, creating and using, 626
 e-mail properties, viewing, 608
 e-mail recipients, selecting, 593
 e-mail stationary, using, 632
 e-mail text, cutting and pasting, 614
 folders, understanding, 586
 Inbox Assistant, using, 631
 message rules
 understanding, 627
 using, 628
 new messages, reading, 594
 News sending format, changing, 288
 newsgroup servers,
 configuring within, 275
 newsgroups, viewing within, 276
 Outbox folder, understanding, 617
 read messages, determining, 618
 receive operation
 initiating, 615
 stopping, 616
 scheduling operations, 629
 send operation, initiating, 615
 specific message, finding, 600
 spelling options, using, 592
 starting, 274, 584
 toolbar, understanding, 587
 Unread Messages, displaying only, 598
 window columns, customizing, 589
 window layout, customizing, 588
pagers
 sending e-mail from, 883
 using with e-mail, 882
PAL, see Personal Access List, 307
parenting tips,
 finding,
 using the World Wide Web, 681
passwords
 Internet Content Advisor,
 controlling, 364
 preventing the stealing of, 90
 using effectively, 89
 working with, 88
pcx file format, using, 191
PDAs, see Personal Digital Assistants,
pdf files, using, 210
Perl, understanding, 793
Personal Access List
 conferences, holding, 312
 messages
 responding to, 311
 sending, 310

names, editing and removing, 313
online status, understanding, 314
software, installing, 308
understanding, 307
users, adding to, 309
Personal Digital Assistants
e-mail, using with, 888
using, 886
Personal Web Server
adding sites to, 530
Home Page Wizard, using, 528
installing, 524
personal files, viewing by others, 531
Publishing Wizard, using, 529
starting and stopping, 525
understanding, 523
viewing, by other users, 527
Web site, moving to, 550
Web site created on, browsing, 526
PGP, see Pretty Good Privacy, 453
Photo Editor, using, 214
PhotoDisk Web site, using, 538
physical security, understanding, 428
PICT file format, using, 192
Pine
checking e-mail with, 239
e-mail
attaching files to, 243
deleting, 240
replying and forwarding, 242
sending, 241
ending, 244
folder list, viewing, 238
Q command, using, 244
starting in a shell account, 237
understanding, 236
ping utility
pings
sending a set number of, 254
sending continuously, 252
sending different sizes, 255
route, specifying, 261
understanding, 251
ping
avoiding the break up of, 256
priority, setting, 258
route, remembering, 259
sending, different sizes, 255
sending a continuous number of, 252
sending set number of, 254
specifying, 257
time stamping, 260
wait time, setting, 262
png files, using, 177

Point to Point Protocol, see PPP,
Point to Point Tunneling Protocol, see PPTP,
PointCast, using, 514
point-to-point tunneling protocol,
introduction, 116
POP protocol, understanding, 865
pornographic images, discussion, 360
portable, MP3 players, using, 370
Post Office Protocol, see POP, 865
PPP protocol, understanding, 868
PPTP protocol
connecting to private network,
using, 878
understanding, 869
Pretty Good Privacy
decrypting messages, 458
digitally signing with, 456
encrypting messages with, 457
encryption key, creating, 455
getting, 453
software, installing, 454
Primary Rate Interface, description, 19
prn file format, using, 186
Prodigy
access number, changing, 64
account information, changing, 66
e-mail, checking, 65
icon, using, 63
site map, using, 62
software, installing, 60
starting to use, 61
programming languages
ActiveX, understanding, 791
DHTML, understanding, 799
HTML, understanding, 798
Java, understanding, 776
Perl, understanding, 793
Python, understanding, 795
VBScript, understanding, 789
XML, understanding, 800
Project Gutenberg, examining, 698
properties
modem, displaying, 94
modem dialing, configuring, 95
protocols
definition, 3
introduction, 860
TCP/IP, introduction, 3
Proxy Server 2.0
active caching, understanding, 811
content caching, understanding, 809
passive caching, understanding, 810
SOCKS Proxy Service,
understanding, 814

understanding, benefits of, 808
using, as a firewall, 815
Web Proxy service, understanding, 812
Winsock Proxy Service,
understanding, 813
proxy servers
using, 807
with Internet Explorer, 817
with Netscape Navigator, 816
public key, distributing, 445
public key encryption, understanding, 442
Publishing Wizard, using, 529
push technologies
introduction, 514
understanding, 797
pwd command, using, 231
PWS, see Personal Web Server,
Python, understanding, 795
Q command, using, in Pine, 244
quote command, File Transfer Protocol,
using, 137
r switch, using, 259
rated sites, access to, controlling, 363
ratings, for sites, getting, 365
RDP protocol, understanding, 873
Real Audio sites, listening and viewing, 459
real estate broker, finding,
using the World Wide Web, 709
RealPlayer
Presets menu, using, 462
Sites menu, using, 463
software
upgrading, 460
software, using, 461
Remote Desktop Protocol, see RDP,
remote user, disconnecting a, 115
Request for Comment (RFC), Best Current
Practice, understanding, 6
Request for Comment (RFC)
finding, 5
For Your Information,
understanding, 6
looking at, 6
Standard Track, understanding, 6
understanding, 4
restaurants, finding,
using the World Wide Web, 724
RFCs, see Request for Comment,
ROUTE CHANGE, understanding, 849
ROUTE command
understanding, 845
using, to add a route, 847
ROUTE DELETE, understanding, 848
ROUTE PRINT, understanding, 846

s switch, using, 260
screen saver, displaying channel as a, 504
scripts, understanding, 577
sea file format, using, 198
search, refining a Web, 482
search engines
 altavista.com, using, 478
 excite.com, using, 474
 GO Network, using, 473
 goto.com, using, 479
 hotbot.com, using, 477
 lycos.com, using, 475
 meta, using, 490
 MSN Web Search, using, using
 Snap.com, using, 472
 understanding and using, 470
 yahoo.com, using, 475
search results, understanding, 481
searching
 sites, multiple, 486
 using 1blink.com, 493
 using All-In-One Page, 491
 using InfoZoid, 492
 with WebFerret, 487
Secure Socket Layer, understanding, 450
security
 encryption, understanding, 439
 firewalls, understanding, 430
 hackers
 protecting from, 429
 understanding, 431
 network, understanding, 427
 physical, understanding, 428
 understanding, 426
security zone
 adding to, 934
security zone settings
 setting, 933
 understanding, 932
self-extracting executable files, using, 221
Serial Line Internet Protocol, see SLIP,
server extensions, FrontPage 2000,
 understanding, 555
server side includes, understanding, 788
servers
 MetaFrame, understanding, 378
 Microsoft Terminal Server,
 understanding, 377
 proxy, using, 807
 WinFrame, understanding, 376
sex settings, specifying, 362
shareware
 getting, at shareware.com, 771
 understanding, 769

shell account
 starting Pine, within, 237
 understanding, 229
shells, Unix, understanding, 249
shopping, using AOL, 33
signatures, digital, understanding, 443
Simple Mail Transfer Protocol,
 see SMTP, 866
Simple Network Management Protocol,
 see SNMP, 864
single key encryption, understanding, 441
sit file format, using, 194
SLIP protocol, understanding, 867
smart cards, understanding, 444
SMTP protocol, understanding, 866
Snap.com, using, 472
SNMP protocol, understanding, 864
software
 Apace Web Server, obtaining, 827
 CU-SeeMe, configuring, 383
 CU-SeeMe, understanding, 382
 encryption, understanding, 448
 for a new modem, installing, 92
 for MSN, getting, 41
 getting shareware, 771
 Juno Mail, getting, 902
 NetMeeting, getting, 392
 PAL, installing, 308
 Pretty Good Privacy, installing, 454
 Prodigy, installing, 60
 RealPlayer, upgrading, 460
 types on the Internet, 152
 virus protection, understanding, 436
 WebTV for Windows 98,
 installing, 522
source code, behind Web pages,
 viewing, 921
speaker volume, modems, controlling, 103
speed dials, within NetMeeting,
 creating, 402
sports
 ESPN Web site, viewing, 752
 listening, on the Internet, 516
 watching, on the Internet, 517
spreadsheets, adding, to Web pages, 581
SSL, see Secure Socket Layer,
stationary, using with e-mail, 632
stock ticker, using, 515
stocks, buying online, 740
subnet masks, understanding, 76
subscriptions, channels, comparing, 500
Supreme Court Web site, viewing, 764
switches
 a switch, using, 253

all switch, using, 839
batch switch, using, 840
f switch, using, 256
I switch, using, 257
j switch, using, 261
k switch, using, 261
r switch, using, 259
s switch, using, 260
v switch, using, 258
w switch, using, 262
tables, inserting, into Web pages, 571
tar command
 introduction, 223
 using
 to create archives, 224
 to extract archives, 225
T-carrier lines, understanding, 20
TCP/IP
 address configuration
 displaying with IPCONFIG, 835
 displaying with WINIPCFG, 836
TCP/IP protocol
 configuring, 863
 installing, 862
 understanding, 861
teachers, and the Internet, 682
telephony, understanding, 418
Telnet
 checking e-mail with, 235
 site
 getting around a, 231
 listing files and directories, 230
 logging into a, 228
 starting a program at a, 232
 starting the program, 227
 understanding, 226
 using, to work other Telnet sites, 233
 using to visit libraries, 234
temporary files, managing, 924
Terminal Server, Microsoft,
 understanding, 377
text, within Web pages, using, 573
tga file format, using, 193
themes, FrontPage 2000, using, 562
Thin Client
 benefits of using, 375
 introduction, 373
 understanding, 374
 using, 379
 Web site, using, 380
Thomas Web site, using, 757
thumbnails, understanding, 213
tiff files, using, 175
Time to Live counter, understanding, 257

1001 INTERNET TIPS

toolbars
 FrontPage 2000, understanding, 578
 FTP Explorer Program, using, 156
 Internet Explorer, using, 910
 Netscape Messenger, using, 636
 Outlook Express, understanding, 587
 Windows 98 Address toolbar, using, 907
Total Finger program, installing, 264
toys, buying online, 725
trace command, File Transfer Protocol, using, 149
TRACERT
 passing through, 853
 setting number of hops, 852
 understanding, 850
 using, 851
 wait time, changing, 854
transfer mode
 FTP Explorer Program, changing, 165
 setting, 125
Transmission Control Protocol/Internet Protocol, introduction, 3
travel, booking, using Expedia, 718
travel reservations, making, on AOL, 27
troubleshooting, modems, 109
txt file format, using, 183
Type of Service, understanding, 258
UART, see Universal Asynchronous Receiver Transmitter
Uniform Resource Locators, understanding, 85
Universal Asynchronous Receiver Transmitter, settings, configuring, 107
Unix
 free versions of, getting, 248
 understanding, 229
Unix shells, understanding, 249
Unix tar utility, running, 223
updating, using Windows Update, 960
URLs, see Uniform Resource Locators, 85
USA Today, viewing online, 747
USENET, understanding, 269
usernames, understanding, 87
utilities, ping, understanding, 251
uu file format, using, 195
uud file format, using, 195
uue file format, using, 195
v, switch, using, 258
vacations, setting up, using the World Wide Web, 714
VBScript, understanding, 789
Verisign, digital ID, getting from, 447
Veronica, understanding, 305

violence settings, specifying, 362
virtual private networking, understanding, 116
virtual private networks
 setting up, 876
 using, 875
Virtual Reality Modeling Language
 support, installing, 424
 understanding, 423
 Web sites, viewing, 425
virus protection software
 understanding, 436
 updating, 437
viruses
 catching, 434
 checking, on the World Wide Web, 438
 macro, understanding, 433
 understanding, 432
 worms, understanding, 435
Visual InterDev, understanding, 582
VPN Adaptor, installing, 879
VRML, see Virtual Reality Modeling Language
w switch, using, 262
Wall Street information, on AOL, getting, 39
Wall Street Journal, viewing online, 749
Wallet, Microsoft, installing, 935
WANs, see wide area network
wav file format, using, 207
weather information, finding, using the World Wide Web, 753
Web address, inserting, into e-mail, 607
Web agents, understanding, 485
Web browser
 downloading files, using a, 171
 using, as a gopher client, 302
 security zone settings, understanding, 932
Web Digest, using, 542
Web directories, within NetMeeting, using, 405
Web forms, understanding, 576
Web page address, sending, using ICQ, 335
Web page components, FrontPage 2000, using, 569
Web pages
 adding to the World Wide Web, 14
 default, changing, 922
 designing, 532
 graphics, adding, 535
 images, inserting, 572
 linking, 548

 printing, 958
 refreshing, 949
 source code, viewing, 921
 spreadsheet, adding a, 581
 tables, inserting, 571
 text, using within, 573
 viewing, on PDAs, 887
Web portal, understanding, 466
Web root, folders, using, 554
Web Search Box, ICQ, using, 346
Web site subscriptions, understanding, 507
Web sites
 available offline, 508
 databases, connecting to, 575
 effectiveness, understanding, 553
 non-rated, controlling access to, 363
 offline, synchronizing, 511
 offline, understanding, 507
 poor, learning from, 533
 purpose of, defining, 552
 rated, controlling access to, 363
 ratings, getting, 365
 subscribing to, 508
 Thin Client, using, 380
Web tutorial, taking, 955,
WebFerret Search Utility, using, 487
WebTV
 TV unit, getting, 519
 understanding, 518
 using, 520
WebTV for Windows 98
 software, installing, 522
 understanding, 521
Welcome Window, on AOL, understanding, 35
What You See Is What You Get, see WYSIWYG, 546
White Page Directories, using, 498
White Pages, on ICQ, using, 358
Whiteboard, using, within NetMeeting, 399
Whois
 understanding, 266
 using, 267
wide area network, understanding, 69
WinAmp
 installing, 368
 using, 369
Windows 98
 Address Toolbar, using, 907
 Dial-Up Networking, discussion, 112
 Dial-Up Server, using, 113
 DNS server, configuring, 82
 modem settings, customizing, 91

Windows Internet Naming Service,
 using, 801
Windows Update, using, 960
WinFrame servers, understanding, 376
WINIPCFG, using, 836
WINS, see Windows Internet Naming
Service
WinZip
 adding files to archives, using, 220
 creating archives with, 219
 evaluation version, downloading, 217
 evaluation version, installing, 218
 introduction, 201
 purchasing, online, 216
 understanding, 215
wizards
 Home Page Wizard, using, 528
 Internet Connection Wizard,
 using, 945
 Invitation Wizard, using, 341
 ISDN Wizard, using, 110
 Publishing Wizard, using, 529
wmf files, using, 179
Word Wide Web
 history of the, understanding, 12
 Thin Clients, benefits of using, 375
 adding Web pages to, 14
 applications delivered via,
 understanding, 372
 checking viruses from the, 438
 defining businesses on, 536
 finding RFCs on the, 5
 gopher, comparing, 304
 Internet, differentiating between, 11
 popularity of, understanding, 13
 Real Audio sites,
 listening and viewing, 459
 searching
 using altavista.com, 478
 using goto.com, 479
 using hotbot.com, 477
 using lycos.com, 476
 using SNAP.com, 472
 using the GO Network, 473
 using yahoo.com, 475
 with excite.com, 474
 with MSN Web Search, 471
 Thin Client, using, 379
 understanding, 10
worms, understanding, 435
WYSIWYG HTML Editor,
 understanding, 546
XML, see Extensible Markup Language
yahoo.com, using, 475

Yellow Page Directories, using, 499
z file format, using, 200
Z MUD client, using, 670
zip file format, using, 201
zip files, using WinZip, 215
zoo file format, using, 202